4-11(4)

ALSO BY R. TRIPP EVANS

Romancing the Maya: Mexican Antiquity
in the American Imagination, 1820–1915

GRANT WOOD

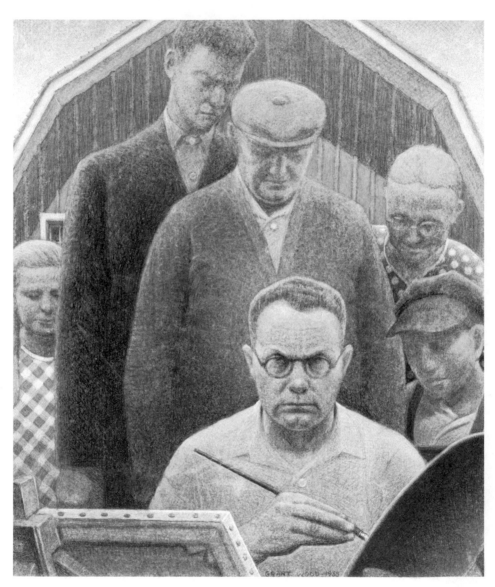

Grant Wood, *Return from Bohemia*, 1935

GRANT WOOD

[A LIFE]

R. TRIPP EVANS

ALFRED A. KNOPF NEW YORK 2010

THIS IS A BORZOI BOOK
PUBLISHED BY ALFRED A. KNOPF

Library of Congress Cataloging-in-Publication Data
Evans, R. Tripp, [date]
Grant Wood : a life / by R. Tripp Evans.—1st ed.
p. cm.
Includes bibliographical references and index.
ISBN 978-0-307-26629-3
1. Wood, Grant, 1891–1942. 2. Painters—United States—Biography.
I. Title.
ND237.W795E93 2010
759.13—dc22
[B] 2010018019

Manufactured in the United States of America
First Edition

The text of this book was set in Garamond.
Designed by Virginia Tan

COVER: Grant Wood, *Death on the Ridge Road* (detail), 1935. Oil on masonite panel,
39 x 46¹⁄₁₆ in. in frame. © Estate of Grant Wood / Licensed by VAGA.
Williams College Museum of Art, Williamstown, MA,
Gift of Cole Porter (47.1.3.). For complete image, see color plate 20.

for Ed

este livro e meu coração

[CONTENTS]

	List of Illustrations	ix
	Introduction	3
ONE	Paint Like a Man	11
TWO	American, Gothic	77
THREE	Wood into Stone	129
FOUR	A Fabled Life	197
	Epilogue	294
	Acknowledgments	315
	Notes	319
	Selected Bibliography	375
	Index	381

[ILLUSTRATIONS]

ii [frontispiece] Grant Wood, *Return from Bohemia,* 1935.

9 Don Wright, *Iowa,* 2009.

13 Francis Maryville Wood, c. 1875.

14 Hattie D. Weaver at sixteen, 1874.

17 Grant Wood's childhood home near Anamosa, Iowa.

22 Grant Wood in 1901.

27 Grant Wood, *Senior Class,* 1908.

30 Grant Wood, *Fanciful Depiction of Round-House and Power Plant,* 1920.

35 The Woods' home on Indian Creek, 1916–17.

35 3178 Grove Court, Kenwood Park.

36 Washington High School class of 1910.

37 Paul C. Hanson in 1909.

37 Vida H. Hanson in 1923.

39 Grant Wood in his army uniform, 1917.

40 Hattie Wood in 1919.

40 Frances "Fan" Prescott in the 1920s.

46 Grant Wood in Paris, 1920.

50 Grant Wood's 1923 Christmas card.

51 Grant Wood with his McKinley Junior High School art students, 1921.

51 *The Imagination Isles* (detail), 1921.

55 Exterior of Grant Wood's carriage-house studio on Turner Alley.

56 Interior of 5 Turner Alley, c. 1925.

57 Grant Wood, door to 5 Turner Alley, 1924.

62 Grant Wood at eighteen.

67 Grant Wood, cannoneer sketch for *Memorial Window,* 1928.

69 Grant Wood with colleagues at the Emil Frei Art Glass Company, Munich, 1928.

74 Grant Wood, *Return from Bohemia,* 1935.

75 Nan Wood at eighteen.

84 Grant Wood, *Cocks-Combs,* c. 1925–29.

87 The "Persephone" cameo from *American Gothic.*

88 Hattie Wood at seventy-one.

99 Grant Wood, *American Gothic* (detail), 1930.

99 Grant Wood, *Woman with Plants* (detail), 1929.

110 Carl Flick at his easel in West Amana, 1937.

111 Arnold Pyle in the summer of 1932.

117 Matilda Peet, late nineteenth century.

137 Grant Wood, *Young Corn,* 1931.

141 Grant Wood, *Appraisal* (detail), 1931.

141 Ed Rowan, 1932.

149 Stone City Art Colony, summer 1932.

150 Grant Wood at the Stone City Art Colony, summer 1932.

152 Two unidentified Stone City Art Colony students, 1932.

153 Adrian Dornbush and Grant Wood, 1932.

154 A life-drawing class at the Stone City Art Colony, 1932.

162 John Steuart Curry and Grant Wood, summer 1933.

170–71 Grant Wood, *Dinner for Threshers,* 1934.

173 Grant Wood, *Dinner for Threshers* (detail), 1934.

174 Grant Wood, *Mourner's Bench,* c. 1921–22.

181 Thomas Hart Benton, *Self-Portrait,* 1925.

189 The "Victorian Revival" interior Grant Wood designed for The Society for the Prevention of Cruelty to Speakers, Iowa City.

192 Grant Wood and Thomas Hart Benton, 1935.

192 Thomas W. Duncan and MacKinlay Kantor, c. 1936.

199 Grant Wood with his wife, Sara, c. 1935.

203 Sara Sherman Maxon as Alan-a-Dale, c. 1912.

213 Grant Wood, *Spilt Milk,* from *Farm on the Hill,* 1936.

214 Grant and Sara Wood, summer 1935.

218 Exterior of 1142 East Court Street, Iowa City.

222 Grant Wood and Nan Wood Graham, Iowa City, c. 1939.

224 Grant Wood, *The Radical,* 1936–37.

224 Grant Wood, *The Perfectionist,* 1936–37.

224 Grant Wood, *Sentimental Yearner,* 1936–37.

226 Grant Wood, *Draft Horse,* 1933.

226 Grant Wood, *Race Horse,* 1933.

227 Grant Wood, *Tame Flowers,* 1938.

228 Grant Wood, *Lilies of the Alley,* 1925.

231 Grant Wood, *In Tragic Life,* 1934.

237 Grant Wood with Park Rinard at 1142 East Court Street, late 1930s.

239 John Steuart Curry, Thomas Hart Benton, and Grant Wood, 1938.

241 Eugen Sandow, 1893.

241 Thomas Eakins, *Swimming,* 1885.

245 Grant Wood, *Sultry Night,* 1937.

248 Grant Wood, *Nude Bather* (alternate title: *Peter Funcke at Indian Creek, Cedar Rapids, Iowa*), c. 1920.

249 Grant Wood, *Saturday Night Bath,* from *Farm on the Hill,* 1936.

250 Grant Wood, *Saturday Night Bath,* 1937.

253 Grant Wood, *First Three Degrees of Free Masonry,* 1921.

253 Critius and Nesiotes, *The Tyrannicides.*

255 Grant Wood, *Charles Manson as Silenus,* 1928.

257 Grant Wood, *Fertility,* 1939.

258 Grant Wood and Eric Knight in 1941.

268 Charles Willson Peale, *The Artist in His Museum,* 1822.

269 Grant Wood, *Shrine Quartet,* 1939.

283 Grant Wood with Nan Wood Graham and Ed Graham, 1940.

288 Grant Wood's summer studio in Clear Lake, Iowa, 1941.

290 Grant Wood sketching a student model, 1941.

291 Grant Wood in Malibu, 1940.

302 Nan Wood Graham and Dr. B. H. McKeeby, 1942.

304 Nan Wood Graham in 1975.

312 Sara Sherman on Orcas Island, Washington, 1958.

COLOR PLATES

1. Grant Wood, *Van Antwerp Place,* 1922–23.

2. Grant Wood, *Adoration of the Home,* 1921–22.

3. Grant Wood, *The Spotted Man,* 1924.

4. Grant Wood, *Woman with Plants,* 1929.

5. Grant Wood, *Yellow Doorway, St. Emilion (Port des Cloîtres de l'Eglise Collegiale),* 1924.

6. Grant Wood (designer), *Memorial Window,* 1928–29, Veterans Memorial Building, Cedar Rapids.

7. Grant Wood, *American Gothic,* 1930.

8. Grant Wood, *Fall Plowing,* 1931.

9. Grant Wood, *Stone City,* 1930.
10. Grant Wood, *Portrait of Nan,* 1931.
11. Grant Wood, *Arnold Comes of Age,* 1930.
12. Grant Wood, *Self-Portrait,* 1932–41.
13. Grant Wood, *Appraisal,* 1931.
14. Grant Wood, *The Birthplace of Herbert Hoover,* 1931.
15. Grant Wood, *Midnight Ride of Paul Revere,* 1931.
16. Grant Wood, *Victorian Survival,* 1931.
17. Grant Wood, *Farmer with Corn and Pigs,* 1932.
18. Grant Wood, *Portrait of John B. Turner, Pioneer,* 1928–30.
19. Grant Wood, *Daughters of Revolution,* 1932.
20. Grant Wood, *Death on the Ridge Road,* 1935.
21. Grant Wood, *Spring Turning,* 1936.
22. John Steuart Curry, *Kansas Cornfield,* 1933.
23. Grant Wood, *Near Sundown,* 1933.
24. Grant Wood, *Parson Weems' Fable,* 1939.
25. Grant Wood, *Iowa Landscape / Indian Summer,* 1941.
26. Grant Wood, *Adolescence,* 1940.

GRANT WOOD

INTRODUCTION

SOME TIME IN THE LATE 1930S, Grant Wood confided to his sister that he had a double. Mistaken for the artist by Wood's lifelong friends and even his aunt Jeanette, this shadowy figure had appeared as far away as Omaha and as uncomfortably close as the painter's home in Iowa City. The story of Wood's doppelgänger appears only briefly in his sister Nan's memoirs—the reference is casual, the mystery left unsolved—yet it raises related questions about the impression Wood made on those who knew him best, and reveals, to use Nan's words, one of the many "strange by-products" of her brother's fame. Typically more amused than alarmed by his own celebrity, Wood confessed that in this instance "the matter makes me feel a little queer."

The fact that a stranger could have fooled the artist's family and friends so easily may be explained, in part, by their occasional inability to recognize Wood himself. As the painter related in his unfinished autobiography, his father sometimes failed to register Wood's presence even when the two stood in the same room. Similarly, following the artist's return from a summer in Paris in 1920, his neighbors in Cedar Rapids claimed not to recognize the man they'd known for decades. Even Wood's mother, who lived with him until her death at seventy-seven, could not identify her son when presented with a recent photograph of him in 1929.

Wood fared little better with the general public. His popular image as the Artist in Overalls allowed Wood to simply vanish when he appeared in his street clothes; despite ubiquitous images of the artist that had appeared in the national press, a reporter in 1938 noted that Wood "can spend two hours in Union Station in Kansas City without exciting any notice at all." Such an uncanny talent for blending into the

woodwork—reflected, rather fittingly, in Wood's brief stint as a cam-
ouflage artist during the First World War—was matched by a lifelong
habit of self-deprecation. In a typical interview at the height of his
fame, Wood claimed: "I'm the plainest kind of fellow you can find.
There isn't a single thing I've done, or experienced, that's been even the
least bit exciting."

Countless profiles of the artist in the 1930s celebrated his very ordi-
nariness as the source of his work's appeal. For these critics, Wood's life
and imagery appeared to reflect the values of a similarly unassuming,
and now vanished, rural American Golden Age—a period untainted by
the complexities and strident individualism of the modern world. In
1936, the *Daily Iowan* went so far as to print a scientific recording of
Wood's brain waves; as uniform and predictable as a sine curve, the
painter's "large, regular, and smooth" brain waves—whose pattern,
indeed, bore a striking resemblance to the rolling hills of his
landscapes—were favorably compared with the "irregular and more
complicated" brain waves of a psychology professor at the University of
Iowa. Wood's physiological makeup, it seems, represented as much of
an historical throwback as his work did.

Critics in our own time have often perpetuated this two-dimen-
sional image of the artist, yet even the most cursory investigation of
Wood's life calls into question its supposedly uncomplicated character.
Not only do we encounter a self-proclaimed "farmer-painter" who
never farmed, but also a young man whose earliest vocations lay in the
fields of jewelry design, interior decoration, and theatrical production.
Faced with Wood's public reputation as a naïve, parochial artist, more-
over, we must account for his early training in a prestigious French
atelier, his ambitious one-man debut in a Paris gallery, and his careful
study of Old Master paintings. Finally, we must reconcile this appar-
ent paragon of such "heartland" values as civic virtue and traditional
Christian morality with a man who often bristled at small-town life,
belonged to no church, and spent most of his life masking—not always
successfully—his homosexuality.

Wanda Corn claims that "it has been Grant Wood's fate to be
widely known but narrowly understood," yet I would argue he is every
bit as narrowly known as he is understood. Conservative champions
applaud the painter as a folksy chronicler of a bygone America, or a
gentle satirist of small-town foibles, whereas his detractors claim (for

the very same reasons) that he promoted a cloying, phony, or even sinister form of nationalism. Whether sympathetic or hostile to the artist's work, both camps miss the man who stands before them—and certainly, they fail to account for the arresting elements that haunt his imagery.

Wood's subtly distorted figures and tumescent landscapes, his esoteric and sometimes intentionally incorrect historical quotations, as well as his unsettling juxtapositions of scale, place, and time all belie his work's presumed legibility and communal spirit. Indeed, if we stop to consider some of the paintings for which he is best known—works like *American Gothic* (1930), *Victorian Survival* (1931), or *Parson Weems' Fable* (1939)—it is clear that his most successful images are also among his most unnerving and impenetrable. First-time viewers of these paintings often find it difficult to reconcile their immediate emotional response with the scenes before their eyes, and with good reason. Tickling our subconscious in unexpected ways, these images appear to provide a rather startling view of the artist's, as well.

American Gothic perfectly illustrates this phenomenon. Although the painting is often interpreted as an unmediated reflection of rural American values, most viewers feel neither warm nostalgia nor smug contempt when they first encounter the picture. Rather, they experience an indefinable dread. For a whole host of reasons, *American Gothic* is a profoundly creepy image—"or it can be," as Steven Biel suggested in his 2005 study of the painting, "if you look at it carefully."

The work's extraordinary fame, of course, has made it difficult for anyone to properly see it. Its composition has become an almost instantly recognizable sight gag—after the *Mona Lisa*, it may be the most parodied painting in the history of art—yet it is the rare viewer who can name its maker, determine its subject, or even identify the intended relationship between its figures (most audiences assume that the pair represents a married couple, but the artist himself insisted they were a father and daughter—a factor that, in and of itself, considerably complicates the work). Not only do *American Gothic*'s innumerable recastings obscure the artist along with his intentions, but they also banish the original work's palpable sense of confrontation. It is easier by far—a great relief, in fact—to see the likes of Paris Hilton, Paul Newman, or the latest lampooned politician holding the farmer's menacing pitchfork.

To understand the discomfort that *American Gothic* inspires, we must strip away its parodies and reproductions and consider the unique circumstances of its creation and creator. "Every masterpiece came into the world with a measure of ugliness," Gertrude Stein once wrote; "[Raphael's] *Sistine Madonna* . . . is all over the world, on grocers' calendars and on Christmas cards; everyone thinks it's an easy picture. It's our business as critics to stand in front of it and recover its ugliness." The "ugliness" Stein perceives in the *Sistine Madonna,* and that we may find in abundance in Wood's imagery, has less to do with notions of beauty or design than it does with the works' potential to move viewers in unexpected ways. By recovering this dimension of Wood's art we not only better understand the man himself, but we also rescue his remarkable works from the charge (or the accolade) that they are in some way "easy" pictures.

Rather than presenting Wood and his work as paradigms of Depression-era America, as so many have done, this study seeks to illuminate the profound and fertile *dis*connection between the artist and his period. More particularly, I am interested in the ambivalence Wood felt toward his native environment, and in the ways his allegiance to regionalism—the movement with which he is most often associated—served important private and immediate ends, rather than political or cultural ones. As if by pentimento, I hope to reveal the indelible traces of desire, memory, and dread that lie just beneath the surfaces of his work—elements that have little, if anything, to do with national character.

Even more so than any of his critics, it is Wood himself who has hampered our full understanding of his art and its motivations. Throughout his life he attempted to present himself and his work as the reflection of "authentic" American manhood—conceived as heterosexual, hardworking, wholesome, and patriotic—precisely because he believed he had fallen short of this model himself. Not only did Wood fail to achieve his father's rather daunting model of masculinity, but his short-lived "bohemian" period in the 1920s also inspired chronic suspicions concerning his character, associations, and private life. The defensive, all-American image Wood adopted in response to this scrutiny has provided as much relief to his promoters as it has fodder for his critics; yet it has also led to their rather meager harvest from his work. If we are to make better sense of his imagery, then it is our

business to recapture the compelling "ugliness" in his work (to borrow Stein's phrase) and to restore it, as well, to the man himself.

To begin to separate the artist from his mythology, we must first understand the context of Wood's rehabilitation in the 1980s—a development that ended nearly four decades of critical neglect following his death in 1942. The exhibition that reintroduced Wood to the nation, the Whitney Museum's 1983 *Grant Wood: The Regionalist Vision*, coincided rather neatly with the dawn of the Reagan era. In Wood's sunny, presumably uncomplicated imagery, conservative art critics could have found no more perfect illustration of President Reagan's relentless optimism and call to "traditional American values." Joseph Czestochowski, for example, praised Wood's art for representing "a timeless appeal to our sense of nationalism"; the artist's imagery reflected "a healthy America," he proposed, epitomizing the belief that "art and culture function best when they reflect our native heritage and emphasize the traditional values that exemplified past achievements."

At the close of the 1980s, a decade that witnessed the Christian Coalition's increasingly powerful attacks on avant-garde American artists, *American Artist* echoed Czestochowski's sentiment. Celebrating Wood's admirable appeal to decent, middle-class Americans, the magazine noted the artist's "intense sympathy for time-tested American values." If it was still "Morning in America," as Reagan's 1984 campaign had promised, then Wood's work perfectly reflected the era's patriotic glow.

That Wood's art could be marshaled to represent foggy notions of "America" and "American values" was hardly a new idea. In the artist's own day, critic Thomas Craven referred to Wood as an "American of the best type . . . independent, courageous, resourceful, industrious, and healthy in mind and body," a man whose work "[bore] as genuine a U.S. stamp as a hotdog stand." For his part, after seeing Wood's 1935 show at the Ferargil Gallery in New York, Malcolm Vaughan wrote that to love Wood's work was equivalent to loving America itself. In this earlier period, however, even sympathetic critics like Dorothy Grafly of the *Philadelphia Record* tempered such views, cautioning: "That [Wood's work] is American no one can deny; but that it is all of America, or even a composite America, is more than debatable."

How is it, then, that in our own time conservative celebrations of Wood's work not only go unchallenged, but are even reinforced by pro-

gressive institutions and critics? The answer lies, I believe, in the tremendous symbolic weight placed upon the Midwest—and more specifically, upon small-town life there—in recent years. Ever since the 2000 presidential election, of course, the polarization of American politics has been graphically represented by the presumably liberal/Democratic "blue" states on either coast and by the conservative/Republican "red" states located at the nation's center. Not only has the simplicity of this graphic proven to be extraordinarily powerful, but it has also aligned iconic figures like Wood with red-state territory (as one recent midwestern travel brochure proclaims, "Welcome to Grant Wood Country!").

If the national is to be found primarily in the local, as Wood's critics so often suggest, then we must also understand how and why the conservative imagination has privileged the Midwest over other American locales. In his 2004 study *What's the Matter with Kansas? How Conservatives Won the Heart of America,* Thomas Frank explains that in the conservative imagination, "red" and "blue" regions of the United States represent entirely different sociological profiles. The blue states are believed to embody moral relativism, bookishness, and a foreign sense of elitism, whereas the red states are felt to exemplify decency, piety, hard work, and patriotism. In a similar way, Wood's critics—both past and present—have distinguished the character of this midwestern artist from that of his urban, East Coast contemporaries.

Given conservatives' promotion of the Midwest as the heart of "real" America, there are signs that Wood's work has become an even more powerful political tool today than it was in the 1930s. In 2002, to cite a striking example of this phenomenon, one lobbying group suggested renaming the Federal Marriage Amendment "the *American Gothic* Amendment," explaining that the proposed legislation was "designed to preserve traditional heterosexual marriage, captured by Wood as the bedrock of American society." It is a wonderful irony, of course, that in 2009 Wood's native Iowa became the fourth state in the country to legalize same-sex marriage. Reinforcing the belief that Wood intended to celebrate heterosexual normalcy in *American Gothic,* many of the political cartoons that appeared in the wake of the Iowa Supreme Court's decision replaced the painting's models with a beaming, same-sex couple. The artist's putatively conservative values, it would seem, had been turned on their head.

Don Wright, *Iowa,* 2009

Five years prior to the Iowa court decision, the moral authority of Wood's work had become, quite literally, part of American common currency. In 2004 the U.S. Mint chose the artist's painting *Arbor Day* (1932) to adorn the new Iowa state quarter—a distinction that placed Wood in the prestigious company of John Trumbull and Emanuel Leutze, whose iconic *Declaration of Independence* (1818) and *Washington Crossing the Delaware* (1851), respectively, represent the only other American paintings to be similarly honored. In the press release accompanying the coin's unveiling, the U.S. Mint explained that Wood "spent his career as a proponent of small-town values, which he celebrated in the iconic images of small-town plain folk." That the artist himself is perceived to symbolize these small-town values, as much as his image of a rural tree-planting ceremony, is evidenced by the inclusion of his full name on the coin—an honor that neither Leutze nor Trumbull shares.

Beyond their basic misreading of Wood's work, both of these examples highlight the divide that has long existed between Grant Wood the icon and Grant Wood the man. How might supporters of the Federal Marriage Amendment react, for example, to the news of Wood's homosexuality? How, indeed, would the U.S. Mint respond to the artist's youthful renunciation of the "Babbitty" Midwest and, in his own words, the "gloomy inhibitions" of its small towns? Would he

remain the painter laureate of the territory that has become, as Thomas Frank claims, the "repository of national virtue"?

In 1983 the critic Hilton Kramer attacked Wood's oeuvre, and by extension the artist's Whitney retrospective, claiming that the painter was "a handy instrument for anyone wishing to turn back the cultural clock to the so-called good old days." Kramer's criticism was justified in its exposure of an all-too-common phenomenon—the misplaced gratification conservatives tend to derive from Wood's work—yet it makes no distinction between the artist's motives and those of his champions. Like so many who have written about Wood, Kramer fails to account for the personal factors that complicate everything we may think we know about his paintings.

Remarkably, most of the neglected elements in Wood's story are neither missing nor invisible. The artist's multiple closets—whether defined by his struggles with family, region, or desire—constitute no hidden realm, neatly tucked somewhere behind his public identity. Rather, they remain stubbornly and inextricably intertwined with it; the erasures, revisions, slippages, and unsettling juxtapositions that invest his work with so much of its power were all produced in plain sight. Any honest measure of Wood's art, then, preserves the transparency of his work fully intact. It is only our perception of *what* these images so nakedly reveal that requires adjustment.

PAINT LIKE A MAN

AT THE AGE OF SEVEN, Grant Wood boldly inscribed one of the cellar beams in his family's Anamosa, Iowa, farmhouse with the words: "Grant Wood was bon [*sic*] here." Although the gesture seems to indicate a prescient sense of his later fame—a celebrity that would, indeed, depend upon his roots in Iowa farm country—there is little evidence that the young Wood envisioned any future beyond his father's cornfields. The inscription does suggest, however, certain elements that would later become central to the artist's work. These include a rather elastic approach to his biography (Wood's mother had not, in fact, delivered him in the family cellar); a studied folksiness (the artist's sometimes intentional misspellings were regarded as part of his country charm); and perhaps most importantly, a resistance to paternal authority—for on the day of this admittedly tame act of vandalism, Wood had been banished to the cellar by his father.

The real birth that seems to have taken place here was a creative one. As Wood's sister Nan later recounted, it was in the family's cellar that her brother made his first drawings—works that evolved from "scribbling on the walls" and studying the pattern and color of his mother's stacked preserve jars. That he could find inspiration in such an inhospitable environment—a dark and frightening place where, as he later recalled, "damp chill . . . and a musty, earthy smell hung in the still air, mingled with the sour stench of last season's cabbages"—indicates the resourcefulness he would later exhibit as an adult. Compelled to negotiate a culture that strongly discouraged men from choosing artistic careers, and one that had fixed ideas concerning how those who did should work and live, Wood found in his art the possibility of resistance to these expectations, if not an escape from them.

Born on the eve of Valentine's Day in 1891, Wood later associated himself with Cupid's childish prankishness. His parents named their second son, however, for one of the paragons of nineteenth-century American manhood: Ulysses S. Grant. In the late Victorian era, the use of General Grant's name had become almost talismanic—evoking not only the powerful man himself, but also the male gender in a wider sense (a fact that explains his parents' odd choice, given their Quaker pacifism and Southern origins; in 1874, to cite an earlier example, Herbert Hoover's father—another Iowan Quaker—is said to have reported his newborn son's gender simply by announcing, "Well, we have another General Grant at our house"). Added to the surname of this iron-jawed warrior was the first name of Wood's maternal grandfather, DeVolson Weaver—an early Iowan pioneer whose reputation for masculine courage was equally, if more locally, admired.

By all accounts it was Wood's father, christened Francis but known by his middle name, Maryville (pronounced "Mervil"), who embodied the formidable traits of his son's namesakes. Maryville Wood was widely recognized within his community as a tireless and physically powerful worker, a plain dealer in matters of business, and a pious man whose religious convictions bore no taint of stereotypically feminine sentimentality. Described in his 1886 wedding announcement as "the manliest of men, and one of the most energetic and prosperous of our young farmers," Wood's father was eulogized fifteen years later as the apotheosis of all that was "noble and sublime in true manhood," evidenced by his "manly" piety, his "manly brow," and even his library, which was restricted only to those works "such as tended to build up a true and grand manhood."

The son of devout, abolitionist Quakers who settled in Iowa in 1859—Joseph and Rebecca Wood had left their native Virginia following John Brown's hanging—Maryville had perfectly fulfilled his period's expectations for its young men. Profoundly religious and sober even in his youth, Maryville completed two years at Lenox College in Hopkinton, Iowa, before purchasing eighty acres adjoining his parents' land in 1879. From this date forward he successfully managed both his father's farm and his own, always with an eye toward expanding his family's acreage.

In Wood's accounts of his father, Maryville appears as something of a stock character: a humorless, grim, and hardworking figure whose life

followed an orthodox and unimaginative trajectory. The choices that he made in his life, however, defy such a two-dimensional image. To begin with, Maryville's decision to enter college was an unusual one for the son of strict Quakers—a sect that still believed higher education led to prideful bookishness and worldly behavior. Although he certainly avoided the latter charge, the contents of his library do suggest an unusual degree of scholarly engagement for someone of his time, place, and religious background.

Equally unorthodox, given his occupation, was Maryville's decision to delay marriage until his thirties. By the time he married Hattie Weaver—a twenty-eight-year-old schoolteacher who, by the standards of the day, would have been considered beyond marriageable age herself—he had been farming his own land for seven years with no apparent urgency to wed. Indeed, the fact that he married at all set Maryville apart from his siblings. Not only did his sister Sallie never marry, but neither did his brothers Clarence and Eugene; a third brother, Charles, ran away from home at an early age and was never heard from again. The burden of carrying on Joseph Wood's name, then, rested with Maryville alone.

Francis Maryville Wood while a student
at Lenox College. Tintype, c. 1875

Hattie D. Weaver at sixteen, twelve years
before her marriage to Maryville Wood.
Tintype, 1874

In the first decade of their marriage, Hattie bore Maryville three
sons: Frank in 1888, followed by Grant in 1891 and Jack in 1893. Six
years later the boys were joined by a baby sister, Nan, whose arrival may
well have been unanticipated (by this date, Hattie and Maryville were
both in their mid-forties). Among this next generation of Woods, sim-
ilarly late marriages—all of them childless—effectively ended Joseph
Wood's line. After her own name in the Wood family Bible, Nan later
wrote: "The end of this branch."

Wood repeatedly characterized his father as a loner, a man of such
gloomy self-sufficiency that he often failed to acknowledge the other
members of his family. "There was a certain mystery and loneliness
about father that I sensed even as a child, a strange quality of detach-
ment which no one would ever be able to understand," Wood recalls in
his unfinished autobiography, *Return from Bohemia;* "we loved him and
revered him, yet we sensed [in Wood's manuscript, "sensed" is crossed
out and replaced with "knew"] that he was not one of us." As Nan later
discovered, Maryville's distance from his own wife was one of rather

long standing. Not only had he banned Hattie from their wedding reception—an act that reveals more cruelty than reserve—but he had also lived apart from her during the earliest period of their marriage.

Regarding his father as "the most majestic and dignified of persons," Wood insisted that everything Maryville did on the farm was "the model by which all other performances were approved or condemned." It was Maryville himself, of course, who determined the merits of his sons' performances—punishing incompetence or insubordination with a severity Wood accepted as his due; "I never questioned the infallibility of his judgments," the artist insisted, "or even resented being punished by him." According to Wood's first biographer, Darrell Garwood, "Maryville had been brought up in a school of strict discipline, and he tried to keep the tradition going" with willow-switch lashings and trips to the cellar. In the wake of such episodes, Garwood adds, "Hattie would become very tense and busy over her stove," whereas Maryville would read aloud to Wood from Gibbon's *Decline and Fall of the Roman Empire*—a bizarre ritual that may explain the artist's later, and rather peculiar, take on historical narrative.

The only other adult in the Wood home was a rough-mannered farmhand named Dave Peters, a man who lived only briefly with the family, yet who appears with surprising frequency in the artist's childhood accounts. Wood describes Peters as an unsmiling, "long, grotesque figure" with a bushy red beard; "even the way he walked was queer—striding along, hunched over and scowling at the ground, as if bound on some secret mission." Although clearly intimidated by Peters as a boy, Wood also recalled genuine pleasure in the attention that he showed him. Peters would surprise him with toy windmills and slingshots, and often regaled Wood and his brothers with thrilling stories of Indian battles. Peters also shared Wood's fondness for poring over the family's tintype albums—a pastime Maryville was not likely to have indulged, and one that would later have a profound effect on the artist's imagery.

Wood's memories of the farmhand were not all nostalgic, however. Unpredictable in his behavior, Peters could swing from gruff affection to anger and "twisted silence"—a transformation that often appears to have caught Wood off-guard. Even more unsettling than the farmhand's temperament was the physical threat he appeared to represent. Consistently in *Return from Bohemia*, Wood compares Peters to a threatening bird; "hawklike," "strut[ting] like a game-cock," and "fre-

quently ruffled," the farmhand appeared to him like "a great, beaky bird" with "sharp, condor-like eyes."

Wood's descriptions of Peters's "talon-like hands" and "whiskered lips" provide a disturbing (and even provocative) image of the farm-hand—one made all the more troubling by the story of their first encounter. After watching Peters harness a team of horses in the stable yard, Wood recalls, "[I was] caught [by] a jolt in the backsides that sent me sprawling on my face in a patch of dirt"; knocked down by a bearded ram, Wood was left "alone with my wounded pride and bruised buttocks." Added to this bizarre conflation of events—to say nothing of the scene's superimposition of the bearded man and bearded goat—is its rather revealing ending. Maryville is too far away to help the boy, and so it is his mother who calls Wood into the safety of the house.

Regardless of whether Peters posed a sexual threat to the young boy, as Wood's potentially veiled memories of him might indicate, his relationship to the hired man was certainly a complicated one. When Peters abruptly disappeared around the time of Wood's ninth birthday—the farmhand simply left one morning without a note— Wood was inconsolable. Not only did he find the suddenness of Peters's departure unnerving, but he also appears to have felt the separation from his father and brothers more keenly in Peters's absence. In a letter to his aunt Sallie around this time, Wood claims to be "all lonsome [sic] at home" and signs, "your lonsome little Grant."

Of the three Wood boys, it was Maryville's oldest son, Frank, who resembled him most. A precociously capable farmer, athlete, and mechanic, Frank was described by Garwood—in pointed contrast to Wood—as the very model of a "real boy." Having begun to shoulder adult responsibilities on the farm as an adolescent, Frank inspired nearly as much awe in the young Wood as their father did. For his part, the artist's younger brother Jack shared Frank's interests in sports, mechanics, and hands-on labor; although he was too small to work on the farm, his mischievous nature and quick temper earned him a kind of mascot status with Frank and the other men.

By his own admission, Wood was a quiet, sensitive, and physically awkward child—neither strong enough to join his father in work, nor spirited enough to warrant Maryville's gruff protectiveness; even hold-ing his father's hand, Wood once confided, made him feel like a fish

caught on a line. The artist found solace, instead, in his mother's company. No doubt sensing her son's feelings of isolation, Hattie included him in her gardening activities and taught him to name each of the flowers and plants she grew—an early introduction to the natural world that, even more so than farming, first inspired Wood's love for his native landscape. Considering him a mama's boy, Wood's brothers treated him with disdain and occasional violence; even Maryville, Garwood writes, "looked at Grant now and then and wondered how he happened to bring such a son into the world."

As the artist later told his sister, it was not until Nan's birth that he felt a sense of belonging to the family. Nan writes that "our two brothers had brown hair and were on the slender side, while Grant was blond and inclined to be chubby. He had wondered why he didn't look like his brothers. I looked so much like him that he was convinced that he was a member of the family."

The great importance Wood placed on his position in the family derived at least in part from the geographical isolation of his childhood. Indeed, until his adolescence, the artist's only experience of urban life was the occasional visit to nearby Anamosa—a village of less

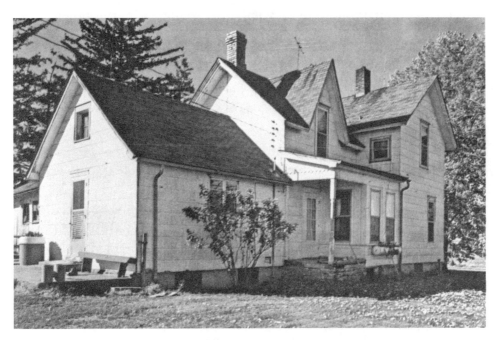

Grant Wood's childhood home near Anamosa, Iowa

than two thousand, whose Main Street ran only a few hundred yards long. Thirty miles from Cedar Rapids, and even considerably distant from neighboring farms, the Wood home functioned as a world unto itself. "Closely confined to this patch of Iowa farmland," Wood later recalled, his family lived "as completely shut away from the outside world as if [we] had been on an island in the ocean."

The extraordinary seclusion of this environment naturally lent its inhabitants a larger-than-life presence. Maryville and Hattie appear like demigods in Wood's childhood accounts, and even Peters "did not seem to belong to this world." The artist's later memories of these figures—the saintly mother, the ogre-like farmhand, and the majestic father—are not just refracted through the normally magnifying lens of childhood, then, but also tempered by his lack of exposure to other models. During the particularly claustrophobic months of winter, Wood explained, he felt at once swaddled and confined within the bosom of his family; it was at these times that he "felt most strongly the clumsy, inarticulate affection that bound us together."

If the unique circumstances of Wood's childhood—its profoundly rural setting, his father's strict expectations, and his own emotional makeup—established early self-doubts concerning his masculinity, then the cultural context of his youth only compounded this problem. Profound transformations in the raising of boys, and in the calibration of masculinity for men of all ages, reached something of a crescendo in the decade of Wood's boyhood: "At no other time in the nation's history," David Lubin writes, "had males so much cause to worry about whether or not they were being male." Anxieties concerning the cultivation of "true" manhood crept even as far as the nursery, shaping cultural beliefs concerning the meanings of boys' patterns of play, how they learned, and even such mundane details as their color preferences, clothing, and speech.

The crisis that these transformations reflect was rooted in an earlier part of the century. For the generation following the Civil War, fears concerning boys' overexposure to domestic, religious, and educational spheres—all coded feminine—led to a new emphasis on boys' toughness and their strict gender separation from girls. Wood's was the first generation of American boys, for example, to be given short haircuts and dressed in adult-style pants before the age of six—practices that ended the more traditional custom of dressing both genders alike

before this age. Furthermore, child-rearing experts like G. Stanley Hall claimed that reading "too many" books, engaging in activities such as drawing or music, and even demonstrating kindness to animals and playmates—all inclinations that Wood himself exhibited as a child—were considered patently "un-boyish." Instead, parents were counseled to encourage rough physical play in their sons and "a healthy strain of animality." No figure in this period extolled such attitudes more vociferously than Theodore Roosevelt, who declared in 1899: "I feel we cannot too strongly insist upon the need for rough, manly virtues" in the education of boys.

Roosevelt's exhortation reflects his era's unprecedented conflation of boyhood and manhood—one that placed premature expectations upon the boys of Wood's generation. (Conversely, men in this period were encouraged to recapture the adolescent wildness that might have been muted by feminine "overcivilization.") Language kept pace with this elision, evidenced by the new practice—first noted in the decade of Wood's birth—of referring to certain kinds of boys as "manly." That Wood himself felt the burden of these expectations may be clearly seen in a 1901 description of Maryville's sons. The *Anamosa Eureka* praised the Wood brothers—aged fourteen, ten, and eight—as "manly boys," "strong and manly brothers," and "strong young men, upon whom the dear mother will lean."

Wood's failure to fulfill his period's—and father's—expectations may be traced to his first attempts at drawing. In his hidden "studio" beneath the family's kitchen table, Wood explains, "I had privacy and could peer out at the world through the arched openings in the red-checkered tablecloth." That this location provided an effective hiding place raises the question, of course, from whom did he need to conceal his art? Certainly not from Hattie, who appears to have suggested the arrangement in the first place, but from Maryville—whose very presence seems to have paralyzed him. Even when concealed beneath the table, Wood drew only after his father had left for work in the fields.

Maryville's disapproval of his son's budding interests derived in part from his Quaker insistence on "truthful" imagery, yet he was also clearly concerned about the presumed *effeminacy* of making art. As Garwood explains, "The father liked masculine qualities, and regarded history, science, hard work and the proper exercise of authority as mas-

culine; religion, art, and light fiction as somehow feminine." Upon see-
ing Wood's first representational work, a Plymouth Rock hen sitting on
an improbably large number of eggs, Maryville reportedly referred to
the image as an example of the boy's "mischief" (and certainly not the
kind of boyish misbehavior that the age applauded). Indeed, most of
Wood's first subjects—Hattie's garden or brood of hens—must have
struck Maryville as inappropriately domesticated and feminine.

Equally problematic were the works' imaginative premises. Consid-
ering any form of fiction a sinful departure from factual observation,
Maryville went so far as to ban fairy tales and other children's literature
from the Wood home. As the artist himself frequently recounted, his
father once demanded that he walk miles to a neighboring farm to
return a schoolmate's copy of Grimms' fairy tales. From an early age,
then, it appears that Wood attached a sense of shame to his artwork
and its attendant sense of fantasy—even if, and perhaps because, they
allowed him to escape his father's rigid expectations.

The story of Wood's artistic development includes no early recogni-
tion of his precocious genius, nor do we find in his childhood years any
mentors who encouraged his work. More important than his innate
ability or opportunities, it seems, was his intense emotional investment
in his artwork. Addressing a group of parents at a conference in the
1930s, Wood noted the almost pathological shyness that had fueled his
early imagery:

> I was as bashful a child as ever lived. I could not speak a piece at
> the Sunday School entertainment, or sing a song at the school
> assembly. But I would pour out all my emotions and longings in
> a painting . . . Give a child a piece of paper and he will not ask
> questions. He will make drawings. This does not mean that he is
> "queer" . . . Expression, contrary to the popular notion, is not a
> mere overflowing of emotion such as crying and screaming. It is
> a controlled activity involving the selection and organization of
> materials of past experience and their fusion with present situa-
> tions to create new forms.

Although Wood's words reflect the thoughts of a mature man, they
nonetheless bear the traces of a childhood in which art was both his
greatest protection and the very location of his vulnerability. His use of

the word "queer," in particular—while lacking some of the term's modern nuances—indicates his awareness of art's perceived effeminacy. Similarly, the connection that he makes between "expression" and "crying and screaming" summons period stereotypes concerning female hysteria. More importantly, Wood's speech reveals that the most compelling element of his mature work—his selective reorganization of past experience—was present in his art from an early age, and appears to have served a deeply cathartic function.

The childhood experience that shaped Wood's life and career more than any other was the sudden death of his father in the spring of 1901, from apparent heart failure. Underscoring the unexpected nature of Maryville's death, the *Anamosa Eureka* proclaimed rather tersely: "DROPPED DEAD. Mr. Francis Maryville Wood, of Jackson Township, Is No More." For an event that would so radically alter the Wood family's fortunes, its details and immediate aftermath receive a puzzlingly detached treatment in Wood's autobiography. The artist expresses greater grief, it would appear, in his farewell to the family dog.

Of his father's funeral, Wood remembers: "I was crying, but it was because I was tired and frightened, not because I realized my father was dead and that I should mourn." As for the reactions of his family members, the artist begrudges their "businesslike" distress, "grieving so confidently, and so confidently consigning him to the hereafter." Recalled by Wood as an adult, of course, this memory reflects more than just the confused grief of a ten-year-old boy. At the time of his father's death Wood was certainly old enough, and demonstrably sensitive enough, to have grasped the gravity of such a loss. His resentment at his family's grief, then, may stem less from childish bewilderment than from his envy of those able to consign Maryville to his grave—a feat that Wood himself never accomplished. As the artist later said of his father, Maryville's "stern, haunting loneliness . . . would never surrender—even to the earth."

That Wood relates his father's death so peremptorily in his autobiography hardly diminishes its power within his narrative. For, following his account of Maryville's funeral and the family's subsequent departure from their farm, the manuscript abruptly halts. The last line of Wood's never-completed work is both non sequitur and cliffhanger: as the family travels to their new home in Cedar Rapids, a figure on horseback overtakes them to announce the news of President McKin-

Grant Wood in 1901,
the year of Maryville
Wood's death

ley's assassination. In her insightful analysis of this passage, Sue Taylor suggests that it may indirectly reflect the guilt Wood felt concerning his father's death. "This association of Maryville's death and a presidential murder," she writes, "compares the Wood family's loss to a national catastrophe, an unfortunate act of nature to the willful, criminal deed of a treasonous subject."

Wood later confessed that, in leaving the farm in Anamosa, "I had a vague, calamitous feeling that the world would never be the same again." The artist's prediction was clearly borne out in the years of his adolescence—yet it also belies the spirit of his eventual imagery, which insistently portrays the contemporary world as if it had remained unchanged from the time of his boyhood. The archaic character of his mature subjects reflects not only Wood's nostalgia for a simpler time, then, but also a form of developmental paralysis—an internal clock forever stilled by Maryville's death; as Hilton Kramer has noted, "No account of [Wood's] painting . . . can ever be expected to make much critical sense until this particular psychological deformation is given its due." In an unusual moment of self-awareness, the artist himself once acknowledged that "we're conditioned in the first twelve years of our lives and . . . everything we experience later is tied up in those twelve years." The results of his own "conditioning" appear to have been fixed by ten.

WOOD'S LIFE in Cedar Rapids represented a radical departure from the rural environment of his boyhood. The predictable rhythms of the agricultural cycle all but disappeared, whereas his family—once the extent of his known world—were reduced to playing smaller roles in a much larger cast. With no prior experience of this or any other large city, Wood must have been astonished by Cedar Rapids' size and bustling downtown. Compared to the tiny, pioneer-sized town of Anamosa, Cedar Rapids was a booming metropolis of fifty-five thousand (in the previous decade alone, its population had more than

doubled). New to Wood, too, was the sprawling presence of the city's agricultural processing plants—including the North Star Oatmeal Mill, soon to became the regional powerhouse Quaker Oats. Towering grain elevators clustered at the city's edge, clanging freight cars ran through its downtown, and lingering over all was the pleasant aroma of toasted oats.

Prior to the move from Anamosa, the only school Wood had known was the Antioch County School—a rural, one-room schoolhouse a few miles from the Woods' farm. Given the artist's later romanticization of this schoolhouse, it clearly represented another early sanctuary for him—the institutional equivalent of his studio beneath the kitchen table, overseen by a similarly maternal woman. When the artist entered the fourth grade at Polk Elementary School in Cedar Rapids, by contrast, not only were his teachers and classmates complete strangers to him, but it was also the first time Wood had encountered so many boys his own age. It was a difficult period of adjustment. As Nan later recounted:

He found it hard to talk to people and he blushed easily. Grant often had attended the Antioch School barefoot and clad in overalls. Now he was surrounded by city kids in tight-legged knee-pants and turtle-neck sweaters. His own "city clothes," selected and paid for by Uncle Clarence, were long pants, a vest, a white shirt, and a big bow tie. Grant's chubby frame, round face, and curly blond hair accentuated the different look of his attire. The boys razzed him and made him the butt of their jokes.

Wood found relief, at least, in the greater freedoms he was allowed at home. Following Maryville's death, authority in the Wood family had nominally transferred to Hattie's father and brother; in practice, however, it was she who now led the household. Despite her sporadic attempts "to carry out Father's stern beliefs," as Nan explained (fairy tales and fiction remained banned from the home, for example), the nervous and passive Hattie was hardly the disciplinarian Maryville had been. The days of corporal punishment and cellar banishments had disappeared along with the artist's father.

Gone, too, was the need to conceal Wood's artwork. Hattie's attitude toward her son's drawings had always sharply differed from her

husband's; in their new home, not only did she allow Wood to work above the family dining-room table, but she even reserved the table exclusively for her son's use. This newfound liberty, however, came at the price of Hattie's increased dependency. Although Wood did not assume the role of paterfamilias at the age of ten, as more than one profile of the artist would later suggest, his brother Frank's eventual departure from the home cast the teenage Wood as Hattie's primary caretaker and emotional mainstay. In supporting her son's developing artistic talents, then—including his precocious gift for interior decoration, for which Wood soon had paying clients—Hattie may well have been keeping an eye on her own future.

Outside of his own family, Wood's first validation as an artist came from his teachers in the Cedar Rapids school system. Chief among his supporters was Emma Grattan, who often excused Wood from his regular classes to draw in the privacy of her office (an arrangement that echoed Hattie's advocacy and protection of her son). Despite his crippling shyness, or perhaps because of it, Wood developed a broad spectrum of talents in his high-school years—from drawing and painting to furniture, jewelry, and theatrical-set design. Grattan encouraged Wood's love for theater, in particular, sensing perhaps that his strengths as a designer might lend him greater social confidence.

From his teenage years into his twenties, Wood enthusiastically participated in the tableaux vivants Grattan organized. Already rather old-fashioned by the 1910s, tableaux vivants required actors to assemble in frozen poses that recreated iconic works of art. The parlor version of these "living pictures" sometimes elicited audience participation—viewers would be asked to guess the work portrayed—yet Grattan's productions were elaborate, staged affairs with subjects announced well in advance. Designing sets and costumes for these performances, and acting in them as well, Wood learned a number of valuable lessons. Not only did the tableaux allow him to assume new identities without ever having to speak a word, but they also opened his eyes to the power of an insistently archaic medium. If the form itself recalled the entertainments of an earlier generation, then its range of visual references ran the gamut from ancient Greece to the contemporary era—all within a single evening or, ingeniously, within a single tableau. The eclectic quotations of Wood's later work, and the various "costumes" he adopted, owe a great deal to these early performances.

Like his forays into the theater, the growing number of interior-decorating commissions Wood undertook as a teenager called upon the full range of his talents—including mural painting, set design, carpentry, and metalwork. The very breadth of his interests in this period, however, obscured any clear career path for Wood—whose brothers had already chosen their own lines of work in the years following the move to Cedar Rapids. Frank had become an auto dealer, and Jack a mechanic. None of Maryville's sons, it seems, had any interest in farming—yet Wood's vocation as an artist, inchoate as it may have been at this point, fell about as far from his father's work as the Wood–Weaver clan could possibly have imagined.

In a later radio dramatization of his life, co-written by Wood and his secretary, Park Rinard, the artist revealed the deeply negative reactions his calling had elicited from the men in his family. The play's opening scene includes a speech from Maryville, who pronounces to his wife: "I'd hate to see him grow up to be a picture-painter. I want him to be a real man." In a subsequent scene, the teenage Wood haltingly confesses his wish to be a painter; to this, his grandfather DeVolson Weaver explodes: "A painter! You mean an *artist*? Of all the nitwit ideas! Painting's all right for women. But for a man—Bah! It's like tatting or crocheting. I'm ashamed of you."

Whether or not these lines represent the men's reactions verbatim, they clearly reflect Wood's memories of their attitudes—ones that retained a palpable sting, even at the height of his fame. As the artist himself once told a reporter, "For a farmer's son in Cedar Rapids, Iowa, to say he wanted to paint pictures for his life work was as startling as a girl to announce that she wanted to lead a life of shame." The equation Wood makes here is a telling one, for male artists were not only associated with sexual license but also—as DeVolson Weaver's line suggests—with a presumably feminine and unnatural form of dissolution.

As early as the 1870s in America, male artists had begun to protect themselves from such suspicion by cultivating a "manly" self-presentation and subject matter. Critics applauded the practice, for along with the general public they harbored caricatures of the artist as a consumptive, hopelessly feminized aesthete. Citing the work of Thomas Eakins and Winslow Homer in his 1901 survey *A History of American Art,* for example, Sadakichi Hartmann praised the artists' "brutality" and "rough, manly force," in distinction to the "prevailing

tendency [in American art] to excel in delicacy." It is noteworthy that in rural Iowa, where the burden of masculinity seems to have fallen even more heavily on artists' shoulders, Wood was lauded in similar terms in the 1930s. Before Wood, Phil Stong wrote in his Depression-era history of Iowa, the state's fine artists had included only a handful of "painting pansies."

Belief in male artists' effeminacy was symptomatic of a larger cultural shift in this era—a period whose amplified masculine expectations required, of course, the definition of what a real man was *not*. Enter the homosexual. In his groundbreaking 1976 study *The History of Sexuality,* Michel Foucault dates this new category to the period immediately preceding Wood's birth; by the time the artist had turned one, the term "homosexual" had officially entered the *Oxford English Dictionary.* The power of this new taxonomy lay in its transformation of an activity (something that men either did or did not do with other men) into a label that was somehow linked to a man's identity. Once homosexuality was believed to be a fixed dimension of a man's character, any suspicion of its presence—even in the absence of homosexual activity—held the potential to destroy.

In an article written for *Cosmopolitan* in 1902, entitled "What Men Like in Men," author Rafford Pyke demonstrates the inherent dangers of this threat. Pyke's essay, which attempts to catalogue the qualities that "real" men admire in one another, devotes an extraordinary amount of space to the identification and habits of the "sissy"—a term whose modern definition also first appeared in the lexicon of the 1890s. Pyke classifies two distinct varieties of sissy in his essay: those whose appearance and habits render them instantly recognizable, and those whose physical bearing and mannerisms may *appear* manly, but who nonetheless harbor a "sissy-soul" visible to discerning observers.

Pyke's warnings concerning the "invisible" sissy exemplify the self-surveillance demanded of Wood's generation. As Quentin Crisp once claimed, for those who reached adulthood in the 1910s, "manliness was all the rage. Men . . . searched themselves for vestiges of effeminacy as though for lice. They did not worry about their characters, but about their hair and their clothes, and their predicament was that they must never be caught worrying about either." The distinction that Crisp draws concerning character is an important one. By the 1890s, "true" manhood had metamorphosed from a model based on such intangible

qualities as fortitude, restraint, and reverence for God—qualities with which Maryville himself was associated—to one almost entirely based upon body type, dress, and vocation.

In all three of these categories, Wood continually fell below the mark. A chubby, awkward child upon his arrival in Cedar Rapids, he had developed into a handsome, suspiciously stylish teenager with a clear attraction to the arts. In the *Senior Class* illustration Wood created for the 1908 Washington High School yearbook, an image that appears to have been a self-portrait, the young artist demonstrates both his foppish bravado and youthful insecurity. As James Dennis writes of this drawing:

> Flanked by dark shadows, [he] stands on the edge of a step, his oversized suit resembling a gnarled vine of highlights and uneven folds. His hands are shoved insecurely into his jacket

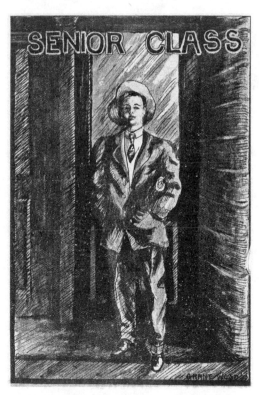

Grant Wood, *Senior Class,* 1908, from the
Washington High School *Reveille*

pockets, a gesture that offsets the token confidence of a broad-
brimmed hat thrown back on the head to reveal a childish face
staring out with a disturbing sincerity . . . [He is] an uncertain
boy costumed and posed in the clothes of a man with a hesitant
foot, feeling for the first step into adulthood.

Wood's clothing choices in this period project not so much the
naïve and inexpert projection of manhood, but rather the carefully
studied and knowing appearance of a young dandy. Arguably, the
accessories he favored—oversized suits, flowing ties, hats with exagger-
ated brims, and even a raccoon coat that he reportedly "always" wore—
rendered Wood more, rather than less, conspicuous among his peers in
Cedar Rapids. The clothing of the dandy, however, is always a form of
defense. Like the artist's eventual adoption of farmer's overalls, these
outfits represented as much a submission to convention as an exaggera-
tion of it.

Understanding only too well the equation that society made
between artists and homosexuals, the nineteen-year-old Wood tem-
porarily set aside his easel in 1910. Eager to begin his adult life beyond
Cedar Rapids, he in fact took the first train out of town on the day of
his high-school graduation ceremony. His destination that summer was
Minneapolis, where he planned to begin a career as a skilled craftsman.
Enrolling at the Minneapolis School of Design and Handicraft, also
known as the Handicraft Guild, Wood soon became a disciple of the
school's director, Ernest Batchelder.

Wood had long admired Batchelder's work in Gustav Stickley's
magazine, *The Craftsman;* indeed, by the time of his enrollment at the
Handicraft Guild, he had already completed several correspondence
courses with Batchelder. One of the leading lights of the American Arts
and Crafts Movement, Batchelder was both a respected practitioner
and a nationally known design theorist. In 1909 he had founded a suc-
cessful art-tile company in Pasadena, and in the year that Wood
enrolled at the Handicraft Guild, he had published one of the move-
ment's seminal texts, *Design in Theory and Practice.* Influenced by
Gothic revival design and the late-nineteenth-century vogue for Japan-
ese prints, Batchelder's approach to design advocated simple organic
shapes, complementary line and pattern, and an emphasis on materials'
intrinsic natural qualities.

That summer Wood embarked on an intensive study of metalwork, an activity he had first taken up in high school. With access to a forge and more sophisticated tools at the Handicraft Guild, Wood created jewelry and small decorative items that combined Batchelder's Gothic-cum-Asian aesthetics along with a careful attention to technical mastery and utility. The Arts and Crafts Movement had been founded upon just such an approach, epitomized by William Morris's often-invoked Golden Rule: "Have nothing in your houses that you do not know to be useful, or believe to be beautiful." For Wood, whose varied talents were united in his love of beautifully designed environments, Morris's gospel struck a rather deep chord.

Wood also must have realized that craft represented a more gender-appropriate outlet for his artistic impulses. In his metalsmithing and woodworking, he demonstrated a commitment to strenuous physical activity that he knew was all too absent from his easel work; as he would later defensively insist, "Painting is more work than you realize." Even after Wood had achieved success as a painter, critics continually summoned his background in craft as the touchstone for his painting—stressing the labor that his art required, rather than the emotional or intellectual investment it demanded. One critic in the 1930s claimed, for example, that "[Wood] is a man very capable with his hands, and paints a picture with the same approach he'd use in building a house or making a cabinet"; another asserted that "with equal facility and artistry, Wood repairs a watch, pitches hay, paints a picture, and dresses stone." In the logic of such assessments, Wood's painting simply belonged to a continuum of physically demanding activities in which all men engaged.

Perhaps not surprisingly, Wood's interest in decorative metal-smithing was not viewed as sympathetically back home (as Garwood noted in the 1940s, "Making jewelry and decorative items . . . could hardly be considered work"). Hoping perhaps to follow the path of his more mechanically inclined brothers, Wood found a position in 1910 as a machinist's assistant at Cedar Rapids' Rock Island Railroad shops. Compared to the Handicraft Guild—a progressive community of craftsmen, artists, and designers—the Rock Island shops were a dark, claustrophobic, and deafening industrial environment. It is not difficult to understand Wood's misery there. Trained in meticulous design and accustomed to a lively exchange with his fellow artists, he now

spent his days "just turning a wheel." A back injury eventually delivered him from the job.

Surprisingly enough, a decade later Wood celebrated the Rock Island roundhouse in a mural for St. Luke's Hospital in Cedar Rapids. Entitled *Fanciful Depiction of Round-house and Power Plant,* Wood's image turns the grimy, industrial behemoth of the Rock Island facility into a fairyland castle of spires, turrets, oriole windows, and Gothic flying buttresses—all nestled within a lush, romantically overgrown landscape. The image is a rather telling one. Not only does it illustrate the defensive function of Wood's imagination—here was a place that the artist loathed, transformed with ten years' hindsight into a fantasy of beauty—but it also demonstrates the extent to which Wood had imbibed the Arts and Crafts Movement's love for the Gothic era.

Batchelder exhorted his students to revive "the spirit that built the cathedrals of France," a time when society made no distinctions between craftsmen and artists (indeed, the name of the Handicraft Guild itself reflected this emulation of medieval craftsmanship). For his part, Morris argued in a 1884 essay, "A Factory as It Might Be," that industrial facilities should "stand amidst gardens as beautiful as those of Alcinous," and would do well to "emulate the monks and the craftsmen of the middle ages in [their] ornamentation." Whether or not

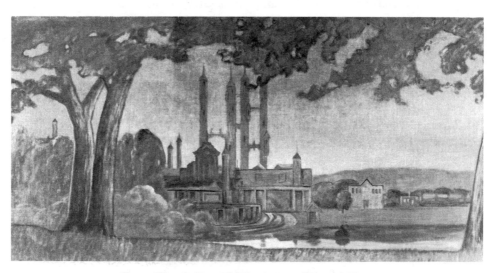

Grant Wood, *Fanciful Depiction of Round-House
and Power Plant,* 1920

Wood knew Morris's essay, his makeover of the Rock Island shops demonstrates a similar sense of longing; just as Morris hoped to return England to a romanticized, preindustrial past, Wood too wished to transform Iowa into a more hospitable environment. It was a strategy that would serve him well in the years to come.

After a second summer under Batchelder in 1911, Wood joined Kate Loomis's art-metalwork studio in Cedar Rapids. Acting as both mentor and patron to the young artist, Loomis hired him to redecorate her home and encouraged him to exhibit his designs at the Art Institute of Chicago. The work they produced, mostly jewelry and hammered-copper items, exhibited a predictably labored, hand-crafted aesthetic. The oversized rivets, visible hammer marks, and intentionally unfinished edges of their pieces reflect the movement's insistence upon "natural," utilitarian design—and provide, as well, a visual corollary to the rough qualities so vigorously promoted in the raising of boys.

In addition to working in Loomis's studio that year, Wood also taught and attended classes. During the 1911–12 school year he taught at Rosedale, a one-room county schoolhouse located six miles outside Cedar Rapids. Wood's twenty-one students, who ranged in age from six to thirteen, later remembered him as a generous and creative instructor. That his students "learned more drawing than is usually the case in a country school," as one of his students later recalled, is unsurprising given Wood's impressive new commitment to his own training. Three nights a week, for nearly four months in 1911–12, Wood took the Inter-Urban Railway to Iowa City for life-drawing classes at the University of Iowa. Although the artist's later claim that he never enrolled at the school may be technically true—Wood never actually paid for these classes—his insistence that he learned nothing there strains belief.

Wood's instructor at the university, Charles Cumming, was both a talented academic painter and a kind of proto-regionalist. Trained at the prestigious Académie Julian in Paris, Cumming had committed himself to Iowa subject matter upon his return and made a conscious decision to permanently settle in his native state. In 1911–12, Cumming was working on an historical-mural project for the Polk County Courthouse—a commission that may explain Wood's sudden interest in American history that year, as well as his failed attempt to land a mural commission in Cedar Rapids. Cumming's use of two distinct painting styles provides yet another connection to Wood's early work.

For public works and classroom instruction he used a conservative, academic approach, whereas his sketches and noncommissioned work featured a more fluid, impressionist style. Throughout the 1910s and 1920s, Wood would make a similar distinction in his own painting.

Deciding not to seek another year at Rosedale, and having outgrown Kate Loomis's small studio, Wood left Cedar Rapids once again at the start of 1913—believing, no doubt, that the move might this time prove to be permanent. Through connections at the Handicraft Guild, the artist joined the Kalo Art Craft Community in the Chicago suburb of Park Ridge. At this large-scale silver studio, Wood made jewelry and chased patterns onto the handcrafted hollowware for which Kalo was regionally well known. Founded in 1905 by Clara Barck Welles, this quasi-utopian group of skilled male craftsmen and female designers deeply impressed upon Wood the power and security of artistic community.

Six months after he began at Kalo, Wood resumed his art studies at the Art Institute of Chicago. Lasting less than a month at the school that fall, he re-enrolled in January 1914—this time committing to classes three times a week for nearly five months. Although Wood and his supporters later downplayed the importance of his academic training, his experiences in Iowa City and Chicago belie his reputation as an autodidact. Not only did these classes establish the foundation for his later education in Europe, but they also served him well in the public commissions that came his way in the 1920s.

When the Kalo Art Craft Community dissolved in 1914, Wood and a fellow Kalo silversmith named Kristoffer Haga remained in the neighborhood to establish their own studio, the Volund Crafts Shop. Renting a large farmhouse in Park Ridge, Haga and Wood kept their shop on the top floor and shared rooms below with B. B. Anderson and Daniel Pedersen, two former co-workers who continued to work for Welles at Kalo's Chicago store. Life and work flowed seamlessly together in Wood's new living quarters. After the communal meals the housemates took turns cooking, Haga and Wood would work late into the night in their studio—sometimes coming to bed as Anderson and Pedersen were leaving for their jobs in the morning. For Wood, who had never maintained an easy relationship with his brothers, these men represented a new and welcome form of masculine camaraderie. (Indeed, it is a measure of his security in this new environment that the

otherwise bashful Wood reportedly took nude "shower baths" in the yard during rainstorms.)

Beyond the close circle of Park Ridge, the twenty-three-year-old Wood appears to have been a bit of a loner—and certainly, he had no dating life; according to Garwood, the artist "had no friends among girls, and seldom spoke of women" in this period. On Saturday nights, his routine reportedly involved dressing up and taking the train into Chicago, by himself, to see the latest movie. In light of a remark that the artist Aaron Bohrod made many years later, it is tempting to speculate that Wood's excursions might have masked a double life in Chicago—a city that even in the 1910s fostered a sizable homosexual community. Following Wood's death, Bohrod claimed that Chicago had positively "foam[ed] with tales of this famous little artist" that belied Wood's "prim, meticulous exterior."

Whatever the extent of the artist's newfound freedom in this period, Wood clearly thrived in his new environment; had the Volund Shop proven more successful, his life might have taken a very different trajectory. It was not to be. Hard hit by the lean years of the First World War, the shop was forced to close in 1916. With more time on his hands, Wood enrolled at the Art Institute as both a day and a night student; staying long enough to garner an honorable mention in his life drawing class, he watched his savings from the Volund Shop quickly disappear. Broke, and with little idea what direction to take next, he returned to Cedar Rapids.

DURING WOOD'S YEARS IN Park Ridge, Hattie's financial situation had deteriorated rather seriously. Returning in January of 1916, Wood found his mother living with relatives and renting out the family home in order to meet her mortgage payments. By spring, Hattie had lost the house in a foreclosure. Selling the family's furniture to pay Hattie's debts, Wood and his mother spent the winter on Indian Creek in a small, unheated shed that he built with the help of his friend Paul Hanson. The following year, Wood and Hanson built a larger, one-room bungalow for the Woods—and a neighboring house for Hanson and his wife—in the remote suburb of Kenwood Park.

Eighteen-year-old Nan, who had been living with her brother Frank and his wife in Waterloo, Iowa, returned to Cedar Rapids that year.

With Jack now living on his own, Nan claimed "the family unit became we three" from this time forward—an exclusive circle limited to Hattie, Nan, and Wood. In some respects, the trio's insularity followed a well-established pattern. As children, for example, Wood and Nan had referred to Hattie as "Mom," whereas Frank and Jack had used the more formal "Mother"; similarly, the nicknames Wood and Nan invented for each other—"Gus" and "Nicky," respectively—were used solely within this closed circuit. Shadowy figures at best in Nan's and Wood's childhood accounts, Frank and Jack vanish almost completely from the subsequent narrative of the Woods' family life.

By contrast, the lives of "we three" became rather claustrophobically intertwined over the following decades—a bond that neither Nan's eventual wedding, nor Wood's professional success appeared to weaken. For much of this period, the three shared not just a home but a single room. Of their Kenwood Park bungalow, Nan claims "there were no cabinets, not even a closet"—a situation that "sure made it tough for us with no place to hang our clothes" (to say nothing of their lack of privacy in removing them).

Beyond the tight-knit circle of his family, Wood found support among a small coterie of artists in Cedar Rapids. Chief among these was his friend Marvin Cone, whom Wood had met when the two were freshmen at Washington High School. Outgoing, talented, and handsome, Cone appears to have provided the painfully shy Wood with a measure of social and artistic confidence. Given their shared interests in painting, theater, and tableaux vivants, the two had been inseparable in their teenage years. As Nan later recounted, Cone and her brother would "spend the dawn hours copying the Old Masters together." "When Grant went sketching I was his companion," she adds, "but when Marvin Cone went with him I had to stay behind. I was terribly jealous of Marvin."

Wood's relationship with Cone, and his similarly intense friendships with other men in this period—including Harold Kelly, a fellow member of the Handicraft Guild, and Paul Hanson, Wood's neighbor in Kenwood Park—provide early examples of the one-sided "crushes" that would crop up with increasing frequency in the artist's life. In the summer of 1911, Wood brought Kelly home to Cedar Rapids. Working for the Woods' neighbors, the Woitesheck sisters, the young men shared quarters in the sisters' hayloft—a step up from the summer

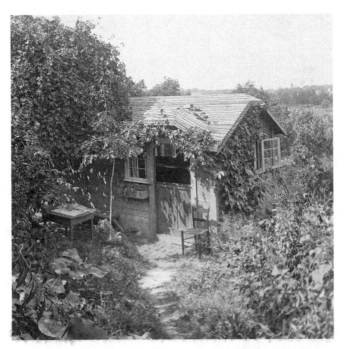

The shed on Indian Creek where Grant Wood and
his mother spent the bitterly cold winter of 1916–17

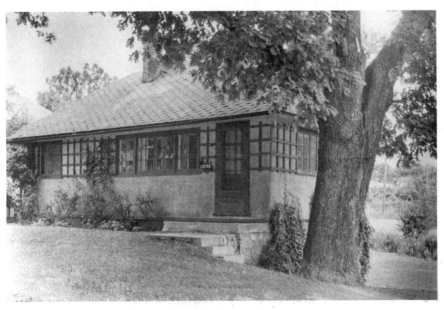

3178 Grove Court, Kenwood Park. Grant Wood built this
one-room bungalow on the outskirts of Cedar Rapids in 1917; he,
Hattie, and Nan Wood lived here until 1924.

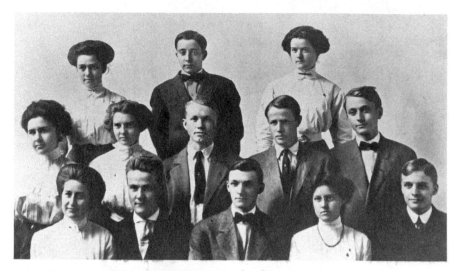

Washington High School class of 1910. Grant Wood appears at center,
his friend Marvin Cone at lower right.

Kelly and Wood had met, when the two had "roomed" in a Minneapo-
lis park and worked as night guards at a funeral parlor. In Cedar
Rapids, Nan later recalled, "the girls went crazy about this handsome,
dark-haired fellow"—whereas Wood, after a few months, appears to
have dropped Kelly rather unceremoniously.

The artist's friendship with Hanson began during the summer of
1910, following Wood's departure from the Rock Island Railroad shops.
In the spring of the following year, the men had formed a commercial
photography and illustration studio; although the enterprise proved to
be short-lived, Hanson continued to look after Wood like an affection-
ate older brother, even splitting his paychecks with the artist. Hanson's
wife Vida was less indulgent with Wood. Finding his affection for her
husband cloying, and irked by Wood's financial dependency on him,
she later provided the artist's first biographer with some of the book's
more damning passages concerning Wood's sexuality. Not long after
Vida had married Hanson, he appeared as the heroically chiseled, semi-
nude figure in Wood's 1920 allegory *Adoration of the Home;* by this
date, however, Wood's friendship with the man had already changed its
tenor. Like Cone, who would marry Winifred Swift the following year,
Hanson was demoted from leading man to supporting actor.

Wood's own marriage prospects in this period were as good as any

Paul C. Hanson in 1909

Vida H. Hanson in 1923.
Vida posed twice for Grant Wood:
once in a now-lost portrait with
her infant son Bobby, and subse-
quently as the figure of Religion in
Adoration of the Home, 1921–22.

young man's in Cedar Rapids. The nearest he came to the altar, how-
ever, was during his brief acquaintance with Vida's sister, Dawn Hatter.
On her visits to the Hansons, Dawn and Wood were often paired
together in outings with Paul and Vida—who assumed, given their
close relationship with the Wood family, that a marriage proposal
might be forthcoming. It never materialized. As Vida later—and rather
obliquely—explained, the artist's interest in her sister "lacked the reck-
less passion or other incentives necessary to conclude such matters."

Noticeably uncomfortable when left alone with Dawn, Wood report-
edly told Vida: "I guess I'm just not interested in women." The bald-
ness of this admission strains belief—Wood typically cited his
responsibilities to Hattie as his only impediment to marriage—but it
nonetheless accurately reflects Vida's, and others', private understand-
ing of his bachelor status.

It was around this time that Wood decided to join the U.S. Army
Corps of Engineers. His enlistment in 1917 struck many who knew him
as out of character, yet from Wood's perspective this was all to the
good. Not only did it provide him with an unimpeachably masculine
role, but it also removed him—for the time being, at least—from the
matrimonial pool of Cedar Rapids. Following an awkward farewell to
Hattie and Nan ("Our family never had been demonstrative," Nan
recalls, "as Father had not believed in a show of emotion"), Wood was
stationed outside Des Moines at Fort Dodge, where he passed his free
time sketching portraits of his fellow soldiers. After an appendicitis
attack landed him in an army hospital, Wood was transferred to Wash-
ington, D.C., where he joined the American Expeditionary Force
Camouflage Division. Charged with camouflaging heavy artillery and
creating convincing cannon "dummies," Wood found that his back-
ground in theater design served him surprisingly well.

On the eve of Wood's deployment overseas in 1918, the Armistice
was signed. The artist came home to a relieved family—he remained
Hattie's primary source of income and emotional support—and soon
began work as an art instructor at Jackson Junior High School. Jack-
son's principal, Frances "Fan" Prescott, was initially skeptical about her
new hire. Perceiving Wood to be "shy and gentle, very quiet and
timid," as well as somewhat eccentric (he had shown up for his inter-
view in his army uniform), Prescott reportedly asked the school super-
intendent, "What have I done to you that you have inflicted Grant
Wood on me?" Relatively quickly, Wood's helplessness seems to have
won Prescott over. If he overslept for his classes, she appeared at his
home to drive him to work—and when he once failed to register his
students' grades (Wood claims to have forgotten the boys' names), she
came to his classroom and took care of the matter herself.

Prescott's indulgent attitude toward Wood belied the steely and
domineering personality for which she was far better known. Not only
did she extend Wood unusual allowances—mostly because she believed

Grant Wood in his army uniform, 1917

him to be a superb, if unorthodox, teacher—but she also attempted to guide him, as one of his friends later wrote, "by immediate or remote control . . . the remainder of his life." Prescott's was not the only stony heart to soften for the artist. Throughout his life, it seems, Wood's boyish manner and painfully obvious vulnerability inspired protectiveness from older women who, like Prescott, did not normally suffer fools gladly.

Prescott's steadfast loyalty to Wood may well have derived, however tacitly, from a vulnerability that the two shared. For most of her adult life, Prescott maintained a romantic relationship with Dr. Florence Johnston, a Cedar Rapids anesthesiologist. Although the women lived separately, and made no public declaration about their partnership, their inner circle understood the two to be a couple. Richard Nelson, a native of Mount Vernon, Iowa, recalls, "I'm one of the few who talked openly with them about it, because of their concern for me." (The women urged Nelson, a young gay man with a vocation in the arts, to leave Cedar Rapids for New York. "It was so difficult in those days," Nelson adds, "for anyone to be who they really were.") Whether or not

Frances "Fan" Prescott
in the 1920s

Hattie Wood in 1919,
photographed
by Grant Wood after his
return from
military service

Prescott shared the same advice with Wood, she and Dr. Florence—as Johnston was known in town—did their best to shield him from gossip concerning his bachelorhood. In one instance in the late 1920s, they brought him as their date to a Cedar Rapids costume ball; appropriately enough, Wood came dressed as a fish caught in a giant net held by the two women. The trio won first prize.

From Wood's accounts and those of his former pupils, it is clear that he also shared a mutually supportive relationship with the boys in his art classes. Not only did he discover a newfound measure of authority and independence as a teacher, but the position also provided him with his first professional outlet as a fine artist. Treating his students and their artwork with the respect he had craved as a child, Wood was rewarded by his inclusion as one of the boys' own—a relationship that freed him from adult male expectations (Prescott worried only

that he might identify too strongly with these boys), and one that provided him the opportunity to relive his childhood in more sympathetic surroundings. Although he would later fantasize about escaping to the bohemian world of Paris, at this stage Wood appears to have relished the liberated—and sexually blameless—environment of the classroom.

In the fall of 1919, Wood participated in the first public exhibition of his paintings. Held at Killian's department store in downtown Cedar Rapids, this joint show featured twenty-three small panel paintings by Wood and thirty-one by Marvin Cone. Wood's subjects, mostly rural outbuildings and local landscapes, were all painted in an accomplished impressionist style—a manner he had adopted at least five years before, and one to which he remained unflaggingly loyal until the late 1920s. Local reactions to the show were encouraging, yet there was certainly no hint at this stage of the tremendous popular appeal of his later work. Indeed, the style and subjects of these early paintings failed to distinguish his work from that of any other local, aspiring artist.

Van Antwerp Place (see color plate 1) exemplifies Wood's technique in this early period. The visible impasto of the painting's surface, its cropped composition, and the plein-airism of its execution (literally, its "outdoorsiness") all proclaim Wood's allegiance to the principles of French impressionism, and even demonstrate his ability to improvise within the style. A tightly focused composition centered on a twisted tree trunk and sun-dappled wall, the image is built up from several layers of thickly applied paint. Into the still-wet surface, Wood dragged either the end of his brush or a palette knife to reveal the ochre-colored ground of the composition board beneath—creating a hard and linear element that complements the work's pattern of painterly, buttery brushstrokes and summons Ernest Batchelder's insistence on the importance of strong line.

In an unusual work that Wood painted around the same time, he appears to have experimented with more avant-garde approaches. Nan's recollection of this painting, an abstract composition Wood simply entitled *Music,* is that one evening her brother announced: "I'm going to paint the colors and sounds of music in [Rimsky-Korsakov's] 'Song of India.' I'm going to do it in a modernistic style and have a lot of fun with it." Wood proceeded to play the song over and over, interpreting its musical structure in swirls of brilliant color. When he

later exhibited the work at the Cedar Rapids Art Association, Wood installed a phonograph alongside it to play "Song of India" and affixed the painting with a preposterous $1,000 price tag.

Wood later dismissed *Music*'s style and inflated price as nothing more than a gag. The artist's sincerity in this experiment, however, is demonstrated by the fact that he repeated the same exercise with his students at the newly built McKinley Junior High School (where Fan Prescott had moved as principal). Paul Engle, one of Wood's former students, remembers that "one day [Wood] brought a phonograph to class and played a recording of 'Song of India,' while tracing on an abstract painting. He had done the outlines and colors, which he alleged represented the musical equivalents." However much Wood later distanced himself from this work, *Music* indicates his brief emulation of contemporary painting movements such as synchromy—an approach that sought to ally color, emotion, and music in abstract compositions.

Wood's painterly experimentation in these years eventually proved to be problematic for him. Because the artist's later critics found it difficult to reconcile Wood's fluid early work with the hardened quality of his mature paintings, they often spoke of his work in the 1910s and 1920s as an "unnatural" chapter in his artistic evolution—an impediment he had had to overcome in creating a national expression. More surprisingly, some believed Wood's longtime allegiance to impressionism was a purely foreign affectation, one presumably learned in a dark, Parisian atelier. (Even Wood's friend William Shirer, who knew his work long before Wood's Parisian period, claimed it was only after the artist traveled to France that he "fell . . . under the spell of the Impressionists.") Given the emphasis that critics placed on Wood's abandonment of the technique in the late 1920s, it is important to understand how impressionism was perceived in these years.

By the late 1910s, impressionism had traveled a long distance from its radical roots in 1860s Paris. Staging independent salons, rejecting traditional studio practices, and unshackling their subject matter from traditional narrative or didactic constraints, the impressionists had established a beachhead for subsequent generations of iconoclastic French modernists. By the time of Wood's early artistic development, however, the visual conceits of impressionism—painting *en plein air*, the dissolution of form through studies of light, and the rapid,

painterly application of paint—had already become, by modernist standards, hopelessly *retardataire* in the movement's country of origin.

As Horst Janson has indicated, in the late 1910s "Impressionism was as commonplace in America as it was in France; it was a conservative and generally accepted mode of painting whose most distinguished practitioners, with few exceptions, had been dead for some time." Indeed, Wood's introduction to the great masters of French impressionism occurred not in Paris, but in Chicago—where the Art Institute held one of the most extensive impressionist collections outside of France. The work at Wood's 1919 show fully conformed to popular notions of contemporary painting, then, while maintaining a safe distance from the more radical forms of modernism that American audiences found objectionable.

Given Wood's extraordinary sensitivity to the tenuous position of the male artist, however, he must also have been aware of impressionism's consistently feminine associations. Norma Broude has demonstrated that, from the turn of the twentieth century until the 1940s, impressionism was categorically perceived as "an art gendered female both by its conservative critics and by its avant-garde competitors." It was only in the latter part of the twentieth century, she explains, that the movement was "effectively re-gendered . . . and endowed with stereotypical attributes of masculinity"—including optical realism, scientific objectivity, and a clinical approach to vision and light—in order to rehabilitate the style as the foundation of male-centered modernism.

We must consider, then, how impressionism's contemporary gender reassignment has obscured the original reception of works like Wood's *Van Antwerp Place*. Rather than presenting a scientific study of light conditions divorced from sentimentality, Wood's painting would have suggested a passive, romantic, and emotionally charged approach to his subject—a "feminine" strategy just as easily seen in his experimental *Music*. Even Wood's thick application of paint would have borne gendered associations. In the post-Pollock era, we are predisposed to consider painterly strokes as "masculine" marks upon the canvas; yet for conservative critics of the 1910s and earlier, as Broude writes, "quick and fluid brushwork [was] objected to as feminine, and suitable only to the limited intellectual capabilities of women," who presumably could not master conventional draftsmanship. None of this is to say that con-

servative audiences condemned the style, but impressionism's feminine associations do explain Wood's, and his critics', later declarations that it had never been a "natural" method for the artist.

IN THE SUMMER OF 1920, Wood and Cone sailed to Europe for an extended stay in Paris. Wood, who had anticipated making this pilgrimage for many years, no doubt felt a sense of fresh urgency following his joint show at Killian's—where Cone's paintings from a previous trip to France had lent him an enviable artistic legitimacy. Never having traveled outside the Midwest, Wood saw in Paris the exciting possibility of a new world. Growing impatient with painting local farmhouses, and no doubt chafing at his well-worn roles in Cedar Rapids—schoolteacher, local eccentric, dutiful son—he longed to redefine himself as much as his art.

Given the tremendous artistic ferment in Paris following the First World War, it is remarkable to see how *little* his painting changed that summer. The artist's small easel studies from this trip, mostly touristy scenes of Parisian streets and gardens, clearly represented fresh subject matter for Wood. Stylistically, however, they were virtually indistinguishable from the paintings in his 1919 Cedar Rapids show. What, then, was Wood seeking in Paris—and what, of any significance, did he bring back home? The answers appear to be, respectively: freedom and a beard.

Regarding this first trip to Paris, Wood explained in 1940 that "when I told my friends in Cedar Rapids, Iowa that I was going [there] to paint, I immediately became an outcast. It wasn't considered manly to be an artist. Then I read H. L. Mencken's articles, and decided I must leave the Bible Belt at once and go to Paris for freedom." Wood's youthful admiration for Mencken's syndicated columns reveals his early, and rather strong, antipathy toward his native region. A blistering crusader against the perceived hypocrisy, prudishness, and bigotry he associated with middle-class America (the "booboisie," as he called it), Mencken located the epicenter of this philistinism squarely in the Midwest. As Gore Vidal has noted, the more one read Mencken, "the more one eye[d] suspiciously the knuckles of his countrymen, looking to see calluses from too constant a contact with the greensward."

Extraordinarily popular with the disaffected youth of Wood's

period, Mencken's acerbic columns were as widely consumed and repeated as *The Daily Show with Jon Stewart* is in our own time. The "Grand Marshal of the Romantic Army," Mencken spoke to a generation that longed to exchange the restrictions of provincial hometowns for the unparalleled freedom and anonymity of bohemian Paris, Berlin, and New York. For Wood, who found Cedar Rapids only slightly more hospitable to his interests than Anamosa, it must have appeared that little had changed since Oscar Wilde's 1882 visit to Iowa ("If art is responsible for the like of him," the *Sioux City Journal* had bluntly declared, "we want no art"). "Only by going to Paris," Wood claimed, could the Midwest's "gloomy inhibitions be shaken off."

During his first stay in Paris, Wood reinvented his lifestyle, if not his art. Leaving behind the one-room, suburban cottage that he shared with his mother, he now lived in a rooftop pension on the boulevard de Port-Royal. The quiet entertainments of Iowa, where even vaudeville was still viewed with suspicion, gave way to evenings at the Opéra and the Comédie-Française, sketching in Montmartre, and ritualized, day-long stints at the famed Café du Dôme. Across the city, Wood encountered a broader range of Americans than he had ever known at home; indeed, by 1920, the American population in Paris had reached such numbers that the term "colony" hardly encompasses its scope. As Richard Miller has written, these émigrés constituted a complete "liberal, bourgeois, American town, established within Paris, without Babbitt."

Though he made little attempt to learn French, Wood claims he made "a serious study of French customs and taboos" on this trip, reveling in the city's liberal customs and its extraordinary variety of inhabitants. In a postcard to his mother that also reflects his penchant for punning, Wood notes that after a full day of sketching in the streets of Paris, "I got three dandies yesterday." All that summer Wood drank and ate copiously, smoked continually, kept late hours, and appears to have made new friends with uncharacteristic ease. Appropriately enough, he named the portrait that Cone painted of him during this trip *Overstimulation*.

In a photograph taken of Wood that summer, we see his Parisian transformation rather strikingly illustrated. Seated at an outdoor café, Wood raises a full mug of beer and appears to have just finished a cigarette or is about to light one. (It was on this trip that the artist's lifelong,

Grant Wood in Paris, 1920,
photographed by Marvin Cone

heavy smoking habit began—a practice still considered suspiciously bohemian in Cedar Rapids.) Wearing stylish, horn-rimmed glasses and an open collar, Wood sports slicked-back hair, a rather rakish beard, and an unmistakable new look of self-assurance. The baby-faced, somewhat prim art instructor who left Cedar Rapids that spring had evidently been replaced by a confident and even worldly young man.

It was Wood's beard that Cedar Rapids found most shocking when he returned that fall. For him this new growth might naturally have recalled Dave Peters's woolly virility—yet by the 1920s, beards on American men had evolved from a sign of manliness to a suspect, and nearly opposite, meaning. As one historian in this period remarked, "The simple possession of a beard [was] enough to mark as curious any young man who [had] the courage to grow one." Disappearing from the faces of "respectable" American men as early as the 1910s, beards had remained fashionable primarily only in urban and distinctly bohemian settings—leading moral watchdogs to speak in the same breath of "prostitutes and bearded men of the world." The association

between beards and artists was a particularly strong one, fueling stereotypes concerning their antisocial and promiscuous behavior.

In the surprising number of anecdotes concerning Wood's beard, it is always its particular inappropriateness for him, even more so than its misalignment with local custom, that his family and neighbors emphasize. Although the artist's beard appears well-groomed and even dashing in surviving photographs, it was denounced by Wood's circle as "ridiculous," "ghastly," "clownish," "uncomely," "incongruous," and even "un-Iowan," whereas its modest proportions were described as "spectacular" and "flamboyant." (Nan even claims, against all evidence, that the beard was long enough to drag in Wood's paint palette.) Beyond the issue of its size, the beard was criticized for its unusual, central parting and auburn color—a hue improbably described as "pink" and "flaming." Vastly preferring his formerly boyish appearance, the artist's friends claimed not to recognize him until, a week after his return, he grudgingly shaved the beard off.

Wood's short-lived new look appears to have struck his community as a reflection of his transformed character: Paris had sent home a changeling. As Nancy Marshall has written about this episode, "[Wood's] beard, which crops up frequently in comments about this period of his life, was clearly a potent symbol of the superficial, bohemian modernism that could—and should—be as easily dispensed with as shaved whiskers." In Iowa, as elsewhere, this bohemian modernism was inextricably tied to sexual license. "We sell our sons into Bohemian slavery and they return corrupted and altogether unmanned," the art critic Thomas Craven railed in this period, adding that "even the most degenerate of vices are rendered tantalizing to youth, when practiced by youth in quaint surroundings." That Craven means to link this "most degenerate of vices" with homosexuality is clear, for, as he subsequently warns, "men in tight trousers" routinely prowled the streets of Paris "on the hunt for the coarser forms of sexual commerce."

To a certain degree, Craven and like-minded critics were perfectly right about Paris. By the 1920s sexual freedom had reached extraordinary heights in the city, taking second place in this decade only to Berlin. Whether or not Wood chose to participate in this aspect of Parisian culture is unknown; yet he could hardly have been unaware of its existence—nor, indeed, would it have failed to shock him. Traveling

from the Midwest—where, as late as 1898, some states still sanctioned
the castration of homosexuals—to Paris, where sexual love between
men was, in the words of one observer, "no more significant than the
preference for coffee over tea," must have felt like landing on the
moon.

In his own memories of Paris in the 1920s, George Orwell notes the
extraordinary visibility of its homosexual subculture. "Gruff-voiced
lesbians in corduroy breeches and [homosexual] young men in Grecian
or medieval costume," he writes, "would walk the streets without
attracting a glance, and along the Seine banks by Notre Dame it was
impossible to pick one's way through the sketching stools." Orwell's
conflation of the artistic and sexual aspects of bohemia reflects his
period's belief that this culture, regardless of its location or the range
of presumed moral offenses, was to a certain degree *always* coded
homosexual—just as, in turn, bourgeois mores were considered to be
innately heterosexual. No one understood the power of this opposition
more clearly than Wood himself, who later went to great lengths to dis-
tance himself from stereotypical notions of the French bohemian and
equally suspect dandy or *flâneur*. Talking with an Iowa reporter in the
1920s, the artist explained, "I'm a picture painter, but not a boule-
vardier, thank heaven."

Neither, it seems, did Wood belong to the ranks of the rowdy Amer-
ican *débauchés* in Paris. Whereas painters like Thomas Hart Benton
and other expatriate artists kept French mistresses, experimented with
opium, fathered illegitimate children, and suffered routine bouts with
venereal disease, Wood's most shocking Parisian adventure involved
losing his coat at the famed Quatre Arts costume ball. Dressed as a
"savage" for the ball, Wood claims, he had been stranded "nude" in the
center of Paris; recalling the event in an interview years later, he
explained: "Never before have I seen such scenes of revelry, such aban-
don, such costumes . . . That is the most hectic night I ever put in, or
would ever desire to spend." According to Rolf Armstrong, an acquain-
tance of Wood's in Paris and a self-described "painter of pretty girls,"
Wood was more often a chaperone to his fellows than a partner in
crime. "When the rest of the boys staggered home full of *vin rouge ou
blanc*," Armstrong recalled, Wood "was always on hand to put them to
bed."

Wood's so-called "return from bohemia"—the phrase he later used

as the title for his autobiography—was a decidedly ambivalent one. Throughout the 1920s, his continued attraction to Paris and its "un-Iowan" mores remained as firmly fixed as his Menckenian distrust of his region and perpetual desire for reinvention (evidenced by his short-lived practice, in the mid-1920s, of signing his work solely with his middle name, DeVolson). Considering this period in a 1940 interview, Wood explained: "I came back [from Paris] with a long red beard, Latin Quarter manners, and proceeded to offend everyone at home. For a while I thought I might try to get along with the folks in Iowa, but I concluded it wasn't worth it and went abroad again."

By the mid-1920s, Wood had returned to Paris for three extended stays, at one point enrolling at the well-respected Académie Julian. The longest of these periods lasted for more than a year. Taking a leave of absence from teaching, Wood remained abroad from June 1923 until August 1924; in addition to Paris, he traveled to the south of France and spent the winter with a group of fellow painters in Sorrento, Italy. Because Wood and his contemporaries recorded so little about this trip—with the exception of a frequently repeated story in which Wood (unknowingly) paints the exterior of an Italian brothel—it is difficult to reconstruct in any detail how he spent this fourteen-month period. We can assume, however, that Wood's wide-ranging travels that year (the longest time he had ever spent away from home) were powerfully affecting for this small-town boy.

Although Wood's impressionist style predominated in these years, regardless of where the artist was living, in 1921 he experimented with a new approach that would have far-reaching implications for his work. Back in the classroom in Cedar Rapids, Wood designed an ambitious 150-foot mural with his ninth-graders—a project that not only demonstrated his talent for decorative abstraction, but also revealed his boyish sense of fantasy. In his lengthy dedication speech for this mural, a work he named *The Imagination Isles*, Wood offered a kind of apologia for the social value of the artist:

> I invite you to come with me on a ten-minute trip through the Imagination Isles . . . No human being can visit these islands. Only the spirit can come . . . [There] we may live as long as we please in our choice of mother-of-pearl palaces without fear of intruding upon anyone or of anyone intruding upon us . . .

Grant Wood's 1923 Christmas card

It is difficult to find people who can produce this material of dreams. A very, very few people have this ability so strongly marked in youth that they are set apart and given special training. These people become musicians and poets and painters. They are valuable because they can lead others . . . into the delightful land where their spirits are trained to dwell . . . We can never leave our heavy bodies for even short vacations . . . [but] through luck or natural ability or special training, somehow that happy man can still find his way to long refreshing vacation trips to the Imagination Isles.

Wood's revealing speech indicates not only his own longing for escape—his, after all, was the only "heavy body" on the stage—but also his belief that artists were uniquely qualified to broker such flights from reality.

In its repetitive patterning and dreamy stylization, the mural points to Wood's fantasy landscapes of the 1930s—works that, due to their seemingly childish style, attracted as much condemnation as praise. Wood's later feelings about his *Imagination Isles* speech starkly reflect this criticism. Years after her brother's death, Nan wrote above the orig-

inal transcript of this speech: "Grant later thought that what he wrote about *Imagination Isles* was terrible, and he was very ashamed of it."

The following year Wood undertook another large-scale, allegorical work. Commissioned by Henry Ely, the owner of a Cedar Rapids real-estate office, *Adoration of the Home* (see color plate 2) was intended to serve as a kind of billboard for Ely's company. Whereas *The Imagination Isles* had allowed Wood to sidestep adult expectations through

Grant Wood with his McKinley Junior High School art students, working on *The Imagination Isles,* 1921. Wood, who appears at far left, treated the boys as his artistic peers.

The Imagination Isles (detail), 1921

childlike exploration and fantasy landscapes, here he presented a near-caricature of mature, Iowan manhood through the lens of classical allusion. The resulting combination—one part Iowa, one part fantasy—would prove to be an especially fertile one.

In *Adoration of the Home,* classical deities and allegorical figures rub elbows with ordinary Cedar Rapids mortals. At the left of the composition, a farmer is paired with a woman representing Demeter, the ancient goddess of grain; on the right, farmers, an engineer, and a carpenter are shadowed by Hermes, the god of commerce. The central grouping includes an enthroned, mature woman—a symbol of Cedar Rapids—and at her knee, a naked boy represents Education. With the assistance of Religion, represented as a youthful woman, the boy raises up a small house model, proclaimed in a flanking panel as "the focus of adoring eyes—behold the home!" The figures' allegorical trappings and academic rendering are, in and of themselves, unremarkable for the period. This is precisely how Wood's instructors had trained him to paint. The figures' unusual juxtapositions and costuming, however, merit closer examination.

In this mixture of Greek gods and Cedar Rapids natives—an assemblage that resembles an amateur theatrical pageant more so than a Greco-Roman frieze—we begin to see the way Wood's mature imagination functioned. Casting friends, family, and neighbors in these classical and allegorical roles, the artist created a kind of meta–Cedar Rapids—a small-town version of an Imagination Isle. Beyond its blending of fantasy and home-bound reality, the mural also demonstrates Wood's preoccupation with masculinity. Whereas figural allegories in this era were generally restricted to nude or semi-nude female figures—accompanied, if they were present at all, by men in classical dress—Wood reverses this model in *Adoration of the Home.* Here he decorously clothes his female figures while portraying the work's male figures, both Olympian and terrestrial, in rather arresting states of undress.

Whether the male figures in *Adoration of the Home* were consciously eroticized or not—certainly, this was not the patron's aim—they constitute an important conflation of masculinity and agriculture in Wood's work. Appearing nearly fully nude, Hermes floats toward the right-hand group of farmers in an attitude that James Dennis has described as "mincing." Connected to commerce rather than physical labor, his slender and feminized form is clearly differentiated from the

burly physiques of the men he approaches—none of whom acknowl-
edges his presence. (It is worth noting that the artist would portray
himself as Hermes on his 1923 Christmas card.)

Among these sturdy men, the shirtless central figure displays a mus-
cular torso unlikely to be found in the fields of Iowa—and yet his dark
tan lines and hairy chest negate any presumed connection to idealized
classical models. He is naked, rather than nude. More subtly conceived,
if also more arresting, is the stocky figure of the farmer at far left; given
the outstretched ear of the unusually short cow at his side, the man
appears to possess an impressive and erect phallus. Bracketing the fem-
inine and domestic scene at the center of the work, these men complete
the visual model of Wood's own boyhood: the hypermasculine figures
of Maryville and Peters stand on the outside, whereas Hattie, Nan, and
Wood remain on the inside.

Although the artist was initially quite proud of this ambitious can-
vas (he unveiled *Adoration of the Home* with great fanfare, hosting a
party for the models and their families), he later felt very differently
about the painting. Embarrassed by its academic style, Wood was also
concerned, we must assume—given his later self-consciousness regard-
ing the male nude—about his semi-erotic portrayals of men in this
work. If Wood's *Imagination Isles* speech had made the artist feel
ashamed, then *Adoration of the Home,* at some level, must also have left
him feeling uncomfortably exposed. When a fire damaged Wood's stu-
dio in 1932, he confided to Nan that he wished *Adoration of the
Home*—by then tucked away in storage—had been destroyed.

Whatever Wood may have felt about *Adoration of the Home* later on,
the painting's initial reception and prominent display provided him
with new visibility and patronage in Cedar Rapids. The most impor-
tant connection he made during this period was with funeral director
David Turner, who hired Wood to decorate his funeral home and illus-
trate it in promotional literature. Rather quickly, Turner's role evolved
from that of patron to agent, landlord, banker, and surrogate father to
the artist. "They had always been friends," Nan writes of the two men,
who had known each other since Wood was a teenager; "now, when
Grant was thirty-three and David ten years older, they were taking a
new look at each other." Despite his deep suspicion of artists—Turner
once declared all painters "a bunch of playboys and pimps" and
believed "anyone who visited an art gallery was a sissy"—it was he who

brokered Wood's transition from amateur painter and art teacher to professional artist and regional celebrity.

AFTER WOOD RETURNED FROM his second stint abroad in August 1924, Turner offered him the free use of his funeral home's carriage house—a generous gesture that eventually allowed him to leave his teaching position and paint full-time. In less than a year, Wood converted the structure's former hayloft into a remarkably versatile studio and living space. Featuring ingeniously built-in furniture, a hidden galley kitchen, a bathroom with a sunken tub, and a combination studio/bedroom under the eaves, the artist's new home was a marvel of efficiency. Not surprisingly, given Wood's past experience as a set builder, the studio/bedroom area of the loft also served as a stage for amateur theatrical productions. Separated from the rest of the living space by a heavy curtain, this space was first used by the Cedar Rapids Community Players—a group for whom Wood designed, acted, directed, and even wrote.

The artist's wonderfully compact studio, known by the address he had invented for it, 5 Turner Alley, quickly became a local attraction. Journalists praised the loft's "disappearing" furniture and other quirky fittings, including its corn-bushel fireplace hood, a painted trompe l'oeil "tile" floor, and a coffin lid that served as its front door. Treading a fine line between bohemianism and harmless eccentricity, Wood seems to have erred on the proper side; as Adeline Taylor of the *Cedar Rapids Gazette* observed, the studio was "unusual, without being . . . 'artistic.' "

The obvious pleasure Wood took in this small environment, and the extraordinary productivity that it inspired in the 1930s, links this attic apartment directly to the artist's first "studios." Like the cellar in Anamosa or his sanctuary beneath the family dining room table, Wood's hayloft-cum-clubhouse offered him a desirable sense of invisibility and refuge from the adult world. Even the artist's front door acted as a kind of smokescreen. Describing the unique design of this entrance, his friend MacKinlay Kantor later recalled:

> From some warehouse of the Turners he acquired a glass-topped coffin lid of primitive design, and set this into his outside door.

The glass was prepared [by Wood] with a dial, and arrows which could be turned in whatever direction he chose. According to the designation on the glass, a visitor would learn that the artist was asleep, gone out of town, would return at any hour selected . . . was painting, was receiving callers. So on, so on. Early in our friendship he showed us a trick of code according to this style. It meant that he was turning the public at large away from his door, but he would be happy to receive intimates. The arrows were in this position more often than not.

The very fact that entering Wood's studio required a "trick of code" is reflective of his strict sense of privacy. Although he liked to project a gregarious image of himself—one of the permanent settings on the door's dial indicated that he was "Having a Party"—Wood was every bit as inaccessible as his studio.

Exterior of Grant Wood's carriage-house studio on Turner Alley, where he lived from 1924 to 1935. The widened stairs and canopy are modern additions, yet the structure appears much as it did in Wood's day; the dormer to the right of the doorway, added in the early 1930s, marks the location of Hattie Wood's later bedroom.

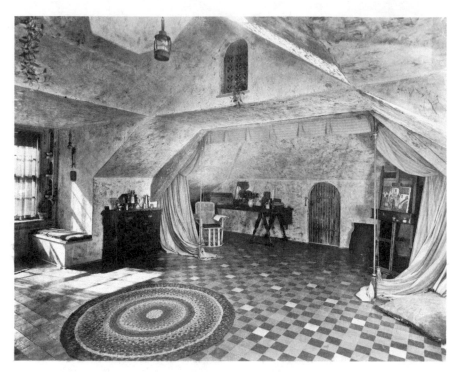

Interior of 5 Turner Alley, looking west, c. 1925. The alcove behind this
curtain served as Grant Wood's studio, a stage for amateur theatricals,
and the loft's sleeping quarters.

Once the renovations at Turner Alley were completed, the painter
invited his mother to join him there—a suggestion that derived, in
part, from the fact that Nan had married earlier that year. Nan's de-
parture from the Woods' Kenwood Park home had happened rather
unexpectedly. Indeed, the entirety of her courtship and subsequent
wedding had occurred during Wood's extended stay in Europe in
1923–24. (When the artist arrived home at the end of August 1924,
she had already been married three weeks.) Wood's new brother-in-
law, Edward Emmett Graham, was a twenty-eight-year-old native of
Macon, Georgia, and a World War I veteran. It is unclear how he came
to live in Cedar Rapids, but at the time he and Nan met he was work-
ing, as Wood himself once had, at the Rock Island line machine shops.
Unbeknownst to Nan when they married, Graham was also a widower
with three children in foster care.

That the couple had wed so quickly and quietly—the newspaper

account of their courthouse wedding claimed that "the marriage came as a surprise to friends of the couple"—suggests the possibility that Nan was pregnant. Whether or not that was true, however, she and Ed never had children of their own. Given Nan's extraordinarily close relationship with her brother, it seems at least as likely that her swift romance and marriage was a punitive response to Wood's long absence. Indeed, the very timing of her wedding—less than a month before her brother's return—appears to betray more spite than necessity, since even a "shotgun wedding" might have been delayed by a few weeks.

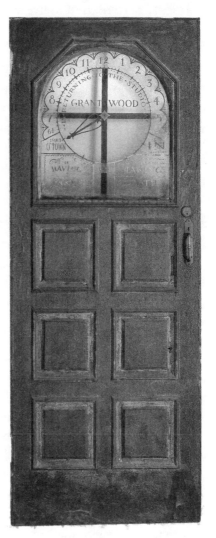

Grant Wood, door to 5 Turner Alley, 1924. The dial Wood affixed to this former coffin lid indicated where to find him at any given time—unless, of course, he did not wish to be found.

For both Wood and Nan, it appears, the complicated dynamic of "we three" would always cast a pall over their romantic relationships. As one of Nan's friends later remarked, "The man who wooed and won Nan had his work cut out for him. She undoubtedly measured him by her brother Grant, who was everything to her—father, brother, and friend." The siblings were also something like sweethearts—in a purely platonic sense, certainly, but at least to the extent that each felt threatened by the other's extrafamilial relationships. Nan took exception to Wood's intimacy with Marvin Cone, for example, whereas she claims that her brother had initially taken her marriage to Ed rather badly. "Seeing our love was hard on Grant," Nan later wrote, with perhaps a degree of satisfaction. From her perspec-

tive, of course, Wood had been the first to break the family's bond—disappearing in Europe for more than a year, and leaving Hattie in her care. When Ed left for the first of many sanatorium stays—his long battle with tuberculosis had been another surprise to her—Nan immediately moved to Turner Alley, thereby restoring the family circle.

If Hattie's invitation to live at Turner Alley had first been prompted by Nan's marriage, then it was equally motivated by Wood's dread of "bachelor artist" stereotypes. As Nan related the artist's decision, "He preferred living close to downtown, but he supposed town gossips were talking about 'what goes on in artists' studios' and liked the idea of mother as a chaperone." Given the thirty-four-year-old Wood's nonexistent dating history, it strains belief that town gossips might have feared his preying on female models or hosting drunken revels. Rather, Hattie's presence at the studio appears to have functioned as a sexual shield for the artist.

Sharing a home with his mother may have initially placed Wood above suspicion, but his attempt to launch a full-scale artists' colony the following year did raise a few eyebrows in town. In September 1926, the *Cedar Rapids Gazette* announced Wood's plans to establish a community of artists' studios along Turner Alley, using his own loft as the anchor to this so-called Latin Quarter. In partnership with Edna Barrett Jackson, a well-known soprano in Cedar Rapids, Wood led a steering committee of sixteen musicians, dancers, singers, and painters who proposed to convert the alley's various outbuildings into studios, a recital hall, and an art gallery—complete with courtyard bistros and space for an outdoor theater. Such a scheme, Wood declared, not only would "advance the cause of all the arts in Cedar Rapids and surroundings," but it would also provide him the support and camaraderie that he clearly missed from Minneapolis, Park Ridge, and Paris.

Although the artist's plan appealed to many city boosters, David Turner chief among them, the scheme was plagued from the start by the deterioration of the buildings slated for conversion, and by public fears that the development would become the "Greenwich Village of the Corn Belt." Anticipating these concerns, Wood and other organizers were at pains to suppress the project's "Latin Quarter" nickname and assured the town that the prospective residents of Turner Alley "were not colorful bohemians, but serious and hardworking people of good taste." (At this point, no doubt, Wood would rather have forgot-

ten the fanciful sculptures he created between 1922 and 1925—a series
regrettably entitled *Lilies of the Alley.*)

The fact that Wood was called to defend such a worthy project, and
to vouch for the respectability of its participants, is a measure of Cedar
Rapids' continued distrust of artists' morality. Since the proposed
colony would have included artists already known and accepted within
the community, the issue appears to have been one of concentration.
Speaking of her involvement with a similar scheme in the 1910s, a writ-
ers' colony in Davenport, Iowa, Susan Glaspell noted: "We were the
queer fish of the town; get the queer fish into one pond and it's a queer
pond."

Eventually Wood and his fellow artists were forced to abandon the
Turner Alley scheme. In an attempt to salvage the project, Turner
offered the group the use of Mansfield House, the site of his family's
previous funeral home; here, Wood and his cohorts established Studio
House—a community that, however reduced in scope and ambition,
was described by the *Cedar Rapids Gazette* as "the most unique art
colony in Iowa." Still sensitive to charges that this venture, too, might
serve as a magnet for undesirables, Wood's fellow Studio House orga-
nizer Hazel Brown later emphatically declared, "Studio House was *not*
[her italics] a Bohemian outfit."

Brown, who lived and worked on the first floor of Studio House
with her companion, Mary Lackersteen, described the colony as "two
old maids and a parcel of painting men." Wood continued to live at
Turner Alley while serving as a kind of moral watchdog at Studio
House—insisting, for example, that "everything considered," no nude
models were to be used in the artists' studios. (He suggested, instead,
that models wear flesh-colored bathing suits.) His fears were clearly
unfounded, for as a satirical story in the *Cedar Rapids Gazette* demon-
strates, the town found this collection of artists harmless almost to a
fault. Recounting the story of a fictional female model named Señorita
Pepita Gallegos, whose disappearance leads the police vice squad to
Studio House, the author of this tongue-in-cheek story explains that
she was found there unharmed, and "in the midst of a tea party" with
three of the house's male residents.

Stories such as these, and similar ones aimed more directly at Wood
himself, indicate that his homosexuality was widely—if still
opaquely—acknowledged by many of those who knew him. In a 1929

article concerning the confirmed bachelors of Cedar Rapids, for example, the *Des Moines Sunday Register* pointedly underscored Wood's lack of interest in the opposite sex. "A topic of conversation at many tea tables and boudoir babbles is Grant Wood," the writer of this piece states, "[who] paints on and on and maintains a discreet silence about marriage." The caption beneath Wood's picture assures readers that he is "Not Disturbed."

In his gossip column for the *Des Moines Tribune-Capital* in 1930, Wood's friend MacKinlay Kantor suggested the artist's homosexuality far more explicitly. Using intentionally provocative lead-ins (the article begins: "Grant Wood lives in an alley"), Kantor highlights the absurdity of seeing Wood as either a lady's man or a debauched artist:

> Grant Wood is a bachelor, and lives with a quiet, sweet-faced woman—who is his mother . . . Pink of face and plump of figure, he was most nearly in character one night when he appeared at a costume party dressed as an angel—wings, pink flannel nightie, pink toes, and even a halo, supported by a stick thrusting up his back. He is a World War veteran.

Not only does Kantor link Wood's costume to common stereotypes of the "fairy"—explaining, no less, that Wood was "most nearly in character" in this outfit—but he also underscores this dig with a thinly veiled reference to sodomy. (In a similar vein, Garwood later claimed that "if a man wasn't right up his alley, Wood had no use for him.") Toward the end of Kantor's article, his description of Wood's well-known studio door left equally little doubt concerning the artist's sexual orientation. Obliquely comparing Wood to Snow White, who lay imprisoned in a glass coffin awaiting her prince's kiss, Kantor writes, "The front door of his apartment is made of glass, but it's a coffin lid. OOOOOOOOooooh . . . !" Following this literary squeal, Kantor exhorts the "boys" in his audience to "look [Wood] over."

Given the later insistence upon Wood's sturdy masculinity and embodiment of midwestern morality, it is surprising to note the frequency and candor of these early references to his homosexuality. That rumors continued to persist until well after the 1920s is demonstrable; yet in instances where the topic is broached, the teasing tone of the 1920s is replaced by an attitude of protective denial. In the 1940s, for

example, Paul Hanson told Garwood that he had often defended the artist "when people spoke of him as effeminate," and explained he had encouraged Wood to cultivate a manlier speaking tone. (Rather uncharitably, Vida described Wood's voice as sounding "like the fragrance of violets made audible.") Similarly, after Wood's death, Winifred Cone defended the artist against the "rough and unkind gossip" that had circulated about him—the nature of which she leaves unnamed.

Wood's anxiety concerning such gossip, and the toll that he rightly believed it might exact on his career, began to manifest itself in the clothing he wore in this period—specifically, in the overalls he chose as his unofficial painting uniform from 1925 until the mid-1930s. The artist's preference for overalls began with a painting commission from the J. G. Cherry Company in Cedar Rapids. Hired in 1925 to depict the company's new dairy machinery for use in its promotional brochures, Wood was ultimately more interested in depicting the plant's workers than its equipment. Because this commission required Wood to spend extended periods of time sketching and studying the men on the plant floor, he was forced to confront the divide between his career and one requiring "manly" physical engagement. In an apparent attempt to bridge this gap, Wood adopted the men's overalls as his own—visually proclaiming his solidarity with them, while eradicating any hint of stereotypically artistic dress.

Wood once admitted that "as a matter of self-preservation" in his early career, "I had to make myself agreeable, to get along with my neighbors; and I formed a habit of studying people . . . and their conduct. That was the only fun I had, that and my painting." His close observation served him particularly well in cataloging the signs by which artists were recognized—especially goatees, painting smocks, and berets—and in avoiding these at all costs. (The affair of his Parisian beard, it seems, represents a rare misstep in an otherwise seamless performance.) In her memoir, Nan insists that Wood scrupulously avoided "any earmarks of the artist." Including a photograph of the teenage Wood in a soft hat and long artist's smock, she explains that he "disliked this photograph, feeling that it made him look 'arty.' " Similarly, Nan relates that when her brother was given an artist's smock for Christmas in the mid-1920s, "he felt silly in it and went back to his overalls."

Grant Wood at eighteen, an image he later dismissed as excessively "arty"

That Wood favored overalls over artist's smocks—which were hardly an exotic item for a painter—says a great deal about how he continued to view his profession. For Wood and his contemporaries, "arty" dress continued to summon all of the negative associations his period attached to male artists: affectation, theatricality, and homo- sexuality. Ironically, of course, Wood's adoption of factory workers' overalls would appear to suggest the very same qualities. Like the exag- gerated forms of blue-collar dress-up that characterized post-Stonewall gay culture—men posing as construction workers and police officers, for example—Wood's uniform appears to have derived from the same kinds of seemingly conflicting motives: the fear of being branded effeminate, combined with the urge (however private) to mirror a desired "type" in an artificial way.

Wood's attachment to workers' clothing did not end with his own body. The large hooked rug that Hattie made for the Turner Alley stu- dio, for example, was assembled from discarded overalls Wood had supplied her—a material he also used to cover the doors of the studio's small eating nook. Stretching denim across these doors and painting them with a bronzing wash to suggest aged leather, Wood finished the doors with hinges in the shape of handlebar mustaches. Like the denim, this hardware recalled for Wood the bodies of powerful laborers—the "unmannered" and mustachioed farmhands whom the artist fondly recalled from the threshing seasons of his boyhood. In the doors' decorative combination of denim, leather, and exaggerated facial hair—one that invites another tempting, if anachronistic, parallel to later gay men's aesthetics—we recognize the same magnification of masculinity that Wood's clothes themselves suggest.

Even as Wood's self-presentation became increasingly masculinized in the late 1920s, he remained committed to the presumably feminine style of impressionism. *The Imagination Isles, Adoration of the Home,* and his portraits of J. G. Cherry workers represented a variety of differ- ent approaches—stylized, academic, and realist—yet in all of the noncommissioned work that Wood undertook in this period, impres- sionism remained his primary mode of painting. Works like *Yellow Doorway, St. Emilion,* painted in 1924 (see color plate 5), demonstrate his proficiency within this style and his knowledge of its history. In both its mood and subject, the painting pays direct tribute to Claude Monet's poetic *Rouen Cathedral* series of 1894—a reference that few in Cedar Rapids might have recognized, but one that was clearly impor-

tant to Wood. Whether painting in Bordeaux or Jones County, Iowa, he approached his subjects with a consistent and evermore sophisticated attention to light, color, and artistic precedent.

In the summer of 1926, during Wood's third and last stay in Paris, he mounted his first one-man show there—a rite of passage he had longed for since his arrival with Cone six years before. Sponsored by the esteemed Galerie Carmine, the exhibition featured forty-seven of his impressionist-style paintings. Although technically accomplished and confidently painted, Wood's work met with critical silence. Profoundly disheartened, if not entirely surprised, he had often felt invisible abroad—where his painting, however skilled, lacked the vigor of the era's more experimental, abstract styles. By the late 1920s, it would seem, the artist's decade-long allegiance to impressionism had led him to a dead end.

IN 1928, TWO COMMISSIONS changed the course of Wood's career. The first, a portrait of David Turner's eighty-four-year-old father, showcased a new, hard-edged style and signaled Wood's awakening interest in the Iowan past. The second commission involved the design of an enormous stained-glass window for Cedar Rapids' Veterans Memorial Building; although he had never before worked in this medium, Wood embraced the opportunity and even oversaw the window's manufacture in Munich. Like the crisp new style that emerged in John Turner's portrait, Wood's experience in Germany would forever alter his work—in ways that are as easily demonstrable as their causes are imperfectly understood.

Portrait of John B. Turner, Pioneer (see color plate 18) presents David Turner's father against an 1869 map of Linn County, Iowa. Juxtaposing his sitter's craggy, unidealized face against the colorful pattern of the map behind him, Wood created a work that defies easy categorization; it is at once a double portrait of a man and his county, and a history painting conceived in living and documentary form. Given Turner's deeply furrowed brow, his portrait may even be considered a kind of landscape-within-a-landscape. As one critic claimed, Turner's face looks like nothing so much as "a fine piece of farmland"—whereas the sitter himself, who found the work deeply unflattering, waggishly referred to the painting as "two old maps." Worlds away from the bread-and-butter portraits Wood occasionally undertook in the 1920s,

the painting marks the first moment at which the artist meaningfully engaged with his region and its history.

In light of the 1930 date Wood later attached to *Portrait of John B. Turner, Pioneer,* scholars long believed that the work postdated the artist's trip to Germany. Removal of the portrait's oval frame in the 1980s, however, revealed its originally recorded date of 1928—a discovery that challenges the traditional narrative of the artist's stylistic "conversion" in Munich. Today it is believed that Wood may have reworked the portrait significantly enough to warrant this redating; yet the fact remains that the two most important elements of the portrait—sitter and map—were in place before the artist left for Germany, and clearly point to a new thematic line.

The nineteenth-century map that forms the work's backdrop, a schematic rendering of Linn County, is surrounded by engravings of its primary towns. In addition to suggesting Wood's budding interest in Iowan history and its artifacts, the map also serves to reinforce the sitter's sense of authority. Not only do maps visually embody surveyed land claims—certainly, they did so for a settler like Turner—but as Svetlana Alpers has indicated, a map is also "by its very nature a visual metaphor that projects the authority of the 'real.' " Seen through the lens of Wood's upbringing, the factual quality of this map therefore mitigates the painter's "feminine" imagination—in much the same way that Turner's stony face eclipses the map's decorative patterning.

Filling the shallow space before this map, Wood's sitter confronts us with a grim and almost scornful look; here, the "authority of the 'real' " assumes human form. Although Wood's sitter was by all accounts a rather congenial person (a "warm-hearted old Scot," in the words of one contemporary), in this work he embodies an unblinking, humorless masculinity—an effect only intensified by Turner's alarming proximity and life-size scale. The combination of these elements produces an uncanny psychological charge never before seen in Wood's work, a development every bit as important as the artist's new linear style or his interest in the Iowan past.

The title of this work further underscores the sitter's confrontational appearance. As Michael Hatt has written, Wood's generation witnessed the rise of the farmer-pioneer as the paragon of "authentic American manliness." To recall Turner's pioneer background, then, was to honor his place within Iowa history—yet Wood's title, and the sitter's expression, seem more admonitory than celebratory. The contem-

porary viewer fails to measure up to this man's legacy, and the sitter appears to know it.

Wood may have initially intended to portray a standard midwestern "type" in this work, yet he also appears to have summoned the very image of his father. That Maryville might have served as the artist's muse in this case, inspiring fertile new material as well as a strikingly original style, appears to contradict all we know about his relationship with his son. Yet we may measure Wood's growth as an artist by the way he confronts his own history in this painting; the portrait serves as a kind of down payment on his debt to Maryville, whose death had freed him to become an artist. Safely contained behind the mask of "Daddy" Turner, as John Turner was familiarly known, Maryville sits before the map that will lead Wood back to his past—and to a new approach that was, to use the artist's own words, founded upon "the materials of past experience and fus[ed] with present situations to create new forms."

Arguably a far more straightforward memento mori, Wood's window for the Veterans Memorial Building (see color plate 6) presents an array of six soldiers beneath a towering allegory of the Republic, dressed in mourning. Representing American conflicts from the Revolution to the First World War, the soldiers form a dark wall at the window's base, broken only by the second figure from the left: the shirtless and barefoot cannoneer of 1812, whose exposed torso not only visually brightens the line of dark uniforms, but also distinctly separates him from his comrades-in-arms.

As seen in *Adoration of the Home,* Wood's window presents a caricature of masculine labor juxtaposed with woman-as-allegory—a chaste arrangement that establishes the work's homosocial, if not explicitly homoerotic, context. If any feminine element is to be found amongst the *Memorial Window*'s soldiers, it is in the figure of the cannoneer. In Wood's original sketch for this figure, the soldier appears less like a Federal-era infantryman than a sort of Americanized Saint Sebastian. Standing in a languid contropposto pose and gazing obliquely at the viewer, the figure exudes youthful vulnerability rather than the mature military bearing of the other soldiers. (Remarking upon this difference, one *Cedar Rapids Gazette* reporter jokingly suggested that the figure had lost a game of strip poker with his fellows.) When the window was finally completed in late 1929, the cannoneer's erotic charge had all but disappeared. In place of the original figure stands a hardened soldier whose vertical stance and blank stare contain all the sexual frisson of a

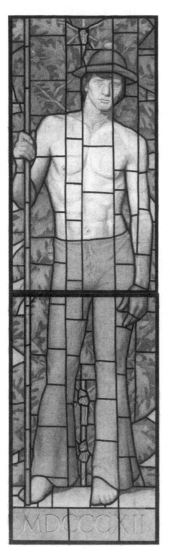

Grant Wood, cannoneer sketch for *Memorial Window*, 1928. The model for this figure was most likely Wood's assistant, Arnold Pyle.

corpse. Whether the dramatic shift in the cannoneer's image represents the choice of the window's glaziers or of the artist himself is unknown, yet it stands as a reminder of the ways in which Wood himself was transformed by his 1928 trip to Germany.

During the three months that Wood supervised the manufacture of his window in Munich, he experienced an artistic epiphany. Powerfully drawn to the fifteenth-century Flemish and German paintings in Munich's Alte Pinakothek, he later explained, he found in these works the possibility to reinvent his style. First, he was struck by the painters' reliance upon regional scenery and contemporary costume, regardless of the works' historical or religious subject matter; second, he admired their meticulous craftsmanship and the hard, linear quality of their work; and last, he was intrigued by the ways these artists exploited surface pattern in the service of abstract design and narrative. Increasingly in his own work, Wood would seek similar kinds of "decorative adventures," as he called them, in sitters' clothing, props, and even in the land itself.

Horst Janson later questioned the artist's Alte Pinakothek "conversion legend," claiming that the story too neatly disposed of Wood's early career. Adopting the voice of Giorgio Vasari, the inventive chronicler of Renaissance artists' biographies, Janson writes:

There once was a young Midwestern painter who, following the custom of his day, went to Paris in the early 1920s to learn about art. He tried as best he could to become a bohemian in the accepted manner, wearing a beret and painting Impressionist

pictures, but he felt increasingly unhappy in this role. Then, one day, he went to Munich, where he saw the works of the Old Masters of Flanders and Germany, and he realized that these artists were great because they drew inspiration from their immediate environment . . . He decided to do the same, so he returned home to Iowa, renewed his ties with his native soil, and out of this experience formed the style that made him famous overnight when he painted *American Gothic*.

Janson's summary of Wood's Munich epiphany—an account that the artist himself told in much the same way—highlights its many lacunae. To begin with, Wood's impressionist style had long preceded his first stay in Paris—just as his linear style and regionalist subject matter had predated his German trip. One must also consider Wood's abundant exposure to Northern Renaissance painting prior to his discovery of the Alte Pinakothek's collection. Not only was he deeply familiar with the Old Master galleries of the Louvre, but in 1920 he and Marvin Cone had also traveled to Antwerp specifically to study the work of the Flemish masters.

Janson proposed that the catalyst for Wood's stylistic change was in all likelihood a far more modern German source: the work of the Neue Sachlichkeit or "New Objectivity" painters of the 1920s, whose severe, hyperrealist portraits were themselves loosely based upon Flemish and German masterworks. If Wood refused to acknowledge his debt to this group, Janson argued, it was only because the artist's later regionalist rhetoric renounced *any* form of contemporary European modernism. Other scholars have suggested, however, that given Wood's genuine resistance to modernism—evidenced by his apparent lack of interest in the Parisian avant garde—the similarities between Neue Sachlichkeit painting and his post-Munich style could only be coincidental.

Most likely, the true story of the artist's stylistic conversion contains elements of both theories. Wood's mature work certainly owes a great deal to the style of the Flemish and German masters, and it is also reasonable to assume that he felt an affinity with the Neue Sachlichkeit painters—whose brand of modernism, in contrast to the abstraction of contemporary French painting, lay familiarly anchored in the past. Even considered together, however, these accounts fail to answer two central questions about Wood's new approach. First, why did he

change his work so radically at this relatively late stage in his career, and after so much prior exposure to the same models? And second, how did the Flemish and German Old Masters—or even the Neue Sachlichkeit painters, for that matter—manage to cure Wood's chronic restlessness, reconciling him so completely and swiftly to his own region? The answers to these questions lie not in the artist's new style, but in the way he characterized his final break with bohemia.

By the 1920s, Wood's routine trips to Paris had become part of the rhythm of his life as an artist. Although he had grown careful not to confuse Continental customs with the ways of Cedar Rapids, he never vilified Paris until after his return from Munich; indeed, by his own account, he thoroughly enjoyed his stays abroad and felt that his travels had been crucial to his growth as an artist. In stark contrast, once he returned from Germany and decided to settle permanently in the Midwest, Wood told a reporter: "I had my fling in Greenwich Village and finally became thoroughly disgusted. When I came back and settled down [in Iowa] I had a lot to undo." The odd substitution that he makes

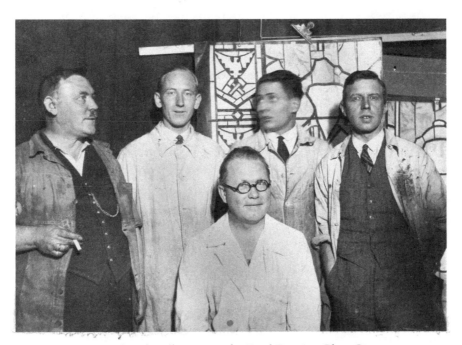

Grant Wood with colleagues at the Emil Frei Art Glass Company, Munich, 1928; when Hattie Wood first saw this photograph, she failed to recognize her son.

in this instance—replacing his stints in Paris and Munich with Green-
wich Village, a place he had never lived—may be read as colloquial code
for bohemia in a more general sense. The rest of his statement, however,
is more cryptic. What exactly had inspired his disgust there, and what
about this experience had had to be "undone" following his return?

Later critics characterized the artist's return to Iowa in equally curi-
ous ways. Wood's champion Thomas Craven insisted, for example, that
despite the environment to which the painter had been exposed
abroad, "there was no need for [Wood's] physical readjustment; he had
preserved his living habits intact" and "resumed his natural line of
development." If any residual taint of bohemia remained, another
critic reassured the public, Wood "[had] been thoroughly renovated by
fresh Iowa air." For his part, the critic Marquis Childs wrote that when
Wood returned from Germany, "he had a thorough house cleaning,
and discarded all the coy figurines and brilliant stuffs he had been
painting so long." (He in fact did nothing of the sort; these "coy" and
"brilliant" elements remained a part of the artist's home, if not of his
paintings.)

As purposely veiled as such statements may be, they all clearly indi-
cate a narrowly averted *moral* crisis in Munich, rather than an aesthetic
one. The nature of this crisis may be located easily enough, for the free-
dom and visibility of homosexual culture in Weimar Germany sur-
passed even that of Paris—and it did so, moreover, in ways that Wood
might have found far more appealing. Unlike their counterparts in
1920s Paris, gay men in Weimar Germany were not only more fully
integrated within the dominant culture, but also far more invested—as
Wood was himself—in heterosexual models of hypermasculinity.
Munich's conservative, Catholic, and increasingly National Socialist
character in the 1920s was certainly a far cry from Berlin (which
became, for a brief time, the most sexually liberated spot on the globe),
yet even here he would have encountered, in Jonathan Weinberg's
words, "what amounted to a cult of male beauty."

It makes far more sense, then, that the disillusionment and self-
loathing Wood professed following his return from Munich derived
from his environment, rather than from any frustration he might have
felt with impressionism (a mode in which he continued to paint, rather
contentedly, in Munich). Surrounded for the first time by a sizable and
visible community of homosexual men, he may well have reacted the
way Christopher Isherwood did when he first encountered this scene in

Weimar Germany. In his 1976 autobiography, *Christopher and His Kind,* Isherwood (speaking in the third person) explains:

> He was embarrassed because, at last, he was being brought face to face with his tribe. Up to now, he had behaved as though the tribe didn't exist and homosexuality were a private way of life discovered by himself . . . He had always known, of course, that this wasn't true. But now he was forced to admit kinship with these . . . fellow tribesmen and their distasteful customs. And he didn't like it.

Although Wood had certainly encountered his "tribe" before in Paris, the difference in this case is that he was often mistaken for a local in Germany—a factor that would have impressed him visually ("I *look* like these men") and allowed him to navigate this environment more easily. "Blending in with the local population," Jane Milosch writes about Wood's time in Munich, "made it easy for him to observe and absorb." Whatever experiences propelled Wood to this new stage in his career, from the time of his return from Munich until his death he devoted himself—in both his work and his rhetoric—to distancing himself from the period that this German trip had crowned. As his friend William Shirer later explained, Wood was at this critical stage "depressed and in some kind of revolt, I felt, against himself."

Following his return to Iowa, Wood renounced all ties to Europe and its artistic culture (with the exception, of course, of the Flemish and German Old Masters), embracing the hardened style and regional focus he first explored in *Portrait of John B. Turner, Pioneer.* The language that Wood and his critics later used to describe this change is almost always framed in oppositional terms. Wood's new approach was described as masculine, disciplined, and thoroughly American—in contrast to his early "European" style, which was dismissed as feminine, formless, and even "unnatural" and "sleazy."

Popular notions that impressionism represented a feminized, weak, and undisciplined mode of painting were of course inextricably linked to the presumed traits of bohemian life itself. Describing Thomas Hart Benton's similar abandonment of this style, for example, *Time* claimed that "six wartime months in the U.S. navy knocked French Impressionism out of him." In distancing Wood from his impressionist period, then, the artist and his champions were keen to demon-

strate that this technique—as well as the mores of its presumed environment—had always been foreign to his nature. Like those who reacted so strongly to Wood's beard, his critics could not reconcile this style with the artist they believed they knew.

Despite the seamlessly high quality of Wood's impressionist paintings, and the decade-and-a-half these works span, many from the 1930s until our own day claim he was either uncomfortable or incompetent in this mode. In the 1980s, for example, Wanda Corn proposed: "all of these early works are timid and self-conscious. Wood's temperament— that of a tidy and meticulous craftsman—kept him from ever being able to fully adopt (or understand) the Impressionists' sensuous style." The paintings themselves defy such an assessment. Not only do they show great technical proficiency and compositional strength, but they also demonstrate the impressionists' attentiveness to mood as manifested through light. Corn's claim that Wood failed to understand the "sensuous" style of the French, moreover, serves the same purpose as the often-repeated yarn about Wood's inability to identify the Italian bordello he painted in 1924. Surely, these offerings suggest, Wood was too wholesome (or "tidy") to recognize European decadence.

Early attempts to dismiss Wood's impressionist paintings cast him as an unwilling or resistant participant in this style. (Amazingly, one critic even claimed that the artist had *never* followed "the treacherous by-paths of Impressionism.") In his later years, Wood was only too happy to reinforce this image. "I was taught to slosh the paint on the canvas with a big brush or a palette knife—very thickly and rapidly to get the effect of careless inspiration," he once explained, "but this isn't the way I see things and feel about them." Insisting that impressionism had been foisted upon him as a boy, Wood recalled: "I had been told by my teachers that detail was no longer in vogue, and in grade school when I did a watercolor of currants, with every berry standing out clearly, my teacher held it under a faucet to produce a 'blurry and artistic' effect." The instructor in question, whom Wood naturally identifies as female, is potentially as fictional as the account of the painting's destruction—for the work he describes, painted when the artist was sixteen, remains today in its original, meticulous state.

A similar (and equally apocryphal) anecdote concerns a full-scale nude Wood executed at the Académie Julian, entitled *The Spotted Man* (1924) (see color plate 3). Although his Parisian work always showed strict loyalty to impressionist principles, Wood claimed he painted this

nude as a parody of impressionist technique—a gesture intended, he explained, to shock his instructors at the academy. As a reporter repeated this story in 1937: "He made a careful drawing of a figure and then began to put on the warm colors first; in fact, he slapped on great splotches of red, leaving spaces for greens and yellows," the final effect of which was such a "ghastly impressionistic painting [that when] the masters had discovered the atrocity," Wood was promptly expelled from the academy.

This story was a useful one for Wood. Not only did it distance him from any sincere allegiance to impressionism, but it also demonstrated his disregard for the masters at the Académie Julian (men who, according to Thomas Craven, courted only "the softest and most affected apprentices of the Latin Quarter"). In truth, Wood was never expelled from the Académie Julian—an institution that was widely known, in fact, for the freedom it allowed its students. It seems equally unlikely that the work in question ever served as a prank. Not only is *The Spotted Man* a carefully constructed example of pointillist technique, but it is also clear that Wood cherished the painting; as Garwood later wrote, "Perversely, Grant seemed to like it and to grow more fond of it as time passed." One of very few works that the artist refused to sell, *The Spotted Man* remained on display in his studio until his death.

Wood's struggles against his own artistic impulses did not end with his return from Munich. Indeed, in the best of his mature works, the artist's new sense of order—an approach that one critic described as "disturbingly well-organized"—competes with an unconquerable sense of fantasy, resistance to convention, and even sensuality. Although one mode never surrenders entirely to the other, there are fascinating instances when one becomes visible through the other.

Wood's *Return from Bohemia*, a pastel he made in 1935, provides a particularly fitting example of this conflict. Intended as the cover illustration for his autobiography, the image commemorates Wood's homecoming from Germany; it is rendered in the realist style of his post-Munich work, yet it nevertheless demonstrates the artist's ambivalence about this pivotal moment in his career. Almost buried at the base of the composition, Wood confronts the viewer with a stony gaze. His figure and the work's title clearly suggest the biblical story of the Prodigal Son, yet we see no climactic reconciliation here. Instead, Wood chooses to illustrate the story's nadir—the point at which the errant son wallows in a barnyard.

Grant Wood, *Return from Bohemia,* 1935

Surrounding this self-portrait, in the words of the artist, are "the usual loafing bystanders who find time to watch an artist . . . with contempt, scorn, and an 'I-know-how-to-do-it-better' look." A closer look at this group reveals that Wood has entirely obscured the figures' eyes. If, as one critic claimed, the artist "had acquired a special quality of vision" upon his return to native soil, then we see only blindness in the members of his community. More unsettling than the onlookers' sightlessness are their dramatically bowed heads, poses that suggest a funeral scene rather than one of joyful return. As if to underscore this mood, Wood crowns his composition with the arched frame of a barn—an element that evokes all the solemnity of a medieval altarpiece.

The five figures that surround the artist in this image constitute a very specific cast. The taller of the two men who stand behind Wood is Ed Rowan, the director of Cedar Rapids' Little Gallery and an important figure in Wood's post-Munich career. Between Rowan and Wood

stands the artist's first patron, David Turner. Distorted in odd ways—Rowan's form is unnaturally elongated, whereas Turner's is strangely distended—the men are joined by three figures whose awkward placement renders the scene almost claustrophobically dense. Given the gender and costume of these flanking figures, they, too, may be identified with some certainty.

However chronologically misaligned, these two adolescents and older woman appear to represent "we three": Nan, at left, wears one of the gingham dresses she loved as a teenager; Hattie, at far right, appears as the aging matriarch of Wood's present; and lastly we see Wood himself standing before Hattie in the overalls and cap he wore as a boy. The

Nan Wood at eighteen, the year she
returned from Waterloo to live with her
mother and brother

anachronism of the figures' appearance—Nan from the 1910s, Hattie from the 1930s, and Wood from the 1890s *and* the 1930s—tells us that the artist's reorganization of the past was not always neat or linear. The retrospective quality of these figures, Wood's multiple appearances, and the scene's suffocating, mournful mood proclaim the painter's anxieties about becoming a man and coming home. He is all grown up, with no place to go.

Missing from this ghostly assembly is Wood's father. Or is he? If Wood had substituted John Turner for his father in Turner's 1928 portrait, then here we see the strategy playing out once more—this time, far more appropriately, in the form of the artist's surrogate father David Turner. Framed like a medieval saint with a wool cap for a halo, Turner embodies the Maryville of the artist's reimagination: heralding his son's return, he bestows a blessing on the artist's canvas. Appropriately enough, this figure's body is also undeniably maternal—as suggested by the rounded, almost pregnant torso from which the adult Wood appears to emerge. Peering out at the viewer from this space, he faces us as a creature reborn.

AMERICAN, GOTHIC

WOOD'S "RETURN FROM BOHEMIA" in 1928 had brought him all the way back, it would seem, to turn-of-the-century Anamosa—a time and place not unlike the world Alice found behind the looking glass. Magnified and distorted through the lenses of memory, dread, and desire, the artist's family and region reassumed the proportions of his boyhood memory, providing him with a rich new source of material. (Indeed, the years between 1929 and 1932 would be the most prolific of his career.) Although critics tend to emphasize the distinctly "American" nature of this imagery, the painter's reawakened interest in local subject matter and adoption of a realist style were merely symptoms of the profound changes in his work. To whatever extent Wood's mature subjects embody national character—a highly subjective notion, in and of itself—they do so only by means of a deeply personal and, to cite his most iconic painting, a truly Gothic sensibility. We must not mistake Alice's world for our own.

Although the "Gothic" quality of Wood's mature portraits certainly reflects his admiration for medieval and Northern Renaissance painting, it more closely recalls the word's romantic, nineteenth-century context. As Steven Biel has noted, in this more recent period the term evoked all of the unsettling (and thrilling) associations at the heart of the Gothic novel: "gloom, terror, haunting, possession, decay, seduction, incest, and hidden perversions." Like visual descendants of this literary genre, Wood's early portraits reveal a similarly complex matrix of unorthodox family relationships, sexual anxiety, and a recurring fascination with death.

That Wood consciously intended for his Gothic iconography to be decoded is doubtful, yet its presence cannot be ignored—nor can we

dismiss his participation in its construction. In the subcategory of the "paranoid Gothic" novel, as Eve Kosofsky Sedgwick has written, the male hero believes his inner thoughts may be read by an opposing figure whose dominance he alternately fears and desires. Acting in a similar relationship with his audience, Wood disguises the personal content of his work—wrapping his paintings in the flag or cloaking them in homespun humor, while simultaneously appearing to court his own exposure. The public dimension of his imagery, then, always exists in tension with its opposing private character. Any notion that these works display a superficial folksiness—or indeed, that the artist does so himself—must be abandoned altogether.

Ironically, Wood's new allegiance to realism coincided with his retreat from strictly objective observation. Whereas impressionist technique had compelled him, first and foremost, to observe the effects of light, shade, and color (however romantically tinged), the painter now attempted to confront the complicated feelings he held for the places and people of his childhood. As he later explained, "Once I started painting out of my own experience, my work had an emotional quality that was totally lacking before." This new approach not only made his painting more difficult, but it also significantly tightened his (already rigid) self-surveillance. Having renounced the escape valve of bohemia, he had no choice but to face the ghosts of his past and the host of dangerous instincts they had resurrected. Keeping these at bay required Wood's constant vigilance—and also, we will see, the considerable powers of his imagination.

Following his return from Munich, Wood shifted the primary focus of his painting from plein-air landscapes to figural work. Turning to family members and others in his immediate circle, the artist created works that combined traditional portraiture and allegory in unconventional ways. The first indication of this new approach appears in *Portrait of John B. Turner, Pioneer,* but by far the most important was Wood's portrayal of his mother, *Woman with Plants* (1929) (see color plate 4). Painted soon after his return to Iowa, this portrait powerfully illustrates his work's new psychological complexity and suggests, as well, the mixed feelings he had about his homecoming.

Although *Woman with Plants* represents the second painting in Wood's mature style, he always spoke of it as the first—a position he later artificially reinforced by postdating *Portrait of John B. Turner, Pioneer* to 1930. To understand the works' correct chronology, however, is

to recognize the ways in which Hattie's portrait responds to the earlier painting. Not only does Wood replace the Iowan patriarch of *Portrait of John B. Turner, Pioneer* with a maternal substitute, but he also lends his subject a contemplative and sympathetic expression—one that reverses Turner's disapproving, confrontational gaze. Similarly, in Hattie's portrait we see Turner's scientifically ordered map transformed into a romantic, emotionally charged Iowan landscape. Here, imagination triumphs over fact—and by extension, Hattie trumps Maryville's surrogate.

Wood's insistence that Hattie's portrait preceded Turner's was essential to the narrative of his artistic rebirth, a story in which his mother naturally plays the starring role. In the frequently repeated account of Wood's homecoming, he returns to his mother's kitchen and finds Hattie patiently awaiting him in an old-fashioned apron. As the artist later explained to the *Chicago Tribune,* "I spent twenty years wandering around the world hunting 'arty' subjects to paint. I came back to Cedar Rapids, my home town, and the first thing I noticed was the cross-stitched embroidery of my mother's kitchen apron." It was this rather mundane scene, he insisted, that banished his wanderlust forever and opened his eyes to the sublime potential of the familiar—not only inspiring his mother's portrait, but also determining his mature style and artistic mission. The painter's Alte Pinakothek epiphany, it appears, had served only as a catalyst for this moment.

Although Wood told several different versions of this story over the course of his career, Hattie's apron is always a central detail (variously described as green or white, linen or cotton, embroidered or plain), and the scene either takes place in her kitchen or at its screen-door entrance. Most importantly, the event is always linked to the day of Wood's return to Cedar Rapids—either post-Munich or, somewhat illogically, following his 1920 trip to Paris. Secondhand accounts of the event even conflate it with the painting of Hattie's portrait itself. In a 1939 profile of the artist, a journalist explained: "[When] Grant Wood came home . . . [he] saw his mother in a green print apron, trimmed with white rickrack braid, and holding a sansevieria plant in her hand. Almost as soon as he kissed her, he started to do a painting of her, and that's how he got started."

Evidence suggests that this reunion represents a symbolic, rather than an actual, event. By this date, of course, Hattie was already living in Wood's studio at Turner Alley; tucked away to the left of the second-

story landing, the loft's tiny kitchen featured no screen door, nor could it have easily accommodated two adults. (The setting Wood describes belongs, instead, to Hattie's former home in Kenwood Park.) In the end, the story's historical accuracy is far less important than its revealing psychological dimensions. Not only does the artist clearly fetishize Hattie's apron in this narrative—transforming the garment, like a child's security blanket, into a symbolic substitute for her body—but he also ascribes magical powers to Hattie herself. With a single kiss or a loving look, she is able to disenchant him from the spell of bohemia.

Wood's homecoming story is further complicated by its uncanny similarity to a scene from his childhood, recounted in *Return from Bohemia*. The artist claims that one morning, as he watched his father work in the barn:

> I looked up and saw mother standing in the doorway, the intense sunshine glancing from the white surface of her apron. The sun made a blurred gold outline against her brown hair. She had a tall glass of milk in one hand, and two molasses cookies in the other. Her apron smelled clean and crinkly as a cool morning smells . . . Her voice rang with a slightly abstract twang, bearing the slightest hint of prophecy.

Later on, the passage continues:

> If father was stern and remote to me, mother, by contrast, was very human and close . . . I thought she must be the most beautiful woman in the world. I watched her face intent on father's actions. From her expression, one might guess that he could do nothing that was not perfect in her eyes.

Embedded in this scene is the family romance that shaped so much of Wood's life and work. The artist's adoration of his mother, and his sensual relationship to her body—her smell, voice, appearance, and even the food she carries—triangulates against Hattie's own worship of her husband, Wood's rival for her affection. In his original conception for his mother's portrait, Wood had intended to portray her canning fruit—a composition that would have evoked equally powerful echoes of this affecting scene in the barn. The artist associated canning jars

with farm life in a general sense, but more specifically he linked them to the family cellar. During his periodic banishments to this space, a captive to his father's authority, Wood undoubtedly perceived Hattie's canning jars as a comforting and sensual token of her presence there. (Indeed, these jars served as the inspiration for some of his earliest imagery.)

On its surface, Hattie's portrayal in *Woman with Plants* is a rather straightforward study. Depicted at three-quarter length and turned toward the viewer's left, the artist's mother holds a tall, potted sansevieria plant on her lap. The large, veined leaves of a begonia plant share the immediate foreground of this image, and in the distance Wood depicts an autumn landscape dotted with haystacks, a barn, and a windmill. Hattie wears a green apron trimmed in gold rickrack, a black, long-sleeved blouse, and a cameo featuring a woman's profile. Like the fifteenth-century portraits Wood admired in the Alte Pinakothek, this is a courtly and iconic image—a celebration of Hattie's quiet dignity, and a tribute to her stewardship of the land. Comparing this work with James McNeill Whistler's better-known *Arrangement in Grey and Black, No. 1: Portrait of the Artist's Mother* (1872), Thomas Craven wrote that "in vitality and the enduring substance of sacrificial devotion, it reduces Whistler's mother to a fragile silhouette."

The costume and accessories in this portrait all belonged to the artist's mother, or to the small studio environment she shared with her son. The apron she wears is the same one described in Wood's homecoming story; typical of the kind she had worn in Anamosa, these "country" rickrack aprons remained a staple of Hattie's wardrobe long after the family's move to Cedar Rapids. (Her son was not the only one, it seems, who felt nostalgia for the farm.) Hattie's curiously doubled wedding band may represent a combination of Maryville's ring and her own, whereas the cameo at her throat had been a gift from Wood's travels abroad. Lastly, not only was the studio at Turner Alley filled with potted plants—begonias were a particular favorite of Hattie's—but the studio's south-facing bay, where she posed for this work, was also fitted with niches for her indoor garden.

Like the overdetermined objects encountered in dreams, each of these accessories serves multiple functions in Hattie's portrait. Indeed, from a very early age, Wood appears to have invested his imagery with

a similarly multilayered iconography. At three, for example, the artist reportedly drew a series of semi-circular arches that represented "my own private way of representing a Plymouth Rock hen"; in addition, the pattern recalls the arched openings of the tablecloth that surrounded the boy's first "studio." Creating a symbolic code to describe the world is common enough in young children, for whom imagery precedes the mastery of language. In Wood's case, however, the communicative power of imagery eclipsed speech well into adulthood—just as the contours of his inner landscape occasionally overshadowed the world of objective reality. If the artist had lost both of his arms, he once famously said, his work would remain unchanged because "I have what I've got in my head."

Hattie's green apron in *Woman with Plants* echoes the landscape behind her, yet in a more specific sense it suggests her own, fertile body—one from which a vigorous plant appears to emerge. Wood's association between his mother and textiles had always been particularly strong. Not only did he feel a deep attachment to Hattie's aprons (the strings of which, it must be said, were never cut), but also to the tablecloths, hooked rugs, and quilts she made; the wedding dress and mourning veil that marked her marriage to Maryville; and even her pink flannel nightgown, an article Wood himself wore to a costume party in the late 1920s. Appropriately enough, when he relined the frame for *Woman with Plants* in 1935, Wood used damask from one of Hattie's tablecloths.

Bearing at least as much psychological freight in this image is the sansevieria plant Hattie holds—the centrality of which is suggested, indeed, by Wood's original title for the painting: *Woman with Plant,* rather than the less specific *Woman with Plants.* Like the sitter herself, sansevieria was well known for its resilience and hardiness, and its cultivation was often linked to domestic virtue in a wider sense. Such straightforward associations with the artist's mother, however, fail to account for the plant's bizarre depiction in this work. Not only does Wood exaggerate the height and thinness of the plant, but he also places it rather awkwardly on his mother's lap. Even Hattie's attitude toward the plant is a bit strange. In a manner that seems unusual for a farmer's wife, she holds the sansevieria in a rather precious way—while at the same time demonstrating an odd lack of concern for the mud it might leave on her good apron.

Wood's unusual compositional choice may be explained, to some degree, by Hattie's regal pose itself. Simultaneously cradling this plant and presenting it to the viewer, her figure rather pointedly summons the image of a Madonna and Child. Not only had Wood explored this same formula in his earlier work—in the 1910s, he painted Vida Hanson and her son Bobby as a contemporary Madonna and Child—but he also found the subject particularly well represented at the Alte Pinakothek. Indeed, one of the crown jewels of the museum's collection, Hans Memling's *The Seven Joys of the Virgin* (1480), demonstrates two unusual elements that resurface in Hattie's portrait: Memling's Mother and Child appear against the backdrop of a vast, hilly landscape, and at the Virgin's side we find a potted plant where we would normally expect to see the infant John the Baptist.

Leonardo da Vinci's *Virgin and Child* (1478), another masterwork in the Munich collection, may have provided Wood with an even closer model for *Woman with Plants*. In Leonardo's painting, the Virgin is depicted in three-quarter-length format before a landscape tinged in autumnal colors. Her central, oval brooch and the potted plant at her elbow mirror those in Hattie's portrait, as does the oddly off-center infant on her lap—whose outstretched arms parallel the sansevieria's upward-twisting "limbs." (Indeed, even the English title of Leonardo's work—*Madonna with a Vase of Flowers*—parallels the title Wood gave to his own painting.) Given this source, or simply the influence of similar types, the lovingly tended plant in Hattie's lap reads as an emblem of her son's birth, growth, artistic renewal, or even his return to the womb—an indication of the artist's wish for a biological "homecoming."

Wood had employed a similar Madonna-and-plant formula in a painting from the mid-1920s, entitled *Cocks-Combs*. Pairing a potted cockscomb plant with a ceramic Madonna and Child figurine, Wood turned what might have been a rather prosaic still life into something slightly more sinister. Given the mismatched scale of the plant and the statuette, a much-loved souvenir from his 1924 trip to Italy, the cockscomb towers above the figure group. Rippling and seemingly animated, the spreading plant rises from the rear of the composition in an almost threatening way—an effect James Dennis similarly identifies in Wood's later depictions of "sublimely" overgrown and "animalistic[ally] clawing" trees.

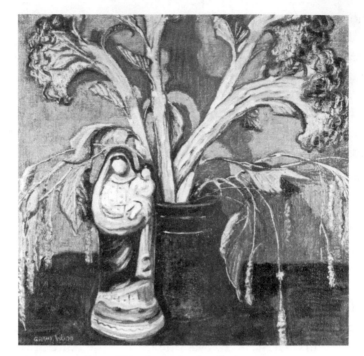

Grant Wood, *Cocks-Combs*, c. 1925–29

In the muscular stalks of this cockscomb plant, the very name of which implies a certain phallic aggressiveness, we see the model for the twisting sansevieria in Hattie's lap. Here, however, the plant threatens the viewer—transforming Hattie's figure from a loving Madonna to the reptilian figure of Medusa (indeed, due to its sinuous form and variegated coloring, sansevieria is familiarly known as "snake plant"). As if summoning the Gorgon's power to immobilize, this serpentine growth emerges from the very apron that forever planted Wood in his native soil—an indication, perhaps, that the artist considered his return as much a curse as a blessing.

As if to reconcile these affective opposites—the nurturing Madonna and vengeful Medusa—Wood casts his mother in a third, and more important, role: Demeter, goddess of grains and the harvest. In ancient Greek mythology, the story of Demeter and her daughter Persephone was intimately connected to the origins of farming. When Persephone is abducted by Hades, lord of the Underworld, Demeter condemns the continuously fertile crops of the earth to fall barren as she searches for her missing daughter. Once recovered, Persephone is consigned to

return to Hades for the winter months of every year—a punishment for having consumed six pomegranate seeds during her stay there. Demeter subsequently initiates the cycle of agricultural seasons, providing renewal of plant life upon her daughter's return in the spring, followed by the fall harvest and winter's dormancy.

No classical deity lent herself more appropriately to an Iowan context than Demeter, whose patronage of agriculture and grain was popularly linked to corn, the state's staple crop. First associated with this New World plant in eighteenth-century American poetry, Demeter had by the end of the nineteenth century developed into a cherished icon of Iowa county fairs—a fitting symbol of the state's most important source of revenue. At the Sioux City Corn Palace in 1887, for instance—the first of several midwestern exhibition halls built entirely from corn—Demeter appeared as the consort to King Corn, complete with cornstalk scepter and elaborate cornhusk gown. As Guy Davenport has written, in such instances the goddess's elastic image "extends the shores of the Mediterranean all the way to Iowa." Steeped in this regional iconography himself, Wood included Demeter not only in his earlier *Adoration of the Home* mural, but also in the classically inspired door panels he painted for the Van Vechten Shaffer home in Cedar Rapids—a commission that coincided with his creation of *Woman with Plants.*

Following Wood's return from Germany, his use of classical allusion had grown more sophisticated. At the Alte Pinakothek he was particularly drawn to the Northern Renaissance painter Pieter Bruegel, whose work cleverly fuses classical and biblical narratives with contemporary figures, scenes, and dress. Although Wood's critics often claim he learned only decorative lessons from the Flemish master, it is clear that he also understood the affective and intellectual power of Bruegel's anachronisms. Adapting this approach to his own period, Wood gave up "the pallid Classical allegories of the gingerbread era," in the words of one critic, to become "the Bruegel of the Bible Belt." This shift in Wood's work may be traced directly to his mother's portrait, in which he achieves a successful classical allusion without any of the toga-clad figures of his early work. The painting is at once an individualized portrait and an allegory. (As Wanda Corn notes, it is clear "how hard Wood worked . . . to make her into a kind of immovable, mute monument.")

Demeter's attributes may be read in both obvious and subtle ways in *Woman with Plants.* The potted sansevieria, along with the begonias

that nestle at the sitter's elbow, identify Hattie with the goddess of domesticated plants as surely as the harvest scene behind her illustrates the opposing dimensions of Demeter's grief: infertility and revenge, versus bounty and generosity. Even more striking is the parallel between Hattie's portrayal and classical descriptions of the goddess. Grief-stricken and weary, yet also profoundly stoic, the powerful and beautiful Demeter sought anonymity on her rescue mission by assuming the frame of a weak and elderly woman.

Like Demeter, too, Hattie is a woman in mourning. Portrayed in long, black sleeves—a formal note at odds with her workaday apron—the artist's mother bears the same expression Wood recalled from the day of Maryville's death. As he entered the room where his father's corpse lay, he later recounted, "Mother was standing at the window looking into space. Her body sagged forward as if she were very tired . . . When the others came in, she did not seem to notice." Hattie's strangely inert, stiffened hands summon another of the artist's memories from this time; during Maryville's funeral, he recalls, his mother "reached over and took my hand. But that was small comfort; her hand was cold and lifeless." The painting's autumnal landscape, of course, serves as yet another emblem of Hattie's—and by extension, Wood's—grief over Maryville's loss. (Rather fittingly, the view over her shoulder would in reality have been the exterior of the funeral home's viewing room.)

Perhaps the most powerful evidence for Wood's conflation of his mother and the grieving Demeter is found in the brooch Hattie wears. Portrait brooches, particularly in the Victorian era of Wood's boyhood, were often worn as a sign of mourning for a family member; the figure in Hattie's cameo, however, indicates *Demeter's* loss rather than her own. Although only impressionistically rendered in Hattie's portrait, the cameo Wood gave his mother depicts Demeter's missing daughter. Identified by her crown of pomegranates—a symbol of Persephone's annual exile to Hades—the figure also features Persephone's characteristically unkempt hairstyle. The cameo's appearance in this work is hardly accidental, for as Nan later recalled, Wood had originally purchased the brooch for their mother because "he thought the girl on the cameo looked like me."

Despite the brooch's critical role in *Woman with Plants*, its relative illegibility in the painting begs a larger question: Why would the artist

The "Persephone" cameo worn by Hattie Wood in *Woman with Plants*, 1929, and subsequently by Nan Wood Graham in *American Gothic*, 1930.

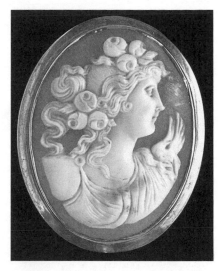

have constructed such an elaborate classical allusion, only to leave its key motif in unreadable form? The answer lies in Wood's rather complicated return to Iowa. From the moment he renounced bohemia, it seems, Wood appears to have taken refuge in allusions that often specifically excluded external audiences; like the cloistered space of his first "studio" beneath the kitchen table, these private allegories allowed him to hide in plain sight. The tension this new approach introduced in his work—the tug-of-war between transparency and inscrutability—is, in fact, the very source of his images' power.

Unlike those who worked under the banners of surrealism or magic realism in this era, Wood was never interested in mining psychological material for its own effect. His multilayered and deeply personal iconography is as well hidden from the casual viewer as it probably was, at some level, from the artist himself. Wood may have consciously intended to portray his mother, a farm, or a rural genre scene, but these familiar subjects set into motion the complex machinery of his inner world—a realm where the demigods of his youth retained their divine status, and where Iowa's rolling hills were invested with the power to console, seduce, or destroy him.

If Wood did not intend for Hattie's allegorical identity to be read by the viewer, then what *private* role did she perform in this guise? Never a farmer himself, and seemingly uninterested in the agricultural crises of the 1920s, Wood is unlikely to have portrayed his mother as a symbolic reassurance of the harvest's return. Rather, his conflation of Hattie and Demeter seems to hinge upon the women's shared narratives—stories that are centered on loss and incomplete redemption. Taking into account the homecoming scene that inspired this painting, Wood appears to draw a parallel between his own return

Hattie Wood at seventy-one, the year Grant Wood painted her portrait in *Woman with Plants*.

from bohemia and Persephone's recovery from Hades. Demeter's daughter belongs to two worlds, and yet fully to neither; after Munich, Wood found himself similarly transformed.

If we take a closer look at Hattie herself, as opposed to the various identities she assumes in *Woman with Plants*, we find a rather gentle, passive, and anxious woman. Affectionately known as "Woody," the artist's mother appears in contemporary accounts like a rather wooden character—a kind of living prop in the artist's studio. "It wasn't her life that was being lived in those eleven years at 5 Turner Alley," Garwood wrote in his biography of Wood; "even people who visited in the alley for years didn't know what kind of person she was, except that she was plain and quiet and quaint and seldom went anywhere." Critic Thomas Craven reinforced this two-dimensional image of Hattie, claiming that she spent most of her days alone in the studio, silently "wondering, perhaps, whether her boy should lose her before she lost him again."

Nan provides an alternative explanation for her mother's sense of reserve. Deeply private and house-proud, Hattie had left her own home rather reluctantly in 1925; her move to Wood's studio, Nan relates, was "solely to please Grant." For her first ten years at Turner Alley, Hattie slept under the loft's western eaves in a pull-out bed alongside her son's. (Amazingly enough, Nan, too, squeezed into this sleeping alcove for many years.) In 1932 Wood created a private bedroom for his mother from a former storage space, yet even this room remained unfurnished for another three years. The close quarters at the studio were a difficult adjustment for Hattie—the total living space there measures less than nine hundred square feet—but so too was the constant stream of artists, actors, and curiosity seekers who passed through its doors and often stayed for meals. "Mother's hot dog stand,"

as Wood dubbed the studio's fold-down dining counter, appears to have reflected his own love for company more so than hers.

Hattie's social discomfort at Turner Alley was further compounded by the anxiety she felt for her son—an emotion that often eclipsed demonstrations of pride or affection (Craven notes she "was proud of her boy, but kept her pride locked up within her"). Given her precarious financial situation and her son's childish grasp of economics, Hattie was particularly vocal in her concerns about Wood's ability to earn a living as an artist. Privately, she may also have feared for his reputation. Craven explains that it was Hattie "who encouraged [Wood] to make a man of himself as an artist, and to win the allegiance of people not precisely noted for aesthetic tastes"—an assessment that, however embellished by the critic, may nevertheless reveal an underlying truth. Hattie encouraged her son in his vocation, but, like Wood, she never fully emerged from Maryville's shadow. The urge to hide her son beneath the kitchen table remained a rather strong one throughout her life.

If Maryville's presence had had an arresting power on Wood's art, then Hattie's companionship at Turner Alley presented an equally powerful barrier to his marriage prospects. Explaining his inability to wed Dawn Hatter, Wood had told friends, "I'd like to marry Dawn, but I have my mother"—a sentiment he later repeated to Fan Prescott, explaining that he would never marry while Hattie was still alive. Such protestations, of course, served as a convenient alibi for the artist's suspicious bachelor status (there is no evidence that Wood *wished* to marry), yet they also point to Hattie's complicity in this arrangement. With three other grown, married children, Hattie need not have depended solely upon Wood for support. Because she did rely upon his earnings, of course, meant that she was more intimately involved in her son's career than she might otherwise have been. In her complicated roles as muse, accountant, and housekeeper to her son, she left little room for a potential spouse.

Wood's insistence that "mother" and "wife" represented mutually exclusive categories led some in his circle to view his bond with Hattie as unhealthy. Indeed, in at least two instances, writers who knew Wood rather well erroneously refer to Wood and Hattie as a married couple. The first, a kind of typographical Freudian slip, appears in Park Rinard's 1940 screenplay of the artist's life; although he refers to Hattie's character throughout the script as "Mrs. Wood," in one instance he calls her "Mrs. Grant." Later, in an article concerning the artist's Turner

Alley years, Horst Janson mistakenly refers to Wood as Hattie's husband (given Janson and Wood's enmity, the error might well have been an intentional jibe). In both of these cases, we see the strength of Hattie's surrogate role at Turner Alley. Not only did she shelter the artist from potential gossip concerning his bachelor status, but she also served as a platonic "place holder" for a wife.

Like Hattie herself, *Woman with Plants* functioned as a kind of talisman for the artist—an icon that offered protection in exchange for devotion. (Indeed, throughout his career, the painting remained Wood's favorite.) When the Cedar Rapids Art Association offered to purchase Hattie's portrait not long after its completion, Wood flatly declined, explaining that the painting had been a gift to his mother. Convinced he could easily paint another in its place, however—and perhaps only too aware of his emotional attachment to the work—Hattie insisted that Wood sell it. The artist never brought himself to reproduce *Woman with Plants,* yet in less than a year its visual elements and complex iconography would resurface in the painting that forever redefined his career.

IN THE BRIEF PERIOD between Wood's return to Iowa and his creation of *American Gothic,* the artist's reputation had remained an emphatically local one. At this stage, his paintings still competed more successfully at state fairs than they did in serious exhibitions. In 1929, for example, *Portrait of John B. Turner, Pioneer* won the portrait prize at the Iowa State Fair in Des Moines, whereas *Woman with Plants* went virtually ignored at the Art Institute of Chicago's annual American show. Whether impressed by Wood's work or not, no critic yet wrote about its connection to American identity. (The artist's hometown newspaper declared him another Rembrandt following his success at the state fair, not another Gilbert Stuart.) If we are to excavate the original meaning behind the artist's most famous work, then—as opposed to the significance Wood and others attached to the painting following its spectacular debut—*American Gothic* must be understood within the continuum of *Portrait of John B. Turner, Pioneer* and *Woman with Plants.* In all three works, and in *American Gothic* most of all, it is not the artist's patriotism that we see on display but a fractured return to his own past.

Wood's inspiration for *American Gothic* (see color plate 7) dates to the spring of 1930, when he discovered a small Victorian-era farmhouse on a trip to Eldon, Iowa. Particularly drawn to the house's "queer Gothic window," Wood considered this overscaled feature comically marooned on the façade of this tiny, isolated structure. A distant descendant of the great cathedrals Wood had painted in France and Germany, this farmhouse embodied for him all of the admirable and provincial qualities of rural Iowan culture. As he later (and rather unflatteringly) declared, "Our cardboardy frame houses on Iowa farms are especially suggestive of the Middle West civilization." Even the term for the farmhouse's style, familiarly known as "American Gothic" or "carpenter Gothic," seems to have provided Wood with an irresistible contradiction in terms.

The stark and colorless faith of the house's presumed inhabitants, as the painter envisioned them, no more resembled the grandeur of medieval Christianity than the home's upper window recalled the cathedral of Chartres. Indeed, Wood's initial goal in painting *American Gothic* had been to create an analogous relationship between the farmhouse and its imagined owners; "I simply invented some 'American Gothic' people to stand in front of a house of this type," Wood explained to the *Des Moines Register* in 1930, adding that "it was my intention to do a Mission bungalow painting as a companion piece, with Mission bungalow types standing in front of it." Although Wood never created *American Gothic*'s pendant mission image, his proposed juxtaposition of the two styles—one belonging to the Victorian era, the other to the twentieth century—is indicative of the split that characterizes his work in a more general sense. Not surprisingly, it is the twentieth-century example that he never got around to.

Wood's original concept for *American Gothic* may be easily read in the finished work—a Victorian house paired with Victorian "types"—yet this setup alone fails to explain the painting's uncanny chill. More than just a send-up of Mencken's Bible Belt "booboisie," it is an eerie and even sinister image. Perhaps the most unsettling element in the painting is the clear misalignment between the sitters' ages—a detail that has inspired endless speculation concerning their relationship. Are we faced with a May-December romance, or a father and daughter? Wood himself seemed occasionally confused over the issue, yet neither possibility ultimately relieves the viewer's sense of discomfort. Beyond

the sitters' age discrepancy, there is also the disturbing quality of their frozen gazes and the aggressive foregrounding of their bodies—a visual confrontation pointedly underscored by the farmer's menacing pitch-fork.

Between these enigmatic and vaguely threatening figures hovers the Gothic window that first inspired Wood's composition. In its centrality and elevated position, it echoes the strategic placement of mirrors in the Northern Renaissance paintings Wood admired. Perhaps the best-known example appears in Jan van Eyck's iconic dual portrait, *The Arnolfini Marriage* (1434)—a work whose paired male and female figures, moreover, illustrate an age gap every bit as troubling as the one seen in *American Gothic*. Whereas van Eyck's central mirror draws the viewer and even the artist himself into the space of the painting, however, Wood's darkened and depthless window effectively shuts us *out* of his scene—if, indeed, we could get past the pitchfork. A vanishing point in more than one sense, then, the empty window suggests all the dimensions of the Gothic in its romantic, nineteenth-century context. Family secrets, dead bodies, incest, and murder all haunt this work, and they enter the painting here.

In Wood's personal iconography, the pointed arch held greater resonance, and a longer history, than any of his other recurring motifs. The first representative marks he had made as a boy, of course, were the arched circles that represented his favorite hen. In the childhood hide-aways where he produced such images, moreover, we see the same shape repeated: the arched openings of his kitchen table "studio," the pointed gable of the barn's hayloft, and the steep pitch of the Anamosa farmhouse's attic. Added to these early associations is the adult Wood's fascination with Gothic doorways—a subject found throughout the artist's Parisian paintings, and one that wholly dominated his 1926 show at the Galerie Carmine.

As the *New York Herald* noted about this exhibition: "Doorways and entrances invariably intrigue Mr. Wood, and nearly all of the paintings are constructed around that mysterious transition from indoors to outdoors which has played such a tremendous part in the civilization of man." More perceptive than he realized, the *Herald* critic explains the symbolic value that Wood appears to have attached to the Gothic arch: its role as a threshold between inside and outside, public and private, real and imaginary, living and dead. The arched perimeters of his childhood haunts marked the boundary between his world and

the one where adults ruled, just as the hen's feathers in his first drawing separated the bird's tactile exterior from its edible flesh.

Wood's fascination with arched forms may also be traced to his admiration for nineteenth-century folk art, particularly the genre of mourning pictures. In these works, prominent Gothic arches form part of a general iconography of death: urns, weeping willows, grapevines, and slow-moving rivers similarly underscore the grief of the images' human figures. The window in *American Gothic,* too, casts a pall over its scene—starkly triangulating against the rictus-like expressions of this couple, and providing the viewer with a key to the work's mood. As one early observer remarked upon first seeing the painting, it might have been more appropriately entitled *Return from the Funeral.*

Wood's preoccupation with death and the funereal—an element that may be found throughout his work—belies his popular reputation as a painter of only sunny, optimistic, or gently humorous themes. A self-described lugubrious child, he was attracted from an early age to Victorian sentimentality and the era's elaborate displays of mourning. Indeed, in his earliest surviving letter, Wood solemnly describes a local neighbor's death and burial, capitalizing the verb "Died" if not the name of the deceased woman herself (one "mrs cheshire"). After his father's death and well into his twenties, the artist reportedly enjoyed "getting lost" in solitary graveyard walks—a practice that the intensely private Wood probably found, as his Victorian predecessors had, more restorative than morbid.

Professionally speaking, Wood's early connections to the funeral industry were also particularly strong. In his first job away from home, of course, Wood had worked as night watchman in a funeral home—a position that led, in turn, to his various roles at the Turner Funeral Home in Cedar Rapids. Throughout the late 1910s and into the '20s, Wood not only served as Turner's interior decorator and promotional artist—roles that he undertook, as well, for at least one other funeral home in Des Moines—but he also designed Turner's casket biers. Indeed, Wood's paintings themselves were first marketed at funeral directors' conventions; citing his own collection of the artist's work, David Turner promoted the artist's elegiac, impressionist landscapes as particularly appropriate to the decoration of viewing rooms.

Although *American Gothic* never hung in such a context, it must be remembered where Wood created this painting: a studio in the shadow of a funeral home, perched above a garage for hearses, and entered by

way of a coffin lid. The upper window to this macabre door—a feature intended to display the face of the deceased—framed both visitors to the studio and its host as the living dead; once inside the artist's studio, moreover, visitors passed between two bronzed "death masks" Wood had made of his (living) friends Larry Bartlett and Harland Zimmerman. In certain respects, then, the birthplace of *American Gothic* may be likened to its creator. Typically described as a light, cheery, Arts and Crafts–inspired space, Wood's studio had an equally notable morbid streak.

The farmhouse in *American Gothic* suggests its own connection to the artist. Not only do its squat, comical proportions reflect Wood's image of his own body—as derived from others' uncharitable descriptions—but its Gothic masquerade also recalls the artist's enthusiasm for masked balls and theatrical costume. Considered in this light, the farmhouse may be seen as the painting's third principal figure—a captive witness to the enigmatic and vaguely incestuous scene it faces. Describing his childhood home in similar terms, Wood recalled that the Anamosa farmhouse "stood bleak and curtainless, like a man without any eyelids." Forming a tableau vivant like those Wood had participated in as a teenager, the three actors in this frozen composition tug at the audience's memory of a familiar image; in this case, however, it is the artist alone who recognizes the scene.

The selection of *American Gothic*'s models appears, at first take, to have been as fortuitous as Wood's choice of the Eldon farmhouse. In his search for Gothic "types," Wood had asked his sister and his dentist, Byron McKeeby, to pose for the painting—a choice that made far more sense in McKeeby's case than it did in Nan's. The elongated and rather grim face of Wood's dentist was perfectly suited to the artist's purported theme, yet his attractive, fresh-faced sister bore no visual connection to the Gothic revival farmhouse (nor, indeed, was she a natural match for the much older McKeeby, who was sixty-two to Nan's thirty). In an interview shortly after the painting's debut, Nan explained that she had been the artist's second choice for the female figure:

> As he put together his composition for the house and two people while he was at the breakfast table that morning in 1930, he said he had models in mind—a man and a woman who would be just perfect. However, he was afraid to ask the woman, fearing

she would be angry at the idea of being made something less than beautiful . . . Grant never told me whose place I took as the model, but I'm sure it was a spinster who had hounded him.

Nan's recollection is curious for several reasons. First, Wood's reluctance to ask his first choice for the female model would have been strangely out of character; indeed, in much of his subsequent work, the artist often asked friends and neighbors to model for paintings they knew might present them in an unflattering light. Second, even if Wood had chosen to spare the feelings of his intended model, it is equally unusual—given his close relationship with Nan, and their shared delight in poking fun at Cedar Rapids types—that he would not have revealed her identity to his sister. That the model might have been a spinster interested in "hounding" the unmarried artist, as Nan suggests, may be safely dismissed altogether.

A closer look at *American Gothic* suggests that Wood's first choice was, in all likelihood, his mother. At the time he began this painting, of course, the artist was planning to replace Hattie's recently purchased portrait. In *American Gothic,* he nearly does so. Not only do Nan's apron, cameo, and long, black sleeves reprise Hattie's costume in *Woman with Plants,* but she, too, is associated with potted sansevieria and begonia plants. Appearing in miniature form just over Nan's shoulder, these plants provide a subtle reminder of the 1929 portrait that, metaphorically speaking, lurks in the background as well. Never again would the artist transcribe elements from one painting to another so directly.

If Hattie had been Wood's intended model, then his reluctance to approach her makes perfect sense. Not only did the artist's mother dislike posing for him, but given the context of this image, it is also nearly certain she would have refused his request. To have painted his mother before a farmhouse so like the Woods' former home in Anamosa, the artist would have recalled Hattie's life on the farm in an uncomfortable and even painful way. To have paired her with a stern farmer consort, moreover, would have resurrected her role as a wife rather than a widow—a proposal she would doubtless have found inappropriate. By substituting his sister for his mother, rather than simply choosing an age-appropriate surrogate for Hattie, Wood managed to defuse the unsettling image of his parents' reunion while still preserving the work's

familial theme. The final result is, of course, all the more arresting. The pentimento of Wood's original choice remains visible in Nan's borrowed costume and companion, but not in her age or bearing.

McKeeby's identification with the farmer in *American Gothic* later defined his life in ways he found profoundly irritating—he had posed for Wood only under the condition of anonymity, and was (falsely) promised that his image would be rendered unrecognizable—yet the role he plays in this painting is more stunt double than leading man. As appropriate as McKeeby's features might have been for *American Gothic*'s expressed purpose, his affable personality was as far removed from his threatening portrayal as John Turner's depiction had been from his own. Once again, it appears, Wood had projected onto his sitter his childhood memory of Maryville. In *Return from Bohemia* he describes his father as "tall and gaunt," "straight and solemn," and "tall and bony," with a "solemn, stern, angular face"; relying upon Wood's memory, Nan herself describes Maryville as "a lean and lanky six-footer, with a stern and serious face."

As if to signal this substitution in *American Gothic*, the artist replaces the octagonal eyeglasses his dentist wore with Maryville's round, wire-rimmed frames. However inconsequential such a choice might seem, it is important to note that Wood invested his father's eyeglasses with an almost totemic power. Not only were they the sole personal article of his father's that he kept, but he had also ordered an identical pair for himself after his return from Munich. If Hattie's kiss had broken the spell of bohemia, then it appears Maryville's eyeglasses had endowed Wood with his new sense of vision.

In an interview from the late 1930s, the artist himself hinted that McKeeby's and Nan's portrayals in *American Gothic* represented a kind of double exposure. Explaining that he had worked with live models in painting *American Gothic*, Wood added that the two figures were also inspired by "tintypes from my own family album." That he had chosen not to replicate family pictures in this case, as he had done in other works from his teenage years onward, suggests that *American Gothic*'s sources include the stiff and unsmiling tintypes of his parents—the only images, of course, that he could not bring himself to directly reproduce. Rather, Wood distilled his parents' likenesses to their eyes alone—features he once described as having "a quality bleak, far-away, timeless."

If the expressions of *American Gothic*'s couple suggest the qualities Wood perceived in Hattie and Maryville—the long-suffering nature of his mother, and the confrontational personality of his father—then so, too, does the direction of their gazes. Whereas the female figure turns away from the viewer, bearing the same mournful and distracted expression Hattie wears in her 1929 portrait, the farmer appears at first to look directly at the viewer. (As one critic claimed, "His eyes pierce you with a fanatical stare.") Closer examination reveals, however, that the farmer's gaze is also turned from us. The effect is gradual and unsettling—he appears to have *just* missed meeting our eyes, and seems to have done so intentionally.

Because we instinctively seek in others' expressions their reactions to our presence, the farmer's subtly averted gaze makes us feel uncomfortably absent—an impression only heightened by his alarming proximity. In establishing this peculiar standoff between sitter and viewer, Wood deftly illustrates his own feelings of invisibility before his father. His autobiography provides numerous examples of Maryville's inability or unwillingness to acknowledge his presence, even in instances when father and son stood rather near to one another. "Always," Wood recalls, "he was looking away."

Maryville's connection to this work explains Wood's curious vacillation concerning the figures' relationship. The artist routinely insisted that the couple represented a father and daughter, yet on at least one occasion he referred to the male figure as the woman's husband. This possibly unintentional slip is rendered doubly strange when, in the course of the same interview, Wood cites the appropriateness of using his "maiden sister" for the female figure. To suggest that the woman in *American Gothic* was both a "maiden" as well as a married woman was as odd as his implication that Nan herself had been unmarried when she posed for him. (Although she continued to live with Wood and Hattie, apart from her husband, Nan had in fact been married for six years by 1930.)

In Wood's mind, of course, all of these contradictions were resolved by Nan's dual, imaginary roles in the image: she represents the still-married Hattie as well as Maryville's grown, unmarried daughter. Similarly, although "husband" and "father" would appear to represent mutually exclusive categories, the two roles were naturally wed in the figure of Maryville—whose context changed with Nan's inclusion, but

not his identity. Had Wood chosen a different female model for this work—someone as casually related to the artist as Dr. McKeeby—the spell would have been broken. However strange Nan's appearance in this work may appear, then, hers was the only face, after Hattie's, that could have fixed Maryville in this painting.

Even more remarkable than Wood's alternating designations for these figures is his initial *silence* concerning their relationship. In his first printed rebuttal to the painting's misinterpretation, he nowhere corrects popular assumptions that the pair represented a married couple. Indeed, regarding the erroneous reporting of the painting's title— several newspapers had dubbed it *An Iowa Farmer and His Wife*—Wood explained only that his figures were not intended to represent Iowans. It was Nan, rather than her brother, who first identified this couple as father and daughter. In a letter to the *Des Moines Register,* she invented a lengthy fictional narrative for the painting that has, in many ways, shaped its interpretation ever since. "I am not supposed to be the gentleman's wife," Nan explains,

> but his daughter. I get my ash blond hair from my mother's side of the family; Papa keeps a feed store—or runs the village post office—or perhaps he preaches in the little church. When he comes home in the evening our Jersey cow out in the barn starts to moo, and so father takes off his white collar, puts on his overalls and old coat, and goes out to hay the cow. I am supposed to be one of those terribly nice and proper girls who got their chief joy in life out of going to Christian Endeavor and frowning horribly at the young couples in back seats if they giggle or whisper.

In its surprising detail and acerbic tone, Nan's account tells us far more about herself than it does about this painting. Young, attractive, and fun-loving, Nan had often felt the sting of Cedar Rapids gossips, whose faces she clearly saw reflected in the prim female figure of *American Gothic.*

If we put aside the relationship between *American Gothic*'s two figures, as we ultimately must do—its insoluble nature is one of the very sources of the painting's power—another mystery remains concerning their identities: are these rural farmers or small-town folk? Wood claimed the latter, yet even in this case we are faced with a visual contradiction. In his initial sketch for *American Gothic,* the artist had

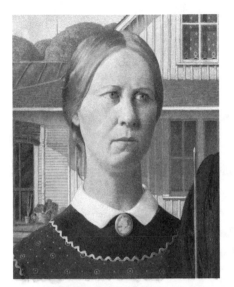

Grant Wood, *American Gothic* (detail), 1930, and *Woman with Plants*
(detail), 1929. In casting his sister as Hattie's surrogate, Wood created
a mirror image of his mother's portrait.

depicted a rake in the male figure's hand—thereby suggesting the lim-
ited gardening of a small-town setting. By replacing this rake with a
three-pronged pitchfork, an implement Iowan audiences would have
immediately associated with a farm (albeit a rather antiquated one),
Wood shifted the painting's context to a more recognizably rural scene.
The distinction here may seem a rather fine one, but its importance lies
in the way that it marks Maryville's insistent presence in the work. It is
his figure, rather than that of his female companion, who draws Wood
back to the farm—even against the artist's original intentions.

The pitchfork in *American Gothic* not only reflects the Victorian
world of Wood's boyhood but it also summons, once again, the classi-
cal narrative at the heart of *Woman with Plants*. If Hattie's portrait sug-
gests Demeter's grief for her missing daughter, then here we see
Persephone in the company of her Underworld abductor. Indeed, if
one were to place the paintings side by side, the mother's eyes even
appear to meet those of her captive daughter. Serving as a kind of
sequel to the earlier portrait, then, *American Gothic* preserves the story's
continuity while including new details that drive the plot forward.

The most important of these additions is, of course, the pitchfork.
Not only does this implement evoke popular caricatures of the Christ-
ian devil, but by extension, it also suggests the figure of Hades.

Although Satan and Hades differ in many important respects, their Underworld connection has made their conflation a relatively common phenomenon in Western art and literature. In his own analysis of *American Gothic*'s pairing, for example, Guy Davenport freely mixes the identity of these Christian and classical characters—referring to Wood's couple as Dis [as Satan is named in Dante's *Inferno*] and Persephone, "posed in a royal portrait."

Indeed, like the royal portraits of Wood's beloved Flemish masters, *American Gothic* includes emblematic devices identifying the sitters' respective realms. Whereas the germinating plants on the farmhouse porch appear to sprout from the woman's shoulder, on the farmer's shoulder we see a pointy red barn—a building that did not exist in the original Eldon setting. Beyond its suggestion of Hades' fiery world, this structure is also specifically tied to Wood's memories of Maryville. When the Woods left Anamosa, they brought with them a single piece of furniture made by the artist's father: a "little red grocery cupboard . . . coated with red barn paint and equipped with an iron latch. I had always liked it," Wood recalled, because "it had seemed like a little house to me."

Although the costume and accessories worn by the female figures in *Woman with Plants* and *American Gothic* might appear to identify Demeter alone, in classical depictions this mother and daughter are in fact identified by their matching garments. Only their opposing ages distinguish the two women, who are otherwise seen as doubles. Persephone's distinction from her mother, then, is purely geographical—as evidenced by the placement of *American Gothic*'s female figure. Illustrating the aftermath of Persephone's descent, Wood not only places this woman below the painting's horizon line, but he also positions her behind her consort's pitchfork. Her look of resignation, rather than virginal alarm, tells us she is already lost to the world above.

The tendril that escapes this figure's tightly bound hairstyle summons Persephone's traditional depictions even more emphatically. As seen in the cameo Nan wears, Persephone's unbound hair indicated the swiftness and violence of her abduction. Wood's figure may present a tamer form of disarray, yet her strict sense of decorum makes this obvious lapse all the more noteworthy. This "provocative curl," as Thomas Hoving describes it, suggests the loss of innocence at the heart of Persephone's story—for in her loosened hair, a motif that traditionally sig-

nals a woman's abandonment of sexual inhibitions, we see reflected her physical union with Hades. This hint of sexual experience is further underscored by the darkened bedroom window Wood positions between these two figures, and by the image's inevitable (if ironic) connection to jokes about promiscuous farmers' daughters.

If the figure's unraveling hair marks her as a victim, however, then it also suggests her potential as a predator. For in its clear resemblance to Hattie's sansevieria plant, Nan's serpentine lock of hair connects her all the more closely to the immobilizing, snaky-locked figure of Medusa. So, too, does this "maiden's" unblinking, stony gaze. As Laurie Schneider Adams has argued, the Gorgon's power of attraction and repulsion were founded upon fears of adult, female virginity and the sexual independence it implied. In a passage that might easily describe this figure, she writes: "Medusa's glare is the cold look of chastity."

Occupying an ambiguous space somewhere behind her consort, Wood's female figure focuses her gaze directly on his back— transforming him, it would seem, into a living corpse. Indeed, the unpainted areas of the farmer's overalls themselves suggest a wraith-like immateriality; in these brown patches of exposed artist's board, we look directly "through" the farmer. A closer look at these overalls reveals that their soft, weathered seams directly mirror the tines of the farmer's steely pitchfork. The gaze of his companion, it seems, has rendered the farmer's pitchfork as inert as the man himself. Like the images of Medusa once placed outside Greek temples, Wood's female figure therefore acts like a modern apotropaic device: a shield to protect the living from the malice of the dead.

That Nan's figure might bear comparison to Medusa and her frigid gaze was first expressed by Mrs. Earl Robinson, a farmer's wife from Collins, Iowa. Her letter to the *Des Moines Register,* entitled "An Iowa Farm Wife Need Not Look Odd," reads in part: "Mr. Wood may have depicted his subjects true to life, but the next time he might choose something wholesome to look at and not such oddities. I advise him to hang this portrait in one of our fine Iowa cheese factories. That woman's face would positively sour milk." Although her closing comment is comically intended, Mrs. Robinson nonetheless pinpoints the source of the painting's power—demonstrating that popular reactions to *American Gothic* were often more perceptive than its official criticism. In her printed response to this letter, Nan revealed a bit of her

own inner Gorgon. "I wish that jealous woman [from Collins] would send me her photograph," she wrote. "I have a very appropriate place to hang it."

To whatever extent Nan may have seen herself in *American Gothic* (a connection at odds, it must be said, with her initially negative perception of its female figure), it is in fact *Wood's* identity that we read most clearly in this painting. Referring to the spinster "type" that the artist presumably intended to portray in *American Gothic,* Wanda Corn describes these women as daughters "whose excessive duty to family kept them from ever leaving home, where they cared for aging or widowed parents and where they withered as social creatures"—a characterization that reflects Wood's experience far more so than it does his married sister's. If *Woman with Plants* suggests a parallel between Wood's homecoming and Demeter's loss, then *American Gothic* equates Persephone's fate with Wood's own feelings of exile upon his return. Like the female figure in this painting, Wood may have been resigned to his captivity, but neither was he defenseless against it.

AMERICAN GOTHIC DEBUTED AT the Art Institute of Chicago in the fall of 1930. Whereas *Woman with Plants* had failed to attract much attention at the same venue just a year before, the artist's latest entry was the universally acknowledged hit of the show—a triumph that derived in no small part from the painting's powerful psychological charge. Given its multilayered iconography, critics and popular audiences projected a host of different, and often conflicting, meanings onto the painting.

Many Iowans who first saw *American Gothic* were angered by the image, perceiving in it a parody as cruel as it was inaccurate. Citing the archaic character of the figures' clothing and accessories, for example, Mrs. Inez Keck of Washta, Iowa, wrote to the *Des Moines Register* that "perhaps [the artist] has not been in Iowa since he was a little boy." Beyond noting the painting's anachronistic appearance, locals also took exception to the "unwholesome" nature of the sitters' age discrepancy (the figures continued to be taken for a married couple, despite Wood's insistence to the contrary) and frequently remarked upon the figures' perceived unattractiveness. To Nan's lasting fury, one Iowan housewife claimed that the female figure in *American Gothic* resembled nothing so much as "the missing link."

What these Iowans perceived as an unjustified attack, of course, Mencken's disciples considered a fitting portrayal of the Babbitty, Bible Belt mentality they believed defined the Midwest. In the *Boston Herald,* Walter Pritchard Eaton offered this assessment of Wood's painting:

This is a portrait less of two individuals than of the very "dissidence of dissent" . . . caricatured so slightly that it is almost doubly cruel, and though we know nothing of the artist and his history, we cannot help believing that as a youth he suffered tortures from these people, who could not understand the joy of art within him and tried to crush his soul with their sheet iron brand of salvation. They are rather terrible.

Critics in both camps—indignant Iowans on the one side, and gratified urbanites on the other—were united in their belief the artist had a score to settle in this image. Although these interpretations miss the mark to some degree, they draw far closer to an understanding of the painting's psychological dimensions than its flag-waving admirers and leftist critics would ever do.

American Gothic's figures, of course, *do* represent primitive and even "rather terrible" historical throwbacks for the artist—and certainly, they recall the rigidity of the world in which he was raised. That he intended to ridicule these figures, however, is doubtful. As the artist himself later explained, "I admit the fanaticism and false taste of the characters in *American Gothic.* These people had bad points, and I did not paint them under, but to me they were basically good and solid people." What little satire may be found in *American Gothic,* then, exists only in the artist's original (and ultimately somewhat tangential) premise to capture the resemblance between a farm couple and their home. Wood respected his parents too much, and loved them too deeply, to have attacked them in this work.

The critic Robert Hughes notes this reluctance in *American Gothic,* yet he does so in a way that might have gratified the homophobes of Wood's own day. *American Gothic,* he writes, is "the expression of a gay sensibility so cautious that it can hardly bring itself to mock its subjects openly." By implying Wood simply wasn't man enough to take on these characters, or that he chose to snicker at them only from a safe distance, Hughes appears to conflate homosexuality with cowardice. More careful analysis of the work uncovers, by contrast, its extraordi-

nary sense of restraint, strength, and inventive subversion—all of which more accurately reflect the work's "gay sensibility," if one is to be found at all, than the furtiveness Hughes perceives.

In Wood's own day, the notion that *American Gothic* represented a satire of midwestern types was less common than the competing claim that it embodied a sincere and patriotic reflection of America. In its front-page review of the Art Institute's exhibition, the *Chicago Evening Post* featured a large reproduction of *American Gothic* under the headline: "American Normalcy Displayed in Annual Show; Iowa Farm Folks Hit Highest Spot." For its part, the *Chicago Daily News* proposed that the work's patriotic appeal placed it not only above other works at the 1930 show, but also at the forefront of American art, period. *American Gothic,* the newspaper claimed, was quite simply "one of the finest records of Americana that has ever been painted." Although the Art Institute's exhibition jury had initially rejected Wood's painting— a bombshell that Steven Biel has recently revealed—its members quickly fell in line with the work's more ardent critical supporters. As one brochure to the exhibition read, *American Gothic* "is interesting, because it is entirely of us."

For those who perceived a national self-portrait in this work, it was important to distinguish its regional focus from other, less "American" parts of the country. As C. J. Bulliet, the art critic for the *Chicago Evening Post,* wrote of *American Gothic:* "The biggest 'kick' of the show comes—not out of New York or Woodstock or the effete east, nor even out of Al Capone's jazzed up realm—but out of Cedar Rapids, Iowa." Bulliet makes an important distinction here between the painting's rural, midwestern milieu—the source of its powerful "kick"—and the presumably fey, elitist atmosphere of the East Coast or corrupt environment of Chicago. If the success of *American Gothic* served to sharpen this rural/urban divide, then so, too, did perceptions of Wood himself—a view the *New Yorker* expressed in no uncertain terms: "As a symbol [Wood] stands for the corn-fed Middle West against the anemic East, starving aesthetically upon warmed-over entrees dished up by Spanish chefs in Paris kitchens. He stands for an independent American art against the colonialism and cosmopolitanism of New York."

Such criticism demonstrates that *American Gothic* and its creator were believed to be entirely home-grown products, safely immunized from the taint of European decadence. Ignorant of the artist's Parisian sojourns and initial allegiance to impressionist style, Bulliet begins his

paean to *American Gothic* by applauding the waning influence of French impressionism at the 1930 show. *American Gothic,* he explains, demonstrates "masterful technique, and yet"—he carefully adds, lest this phrase conjure images of a Parisian atelier—"[it] remains AMERI-CAN" (his capitalization). Equally unaware of the artist's background, the Art Institute praised Wood as "an American with an original view-point, without a vestige of foreign influence," adding that *American Gothic* "could have been painted in no other country."

Even once the story of Wood's Alte Pinakothek epiphany became more widely known, his debts to the Flemish and German Old Masters were forgiven due to the absurd belief that these artists, like Wood, were nothing more than simple, rural artists themselves. As the art critic Gilbert Seldes wrote, Wood's foreign influence "comes from the simple and primitive Europeans, not from the sophisticated ones." In rather seamless fashion, the artist's plain style also summoned the simi-larly "primitive" style of the first American painters—men like Ralph Earl, Charles Willson Peale, and John Singleton Copley, whose colo-nial- and Federal-era portraits were characterized, in the words of Alfred Barr, by their striking plainness and "severe sense of fact."

As the story was often told in the 1930s, American painters in the late nineteenth century had traded this realist birthright for the for-eign, and therefore suspect, brushwork of Velázquez, Manet, and the impressionists. Those familiar with Wood's early style indicated he had followed the same unfortunate path. Arthur Millier wrote, for ex-ample, that the artist had initially "suppressed his native desire for precision and detail" in adopting the exotic brushwork of the impres-sionists, whose "pink and mauve splotches . . . were entirely unsuitable to the sharp delineation of the characters of the [American] people." Following the artist's return to Iowa, another writer noted, he had at last exchanged the "purling brooks [and] sentimental daisy fields" of the French for "the clean, clear hills . . . and the sharper stones of America."

With works like *Portrait of John B. Turner, Pioneer, Woman with Plants,* and *American Gothic,* critics proposed, Wood had single-handedly reversed the tide that had pulled so many in his generation to Paris. The *New York Times*'s Edward Alden Jewell declared the painter had earned his "toga virilis" for ending Americans' perilous fascination with impressionism, whereas Seldes wrote that: "Grant Wood is calling us back to . . . simplicity, and even a hardness." Rather pungently,

another writer observed that the artist had replaced the vogue for Continental affectation with his own "Midwestern tang."

The overwhelmingly masculine characterization of Wood's new style—primitive, controlled, hard, potent, and even *sweaty*—bordered, in the words of one Cedar Rapids critic, on the pornographic. Adeline Taylor praised *American Gothic* as a "stiff job," the result of a "metallic" quality "that [had] injected itself in [Wood's] roguish roundness." Having given up impressionism, she continues, Wood "has started amusing himself with meticulous reproductions of personalized hardness." What Taylor and others viewed as a kind of phallic swagger in Wood's art was, of course, distinctly at odds with the artist's profound sexual reticence and masculine insecurity. Although Wood's work had indeed stiffened following his return from Germany, both stylistically and physically (after 1929, he switched from canvas to panels), his new style reflected a personal erasure more so than it did his emphatic presence.

Under Wood's new, traceless strokes, the former spontaneity of his painting completely disappeared. Exchanging the rapid application of his early work for a technique of almost pathological slowness, he now spent months completing paintings that might formerly have taken him less than a few days—a process he claimed was closer to "sweat[ing] blood" than painting. Even once he had finished a panel, Wood typically spent hours smoothing over its glazed surface with a razor blade, removing all evidence of his own hand. This new technique appears to have ensured that, despite Wood's return to the threatening world of his boyhood, its scenes and characters would remain safely trapped in amber—caught beneath impermeable glazes and strictly, painstakingly reordered to his own design. That uncanny visual eruptions still occurred in his work (and indeed, that they often proliferated in direct proportion to his strict sense of control) demonstrates both the fertility and the volatility of his unconscious imagination.

The critical attention Wood received for *American Gothic* was as gratifying to him as it was truly overwhelming. Never in the history of American art had a single work captured such immediate and international recognition; by the end of 1930, the painting had been reproduced in newspapers around the globe, inspiring endless speculation about its sitters and meaning (as the *Cedar Rapids Gazette* crowed that winter, "Grant Wood Hailed from West to Berlin as a Discovery"). Never before, either, had a painting generated such widespread curios-

ity about its artist. Nan claims she and her mother "were shocked and couldn't believe our eyes" by the regular invasions of privacy that followed *American Gothic*'s success:

> Strangers now considered the studio a public place rather than the home where we lived . . . People walked in without knocking and toured the studio. People we never saw before would open cupboard doors . . . [and] pull the cords to the curtains that hid our beds, and I heard one of them say, "Mr. Wood sleeps here, and his mother sleeps here and his sister sleeps there." Once they caught me in bed. A group arrived while we were eating, and one of them said, "You just go on eating; that's perfectly all right."

Nan's recollection indicates that she, Hattie, and Wood constituted the studio's main attraction—a living tableau that, like *American Gothic* itself, inspired unrelenting fascination. From this point on, Wood's life was shaped by his keen awareness of this public surveillance and its unwelcome consequences.

Within a year of *American Gothic*'s debut, to cite a rather striking example of the artist's new vulnerability, Wood was targeted by a blackmailer. In Nan's version of the event, one evening she answered a knock at the studio door to find "a tall, skinny youth"—a man, in fact, in his late twenties—asking to see the artist. "Grant went to the door," she explains, "and when the young man said it was something private, they stepped outside and pulled the door shut. They talked so long that Grant's dinner grew cold." When he returned to the table, a visibly shaken Wood told his mother and sister that the visitor had claimed to be his illegitimate son. He had only avoided the stranger's blackmail attempt, he explained, by pointing out their relatively slim age difference. At twenty-nine, the man was only a decade younger than the artist himself.

In the slightly different account Wood told his friend Bruce McKay, the mysterious visitor—described as six feet tall, thin, "with long black hair in need of cutting"—had found the artist alone at his studio. Describing the young man's motives as professional rather than financial, Wood recounted that, following the foiled blackmail attempt, the visitor had "said he was an artist and wanted to study with me."

Despite the absurdity of the young man's story, and the apparent harm-
lessness of his subsequent request, Wood was clearly unnerved by the
incident. "I got rid of the boy as quick as I could," he confided to
McKay, "but he said he's coming back to see me. It's got me worried."
McKay found the story more comical than alarming. "I started to
laugh at the idea of [Wood's] being the father," he writes, adding that
"Grant looked at me in a puzzled manner, not fully understanding my
amusement." In his summary of this episode, McKay philosophically
suggests that "all artists are, I suppose, after they become famous, pur-
sued by queer people."

In truth, Wood's accounts of this stranger are more mysterious than
the young man himself. To begin with, it makes little sense that the
artist's blackmailer would have concocted such an easily dismantled
charge—and certainly, it is unlikely that he would have returned fol-
lowing the exposure of his scheme. Given Wood's disproportionately
fearful reaction to the stranger's charge, and his rather odd recounting
of the incident's denouement, it appears more likely that that the inci-
dent involved a homosexual blackmail attempt. Not only do the age
and appearance of the young man suggest precisely the physical type to
which Wood was drawn in this period, but the episode also clearly rep-
resented a dangerous and unresolved threat for the artist—one that,
unlike the existence of an illegitimate child, held the potential to
destroy his career. In his retelling of the event, then, it was important
for Wood to portray his would-be blackmailer as transparently oppor-
tunistic and none too bright.

Nan likely had her own reasons for including this blackmail episode
in her memoir. By emphasizing the blackmailer's story, rather than
dwelling on the unlikelihood of Wood's potential fatherhood, she
leaves open the possibility that Wood *might* have had an affair with the
young man's mother. Nan's insistence upon her brother's romantic
interest in women—an assertion that grew increasingly shrill over the
years—almost certainly reflected her anxieties concerning Wood's
"bachelor" status. And she had good reason to worry. Not only did
local newspapers unkindly reference the artist's nonexistent dating life,
but by the mid-1920s Wood had also begun to take on handsome
young men as protégés—a pattern that would continue until the end of
his life, and one that raised continual suspicions regarding his sexuality.

During his extended year abroad in 1923–24, for example, Wood

had grown close to a young man named Marcel Bordet. Introduced to this native Parisian during a trip to France in 1924, Wood's friend and onetime patron Henry Ely described Bordet as "a talented youth . . . who spoke English well and knew all the twists in the city's night life." As charming as Ely found Bordet, however, he was skeptical about Wood's plan to find the Frenchman a teaching position back in Cedar Rapids—and disturbed by the artist's intention to share his crowded living quarters at Turner Alley with the young man (a situation that, indeed, would have proved almost comically disastrous). Advising the artist to return home without his friend, Ely was relieved to see the two men part ways.

Nan makes no mention of Bordet in her own memoir. Instead, she claims that her brother returned from Paris despondent over a failed romance with a woman named Margaret. Wood had intended to marry Margaret and bring her home to Cedar Rapids, Nan explains, but had ended the affair upon discovering she was independently wealthy—an explanation that makes little sense, given his perpetual excuse that he could not support a wife in addition to a mother. Considering the similarity between their names, it is tempting to speculate whether Margaret, whom Wood described to his sister as a "dark and slender" fellow artist who "adored having a good time," was in fact a pseudonym for Marcel. Indeed, aside from Nan's memoirs, there is no mention of anyone named Margaret from this period in the artist's life—nor does her name appear in the accounts of Wood's fellow expatriates. Seeking more information about this woman following her brother's death, Nan was told by Wood's secretary that "there was never a single line from [Margaret] or a single reference about her in any of [Wood's] correspondence."

Not long after Wood's return from Cedar Rapids, Bordet's place was taken by two similarly young, handsome, and dependent young men. The first of these, Carl Flick, was an amateur painter from nearby West Amana, Iowa. Beginning in the late 1920s, Wood had often visited the Amana colonies on painting expeditions; this independent religious community, a group of seven villages founded by radical German Pietists in the 1850s, clearly appealed to him for its anachronistic character. From the time of their first meeting, probably around 1929, it was the twenty-five-year-old Flick himself who drew Wood to the colonies. Flick soon became Wood's protégé, accompanying him on sketching

Carl Flick at his easel in West Amana, 1937

trips, visiting the artist in Cedar Rapids, and sharing meals with him in Amana's communal kitchens. Their attachment would remain strong for the rest of Wood's life.

Wood's connection to Arnold Pyle was of longer standing. One of the artist's former students from McKinley Junior High School, Pyle had apprenticed with both Wood and Marvin Cone in his teenage years. Following his graduation from high school, he joined Wood's studio full-time, acting as the artist's assistant, frame maker, and unofficial business manager. Given the light duties these roles must have carried in the years before *American Gothic,* and taking into account Pyle's rather indifferent abilities as an artist, it appears that Wood's decision to

Arnold Pyle in the summer of 1932. Within a year of his coming-of-age portrait, Pyle sports the thin mustache of a matinee idol.

hire the young man was based more upon generosity than necessity. Despite his unimpressive earnings at this date, Wood no doubt wished to provide his former student with the support he had once longed for himself.

Pyle's youth and good looks must also have played some part in this arrangement. With his thick shock of dark hair and slight frame, he not only resembled Carl Flick, but also the descriptions of Bordet and Wood's would-be blackmailer. Pyle clearly resembled a "type" to which Wood was drawn in the 1920s, and their friendship echoed the pattern of Wood's earlier crushes on Harold Kelly and Paul Hanson: a temporary and all-consuming attraction that was likely, for Wood, a one-sided affair, too. Like Hanson, too, Pyle occasionally modeled for the artist—notably inspiring, as Jane Milosch has recently suggested, the eroticized cannoneer in Wood's 1928–29 *Memorial Window*.

Not only did the two become constant companions—when they weren't working at the studio, they could be found at their favorite downtown haunt, the Butterfly Teashop—but Wood also gave his assistant a number of sentimental gifts, including a fragment from one of his finished paintings and a charcoal self-portrait. Following the young man's twenty-first birthday in 1930, Wood even painted Pyle's portrait—a mark of distinction all the more remarkable given the many portrait commissions the artist routinely refused. In this quasi-allegorical image, entitled *Arnold Comes of Age* (see color plate 11), Wood not only revealed the traces of his desire for Pyle, but also his complicated feelings about "coming of age" himself.

Echoing the severe style and format of Hattie's portrait, *Arnold Comes of Age* presents its subject in a three-quarter view against an autumnal Iowan landscape. Offsetting Pyle's pale, heart-shaped face

with a thick crown of black hair, Wood exaggerates the natural propor-
tions of the sitter's head. (Indeed, given the work's still visible under-
painting, it appears that he originally painted Pyle's head even larger
than its current size.) If Hattie's heavy, germinating body had appeared
to grow directly out of the ground in her portrait, then Pyle's semi-
pneumatic form seems to gently float above the land.

Pyle's separation from his environment is tempered by the clear par-
allels Wood draws between his figure and the painting's natural ele-
ments. The delicacy of Pyle's slim torso is reinforced by the trompe
l'oeil butterfly that rests on his right arm, whereas his muscular, elon-
gated neck is echoed by the tree trunks that flank his body on either
side. Cutting across these vertical elements are three distinct horizontal
planes: the harvested fields beyond Pyle's figure; a narrow stretch of
river; and in the immediate foreground, the river's shaded bank. Along
this bank, Wood includes the figures of two slender, nude youths—a
tiny tableau that, like the landscape itself, brackets and reinforces the
presentation of Pyle's body.

In traditional readings of this coming-of-age image, its water ele-
ment is interpreted as a river of life. Mirroring one another on its
opposing shores are the nude bathers and the twin bales of harvested
grain; the swiftly moving water separates youth and maturity for these
figures, then, just as it does for Pyle. Further underscoring this
metaphor are the trees that frame the artist's assistant. One is thin-
limbed with new green buds, whereas the other is a mature, thick-
barked tree with striking fall foliage. Perhaps the most recognizable
symbol of Pyle's transformation into adulthood is the butterfly that
hovers over his sleeve. An ancient symbol of metamorphosis and
renewal, this newly hatched creature appears to occupy the viewer's
own world—alighting on the portrait as if drawn there by the sitter
himself.

Despite this optimistic symbol of new life, the painting is ultimately
a rather mournful image. Not only is the sitter's costume dominated by
the black color of his sweater, but the faraway look in his eyes also sug-
gests the contemplative sadness of Hattie's portrait. (Even Pyle's dis-
tinctive hairline, known as a "widow's peak," is a subtle funereal detail.)
Enveloping this figure like a shroud is the low, fading light of an
autumn sunset. A golden glow spreads across Pyle's features and the
harvested field, leaving in its wake an ominous shadow that bisects
the sitter's torso and plunges the two swimmers into semi-darkness.

Although these figures should signify the vitality of youth, even their presence suggests a somber note. The downcast head and arched back of the standing figure, in particular, introduce a palpable note of despair—whereas his dripping hair suggests the willow branches of nineteenth-century mourning iconography.

These bathing figures epitomize Wood's Gothic sensibility, in both the romantic and medieval sense. By juxtaposing a pair of retreating nudes with the substantial trunk of a tree, Wood recalls traditional images of Adam and Eve's expulsion from the Garden of Eden—a narrative less about youthful innocence than its loss. Indeed, miniature expulsion scenes often appear in the medieval altarpieces Wood admired; in paintings of the Nativity or Crucifixion, for example, Adam and Eve often lurk in the background, serving as foils to Christ's redemptive mission. In Pyle's portrait, by contrast, the figures function more like a Greek chorus—repeating the work's central message of vanished innocence, and implying the threat of punishment.

The contrast between youth and maturity in *Arnold Comes of Age* not only indicates Pyle's transition from adolescence to adulthood, but also the respective ages of Pyle and Wood. That the painting concerns both men, rather than Pyle alone, is suggested by the consistent twinning device Wood uses—seen in the pairs of swimmers, haystacks, bushes, and trees that frame the sitter. Even the painting's butterfly implies the men's pairing. Not only does it recall the name of their favorite café, but its placement also mirrors the artist's signature on the figure's opposite sleeve.

Considered as a combination of artist and subject, the mournful quality of this portrait makes far more sense. For, in addition to celebrating his new maturity, this bittersweet tribute demonstrates that Pyle had reached a more erotically charged (and therefore, for Wood, a more perilous) age. As if to identify the very site of his assistant's "coming of age," Wood marks his lower torso with a monogrammed belt buckle—an accessory almost certainly of his own design. Not only was Wood an accomplished metalsmith, but the entwining of the letters on this buckle is also typical of the monograms he produced for the Kalo shop in Park Ridge.

If *Arnold Comes of Age* suggests Wood's ambivalence about his assistant's maturity, then it also reveals the anxiety he felt concerning his own adulthood. Throughout his mature career, the artist not only remained visually and emotionally fixated on the period of his boy-

hood, but he also cultivated a childlike dependence, passivity, and appearance. Frequently described as baby-faced and cherubic (in Paris, Wood had been dubbed "Baby Camay" for his perceived resemblance to an infant in a popular soap ad), the artist went to great lengths to encourage this image—producing caricatures of himself as a childish figure, and often appearing at costume parties dressed as the baby Cupid. Following one such episode in 1930, Adeline Taylor wrote in the *Cedar Rapids Gazette:*

> When Grant Wood attended the Beaux Arts Ball . . . represent-
> ing Cupid, he created a sensation. With his round, seraphic face
> and his rotund, cherubic figure he had always been dubbed
> Cupid. But it's one thing to have a nose that's slightly stubby, a
> chin that dimples, hair that still curls into soft golden ringlets, a
> voice that's soft and slow and gentle, and it's another thing to
> admit it.

Wood's slow, halting speech pattern, remarked upon by Taylor and others, was considered a juvenile if forgivable affectation. "He spoke like a schoolboy reading in a bad light," one contemporary wrote, "with pauses so that the listener had constantly to pick up his words and string them into sentences."

More than any other trait, it was Wood's absentmindedness that epitomized his childlike persona. Frequently known to lose his keys, his wallet, train tickets, and address books, he also routinely overdrew his bank account, forgot to pay bills, neglected to file his income taxes, and was known for missing appointments or showing up on the wrong day. He failed to remember telephone numbers, including his own, and although he was fully able to drive, he preferred not to—relying on others, instead, to chauffeur him around town. Far from the rowdy adolescence his generation had been encouraged to retain, Wood's behavior suggests instead an almost infantile helplessness.

Nan, David Turner, Fan Prescott, Paul Hanson, and a small coterie of others acted as Wood's surrogate parents. Although they claim to have indulged his puerile behavior because he was an artist, it is likely that they felt more comfortable casting him in the role of a child—someone whose simplicity placed him above sexual suspicion. (Indeed, at the artist's funeral, the biblical readings Nan selected to "suggest the

life and character" of her brother were all related to the innocence of children.) Not all of those who knew Wood, however, were charmed by his arrested development. As the critic Lincoln Kirstein once claimed, "Grant Wood is a member of the Great American Fraternity of permanent adolescents, boys who are old enough to know how old they can afford to grow up." For Wood, of course, the age of ten represented an impassable boundary.

• In some respects, Wood's passivity represented a form of aggression. By forcing others to manage his affairs, wait for him, or listen patiently while he spoke (Wood's words emerged, one observer remarked, like a message from a telegraph wire), he punished those around him for the boyish, nonthreatening, and fundamentally asexual role they compelled him to play. Assuming nearly all of Wood's adult responsibilities for themselves, the artist's handlers paid a high price for this unspoken arrangement—yet they remained protected, in turn, from the potential meaning of Wood's problematic bachelorhood.

However well the artist might have played this childlike role, his paintings reveal a decidedly adult complexity. Indeed, in Pyle's portrait Wood's mournful conception of adulthood is countered by the visible traces of mature (if sublimated) desire. Behind the figure of his assistant, for example, he portrays the work's youthful nudes in a decidedly voyeuristic manner. Not only are the figures unaware of the viewer's gaze, but their exposure is rendered all the more titillating by the contrast between their tanned limbs and pale torsos. More arresting than the figures' state of undress is Wood's clear suggestion of sexual receptivity in the pose of the standing figure. Leaning forward with his buttocks exposed, this youth not only invites the viewer's penetrative gaze, but also appears to brace himself against the tree's sturdy trunk. As if to isolate and reinforce the image of this swimmer's buttocks, the artist repeats their shape in the clefted, oddly fleshy bush that appears to the left of the sitter's head.

The butterfly in Pyle's portrait provides yet another indication of Wood's desire. Multivalent in its symbolism, the butterfly not only suggests the sitter's metamorphosis into adulthood, but also the particular brand of feminized, youthful beauty with which young men of the late nineteenth century were often associated. Along with lilies, in fact, the butterfly was one of the primary icons of the foppish Aesthetic Movement and its youthful, androgynous adherents. By associating his assis-

tant with this butterfly, Wood casts Pyle as an object of beauty and longing—an ethereal creature as delicate as it is elusive. Like a butterfly specimen himself, Pyle is pinned down for inspection: one sleeve secured by the insect, the other by Wood's own name.

Considering the erotic undercurrents in this image, it is worth noting that Pyle's portrait directly preceded, and may even have overlapped with, the creation of *American Gothic*. In the figure for which Nan modeled, we see a look of concern that no doubt mirrored her real anxieties concerning Wood's connection to his assistant; and in the threatening stance of the farmer, moreover, Wood projects the attitude Maryville himself might have shown the artist's protégé. Parental guardian figures in Wood's paintings, it seems, were critical to the artist's self-surveillance. Not only did these imagined chaperones act as visual deterrents to his more dangerous impulses, but they also allowed him to exorcise the very anxieties these figures inspired.

In a rather unsettling work from 1931, entitled *Victorian Survival* (see color plate 16), Wood provides a striking example of this dual strategy. Whereas Hattie's and Pyle's portraits had suggested the look of Northern Renaissance court portraiture, here we see Wood's maternal great-aunt, Matilda Peet, in a near-reproduction of a nineteenth-century family tintype. Seated with her hands decorously folded on her lap, she peers out at the viewer with the same grim expression seen on *American Gothic*'s models (figures derived, at least in part, from a similar source). Closer consideration of *Victorian Survival*, however, reveals elements clearly foreign to a staged Victorian photograph—including the work's exaggerated scale, its anachronistic inclusion of a telephone, and, most of all, the freakish distortion of its subject's rope-veined neck.

Wanda Corn sees in this image the clash between the nineteenth and twentieth centuries. Mimicking Aunt Tillie's elongated form, the tall, candlestick telephone beside her:

> mocks everything the woman represents. Whereas she is old-fashioned and set in her ways, the dial phone . . . is the most progressive instrument of the day. She is reserved and repressed, but the phone is perky and alive . . . inviting someone to pick it up and talk into its mouthpiece. There is no way, the artist suggests, for the prim Victorian world . . . to adjust to the jangling, intrusive world of the telephone. They are creatures from two

Matilda Peet, tintype, late nineteenth century.
The photographic source for Grant Wood's 1931
Victorian Survival (see color plate 16) presents his
great-aunt in a far more dignified light.

completely different social systems; the phone is the victor, Aunt
Tillie, the victim.

Corn's reading tells us much about the telephone's power in this image,
and rightly identifies Wood's figure as an exaggerated and even cruel
illustration of a Victorian "type." The interpretation fails to explain,
however, the work's palpable Gothic horror. As with *American Gothic,*
the artist may well have intended a humorous juxtaposition here—but
if so, the joke has once again gotten away from him.

The scale and photographic versimilitude of *Victorian Survival* place it among the artist's most bizarre works. Although nineteenth-century photographs occasionally approached the size of traditional portraits, they far more commonly reflected the scale of the painted miniatures they replaced; tintypes like the original of Aunt Tillie, itself less than four inches high, were private, fragile, and semi-devotional images usually set in lockets or small, velvet-lined cases. In *Victorian Survival,* by contrast, Aunt Tillie's figure is projected nearly a yard high. She dwarfs the viewer, and yet her surrounding frame retains the traditional red velvet lining and arched crown of a handheld Victorian case. Such an uncanny enlargement would be lost on the viewer without Wood's extraordinary approximation of the image's original medium. Painted in sepia tones, with nearly imperceptible brushstrokes, the monstrous figure of Aunt Tillie projects the thrill of a P. T. Barnum hoax. We face an apparently objective, authentic document, yet we cannot trust our own eyes.

Although Wood often elongated the necks of his sitters, *Victorian Survival* provides an unusually exaggerated example of this mannerism—one clearly intended to echo, as Corn has suggested, the vertical shape of the telephone. If we consider the link Wood so often made between elderly matrons and their surveillance of community morality, then the figure in *Victorian Survival* appears to share even more with the telephone than its shape; for, in addition to representing the "jangling, intrusive" modern world, the telephone was also a powerful conduit for gossip. Lying in shadow behind Aunt Tillie, whose concealed right hand itself indicates a note of treachery, the telephone is more accomplice than opponent—an offstage voice, whispering something salacious (and apparently mortifying) into Aunt Tillie's overscaled ear.

As if to sever this line of communication, Wood silences not the telephone, but the sitter—neatly slicing her voice box with a black choker. Corn, too, sees violence in this passage. "This choker cuts across the woman's thick neck," she writes, "like the blade of a guillotine . . . She has so firmly gagged herself that she appears both unwilling and incapable of speech." As the creator of this image, of course, it is *Wood* who robs this figure of speech. Given the sitter's unnaturally distended neck, moreover, it appears that the phone has been forced down her throat—leading it to temporarily assume, like the body of a

snake, the shape of the sitter's last meal. The violence of Aunt Tillie's distortion—what the *Demcourier* called "an agreeable bad-blood let-ting" enacted upon "the poker-swallowing age in which [Wood] was born"—is a measure of the threat Wood perceived upon his permanent return to Iowa. She is indeed a victim here, but it is not the modernity of the telephone that undoes her.

Victorian Survival appears to embody a range of authority figures from the artist's life. Maryville's sister Sallie, for example, may be just as easily recognized in this figure as Aunt Tillie; whenever Sallie attended family gatherings, Wood claims, "the shadow of her grimly-corseted figure fell like that of a patron saint." (For her part, Nan remembered Sallie's "black eyes, coal-black hair, and ghostly, dead-white complex-ion.") Given the sitter's trappings of widowhood, moreover, she also bears comparison to Hattie's portrayal in *Woman with Plants*. Both women wear mourning attire, a commemorative cameo, and promi-nent wedding ring (a detail that in fact distances *Victorian Survival* from Wood's unmarried aunts).

More subtle, and perversely playing against gender, is this figure's uncanny suggestion of the farmer in *American Gothic*. Not only do her slightly averted gaze, ramrod posture, and unseemly, fleshy expo-sure link her to this figure—to say nothing of the weapon she holds at the ready—but these elements also represent clear departures from the original tintype. (Here, a more relaxed Aunt Tillie gazes directly at the viewer in a high lace collar.) Like *American Gothic*'s menacing farmer, the figure in *Victorian Survival* is a living corpse—a reassem-bled one, in fact—endowed with the same potential to punish. Ironi-cally, it is the figures' inescapably phallic character that allows Wood to defuse the threat they pose. Whereas the farmer's steely virility is undercut by the wrinkly softness of his overalls and deflated cheeks, the sitter in *Victorian Survival* embodies a tumescence that can be main-tained only by a choking cock ring. Her "survival" is unnatural and Gothic, rather than sentimental or comical.

WOOD'S WORK IN THE early 1930s reflects a range of different genres—his landscape and history paintings from this period, dis-cussed in the following chapter, indicate the variety and inventiveness of his work at this stage—yet it was his family portraits, always cast in

coded or allegorical form, that most starkly illustrate the consequences of his "return from bohemia." Before he could rescript his own past, it seems, he had to establish its cast of characters and determine the roles each actor would play. Once he accomplished this task, portraiture held little interest for him. Indeed, after 1931, Wood's family members disappear from his work almost entirely.

The last portrait Wood undertook in this early period was his striking *Portrait of Nan* (see color plate 10). Central to the understanding of his work, and a fitting crown to the first phase of his mature career, this 1931 portrait culminated the cycle he had begun with *Woman with Plants* and *American Gothic.* Whereas these earlier works celebrate Hattie in one form or another, here Wood pays homage to Nan alone. Sharing the style and mannered pose of Hattie's portrait, as well as the haunting quality of *American Gothic* and *Victorian Survival, Portrait of Nan* completes the artist's tripartite exploration of "we three"—a series in which Wood himself always plays a cameo role.

Portrait of Nan presents the artist's sister in a painted "Hitchcock" chair before a large green curtain. Directly facing the viewer, she holds two unusual accessories: a ripe plum and a live chick. Unlike the figure for which she had modeled in *American Gothic,* Nan appears here in an up-to-date, marcelled hairstyle and contemporary clothing—including an arresting polka-dotted blouse Wood designed expressly for this portrait. Reversing the formula of *Victorian Survival,* the artist anchors the modernity of Nan's appearance within the comforting semblance of the past. The portrait's heavy framing curtain, stark background, oval format, and Federal-era chair evoke many of the formal elements found in nineteenth-century American folk painting; James Dennis argues that these "trappings of a colonial portrait" somehow compromise the effect of this "up-to-date glamour girl," yet Nan is in fact all the more remarkable for her occupation of both worlds.

In painting his sister's portrait, Wood hoped not only to make up for the unkind criticism aimed at *American Gothic*'s female figure, but also—and perhaps more importantly—to avoid the disparagement of midwestern "types" that had accompanied *American Gothic*'s success. Given the inevitable comparisons between Nan's two portrayals, however, and the relatively slim period that separates these two works, the artist's expectations for *Portrait of Nan* appear to have been overly optimistic. In her review of the painting, Emily Genauer of the *New York Herald Tribune* wrote:

Portrait of Nan is of a young blonde woman dressed in cheap finery and holding a baby chick in one hand and a piece of fruit in the other. Dexterously composed in a manner obviously deriving from American folk painting . . . the subject has been endowed by the artist with all the bigotry, stupidity, and ignorance which are rife in the provinces, and are Wood's special target.

As Genauer's review suggests, following the success of *American Gothic,* Eastern audiences considered Wood's paintings to be the visual equivalent of Mencken's newspaper columns. (Indeed, for cosmopolitan critics like Genauer, the *sole* virtue of the artist's work lay in its perceived critique of the American hinterlands.) The same misreading of Wood's intentions has characterized the critical divide over his work ever since—one always centered on the question, Is he one of us or is he one of them? For Wood, who had spent his life trying to avoid this very question, *Portrait of Nan* exposed him in an even more uncomfortable way than *American Gothic* had. Pulling the portrait from public view soon after its completion, the artist "did not want things read into the painting that were not there."

If Genauer had misidentified the painting's intent, then she rightly suggested its affinities with Nan's earlier portrayal. Although Wood corrected the physical distortions Nan had allowed in *American Gothic,* he did little to dispel the chilly effect of the earlier work—and managed, in fact, to amplify this quality. In *Portrait of Nan,* the sitter's gaze is both unsettlingly direct and unreadable (Nan labeled the work a "latter-day *Mona Lisa*"), whereas the odd pair of objects she holds are all the more unusual for the way she presents them to the viewer. Combined with the overscaled pattern of the sitter's blouse and the shallow, unarticulated background behind her, Nan's portrait evokes all the uncanny elements of a dream.

In her own account of the painting's origins, Nan claims to have indirectly suggested its props. She explains that she had purchased the chick as a pet: "As I was showing it to Grant," she writes, "I held a plum I was about to eat in my other hand. He said, 'Hold it. That's how I'm going to paint you. The chick will repeat the yellow of your hair, and the plum will repeat the color of the background.' " The serendipitous choice Nan describes does not discount the objects' potentially deeper meaning for Wood; he may have been attracted to their formal proper-

ties, but he always chose his sitters' attributes with a clear sense of their symbolic value. As for Nan's suggestion that Wood's inspiration was followed by rapid execution—an account that recalls apocryphal stories about *Woman with Plants'* creation—the truth is, the portrait took him nearly four months to complete. Considering the extraordinary amount of time and emotional energy Wood invested in his paintings, this work is no more a straightforward portrait of his sister than *American Gothic* is a simple image of a farming couple.

The portrait's numerous folk-inspired motifs have led critics to link Nan's accessories to symbols found in early American painting. The inclusion of birds or other small animals, along with flowers or fruit, was a mainstay of feminine iconography in the eighteenth and nineteenth century—an indication of such "womanly" virtues as delicacy, reproductive fertility, and tenderness. Nan's portrayal in this image, however, produces an unsettling disconnect between these attributes and their conventional context. In her strange detachment from these objects, and in the forceful quality of her gaze (*Art Front* claimed Nan's expression betrayed "an effect of cruelty"), we see none of the gentleness or stereotypically feminine charm of her supposed colonial forebears.

Indeed, Nan's life and emotional makeup suggest she was neither a maternal nor a particularly sweet-natured woman. Known for her quick temper, sharp tongue, and long memory for perceived slights, Nan often exhibited a peevish tone in her interviews and writing. At the time Wood painted her portrait, moreover, she and her husband Ed had consigned his three children to a series of foster homes. Ed had initially taken this measure following the death of his former wife from tuberculosis—he was then battling the disease himself—yet he and Nan failed to bring the children home even after his recovery. Nan never met the children until they were grown, and claims to have actively discouraged Ed from visiting them. As she later recalled, "They were resentful and terribly mad . . . They blamed him and they blamed me, too." It is perhaps fitting, then, that when schoolchildren at Wood's memorial retrospective were asked which they preferred, Nan's portrayal in *American Gothic* or in *Portrait of Nan,* they immediately chose the former. The artist's sister, they believed, was somehow not as "nice" in her portrait.

If the objects in Nan's lap resist conventional associations with nur-

turing and gentleness, then we are left to consider their function within Wood's personal iconography. Wanda Corn sees in these attributes an implicit regional connection. The plum and chick, she suggests, "represented for Wood all that was beneficial and wholesome about the Midwest." Although this interpretation may hold true at a certain level, it fails to account for Wood's personal identification with birds—and with chickens, in particular. In his later allegorical self-portrait *Adolescence,* for example, the artist portrays himself as a young and featherless rooster. According to Garwood, the "model" for this later painting—a work completed in 1940, but conceived as early as 1931—was in fact the same chick we see in Nan's hand. Whether or not this claim is true, the symbolic connection between the two birds cannot be denied. In *Portrait of Nan,* then, just as in Hattie's earlier portrayal, we see the most important women in Wood's life paired with emblems that suggest their relationship to the artist himself.

Considered together, Wood's portraits of his mother and sister form a rather striking oppositional symmetry. Reversing the setting and emotional charge of *Woman with Plants, Portrait of Nan* embodies warmth rather than coolness, youth versus age, spring versus autumn, and interior versus exterior. If Hattie is a chaste Madonna in her portrait, then Nan represents a very different kind of single mother—Venus, the embodiment of sexual love and mother to the winged Cupid (a figure with whom Wood, of course, also identified himself). A world apart from her portrayal as the virginal spinster in *American Gothic,* here Nan's cascading hair, fashionable appearance, and confrontational gaze indicate she is a woman to be reckoned with. As if to signal her independence, Wood once again casts the married Nan as a "maiden" in this image, evidenced by her conspicuously absent wedding ring.

The figure's sexual charge may also be read in her setting and props. The curtain at left draws back in fleshy folds to reveal an oval, rosy interior—a vaginal reference only amplified by the clefted plum in Nan's lap. Indeed, for one critic, the connection between Nan's body and farm products—one almost unavoidably sexualized—constituted the work's central meaning. In his review of the painting, Lincoln Kirstein notes that Nan's "shameless" expression is characterized by a "vegetable smugness"; he describes her as "a corn-fed Middle Western girl, fattened on fresh vegetables and thick cream" and adds, in a rather

grisly aside: "If you were to cut this girl open, you would find tissue like the inside of a melon; solid, juicy, cellulose."

Kirstein's connection between the interior of Nan's body and that of a juicy, red melon—a common enough metaphor in art criticism, if expressed in an unusually disturbing way here—reflects Wood's own sensitivity to the sexual symbolism of fruit. In a 1929 review of Mary Cecil Allen's *Painters of the Modern Mind,* Wood wrote:

> I have reached the state where the sight of a pear embarrasses me in a mixed crowd—I have become pear conscious from attending modernist exhibitions. I am not alone in this. Many a "nice" person gets, all innocently of course, an erotic sensation from the modern fruit painting . . . Slimy things have been done with apples, peaches, and even onions . . . I am annoyed in the galleries, having to slink past the[se] pictures.

Wood's experience before such images, it would appear, is reflected in the chick's confrontation with the plum. Seemingly overwhelmed by the fruit Nan offers, the frozen chick averts its eye toward the viewer (a sign, perhaps, that it is "plum conscious").

The *New York Sun* claimed Nan's figure represented "an up-to-date rural goddess of the farmyard and orchard," a reference that once again summons the Persephone narrative of *Woman with Plants* and *American Gothic.* Not only does the alluring, ripe fruit in Nan's lap recall the fertility Demeter orchestrated for her daughter's homecoming, but it also marks Persephone's annual exile in Hades—a sentence that followed her consumption of forbidden fruit. (Even the work's rosy background seems to reflect the underworld's fiery glow.) Doomed to her part-time role as the Queen of the Dead, this figure bears the same look of gloomy resignation Nan wore in *American Gothic*—and features, as well, the loosened hair that marks her loss of innocence. Despite its implicit eroticism, Nan's portrait remains a cautionary image of sexual crime and punishment. The sitter's gesture is a warning, not an invitation.

However complicated Wood and Nan's relationship might have been, it is unlikely that her portrayal here represents any incestuous longing on the artist's part—nor, indeed, does it suggest his latent desire for women in a general sense. If we stop to consider his more

likely erotic tastes, then the plum in Nan's hand must be viewed through a less conventional lens: not as a marker of the female genitalia, but as the downy head of a penis, or a pair of youthful male buttocks. The connection between ripe fruit and the objectified male body has a rather long history in Western art. In the coded imagery of Caravaggio, Botticelli, and Cellini, for example, the bodies of semi-nude, youthful men often echo the clefted, velvety fruit they offer to the viewer, pluck, or sit on. The implicit homoeroticism of these works was necessarily disguised, as it is in Nan's portrait. This does not mean, however, that the traces of Wood's desire have been fully erased. As Jonathan Weinberg has noted, "identifying homosexual content [in a work of art] . . . cannot be done merely by pointing to the portrayal of certain sexual acts"; instead, viewers must be attentive to the "placement of seemingly neutral elements that gives them a peculiar quality."

That the overdetermined elements in *Portrait of Nan* might reflect Wood's sexual anxieties does not preclude their connection to Nan's personal history, of course. Given the chick's inevitable connection to Easter, for example, it is noteworthy that Nan's own "loss of innocence" in marrying Ed had taken place at Easter time. More specifically, we may read in Nan's portrayal a rather pointed reference to an incident from her adolescence. Recalling her Cedar Rapids girlhood, Nan's neighbor Martha Rozen explained that

> at the age six or seven, I wandered across the alley [that separated their backyards] . . . to see the goat tethered to the Woods' barn . . . Nan rushed out of the kitchen to make sure I kept a safe distance from their nanny goat. Then she invited me in for cookies . . .
>
> But she liked playing tricks, too. One summer day when I was admiring the nanny goat, she said, "Follow me, I'll show you a live plum." That puzzled me. High up in their plum tree, slightly hidden by the leaves, was a small dark object. By a stretch of the imagination, it could be an overripe plum that somehow was slowly changing its outline.

Mesmerized by this "live plum," Rozen continues, she was horrified to discover that the object was, in fact, "a small, curled-up bat hanging by its feet"—a creature that scared her "out of [her] wits." In light of this

bizarre episode (one that, given Wood's and Nan's intimacy, was almost certainly known to the artist himself), *Portrait of Nan* assumes a rather startling new meaning. In the plum held out to the trusting baby chick, we see the lure of Nan's nasty trick—whereas the black, bat-shaped ties at the shoulders of her blouse illustrate the story's climax. Not only do these bat motifs complete Nan's identification with Persephone (Hattie's cameo depicts the goddess with similarly winged shoulders), but they also dispel any notion that her figure is to be read as a representation of feminine tenderness.

Considering Nan's age at the time, and the sexual connotations of the hairy, animated plum Rozen describes, the story may well point to an unwelcome sexual revelation on Nan's part—specifically, the exposure of her own adolescent genitals. (Indeed, the recurring detail of the "nanny" goat, in its connection to Nan's own name, suggests a similar form of substitution.) We will never know if Rozen's account masks an actual sexual trauma—and in any case, one could legitimately question the artist's access to such a screened memory. Yet even taken at face value, the story exposes a darker side to Nan's character. Its translation to her portrait, moreover, reveals Wood's preoccupation with her power.

The primary source of Nan's authority in her portrait is her blank, arresting gaze. If the obliquely turned eyes of the female figure in *American Gothic* had held her consort in a state of frozen animation, then here we find *ourselves* riveted before the icy stare of this young woman; as Camille Paglia has written, even "the most beautiful woman, making herself a perfect stillness, will always turn Gorgon." Indeed, Nan "turned Gorgon" in nearly every work for which she modeled—including the towering figure of the Republic in the Veterans Memorial window, whose gaze envelops the stiffened bodies of six dead soldiers below her. In *Portrait of Nan,* not only does the sitter's milky stare suggest Medusa's appearance, but so too do her rippling locks, the bats at her shoulders, the glowing red interior in which she sits, and the scaly, reptilian curtain by which this space is framed. As if to demonstrate the effects of her power, Wood even presents us with a sample of her magic: the frozen, inanimate chick perched on the sitter's outstretched palm.

Considered more closely, Nan's gaze appears all the more uncanny for its subtle bifurcation. Rather than a representation of Nan's actual

appearance—she did not, in fact, have a "lazy" eye—this detail may point to Wood's role as the work's primary audience. The artist's contemporaries often noted that when he contemplated one of his paintings, he tended to rock or sway from side to side in a trancelike state, sometimes varying the movement by "teetering and weaving" on his heels. Such a practice, of course, would have placed Wood within *both* fields of the sitter's vision—and given the same logic, it would also have marked him as the single object of the figures' misaligned gazes in *American Gothic.*

Amplifying and multiplying Nan's cockeyed gaze are the enormous black polka-dots covering her blouse. That these circles represent more than just the artist's love for repetitive decoration is demonstrated by their peculiar size and striking darkness, a design one critic described as "violently polka-dot." In the plant and animal kingdoms, similarly repetitive circular patterns create what visual psychologists call an "aposematic" effect. Confronted by what appear to be multiple sets of eyes, potential predators fail to see the body these patterns cover. Humans are just as susceptible to this form of "cyclophobia," as James Elkins has written, and even uniquely able to create and adapt this defense. Not only do Nan's exaggerated polka suggest just such a strategy, but they also summon the horrible roundness of Medusa's never-sleeping gaze.

The defensive patterning of Nan's blouse may be directly linked to Wood's fears concerning the female body. Not only did he avoid painting young female sitters—*Portrait of Nan* constitutes the one intriguing exception to this rule—but rather remarkably, given his extensive academic training, he also appears never to have painted a female nude. The women in Wood's paintings typically appear as desexualized "types": dowdy matrons, unattractive spinsters, and aging matriarchs. As the artist himself rather tellingly declared, "I don't like to paint pretty women." In Nan's portrait, this anxiety manifests itself most clearly in Wood's handling of her torso. Misaligning Nan's breasts and placing them just above her belt line, Wood evokes less the body of an attractive young woman than he does Aunt Tillie's similarly asymmetrical, deflated bosom in *Victorian Survival.*

The giant polka dots on Nan's blouse distract us from this awkward passage, yet they also hold an unsettling fascination. Indeed, her body appears to be riddled with cartoonish black holes bored by our own

eyes—or more particularly, by Wood's rounded spectacles. Taking into account the perceptual equivalence between eyes and nipples—features that are mutually reinforcing, rather than mutually exclusive—the curious, positive-negative magnetism of these circles makes far more sense. If at first glance Nan's breasts seem to disappear beneath this distracting pattern, then this camouflage also subliminally exposes and multiplies them. Such a strategy recalls the old joke about the elephant that tried to hide in a jar of M&M's: by painting its toenails different colors, the elephant believes no one will see it.

Wood's fascination with Nan's power cannot be separated, of course, from his sense of competition with her. The artist claimed that Nan's birth had increased his own sense of belonging to the family, yet her arrival must also have threatened the nine-year-old Wood's position within the home. Indeed, in his earliest description of Nan, Wood imaginatively describes his four-month-old sister with a full set of teeth "as sharp as splinters"—an observation that betrays his wariness of the family's newest member, and one that even appears to foretell Nan's prickly personality. Nan's marriage in 1924 indicates yet another point of competition with her brother. Not only had she broken the magic circle of "we three" when she married, but in leaving home and becoming partnered, she also assumed roles that the artist felt were unavailable to him. Consoling himself with disguised parts in his own compositions—the spinster figure in *American Gothic,* a lovingly cradled snake plant in *Woman with Plants,* or a trusting chick in *Portrait of Nan*—Wood appears to have longed, at some level, to *be* his sister and assume her privileges within the family.

Nan's role as her brother's muse ended with *Portrait of Nan.* After completing the painting, Wood reportedly told his sister, "It's the last portrait I intend to paint, and it's the last time you will ever pose for me." Having posed for him most of her life, Nan was naturally taken aback by her brother's pronouncement. When asked for an explanation, Wood simply told her, "Your face is too well known." Nan had indeed become too recognizable a type in Wood's work, yet her familiarity had also become, for the artist, a dead end. The psychological richness of his family romance had, in these powerfully sublimated portraits, been fully mined—and so, with the completion of *Portrait of Nan,* this three-part "Persephone cycle" resolved into a hermetic completeness.

WOOD INTO STONE

THE HALF-DECADE THAT followed the success of *American Gothic* constituted the most fertile and creative period of Wood's career. If the artist's family had provided the initial source for his post-Munich creativity, then he found equally powerful inspiration in his native landscape and the recording of personal, regional, and national history. Within these natural and historical environments, the artist wrestled with the same anxieties embedded in his early portraits. Whereas the portraits suggest Wood's emotional paralysis before the figures of his childhood, however, his landscapes, genre scenes, and history paintings reveal him to be an active stage manager. In the elaborate sets of these paintings, the artist was able to edit his own history—reimagining time and place in ways that challenged not only his father's Quaker insistence upon historical fact, but also the very sanctity of American icons and painting traditions.

As productive and successful as this period might have been for the artist, it was also one fraught with new pressures. Never had the stakes been so high in Wood's career, nor had the artist's control over his own image been more difficult to maintain. As Wood's friend Paul Engle explained in a 1977 interview, "Sudden success also brought almost instant sadness and darkness to Grant, [but] that is another story. He was a gifted, fine, complicated person . . . [whose] outward, cheerful, plain-person image concealed a troubled life."

The public validation Wood received for his work removed much of the shame he once attached to his calling, yet it also placed him in an unforeseen role—one for which he often appeared distinctly unfit. Well practiced in the art of concealment, Wood had been able to adopt a variety of different identities in his early career. Upon assuming the

mantle of "America's painter" in the 1930s, by contrast, he found him-
self cast into rocky permanence—a monument to the very things about
which he felt most conflicted: masculinity, region, and family. Ironi-
cally, of course, his inner world remained on display for all to see.
Sealed beneath layers of patriotic varnish, Wood's childhood fantasies
and adult fixations float just beneath the surface of his work—
stubbornly defying the artist's, and his critics', attempts to paint them
under.

Nowhere is this public/private divide more vividly illustrated than
in the artist's dreamy landscapes from the early 1930s. Although these
unusual paintings served a deeply private function for Wood—and
consequently baffled even his most supportive critics—they have been
praised in more recent times as the very distillation of his rural "values"
and patriotism. Tracing the artist's lineage back to the great American
landscape painters of the nineteenth century, Joseph Czestochowski
wrote in 1981 that Wood's approach to the land similarly presented
"nature as a source of virtue, a place to contemplate the sublime, an
avenue for spiritual sustenance, and, ultimately, a symbol of national
unity."

In their avoidance of the disastrous realities of farming in the
1930s—a world of drought, dust storms, falling prices, and violent farm
strikes—Wood's sunny, joyful landscapes were hailed even in his own
time as a testament to "the order and harmony of the rural commu-
nity." As one critic wrote in the 1930s: "Let radical artists concern
themselves with forced sales, with strikes, foreclosures, and so on. It is
none of Mr. Wood's affair . . . He realizes that people like to buy nice,
pleasant pictures, and that's what he's giving them." To consider
Wood's "nice, pleasant" landscapes as hymns to national character,
however, or to perceive in them a sedative for the political and eco-
nomic upheavals of his era, is to misunderstand their purpose. After his
return from Munich, Wood longed to return not only to the shelter of
his family—centered in the figure of Hattie—but also to the comfort-
ing familiarity of his regional landscape. Although he had often painted
Iowan scenery in the 1920s, rendering its farmhouses and fields in the
romantic naturalism of impressionism, he returned in 1928 with a new
sense of vision.

No longer interested "in vague terms of sunlight effects," Wood
claimed that he wished to paint the scenes of his childhood "as they
existed for me." Whereas his mature portraits demonstrated a harden-

ing of both line and subject, Wood's new landscape style embodied a joyful escapism. If the painter's fanciful rendering of the Rock Island roundhouse had reflected William Morris's essay "A Factory as It Might Be," then these images represent "Farms as They Might Be"—for Wood, at any rate. In these deeply mannered landscapes, we encounter a luscious, parallel universe where the painter's primal physical impulses play out at the scale of the earth itself.

Wood showed his first landscape in this new style, *Stone City* (see color plate 9), at the same 1930 Art Institute exhibition that launched *American Gothic*. Hanging together in Chicago, the paintings appeared to be the work of two completely different hands—a puzzling juxtaposition of glowering, tight-lipped realism and playful fantasy. The hardened characters in *American Gothic* carried the day, of course, striking an emotional chord with critics and the public that *Stone City* clearly did not. Buried by the avalanche of press *American Gothic* received, *Stone City* was criticized—as Wood's subsequent landscapes would be—for its perceived overemphasis on design and troubling departure from visual reality. As one reader of the *Omaha World Herald* claimed, *Stone City* "look[ed] like the work of someone from an insane asylum."

Critic Thomas Craven exhorted Wood to abandon his "quaint" and "overly decorative" landscape style for "a naked statement of the Iowa terrain . . . a realistic job without frills or fancy, a picture in which the trees and farms are as sharply delineated as the faces of his portraits." What Craven failed to understand, of course, was the mutually sustaining relationship between these different styles—for the psychological intensity of *American Gothic* could never have been sustained without the emotional outlet that a work like *Stone City* offered.

The town of Stone City had been a fixture of Wood's boyhood. Situated along a picturesque stretch of the Wapsipinicon River, twenty-five miles northeast of Cedar Rapids and a short distance from the Woods' former farmhouse, the town had flourished between the 1870s and 1890s due to its vast limestone quarry—a resource owned and operated by an extraordinarily civic-minded, if somewhat eccentric, man named John Aloysius Green. Commissioning a railroad station, post office, school, speculative housing, and even a combination hotel/opera house in the city's native stone, Green endowed this tiny community of 600 with an almost surreal sense of monumentality—and crowned it, naturally enough, with a twelve-room, limestone mansion for himself. With the advent of cheaply produced Portland cement

in the 1890s, the demand for Stone City limestone came to an abrupt
end. By the time Wood painted the site in 1930, it had become a virtual
ghost town—its streets empty, quarry abandoned, and even the Green
Mansion shuttered and empty.

Although Wood was clearly drawn to Stone City's romantic state of
neglect—the site was a favorite sketching destination for the artist, who
used to bring Arnold Pyle there in the 1920s—his painting transforms
the town's semi-deserted hills into a scene of ordered, teeming abun-
dance. The immediate foreground of this painting establishes the
scene's rigid organization as well as its juicy fullness. Perfectly aligned
rows of corn shoot up from the soil of a newly planted field like tiny
geysers, plummeting away from view as if to suggest their infinite num-
ber. The landscape beyond brims with well-tended fields, full barns,
and even the suggestion of a reactivated quarry. That this scene is
meant to be read as a current view of the town, rather than a tribute to
its nineteenth-century heyday, is indicated by the contemporary bill-
boards Wood includes along its central, winding road.

Despite its anchors to the present, *Stone City*'s setting hardly consti-
tutes a documentary image. With its rubber-ball forests and careening,
roller-coaster topography, it is a landscape of pure childhood fantasy—
a "Never-Never Land," as one critic negatively described Wood's land-
scapes. The semi-abstracted, decorative geometries Wood introduced
in this work sprang from a variety of sources. Among these are the
inventive landscapes of his favorite Northern Renaissance altarpieces,
whose perfected scenery conveyed the natural world's divine order.
Closer to home, Wood's inspirations included the rigidly organized
landscapes of American folk painting and the formulaic scenery of
nineteenth-century willowware china—a pattern the artist collected
himself, and one that he reproduced in subsequent paintings.

The most important source for the artist's landscapes, however, in
both a visual and a psychological sense, was the *Imagination Isles* mural
he had designed at McKinley Junior High nine years before. At the
mural's unveiling, Wood had told the assembled audience, "You shall
see brilliantly colored trees of shapes unknown to science, fantastic
tropical plants with luscious fruits and flowers in amazing profusion
[that] wait only your coming." Not only do the islands' bulging land
masses and stylized topiary trees re-emerge in *Stone City*'s hills and
forests, but Wood's description of *The Imagination Isles* also evokes the
painting's sense of emotional release.

"The happy man [who] can still find his way" to the Imagination Isles, Wood claimed, would discover a world free from fear, unwanted intrusions, and even financial difficulties. In this paradise of fragrant smells, warm waters, and succulent fruits, all "mental shut-ins" were invited to lay their burdens down. By investing *Stone City* and subsequent landscapes with the spirit and visual character of *The Imagination Isles,* Wood refashioned his native region into a similar kind of sanctuary—an imaginary world composed, like the Imagination Isles, from "the material of dreams."

Stone City's evocation of childish escape derives not only from its playful distortions of visual reality, but also from its suggestion of the physical pleasures of infancy. Wood invites the viewer to slide down Stone City's velvety hills, peek into its doll-sized houses, and skate across the mirrored surface of a turquoise-blue Wapsipinicon River. The downy trees and taut, rounded hills implore the eye to "touch" them, feel their softness, and test their apparent elasticity. (Referring to Wood's "inflated hillocks," a contemporary critic suggested that "one might poke one's finger into them and have them rise back into shape.") The repetitive nature of these forms also manages to convey the reassurance of *being* touched. As James Elkins has written, "gentle, insistent curvilinear lines" in an image evoke the memory of a mother's caress—an act that seeks, through rhythmic motion, to comfort and "prov[e] the bulk of the child, making sure it is whole and round." In his working method for his later landscapes, Wood himself adopted this gesture. Creating clay models for his hills, the artist would smooth their contoured surfaces into the shapes he desired.

Beyond their pleasurable sense of tactility, Wood's landscape forms also appear, by a kind of infantile logic, to be edible. Indeed, from the artist's day until our own, Wood's landscapes have often been negatively characterized in terms of cloyingly sweet dessert fare; as Elizabeth Clarkson Zwart declared in the early 1930s, the painter's hills looked like nothing so much as "generous helpings of sweetbread." In his 1983 attack on Wood's work, Hilton Kramer echoed this sentiment. The artist's idealized scenes constituted an "immaculate marzipan" candy-land so far removed from the grim realities of 1930s farming, he insisted, that "the only disaster likely to occur is a stomachache from too many sweets."

From an early age, Wood had learned to associate sugary foods with illicit pleasure. When exiled to the cellar by his father, the artist

recalled, "I contented myself down there with scribbling on the stone walls, inspecting the shelves of preserves and jellies, and sticking my finger in the molasses barrel to sample the sugary syrup." As Wood later told his sister, he felt that his time below ground "wasn't much of a punishment, because the cellar was full of goodies—nuts, barrels of apples, jars of home-canned pickles, jams and jellies." In his adult years, the artist's craving for sugar bordered on the compulsive. Nan explains, for example, that "Grant had sugar on his lettuce, sugar on his tomatoes, and sugar enough to fill half his coffee cup." Indeed, Wood's prodigious coffee and smoking habits reveal yet another dimension of the same fixation; before eating his breakfast, he routinely consumed up to four cups of sugary coffee, along with eight or more cigarettes.

The artist's wish to recapture the primal pleasures of childhood provides a rather striking example of sexual sublimation. In the infantile pleasure dome of *Stone City,* Wood was able to explore a forbidden form of sensuality in the guise of more socially acceptable appetites. Like the sexually suspect bachelors Eve Kosofsky Sedgwick considers in nineteenth-century literature, Wood, too, exhibits "a visible refusal of anything that could be interpreted as genital sexuality . . . [but rather] a corresponding emphasis on the other senses."

Although Wood may have disguised the sexual nature of his landscapes, even to a certain degree from himself, the object of his desire is only partially abstracted in these works—for in the undeniably erotic curves of *Stone City,* we register the muscular outlines of a powerful male body. The artist's autobiography routinely describes Iowan scenery in stereotypically male terms. The land is raw, solid, thrusting, and active; through its "rounded, massive contours, [it] asserts itself through everything that is laid upon it." *Stone City* similarly suggests the land's virility and sexual potency. From his broadly stroked sketch to the work's final, polished execution, the artist transforms his composition into the rigid smoothness of an erect penis—and even includes, in the work's foreground, a seemingly endless battalion of ejaculatory corn sprouts.

Critics' tendency to read Wood's landscapes as erotic celebrations of the *female* body must rely upon a metaphor that the artist himself avoided: the union of an active, potent farmer with the passive, penetrable, female earth. As Wanda Corn proposes, "Mingling eroticism with ecstasy, Wood made the relationship between the farmer and mother earth into a Wagnerian love duet"; the farmers in Wood's land-

scapes, however—when they appear at all—are no match for the sub-
lime scale and rippling power of the land. To read in these undulating
hills the alluring body of a "gigantic reclining goddess," . . . "coax[ed]
into abundance" by her farmer lover, moreover, is to ignore the artist's
categorical avoidance of the female nude—and to dismiss, as well, his
demonstrable fear of women's sexuality (an attitude Corn herself notes
in Wood's female figures).

The ambient heterosexism of such readings, which fly in the face of
everything we know about Wood, must also ignore the numerous,
clearly objectified male nudes that the artist depicted throughout his
career. Indeed, Wood's fetishization of the male body, and of the but-
tocks in particular, is evident in his work as early as his 1924 *The Spot-
ted Man* (see color plate 3). Not only does the artist render his model's
powerful back with careful attention, dramatically highlighting its
curves, but in painting the figure from behind, he also defuses any
potential challenge to his own gaze. That Wood's muscular hills might
embody a similar attraction to the male body, then—however coded
this desire may have been—makes abundantly more sense. Invalidating
the trope of the fertile mother earth was hardly a sacrifice for Wood,
who demonstrated an utter lack of interest in the productivity of real
farms. As evidenced by his paintings, his writings, and even his
wardrobe, the painter considered the farmland of Iowa, above all, as a
metaphor for male strength and beauty.

Not only does Wood reveal his reverence for the male body in *Stone
City,* but he also suggests its potential for penetration. In the curiously
clefted hill that appears in the painting's upper-right-hand corner, the
viewer registers a pair of rounded, passively upturned buttocks. Firmly
belted by an encircling road, they are penetrated at their base by a felic-
itously placed tree. The unusual, cloven foliage of this tree draws fur-
ther attention to the hill's division—features that do not appear in the
painting's original sketch—while also foreshadowing the outheld plum
in the following year's *Portrait of Nan.* If the plum in Nan's portrait
indicates temptation, however, this tree indicates forbidden fruit
already consumed. Underscoring the latent eroticism of this scene is
the tiny, nearly hidden billboard that appears along the shaded path
toward this hill. Featuring a smoking man in a bright red necktie, this
Chesterfield cigarettes advertisement bears the slogan "They Satisfy."

Despite the minuscule size of this *Stone City* billboard, audiences
noticed it immediately when the painting was first shown. The *Water-*

loo Courier noted that "Mr. Wood watched the spectators around the picture at the Art Institute during the American show. One man spied the billboard in a righthand corner, pushing closer through the crowd to see it. He read, 'They Satisfy.' A broad grin spread over his face. He chuckled and walked way." This anecdote indicates not only that Wood intended the billboard to be legible, but also that he considered it an important (and humorous) detail—for it was he, of course, who shared this story with the *Courier.*

The necktie on the billboard's model, an accessory that does not appear in any known Chesterfield ad from the late 1920s, is itself potentially significant. George Chauncey has demonstrated that, as early as the 1910s, homosexuals had begun to wear red neckties as a coded way of identifying one another. Although this cruising accessory was mostly limited to urban settings, it had achieved a kind of emblematic status by 1930—a bit like single earrings in the 1970s—and could hardly have escaped Wood's attention. By coupling this motif with a figure smoking a cigarette (an activity identified, then as now, with postcoital bliss), the artist appears to have constructed a clever, and even dangerous, private joke about the "satisfying" nature of his rippling topography.

That this type of landscape satisfied the artist, at any rate, is perfectly clear—for he remained fiercely attached to this new style, despite its lukewarm (and sometimes even sharply critical) reception. In two subsequent landscapes from 1931, *Young Corn* and *Fall Plowing* (see color plate 8), Wood reprised *Stone City's* joyous release while amplifying the muscularity of its clefted "massive contours." In the rhythmic rise and fall of these hills, the viewer experiences both a sense of weightlessness and the pleasurable tug of gravity—the very evocation of flying, in fact, traditionally associated with sexual euphoria in dreams. Although *Young Corn* was commissioned as a memorial tribute to a Cedar Rapids schoolteacher, the painting's swelling landscape is less elegiac than ecstatic. Indeed, these pneumatic hills even overshadow the work's ostensible protagonists—the tiny "crop" of school-aged children depicted on the teacher's family farm.

In *Fall Plowing,* Wood combines an eroticism of greater intensity with a discernible note of melancholy. Before a panoramic landscape bathed in the slanting light of a setting sun, the artist presents an abandoned "walking plow"—a preindustrial relic of the 1830s, whose bright

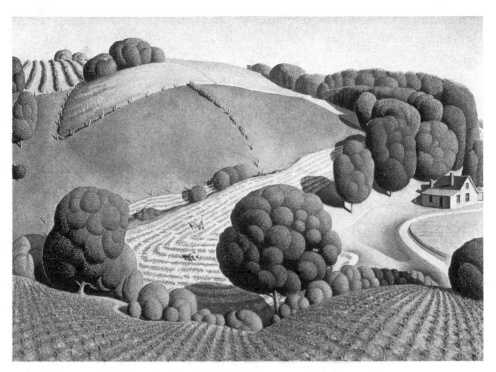

Grant Wood, *Young Corn*, 1931

metal blade lies half-buried in the earth. The plow's anthropomorphic form, along with the fleshy, puckered flap of soil that it lifts, constitute a startlingly sexualized image. As in *Stone City*, the visual metaphor implies anal, rather than vaginal, penetration—a reference made all the clearer by the muddy opening in the soil and by the placement of this detail at the literal "bottom" of the painting. If the land itself is masculinized in this image, then so too is the plow. It stands as a phallic monument not only to a bygone agricultural past, but also to the absent farmer who has left his equipment in mid-stroke.

This scene may represent "the most erotic passage Wood ever painted," as Corn rightly claims, yet it is also a powerful indication of his father's ghostly presence. In *Return from Bohemia*, Wood describes his father's corpse and its burial in ways that link Maryville to the contoured panoramas of his landscapes. Upon first encountering his father's body, Wood claims, "I could see the lower end of the bed and the long, still mound of covers under which father lay." The following week, he recalls, "they buried him in . . . the same rich soil, the same

firm, rolling hill-land he had farmed from boyhood." If we consider the landscape in *Fall Plowing* as a kind of burial shroud, then the plow's function within this image surely takes on a more sinister tinge. What at first appears to be a tender or loving gesture—the plow gently lifts the fragile soil, without breaking it—assumes the petrifyingly slow reveal of a horror film. As if raising the hem of a heavy stage curtain, the plow pulls back the soil to expose the scene's inherent artificiality, forcing us to peek into the frightening darkness beyond.

Providing the viewer with action as well as conclusion, Wood shows us what lies behind the curtain. For in the long field that stretches just above the plow, we cannot help but register the slackened and flayed back muscles of a dead man—robbed not only of his shroud, but also of his fleshy exterior. The scene is a fitting illustration, it seems, for Wood's recollections of the Iowa farmland of his childhood. As a boy, he recalls, "I first began to experience a feeling that was strong in me ever after: namely, that these low hills were *haunted.*"

The tangled themes of punishment, sexuality, and death in this unusual landscape reflect the same powerful formula found in *American Gothic.* In *Fall Plowing,* Wood triangulates his father's presence through a plow rather than a pitchfork, but the message remains the same: the artist's freedom may be purchased only at the price of Maryville's death. In both *American Gothic* and *Fall Plowing,* moreover, the works' central props represent significant departures from the artist's original intentions. Whereas *American Gothic*'s original composition called for a garden rake, Wood's first sketch for *Fall Plowing* features a tree rather than an abandoned plow at center stage. Although a tree might just as easily have summoned Maryville's ghost—the potential pun on "wood" and "Wood" certainly appears in later examples of the artist's work—the ownerless, archaic plow far more effectively marks Maryville's presence in Wood's semi-erotic Arcadia. Like the scythe of the Grim Reaper, it threatens to expel the artist from the very sanctuary he has created. As if to forestall this confrontation, Wood depicts his exhumed father in a dead man's float.

WOOD'S DEEPLY MANNERED LANDSCAPES left many viewers scratching their heads—as one visitor to the Art Institute said of *Stone City,* "I wouldn't give thirty-five cents an acre for that land"—yet most Iowans believed his paintings heralded the state's cultural arrival.

Proudly writing about Wood's success in Chicago, Iowan poet Don Farran wrote that the artist had "at last put Iowa into long pants." Ironically, the same public that insisted upon Wood's eternal adolescence and naïveté would increasingly expect him to represent his region's artistic maturity and sophistication—placing him on a pedestal as lofty as it was precarious.

In early 1931, the director of Cedar Rapids' Little Gallery, Ed Rowan, organized a celebration for Wood that clearly indicated the depth of local investment in the painter's success. Nan relates that Wood's "doings had been local news for years," yet this event was of an entirely new order. In an article entitled "Folk Jam Little Gallery to Honor Grant Wood, Artist," the *Cedar Rapids Gazette* reported: "The entire event had a distinctly civic stamp. It was a community's homage to a creative artist, and as Mr. Rowan said, 'it might be compared to similar meetings in fifteenth-century Florence, when at the invitation of some Lorenzo the populace met to pay obeisance to a Botticelli.' "

Rowan's cultivation of the arts in Cedar Rapids was, if not on the scale of a Lorenzo de' Medici, certainly a profound one. A Harvard-educated Chicago native, Rowan had brokered a $50,000 grant from the Carnegie Foundation in 1928 to establish the Little Gallery—a downtown art venue that hosted traveling exhibits, art-education programs, a workspace for interior designers known as the "Better Homes Room," and modern-dance recitals. Young, urbane, handsome, and endlessly energetic, Rowan was dedicated to promoting local talent during his six years as the director of the Little Gallery. Not only did he consider Wood his greatest discovery, but he also took partial credit for *American Gothic*'s creation. (It was he who had brought Wood to Eldon, site of the painter's now-iconic farmhouse.) In his 1935 pastel *Return from Bohemia,* Wood clearly suggests Rowan's role as midwife to his fame; appearing behind the "pregnant" form of David Turner, Rowan stands in position to deliver the artist who faces us.

Not long after Wood's reception at the Little Gallery, Rowan appeared in the artist's 1931 painting *Appraisal* (see color plate 13). Even more so than the artist's early portraits, this work blurs the line between portraiture and allegory—and illuminates, moreover, the strict separation Wood maintained between his private sources and his works' public meaning. That Rowan might have served as one of the artist's first models is unsurprising. That he appears in such radically altered form in *Appraisal,* however—cast, in fact, as a woman—demonstrates that

we cannot always trust our eyes when it comes to the painter's "folksy" imagery.

In *Appraisal,* Wood presents two women whose dress and attitudes are intended to summon their opposing worlds. Facing a sophisticated, fashionably attired woman from the city, a humbly dressed farmer's wife presents a rooster for the woman's inspection. As traditional readings of this work suggest, the "appraisal" in this instance is centered less on the sale of the bird, than on the women's evaluation of one another. Not surprisingly, the artist portrays the country woman more sympathetically than her urban counterpart; despite her clothes-pinned jacket and frumpy knit hat, she is nobler and more monumental than her overdressed, double-chinned, and myopic companion. (Like the onlookers in Wood's later *Return from Bohemia,* the city woman's eyes appear to be closed; she, too, is incapable of appreciating what she sees.)

If one scratches beneath the surface of this work, its figures tell a very different story. As Wood's friend Hazel Brown later explained, the inspiration for this painting derived from an argument between the artist and Rowan. Angered that the Little Gallery director had dismissed his proposal for an all-local show—Rowan typically favored mixing local artists with urban painters—Wood vented his spleen with Brown and her partner, Mary Lackersteen. "Grant had to do something to get it out of his system," Brown writes, "and he had some luck."

Wood explained to the women that he intended to cast the sophisticated Rowan as a dowdy farmer's wife in *Appraisal.* According to Brown, Wood initially intended to portray the farm woman cringing in the face of her city counterpart—a dig at Rowan's presumed sympathies, and one that would have considerably undercut the work's reading as a celebration of rural pride. Lackersteen, who herself posed for the city woman's figure, eventually reconciled the two men. Wood subsequently transformed the country woman, Brown explains, to "a tall, erect, good-looking farm woman, neatly dressed. It was so like Grant," she adds, "to soften his *Appraisal* after the peace pact with Ed."

Brown mentions Lackersteen's role in *Appraisal* rather casually, yet her partner's presence colors its interpretation in another important way—one that Wood certainly would not have shared with "the girls." Lackersteen and Brown's partnership clearly suggests, if not an overtly

lesbian relationship, then at least the kind of intimacy the period politely labeled a "Boston marriage." Indeed, Studio House seems to have served as a kind of haven for those who did not easily fit into the period's pre-established gender roles. Within this charmed circle, Brown fondly remembered, "one had a special kind of exciting and 'howling' life" in the heart of conservative Cedar Rapids. Lackersteen's gruff nature and salty vocabulary, in particular, made her a popular target for the "affectionate technique of loaded insults" that the men of Studio House engaged in—the very kind of campy, and basically good-natured, sense of humor Wood himself enjoyed. Smelling a dead mouse in the gift shop, for example, one male resident at Studio House joked, "Oh, that's just Mary. She'll dry off sweet eventually." Lackersteen's appearance in *Appraisal* may represent another, if far more loaded, form of teasing.

That the women's mutual appraisal might concern something more intimate than a business transaction, or a straightforward juxtaposition of rural/urban "types," is suggested in a number of ways in this painting. Most striking, of course, is the rooster that visually links the women. Not only does the bird act as a phallic pun—it is a cock, after

Those who knew the Little Gallery's self-assured director, Ed Rowan, seen at right in 1932, might not have recognized him as the humble farm woman in Wood's 1931 *Appraisal,* on the left (detail; see color plate 13).

all—but the country woman's disembodied left thumb also appears to endow Lackersteen's figure with a small phallus. Projecting from the fur lining of her coat and parting the bird's feathers, this element appears to consummates the women's exchange. Given Wood's previous icon-ography, the painting's background provides another indication of the city woman's masculinity—for the red barn with which she is associ-ated in this image, and the white farmhouse before which the country woman stands, recall the gendered structures with which the male and female figures of *American Gothic* are themselves aligned.

Considering Rowan's gender-crossed figure in this work, as well as the period's stereotypes concerning "butch" women like Lackersteen, the implicit sexual tension between these figures is rather richly com-plicated. In a nod to the unorthodox nature of this confrontation—or perhaps, in an effort to manage his own discomfort with the scene he had created—Wood originally painted the two women behind a chicken-wire fence. In shortening the work, Wood not only switched its format from vertical to horizontal (the removed section constituted nearly a third of the painting's original height), but he also eliminated the overlapping lower torsos of the figures—a passage that originally suggested the painting's sexual undercurrents even more clearly.

Appraisal powerfully demonstrates that Wood's best work always operated on multiple public and private levels, none of which need be mutually exclusive. We move from the work's public meaning (country meets city) to a semi-private, inside joke (Ed Rowan in drag), and finally to its most deeply hidden reading (a semi-erotic "appraisal" that hints at Wood's own unconventional attractions). At each level of analysis, the painting's structure not only remains fully intact, but also deepens—however much its layered readings may blur the work's cate-gorization. Is *Appraisal* a genre scene or a pair of portraits? For Wood, of course, it was both—as it must be for us, too, if we are to understand it and similar hybrid paintings like *American Gothic* in a more complete way.

WHEREAS WOOD'S SUBJECTS IN the early 1930s initially revolved around the places and characters of his childhood, they soon reflected more broadly historical material—a shift that indicates his burgeoning self-consciousness as a national figure. In two paintings from 1931,

Midnight Ride of Paul Revere and *The Birthplace of Herbert Hoover,* he summons the "grand manner" history paintings of the nineteenth century. In doing so, however, he also manages to playfully subvert the power of these images. The American past, it seems, was as susceptible to Wood's reimagination as the land of Iowa itself—even, and often intentionally, at the expense of historical accuracy.

Like Wood's dreamy farmscapes, *Midnight Ride of Paul Revere* (see color plate 15) presents its subject through the lens of childhood. In this deeply unconventional composition, Revere's galloping figure is seen from a vantage point so high that his tiny figure is nearly lost. Similarly toylike are the town's crisp, simplified buildings; like a haphazard collection of dollhouses, they appear insubstantial and weightless. Even the horse Revere rides, modeled upon an antique hobby horse the artist had seen, evokes the world of the nursery more so than it does the operatic history paintings of the Victorian age. History unfolds on the playroom floor in this image, directed by the towering figure of a child.

Not surprisingly, the source for Wood's subject came from his own childhood. Inspired by Longfellow's 1863 "Landlord's Tale," a poem the artist claimed "made quite an impression" upon him when he first heard it, the painting takes its title from the poem's memorable opening lines: "Listen, my children, and you shall hear / Of the midnight ride of Paul Revere." Playing nearly as great a role as Revere in Longfellow's poem is Boston's Old North Church, whose towering steeple holds the lanterns signaling the British approach ("One, if by land, and two, if by sea"). In the fifth stanza, Longfellow recounts the breathless ascent of Revere's accomplice:

> By the trembling ladder, steep and tall,
> To the highest window in the wall,
> Where he paused to listen and look down
> A moment on the roofs of the town,
> And the moonlight flowing over all.

Although this climbing figure is absent from Wood's church, the artist imaginatively casts us in his place; like him, we peer down on the moonlit village and watch the drama take place beneath us. In Longfellow's description we encounter the model for Wood's towering structure:

He saw the gilded weathercock
Swim in the moonlight as he passed,
And the meeting-house windows, blank and bare,
Gaze at him with a spectral glare . . .

The painter's evocation of this boyhood poem, and the childlike scale to which he reduces its elements, invite the viewer to return to the safety of the nursery and the pleasure of tall tales. In her perceptive analysis of this painting, Karal Ann Marling suggests that Wood "brings his audience face-to-face with the compelling truth of a lovely lie, daring the viewer to choose the hard adult realities of a modern present over the potent childlike fantasies slumbering in his heart." Such a reading suggests, of course, that "the hard adult realities" of 1931— namely, the Great Depression—had triggered an escapist response in the artist, who offered this "national lullaby" to an anxious nation. The extent to which the painting's drama also represented a personal escape for Wood, however, justifies a closer look.

If Longfellow had played loosely with Revere's story—the famous signaling lights appeared in Boston's Christ Church, for example, rather than in the grander Old North Church—then Wood's painting subverts its authenticity while also reinventing the poetic version of the event. Although the central structure in *Midnight Ride of Paul Revere* clearly summons Longfellow's Old North Church, Revere never passed this structure on his ride—nor does the poet himself place him there. In his depiction of this steeple, moreover, Wood transforms Old North Church with elements borrowed from Boston's Old South Meeting House. Such anomalies may seem trivial, yet they are noteworthy given the careful research for which the artist was otherwise well known. Most surprising of all is the absence of any signaling lights in Wood's steeple; the church may upstage the rider in this painting, but it is utterly stripped of its principal narrative function. Even the work's oddly truncated title, *Midnight Ride of Paul Revere,* subtly undercuts the story's drama. Given the absence of a definite article (The *Midnight Ride*), Wood's title appears to describe no specific event.

The painting's anachronistic elements are as remarkable as its narrative inaccuracies. Marling suggests that its houses are lit as if by "glaring electric bulbs," connected by a "smooth concrete highway, circa 1931," and contained in a landscape that suggests contemporary Iowa far more so than eighteenth-century New England. (Even the cylindrical

bluffs behind the church, James Dennis has noted, look suspiciously like the grain elevators that ringed Cedar Rapids.) As Wood himself explained:

> The background has already been criticized as not at all like that of New England. An Easterner who visited my studio called my attention to this mistake. I told him I was glad it was not like New England, because there is some satisfaction in that, inasmuch as New Englanders are so given to misconceptions of the Middle West.

The artist's transformation of the New England landscape, however, was not simply intended to irk Eastern audiences—for, as Wood notes in his autobiography, this substitution had first occurred to him as a child. At the age of eight, Wood was enthralled by Dave Peters's stories of cyclones; for a brief period, he writes,

> talk about cyclones ran wild in my imagination. Several nights before, mother had read Frank and me "The Midnight Ride of Paul Revere" . . . Slowly and unconsciously now, my fancy began to recreate the story in a new pattern. In this version I was Paul Revere; the lantern in the Old North Church was a funnel-shaped cloud; and the approaching disaster was a dreaded "cyclone." I saw myself warning the countryside in the nick of time and being handsomely praised when the storm was over and everyone had been saved.

In his childhood recasting of Longfellow's poem, then, not only does New England turn into Iowa, but Revere also becomes the young Wood—a dual projection that suggests the painting's private, rather than its patriotic, dimension.

On the day after Wood's vision of the church/cyclone—an image that bears its own psychological freight, given his strict religious upbringing—he attempted to stage the very act of heroism inspired by Longfellow's poem. Raising a false cyclone alarm at his schoolhouse, Wood led a panicked exodus from the school. "The younger children began to cry and scream," he recalled, adding that "the broad face" of his teacher, Miss Linden—a woman Wood idolized—was "suddenly transfigured by fear." Once his teacher had "got[ten] control of herself

enough to realize that it was a bright, shiny day with no threatening clouds in sight," he explains, she dragged him behind the schoolhouse by the nape of the neck. "She was a strong woman," the artist recounts, and "didn't stop spanking until she was exhausted. I bawled and screamed my innocence, but my cries were drowned in the silence of the prairie." In *Midnight Ride of Paul Revere* Wood not only vindicates himself, but he also controls the course of events. He is back in the saddle, indeed.

As the hero of his own folk legend, Wood recasts Revere's story in a way that also defies his father's religious insistence upon "truthful" imagery. ("We Quakers can only read true things," the artist's father had told him.) For Maryville, the study of history was a deadly serious enterprise—one that could "only [be] gratified from the purest sources." The dry and factual accounts he favored, of course, not only were anathema to Wood's imagination—both as a child and as an adult—but they were also central to his memories of corporal punishment. One need only imagine the still-smarting young Wood, compelled to listen to his father's recitation of Gibbon, to understand his resistance to historical discipline.

The strange omissions, substitutions, and anachronisms Wood weaves into his childlike version of Revere's ride clearly demonstrate his yearning for independence from Maryville. From the opposite side of the grave, he thumbs his nose at the factual purity his father so deeply valued, promptly making off for the very fantasy world from which Maryville and religious tradition banned him. Like *American Gothic*'s pitchfork-wielding sentinel, or *Victorian Survival*'s glowering, steeple-necked sitter, the top-heavy spire of Wood's church looms threateningly over the tiny rider—yet he manages to fly past unharmed. In this exhilarating image, Wood succeeds not only in revisiting his childhood, but also in revising it.

IN THE SAME YEAR that he painted *Midnight Ride of Paul Revere*, Wood produced an even more mischievous historical work. Ostensibly a celebration of the Hoover family homestead in West Branch, Iowa, *The Birthplace of Herbert Hoover* (see color plate 14) was commissioned by a local group of Republican businessmen; hoping to present the work to Hoover himself, these men had chosen Iowa's best-known painter to glorify its most famous politician. Upon seeing the final

1. *Van Antwerp Place,* 1922–23.
The tree in this early landscape shows the human qualities Wood so often assigned to local scenery. Its muscular trunk and limbs reappear in his 1937 lithograph *Sultry Night* alongside a standing male nude.

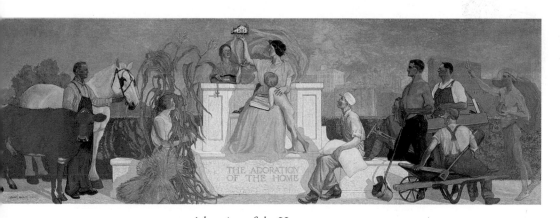

2. *Adoration of the Home,* 1921-22.
Unlike the allegorical figures in this work, Wood himself felt deeply ambivalent about home; the painting's patron, Henry Ely, later funded Wood's year-long stay abroad in 1923–24.

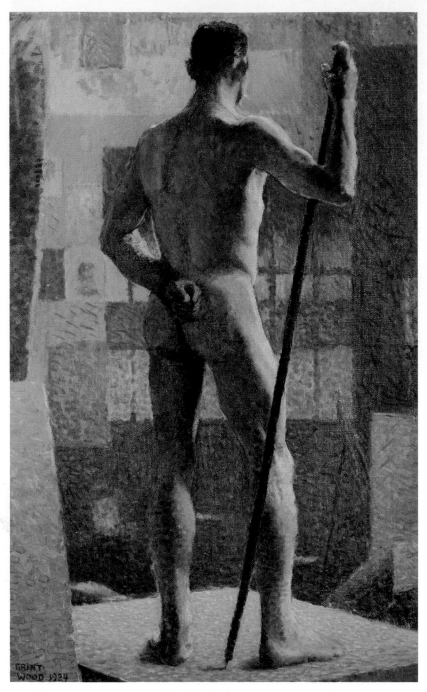

3. *The Spotted Man*, 1924.
Completed during Wood's time at the Académie Julian in Paris, this
academic nude remained in his studio until the artist's death.

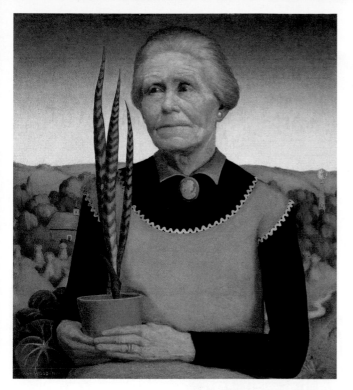

4. *Woman with Plants*, 1929.
Throughout Wood's time in
Europe it was his mother,
Hattie, who anchored him to
Cedar Rapids.

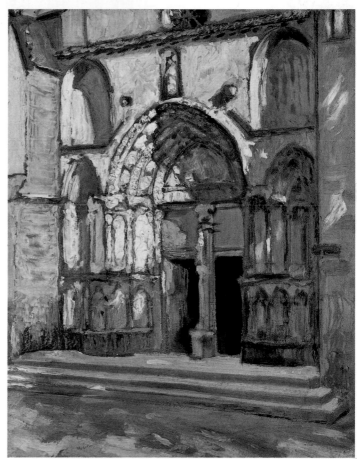

5. *Yellow Doorway,
St. Emilion (Port des
Cloîtres de l'Eglise
Collegiale)*, 1924.
Wood's fascination with
Gothic archways links this
work to *American Gothic*,
painted six years later.

6. Grant Wood (designer), *Memorial Window,* 1928-29; Veterans Memorial Building, Cedar Rapids. The artist's sister appears as the grieving figure of the Republic, dressed in her mother's mourning veil. Opposite, she wears her mother's apron and cameo in Wood's best-known work.

7. *American Gothic*, 1930.

8 and 9. Opposite page: *Fall Plowing*, 1931 (top), and *Stone City*, 1930 (bottom). Wood's responses to his native landscape ranged from nostalgia to ecstasy; in *Stone City*, the tiny billboard at far right reads: "They Satisfy."

10. Right: *Portrait of Nan*, 1931. The shape of this commanding portrait takes its cue from the portraits of colonial-era clerics.

11. *Arnold Comes of Age*, 1930. The twin themes of desire and loss in Arnold Pyle's portrait are underscored by the retreating nudes seen at lower right.

12 and 13. *Self-Portrait*, 1932–41 (left) and *Appraisal*, 1931 (below). The artist's deadly serious self-portrait is far-removed from the satirical portrayal of his friend Edward Rowan, whom he painted as a woman (below, holding the rooster).

result, however, they perceived more satire than tribute in the painting. The work was promptly returned to the artist, unsold.

Wood's depiction of the President's birthplace—a two-room cottage that embodied, in Hoover's words, "physical proof of the unbounded opportunity of American life"—undercuts the structure's iconic importance by burying it within the painting's composition. Indeed, only those already familiar with the historic site would have been able to distinguish the 1871 cabin from the later, much larger house that eclipses it. Doorless and half-obscured, the cottage attracts no more notice than its neighboring chicken coop. Wood indicates its significance only by the subtlest of details; in the foreground a tiny figure gestures in the direction of the cottage, whereas at the site's roadside, an unimpressive sign reading "Hoover" appears next to a boulder bearing a historical plaque. Rather than investing this site with gravity, these elements only underscore its anemic character.

Considering the circumstances of the painting's commission, Wood's irreverence is puzzling. Although Hoover's political star had fallen rather precipitously in this period, it is doubtful that the artist had a political axe to grind. (Wood later became an ardent New Dealer, yet politics held little interest for him at this stage.) To understand why he might have targeted Hoover in this work, along with those who would enshrine his history, we must consider the ways in which the President's life and bearing recall those of the artist's father.

A near-contemporary of Maryville's, Hoover was raised by devout Iowan Quakers and known for his strict sense of reserve. "He eschews loud colors and adornments," wrote a contemporary admirer, "[and] uses plain speech to express his thoughts. He relies on logic and reason to support his arguments." Iowa's first U.S. President, Hoover was considered a paragon of midwestern masculinity, morality, and authority; by extension, Hoover's supporters viewed the President's humble birthplace as the very source of his values and temperament. In drawing attention to the absurdity of this monument, then—and therefore questioning the importance of the man himself—Wood not only challenged an Iowan icon, but he also made a simultaneous strike against Maryville.

If we compare Wood's finished version of *The Birthplace of Herbert Hoover* with its initial sketch, we also see how the painter inserted himself into this image. In his original study for the painting, Wood included a small, inset image showing the Hoover birthplace in its orig-

inal, freestanding state. This historical reminder not only provided a
sentimental note to the work (Wood directly borrowed this formula
from Currier and Ives lithographs of historic sites), but it also allowed
the viewer to locate the original structure within its contemporary con-
text. By replacing this feature with the canopy of an oak tree, Wood
managed to reduce the cottage's legibility while also investing the work
with a nod to his own history—for, at the age of thirteen, he had won
his first national art prize with a drawing of similarly clustered oak
leaves.

In this seemingly innocuous detail, Wood manages to eclipse the
significance of Hoover's birthplace by referencing the humble nature of
his own origin. Indeed, given the painting's unusually high viewpoint,
the fanciful, rounded form of Wood's oak tree suggests the woolly head
of a swaggering giant—the artist-as-colossus, towering over the doll-
like structures before him, just as the viewer looms over Boston in
Midnight Ride of Paul Revere. Within a work that already subverted the
original intent of its commissioners, this coded reference provides fur-
ther proof that Wood's conception of national history was always
refracted through an autobiographical filter—even at the expense of his
works' transparency.

NOT LONG AFTER COMPLETING *The Birthplace of Herbert Hoover*,
Wood realized his long-held dream of establishing an artists' colony.
Conceived on a grander scale than his Turner Alley scheme of the
1920s, this colony was intended to encourage regional artistic expres-
sion through communal living, traditional art instruction, and an
immersion in the Iowa landscape. The location Wood chose for this
venture, appropriately enough, was Stone City. Frozen in time, this
tiny and virtually abandoned town not only appealed to the artist's
romantic streak, but its proximity to Anamosa also allowed him to
return, temporally as well as geographically, to his boyhood.

The Stone City Art Colony operated for two summers, in 1932 and
1933, offering two- and six-week sessions with a faculty of eight instruc-
tors. Ed Rowan acted as the colony's chief promoter and financial
architect, whereas its directorship fell to Adrian Dornbush, an art
instructor at the Little Gallery with a long résumé in arts administra-
tion. Wood officially served as "artist in residence" at the colony, yet

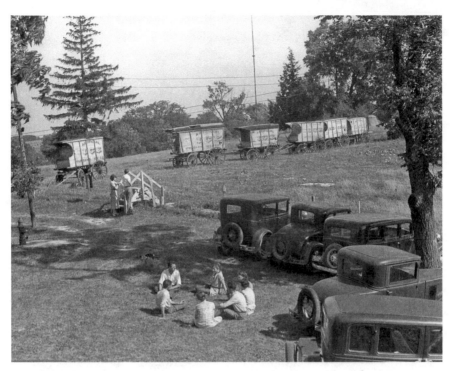

Stone City Art Colony, summer 1932. The Hubbard Ice Company wagons, seen in the background, served as the colony's male dormitory.

he was intimately involved in all decisions regarding its design, publicity, and curriculum. In the former Green Mansion and its outbuildings, the school offered classes in painting, lithography, frame making, drawing, and sculpture. For the colony's refectory, Wood built long, communal tables intended to encourage the enterprise's family atmosphere. Not surprisingly, the red-checkered tablecloths he ordered for these tables evoked his own family and first "studio" rather pointedly.

Female students at the colony were housed in the Green Mansion, whereas male students and faculty lived outdoors—either camping on the grounds of the mansion, or in one of the ten former ice wagons donated to the colony by a Cedar Rapids ice company. Wood encouraged students to paint murals on the sides of these "gypsy wagons," creating an outdoor gallery that extended from the town's former water tower to the Green Mansion. Appropriately enough, Wood painted an enormous, folk-inspired landscape on the outside of his own wagon—

Grant Wood painting his ice-wagon mural at the Stone City
Art Colony, summer 1932

whereas on the inside, as the *Cedar Rapids Gazette* reported, "the elabo-
rate . . . mid-Victorian is changed to modernism with a coat of alu-
minum paint."

Contemporary newspaper coverage of the colony demonstrates that
the venture inevitably summoned stereotypes of the bohemian artist.
To disarm such criticism, Wood, Dornbush, and Rowan cultivated a
vigilantly wholesome atmosphere at Stone City—suppressing per-
ceived "Greenwich Village cliques" among the students, providing life-
drawing models with chaperones, and inviting local residents to attend
Sunday receptions at Stone City's former opera house. Wood distanced
the colony from art theorists as well, who constituted their own dubi-
ous category. Founding the "Banana Oil Art Research Society" at Stone
City, the artist explained that the group's mission was "to razz and
befuddle fancy art critics."

Visiting the colony in the summer of 1933, a reporter for the *St.
Louis Post-Dispatch* wrote:

There is a remarkable lack of artistic froth about the colony. The artists and potential artists here don't feel it necessary to dress the part or affect the mannerisms often associated with the profession. Grant Wood works in overalls, and the rest of the men wear quite nondescript clothes. The women also avoid the freakish and bizarre in attire . . . satisfied with conservative skirts. Only one beret and smock were in evidence the other day, and there wasn't a Van Dyke beard on the place.

Almost to the disappointment of the press, it seems, the communal life at Stone City was no more bohemian than an adolescent summer camp—characterized as it was by campfires, poetry readings, dulcimer concerts, and a strict separation of the sexes where sleeping arrangements were concerned. It was "a school to which mothers were quite willing to send their daughters to paint," and a community where men displayed a "brotherly, man-to-man attitude" toward one another.

Writer John Seery suggests that Stone City may have provided a kind of masculine idyll for Wood—a male-dominated atmosphere that, in and of itself, indicates the artist's same-sex preference. With this colony, Seery claims, "Wood's dreams of relocating the bohemian activities of the Latin Quarter . . . may have been about more than merely aesthetic collaboration." Given what we know about Stone City, however, this assessment seems at least partly off the mark. First, female students always outnumbered men at the colony, often by a large margin. Second, given Wood's deeply ingrained fear of exposure—and the scrutiny with which the colony itself was observed—it is difficult to imagine he would have considered Stone City a sexual outlet, even given the presence of such openly homosexual men as Dornbush.

That Wood might have sought something "more than merely aesthetic collaboration" with his fellow men at Stone City, however—if not in an overtly sexual sense—may well be true. One must consider, for example, the dramatic shift in the artist's living arrangements during these two summers. Leaving Hattie and Nan behind in Cedar Rapids, Wood surrounded himself for the first time since Park Ridge with a coterie of men who shared his interests in the arts, represented no threatening invitation to bohemianism, and whose genuine affection for him must have been deeply satisfying. John Bloom, the colony's groundskeeper and later a celebrated artist in his own right,

Two unidentified Stone City Art Colony students, 1932

shared Wood's wagon for much of that first summer—whereas Wood's protégés, Carl Flick and Arnold Pyle, were quartered nearby. Living openly with these men, and even *in* the open with them (if Wood's well-appointed wagon may be considered a form of outdoor living), the artist balanced his father's model of healthy outdoor "labor" with his mother's sensitivity to natural beauty.

Wood's rediscovery of the Iowa landscape had been profoundly shaped by his close friendship with Jay Sigmund, a Cedar Rapids writer who encouraged Wood to celebrate their region long before the artist formalized this calling at Stone City. Sigmund made his living in Cedar Rapids as an insurance executive, yet his passion was writing poetry that extolled Iowa and its people—a cast of characters that includes the same sturdy farmers, long-suffering mothers, and acid-tongued spinsters we encounter in Wood's later work. Given his rural upbringing and lack of formal education, Sigmund was remarkably well versed in the poetry of Verlaine, Rimbaud, Baudelaire, and Whitman. Accompanying the artist on excursions along the Wapsipinicon River, and host-

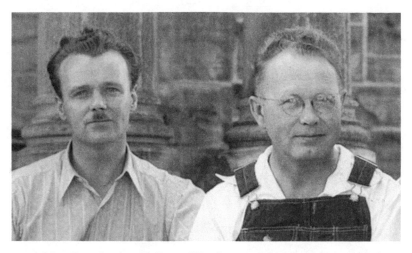

Adrian Dornbush and Grant Wood, 1932. After the colony folded
in 1933, Dornbush moved to Key West.

ing him in his home in the remote village of Waubeek, Sigmund
opened the artist's eyes to these writers and to the features of a quickly
disappearing rural Iowan world—the experience of which, despite
Wood's later assertions to the contrary, had by the 1920s become only a
distant memory for the painter.

Sigmund's 1924 collection of poems, *Land o' Maize Folk,* typifies
his work. In its introduction he writes: "Not many flowers bloom in
the 'Land o' Maize Folk.' They bloom in the cultivated gardens of
the east . . . Corn grows here, not roses, and there are weeds along the
fence. Life in the 'Land o' Maize Folk' is somber—sometimes sodden."
In this and subsequent collections, Sigmund praises the grave beauty of
the Iowa landscape. In a 1926 poem simply entitled "Grant Wood," he
encourages the painter to approach his native landscape in a similar
manner; Sigmund writes that the artist's rural audience, the "men full
of toil-sting," would be forever grateful "that their barns and stacks had
thus found song."

By the early 1930s, Wood had more than fulfilled Sigmund's vision.
Not only had he fully reawakened to the beauty of his region, but he
had also cast himself as one of Sigmund's "men full of toil-sting"—
referring to himself as "just a simple Middle Western farmer-painter."
Wood's insistence on combining these two labels may be directly

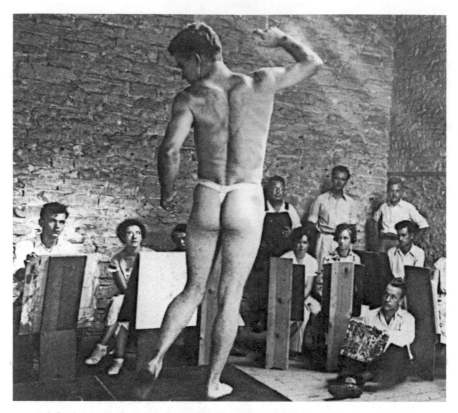

A life-drawing class conducted in the Green Mansion's former ice house,
1932. Standing to the right of the model are Grant Wood (in overalls and
leaning against the wall), Adrian Dornbush, and Marvin Cone.

linked to Maryville's expectations for him. Eager to prove he had
become, in effect, a kind of farmer—however mutually exclusive
Maryville would have considered farming and painting—Wood
believed his new venture had allowed him at last to follow in his father's
footsteps. The metaphorical connection went only so far, of course, for
Wood's life as a painter and academic was a far cry from the harsh real-
ities of 1930s farming. (As he joked with a reporter around this time,
"I'm a pretty good farmer. I've a grand flower garden at home.")

By linking painting and farming, Wood managed to associate his
art with physical labor while distancing himself from the suspiciously
intellectual milieu of bohemia. Famously claiming that "all the really
good ideas I've ever had came to me while I was milking a cow"—an
activity that belonged, it must be said, to Wood's adolescence—the
artist explained to the *New Orleans Times-Picayune:* "You don't get pan-

icky about some '-ism' or other while you have Bossy by the business end. Your thoughts are realistic and direct." A year before the founding of Stone City, Joseph Pollett wrote in similar tones about American artists. "We are farmers and roughnecks," he explained, as opposed to European modernists, who were more like "a group of professors; too much aesthetic knowledge theoretically, too little brute vitality."

Wood's wish to identify himself with roughnecks, rather than professors, was most apparent in the overalls he continued to wear. If the noisy, industrial environment of the J. G. Cherry plant first invested them with the stamp of blue-collar factory work, then Stone City recontextualized Wood's unofficial uniform as farmer clothing—and more specifically, of course, it allied him with Maryville. Although Hilton Kramer claims that the artist's overalls represented his attempt "to dress up as his father," it would be more accurate to say Wood was dressing up *for* his father—attempting to prove that his fame as a painter could naturally coexist with the role for which Maryville had originally intended him.

Wood's overalls had always served as an effective shield against charges of bohemianism. Writing about the artist's studio in 1931, one critic offered: "He dresses in old overalls while he paints—there's little of the Left Bank Bohemian about him . . . [Wood is] a man, and Midwestern to the core." For his part, after his visit to the Stone City Art Colony in 1933, René d'Harnoncourt declared that Wood's dress posed a challenge to East Coast elitism. "We on the sunset of the Mississippi had accepted that art wore a full dress suit and spoke with a New York accent," he offered; "now we are glad to find that . . . it may be at its best in overalls." In later eulogies of the artist, critics like Helen Magner even went so far as to celebrate the presumably national character of Wood's clothes: "Wood was an American even in details of dress. In past years artists adopted smocks for their own . . . the working costume of French peasants. Grant Wood wore the work clothes of his own country when he painted, overalls such as a farmer or mechanic would choose."

Unaware of the irony of her own statement—denim had first appeared as a French workers' fabric, and overalls were themselves another European import—Magner's comments nevertheless illustrate the potent symbolism of Wood's costume. Not only did it serve as an emblem of his working-class status, whether urban or rural, but it was also perceived as intrinsically more democratic than the supposedly

affected artist's smock. As Wanda Corn has noted, however, Wood's other sartorial choices often undercut the populist effect of his overalls. "In wearing his denims with a starched, long-sleeved shirt and two-toned shoes," she writes, "he crossed the regional with the modern."

Throughout his time at Stone City Wood remained busy, completing two works in 1932 that perfectly demonstrate the dual nature of his regional interests. In the first, a painting entitled *Arbor Day,* he depicts a nostalgic, almost cloyingly sweet scene in which children and their teacher plant a tree beside a one-room schoolhouse—a structure loosely based on the Antioch County School. Although the work had been commissioned by the Cedar Rapids school board to honor two local schoolteachers, the scene's anachronistic elements clearly evoke Wood's own childhood, rather than a contemporary scene from the 1930s. In Wood's other major painting from this year, *Daughters of Revolution* (see color plate 19), the artist portrays an entirely different version of rural, community "values"—a sharp parody of small-town chauvinism that garnered nearly as much praise and righteous indignation as *American Gothic* had two years before. Even Gertrude Stein weighed in on the painting, claiming in admiring tones that "Grant Wood is the all-time menace; he is America's first artist."

In *Daughters of Revolution,* three conservatively dressed matrons stand before a reproduction of Emanuel Leutze's iconic *Washington Crossing the Delaware* (1851). Apparently interrupted at a tea, the women regard the viewer with a look of undisguised contempt—expressions that instantly recall John Turner's confrontational look in his portrait, as well as the penetrating gaze of *American Gothic*'s farmer. In this case, however, the viewer hardly feels threatened. Just as he had done in *Victorian Survival,* Wood defuses the potential power of these women by cruelly distorting their bodies. With their tightened lips, beaky noses, and thick, elongated necks, the women resemble nothing so much as a puffed-up group of hens. Indeed, even the central figure's bony hand—modeled by Fan Prescott—recalls a chicken's talon.

If Wood had aimed *Victorian Survival* at the strict matrons of his boyhood, then in this instance his target is more specific and contemporary. As the title of this work suggests, these women belong to that venerable institution, the Daughters of the American Revolution—a group against whom Wood held a long-standing, and mutual, grudge. In 1928 the DAR had expressed its outrage that Wood's Veterans Memorial window was to be produced in Germany, the United States'

most recent former enemy. In order to highlight the organization's hypocrisy, Wood juxtaposes his figures against Leutze's famously patriotic image; this work, too, had been created in Germany—and by a German artist, no less. By contrasting Washington's heroic sense of courage with the women's fey brand of dignity, moreover, Wood also pokes fun at the DAR's genealogical membership requirement—a criterion he felt betrayed the American principles of egalitarianism. The paltry inheritance that these "daughters" represent is as far removed from the Founding Fathers' bravery, he demonstrates, as the central figure's delicate teacup is from the Boston Tea Party.

In her own analysis of *Daughters of Revolution,* Karal Ann Marling suggests that this coupling of masculine heroism and feminine preciosity is seen most clearly in the figure at the far left. In order to underscore the depths to which revolutionary principles had sunk, Wood transforms Washington's regal pose and powdered hair into an elderly woman's self-satisfaction and gray, wash-and-set hairdo—a gender reassignment that the artist had clearly (and equally misogynistically) employed to ridicule Rowan in *Appraisal.* This female version of the Founding Father served both to lampoon the omnipresence of Washingtonian imagery in 1932, the widely celebrated bicentennial year of his birth, and to satirize the hyperbolically masculine qualities these images conveyed. Several widely read biographies of Washington in the 1920s, in fact, had gone so far as to emphasize the Founding Father's sexual prowess—a dimension of Washington's personal life that creates an even starker contrast, Marling suggests, between General Washington's confidently splayed legs and the prim attitudes of the women in the foreground.

Marling's reading of *Daughters of Revolution* challenges the patriotic intentions so often ascribed to Wood's work, while also suggesting the central theme of *American Gothic* and *The Birthplace of Herbert Hoover:* the portrayal of father figures as either inert or ridiculous. Washington, the country's ur–father figure, is not only rendered powerless behind the mask of his scolding, female double in *Daughters of Revolution,* but he is also safely contained behind glass in a foxed and faded engraving. Indeed, the very inclusion of Leutze's image suggests another form of filial disrespect. Seen by many as Leutze's twentieth-century successor, Wood labored in his shadow; as one critic from the 1930s noted, *American Gothic* had "become *almost* [my italics] as well known to the U.S. public as *Washington Crossing the Delaware.*" By shrinking Leutze's

enormous, operatic painting to domestic, Currier and Ives scale, Wood transforms it into nothing more than an example of middlebrow, patriotic kitsch.

Both *Daughters of Revolution* and *Appraisal* summon the notion of "camp" aesthetics that critics occasionally associate with Wood's imagery. Robert Hughes dismisses *American Gothic,* for example, as a "sly exercise in camp," whereas Hilton Kramer claims that *Daughters of Revolution* and other examples of the artist's work "enter our experience as examples of Camp. We are amused by them, we are made to feel superior to them, we think they are 'good' just because they are so 'bad,' etc. But this tends to be true of a great deal of what we see in . . . Grant Wood['s work]. It simply cannot be taken seriously as painting." To better understand the role camp plays in Wood's art—an element that exists, in successful and positive ways, in a number of his works—we need a better understanding of the term than either of these critics provides. For while Hughes erroneously conflates camp with deception, Kramer is really speaking about kitsch, rather than camp.

More accurately defined, camp is a form of creative subversion—visual, verbal, or performative—whose principal target is the artifice of gender. Primarily associated with gay men, camp not only turns the tables on traditional gender identity, but it also highlights the power imbalance between heterosexual and homosexual. Its currency is the inside joke or reclaimed stereotype, elements that exclude the majority culture by ridiculing its prejudices. Like all forms of comedy, however, camp is also fundamentally conservative. As Christopher Isherwood has written, "Camp always has an underlying seriousness. You can't camp about something you don't take seriously. You're not making fun *of* it, you're making fun *out* of it."

In Wood's work, camp aesthetics should not be confused with satire in a more general sense. There is nothing particularly campy, for example, about Wood's stated goals for *American Gothic.* His intended parody of false taste bears no specific attachment to male or female, nor do his figures themselves challenge traditional gender roles (quite the reverse, in fact). The campiness of *Appraisal* and *Daughters of Revolution* is far more clear, both in Wood's reversal of the figures' genders and his mismatched allusions to their genitals—the "cock" in *Appraisal,* and the phallic, elongated necks in *Daughters of Revolution.*

Wood's brand of camp is apparent, too, in his exaggeration of his figures' gendered traits. Clothing is as important an indicator of femininity in *Appraisal* (originally titled *Clothes*) as body language and accessories are in *Daughters of Revolution*—seen particularly in the figure who holds, rather preciously, a willowware teacup. Not only does this artifact underscore the woman's sense of affectation and bourgeois aesthetics, but it also obliquely feminizes the artist himself—for although Wood may have associated this pattern with his elderly female relatives, it is he who lovingly preserved their china and expanded its collection. The campy subversions in this image, then, exist at a variety of levels that operate simultaneously. The work is as rich, in a comedic sense, as it is psychologically dense.

The playfulness Wood demonstrates in *Daughters of Revolution* and *Appraisal* was notably absent in his self-presentation. The artist's famously self-deprecating sense of humor had, it seems, a limited range of targets: his physical appearance and presumed lack of sophistication were fair game, whereas his clothing, bachelor status, and unorthodox relationships (with his mother, sister, or male protégés) were strictly off-bounds. Indeed, apart from his love for costume parties, Wood was deadly serious when it came to his public image—an attitude that grew only more pronounced, and fraught with self-doubt, as his fame grew in the 1930s. In the self-portrait that he began in 1932 (see color plate 12), we see this combination of gravity and uncertainty in its starkest terms.

Wood undertook this painting for a competition of artists' self-portraits, sponsored by the Iowa Federation of Women's Clubs. (It is worth noting that Carl Flick, who also took part in the competition, entered a self-portrait clearly patterned after his mentor's). The ambivalence Wood felt toward his own entry is reflected in the painting's complicated history. Although he submitted a finished version for the competition, Wood began to rework his self-portrait almost as soon as it returned to his studio—where it remained, unfinished and emphatically labeled "SKETCH" above his signature, at the time of his death a decade later.

The image is a telling one in a number of ways. Portrayed against an Iowa landscape strikingly similar to the one in his mother's portrait, this nearly life-size figure occupies a space uncomfortably close to the viewer. Not only do Wood's head and shoulders fill the frame, but they

also extend just beyond it. Despite its unconventional scale and close proximity, the artist's wary and self-conscious figure bears none of the implicit threat that his sitters so often project. The only discomfort we sense here is Wood's own.

To describe a self-portrait as "self-conscious" may sound tautological, yet as T. J. Clark has noted, the painter's task in depicting his or her own image is to *remove* the effects of self-objectification. "Self portraits are partly made," he writes, "against [a] background of suspicion, and the look in them has to signify above all else that the painter has cast a cold eye on his subject matter." That Wood fails to create this sense of distance in his self-portrait is less a sign of his narcissism than an indication of his chronic self-surveillance. Not only was it impossible for him to cast an objectively "cold eye" upon himself, but it was equally difficult for him to choose the mode of his self-presentation—for which of his selves was he to portray?

Wood's indecision may be read most clearly in the unfinished passages of his clothing, areas that stand in marked contrast to the rest of this otherwise carefully finished image. The artist first depicted himself in overalls—the outlines of which remain visible in the work's underpainting—and subsequently in an open-collared shirt; ultimately, he covered this section with a blue ground color and simply left it unresolved. Further overpainting indicates that Wood also reduced the size of his head in this image, while increasing the girth of his neck and shoulders—thereby suggesting the sturdy build of a corn-fed laborer, rather than the stereotypically soft or anemic figure of an artist.

Although the painting provides not a single straightforward clue to Wood's profession, the work's background hints at a somewhat elevated sense of artistic identity. In the golden atmosphere that surrounds his head, Wood projects the aura of a devotional icon—an effect distinctly at odds with the painter's haunted expression. The inclusion of a windmill in this portrait, moreover, derives from Renaissance artists' similar use of artistic emblems. As Wood himself explained, "The Old Masters all had their trademarks, and mine will be the windmill."

Wood's inability to clearly define his own image—a prolonged exercise in tilting at windmills, indeed—is pointedly demonstrated by his friendship with the artist John Steuart Curry, whom Wood invited to Stone City in the summer of 1933. Although their collaboration at the colony lasted less than a month, it established a lifelong connection

between the two men. In the alternative masculine paradigm that Stone City fostered—where men were men, as well as artists—Curry seems to have provided a kind of perfecting mirror for Wood. His background, self-presentation, and personality reflected the Iowa artist's in striking ways, yet he also embodied qualities Wood found beyond his reach.

A native of Kansas, Curry had produced most of his midwestern subjects from the safety of a Connecticut studio (the summer of 1933, in fact, marked the artists' first meeting). His first major critical success, *Baptism in Kansas* (1928), had effectively declared his independence from the school of Paris—where he, like Wood, had studied for extended periods in the 1920s. Although this work hardly achieved the international fame *American Gothic* would two years later, Curry's striking image of an open-air, adult baptism—a ritual conducted in a contemporary barnyard, before a crowd of humbly attired observers— was received in similar terms. Critics felt that his "home-grown" sub- ject, matter-of-fact style, and personal connection to the region lent the painting a notable authenticity (for better or worse). Laurence Schmeckebrier praised Curry's "sincere reverence and understanding" in this image, whereas Edward Alden Jewell saw only "a satire on reli- gious fanaticism."

If the trajectories of Curry's and Wood's careers resembled one another in remarkable ways, then so did their childhood experiences. Raised on a Kansas farm, Curry lived in the shadow of a father every bit as difficult and demanding as Maryville—and one who similarly disap- proved of his son's vocation. As if taking a page from Wood's life story, Curry's biographer writes that the artist's father, a cattle rancher, "at times found it rather trying to see his husky, twelve-year-old son draw- ing pictures on white paper." Unlike Wood, however, Curry never romanticized this period of his life or wished to be associated with his father's work. "I'd rather draw a picture of myself shoveling manure than do it," he once quipped.

Visitors to Stone City found the men's physical resemblance to one another even more noteworthy than their shared artistic vision. As Keith Kerman of the *St. Louis Post-Dispatch* noted, the two artists were

surprisingly alike, not only in attitudes of mind but even in appearance and manner. These two painters . . . are of approxi-

John Steuart Curry and Grant Wood at the Stone City
Art Colony, summer 1933

mately equal height, both are of comfortable girth, and their facial resemblance is marked. They are amiable fellows and they talk slowly and quietly. They seem to be absolutely devoid of affectation. There is no artistic window dressing about them.

Whether the two were completely without affectation is debatable, for in the photo that accompanied this article, Curry and Wood posed in identical overalls. The *Omaha Bee-News* noted the men's outfits as well, reprinting this photograph along with the caption "Quits Kansas for Iowa Denim."

Far from drawing attention to the artificiality of the men's matching overalls—a choice made all the more noticeable, given their absence on the rest of the Stone City faculty—newspapers exploited the artists' similarities in similarly staged photographs. The two men are shown smoking together, sitting in paired rocking chairs, and sketching one another; rather tellingly, in at least one example, a newspaper even transposed Wood's and Curry's names in its identifying caption. The

fact that Wood encouraged such comparisons—posing with Curry, costuming him, and inviting him to Stone City in the first place—suggests he saw in Curry qualities he wished to associate with himself.

For all of their apparent similarities, Curry differed from Wood in certain physical respects—or rather, the press often described his body differently. Wood's profiles most often suggested his stereotypically feminine or childish attributes; he is described as "round, pink, and wholesome," "rosy and plump," "cherubic," and generally soft. By contrast, Curry's coverage emphasized the masculine qualities of this "massive, fleshy, physically powerful man" and frequently referenced his former career as a collegiate athlete. Thomas Craven claims Curry had the body "of a born football player," whereas *Time's* art critic (who refers to Wood in the same article as a "shy Bachelor") labels Curry "a potent footballer."

If the distinction between Wood's and Curry's bodies is difficult to make out in period photographs, then the divergence in their painting styles is clear enough. Rather than depicting quiet genre scenes of sun-dappled farms, Curry made a name for himself as a painter of action and conflict. His images of athletes, cataclysmic storms, and animal violence formed natural corollaries to his later, more politicized themes of racial injustice, war, and political corruption. James Dennis perceives in Curry's subject matter the "masculine force that dominated his personality"; this painter, he writes, was at his core a "Kansas farmboy, athlete, hunter, and illustrator of adventure stories" who showed a remarkable "preference for the masculine."

Not only was Curry's imagery rawer and more elemental than Wood's, but his approach to painting also differed from the Iowa artist's in significant ways. Whereas Wood often spent weeks meticulously building up his paintings, Curry's method was marked by action and spontaneity. Curry's stepdaughter once explained that

> when [Curry] was working his blood pressure would go up and the tension would build. He would never talk about what he was going to do, because he said if he talked about it too much he'd never do it. He just seemed driven. Then when the painting was done he'd collapse and say, "I'll never paint again." The blood pressure would drop and he'd say, "No more ideas, I'm dry." That was the time when he was taciturn . . . and impotent.

The connection here between painting and sexual potency—one that mid-century critics would echo in their descriptions of Action Painting—indicates that Curry's style was perceived to be as athletic and virile as the man himself. Although his loose brushwork brought him as much negative criticism as praise (the same may be said for his sometimes histrionic imagery), he clearly embodied a brand of masculinity Wood had been raised to admire.

Because the two presented a similar face to the world, Curry's manly image appeared to rub off on Wood that summer. After her visit to Stone City, critic Adeline Taylor noted that *both* artists shared "rugged foundations rather than comely exteriors," an assessment Wood must have found deeply gratifying. Because Curry represented a more attainable ideal than Maryville had (he was both a painter and a "real" man), their friendship allowed Wood to successfully manage his father's expectations. Together, the two men formed a kind of perfected version of Wood—a notion Taylor suggests, however unwittingly, in predicting that "perhaps [Curry and Wood's] most portentous pioneering will be done in double harness."

Wood's hopes to create a permanent artists' community at Stone City—a vision only strengthened by Curry's much-touted presence at the colony—abruptly ended in August of the same year. Although enrollment had increased from ninety students in 1932 to over one hundred in the summer of 1933, the colony had lost money almost from its first week of operation. Conflicts erupted, as well, over Wood's teaching methods. At the start of the 1933 session, instructor David McCosh had resigned from the colony, claiming Wood was cultivating a generation of "little Woods" rather than fostering a diversity of approaches. Equally frustrated with Wood's teaching style, student Robert Francis White encouraged a small group to leave the colony. Although McCosh's resignation and White's student "revolt" do not reflect any widespread discontent at Stone City, they clearly indicate that the community was not as unified as it was often portrayed.

In addition to financial problems and pedagogical disagreements, another important factor in the colony's demise was Hattie's disapproval of the enterprise. Always anxious regarding Wood's financial well-being, the artist's mother was especially troubled by his connections to Stone City; not only did he refuse a salary there, but he was also determined to pay the colony's debts from the sale of his own work. Equally unsettling to Hattie were Wood's long absences from

Turner Alley. During the summers of 1932 and 1933, the artist had moved semi-permanently into his ice-wagon quarters at Stone City—a taste of independence that seems to have led, in turn, to his rental of a private studio in Cedar Rapids (the location of which he concealed even from Hattie and Nan).

Enlisting the help of David Turner, Hattie forced her son's hand regarding Stone City's future. Turner warned the artist that if he pursued a third year at the colony, as he had planned to do, he and his mother would no longer be welcome to live at Turner Alley. Hattie's engineered threat was an empty one, of course—she had no desire to be evicted from her own home—yet Turner's ultimatum left Wood with no alternative but to close the colony. Unaware of Hattie's role in this episode, Wood blamed Turner for Stone City's demise—a resentment that would deepen over the years, and eventually lead to a permanent rift between the men. In the fall of 1933 Wood resumed his former life at the studio, yet by this date the familiar routine of Turner Alley was already in a state of decline. Within two years, seismic changes in the artist's life would permanently transform where, how, and with whom he lived.

IN THE FALL AFTER Stone City's closing, Wood found solace in his new role as Iowa's director of the Public Works of Art Project—a short-lived federal relief program later subsumed within the Works Progress Administration. As director of the PWAP, Wood headed a group of thirty-four artists charged with creating a series of murals at Iowa State University in Ames. Carried out between January and June of 1934, the murals were intended to chart the stages of Iowa's cultural history. Fittingly, Wood drew his inspiration from Daniel Webster's 1840 declaration "When tillage begins, other arts follow"—a theme that allowed him to illustrate a seamless progression from farming to painting. Alongside murals devoted to Iowa's pioneer past, Wood installed images of the "practical arts" that appeared in the wake of the state's settling: agriculture, veterinary medicine, home economics, and engineering. Ironically, the intended finale—a mural that was to depict the arrival of the fine arts in Iowa—was ultimately abandoned.

Given Wood's role as the project's designer rather than its painter, the Iowa State murals bear little of the psychological freight, and certainly none of the satire, seen in his other work. The commission was

an important one, however, for it cemented his position at another school—the University of Iowa in Iowa City (or the State University of Iowa, as it was then known). Because the local PWAP office operated out of the University of Iowa, the artist was officially paid for teaching a "class" in mural painting to the team of university students who executed his Iowa State murals.

To the astonishment of Wood's colleagues in Iowa City, upon completion of the first phase of the mural project in June 1934, he was permanently appointed an associate professor of fine art—despite the fact that he held no degree higher than a high-school diploma and had no experience teaching at the college level. As surprising as the appointment may have been to his peers, however, the artist's celebrity ensured popular approval of the university's decision. As the *Des Moines Register* said of Wood's new position, "The *Register* can think of nothing more appropriate than that the State University of Iowa should take into its art faculty a native son who has made for himself a national reputation . . . It is gladdening that Mr. Wood is not without honor in his own land."

In Wood's own view, the importance of his positions within the PWAP and at the University of Iowa lay less in the prestige these jobs carried than in the sense of community they offered him. Referring affectionately to his mural team as "my boys," Wood recaptured the schoolroom atmosphere of the *Imagination Isles* project and the easy male camaraderie of his Stone City summers. Disagreements between Wood and his PWAP assistants, however, soon cast a shadow on the venture. Echoing McCosh's and White's complaints at Stone City, the muralists resented Wood's heavy hand in directing their work; as artists in their own right, and grown men besides, they found Wood's attitude toward them both stifling and patronizing. Matters reached a head in 1935, when twenty-one of the artist's "boys" signed a petition to oust him as director. "I'll never forget the look of disillusionment and shock on his face as he read the petition," Nan later recounted. Although the PWAP board in Washington refused to remove the artist, the injured Wood resigned.

The artist's disappointment over the PWAP directorship, and his bruised feelings over the muralists' petition, were partly assuaged by the weekly painting clinic Wood conducted at the University of Iowa. As the university's newspaper, the *Daily Iowan,* described these communal

gatherings, "People, old and young, professionals and amateurs, bring as many as 100 pictures in an afternoon to this clinic. Each 'ailing' picture is clipped to an easel and 'diagnosed' by Professor Wood." The artist's clinics endeared him to students and the local community, yet they also drew negative attention from his colleagues—who found Wood's folksy, directive teaching style and dismissal of art theory detrimental to students' education. For the moment, however, Wood was untouchable.

THE YEAR BEFORE WOOD'S University of Iowa appointment, a pivotal show at the Kansas City Art Institute cast his work, for the first time, as part of a unified national movement. Conceived by the New York art dealer Maynard Walker, this 1933 exhibition bore a rather ambitious title—American Art Since Whistler—yet of the thirty-three artists included in the show, Walker clearly favored narrative realists over abstract painters, and "home-grown" artists over expatriates. Highlighting particularly the paintings of Wood, Curry, and Thomas Hart Benton, Walker presented their work as a coherent, intentional development within American art. Eventually known as American-scene painting, or simply regionalism, this invented movement would utterly redefine the terms of Wood's criticism.

In a lengthy statement to *Art Digest* in September 1933, Walker explained the inspiration for his exhibition. "One of the most significant things in the art world today," he declared, "is the increasing importance of real American art . . . art which really springs from an American soil and seeks to interpret American life." This new movement hailed from a surprising location—"our long backward Middle West"—and found its greatest expression, Walker maintained, in the work of Wood, Curry, and Benton. Insisting these men promoted "sincere" subject matter in their work, rather than "the bizarre and sensational," the dealer was quick to note that the three artists had severed all ties to Europe. The indigenous expression of these "real Americans," he explained, was poised to eclipse "the shiploads of rubbish . . . imported from the School of Paris."

Similar press releases proclaimed that this heroic triumvirate sought to correct the excesses and "colonialist" attitudes of New York's 1913 Armory show. Officially known as the International Exhibition of

Modern Art, this colossal show—held at New York's 69th Regiment Armory—had provided the United States with its first comprehensive introduction to European modernism. Artists who saw the show in New York or Chicago, where the exhibit later traveled, were electrified by what they encountered. Seeing firsthand the work of the impressionists, postimpressionists, fauvists, cubists, and early dadaists, this first generation of American modernists eagerly adopted the styles of their European contemporaries and soon considered a stint in Paris imperative to their education—an attitude that Wood, Curry, and Benton themselves initially embraced.

If the Armory show represented a watershed moment in the development of American modernism, however, then it also initiated the great divide between academic and popular art criticism in the United States. Encouraged by journalists who delighted in ridiculing the show's more daring works, crowds thronged the Armory show to see for themselves the "widely talked of eccentricities, whimsicalities, distortions, crudities, puerilities and madness" on display there. In the following decades, the American avant-garde was as increasingly drawn to European abstraction as the popular press was shocked by its forms and perceived decadence. Exploiting these decades-old prejudices, Walker's declaration of an accessible, patriotic, and values-laden form of modernism was therefore a potent call to arms.

American Art Since Whistler was, in fact, not much more than a sales ploy. Walker and his business partner Frederic Newlin Price, founder of the Ferargil Gallery in New York City, had mounted this exhibition to create a more marketable identity for the artists Ferargil represented. By the early 1930s Walker and Price had added Wood and Benton to their stable, and in 1933 they signed Curry—whose *Baptism in Kansas* had been purchased by the Whitney Museum the year before. Attempting to capitalize on Curry's successful showing at Chicago's Century of Progress fair in 1933, Price and Walker staged a solo exhibition of his work that April. To the dealers' disappointment, however, the show only seemed to highlight the critical dismissal of midwestern artists and subject matter. In its review of the Ferargil Gallery exhibition, *Time* claimed: "In the Prairie states, first-class artists are as rare as mountains." Allowing only two exceptions to this rule—Wood and Curry—*Time's* reviewer noted Curry's poor reception in his home territory, and offered only lukewarm praise for his work at the Ferargil show.

Walker's decision to stage American Art Since Whistler in Kansas City, rather than New York, was therefore a rather calculated one. A native midwesterner himself, Walker believed this choice would send a strong message about the power of regional (and rural) identity; from a purely financial perspective, of course, he also hoped that the setting would provide a more sympathetic environment for Ferargil's artists. In hindsight the move was particularly shrewd, yet it also carried a number of risks. Not only were midwestern audiences famously mercurial in their reception of local artists, but they were also suspicious of New York galleries like Ferargil and deeply resented any hint of Eastern condescension.

Equally problematic was the show's shaky premise. Given the diverse styles of the three men, as well as their relative unfamiliarity with one another (Wood had known Curry less than a year, and would not meet Benton until 1934), Walker's suggestion that the artists had been working in concert stretched the truth considerably. In the end, his gamble paid off. The appeal of a new American school of painting, even a clearly synthetic one, found fertile ground among conservative collectors and the national press. By the following summer, the Ferargil Gallery reported its best year since the stock market crash; as one critic claimed, its dealers "were again beginning to take cocktails with luncheon."

In the heady year that followed Walker's show, Wood executed his largest and most ambitious painting to date—an unusual composition entitled *Dinner for Threshers.* The monumentality of this panel reflected the scale of Wood's Iowa State murals, as well as the artist's new self-image as a leader within a national movement. (At nearly seven feet long, the work was so heavy that it eventually snapped the easel on which it was painted.) Featuring a cast of twenty-one figures in a stagelike, architectural cutaway, *Dinner for Threshers* celebrates the communal meals that accompanied the threshing season of Wood's boyhood. As the artist explained, "*Dinner for Threshers* is from my own life. It includes my family, our neighbors, our tablecloth, our chairs and our hens . . . it is of me and by me." Part genre scene and part family portrait, then, the work powerfully evokes Wood's nostalgia for the days of his Anamosa youth—and summons, as well, the desire and dread that haunt his memories of this period.

For Wood, threshing day was "the big event of the year . . . the

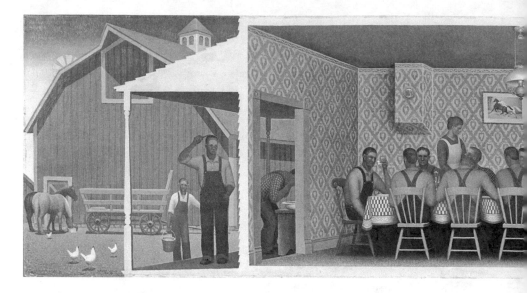

excitement of which I shall never forget." Predictably, he was as fasci-
nated by the men who worked the giant threshing machine (or the
"dragon," as he called it) as he was by the engine itself. Too young to
work alongside the men, Wood claims he watched their performance
from a safe distance, clad in his "best overalls." The men "laughed and
spat and swore lustily while they got their dragon ready," led by "the
dashing, devil-may-care young farmer who operated the engine," a
neighbor of the Woods' named Slim O'Donnell. Relating his first
encounter with O'Donnell, Wood explains:

> He was known in the vicinity as a plunger and dare-devil who
> cared more about baseball and horse-racing than he did about
> tending his farm . . . He sat under the canopy of the engine,
> handling the levers in such a grand manner that one could not
> help admiring him . . . and spitting great gobs of tobacco juice.
> Finally his glance lit upon me.
> "Hello there son," he drawled. "What's your name?"
> "Grant," I piped, the blood rushing to my face.
> "Grant what?"
> "Grand [sic] Wood."
> "Your hair's kind of red, ain't it?"

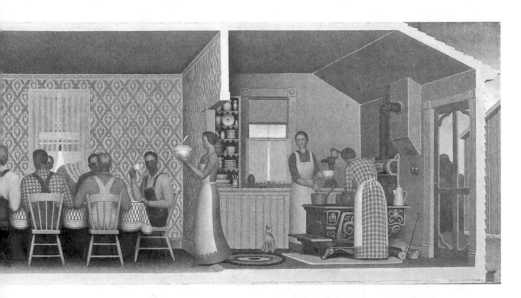

Grant Wood, *Dinner for Threshers,* 1934

"Y-yessir."

"Well then I guess I'll call you Redwood."

The threshing crew guffawed appreciatively, and I stared at the ground, speechless and pleased.

Wood's hero-worship of O'Donnell and the threshing crew not only demonstrates his longing to enter this charmed circle ("I did my best to duplicate the performance of the threshers," he relates), but also his attraction to their physical power—as evidenced by his blushing exchange with O'Donnell, whose command of the threshing machine "shook the earth beneath me." Indeed, in Wood's mind, the mighty machine embodied the masculine energy of O'Donnell and his crew. Like the threshers themselves, he recalls, "the engine was . . . hot and sweating from its long day's labor, and the air was pungent with the smell of hot oil." At the close of the day, O'Donnell invites an ecstatic Wood to blow the final whistle:

I clambered up to the seat beside [O'Donnell] so fast that I skinned my shin . . . I could not reach the whang which blew the whistle, even from the beam over the driver's seat, so O'Donnell lifted me up. I grasped the leather thong firmly and tugged.

"Schleep!" screamed the whistle, loudly enough to shake down the strawstack. I let go in fright.

"That'll never do," said O'Donnell, roaring with mirth. "Give her a real yank!"

This time, I pulled as if my life depended on it, and held on. And what a terrific blast it was!

Given this unavoidably Freudian climax to Wood's threshing day (an event that ended when "the last of our grain dribbled from the separator"), it is clear that the annual event summoned a rather complicated range of emotions in the artist—who was, it must be remembered, in his forties when he recorded these scenes.

In *Dinner for Threshers,* Wood chooses not to depict the chaotic and dangerous scene surrounding the threshing machine, but rather the domestic setting of the Woods' dining room. With its fine wallpaper, lace curtains, and framed lithograph, this stereotypically feminine space serves as a dramatic foil to the decidedly *un*domesticated masculinity of these "ravenous men [who] swarmed in from the fields for dinner." A voyeur to the men's activities even in his own home, Wood recalls: "I went around to the front door and watched the men . . . Never had I seen food disappear so rapidly; it seemed to me their [sic] must be no bottoms to their appetites."

Wood's fascination with the threshers' prodigious appetites is underscored by the ways he depicts the men's bodies. Not only does he draw attention to their powerful backs, accentuated by the crossed straps of their overalls, but he also highlights the curved outlines of their buttocks—the literal "bottoms" of their appetites, and a clear target for Wood's gaze. Although this latter detail is often lost in reproductions of the image, the original panel reveals that the scalloped shapes of the men's rear ends are intended to align with the rounded edges of the draped tablecloth. The seamlessness of this juxtaposition could hardly have been accidental—nor was it the first time Wood had used such a detail. In the 1923 *Mourner's Bench* he made for McKinley Junior High, for example, he carved the top rail of this two-seater into a similar silhouette of paired buttocks. Indicating both the hardness of the wooden seat as well as the likely site of its sitters' corporal punishment (the bench was reserved for those sent to the principal's office), Wood inscribed "The Way of the Transgressor is Hard" along the bench's top rail.

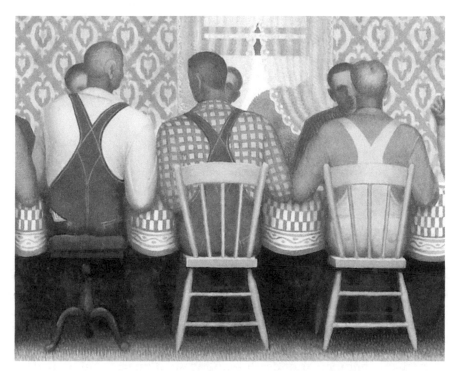

Grant Wood, *Dinner for Threshers* (detail), 1934. The figure at left is
the only known portrait of Wood's father.

In addition to the chorus line of posteriors Wood presents in *Dinner
for Threshers'* foreground, he also pairs the men off across the table from
one another—a composition echoed by the parlor's framed print,
which depicts similarly juxtaposed stallions. (Entitled *Thunder and
Lightning,* the image had been a favorite of Wood's from childhood.)
Given the dinner scene's evocation of hard-earned pleasure and even
excess—a kind of Iowan bacchanal—this phalanx of men projects an
erotic charge at odds with its stridently wholesome subject matter and
squeaky-clean execution. As one baffled critic claimed about the work,
"All is touched in lovely . . . but of course it looks damn queer as a
whole."

Compounding the strangeness of this image is its clear evocation of
Last Supper imagery. Contemporary critics of *Dinner with Threshers*
immediately recognized the style of Wood's Italian sources, if not the
specific scene he had borrowed. The *American Magazine of Art* claimed
that the painting evoked the "cleanliness" of a Fra Angelico, whereas
the *New York Times* compared the painting to the "monumental sim-

plicity" of Giotto. More recent critics have acknowledged the work's specific debts to Last Supper imagery, yet none has attempted to explain Wood's unusual choice in this instance. Why would the artist have selected such a mournful subject—and indeed, one that centers upon a profound betrayal—as the prototype for this celebratory gathering of good neighbors?

To understand Wood's motivation, we must consider the role that Maryville's figure plays within this picture. Although Wood never identified his father's location within the painting, he insisted that the work portrayed "my family" and claimed, moreover, that that this scene was set in 1900—the final year of Maryville's life. If the artist's father is present at all in this scene, then (and it would defy logic if he were not), we may with some certainty identify him as the central figure. Not only does the man's blond hair connect him to Maryville, but his position on the family's piano stool—the least comfortable seat at the table— also suggests his role as an accommodating host.

In its central and slightly elevated position, this figure mirrors Christ's location in traditional Last Supper imagery and echoes, moreover, the prefigurement of death found in such images. Not only does

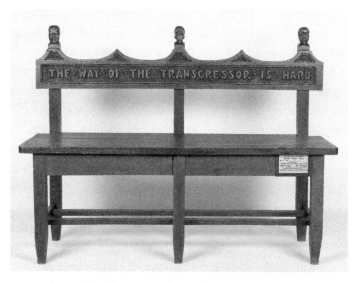

Grant Wood, *Mourner's Bench*, c. 1921–22. Wood's characteristic conflation of punishment and grief was in this case comically intended.

Wood turn Maryville's back to us, but he also summons the scene of his father's death. As Nan related in her memoir: "Father ate a hearty meal of ham and eggs, and after reading the mail, said he thought that he would drive into town. He stepped to the window to view the weather. Mother heard a crash. Father was lying on the floor. His summons from beyond had come." In both a perspectival and metaphorical sense, then, the window in this painting constitutes its true vanishing point.

Surrounding Maryville is a host of figures who reinforce his fate. Identified by the glowing "haloes" of their forehead tan lines, Maryville's assembly of manly apostles adds up not to twelve, but thirteen (a number that, as Wood recalled in his autobiography, his father perversely considered an omen of good luck). Among these men we find another important figure from Wood's Last Supper sources: the Apostle John. Also known as the "beloved" apostle, John is typically depicted in midswoon—resting his head on Jesus's chest, following Christ's announcement of his impending betrayal. In Wood's scene, a farmer similarly leans against the woman who stands behind the table. Not only does Wood make a rather significant substitution in this case (the farmer leans upon a maternal, rather than a paternal, figure), but he also balances this pair directly opposite the window that signals Maryville's death. Facing the woman's breast in a nursing position, Wood's "beloved" farmer-apostle—a veiled self-portrait—constitutes a Nativity scene within the work's Last Supper imagery.

Like the medieval triptychs Wood had admired in Germany, this central composition is flanked by two secondary scenes: at left is the masculine sphere of the barnyard, and at right the feminine world of the kitchen. Triptychs are often similarly gendered. Facing the central image in an attitude of prayer, these works' male and female donors—typically presented in the left and right panels, respectively—not only serve as models to the faithful viewer, but they also mark the divide between the living and the dead.

Not surprisingly, it is Wood and his mother who occupy the donor-panel positions in *Dinner for Threshers*. Echoing medieval conventions of continuous narrative, the artist portrays Hattie and himself several times within each of these spaces—creating a kind of action sequence at the table's margins. Wearing four different costumes, Hattie appears twice at the stove, once in the doorway, and lastly at the table itself. For

his part, Wood may be seen in the three overall-clad youths standing outside the dining room—the second of whom nervously eyes the men from the front door, as Wood recalled himself doing—and finally in the seated man who supports himself at the woman's breast. As if to reinforce his presence in the left-hand panel, Wood includes his identifying symbol, the windmill, and on the barn he inscribes his birthdate—or rather, the date he claimed in his adult years. (Starting in the 1920s, the artist reassigned this date from 1891 to 1892.) At the center of this barnyard scene, Wood signs his own name.

In the sum of its parts, *Dinner with Threshers* not only presents a tableau vivant of Wood's Anamosa childhood, but also—and more importantly—a metaphorical account of his artistic development. From the pseudo-historical date of the painter's birth, we proceed to the table under which he established his first "studio" (indeed, in a nod to his newfound fame, Wood enlarges this space considerably). At the far end of the composition is the artist's first muse. Standing near the screen door from Wood's homecoming story, the aproned Hattie bears the same distracted look of her 1929 portrait. The critical event that links the kitchen table to his mother's groundbreaking portrait, of course, is Maryville's death. He is both the sacrificial lamb in *Dinner for Threshers,* and the corpse continually resurrected from the grave.

AS WOOD COMPLETED THIS deeply layered, monumental work, the critical momentum from Walker's 1933 show intensified rather dramatically. Having declared the artistic poverty of the Midwest just a year before, *Time* pulled an abrupt about-face in December 1934—not only publishing a lengthy feature devoted to the advent of "U.S. Scene" painting, but also placing Benton, the movement's presumptive leader, on its cover (a first for any American artist). The genesis of this story, and the turnaround that it represented, lead directly back to Walker.

In the fall of 1934, a *Time* reporter sent a copy of Walker's catalogue to the magazine's founder, Henry Luce. Although Luce had no particular interest in contemporary art, American or otherwise, the promise of an independent American movement coincided with his notion of an ascendant U.S. culture—famously expressed, seven years later, in his editorial declaring the twentieth century "the first great American Century." Capitalizing on Walker's persuasive rhetoric, *Time*'s "U.S. Scene" feature also made a powerful visual impact—featuring, for the first

time in the magazine's history, full-color art reproductions. Robert Hughes, who later served as *Time*'s chief art critic, claims that the story represented "the only time that *Time* ever created an art movement out of more or less thin air. Suddenly, the front page of American visual culture was taken over by Regionalism."

Introducing its readers to this new movement, *Time* explained that resistance to the "crazy parade" of "arbitrary distortions and screaming colors" promulgated by the Armory show "first took root in the Midwest [with] a small group of native painters." At last, the magazine declared, "the French schools seem to be slipping in popular favor while a U.S. school, bent on portraying the U.S. scene, is coming to the fore." If the "shy" founder of the Stone City Art Colony served as the movement's "chief philosopher," *Time* proposed, then it was Benton who represented "the most virile of the painters of the U.S. Scene."

Benton was eventually rather cynical about his involvement with regionalism. "A play was written and a stage erected for us," he wrote toward the end of his life; "Grant Wood became the typical Iowa small towner, John Curry the typical Kansas farmer, and I just an Ozark hillbilly. We accepted our roles." His part within the movement, however, was far more active than he let on. For if Walker may be credited with the movement's invention, then it was Benton and his close ally Thomas Craven who brought the movement's xenophobia, antimodernism, and conservative brand of masculinity to maturity.

Given his background and early training, Benton's eventual role as the leader of the U.S. scene is remarkable. Far from an "Ozark hillbilly," he was in fact the son of a wealthy lawyer-turned-congressman with a distinguished family tree. Although he hailed from rural Neosho, Missouri, Benton spent most of his life in urban settings—from his adolescence in Washington, D.C., to his adulthood in Paris and New York. (Indeed, it was not until 1935 that he would return to his native Midwest.) Benton's early work widely varied from realistic portraits and landscapes to graphic illustration, cartoons, and colorful abstractions. During his tenure in Paris between 1909 and 1911, he even briefly became a proponent of synchromism—a movement that sought to translate the energy, color, and emotion of sound into painting (the same approach, in fact, that Wood later attempted in his experimental canvas *Music*). In his Parisian years, then, Benton was producing the very type of work popular critics would lampoon at the 1913 Armory show.

Compelled by his family to return home in 1911, Benton found a teaching position at the Kansas City Art Institute. Within just three weeks he left the job, however, citing what would become a familiar complaint: the supposed existence of a powerful and decadent homosexual subculture. "At that time," Benton later wrote,

> Kansas City was a vaudeville and carnival exchange center, and it was a place where the chorus boys would be stranded for weeks at a time. And somehow or other, Kansas City had become a quite developed homosexual center, and it had reached into the art institute. Now listen, I had been to Paris, and I'd never seen anything like that. It shocked the hell out of me. They had a party for me, and they all came in women's underwear and all that stuff. That was something I was absolutely innocent about, and I couldn't stay there.

Benton's bizarre account is worth noting for a number of reasons. Not only is his professed ignorance of Parisian homosexuals rather unlikely, given his unvarnished caricatures of city life there, but so too is his suggestion of rampant transvestitism at the Art Institute. By insisting Kansas City's "chorus boy" culture had somehow leapt into the academy, moreover, Benton reveals his tendency to collapse all arts-related occupations (whether carnival performer or art professor) into a single, suspect category. Later that fall Benton moved to New York City—a strange choice for such an innocent, perhaps, but a place he called home for the next twenty years.

Within a decade of his return from Paris, Benton abandoned the abstraction of his early years. Declaring himself an enemy of modernism, he cultivated a naturalistic figural style that combined his early work as a cartoonist with the color palette and compositional dynamism of his abstract works. Benton's mannered new style featured rounded, simplified figures in dreamy landscapes or chaotic urban scenes. Although he often evoked historical themes in these works, the painter espoused no clear artistic agenda at this stage. The only link between these paintings and Benton's later, nationalist rhetoric is his deeply negative portrayal of academics, artists, and city dwellers—all categories to which he himself belonged.

Benton's critically acclaimed murals for the Whitney Museum, installed in 1932, provide a hint of the bigotry that would later define

his tirades about the state of American art. The panel entitled *Political Business and Intellectual Ballyhoo* lampoons the leftist readership of the *New Masses* and the *New Republic,* respectively, with Jewish and homosexual caricatures—the former displaying a prominent hooked nose, and the latter wearing a fey expression and women's stockings. (For Benton, it seems, cross-dressing and homosexuality were always coterminous.) Of the various prejudices this image displays—against leftists, Jews, and homosexuals—it is Benton's homophobia that would most consistently surface in his subsequent critiques of American high culture.

Even given the general intolerance of homosexuals in this period, the virulence of Benton's prejudice was remarkable. According to his sister Mildred, the painter "did a lot of quite unnecessary talking about fairies taking over the art world. He had this violent hatred of homosexuals. There must have been some terrible urge in him that made him do it. His hatred wasn't natural." That Benton's homophobia might be described as unnatural, however, is not to say that it was foreign to the rhetoric of regionalism—indeed, Walker himself railed against "the freaks and the interesting boys" of the contemporary art scene. The strength of Benton's prejudice, then, may be partly explained (if not excused) by his own fear of being labeled an "interesting boy."

Walker's and Benton's image of the homosexual artist, "summed up," the latter wrote, "by consumptive appearance coupled with feminine habits," derived from the Oscar Wilde stereotypes of their late-nineteenth-century youths. In Benton's case, this attitude was also linked to his father's views. Benton explains in his 1937 autobiography:

> When I was a little child, [my father] saw no harm in my scribbling, but when I grew up and people began to notice it and wonder whether I aimed to be an artist, he became very uneasy . . . Dad was profoundly prejudiced against artists, and with some reason. The only ones he had ever come across were mincing, bootlicking portrait painters . . . who hung around the skirts of women at receptions and lisped a silly jargon about grace and beauty. Dad was utterly contemptuous of them.

In an attempt to toughen up his suspiciously artistic teenage son—who seemed to prefer drawing and poetry to hunting—Benton's father had sent him to the Western Military Academy in Upper Alton, Illinois.

Miserable at the academy, Benton was eventually allowed to leave the school and enroll in art classes at the Art Institute of Chicago. By 1910, he finally made his pilgrimage to Paris. Upon his return to Neosho the following year, Benton claims, he outraged his father not only "by the strange splotches and splashes of color" in his Parisian paintings, but also by his appearance. According to a contemporary profile of the artist in the *Kansas City Star,* the twenty-three-year-old Benton preferred cigarettes to cigars, kept his unconventionally long hair swept up beneath a velvet cap, and favored long, flowing ties over silken shirts. He had become, in other words, the very model of affectation and suspicious androgyny that his father—and later Benton himself—most vilified in artistic culture.

Not only did Benton look the part of an Aesthetic Movement dandy in this period, but by his own admission he was also fairly irresistible to men. In his autobiography, the artist frankly recounts the sexual passes older men made toward him in his youth, and admits that he happily accepted financial support from men whose interest in him was clearly romantic. (By the time of the episode in Kansas City, therefore, Benton had been fully aware that homosexuals *existed*—if not, perhaps, that they congregated in groups.) Benton's later homophobia, and the vitriolic language with which he described the "fairies" of the American art scene, was therefore as starkly removed from his early self-presentation, and from his initially easy relationships with homosexual men, as his later realist style was from his youthful modernism.

On his first voyage to Paris, Benton met a "rather handsome man . . . distinguished by penetrating, shiny black eyes" whom he identifies simply as Ali the Turk. Twelve years Benton's senior, Ali became Benton's constant companion on the ship and his first benefactor after their arrival in Paris. During Benton's early years in New York, he was similarly supported by Ralph Barton—a fellow Missourian and successful magazine illustrator who Benton claims "had a fancy for me and carried me through many tough moments. He was clever, made money easily, and spent it—no small amount on me. I was always living in studios or apartments for which he had paid the rent." The same Benton who later publicly vilified all homosexuals defended Barton against those who found his affected manners off-putting. "Underneath the pretensions of his vanity," he wrote after Barton's suicide in 1931, "it was plain to see that he suffered."

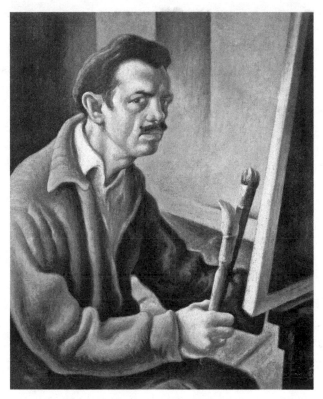

Thomas Hart Benton, *Self-Portrait*, 1925

In later years, Benton attempted no narrative revision of these rela-
tionships. Fondly recounting his early patronage in his autobiography,
the artist demonstrated a remarkable ability to separate the men he
knew from the abstract notion of homosexuals as a category. (Although
he felt genuine affection for Barton, he claimed the "inverted" crowd in
New York made him feel "as if I were down in the cellar with a lot of
toadstools.") Ironically, as Benton's biographer Henry Adams notes, it
was precisely the artist's connections with these men "that enabled him
to transform himself from a small-town boy with small-town ambi-
tions to a serious artist." Benton's eventual friendship with Wood pro-
vides another example of such a debt—and indicates, as well, the ways
he continued to compartmentalize his prejudices even at the height of
his "fairy-baiting" period.

Adams claims that Benton was well aware of Wood's homosexuality,
yet the painter demonstrated a fierce loyalty to Wood in the 1930s and

even long after the Iowan's death. The underlying reasons for this atti-
tude were no doubt rather complicated. In one sense, the relative visi-
bility of Wood's sexual identity—what Eve Kosofsky Sedgwick has
called "the spectacle of the closet"—necessarily enlisted Benton himself
as a fellow keeper of his secret. For "if being in the closet means that [a
gay man] possesses a secret knowledge," Sedgwick writes, "it means all
the more that everyone around him does," as well. Had Benton tar-
geted Wood's homosexuality, not only would he have undermined
their common cause but he might also have drawn suspicion to
himself—proving the childhood taunt, "It takes one to know one."

Although Benton clearly harbored masculine insecurities, these do
not appear to have included doubts concerning his own sexual orienta-
tion. Standing at just five feet two inches tall, Benton compensated for
his small stature with a combative personality, a reputation for hard
drinking, and an earthy way of speaking that often got him into trou-
ble. As Benton's contemporary Horst Janson later wrote, because the
artist was "predisposed to pugnacity by his stature (he seems doomed to
go through life in constant fear of being called 'Shorty,' a condition not
unfamiliar to psychologists), he took refuge in the pose of a virile fron-
tiersman."

Benton's cockiness was particularly evident in the way he broadcast
his sexual exploits with women. With a frankness shocking for its time,
Benton's autobiography recounts his teenage loss of virginity to a
"black-haired young slut who wore a flaming red kimono and did her
hair in curls like a little girl"; his later conquests in Paris, and the
unwonted consequences of these affairs, are covered in equally explicit
detail. By the time of his 1922 marriage to Rita Piacenza, Benton was
also well known for his erotic portrayals—and pursuit—of young
female models and students in New York. Piacenza, a former student of
Benton's herself, had at the time of their wedding just completed high
school.

Even Benton's description of his artistic awakening seems calculated
to emphasize his sexual potency. He had decided to become an artist,
he once said, "from the moment I first stuck my brush into a fat gob of
color"—an image reflected in his 1925 self-portrait, which features two
unusually thick, fully loaded paintbrushes projecting from his lap. It is
no accident that *Time* chose this painting for its December 1934 cover.
Underscoring Walker's and Luce's notion of rugged American individ-
ualism, Benton scowls at the viewer in an almost absurd caricature of

aggressive masculinity—a pose later perfected by Benton's best-known pupil from the 1930s, Jackson Pollock. (Indeed, Pollock's famous "drip" style would distill his teacher's semi-erotic approach to painting—what Benton called "the rich, sensual joy of smearing streaks"—to its most seminal form.)

Benton's combative temperament differed markedly from Wood's strict sense of reserve, yet his personal transformation in the 1920s reflects the Iowan artist's in striking ways. By the mid-1920s, Benton had exchanged the artistic dress of his younger years for a workingman's uniform of plaid shirts and denim; around the same time, he switched from loose abstraction to a starker, more realist style. He credited his time in the navy with these changes. Working in a Norfolk shipyard during World War I, Benton claimed, "down there in Virginia I was thrown among boys who had never been subjected to any aesthetic virus. I realized that psychologically I was much nearer to these boys than I was to the cultivated people of the Chicago, Paris, and New York art worlds."

According to Adams, the primary catalyst for the artist's altered style was not his experience in the navy, but rather the death of his father in 1924. "Something snapped inside Tom after his father's death," he writes, explaining that in the following years Benton sought to "rediscover the world he had shared with his father"—a search that led him back to the places and the figures of his childhood, and a closer approximation of his father's model of masculinity. However artificial Walker's invention of regionalism may have been, then, Adams suggests the movement "corresponded to emotional needs [in Benton] that were both powerful and authentic."

Throughout the 1930s, Benton was joined in his campaign to remasculinize American art by Thomas Craven. Shortly after the painter's move to New York in 1912, he had met Craven at the Lincoln Arcade—an apartment building whose residents Craven described as an "unsavory crew [of] commercial artists, illustrators, starving students, musicians, actors, dead-beat journalists, nondescript authors, tarts, polite swindlers, and fugitives from injustice." (Craven, a native Kansan, was at the time writing poetry under the pseudonym "Jewell.") Immediately drawn to this fellow midwesterner, and possibly seeing in him a future benefactor, Benton moved in with Craven that same year.

According to Craven's son Richard, the two Thomases became

"as close, as inseparable, as two men could be with one another"; from the time they met until Benton married ten years later, the pair either lived together or rented adjoining apartments. In his fond memories of this decade, Craven admiringly recalled Benton's "temper, broad humor, and his genial roughness." For his part, Benton explained that Craven "was a good cook—he'd cook and I'd wash the dishes. They used to think we were a couple of homosexuals because we were always together. But it was for the convenience. I've always liked the association of males, anyhow."

The careers of the two men were eventually as intertwined as their domestic arrangements. While Benton developed as an artist, Craven discovered his talents as an art critic. In Benton's work, Craven recognized a new paradigm of pure, rugged, and masculine American expression—as free from the taint of aestheticism as it was from the hermetic (and, in his view, *diseased*) European modernism espoused by his fellow New York artists. "There is nothing precious in his art," Craven wrote of Benton's painting, "and nothing precious in real Americans."

Craven's attraction to Benton's gruffness, and his admiration for the masculine character of the painter's style, were no doubt linked to memories of his own stern and distant father. (Behind nearly every figure associated with regionalism, it seems, there stands an intimidating or disapproving father. The movement's insistent masculine posturing appears to have been engineered for the sole benefit of this single—and usually absent—audience.) Craven describes his father in terms strikingly like Wood's accounts of Maryville. His father, too, harbored "an unfathomable loneliness in his heart," he writes—a feeling that he characterized as "the sadness of a pioneer." Choosing to become a poet could not have been an easy path for his son; "my leanings toward art," Craven confesses, "excited his gravest suspicions." In looking after Benton, an equally moody son of the Midwest, Craven may well have discovered a compensatory strategy—a way, at last, to set things right with his father.

"Could we have foreseen the dark road we were destined to travel," Craven wrote about his and Benton's struggles as young men,

> we would have said in one voice, "Let us go back to the mountains and the ranges, and marry the women of the soil, and tell our people that in New York art hides her face in shame." But we

were very young, and we pooled our miseries in a common fund of forced jocularity and hard work. A blow for one was a blow for all, and we laughed it off together.

In subsequent books and articles for popular American magazines, Craven forcefully proclaimed his and Benton's separation from this supposedly shameful New York art scene. In truth, of course, not only had they enthusiastically participated in the city's artistic milieu, but Benton had also achieved a certain amount of success within it.

Craven's first book, an ambitious critical history entitled *Men of Art* (1931), examines a range of artists whose work supported powerful regimes—including mercantile Florence, the Dutch trading empire, and the Spanish crown. On the first page of *Men of Art*, Craven sets the tone for his work by praising the aesthetics of Mussolini. (The Italian dictator, Craven believed, had "inspired his people into something that resembles a national consciousness and revived the gorgeous dreams of antiquity.") For Craven, the true artist—always male—was a "sane, healthy and industrious workman" who differed from his fellows only in "the intensity of his endowments." His art, a "healthy act of labor," reached its full potential only when it "contain[ed] meanings which may be verified, shared, and enjoyed by a large audience." Ultimately, of course, these meanings acted in the service of the state. Physical labor, transparency, and patriotism were for Craven mutually reinforcing virtues—and mass appeal, the measure of an artist's success.

In his subsequent treatment of the art of the late nineteenth and twentieth century, *Modern Art: The Men, the Movements, the Meaning* (1934), Craven targeted the school of Paris as the single greatest threat to American art. The book's introduction proclaims: "We have seen a new art spread like a contagion, infecting young men and women everywhere. These cults had their origins in France: they were bohemian in conception and international in membership." The author's insistent conflation of modernism and disease is always connected, in the end, to sexual deviance and gender confusion. Craven warns:

The artist is losing his masculinity. The tendency of the Parisian system is to disestablish sexual characteristics, to merge the two sexes in an androgynous third, containing all that is offensive in both . . . Once [male artists] contract la vérole Montparnasse—

the pox of the Quarter . . . they become jaded and perverse, and, famishing for new stimulants, advance into abnormal lecheries. Eventually they lose all sense of values . . . They are now ready for Gertrude Stein, Sur-Realism, and the infinite subdivisions of abstract art . . . They found magazines in which their insecurity is attested by the continual insulting of America . . . hymns to homosexuality, and pleas for miscegenation . . . It is this sort of life that captures American youth and emasculates American art.

Following this rather stunning tirade, Craven exposes the persons responsible for the degradation of American art. First among these is "that arrant American" James McNeill Whistler—the paragon of late-nineteenth-century aestheticism, and "ambassador from Bohemia to the Anglo-Saxons." Craven writes that Whistler "painted without guts or substance," "dressed like a fairy," and, worst of all, "denied the exis-tence of any national art . . . placing the artist apart from, and above, the social codes governing ordinary mortals." Equal blame is assigned to Oscar Wilde, Whistler's friend and collaborator, for dragging the purity of Anglo-Saxon culture into the Parisian mud. "If Wilde had lived today," Craven claims, "he would have died a glorious death [in Paris], in full apotheosis, President of the International Society of Inverts."

Establishing Benton as the anti-Whistler, Craven devotes an entire chapter to this contrastingly healthy artist. Benton's "thoroughly Amer-ican boyhood," he explains, had fully prepared the artist for his early struggles against aestheticism. Whereas Benton's classmates at the Art Institute of Chicago had fallen "under the poisonous influence of Whistler, Wilde, and Beardsley," Craven writes, Benton "distinguished himself at once by his skill in boxing and wrestling, and by his incom-parable audacity in paint." Craven goes on to insist that, following his dangerous period of testing in Paris, Benton had a patriotic reawaken-ing and dedicated himself to recording the authentic character of his own country. Darkly, he hints that Benton's natural enemies in this mission were either hardened Marxists or "indoor esthetes and neural-gic professors" whose idea of America was restricted to "the sidewalks of New York, the gallery, and the high tea."

Craven's attacks on Marxists, intellectuals, and homosexuals—to say nothing of his admiration for Mussolini—suggest his rather uncomfortable affinity with contemporary fascist attitudes. First noted by Horst Janson following the Second World War, this connection lies

at the heart of the regionalists' later discrediting by the Left. "It is unfortunate that their own views should bear an embarrassing resemblance to certain European ideologies," Janson wrote in 1946, adding that "the regionalist credo could be matched more or less verbatim from the writings of Nazi experts on art." In this essay, however, Janson aims his attack not at Craven, but at *Wood.* To blame Wood for regionalism's strident nationalism and homophobia is a rather ironic injustice—but to do so without referencing Craven's role is particularly misleading.

Any link between Wood and Craven's pseudo-fascist rhetoric was, in fact, forged by Craven himself. By 1934, the critic had turned his praise toward Benton's comrades-in-arms; writing in *Country Gentleman* the year after *Time's* cover story, he proclaimed that all three regionalist leaders were "Americans of the best type: they are independent, courageous, resourceful, industrious, and healthy in mind and body. Not one of them is a hothouse product." The work of these "intrepid Americans," he adds, had at last brought about "a national conviction that our self-styled 'cosmopolitan' artists who persist in practicing the pernicious habits of the Bohemian . . . are doing so because of impotence or incapacity." In a later edition of *Modern Art,* Craven singled out Wood for particular praise, claiming that "he has won the confidence and respect of his own state by making the artist a sober workman and useful citizen." The distinction Craven continually insisted upon between the "healthy," civic-minded leaders of regionalism and the "impotent" bohemians, of course, implies more than just a comparison of their work. For Craven, aesthetics were never divorced from sexuality.

It is difficult to avoid the contradiction between Craven's homophobic rhetoric and the probability of his own sexual attraction to men. In *Modern Art* he confesses, for example, that as a young poet living in Paris he was often sexually pursued by men. Although he recounts these episodes with palpable disgust, he also betrays a suspicious familiarity with the intricacies of Parisian cruising and the elaborate dress codes of its homosexual subculture. His intimacy with Benton, moreover, indicates an attraction that was probably more than just brotherly. In his endless paeans to the artist, Craven lovingly dwells on Benton's "dark, flashing eyes, broad nose, and sensual lips," as well as his "cocky and resplendent physical condition" and "athletic youthfulness." Nor were such descriptions restricted to Benton. Craven

writes that Wood "had plenty of meat on his bones," "broad shoulders, strong arms, and marvelous hands," whereas he admiringly describes Curry's "large head and neck, powerful shoulders, and tapering form."

Regionalism, it seems, provided a convenient closet for any artist or critic who secretly harbored the "vérole Montparnasse." Any consideration of Wood's connection to this artificial movement, then—whether we consider his involvement passive or calculating—must take into account the extraordinarily difficult situation he faced. Craven and Benton's crusade against homosexuals in the art world created a potentially explosive environment for Wood, whose fear of exposure increased in direct proportion to the security regionalism seemed to offer him. Not only did he stand to lose more at this stage in his career, but Craven's writings also significantly magnified the stigma that the public attached to bohemianism and its presumed vices.

In the popular press, the American art scene was now divided between red-blooded, patriotic men and "hothouse aesthetes"—a dichotomy that left Wood very little room to maneuver. The more benign version of regionalism that Wood had espoused at Stone City—a celebratory approach that demonized no individual groups or approaches—was from this stage forward compromised by its links to Benton's and Craven's strident rhetoric. From 1934 onward, Wood found himself negotiating a game whose rules he no longer wrote or even fully understood, and playing a role for which he was wholly unprepared.

As Lewis Mumford perceptively claimed in 1935, Wood's adoption of regionalism represented an unfortunate, unforeseen distraction in an otherwise promising career:

> It is [Wood's] misfortune at the moment that he has become a National Symbol for the patrioteers . . . Wood, the painter, is an honest man still fumbling with his problems—a man who should be given another five years for quiet, untroubled experiment, so that he may find himself, instead of having to live up to an entirely accidental political reputation.

IN HIS NEW ROLE as a "National Symbol" in the 1930s, Wood joined an impressive coterie of midwestern artists, writers, and intellectuals

dedicated to promoting regionalism in a wider sense. One measure of this new status was his 1934 invitation to join Iowa City's prestigious Times Club, a private group that brought speakers of national prominence to the city. Wood's sponsor, Frank Luther Mott, was a colleague at the University of Iowa and co-editor of its respected literary magazine, *Midland*. Careful not to identify himself too closely with the suspicious elitism of the ivory tower, however, Wood—again, with Mott's help—simultaneously formed a phony version of the Times Club dubbed the Society for the Prevention of Cruelty to Speakers. In name and satirical intent, the SPCS was like a latter-day version of Stone City's Banana Oil Art Research Society—yet it also acted as a legitimate rival to the Times Club, attracting speakers of equal, if not greater, reputation.

Wood insisted on decorating the SPCS club room himself, in what he called "the worst style of the late Victorian period." The completed design included strident, floral-patterned carpeting, flocked wallpaper, Currier and Ives lithographs, sentimental framed mottoes, and heavily carved, overstuffed furniture. In orchestrating this elaborate, late-

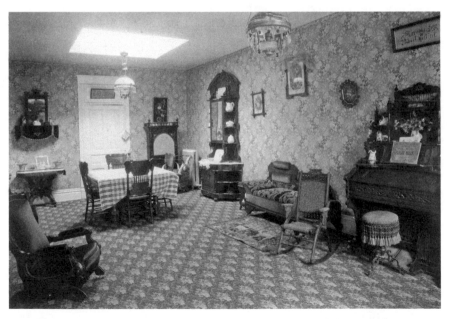

The "Victorian Revival" interior Grant Wood designed for The Society for the Prevention of Cruelty to Speakers, Iowa City. The table at left summoned Wood's first kitchen-table "studio."

nineteenth-century set piece, Wood ostensibly intended to lampoon
the sentimentality and fussy excess of the "Gay Nineties"—an aesthetic
that the 1930s categorically rejected, and that the artist himself dispar-
aged as "flamboyant and meaningless." Given the room's uncanny
resemblance to the interiors of Wood's childhood, however, its decora-
tions were anything but meaningless for him.

In a letter he wrote to Cyril Clemens around this time, Wood
explained to Mark Twain's cousin and biographer how *The Adventures
of Huckleberry Finn* had "cured" him of Victorian sentimentality as
a boy. Particularly struck by the maudlin character of Emmeline
Grangerford, he explained:

> My response to this passage was a revelation. Having been born
> into a world of Victorian standards I had accepted and admired
> the ornate, the lugubrious, and the excessively sentimental natu-
> rally and without question. And this was my first indication that
> there was something ridiculous about sentimentality.

The reaction Wood describes, of course, cannot be separated from the
more specific context of Twain's passage—one that clearly identifies
morbid sentimentality as an inherently *feminine* trait.

Twain presents Emmeline Grangerford's mournful poetry and
paintings as a foil to Huck's rough and unsentimental qualities. Try as
he might, Huck is unable to memorialize Emmeline in the same flow-
ery way in which she herself wrote about the dead; "I tried to sweat out
a verse or two myself," Huck says, "but I couldn't seem to make it go
somehow." Similarly, in Huck's first encounter with the Grangerfords'
house, Twain juxtaposes Huck's masculine outdoorsiness—the very
ideal of late-nineteenth-century boyhood—with the presumably femi-
nine, overstuffed, and overdecorated interior of the home. Huck may
be awed by his surroundings ("I hadn't seen no house out in the coun-
try before that was so nice and had so much style"), but the reader ulti-
mately associates them with the ridiculous figure of Emmeline.

Given Wood's genuine nostalgia for the Victorian interiors of his
boyhood—spaces that he vividly connected with his mother and
elderly aunts—the campy quality of his SPCS rooms conveys a
detectible note of shame. It was not the first time, of course, that the
artist had used humor to distance himself from dangerously feminine

associations. Consider, for example, two of Wood's earlier artistic "stunts": the emotional abstraction he claims to have parodied in *Music,* as well as his purported lampooning of pointillist technique in *The Spotted Man.* In both cases, Wood's fear of the feminine taint of modernism—or, worse, homosexual aestheticism—had led to joking disavowals of what were, in all likelihood, sincere efforts. The artist makes a similar point in *Victorian Survival,* whose cruel distortions tell us more about Wood's relationship to the nineteenth century than they do about his aunt's.

Wood's attraction to Victorian aesthetics was most clearly centered, of course, in his memories of the Anamosa farmhouse—whose kitchen and parlor provide the primary reference points for the SPCS interiors. At the far end of the club's main assembly room, Wood placed a plain, spindle-backed dining set much like the one he had known as a child (its table covered, predictably, in a red-checkered cloth). In another nod to his childhood home, Wood placed vintage photographic albums on the tables of the SPCS parlor. These he filled not with nineteenth-century tintypes, but with "period" photographs of the speakers who visited the club, posed in Victorian clothing and props Wood collected specifically for this purpose.

Rather than a response to the stuffiness of the Times Club, or even a humorous critique of Victorian bad taste, the SPCS looked suspiciously like an interior from one of Wood's paintings (*Dinner for Threshers,* painted the year before, is perhaps the room's closest model). All who entered this space participated in an elaborate tableau vivant directed by the artist himself—who managed, in replicating the interiors of his childhood, to both resurrect his past and establish an ironic distance from its feminine associations. Nowhere is this phenomenon seen more clearly than in the ersatz Victorian photographs Wood staged here. And of all these images, none was more overdetermined than the dual portrait for which he posed with Benton.

Invited to Iowa City as a guest of the Times Club in January 1935, Benton was the first speaker to visit the newly christened SPCS club room. In the photograph taken after his speech, Benton wears a comically long beard and sits in a heavily fringed armchair made from buffalo horns. Behind him stands Wood, his hand tucked into a high-buttoned Victorian jacket and his face nearly hidden by an exaggerated mustache and mutton-chop sideburns. The staging of this

Grant Wood and Thomas Hart Benton at
The Society for the Prevention of Cruelty to
Speakers, Iowa City, 1935

Visiting writers Thomas W. Duncan
and MacKinlay Kantor at the SPCS,
c. 1936

unusual image—one that appears to have unsettled, rather than amused, Benton—instantly recalls the formula of a Victorian marriage portrait. "So codified did this pose become" in the nineteenth century, David Deitcher writes, "that standing and sitting were eventually identifiable as gendered positions. . . . the seated position was habitually reserved for the man, while the woman stood attentively and deferentially behind him." Underscoring the domestic nature of this image was the framed Victorian motto behind the men ("Home Sweet Home") and the surprising performance that followed their portrait session. While Benton played "Frankie and Johnnie" on his harmonica, Wood stepped a lively clog dance for the assembled guests.

The photograph of the two artists was staged as a lark, of course—the *Des Moines Register* reprinted the image above a caption reading "There's Fun as Well as Fame in the Life of the Artist"—yet beneath its apparent harmlessness, it betrays a sense of humor that is also subtly subversive. In this double portrait, Benton's strident masculinity and pathological fear of homosexuals are lampooned with a razor-sharpness that could hardly have been accidental on Wood's part. Not only was Wood well aware of Benton's bigotry, but so too were other members of the SPCS—whose admiration for writers like Langston Hughes and Gertrude Stein, both invited as speakers to the club, suggests the image would have found an appreciative audience there. (Indeed, in their invitation to Stein, the group staged another campy photograph. Wearing white roses, they vowed in their accompanying letter to rename the SPCS the "Rose Is a Rose Club" if she were to honor them with a visit. Stein enthusiastically accepted the invitation, yet her appearance was canceled when a Wisconsin snowstorm grounded her plane.)

In an open letter to Tom Yoseloff, president of the Times Club and Benton's official sponsor that January, Wood references Benton's work in ways that echo the barbed humor of their dual portrait. While poking fun at his own famously gentle nature, he hints that Benton's hypermasculine image and chauvinism were in some ways more noteworthy than his paintings. Regarding Yoseloff's introductions, Wood asks him to bear in mind: "I am modest to the point of being frail and therefore look to you to see that I am not embarrassed by excessive praise, no matter how true it may be . . . As for Thomas Hart Benton's paintings, you should bring out that he has a mustache, a beautiful wife, and comes from Missouri."

Benton's response, which the *Des Moines Register* printed alongside Wood's letter, reveals that his remarks had cut rather close to the bone:

> I should tip you off that America's most celebrated rural paint-ings were, by a strange coincidence, painted by me. My murals at the Whitney Museum and the Museum of Modern Art are simply staggering. My murals at the World's Fair are knockouts. This is the straight stuff. As for Grant Wood . . . I know an ass and the dust of his kicking when I come across it.

The swaggering hostility of this letter reveal Benton's insecurity regard-ing his primacy within regionalism—a position challenged that spring, when the dealer who represented both men launched a major solo exhi-bition of Wood's paintings.

Critical response to this Ferargil Gallery show, Wood's first since Walker's triumphant 1933 group exhibition, demonstrates that region-alism was met with a certain cynicism even at its height. In its review, for example, the *New Yorker* archly concluded that that "one advances neither regionalism nor art by pretending that third-rate art becomes first-rate art merely by the magic of being homegrown." For its part, the *New Republic* deplored the transparency of Ferargil's promotion—claiming, "That Grant Wood should be accepted and celebrated as a representative American painter is of more interest as an economic sys-tem than as an art event."

Regionalism's supporters were well prepared, of course, to challenge such criticism. Characterizing the New York art establishment as effete, overly intellectual, and even unpatriotic, Craven declared its opinions meaningless where "real" American art was concerned. "[Wood] has no need of New York, materially or spiritually," he wrote, for "he won his fame, his markets, and his independence, without the cooperation of seaboard exploiters." Craven's ally Malcolm Vaughan took up the stan-dard even more stridently, casting Wood's show as a kind of patriotic litmus test. "If you love America," he insisted, "you will enjoy this show."

The popular press provided further critical support for Wood's show. Continuing to promote the movement it had helped to create, *Time* lavishly praised the exhibit; Forbes Watson of the *American Mag-azine of Art* joined in as well, hailing Wood as "an almost mythical fig-

ure" in American art and adding, however improbably, that "American collectors who yesterday pursued the great trio, Picasso, Matisse, and Derain, are now in equally eager pursuit of Grant Wood." The reason for this shift, Watson noted, was Wood's common touch. Here was an artist "adept . . . in talking what we commonly call 'the language of the man on the street' [and who] does not stoop to the cultivated."

The show's critical polarization reflected the ever-sharpening contrasts within Wood's own life. The artist had reached the apex of his career, and yet failed to sustain his beloved artists' colony; he was hailed as a leader within a national movement, yet lost the directorship of the Iowa PWAP; and although he had been granted a prestigious teaching post, his colleagues viewed him as a celebrity impostor within the academy. Wood's association with regionalist artists and critics provided him a sense of mission and irreproachably masculine image, yet his expanding role as the movement's spokesman was an uncomfortable one for this extraordinarily private artist. Most unsettling of all for Wood were the changes at Turner Alley. By 1935 Nan had at last moved to Albuquerque with her husband, and Hattie—now in her mid-seventies—had begun to show dangerous signs of ill health. As the magical circle of "we three" began to vanish, so too did Wood's ironclad defense against marriage.

THE EXTRAORDINARY TENSIONS OF this period are clearly reflected in Wood's 1935 painting, *Death on the Ridge Road* (see color plate 20). First exhibited at the Ferargil Gallery show in 1935, the work portrays a scene of imminent disaster: a long sedan passes another car on a narrow county road, while an approaching truck hurtles toward it around a blind curve. Nan claims that Wood's inspiration for this work was a recent close call Jay Sigmund had had on one of the ridge roads near Waubeek; as with *American Gothic* and so many other of Wood's paintings, however, the artist endows this scene with a personal dimension that significantly changes its reading. In Wood's rendering, as opposed to Sigmund's experience, the crash cannot be averted.

One of very few recognizably contemporary subjects within Wood's work—and all the more noteworthy, given the artist's fear of driving—this white-knuckled scene is unlike anything the artist had ever painted. Its careening topography, blighted by towering telegraph poles

and barbed wire fencing, suggests none of the erotic beauty of Wood's earlier landscapes. Rather, its dynamic composition and subject matter evoke his oldest trauma—the sudden death of his father—as well as the escalating, and equally unresolved, anxieties of his adult life.

The painting's jackknifed telegraph poles summon the gossipy telephone of *Victorian Survival*, just as their cross shapes suggest the religious symbolism at the heart of *Dinner for Threshers*. Whereas the threshers' meal had recalled the setting of Christ's last supper, however, here the poles and steeply pitched hill suggest his crucifixion at Golgotha. That we are witnessing an execution, rather than an accidental death, is further underscored by the impending storm clouds at right and the unnatural darkness that steals across the painting's foreground. The immediacy of the scene's implied threat, as well as its contemporary setting, suggest the pressing concerns of Wood's life in the mid-1930s. In the three doomed automobiles, and in the funerary markers that lean and pitch about them, we recognize his tenuous position both within the regionalist triumvirate and his own family.

If the point of impact remains forever stalled in this painting, the same cannot be said of Wood's personal life in 1935. On the morning of March 2, Wood's neighbors read with astonishment that he was to be married that night in a small ceremony in Minneapolis. The fact that Cedar Rapids' "bachelor artist" had a secret fiancée was nearly as dumbfounding as the circumstances of the wedding itself—a ceremony conducted with little warning, far from home, and with no friends or family in attendance. Within six months of Wood's surprise wedding, to a woman many in his circle had never met, his life was transformed in equally profound ways. That fall he would move from Cedar Rapids to Iowa City, a change that not only ended his extraordinarily productive years at Turner Alley, but one that also cast a chill on many of his lifelong friendships. By October, in the impressive new home Wood had bought in Iowa City, Hattie passed away—and with her, the life he had known since childhood.

FOUR

A FABLED LIFE

THE EXTRAORDINARY EVENTS OF 1935—Wood's surprise wedding, the abrupt closure of his Turner Alley studio, and Hattie's death—shook the foundations of what had been, up to this point, a painstakingly ordered life. Although his marriage initially offered Wood a measure of self-confidence, his subsequent move to Iowa City would cut him off from a far more critical base of support. With the mounting hostility of his university colleagues, and the complicated rivalries that would emerge in his new household, the artist was to face some of the greatest challenges of his life armed only with his own rather poor sense of judgment.

Wood's ever-growing national profile in these years only intensified these problems, increasing expectations for his work and magnifying the risk of his personal exposure. The combination of these pressures proved almost paralyzing for him. Not only did Wood's productivity sharply fall off after 1935, but so too did his rigid self-surveillance; indeed, in two instances from this period, the threat of sexual scandal nearly destroyed the artist's wholesome, all-American image. In spite of these crises, or perhaps because of them, he would manage in the late 1930s to produce some of the most arresting images of his career—chief among them, *Parson Weems' Fable* of 1939.

Like this last great painting, Wood's final years themselves suggest the structure of a fable. Whereas fairy tales are typically driven by fantasy and wish fulfillment, fables are cautionary tales—propelled by a mounting sense of anxiety, and far more likely to end in punishment than in rescue. As Bruno Bettelheim has noted, the phrase "and they lived happily ever after" has no place in this genre. Similarly, Wood's life in Iowa City is marked by a series of ill-considered choices and their

inevitable, punitive effects. The artist's complicated family dynamics, professional ambition, and closeted sexuality all appear to lead to a foregone conclusion: this cannot end well. And yet—in Wood's late work, and in his final reflections on his own life, he offers us the chance to do what he could not do for himself. We may rescue him, after all.

In its tone of barely concealed astonishment, the press coverage of Wood's marriage to Sara Sherman Maxon indicates that, despite his new veneer of regionalist masculinity, his sexuality had remained a matter of some debate. Indeed, the *Cedar Rapids Gazette* registered less surprise at the suddenness of the marriage than at the fact that Wood had, as the paper euphemistically phrased it, "digress[ed] from his single track bachelordom." Public perception of the artist "was so far removed from the thought of romance," Wood's hometown newspaper offered, "as to make the culmination of this courtship a major surprise." In a similarly unflattering instance, one Albuquerque newspaper reprinted the couple's wedding photograph along with the caption "They Can Laugh At Critics Now!"

Compounding the surprise of Wood's unexpected wedding—an event that neither Nan nor Hattie attended—was his surprising choice in a bride. A good deal older than Wood and even physically larger than he, the white-haired and matronly Sara was already a grandmother by the time of their marriage. Although she claimed to have been born in 1890, a date that would have made her Wood's senior by only a year, census records indicate Sara was more than seven years older than her new husband—making her fifty-one to Wood's forty-four (or forty-three, as he himself claimed). Beyond the unsettling issues of her age and imposing appearance, Sara was a recent divorcée who had led, by Iowan standards, a suspiciously colorful life as a traveling light-opera singer. When her theater company had toured in the 1910s, sniffed one Cedar Rapids resident, "it is generally reported that she appeared in tights."

In an interview shortly after his wedding, Wood offered little to explain his sudden marriage—stating simply that he and Sara shared a common devotion to the arts and "understood" one another as creative people. Attempting to add a hint of romance to their story (and no doubt to screen their obvious age difference), at least two sources erroneously reported that Wood and Sara had been childhood sweethearts. In truth, the couple had met for the first time only four months before

Grant Wood with his wife, the former Sara Sherman Maxon,
soon after their 1935 wedding

their wedding. What they lacked in shared history, however, was more than made up for by their remarkably similar experiences as children— a phenomenon that explains, at least in part, the attraction these two very different people initially felt for one another.

Sara had spent her early childhood in Monticello, Iowa, a small town ten miles north of Maryville Wood's farm. Her father, Henry David Sherman—first cousin to the formidable Union commander William Tecumseh Sherman—owned a lucrative chain of creameries across the state; a powerful figure in Monticello, he served as the town's school superintendent and also, briefly, as its mayor. Following the death of his first wife, Sherman had married Sarah Elizabeth Secrest in 1863. Nearly twenty years his junior, Sherman's new wife was as well known for her musical abilities and keen intellect as for her beauty. Although she had spent most of her life in Iowa, she felt a strong connection to her family's Kentucky and Virginia roots, and appears to have considered herself something of a transplanted Southern belle (one wonders what she thought of her cousin-in-law, General Sher-

man). The couple raised their four children in a seemingly idyllic, and certainly a privileged, setting. Not only was their imposing brick home on Gill's Hill fully staffed, but it also featured such modern conveniences as indoor plumbing and a telephone.

Following her marriage to Wood, Sara claimed that her "childhood days had been spent so near to [Wood's], but on the other hand our backgrounds were almost completely different." In economic and social terms, of course, she was perfectly right—the plain living and rural isolation of Wood's Anamosa life differed starkly from the more comfortable, and at least marginally more urban, world in which Sara had been raised. From an emotional standpoint, however, Sara's early years mirrored Wood's in rather remarkable ways. In the memoir she wrote near the end of her life, she confessed that her childhood had been marked by profound loneliness and a sense that she had failed her parents' expectations. "I was a complete misfit," she writes, "in the life that presented itself to me."

Sara's relationship with her mother, much like Wood's with Maryville, was a complicated mixture of hero worship, longing, and fear. Describing her mother as distant and imperious, Sara claims "she never came down out of her ivory tower to let me know she even thought about, much less loved me." Occasionally cruel, as well, her mother not only disparaged Sara's looks ("Mama . . . told me in no uncertain terms that I was *not* beautiful"), but she also dismissed the early accolades her daughter received for her singing. Henry Sherman's affection for his youngest daughter partly compensated for her difficult relationship with his wife—a dynamic that parallels, in turn, Hattie's protectiveness toward Wood—yet Sara recalls that her father "never failed to remind me . . . that I had inherited my talent from Mama and must be grateful to her." (Another inheritance, of course, was her mother's first name—the spelling of which, oddly enough, Sara's mother chose to distinguish from her own.)

The most serious point of contention between mother and daughter was the issue of Sara's "unladylike" behavior. To the disappointment of "my little aristocratic Mother, who was a Virginian of the 'old school,' " Sara was drawn to the rough-and-tumble world of boys. She loved baseball, ice hockey, rodeos, and stories of the Wild West—whereas she "hated girls and their dolls and 'indoor sports.' " Characterizing herself as a "lone wolf," a "peculiar duck," and a "wild-cat,"

with "some of the traits of a bulldog," Sara claims she was known in Monticello as "that queer little girl tomboy." At home, whenever Sara's mother negatively compared her to her more feminine sisters, the young girl "would take refuge in my land of make-believe, and refused to let anyone know how I *hurt* inside." Only her older brother Ernest, whom Sara adored, truly "understood and encouraged all the characteristics in me that others considered queer."

In 1893, Henry Sherman's growing dairy business precipitated the family's move to Cedar Rapids. Leaving Monticello behind, the nine-year-old Sara was heartbroken. "From the time we moved to Cedar Rapids," she later wrote, "I knew that I did not belong. Never one to make friends with little girls my age, the whole future seemed bleak." Sara's removal to Cedar Rapids appears, on its surface, almost uncannily like Wood's—the two arrived in the city at nearly the same age, and with similar feelings of dread—yet the challenges she faced in this new environment were in some ways steeper than those Wood later encountered. Whereas Cedar Rapids would offer him a measure of freedom, Sara's sense of surveillance only increased in her new surroundings—where her married sister Edith now joined her mother's efforts "to make a lady of me." (In characteristically salty fashion, Sara admits: "I was no doubt a horrible little bitch" at this age.) Choosing rebellion over assimilation, Sara later recalled, she "[fought] for freedom from the hide-bound conservatism in which my life lay."

At the age of twelve Sara befriended Helen Henderson, a fellow rebel who "had the same curiosity and zest for living that I had." (It was Helen, Sara confides, who first taught her to drink and smoke.) Through this connection, Sara would also discover her calling in music. Helen's father, who managed Cedar Rapids' opera house, persuaded Sara to audition for local singing instructor Ernest Leo; impressed by her talent, Leo encouraged her, in turn, to set her sights beyond Cedar Rapids. Sara's opportunity came through a chance encounter in 1900 with the celebrated soprano Genevieve Clark Wilson. After hearing her sing, Wilson invited the seventeen-year-old Sara to study with her in Chicago. "What a woman!" Sara later wrote of Wilson, who gave her "the love and understanding I had needed so desperately." Sara's parents took a rather dim view of their daughter's vocation—the move to Chicago, she claims, had been supported only by "my adorable brother and champion"—yet she saw the stage as her

salvation. There, Sara claimed, her "childish excursions into the land of make-believe were not considered queer."

Soon after she turned nineteen, Sara began dating a man named Alonzo Jones Maxon. Six years her senior and chronically underemployed, Maxon was considered a "calamitous" match by her mother and father. No doubt encouraged by their disapproval, and eager to throw off the yoke of her family (in Chicago, Sara had been living in "the quiet and exceedingly religious atmosphere" of her aunt Jo's house), she married Maxon that spring. It was to be an abysmally unhappy marriage. Feeling she had traded her parents' expectations for the only more burdensome demands of a husband, Sara later wrote: "Had all of the realistic truths about marriage been made clear to me, the marriage they were all fighting so darn hard to prevent would never have taken place." Maxon, who "was only attracted by the physical me," turned out to be both a deadbeat and a bit of a sadist. Sara considered an immediate divorce, yet feared the potential repercussions from her family. Her sole consolations were the birth of her son Sherman in 1907 ("I felt that at least a child would love me for myself," she writes) and a promising career in light opera.

In the early 1910s, Sara was discovered by the New York composer Jerome Kern—later of *Show Boat* fame—and cast in a revival of Reginald De Koven's *Robin Hood*. A deep contralto, Sara was a natural for the "trouser role" of the outlaw Alan-a-Dale, a part typically played by a woman in a boyish costume. In publicity photos for the tour, Sara appears in the tights that later shocked Cedar Rapids, as well as a fringed miniskirt and thigh-high boots. She had traveled a rather long distance from her Monticello girlhood, it seems, and jettisoned her mother's "ladylike" expectations with little regret. Throughout the 1910s Sara toured extensively with de Koven's company, living for extended periods in Chicago and New York. Following the composer's death in 1920, she traded the stage for theater management, radio work, and eventually a management role in Chicago's burgeoning film industry.

Sara's newfound financial security in the mid-1920s allowed her to purchase a fruit farm in nearby Michigan, a move that her theater friends found "plum crazy" (Sara, it seems, enjoyed a bad pun as much as Wood did). Reveling in the hard work and independence of this new environment—and having separated, at last, from Maxon—Sara lov-

Sara Sherman Maxon as Alan-a-Dale in Reginald De Koven's
Robin Hood, c. 1912

ingly restored the property's farmhouse and revived its orchards; eventually she gave up her professional life in Chicago altogether, and earned her living by directing local choral groups. She later considered her time in Michigan as the happiest of her adult life. By her mid-forties, however, ill health and her adult son's financial dependency forced Sara to give up the farm. Joining Sherman and his new wife in Minneapolis, she was at last divorced from Maxon. "On the granting of that divorce," she writes, "I felt . . . I could completely reorganize my life and start from scratch."

Reinvention was not easy for this newly single, middle-aged woman in the waning years of the Great Depression. Once a figure in some demand in theater circles, Sara now found steady work difficult to come by. Financial support from her family had evaporated as well.

Her father and mother had died in 1917 and 1926, respectively, whereas her brother Ernest—who had become a successful businessman—had died on the day of the 1929 stock market crash. After a disheartening eighteen months of job hunting in Chicago and New York in 1933–34, Sara chose to regroup that fall at her sister Phoebe's in Cedar Rapids. "Little did I know what was in store for me on this trip," she later wrote.

Hazel Brown provides the earliest account of Sara's appearance within Wood's circle. Not long after her arrival at Phoebe's, Sara had appeared in the gift shop that Brown and Mary Lackersteen operated at Studio House. "She seemed somehow familiar, yet neither Mary nor I actually knew her," Brown writes of this first encounter:

> White-haired, beautifully groomed, and blue-eyed, she smiled at us and introduced herself . . . We were alone in the shop so we chatted a bit. As she turned to leave and we turned back to the office, she asked to use our telephone if she might. And then, sitting on the telephone stool, she said to us, "Surely you gals have a list of the eligible men in town haven't you?" We laughed and joked about this one and that one, and she left.

Within a matter of weeks, Sara was seen in the company of Cedar Rapids' most eligible, if also its most confirmed, bachelor. To the surprise of nearly everyone who knew him, Wood appeared to be dating the singer.

The couple seem to have met at a dinner party hosted by Jay Sigmund, not long after Sara's Studio House visit. It had not been an auspicious beginning. "The night we were introduced," Sara later confessed, "I must say that I was not particularly impressed." During their subsequent interactions, a bond slowly formed through the figure of Hattie—who, Sara claimed, "impressed me much more deeply than did Grant. In her I sensed a lonely, starved little soul to whom the burden of living had been too great. From then on, my interest in the Wood family was prompted by mother Wood's need for help and affection."

Sara's immediate connection to Hattie followed a lifelong pattern of adopting older women as surrogate mothers. Having few friends her own age as a child, she had been particularly drawn to "oldsters," as she called them. (Indeed, among her favorites in Monticello had been "a

little wizened old lady" rather coincidentally named Aunt Wood.) From the start of her relationship with the painter, then, Sara's primary role was that of caretaker to the aging and often bedridden Hattie. Her frequent stays at Turner Alley restored the structure of Wood's former home life, yet her presence there also clearly unsettled David Turner. Wood's fastidious landlord lectured him about the unseemliness of this arrangement; as an unrelated member of the family, and an apparent romantic interest of the artist's, as well, Sara struck Turner as a dangerous addition to the studio. Failing to grasp his point—no doubt purposely so—Wood simply explained that Sara was "a good housekeeper, an excellent cook, and an orderly person" who had been kind enough to look after Hattie whenever he was away from home.

By late winter, a series of events accelerated the pace of Wood's and Sara's relationship. After Hattie suffered a mild heart attack in February 1935, Nan returned to Cedar Rapids with the intention of caring for Hattie herself. Not surprisingly, her first encounter with Sara did not go well. Disheveled and taken off guard by Sara's unannounced arrival at the studio, Nan was further piqued by Wood's deference to her future sister-in-law, who had arrived "dressed fit to kill" and showed a disturbing familiarity with the household. Although she planned to remain in Cedar Rapids for the duration of Hattie's recovery, Nan was unexpectedly called back to Albuquerque when Ed was involved in a serious car accident. By the time she returned to Cedar Rapids at the end of February, Sara and Wood had decided to marry.

The prospect of the artist's marriage alarmed not just his family (even Hattie "had grave misgivings about Sara," Nan claims), but also Wood's close-knit circle of supporters. In an attempt to halt the marriage, the artist's friend John Reid invited him to a dinner party organized to dissuade Wood from his plan. Not only did the attempted intervention fail—the humiliated Wood had believed this was to be a congratulatory dinner—but it also permanently alienated him from many of those present, including David Turner. Wood was no doubt as confused as he was angered by his friends' reaction; to his mind, he had at last fulfilled a lifelong expectation. In a terse letter to Turner following this dinner, he explained, "I am sure we are making no mistake," adding that he and Sara, as artists, "take a rather special understanding and because we both of us need and both of us have just that, I am convinced we shall be very happy."

In the strength of their reaction to Wood's engagement, his friends revealed more than just their personal distaste for Sara. As Garwood notes, in Cedar Rapids "Grant was regarded almost as a piece of municipal property, like a monument in the park." Any alteration to his public image, therefore, was the prerogative of the artist's community—which appeared to be as unnerved by his engagement as they had been by his Parisian goatee in 1920. In both cases, Wood's circle regarded his beard (whether metaphorical or actual) as inappropriate, out of character, and an unwelcome reminder of his adult sexuality. By refusing to remain an eternal adolescent, the artist had broken the rules of his unspoken arrangement with Cedar Rapids.

Sara, too, was privately advised to abandon her marriage plans. After meeting Wood at a party in New York during the winter of 1934–35, one of her friends (a man "whose attitude toward me was one of protection as well as friendship") took her aside to discourage the match. To those who had known the lively, unconventional singer from her New York and Chicago days, the socially awkward Wood must have seemed an unusually poor choice in a husband. For his part, Wood's friend MacKinlay Kantor (who had married recently himself) warned Sara that her marriage to the artist "wouldn't work if [they] had to live in Iowa." As if to prove Kantor right, Sara's sister Phoebe expressed her own reservations, hinting that she and others in Cedar Rapids "knew more about Grant and his background than [Sara] did." Even Sara herself "questioned the wisdom of thinking in terms of marriage with Grant," yet she ultimately trusted her "sixth sense" that theirs would be a happy partnership.

Surely, Sara's sixth sense had also registered—even if she did not yet admit it to herself—that Wood was a homosexual. No longer the naïve country girl of her youth, Sara had grown "particularly acute to all human behavior" while living in Chicago and New York, and had no doubt encountered openly homosexual men in her theater circles. Rather tellingly, she admits that when she first met Wood she had "seen too much of the artistic and Bohemian life in New York" to consider him a viable romantic prospect; indeed, from the beginning of their courtship, she writes that "some of his friends who had known him all of his life were more or less amused that he was showing so much interest in a 'woman.'" The reason for Cedar Rapids' amusement could hardly have been mysterious to her. Wood's sexuality, however, appears

to have been a nonissue for Sara—who envisioned their marriage as a "friendship . . . based on mutual understanding of, and interest in, things artistic." As she would later write, "I had no idea of the depth of the conflict which was entering in."

Despite the almost universal resistance the couple encountered, Wood's determination to marry was strengthened by mounting professional and personal pressures. In its profile of the "U.S. Scene" artists the year before, *Time* had made particular note of Benton's and Curry's wives after referring to Wood as a "shy Bachelor"—a troubling indication that, beyond Cedar Rapids at least, the artist's unmarried status was viewed less as an eccentricity than a professional liability. Of even greater concern to Wood in this period was the potential loss of his ailing mother. Not only was Hattie the artist's primary source of emotional support, but her presence in his life was also the very reason, as he often confided to friends, for his perpetual bachelorhood.

Although Sara's age would seem to have made her a rather unlikely match for Wood, he had often formed strong emotional attachments to older women. Like Emma Grattan and Fan Prescott, Sara was a competent caretaker and stern taskmaster; indeed, contemporary descriptions of these two women might just as easily have been made of Wood's wife. Hazel Brown described Prescott, for instance, as "tall, white-haired, blue-eyed, and Irish in eye and tongue," whereas Nan claims Grattan was "a woman of powerful personality and strong likes and dislikes, who never hesitated to speak her mind." Like these women, too, Sara appears to have made no sexual demands upon the artist. As a platonic partner, she was therefore uniquely suited to assume Hattie's role as chaperone at Turner Alley. (Neatly symbolizing this transference of power, Wood borrowed his mother's cameo brooch for Sara to wear at their wedding.)

The exact nature of Sara and Wood's physical relationship can never be known, of course, yet her memoir provides two oblique references to the sexual dimension of their "understanding." In the first, Sara describes the end of a picnic during her courtship with Wood:

> The food we had consumed and the beer we had drunk all contributed to the age-old necessity to take care of nature's urge. Realizing that Grant was less sophisticated in such matters, at least so I thought, I suggested that it would be a good idea for

him to take a walk down the road in one direction while I took one in the other. I am convinced that my frankness at this point was what decided Grant that I was the gal he had been looking for, and that I realized his inhibitions and would never make a point of it.

The oddly unromantic conclusion to this tipsy, secluded picnic offers some rather telling details. Although Sara leaves the extent of Wood's "inhibitions" undefined, her insistence that "she would never make a point" of them—to say nothing of Wood's disproportionate sense of relief—suggests she is referring to more than just his wish for bathroom privacy. It was Sara's sense of discretion, it seems, rather than her "frankness," that settled Wood on marriage.

In an equally revealing passage, Sara claims that when she and Wood traveled to New York before their wedding,

we went as Mr. and Mrs. under an assumed name, and no doubt there are many Iowans who . . . will be horribly shocked at such goings-on. Neither one of us, however, had the least sense of doing anything wrong. In fact, the idea was quite the reverse, for we had no *desire* to wrong each other, and this trip was to prove once and for all whether or not the affection we held for each other could be the basis of a permanent and happy marriage.

Such a "trial marriage," as Sara refers to this two-week period, might at first suggest an exploration of sexual compatibility. Her insistence that the two "had no *desire* to wrong each other" during this trip, however, might just as easily (and far more plausibly) lead to the opposite conclusion. For even if we discount Wood's sexual reticence with women—"he was a trifle timid about some things," Sara offers—her memoir provides ample evidence of her own distaste for sex.

Of her first marriage, Sara claimed: "My wedding night proved to me how deeply I could hate. From then on, I determined that no one should know how unclean I felt." In the weeks that followed, "it was the nights I dreaded, for . . . I had yet to discover, even for myself, that I was attractive to men. I was still that naïve girl whose ideals and ideas emanated from instinctive love of beauty. Most of the details of these months of disillusionment are too sordid to recall." The shame and repulsion Sara first attached to sex cannot be separated, of course, from

her loathing of Maxon himself—yet she also came to believe that her "problem," as she referred to it, was part of her own emotional makeup. (This was a "spiritual" concern, she claimed, "far beyond [Maxon's] comprehension.") Only Sara's mentor Genevieve Wilson seems to have fully understood her predicament. When Sara left Maxon early in their marriage, she writes, "Mrs. Wilson, my teacher and friend, welcomed me back with open arms and understanding for she, too, had a similar problem of longer standing. Because of this, she tried to persuade me to divorce the man I married and not try to carry on."

Whether or not Sara's "spiritual problem" might be read as evidence of her own closeted sexuality—a possibility complicated by her apparently genuine romantic attraction to men—she was no doubt as relieved as Wood to enter a partnership with no sexual expectations. "Here at last," she wrote about their marriage, "was the peace and contentment for which I had been looking." Early in her first marriage, Sara had fallen in love with a man similarly uninterested in "mere physical attraction. We loved the same things, and everything we did was done in absolute accord." Writing in much the same way about Wood, Sara claimed it was "completely impossible for anyone to describe the inception of love and understanding which took place between Grant and me . . . The hours we spent together over many weeks brought us into complete accord."

Considering their marriage at a superficial level, one might characterize Wood's and Sara's motivations rather cynically. He needed cover, and she, financial stability. Wood's choice in a wife, however, was in some ways more alarming than his bachelorhood; and for her part, Sara was too much of a romantic (and far too proud) to have married for money. Rather, as Sara insisted, "the fates had worked together to give us this companionship"—a strong, mutual attraction founded upon imaginative role playing. Whereas Wood had cast Sara in Nan's and Hattie's roles, Sara recognized Henry and Ernest Sherman in her new husband ("the man whom I thought personified all of the qualities I had needed so badly, from the time my father and brother had passed on"). Beyond these connections, Wood was also the Husband-Who-Was-Not-Maxon. Gentle and nonthreatening, he gave Sara "the impression of a schoolboy" and provided her, as she once believed her son would, "the affection that had been denied me through other domestic contacts."

In Sara, Wood saw no battle-scarred, gimlet-eyed former stage

actress, but the "green gal from Ioway" she herself claimed to be. Sharing a tendency to romanticize their growing-up years—periods that had been, in truth, profoundly difficult for them both—Sara and Wood spent much of their courtship exploring the countryside near Anamosa, Stone City, and Monticello. On these long drives through Jones County, Sara claims, "Iowa took on new meaning for me, and I seemed transported back to my childhood . . . Calendar years slipped away, and we were once again just another boy and girl, confiding our innermost dreams one to the other." In viewing one another as children, it seems, each saw in the other the possibility to rewrite their stories with different endings.

SARA WAS TO HAVE a remarkably short run in her new role. Soon after their wedding, Wood realized that his wife was no blushing farm girl, but a grown woman whose resemblance to Hattie ended with her Jones County birth certificate. Whereas he had initially considered her a quiet, maternal type, Sara described herself a bit more accurately as "a more or less intriguing platinum white-haired gal, with good if a little too 'knowing' eyes and a body still having good dimensions [who] enjoyed a well-built, old-fashioned cocktail." (Sara's self-description suggests yet another a parallel to Fan Prescott, described by William Shirer as "a lovely Irish ball of fire.") Earthy and emotionally volatile, Sara was easily moved to anger, laughter, or tears; she did not suffer fools, perceived slights easily, and rarely held her tongue when provoked. Nan, who was far more like her sister-in-law than she would have cared to admit, described Sara as a "driving and forceful" woman—the very opposite, she claimed, of her brother's easygoing personality.

Given the relatively modest way Sara appears to have dressed before her marriage to Wood (her first encounter with Nan notwithstanding), her taste for costly and even daring clothes was one of his initial surprises. For her first interview after the wedding, to cite an early example of Sara's new (or reintroduced) sense of style, she wore what the *Milwaukee Journal* described as "stunning pajamas in the new shade of Tyrolean blue, which perfectly matched her eyes"—an outfit that no doubt raised eyebrows back in Cedar Rapids. Not long afterward, one of Wood's former students was shocked to see the artist's wife answer

the front door in a similar ensemble. Sara's white satin pajamas, the visitor drily observed, were "an innovation."

Like the infamous tights Sara had worn as Alan-a-Dale, her wardrobe appears to have been as disturbing to Iowans for its androgyny as for its risqué character. Writing about Sara's new look, a friend of Hazel Brown's and Mary Lackersteen's declared: "We think Mrs. Wood rather likes to shock people. Being an artist herself—as she so often reminds us—she is bound to be an exhibitionist, but the grown women of Iowa City are not yet wearing pants on downtown streets." Just as this writer suggests, Sara thoroughly enjoyed flouting convention—and she always had. Her "unladylike" ensembles were as much a product of her girlhood rebellion as Wood's overalls were a sign of his filial obedience. In a sense, they were both dressing up for ghosts.

Before their marriage, Sara had encouraged Wood to cultivate his own sense of style. "One of the things Grant needed at that time more than anything else," she writes about this period, "was to change his attitude toward himself." During their "trial marriage," Sara explains: "I went with Grant to a clothing store and chose a new suit of clothes for him, because I had made up my mind and also convinced him that he had neglected long enough making the most of his personality." Banishing Wood's trademark overalls for good, Sara claimed he looked fifteen years younger and far more self-assured; his new wardrobe included sporty checkered pants, multicolored ties, and even stylish new frames for his glasses. The presence of a fiancée, it seems, had freed Wood to resurrect his inner dandy. As Sara herself remarked, it was this new status—even more so than his new suits—that signaled "the real reason for the change in him."

If Wood's wife had proven to be nothing like his mother, then this was in some respects all to the good. Not only did Sara encourage Wood to step outside his well-worn routines, but she also appears to have become a much-needed confidante; "for the first time in his life," she writes, Wood "felt free to tell someone of his boyhood and the days following his father's death." His stories held "a great appeal to me," she explains, "for I knew that in telling them he was unburdening his soul of a lifelong habit of keeping things that hurt him to himself—and certainly, his paintings are indicative of that attitude." Given the difficulties of her own upbringing, of course, Sara made a particularly empathetic audience. Wood revealed to her his childhood feelings of

physical inadequacy (his was a body "which he could not control," Sara
writes), as well as his painful relationship with his father, whom Sara
immediately recognized in the "grim, gaunt, relentless" face of *American Gothic*'s male figure.

One of Wood's more surprising confessions to Sara concerned his
distaste for farm work. Regarding his Cedar Rapids boyhood, she
writes:

> Grant was sent to a neighboring farm before and after school to
> help with the chores. He did some milking, fed the livestock,
> gathered eggs—that sort of thing. I have known many farm boys
> of that age who have had to do the same things and have done it
> either proudly or reluctantly, according to their natures. I have
> known none other than Grant who did it with a sense of shame.
> He told me he felt degraded and dirty after leaning against the
> side of a cow in order to bring down her milk; how he hated the
> snuffling of the pigs snorting after their food; how he loathed
> the feeling of the still-warm eggs, sometimes slippery and offal-
> spattered, as he lifted them out of their nests . . . He told me
> how embarrassed he was at the time because he was sure that no
> matter how much he bathed, he must carry with him the smell
> of the manure which permeated his clothes from working
> around livestock.

The visceral disgust Sara describes in this passage, and the sexualized,
scatological language she uses, were undoubtedly no embellishment
on her part. Not only would she have found her husband's atti-
tude inexplicable—she was an enthusiastic and unsqueamish farmer
herself—but her initial belief that *Wood* enjoyed this life, too, had also
been an important factor in her initial attraction to him. Providing
details too vivid to have been invented, Sara contradicts once and for
all that Wood "got all of [his] good ideas while milking a cow."
(Indeed, in the almost unavoidably sexualized lithograph *Spilt Milk*—
completed the year after his marriage to Sara—Wood demonstrates
that "good ideas" were not the primary by-product he associated with
milking.)

In the summer after she and Wood were married, Sara succeeded in
drawing him out in a more literal sense. Suggesting a vacation from the

Grant Wood, *Spilt Milk*. Wood created this lithograph
for the children's book *Farm on the Hill*, 1936,
by Madeline Darrough Horn.

hermetic environment of Turner Alley—where she had at last moved
her mother-in-law into a bedroom of her own—she convinced the
painter to rent a cottage in Waubeek for the season. "Mother Wood
had not looked forward to being transplanted from the studio in Cedar
Rapids," Sara writes, but after several weeks the household seems to
have settled into a happy routine. Wood found the solitude he needed
for his work, Sara enjoyed long visits with Jay Sigmund and his wife,
and even Hattie's health seemed to improve. "Never in my life have I
spent a more ideal summer," Sara later wrote.

The Waubeek idyll was to be rather short-lived. In late July, David
Turner wrote to Wood requesting that he permanently vacate the
Turner Alley studio. Although Turner claimed to need the apartment

Grant and Sara Wood at Jay Sigmund's Waubeek
cottage, summer 1935

for his soon-to-be-married daughter, his decision to remove the artist
from his home of over a decade—a place that had become an inextrica-
ble part of his work and identity—was in all likelihood based upon his
disapproval of Sara. Surprised and "terrifically upset" at his eviction
from Turner Alley, as Sara later wrote, Wood must also have felt a sense
of déjà vu; for the second time in his life, his familiar world appeared to
be slipping through his fingers.

Sara, who doubtless suspected the real reason for Turner's decision,
persuaded Wood to leave Cedar Rapids altogether. Proposing that they
relocate to Iowa City, she argued that the move would eliminate the
artist's long commute to the university. Privately, she also clearly hoped
to separate Wood from those who disapproved of her colorful past,
clothes, and influence over her husband. (Indeed, in the accounts of

the artist's family and friends, Sara appears like an Iowan Wallis Simpson, *avant la lettre.*)

The antipathy Wood's wife felt for "Cedar Crick," as she disparagingly referred to Cedar Rapids, was one of rather long standing. Speaking of Sara's long-ago stage début in Cedar Rapids, Hazel Brown wrote:

> It was a rare event to have a local girl of a well-known family appear in a professional troupe. The local reaction was amazement, disapproval, interest, and a shout of glee to have some "gossip to talk over." Evidently, Sara herself was to feel the full force of the "disapproval," rather than the more pleasant reactions. She was joked about, made fun of, laughed at, all over town, and her evident resentment of what she considered "a small-minded, middle western" reaction went very deep.

By marrying and removing Cedar Rapids' beloved local boy, Sara had exacted a fitting revenge on the town—yet even after the move to Iowa City, she continued to punish her former detractors. When she invited Wood's longtime friends Billie and Herbert Stamats to a "picnic" at the Woods' new home in Iowa City, for example, the couple found themselves woefully underdressed for the formal dinner party Sara had actually planned. Following this and similar instances of Sara's double-edged hospitality, Cedar Rapids' opinion of Wood's wife turned from disapproval to open hostility. As late as 2005, the daughter of one of Wood's former friends confided: "Sara was what, today, we would have called a bitch."

In the months leading up to the Iowa City move, Sara's ascendancy as the "new" Mrs. Wood cast Hattie's decline into sharp relief. Wood's greater-than-usual attentiveness to his mother in this period reveals his heightened anxiety at the prospect of her death. In late summer he surrounded the bedridden Hattie with the plants they had once tended together—a fitting gesture, given her love of gardening, yet one that also morbidly recalled the funeral biers he had once designed for David Turner. Similarly funereal was the "stained-glass window" Wood created in the room's north bay, made from an assortment of Hattie's colored mason jars. Recalling at once his mother's kitchen, the family's cellar, and his own devotion to the Gothic period, this simple installa-

tion was as evocative of the painter's artistic origins as Hattie's 1929 portrait had been.

Although *Woman with Plants* had long since left Wood's studio, the artist had installed another apparent tribute to his mother in its place. Few might have recognized the connection between this landscape and Hattie, yet the work clearly suggests the artist's preoccupation with her failing health. Wood had painted *Near Sundown* (see color plate 23) in the fall of 1933, following the closing of the Stone City Art Colony and his return to regular life with Hattie. Mirroring his mother's melancholic portrayal in *Woman with Plants,* this elegiac landscape transforms the autumnal Iowa farmland of her portrait into a sublime embodiment of her mourning—and of Wood's anticipatory grief for her. Gone are the vibrant green hills, muscular topography, and fanciful trees of Wood's earlier landscapes. This is Demeter's world, rather than the springtime fantasy of *Stone City* or *Young Corn,* and so Wood exiles their toylike sweetness. Banished, too, is *Fall Plowing*'s suggestion of the worm beneath the soil; *Near Sundown*'s indications of mortality are more subtle and benign. Dark shadows steal quietly across the foreground, and cattle walk languidly back to their barn. The sky is reduced to a glowing sliver of pearl, pushed to the painting's edge by a soft and swollen land.

Near Sundown combines the earth's eternal, factual presence with the temporal impermanence of the body. Instead of the tight, gravity-defying roundness of *Stone City,* these heavy, fleshy hills seek a horizontal plane—a landscape whose furrows and cattle trail suggest the spidery traces of scar tissue, rather than the fresh cuts of a newly planted field. Wood lingers over these gentle slopes with a palpable sense of longing—not for a romantic union, but for a return to the safety Hattie once represented for him. We may recognize the artist himself in the overalled young boy at far right, who makes his way back to the distant farm. No generic representation of Mother Earth, then, this landscape is a portrait of "Mother *as* earth"—a figure whose flesh is modestly concealed in the pooling shadows and darkened forests that mark the approach of death. Appropriately enough, *Near Sundown* is the last painting Hattie ever mentioned in her regular letters to Nan. Sharing the news of its sale to Katharine Hepburn, an uncharacteristically star-struck Hattie seemed at last to grasp the scope of her son's fame.

While Wood worked feverishly to complete Hattie's apartment in his new Iowa City home, she remained in Cedar Rapids as the guest of Marvin and Winifred Cone. Winifred described Wood's reunion with his mother that September as particularly poignant. Hattie, who had recently shown signs of recovery, stood on the stairs and called to her son; according to Winifred, Wood's stammered response conveyed a heartache she would remember the rest of her life. Within weeks of Hattie's arrival in Iowa City, nearly all of the gains she had made in the preceding months quickly vanished. On October 11, she died.

Wood never spoke about this period. Indeed, were it not for Sara, who held a bedside vigil during her mother-in-law's final days, there might have been no record of Hattie's final illness. Not only had the artist refused to visit his mother's deathbed, but he even barred lifelong Cedar Rapids friends from paying their last respects. (Suspecting a counterattack to this snub, Sara claims Turner charged an "exorbitant price" for Hattie's funeral.) Shortly after their mother's death, Nan arrived to find Wood "white and drawn" but clear-minded. Nearly as paralyzed by the event as he, it seems, she devoted no more than a sentence in her own memoir to Hattie's death.

♦ In arranging for his mother's burial, the artist applied one of the guiding principles of his art: keeping Maryville strictly at bay. Defying the wishes of his uncle Clarence, Wood refused to inter Hattie's body in either of the vacant lots adjoining her husband's grave—choosing, instead, to bury her in the neighboring Weaver family plot. Placing his mother next to his maternal grandmother, he reserved the plot next to Hattie's for himself. By the codes of the day, it was an unorthodox arrangement in a number of ways. Not only was it a serious matter to separate the graves of a husband and wife, but it was also unusual for a son to have implied his allegiance to his mother's family over his father's. Wood claimed to have based his decision upon purely aesthetic reasons—he loathed the enormous carved lion Uncle Clarence had added to the Wood plot—yet when his brother Jack unexpectedly died two months later, the artist determined he should be buried in Maryville's section of the cemetery.

Wood cathected his grief in costly renovations to his new home, located at 1142 East Court Street in Iowa City. Although he paid just $3,500 for the impressive, eleven-room house, he eventually spent over ten times that amount on its renovation—an extraordinary sum during

the Great Depression, and certainly for a man who had been living
rent-free since 1924. Built in 1858 by Nicholas Oakes, owner of the city's
first brickyard, Wood and Sara's new home was a monument to the
city's initial building boom. Its neglected state in 1935 had strongly
appealed to the Woods' sense of nostalgia, as well as to their shared love
of theater; like the ghost town of Stone City, or the farmhouse Sara had
once restored, the house allowed them to re-enter and reimagine the
past.

In addition to the structural restoration Wood undertook at his new
home, he was equally interested in bringing its interiors back to their
imagined former glory (as Adeline Taylor of the *Cedar Rapids Gazette*
observed, the artist was "practicing fairyland fiction on an 80-year-old
house"). Filling it with his growing collection of antique American
glass, ceramics, silver, and furniture, he approached the decoration of
East Court Street with the eyes of a curator. Wood had been an avid col-
lector for most of his life; in 1930, for example, the *Des Moines Tribune-*

Exterior of 1142 East Court Street, Iowa City. Wood lived in this restored
pre–Civil War home from 1935 to 1942.

Capital had reported that his studio at Turner Alley was "crammed with quaint bits of pottery . . . and curios." With greater success in the mid-1930s, the painter became more selective concerning the period and quality of the pieces he collected—and consequently, more serious about the historical accuracy of the environments he created.

❧ Abandoning the folksy eclecticism of his Cedar Rapids studio, Wood decorated his Iowa City house with far less whimsy. (Turner Alley's corn-bushel fireplace hood and coffin-lid doorway, it seems, had gone the way of his overalls.) Wood's expanded collection and its new context were less related to Turner Alley, in fact, than they were to the pseudo-Victorian quarters of the Society for the Prevention of Cruelty to Speakers. East Court Street's interiors represented a far greater sense of refinement than the speakers' club (and none of its sense of humor), but they too allowed Wood to play new roles. No longer Cedar Rapids' eccentric, boyish artist, here he became Man of the House and Distinguished Iowan.

Wood's collection of mostly nineteenth-century American items—ironstone ware, amber and flint glass, majolica, willowware china, and Empire-period furniture—reflected his period's keen interest in Americana. Beginning in the 1920s and gaining momentum during the years of the Great Depression, the colonial-revival movement had inspired such high-profile projects as the restoration of colonial Williamsburg and the inauguration of the Metropolitan Museum's American period rooms. To assign Wood's collecting solely to colonial-revival nationalism, however, would be a mistake—for in his decorating, as in his paintings, the personal always eclipsed the patriotic.

Threaded throughout Wood's collection were items intimately connected to his family's history: a Gothic-revival mantel clock, family jewelry, tintype albums, engraved silver spoons, his grandmother's china, and such deeply personal items as Maryville's eyeglasses and Hattie's mourning veil. Augmenting this collection with new pieces, Wood assembled an idealized representation of his childhood—one every bit as selective and incomplete as his autobiography (the contract for which, it so happens, Wood had signed the year he purchased the house in Iowa City). In the tableaux vivants he assembled at East Court Street, Wood demonstrated his worthiness to carry on his family's legacy, despite his failure to meet the more standard expectations of married life and fatherhood.

To defuse the potentially effeminate associations of collecting, the press often presented Wood's decorating as an activity he shared with his wife. The *Des Moines Register* claimed, for example, that Wood and Sara were both "enthusiastic collectors of flint glass" (its front-page photo shows them admiring a covered candy dish), whereas *American Home* insisted the Woods' decorating sensibility reflected "the memories of a farm boy and girl who left their rural Iowa homes years ago to become artists." The real nature of the couple's collaboration was probably more unconventional. Sara was an enthusiastic remodeler—on her farm, she had single-handedly torn down plaster walls and refinished her own floors—yet she had little patience for antiquing. Wood's interests ran in the opposite direction; as Garwood puts it, he was "a handy man, though not in the ordinary sense—he was called in only when an artistic touch was required." Acknowledging the couple's combined gifts, the *Cedar Rapids Gazette* declared that between husband and wife there "was an extraordinary community of taste."

No one found the new "community" of East Court Street more extraordinary than the artist himself. Whereas Sara had spent her childhood in relatively grand surroundings, and had been married once before, Wood seems to have found the scale of his new home nearly as disorienting as his new role within it. Even the pleasure he once took in entertaining seems to have been muted by the unfamiliarity of his new surroundings. "He was used to a studio with low sloping roofs and dormer windows," Garwood writes, "and to his mother, who didn't move around much. Sometimes when his [Iowa City] house was full of guests, passers-by would see him standing behind a corner of the house, hatless, with his suit coat turned up if the night was cold, having a cigarette or a highball by himself."

The dislocation Wood seems to have felt in his new home was only compounded by his decision to separate his living and studio spaces in Iowa City—a change that held profound consequences for his work. Given the extraordinary productivity of his Turner Alley years, and the glacial pace of his work in the mid-to-late 1930s, it appears that Wood derived a great deal of his inspiration from living with his paintings while working on them. As he confided to Nan toward the end of his life, "Things worked out best for me in the [Turner Alley] studio, where I lived, ate, slept, and worked all under one roof and mom did the cooking." Not only had the artist been surrounded by his works-in-

progress at Turner Alley, but also by the small collection of works that he kept for himself. Almost as much as Nan and Hattie themselves, these paintings had served as the artist's muses and companions.

Among these works, the most important was his *Portrait of Nan*—a painting Wood not only refused to sell, but also kept from his sister (for whom it had ostensibly been painted as a gift). Following Nan's departure from Turner Alley, her portrait had effectively functioned as her surrogate, providing a stable and comforting reminder of the continued integrity of "we three." When the painting was installed at East Court Street, its power considerably increased. The sole example of the artist's work to hang in the new house, *Portrait of Nan* now stood in for the entirety of his oeuvre—a position Wood physically reinforced by the central position he chose for the work.

Placed above the living-room fireplace at East Court Street, Nan's portrait exercised full command over its new setting. Not only did Wood repeat the portrait's rose-and-green palette throughout the room's décor, but he also fitted its windows with curtains to match the one seen in the painting. In selecting furniture for this room Wood chose painted Hitchcock chairs like Nan's, as well as several pieces intended to echo the painting's unusual shape—including an oval coffee table, smoking stand, and mirror. Beneath the painting, Wood placed a lounge chair and ottoman of his own design. Reading, smoking, or receiving visitors here, he always did so beneath his sister's penetrating gaze.

However galling Sara might have found Nan's presence at East Court Street—whether in painted or actual form—she was far more troubled by Hattie's *absence* from the house. Following the death of the artist's mother, Sara writes, "I suggested to Grant that perhaps my work was finished as far as he was concerned, for I had no illusions, by that time, that Grant was really in love with me. I had filled a need in his life, and it seemed to me that with the passing of his mother, that need was non-existent." Sara had always known, of course, that the delicate balance of her marriage required its triangulation against her mother-in-law. Without this buffering presence, Sara now found herself face-to-face with a man who, as she later explained, "had no conception of what a wife's need for a husband constituted." In the end, Wood persuaded Sara to remain. "Only the gods know," she writes, "whether I did the right or the wrong thing."

Grant Wood and Nan Wood Graham, c. 1939, seated
beneath her 1931 portrait in Iowa City

When Sara's daughter-in-law Dorothy wrote to her that fall, sug-
gesting that she and Sherman move in with the Woods, the idea
appears to have been met with a palpable sense of relief. "In talking
over the situation with Grant," Sara recalls, "he was most enthusiastic
about their coming, suggesting they have [Hattie's former] apartment
upstairs, and their dinners with us." It was a decision Sara would
deeply regret. "At no time had I considered that . . . my son could in
any way affect my life with Grant," she confessed, adding that after the
Maxons' arrival, "I discovered why Grant was so desirous of having
them with us."

• Sara's handsome, twenty-eight-year-old son formed an immediate
and mutual bond with the artist. Attentive and financially generous to
Sherman, Wood even considered legally adopting him—an offer that
not only reflected the artist's new sense of himself as head of the house-
hold, but also appears to have had Sherman's enthusiastic support.

Expressing surprise at the pace of Wood's intimacy with her son ("I had no idea that Grant's interest would be so spontaneous," Sara writes), she soon felt more threatened than comforted by Sherman's presence.

● Although Sara would later complain more pointedly about Dorothy's influence over Wood, her jealousy concerning Sherman and her husband had a far more plausible foundation. First, given Wood's lifelong attraction to dependent young men, it is likely that his attention to Sherman contained an undercurrent of sexual attraction (however unrequited these feelings might have been on Sherman's part). Second, there is ample evidence that Sara's son exploited Wood's affection for him at her own expense, for both emotional and financial reasons. As his mother later wrote of this period, "There are those who played their cards as they thought [Wood] wanted them played."

The year after they moved into the house at East Court Street, Sherman and Dorothy modeled for Wood's illustrated edition of Sinclair Lewis's *Main Street.* The resulting images, which deviate in important ways from the characters upon which they are based, indicate the new tension Sara sensed in the household. In *The Radical,* Wood's illustration for the character Miles Bjornstrom, Sherman appears not as Lewis's ragged, disaffected intellectual, but as a caricature of rugged masculinity. Wearing a heavy sheepskin-lined coat and hunting cap, he stands in a toolshed and brandishes a rather phallic-looking wooden baton. With his broad shoulders, muscular neck, and exaggerated mustache—a feature neither Lewis's character nor Sherman shared— this über-masculine figure is more Tom of Finland than the bookish Scandinavian of Lewis's novel.

Wood's depiction of the novel's sympathetic protagonist, Carol Kennicott, portrays Dorothy in an equally revealing way. In *The Perfectionist* Dorothy stands with her arms folded, casting a suspicious and appraising eye on the viewer—a look of hauteur subtly undercut by the missed button on her dress. Rather than suggesting Lewis's tireless promoter of culture and aesthetics, this figure appears small-minded and hypocritical. Her sidelong glance suggests judgment rather than judiciousness. Given Wood's close relationship with Sherman, it is tempting to see here an echo of Vida Hanson—who had resented, as Dorothy herself might well have done, Wood's overenthusiastic friendship with her husband.

In another telling figure from this series, *Sentimental Yearner,* Wood

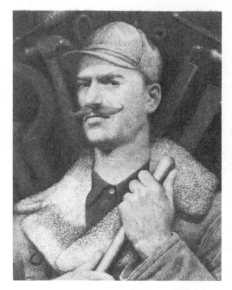

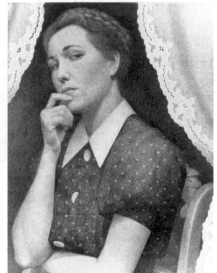

In 1936 Sherman and Dorothy
Maxon posed for Grant Wood's *The
Radical* (left) and *The Perfectionist*
(top right). *Sentimental Yearner* (lower
right), part of the same *Main Street*
series, may have been a self-portrait.

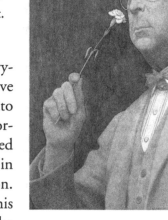

transforms *Main Street*'s poetry-
reading Guy Pollock—a sensitive
yet hardly effeminate figure—into
an Aesthetic-Movement fop. Por-
trayed by Wood as a middle-aged
dandy, Pollock rolls his eyes in
reverie over a pale, pink carnation.
Not only does Wood invent this
detail, but he also subtracts the
character's mustache—a feature that, to the artist's mind, must have
suggested a contradictory element of masculinity. Further underscor-
ing Pollock's preciousness, Wood links this figure to popular caricatures
of Oscar Wilde. Whereas Wilde was often shown in similar transports
over a lily, however, Pollock's figure swoons over a cheap and scentless
flower. His provincial aestheticism is no more than impressive, it would
seem, than the anemic bow tie that he wears.

❧ Wood's colleague Charles Sanders modeled for *Sentimental Yearner*, yet the illustration comes close to a self-portrait. The figure's wire-rim glasses, receding hairline, and sentimentality all point to Wood, just as surely as Lewis's description of Pollock—whose love for poetry and theater mirror the artist's own tastes. No one would have recognized these parallels more forcefully than Wood, who appears to have created a smokescreen around himself by turning Lewis's character into a stereotypical "fairy." If he is the director of this satire, so the logic goes, how could he embody its object?

The oppositional "types" represented by *Sentimental Yearner* and *The Radical* reflect a rather broad theme in Wood's work. Couched within the framework of country versus city, simplicity versus sophistication, or past versus present, the artist's "narratives of confrontation," to use Wanda Corn's phrase, reveal not only his feelings of dislocation as a child, but also his chronic preoccupation with a more crucial distinction: masculinity versus effeminacy. Indeed, according to Eve Kosofsky Sedgwick, nearly *every* defining "pseudo-opposition" in the modern era—urban versus rural, bohemian versus bourgeois, modern versus traditional—boils down to the same homosexual-versus-heterosexual binarism.

The thematic polarization in Wood's work mirrors the oppositions in his public identity. Was he a painter or a farmer? A modern or a reactionary? Lord of the manor or man of the people? Was he, in the end, Emmeline Grangerford or Huckleberry Finn? Wood complicated the question by continually satirizing and distancing himself from that which he insisted he was not: a Victorian, a dandy, or an elitist. In a pair of drawings from 1933 entitled *Draft Horse* and *Race Horse,* for example, Wood juxtaposes hearty rural masculinity with a scene of preening urbane refinement. *Draft Horse* pairs a powerful, thick-limbed workhorse with a correspondingly sturdy farmer in overalls (a figure for which Carl Flick may have modeled); its contrasting image, *Race Horse,* presents a whippet-thin, rather fey jockey who parades an equally delicate horse before a filled grandstand. Unlike their country counterparts, the race horse and the mincing jockey are not only suspiciously aware of their own beauty, but also artificially removed from their "natural" roles. If traditional interpretations suggest this pairing simply celebrates rural values at the expense of urban sophistication— a juxtaposition Wood explored in a more complicated fashion in 1931's

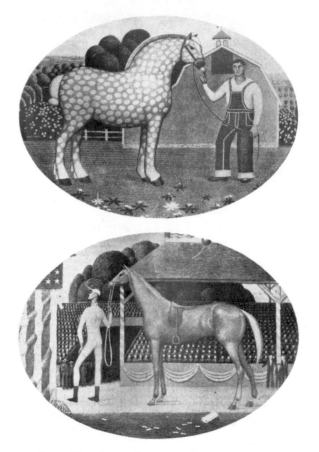

Grant Wood, *Draft Horse* and *Race Horse*, 1933

Appraisal—then we must also consider how these "values" reflect the artist's notion of what it meant to be a man.

• A similarly coded example of this preoccupation appears in Wood's paired lithographs, *Wild Flowers* and *Tame Flowers*. Created following his *Main Street* illustrations, these images contrast wildflowers in a rocky, overgrown setting with an arrangement that includes pansies in a clay pot. Given the inevitable association between homosexuals and pansies, *Tame Flowers* presents the same "unnatural" cultivation and preciousness seen in the jockey and race horse. For men like Wood, moreover, who had been taught to cultivate the "rough, manly virtues" Teddy Roosevelt had celebrated, the difference between "wild" and "tame" bore unavoidable gender implications—as did this floral subject itself. As Wood himself told an audience in 1939, boys properly

considered painting flowers "sissy stuff" and should therefore be encouraged to depict "some form of transportation, sports, or scenes of the Wild West."

Casting a note of suspicion on Wood's tinted flower lithographs, the *Iowa Press-Citizen* suggested he had revived the genre of the "gay print." Although use of the word "gay" in this context does not project the full impact of its contemporary meaning, the term was still linked to notions of effeminacy—particularly in its evocation of the nineteenth century's Gay Nineties. Not only was this period associated with morally suspect behavior, but its culture was also considered problematically urbane. In 1934 the *Minneapolis Tribune* speculated, for example, "There's a suspicion that in the 'Gay Nineties' the boys began to discard the good old reds [flannel underwear] for some of the sissified furbelows of later days."

In their connection to Wilde and the Aesthetic Movement, lilies conjured effeminacy even more powerfully for this generation than pansies—a link that calls us to reconsider Wood's *Lilies of the Alley* sculptures from the mid-1920s. In these works, the artist fashioned the gears and wires of machine parts (possibly collected from the J. G. Cherry plant, where he was then painting) into a floral arrangement that recalls Wilde's cult of beauty even as it points to Wood himself (who was, indeed, the only "lily" to be found on Turner Alley). The works' title is a pun on lilies-of-the-valley, flowers that symbolized "the return of happiness" for the Victorian era; joyous indeed, and created at

Grant Wood, *Tame Flowers*, 1938

Grant Wood, *Lilies of the Alley*, 1925

a clearly happy time in the artist's life, these brightly painted sculptures provide a rare example of Wood's successful integration of wild and tame, nature and culture, masculine and feminine, industrial and organic, as well as heterosexual and homosexual. They are not "either/or," but "both/and."

Nowhere is Wood's divided identity more clearly reflected than in his 1934 book jacket designs for the writer Vardis Fisher. If critics considered Wood's collaboration with Sinclair Lewis a perfect pairing of talents, then his partnership with Fisher demonstrates an even more appropriate meeting of minds and subject matter. Fisher's bizarre, psychologically dense novels are a world apart from Lewis's gentle parodies of small-town life, yet in their Gothic exploration of dual identity they approach a much closer approximation of Wood's own work and life. Clearly struck by Fisher's work, the artist not only completed two jacket covers for him (Wood worked with no other writer on multiple projects), but he also employed a surrealistic style unlike anything else in his mature career. Wood's designs for Fisher hardly represent the finest examples of his work—nor were Fisher's oddball novels, it must

be said, his proudest achievement—yet they illustrate a rare, and important, instance in which he explored the divide between public and private identity.

Born in rural Idaho in 1894, Fisher was raised by a distant, physically powerful father and a mother who encouraged his talent for writing. Fisher's biographer writes that, following Fisher's abandonment of the Mormon faith at eighteen, the writer experienced "a major emotional crisis involving a sexual conflict" that worsened as he grew older. Married to Leona McMurtrey shortly after completing graduate school at the University of Chicago, Fisher was deeply unhappy in the marriage—as was his wife, who eventually committed suicide. Despite his inability to live a life "without pretense," the writer proved to be remarkably candid about his sexual struggles in his novels.

Fisher's four-part "Vridar Hunter" series, for which Wood designed the first two book jackets, presents a thinly veiled account of the author's life. Speaking through his alter ego Vridar, Fisher explains in the first novel—entitled *In Tragic Life*—that "[he] was assured, again and again in a later time, that he was a remarkable child. He distrusted these tales, suspecting they were largely the seed and growth of a mother's wish." Vridar, the tortured farmboy-turned-author, struggles not just with his vocation, but also with a split personality: one side is a cowering simpleton, and the other, a crafty and highly sexualized sophisticate. "So divorced . . . were the two personalities within him," Fisher writes in the first novel, "that the one hardly knew what the other did. The one was sunk in weariness but the other still plotted."

A "morbid introvert," Vridar seeks salvation through "autocorrectivism"—a technique that Fisher's brother Vivian, a psychoanalyst, had written a book about. Achieving a measure of success with this treatment, Vridar eventually marries Neloa, the stand-in for Fisher's wife Leona. ("When far from her," Fisher writes of the sexually ambivalent Vridar, "he could mark the danger zones.") Like Vridar, Neloa has both a wholesome and a sexually corrupt nature; unable to reconcile the two, she (like the real-life Leona) ultimately commits suicide.

Although initially considered too racy for publication, *In Tragic Life* did not even achieve a succès de scandale. Wood's decision to work with Fisher again on the next installment in this series is therefore remarkable—especially considering the more prestigious illustration work he turned down in this period. Wood may well have felt an affin-

ity with the character of Vridar, whose psychosexual struggles provide one of the period's franker explorations of the closet, and whose rural upbringing and conflicted sense of artistic vocation echo his own in rather powerful ways.

● At the base of Wood's jacket illustration for *In Tragic Life*, the blond farmboy Vridar holds his face in his hands, staring through the viewer as if in a trance. Around this figure, Wood depicts the boy's nightmarish vision. At the center are the disembodied heads of Vridar's glowering, square-jawed father and long-suffering mother (figures clearly indebted to *American Gothic*), superimposed against the spine of a Victorian Bible. Below this grouping Wood illustrates a second, cringing adolescent—clad in overalls—who covers his face in shame. In the upper-right-hand corner of the composition, a couple is locked in passionate embrace. Of this pairing, we see only the powerful back of a man and the encircling arm of his partner; next to them, a figure regards the viewer directly, leering and pointing toward the couple.

Filling in the rest of this crowded scene are a series of alternately threatening or horrified faces, some floating hand tools, and farm animals Wood appears to have borrowed from the Quaker folk painter Edward Hicks. The image is compositionally awkward, yet of all the work Wood had undertaken so far, it provides the most literal translation of his inner conflicts. As he would later do with Lewis's work, Wood clearly refracts Fisher's novel through the lens of his own experience—a correction that, in this case, required far less maneuvering.

The cover that Wood designed for Fisher's second novel in the series, *Passions Spin the Plot*, portrayed the two sides of Neloa's split personality (and by extension, Vridan's) in a joined double portrait. On the left, Wood presents Neloa's public side: a beautiful young woman with long, straight hair and an expression of appealing innocence. On the right, he depicts the sexually corrupt, "inner" Neloa: haggard, heavily made up, and coiffed in marcelled waves—the same hairstyle Nan wears in her portrait, and the one he had asked her to remove for her more straight-laced portrayal in *American Gothic*.

The idea for this bizarre, conjoined image had first occurred to Wood in the early 1930s. Inspired by bootleggers who operated across the street from Turner Alley, Wood told Nan he planned "to paint a double-faced man. One side would be a minister, and the other side

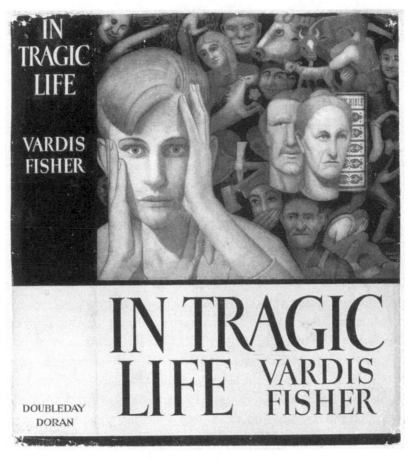

Grant Wood's 1934 jacket design for
Vardis Fisher's novel *In Tragic Life*

would be a gangster" (another combination, therefore, of an innocent, law-abiding persona masking a threatening or criminal private one). Wood eventually abandoned the idea at the request of his mother, who believed "it was one thing to stir up the ire of farmers, but quite another to antagonize gangsters." More perceptive than she realized, she observed that her son "had so many irons in the fire it was too bad *he* wasn't twins."

In her insightful analysis of *American Gothic,* Nancy Marshall perceives similarly split personalities within the individual faces of Wood's farming couple. The complexity of this painting, she offers, rests partly in the viewer's inability to read the sitters' true natures. "With each fig-

ure," she writes, "covering up the well-lit left side of the face produces a more forbidding or hostile visage, while covering the right, shadowed side provides a more innocent and open impression of the characters. In this way, two very different personalities are suggested for each character." Here and in Wood's illustration of Neloa's dual nature, we see the widening split that ran through the artist's own character.

In late 1935, two widely published essays highlighted the strict divide between Wood's public and private identities: the regionalist manifesto "Revolt Against the City" and Benton's blistering critique of the American art scene, "Farewell to New York." If Wood's Ferargil Gallery show had demonstrated the deepening fault lines between the artist and his New York critics, then these essays demonstrated the ever-narrowing ideological gap through which he was forced to pass. Called to prop up the regionalist cause at all costs, Wood found himself supporting not only views that ran counter to his own beliefs, but ones that were also personally prejudicial.

Published the year after Wood's appointment to the University of Iowa faculty, "Revolt Against the City" was long considered to be the artist's most eloquent and persuasive presentation of regionalist philosophy. In truth, however, the essay was ghostwritten by Wood's colleague and SPCS co-founder, Frank Luther Mott—who published the pamphlet as the first installment in his "Whirling Wind Series," a project intended to showcase the work of regionalist writers. Mott's authorship was known to many in Wood's inner circle, including Nan, who perceptively observed, "Revolt was not part of [Grant's] nature." (Neither, it seems, was sound judgment; the artist appears to have lent his name to the project as a personal favor to Mott.)

Repeatedly in this polemic, Mott declares New York and all "Eastern seaport cities" inimical to the development of American art. Wood himself had never made any such claim. As demonstrated by his admiration for the urban "regionalist" Reginald Marsh, Wood's own brand of regionalism simply called for artists to portray the environments they knew best. Although he might have agreed with Mott about the undue influence of Paris (ironically, given Ferargil Gallery's vested interest in regionalism, Mott blames the success of French modernism on the greed of New York galleries), he certainly did not share his colleague's animus toward New York or the East. Indeed, Wood knew he owed much of his success to urban dealers and patrons—audiences

who were far more invested in his evocations of a bygone America than those living in the real Midwest of the 1930s.

• Not only did Wood's regionalist philosophy make no distinction between urban and rural environments, but it also avoided Mott's values-laden rhetoric. Mott's essay claims, for example, that the Great Depression had led to a rediscovery of "frontier virtues": rugged individualism, patriotism, and "Anglo-Saxon reserve." He praises the rural (and more specifically, the midwestern) American for rejecting the "intimacies," "artificial values," and dangerous "cosmopolitanism" of the city—and for dismissing its corrupt, expatriate icons. "Gertrude Stein," he writes, "comes to us from Paris and is only a seven days' wonder." (It must be remembered, of course, that Mott was among those who had invited Stein to Iowa City.) Casting his glance backward, Mott even declares that rural America had *always* held a monopoly on patriotic virtue. Large cities, he writes, were from their very founding "far less typically American than those frontier areas whose power they usurped." If Wood's association with Craven's similarly strident rhetoric compromised critics' perception of him, then in this case the damage was far greater. As late as the 1970s, scholars continued to cite Mott's words as the artist's own.

Even more troublesome for Wood, in an immediate and personal sense, was Benton's "Farewell to New York"—a homophobic diatribe that placed him in a deeply uncomfortable position as Benton's comrade-in-arms. Not only did Benton's rhetoric exacerbate negative stereotypes of homosexuals in the art world, but it also forced Wood to passively endorse his bigotry. Rendering "Revolt Against the City" rather tame by comparison, this 1935 essay declared New York City had "lost its masculinity" since the start of the Depression; Benton placed the blame for this situation on the intellectuals, Marxists, and homosexuals he believed had overtaken the American art scene. It was for the last category, naturally, that he reserved his most vitriolic language. New York, he claimed, had been thoroughly polluted by

> the concentrated flow of aesthetic-minded homosexuals into the various fields of artistic practice . . . Far be it for me to raise my hands in any moral horror over the ways and tastes of individuals. If young gentlemen, or old ones either, wish to wear women's underwear and cultivate extraordinary manners it is all right

with me. But it is not all right with the art which they affect and
cultivate. It is not all right when, by ingratiation or subtle con-
nivance, precious fairies get into positions of power and judge,
buy, and exhibit American pictures on a base of nervous whim
and under the sway of those overdelicate refinements of taste
characteristic of their kind.

Leaving behind the "lisping voice and mincing ways" of the eastern
art establishment, Benton declared his intention to return to his native
Midwest. "The people of the West are highly intolerant of aberration,"
Benton explained in admiring tones, "[and] in the smaller cities, there
are no isolating walls of busy indifference where odd manners and cults
can reach positions of eminence and power." Taking his cue directly
from "Revolt Against the City," Benton proclaimed that in these laud-
ably intolerant small towns, "the promise of an artistic future seems to
lie. The great cities are dead."

In the face of Benton's rant, Wood—who was only too aware of the
Midwest's lack of "isolating walls"—had little choice but to maintain
the united front of regionalism. Indeed, in many ways the ideological
weight of the movement lay heaviest on him. His fellow regionalists
were well aware of the credibility Wood's background lent them—
witness the speed with which Curry donned his Stone City overalls—
and they depended upon him to support their increasingly aggressive
rhetoric. Although Wood made no comment on Benton's essay at the
time of its appearance, he was compelled to address it in his review of
Benton's 1937 autobiography, *An Artist in America*.

Wood cautiously hints at the injudiciousness of Benton's remarks,
yet he ultimately—and heartbreakingly—repeats his connection
between "parasites" and "homosexuals." Wood writes that "Benton has
included a blistering, and, I believe, healthful commentary on present-
day art and intellectualism," and

has a great deal to say about the parasites and hangers-on of
art in general, with their ivory-tower hysterias and frequent
homosexuality. Perhaps Benton has not been just in everything
he has said. I do not know. But I do know that he has brought
out into the open things that ought to be discussed frankly and
sincerely.

The last thing Wood needed in 1937, of course, was for the topic of homosexuality in American art to be brought out in the open—especially given the close relationship he had developed, in the preceding two years, with the man who served as his personal secretary.

IT WAS SARA WHO originally suggested hiring Park Rinard. The year she and Wood were married, Doubleday had contracted the artist to write his life story; leery of her husband's writing abilities, Sara urged the publisher to find a ghostwriter for the project. On her advice Doubleday hired the twenty-three-year-old Rinard, a former bookkeeper who had recently enrolled in the creative-writing program at the University of Iowa. Wood, who appears to have known Rinard prior to the move from Cedar Rapids (how or when the two men met is unclear), enthusiastically endorsed Sara's proposal. "This [writing] arrangement seemed to necessitate taking Park into our home to live," Sara writes, "a circumstance which I was later to regret very much." Once the decision had been made, she recalls, "my sixth sense more or less gave me an impression of what was to follow, that this present set-up in our home was not as ideal as it appeared to be on the surface."

The "set-up" at East Court Street had, indeed, become increasingly bizarre—for Rinard had joined the household on the heels of Sherman and Dorothy's arrival. Already threatened by her son's relationship with her husband, Sara claimed that the addition of Rinard made her feel as if she were "sitting on top of a volcano." Attempting to make sense of the situation from a later date, she explained: "In a way, this may be said to have been the beginning of an end to a period in my life that promised so much . . . In retrospect, I realize that a situation over which I had no control later on was at that time taking form." As for Rinard and Wood's literary collaboration, Sara made the following semi-opaque observation: "The book was never completed, and it is understandable that it was not. My sister Phoebe, who understood conditions much better than I, begged me not to marry Grant. Later I realized why."

• It is hardly surprising that Wood's relationship with his secretary developed as quickly as it did. The attractive and energetic Rinard (or "Parkus," as Wood affectionately called him) shared the artist's love for Iowa history and the fine arts, as well as his passion for gardening;

although Wood was more than twenty years Rinard's senior, their birthdays, just five days apart, were a cause for mutual celebration at East Court Street. Much like Wood, Rinard was a self-effacing and deeply private man—but he was also clear-minded and efficient in ways the artist was not. By the end of his first year at East Court Street, his duties had expanded to include managing Wood's schedule, writing his speeches, modeling, and acting as a liaison between the painter and his agent in New York. (Rinard referred to himself as Wood's "general utility man.") Profoundly capable and unflaggingly loyal, he would be Wood's mainstay for the last seven years of the artist's life.

• The suspicions Sara harbored about Rinard's relationship with her husband, and the whispering campaign that it eventually fueled at the University of Iowa, beg the question: did it ever have a romantic dimension? For Wood's part, at least, the relationship undoubtedly involved a measure of sexual attraction. From the 1920s onward, of course, the artist had fallen for a number of similarly youthful, slight-framed male protégés—from Marcel Bordet to Arnold Pyle to Sherman Maxon. In each of these cases, as in Rinard's, Wood had sublimated his romantic interest through intense, fatherly affection. (Indeed, even in the stories he told of his youthful blackmailer, the artist had characterized the mystery man as a would-be "son.") Rinard could hardly have been unaware of Wood's attraction to him, yet it is doubtful he ever reciprocated the artist's interest in the same way. There is no evidence prior to his meeting Wood, and certainly none after the artist's death, that points to his sexual interest in men.

⌐ That Rinard later married and fathered children is in itself no proof that he was fundamentally heterosexual, yet other factors in his later life do suggest this likelihood—not least of which, if somewhat counterintuitively, was his advocacy of gay and lesbian civil rights when he served as a congressional advisor in the 1970s. Rinard's bold adoption of such an unpopular position would hardly indicate he was closeted himself (quite the reverse, in fact), yet the passion with which he supported this cause suggests it was an issue close to his heart. Knowing Wood as well as he did, Rinard was keenly aware of the battles the artist had faced as a closeted man—and of the threat that his own presence constituted in Wood's life.

Considering Rinard's role as the artist's ghostwriter, we are faced with another important question: to what extent does *Return from*

Grant Wood dictating a letter to Park Rinard at
1142 East Court Street, late 1930s

Bohemia reflect Wood's own voice? Rinard's unfinished manuscript for the book, written between 1935 and 1939, differs in clear ways from Wood's more straightforward, folksy style. Indeed, in certain passages, the work's high-flown language is as foreign to Wood's approach as the academic rhetoric in Mott's "Revolt Against the City." Yet the very nature of this project depended, unlike Mott's, upon extensive interviews with the artist and a close examination of his life, opinions, and relationships. The words may be Rinard's, then, but the memories and impressions are clearly Wood's.

Many of the stories Rinard includes either bear the traces of frequent repetition—he appears to have distilled a Woodian "canon" from the artist's favorite yarns—or they involve a scene of such bizarrely personal dimensions that, in either case, we hear the artist's halting, childlike voice clearly over Rinard's more fluid style. The abrupt end to the manuscript is perhaps the most powerful indication of Wood's intimate involvement with its writing. Rinard was fully capable of fleshing out the details of the artist's post-Anamosa life himself, yet he was com-

pelled to stop his work at precisely the point where Wood could no longer proceed.

Rinard had greater success in managing Wood's speaking career. Given the increasing demands of the lecture circuit, and his chronic fear of speaking in public, Wood could scarcely have managed these performances without his secretary's support. Sue Taylor rightly claims that "one of Wood's most fascinating productions is the persona he crafted for himself on the lecture circuit"—yet it was Rinard who directed and scripted Wood's role as the home-proud, reconstructed Bohemian. Not only did he act as the artist's booking agent and speech writer, but he also traveled with him to lend moral support. The frequency of these out-of-town speaking engagements illustrates Wood's commitment to spreading the gospel of regionalism (however ventriloquized his speeches may have been), yet we must also consider the other attractions of Wood's life on the road. The long absences from Iowa City naturally offered the artist more time alone with Rinard, and less with Sara.

The very freedom with which Wood cultivated this relationship, of course, had been made possible by the protection his marriage and regionalist fame offered him. When *Life* covered a 1938 costume ball that the regionalist trio attended, for example, the magazine prominently featured a photograph of the artists' wives alongside a separate image of Benton, Curry, and Wood posing with a group of scantily clad female attendees. In the caption beneath this second image, the magazine declared: "Three top-notch American artists had no trouble finding congenial company at the Kansas City ball."

This mildly risqué photo is also a rather revealing image (if not in the way *Life* intended). In the front row sit Curry and Benton, each with a pair of costumed women on his lap. Curry sits with his legs splayed and arms confidently encircling his companions' waists, whereas Benton lecherously mugs for the camera, gazing heavenward in an impression of Groucho Marx. At the rear of this group stands a visibly uncomfortable Wood. Bearing an awkwardly strained smile and drawing his shoulders up, he casts his eyes away from the camera. The image and its caption are not only a striking illustration of the sexual role the press demanded from Wood, but they also indicate the extent to which Benton—the self-acknowledged ringleader of what the *Kansas City Star* called "an orgy in the worst sense of the word"—had taken control of the movement's stridently heterosexual image.

John Steuart Curry, Thomas Hart Benton, and Grant Wood (standing)
at the 1938 Beaux Arts Ball in Kansas City

Wood's busy schedule of public appearances in these years took a
heavy toll on his productivity. In the first painting that he undertook
after Hattie's death, and the only one to survive from his four-year mar-
riage to Sara, the artist turned resolutely back to the escapist, sensual
landscape style he had first produced after his return from Munich.
Completed in 1936, *Spring Turning* (see color plate 21) is arguably the
most erotically charged landscape Wood ever painted—a powerful indi-
cation of the amplified sublimation his new life appeared to require.

Spring Turning presents a verdant, springtime landscape in the form
of two monumental earth swells. Rendered in vibrant green and out-
lined in dark squares of exposed brown earth, these pneumatic hills are
profoundly sculptural and immaculately smooth. The composition
borders on pure abstraction, and yet it conveys the unmistakable form
of a human body. The implicit eroticism of this landscape—an image
Wanda Corn rightly describes as positively "swelling and breathing
with sexual fullness"—produces an even stronger subliminal charge
than Wood's earlier landscapes; the source of the work's sensuality,

however, forces us once again to consider Wood's likely preferences. Corn may perceive in these massive contours the "rounded thighs [and] bulging breasts" of a recumbent, fertile earth goddess, yet it is highly unlikely that the painter sought to celebrate the female body in this (or any) composition. Rather, he appears to have monumentalized the same muscular, male buttocks he first depicted in *Stone City*.

Wood makes it clear that we are looking at a backside—and a male one, at that—in several different ways. Not only does he indicate the triangular small of a back at the hills' apex (the sunlit field where we see cattle grazing), but he also includes a darkened creek mouth between these two swelling forms. That this is a man's body, rather than the reclining figure of an earth goddess, is indicated by the hills' boxy form and the deep, characteristically male hollow that appears alongside them. The square patterns of the plowed fields reinforce this silhouette, while also suggesting the outlines of stitched dungaree pockets—a feature that in this period would have suggested only men's clothing.

Spring Turning's erotic evocation of upturned buttocks summons the late nineteenth century's objectification of muscular male bodies—a phenomenon connected (however ironically) to the period's elevated standards of heterosexual masculinity. Beginning in the 1870s and gaining momentum toward the end of the century, American physical culture promoted exaggerated male musculature as the new masculine ideal; this emphasis led, in turn, to a popular subgenre of imagery—often clearly homoerotic—that highlighted the muscular development of the buttocks. Due to the Comstock obscenity laws, which banned images of frontal male nudity, bodybuilders like Eugen Sandow and other physical-culture icons from this period could in fact *only* be displayed nude from behind—a pose that not only appealed to homosexual viewers in a straightforward, "beefcake" sense, but also titillatingly suggested the model's exposed genitals on the opposite side.

It is impossible to calculate Wood's awareness of such images, yet it is important to consider the extent to which men's buttocks were fetishized in the imagery of his youth. Muscular backsides not only represented a physical manifestation of idealized, "real" manhood, but they also became (and for this very reason) a powerful new site of sexual objectification. *Spring Turning*'s hills isolate and monumentalize this form, whereas its title invites the viewer to "turn" this springtime fantasy over, revealing—in the mind's eye at least—precisely what

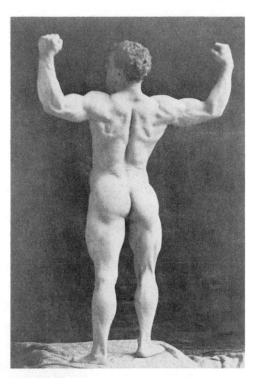

Eugen Sandow, photographed in
1893 by Napoleon Sarony

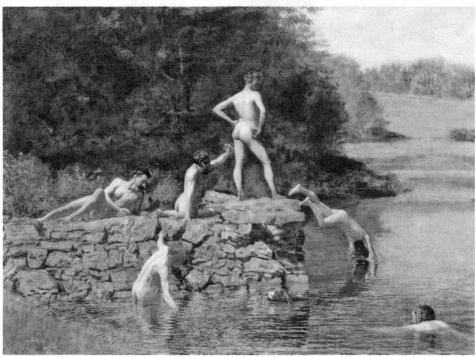

Thomas Eakins, *Swimming*, 1885

Sandow and other models concealed in their oblique poses. Simultane-
ously a target and a tease, the artist's hills emit a doubly powerful sexual
charge.

Considered as a reflection of springtime Arcadia, *Spring Turning*
belongs to a long tradition that sought to identify idyllic, pastoral land-
scapes with the youthful male body. In the generation of American
artists that preceded Wood's, for example, the painter Thomas Eakins
had famously—and even infamously—explored this theme in his 1885
work *Swimming*. By Wood's day, the six male nudes in *Swimming* were
interpreted as a lyrical conflation of man and nature; at a more funda-
mental level, however, the painting shares much of *Spring Turning*'s
implicit homoeroticism. In Eakins's painting, two mature men (one,
the artist himself) bracket the figures of four nude youths. At the cen-
ter of the composition stands Eakins's eighteen-year-old assistant, Jesse
Godley, whose exposed buttocks provide the work's primary focal
point. (Henry Adams writes that the composition revolves around
Godley's buttocks "like the hands on a clock face.") Wood's work, in
turn, manages both to disguise and magnify the same feature—
transforming the earth itself into the shape of youthful, male buttocks.

In Eakins's athletic, male imagery, Adams recognizes a world from
which women were notably excluded—a masculine utopia that we may
see, as well, in *Spring Turning*'s muscular swells. Indeed, in his autobi-
ography, Wood associates the very setting of this landscape with the
manly paragons of his childhood:

> I liked to stand on a crest of a hill and watch father or Dave
> Peters plowing in a field below. They guided the plow parallel to
> the sides of the rectangular field and progressed concentrically
> inward, cutting great square patterns with light stubble centers.

Given Wood's stint in Germany in the 1920s, we must also consider
his exposure to the Frei Körper Kultur, or "Free Body Culture," move-
ment that flourished under the Weimar Republic. Promoting the
youthful male body as a vehicle for nature worship, German magazines
such as *Der Eigene* often presented semi-erotic depictions of androgy-
nous youths in the guise of natural allegory. Wood himself employed a
similar strategy, no doubt independently, in his *Four Seasons* murals for
the McKinley library in 1920. In this series he presents the different sea-

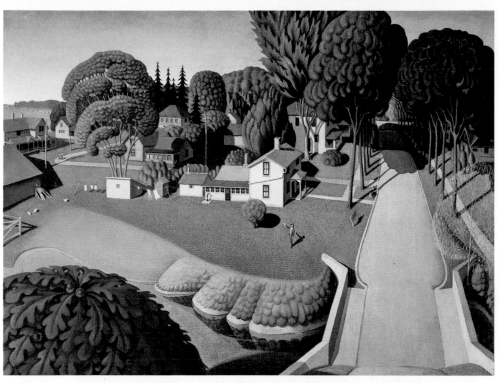

14 and 15. *The Birthplace of Herbert Hoover,* 1931 (above), and *Midnight Ride of Paul Revere,* 1931 (below). In these works, Wood demonstrates his peculiar — and often intentionally inaccurate — approach to historical subjects.

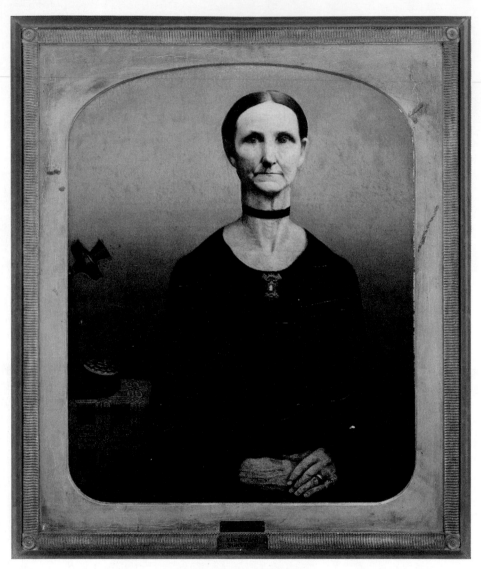

16. *Victorian Survival,* 1931.
Inspired by a velvet-lined tintype smaller than the image shown here,
this distorted portrayal of Wood's aunt Tillie appears slightly larger than
life-size. When compared with the more benign, bucolic imagery for
which he was better known — epitomized by the farmer seen at right —
the figure in this painting reveals a darker side of his imagination.

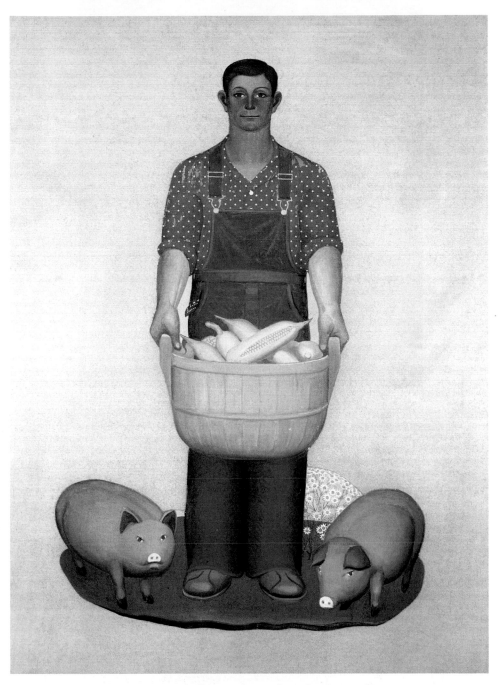

17. *Farmer with Corn and Pigs,* from the *Fruits of Iowa*
mural for the Hotel Montrose in Cedar Rapids, 1932.

18 and 19. *Portrait of John B. Turner, Pioneer*, 1928–30 (above),
established a formula that Wood repeated to comical effect
in *Daughters of Revolution*, 1932 (below). In both,
elderly and authoritarian "types" appear with prints
meant to reveal their inner character.

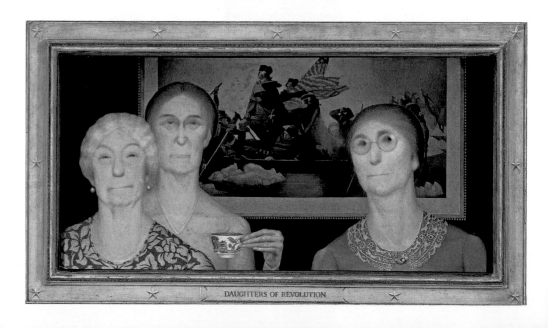

DAUGHTERS OF REVOLUTION

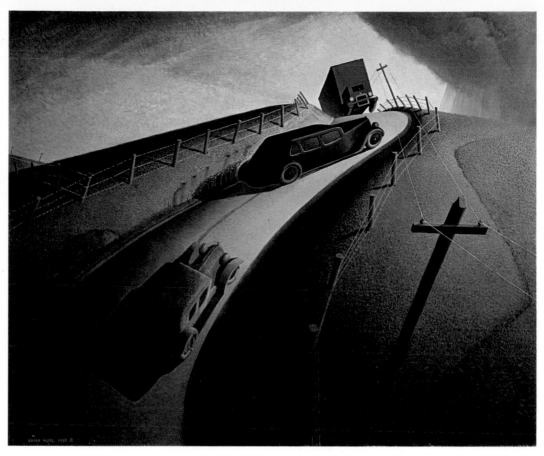

20. *Death on the Ridge Road*, 1935.
A world apart from artist's typically joyful landscapes, this scene portends
both natural and human disaster.

21. *Spring Turning*, 1936.

22. John Steuart Curry, *Kansas Cornfield,* 1936, the artist's "self portrait in vegetal guise."

24. and 25. Opposite page: *Parson Weems' Fable,* 1939 (top), and *Iowa Landscape/ Indian Summer,* 1941 (bottom). In these late works Wood returned to the scenes—and scenery— of his childhood.

23. *Near Sundown,* 1933. Purchased by the actress Katharine Hepburn, this landscape was inspired by another powerful woman: Wood's mother.

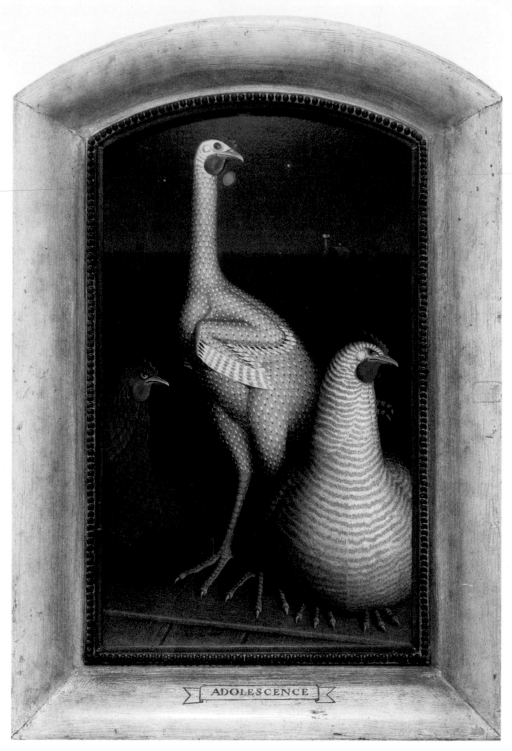

ADOLESCENCE

26. *Adolescence*, 1940.
Wood first conceived of this allegorical image in the early 1930s
but did not complete it until the end of his life.

sons as nude men of differing ages; *Spring,* the most eroticized figure of this group, features a nude youth who casts a shower of seed.

Wood's evocation of a nude male body in *Spring Turning* is more than just a metaphor about natural beauty, of course—it is an image of desire and even consummation. (As one reviewer noted, Wood "knows how to mold hill masses, and how to plow and plant them with rhythm.") Not only does the artist provide a clear target for our gaze— the darkened creek mouth between the two hills—but he also guides us here with the directional arrow of a plowed furrow; "These ruts which cut the hill slopes," Jay Sigmund wrote of Wood's work, "you have turned / To pulsing ribbon things." Indeed, the very scale of these hills invites viewers to lose themselves in the swelling forms. Such an insistent privileging of the homosexual gaze may explain the work's purchase by Alexander Woollcott, the flamboyant theater critic who wrote for the *New Yorker.* More perceptive than he realized, John Steuart Curry later cited Woollcott's patronage as proof that Wood "could make [even] the sophisticated urbanite see the beauty of a straight brown furrow behind a plow."

Whatever physical catharsis Wood's landscapes may have provided him, their style was also a genuine source of anxiety. The year before he painted *Spring Turning,* Wood confessed that his landscapes featured "too damn many pretty curves," yet he admitted, "I am having a hell of a time getting rid of these mannerisms." Not only did critics find Wood's abstracted style objectionable, but they also characterized his approach as stereotypically feminine—a charge that carried dangerous connotations for any male artist in this period, and one to which Wood was particularly sensitive. The *London Studio* claimed, for example, that the "frills and curves" of Wood's landscapes reflected the "purely decorative" look of china patterns; for his part, Craven described these works as "decorative, in the lighter sense of the term." By insisting these "sweetened" and "charming" works properly belonged only in "quaint drawing rooms," Craven further implied a troubling misalignment between the gender of the painter and the feminine (or effeminate) audience for such paintings.

Other critics took a darker view, claiming that Wood's style not only satirized the serious business of farming, but also represented a disturbingly *un*natural point of view. As Henry McBride wrote of *Spring Turning:*

[Wood's] satire goes too far, I think. He paints a *Spring Plowing* [sic] in which the hills resolve, under the plowman's touch, into vast checkerboard squares that are highly ridiculous. That is making fun of nature. Artists should not do that. It is all very well to poke fun at the Daughters of Revolution but you can't do that to anything so serious as spring plowing. Something will surely happen to Grant Wood. Wait and see.

McBride did not have long to wait. In the following year, ironically enough, it was one of Wood's most unflinchingly naturalistic works that landed him in trouble—including a public charge of indecency that nearly unraveled him.

IN HIS 1937 LITHOGRAPH *Sultry Night,* Wood presents a frontal male nude in an empty, moonlit landscape. Standing before a long watering trough, the figure raises a full bucket over his head and pours its water in a slow cascade over his body. In contrast to his tanned limbs, the figure's pale torso appears to glow in the moonlight—an effect that, along with the falling water, draws the eye to the figure's generous thatch of pubic hair and clearly articulated penis. Although the male nudes in Wood's earlier works had never raised concern, *Sultry Night* was condemned for both its frontality and realism—and also, no doubt, for the eroticism its composition and title imply. Given the lithograph's frank imagery and the extraordinary reaction it inspired, this otherwise minor work reveals a visible (and dangerous) faultline in the artist's previously unassailable public image.

Wood produced *Sultry Night* for Associated American Artists, a New York–based group founded by Reeves Lewenthal and Maurice Liederman in 1934. Created to support artists affected by the Depression, as well as to subsidize the public's access to original works of art, Associated American Artists sold limited edition prints through mail-order catalogues and department stores; production runs were limited to two hundred and fifty impressions, and the prints typically sold for five dollars or less. Marketing their venture as a patriotic enterprise, Lewenthal and Liederman employed only American-scene artists in the 1930s—including Curry and Benton, who joined Associated American Artists not long after its founding. In 1937, Wood, too, ended his long-

Grant Wood, *Sultry Night,* 1937

time contract with the Ferargil Gallery and signed on with Associated American Artists. Altruism and love of country were not the group's only motives, of course. American-scene artists significantly expanded their patronage under this arrangement, whereas Lewenthal and Lie-derman were able to capitalize on the movement's popular cachet.

Considering his sharply reduced productivity in this period, Wood appears to have been relieved by the opportunity printmaking offered. Not only had his paintings become extraordinarily time-consuming to produce—between 1936 and his death in 1942, he would complete only four major works—but Wood's personal and professional struggles had also cast a pall over his work. Following his visit to the Ferargil Gallery in 1937, John Selby noted: "The dealer who up till now has handled Wood's work sighed regretfully as over a lost lamb. 'Wood hasn't been painting lately,' he murmured in a gentle voice." If critics and Wood's former dealer were disappointed by this dry spell, however, the artist himself found the situation far more troubling. Throwing himself into

lithography, Hazel Brown later wrote, Wood "began carving stone with a concentration and determination seen in people who are 'working off a mad' . . . he literally dug into the stone as if his life—and peace of mind—depended on it."

Four of the five prints Wood produced in 1937 reflect subjects that audiences had come to expect from him. Three depict scenes of country life, including a new version of his 1932 oil *Arbor Day.* Another print, entitled *Honorary Degree,* recalled the satire of works like *Daughters of Revolution;* at the center of this image Wood includes a short and comically round self-portrait, flanked by two gaunt scholars who award him an academic degree. (That same year, Wood had received an honorary Doctor of Letters degree from the University of Wisconsin–Madison.) In a self-deprecating reference to his own fame, Wood included a central Gothic window over his own figure—a feature that inspired the work's unofficial title, "Scholastic Gothic."

The folksy nature of these 1937 prints only rendered *Sultry Night's* voyeuristic bathing scene all the more shocking. Declaring the work to be an example of pornography, censors at the U.S. Postal Service barred Associated American Artists from sending *Sultry Night* through the mail or featuring the image in its catalogues. (Notably, this ban did not extend to the female nudes Associated American Artists carried.) Cutting the print run on the controversial image, Lewenthal and Liederman limited the edition to a hundred impressions and sold the prints on an exclusively over-the-counter basis. Not taking any chances, distributors took the further precaution of wrapping the prints in plain brown paper.

Questions concerning *Sultry Night's* content forced Wood to defend the innocence of its source. The artist explained that the scene was one he recalled from Anamosa: "In my boyhood, no farms had tile and chromium bathrooms. After a long day in the dust of the fields, after the chores were done, we used to go down to the horse tank with a pail. The sun would have taken the chill off the top layer of water and we would dip up pails full and drench ourselves." Nan seconded her brother's recollection, while at the same time defusing the work's provocative title. "Hired men were given no facilities," she writes; "nights, they slept in the hay [and] baths were drawn from the watering trough . . . The hard-working men looked forward to sultry nights, as these were the best for bathing."

The siblings' memory of such bathing rituals could only have been secondhand, at best. Nan had been an infant on the farm, of course, whereas Wood had been too young to work in the family's fields. Given the artist's accounts of farmhands' modesty, moreover—the men's arms, Wood once explained, were "denuded" only for a quick wash-up before dinner—it also seems rather unlikely that they might have stripped down so thoroughly at the end of a workday (or, indeed, that they might have done so in the family's semi-public barnyard). That the ten-year-old Wood might have witnessed more private, middle-of-the-night bathing scenes is equally improbable—and if true, all the more problematic. It is impossible, then, to interpret this image as anything other than the product of the artist's mature imagination.

In the accounts of Wood's contemporaries, the artist's own bathing habits crop up with peculiar frequency. Among Wood's many innovations at Turner Alley, for example, was a large sunken bathtub set into the bathroom floor; according to Nan, the artist bathed here twice a day and sometimes more often—a habit that compelled her to explain, in one interview, that her brother's fastidiousness did not mean he was in any way "sissified." Indeed, Wood spent so much time in the bath that the portion of his famous front-door dial indicating he was "Taking a Bath" matches the wide section signifying he was "Having a Party"—two pastimes that, for the artist, were not always mutually exclusive.

Wood's well-known shyness did not extend, it seems, to any strict sense of physical modesty. Not only had he shocked his Park Ridge roommates by occasionally taking nude "shower baths" in the yard during rainstorms, but he was also remembered in Cedar Rapids for leading all-male skinny-dipping parties to Cook's Pond on warm summer nights—an activity most men in town had abandoned by their teenage years. In at least one instance from the 1920s, Wood's delight in "social" bathing provoked an angry reaction. When the school engineer at McKinley Junior High, a man named Mr. Hood, agreed to share the school's only private shower with the painter, he was infuriated to find the door to "their" stall painted with daisies and butterflies, beneath a sign reading "Hood and Wood." In this and other instances, it seems, the artist derived a kind of puerile, naughty pleasure from bathing. Not only did it offer him the opportunity for mild exhibitionism, but it also provided the gratifying (and blameless) sight of other male bodies.

Prior to creating *Sultry Night,* Wood had completed or begun a number of works devoted to male bathers, nearly all of which hint at the 1937 lithograph's eroticism. In a large 1920 canvas Wood entitled *Nude Bather,* to cite an early example, he depicts a young man disrobing on a riverbank. Like the bathers in the artist's later *Arnold Comes of Age,* this idealized figure appears at first glance to embody the innocence of youth and unspoiled condition of nature. Indeed, given the work's unusual triptych format and its subject's contemplative air, the painting suggests the reverential mood of an altarpiece.

Unlike the swimmers in Pyle's portrait, however—and differing also from the youthful nudes in Wood's later *Four Seasons* murals, for which *Nude Bather* may have served as a study—this figure is anchored in an unsettling way to the present. The model, Peter Funcke, was a sixteen-year-old neighbor of the Woods' from Kenwood Park. Turned demurely away from the viewer—Funcke had agreed to pose for Wood only on the condition that his face would not be identifiable—he sits on his discarded clothes and peels off one last dark sock, conveying the erotic suggestion of a striptease. In the artist's later *Saturday Night Bath,* created as an illustration for Madeline Darrough Horn's *Farm on the Hill* (1936), the connection between boy and burlesque is even more starkly evident.

A bathing image that Wood planned in 1935, yet never executed, would have placed his subject in a relatively safe, historical context;

Grant Wood, *Nude Bather,* c. 1920. The teenage model, Peter Funcke, posed for Wood on a remote stretch of Indian Creek.

Grant Wood, *Saturday Night Bath,*
from Madeline Darrough Horn's *Farm
on the Hill,* 1936

entitled *The Bath: 1880,* the painting was to portray a farmer in his kitchen, pouring water into a tub for his Saturday night bath. To ensure the authenticity of his image, Wood insisted on finding an original pair of 1880s red-flannel underwear for his model to wear—even going so far as to place classified advertisements in several midwestern newspapers. Although the proposed composition for Wood's painting sounds rather tame, the press found his hunt for the red flannels endlessly titillating. The *Kansas City Star* characterized the artist's search as "the fulfillment of an old desire," whereas the *Minneapolis Tribune* claimed "[Wood] is throwing into the quest a good deal of flaming ardor."

These and similar innuendos concerning the artist's "hot sketch" clearly struck a nerve with Wood, who eventually abandoned the project despite having found both model and costume. Nan recalled that the painting's unkind coverage deeply angered her brother; not only did he insist upon the innocence of his subject, but he also felt unfairly targeted by the press's insinuations. Indeed, not since MacKinlay

Kantor's column of 1930 had critics so broadly suggested Wood's homosexuality—and never before had the morality of his work been called into question in such a way.

Two years later, Wood created a far more provocative bathing subject. Given the snickering that *The Bath: 1880* had inspired, this image suggests either profound recklessness or naïveté on the artist's part. Entitled *Saturday Night Bath*—the same title given to his 1936 *Farm on the Hill* illustration—this large-scale charcoal study presents two nude farmhands in a moonlit barnyard. As one figure peels off his nightshirt, the other dips his bucket into the horses' trough, scooping water in the direction of his companion's exposed buttocks.

The penetrative implication of this gesture is underscored by the phallic shape of the trough and the thick wooden pole nestling against it—elements that point directly toward the back-turned farmhand. Completing this visual metaphor, Wood places a gaping hayloft above this figure. Not only does the opening present a symbolic site of pene-

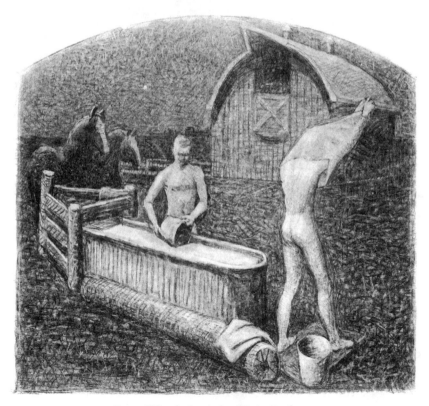

Grant Wood, *Saturday Night Bath*, 1937

tration, but it also reminds us where the two men will sleep. As if to emphasize the importance of this site, Wood repeats its shape in the unusual, arched form of the work itself—a framing device that seems to locate the entire scene within the darkened space of the upper barn.

In *Sultry Night*, Wood transformed this sketch into a far more subtle and arresting image. We encounter a single figure in this scene—the viewer, in effect, becomes the second farmhand—whereas the barnyard has been replaced by a vast and seemingly empty landscape. By emphasizing the secluded nature of this setting, and presenting us with a figure whose eyes are tightly shut, Wood magnifies the implicit voyeurism of *Saturday Night Bath* even as he provides a great deal more to see. Not only does the figures' frontal nudity elicit an initial shock in the viewer, but the water's climactic impact also provides an erotic charge only hinted at in the earlier sketch. Equally significant is the change Wood made in the lithograph's title. Substituting "sultry" for "Saturday," and removing the word "bath" altogether, Wood's title evokes only heat, darkness, and desire.

Sympathetic critics in Wood's day cloaked his startling nude in the guise of a classical allusion. John Selby, for example, declared the image "about as pornographic as a statue of Apollo"—an assessment that clearly ignores the figure's lack of idealization, as well as the artist's failure (as another contemporary noted) to "follow the time-honored tradition of shrinking and shadowing the male parts." The comparison Selby draws between the lithograph and a statue is itself rather telling, for as Michael Hatt has written, sculptural descriptions of the male nude often serve an important distancing strategy. By invoking the solid, impenetrable qualities of stone or bronze—even (and perhaps especially) in contexts where the medium resists such terms—critics exonerate the male gaze from the potentially guilty pleasure of regarding "real" flesh. The distinction Wood draws between his figure's tanned limbs and pale torso, however, represents a problematically *un*sculptural feature. Not only does it highlight the figure's exposure, but it also provides a soft and vulnerable target for the viewer's gaze.

In his first full-scale exploration of the male nude, by contrast, Wood had safely presented its figures in the form of statuary. His *First Three Degrees of Free Masonry*, completed in 1921 for the Masonic Library of Cedar Rapids, illustrates the tripartite initiation of a Mason. Modeling his figures upon famous works of sculpture, he charts the ini-

tiate's progress with versions of Rodin's *The Thinker* (at right), Myron's *The Discus Thrower* (at left), and Critius and Nesiotes's figure group *The Tyrannicides* (center). Given Wood's academic training, it is hardly surprising that he would have chosen such well-known precedents for this work. His decision to quote *The Tyrannicides* in particular, however—especially in the context of an initiation process—was rather provocative.

The original Greek work portrays two Athenian heroes, Harmodius and Aristogeiton, assassins of the tyrant Hipparchus. The two men were also *lovers,* however—as celebrated by ancient historians for their sexual fidelity to one another as they were for their bravery. As if to emphasize the pederastic dimension of their story, Wood not only portrays his figures at different heights (in the original, Aristogeiton's beard alone identifies him as the older man), but he also recasts the pair in an embrace; by contrast, the Greek version presents the men separately, and back-to-back. Only by "shrinking and shadowing the male parts" of these paired nudes, and cloaking them in allegory, was Wood able to get away with using such a frankly homoerotic source. As a new Freemason himself, it seems, he had already learned a great deal about the power of coded imagery.

If *First Three Degrees of Free Masonry* presents male nudes within the reassuring context of classical allusion–however controversial its central source may be—then *Sultry Night* requires uneasy viewers and critics to provide their own veil of modesty for the work. In our own time, the assertion that Wood's nude farmer represents a classical ideal has given way to the view that *Sultry Night* is a metaphor for the sacred relationship between a farmer and his land. In the 1970s, James Dennis labeled this bathing figure an "American Adam"—a "natural man living an elemental existence," whose presence here symbolizes the "ideal agrarian life . . . a mythical promise of spiritual and material self-sufficiency." Amplifying Dennis's reading, the critic H. E. Wooden declared in the 1990s that *Sultry Night* "glorifies the reassuring power of nature, and the virtues of living close to the soil." To suggest that *Sultry Night* simply portrays the bounty of nature, however, depends upon a rather shopworn view of Wood's oeuvre—and denies, moreover, the image's (and the artist's) sexual core.

In Wood's landscapes, the earth and the erotic are always rather closely aligned. To understood *Sultry Night* in terms of natural allegory,

Grant Wood, *First Three Degrees of Free Masonry,* 1921

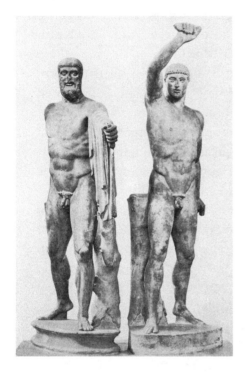

(left) Critius and Nesiotes, *The Tyranni-cides*. Widely reproduced, this classical work was displayed at the National Archaeological Museum in Naples when Grant Wood visited there in the winter of 1924.

then, we must set aside notions of virtue, values, or American history and consider the image instead on Wood's terms. If in earlier land-scapes the artist had projected the male body onto the land, then in *Sultry Night* he neatly reverses this formula; in a transformation that appears to take place before our eyes, land becomes flesh. Beginning with the solitary tree on the far horizon—an element that reads like a human sentinel in this deserted landscape—the eye proceeds toward the foreground's fleshy, gnarled trunk, which mirrors the position and visual weight of the standing figure. In the farmer himself, we witness the scene's final metamorphosis. Not only does his body suggest the tree's vertical trunk, upward-thrust limbs, and mossy "skin," but his genitals and fanning pubic hair also mimic the tree's placement within its own bushy foliage.

The water that effects this transformation is, in effect, a seminal release—a nocturnal emission in which the farmer's entire body

assumes an ejaculatory form. Like the similarly phallic and brimming
horse trough from which he draws this water, the farmer is rigid,
swollen, and overheated; he emerges from the land even as he reunites
with it, accomplishing both acts in a single, climactic gesture. The
structure of the composition only reinforces this allusion. Not only do
the field's diagonally radiating plow lines originate at the water's point
of impact, but the land is also perfectly aligned, horizontally, with the
farmer's torso. His nipples rest directly upon the far horizon line,
whereas the curve of his pelvic muscle seamlessly joins the line of the
crop's near edge. In this intersection between field and farmer, the
image takes on the quality of a double exposure—a fusion that illus-
trates not only the figure's physical connection to the land, but also his
more particular relationship to this planted field.

In an earlier work from 1928, Wood had depicted a similarly com-
posed (if more comically intended) male nude beneath a shower of
champagne. The artist created *Charles Manson as Silenus* as a gag. Pre-
sented to its subject at a Chamber of Commerce dinner for Manson,
Wood's image depicts this Cedar Rapids businessman as Bacchus's
drunken foster parent. Grossly overweight and completely nude, the
figure reels backward on a basket of grapes while holding aloft an over-
flowing glass of champagne. Poking out of the basket like a stand-in
for the figure's unseen genitals, is a champagne bottle spouting another
impressive stream. However inconsequential the work may be in and of
itself, it is an important precursor to *Sultry Night* in that it conflates
nudity with liquid excess, and the male body with an overabundance of
agricultural fertility.

Because Wood does not specify the crop shown in *Sultry Night*, the
work's central figure quite literally "stands in" for the unnamed
plants—and for his generation, of course, no crop was more closely
associated with the male body than corn. The figure of King Corn was
ubiquitous at Iowa state fairs and pageants; consort to Demeter and
rival to the South's King Cotton, this mythical character was the very
embodiment of midwestern potency. Wood, too, anthropomorphized
cornstalks on his family's farm. "Walking along the road to school in
the fall," he recalled, "when the corn was fully grown [and] tasseled . . .
I imagined the stalks were a body of Indian warriors drawn up for a
charge." Wood's vision of these "tasseled giants" draws a clear connec-
tion between mature corn and the bodies of powerful adult men;

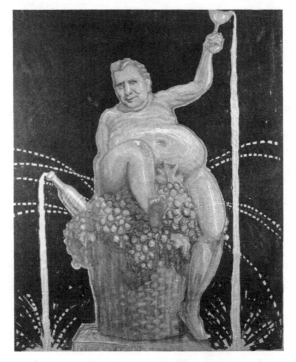

Grant Wood, *Charles Manson as Silenus,* 1928

indeed, in the Iowan vernacular of his childhood, a boy approaching manhood was said to be "husky," "corn-fed," and "tasseling out."

Regionalist art of the 1930s frequently summoned cornstalks as a symbol of virility and sexual potency. In his 1933 *Kansas Cornfield* (see color plate 22), for example, John Steuart Curry depicts a fully-grown cornstalk that one critic described as "a self-portrait in regional, vegetal guise." The artist himself claimed, "I have tried to put into this painting the drama that I feel in the presence of a luxuriant cornfield beneath our wind-blown Kansas skies"—and, indeed, we may recognize Curry in this sturdy cornstalk, its windswept tassels, and outstretched, leafy "arms."

Beyond these more straightforward and wholesome elements, the artist also includes a startlingly phallic ear of corn midway down the stalk. The only one to appear on this otherwise robust-looking plant, Curry's thick (and inexplicably *pink*) ear of corn thrusts upward in a burst of wiry corn silks—a perfect illustration of what was, for rural midwesterners, an almost inescapably sexual metaphor. Not only does

corn lengthen and harden as it grows, but it also signals its ripeness through this spray of silks; to confirm the ear of corn's readiness, moreover, the farmer must either feel along its bulk or peel back its fleshy husk. Given *Kansas Cornfield*'s striking use of this phallic motif, it is remarkable that Thomas Craven—of all men—confessed to Curry about this painting, "At first I did not get [it]."

In a mural series Wood painted for Cedar Rapids' Montrose Hotel in 1932, entitled *Fruits of Iowa,* he too suggested corn's phallic properties rather directly. The panel entitled *Farmer with Corn and Pigs* (see color plate 17) depicts a muscular, overalled figure holding an overflowing bushel of corn. Not only do the figure's massive hands, forearms, and bull-sized neck suggest his brawny masculinity (Wood's model was the hotel's burly construction foreman), but so too do the oversized ears of corn emerging from his basket. Positioned precisely at the level of his crotch, this impressive bushel indicates the man's sexual potency in an almost comical fashion.

Sultry Night manages to conflate farmer and crop in a way that is both subtler and more literal. The farmer's knobby and awkward joints, the spray that appears above his head, and his nested genitals below all mimic the essential features of a mature cornstalk. Beyond these more readily recognizable elements, *Sultry Night*'s figure also exhibits cornlike qualities that would have been familiar only to a farming audience. A widespread folk belief in Wood's childhood, for example, held that corn grew primarily at night and only "came alive" under the cover of moonlight (as Henry David Thoreau wrote in an 1862 poem, "I believe . . . in the night in which the corn grows"). Another feature midwesterners would have associated with this plant is its reputation for prodigious "sweating" in hot weather; in the hottest days of July, a fully grown corn plant can transpire up to nineteen pounds of water in a single day. Wood's figure embodies all of these traits: the cornstalk's awkward straining toward the moon, its unslakable thirst, and even its sweaty pungency. He is a fantasy of King Corn, stripped of his robes.

Wood's 1939 lithograph *Fertility* provides yet another indication of this connection between corn and man. As Henry Adams has demonstrated, this rather prosaic image of a mature corn crop is nothing more than a cleaned-up version of Wood's 1937 sketch, *Saturday Night Bath*. Day substitutes for night here, whereas the nude farmhands are replaced by a crop of sturdy (one-eared) cornstalks. As sanitized as the

Grant Wood, *Fertility,* 1939. The farmhouse at left reprises the one seen
in *American Gothic* from nine years earlier.

scene may be, however, it resists the artist's own bowdlerization—for as
Adams rightly claims, the rounded forms and up-thrust silo in this new
composition are almost unavoidably phallic. Not only does *Fertility*
echo Wood's 1937 sketch and *Sultry Night* in a powerful way, then, but
it also highlights the artist's overridingly masculine characterization of
agricultural productivity. Fertility, in this instance, is rather strikingly
male.

To claim that the farmer in *Sultry Night* is only a conceptual
embodiment, however, would be to ignore this figure's startling indi-
viduality. Indeed, the sense that we confront a real person in this image
fuels much of the work's sexual charge. The live model for *Sultry Night*
has never been identified, yet it is nearly certain Wood used one—not
only given the work's immediacy, but also because the artist found it
nearly impossible to create even semi-abstracted figures from his own
imagination. Of all the likely models for this farmer, the British writer
Eric Knight presents the strongest possibility.

Knight and Wood met in 1937 through Norman Foerster, a mutual

university colleague. Later known for his children's classic *Lassie Come-Home*, Knight was at this stage a relative unknown; new to the university and an amateur painter himself, he would have been as flattered to pose for Wood as Foerster himself had been that year. (Foerster appears in the lithograph *Honorary Degree*.) Contemporary photographs of Knight indicate his marked physical similarity to Wood's bathing farmer. Dark-haired and lanky, he had a high forehead, prominent ears, and long fingers; it is probable, too, that the Englishman—like the figure in *Sultry Night*—would have been uncircumcised.

Further evidence for Knight's role in this work lies in its title's potential pun on his last name. Not only did Wood delight in wordplay with his titles, particularly in instances where these turns of phrase might illuminate his sitters' characters (*American Gothic* and *Daughters of Revolution* are both good examples), but he was also an incorrigible punster and loved inventing nicknames for his friends. Given the romantic/Gothic associations of Knight's surname, the artist would have found its use here almost irresistible—provided, of course, that his spelling concealed the joke. (Consider how much more quickly *Sultry Knight* would have been banned!) Given the midsummer setting of this work, moreover, it is worth noting that Knight—who moved

Grant Wood and the author Eric Knight in 1941. Knight,
a resident at the Iowa Writers' Workshop, spent his summers
with Wood beginning in 1937.

into Wood's ever more crowded house soon after they met—lived with the artist only during the summer months.

The danger that *Sultry Night* represented for Wood, regardless of whether the identity of its model were known, is indicated by the troubling reactions its painted version elicited. Created in tandem with the lithograph and unveiled prior to the Postal Service ban, the painting débuted with great fanfare at Wood's Iowa City home. According to Garwood, the artist "invited more than fifty people to his house for the unveiling of the painting. It stood on a high rack over the sideboard, and both his dining room and his living room were full of men and women that night. Strange to say, it was the men rather than the women who were embarrassed." The discomfort he describes in this passage, and the gender distinction he notes, are as revealing as his reluctance to elaborate upon the scene. Leaving his readers to draw their own conclusion regarding the men's reaction, Garwood explains only that "it might be thought that Wood intended this painting for only select gatherings"—the constituency of which he fails to identify.

The work fared no better in its only public venue. Following the painting's unveiling, Wood sent *Sultry Night* to a national, juried show; rather than the storm of controversy he might have anticipated, however, the artist instead received a terse letter asking him to withdraw the painting. Similarly, the press made little or no comment following the censorship of the lithograph—an eerie silence that sharply contrasts with the ample, teasing coverage that *The Bath: 1880* had inspired.

The ineffability surrounding *Sultry Night* is perhaps the most powerful indication of its homoerotic charge. As Thomas Waugh has written, the "alibi of innocence" surrounding the male nude had all but disappeared by the 1930s—a situation that rendered both the production and consumption of such imagery fraught with the suggestion of illicit desire. For the men at *Sultry Night's* unveiling, then, as for Garwood and members of the press, the nature of what they saw in this image was perfectly clear. To have expressed this recognition, however, would only have attracted sexual suspicion to themselves. Indeed, the nearest admission of *Sultry Night's* homoeroticism may be found in the Postal Service ban—for to consider an image pornographic is, of course, to suggest that the work is sexually provocative for *someone* (and we may safely assume that censors were not overly concerned about heterosexual, female audiences).

Wood's counterreaction to *Sultry Night*'s reception was swift and self-punishing. As Nan explains:

> The painting suffered a rude fate, whether as a result of the postal advice I do not know. Grant was bothered by the thought that some detractor might try to create evil where there was none. He sawed off the portion that portrayed the nude farm hand and burned it. More than half the painting remained.

The artist's violent act of self-censorship not only went far beyond external demands for the work's suppression—critics called only for its removal from the public sphere—but its destruction was also heartbreakingly pointless, since the painting had already been promised to a Wisconsin collector. (*Sultry Night*'s patron eventually accepted the oil in its drastically altered state; originally painted with an arched top, the carved-up painting was now both off-center and robbed of its subject.)

The silence that attended *Sultry Night*'s reception was matched by the artist's own reluctance to discuss the image. Whereas he had eagerly defended himself in past controversies, either in interviews or open letters to critics, in this instance Wood made no comment other than to tersely explain his childhood source for the image. The protective layer of nostalgia that previously shielded his work had failed him in a painfully public way; never again would the artist depict a male nude, in either straightforward or metaphorical guise. The burning of *Sultry Night*'s farmhand, then, constituted a kind of exorcism—Wood's attempt to eradicate a desire that, like his landscape mannerisms, he had "a hell of a time getting rid of."

WHATEVER CATHARSIS *Sultry Night* might have originally offered Wood, in the period following its destruction he found it difficult to go on. Indeed, for more than a year he painted absolutely nothing—by far the longest dry spell in his career. When he eventually returned to his easel, he did so with a new sense of timidity. The paintings from the last years of Wood's life fall into two sharply opposed categories: cloyingly sweet (and therefore blameless) rural imagery, and works that—however powerfully composed—exhibit an anxious preoccupation with exposure and punishment. In these final works, as in

Wood's earliest portraits, the artist retreated once again to the emotional shelter of his reimagined childhood.

The long period of inactivity that followed *Sultry Night* may be attributed in part to Wood's rapidly deteriorating marriage. By the beginning of 1938, Wood's relationship with Sara had become, in Nan's words, "a traumatic nightmare" for her brother. Sara's increasing unhappiness in the marriage manifested itself in dramatic, and sometimes public, outbursts that left Wood paralyzed in their wake. Stories of uncomfortable scenes at the couple's dinner parties, and of Sara's angry retreats to her bedroom, appear in several accounts of the artist's friends and domestic staff; Doris Jones, a former housekeeper at East Court Street, later explained to Nan that she had "left [the Woods'] employ because of the discord and trouble in their marriage." The artist himself, Jones was careful to add, "was a grand person—never mean or high-hat, despite a lot of inner turmoil."

Descriptions of the Woods' marital problems often sympathetically cast him as the long-suffering husband: a patient and forgiving man at the mercy of a domineering, emotionally unbalanced wife. At the outset of their marriage, however, the passive and boyish Wood had clearly admired Sara's strident personality—evidenced by his happy surrender, when the two were first married, to her management of his affairs. ("Sara is working on it" became one of his more oft-repeated phrases.) Wood's attraction to Sara's forthrightness is further suggested by his favorite play, George Bernard Shaw's *Androcles and the Lion*—a story that centers on a mild-mannered, childlike man and his powerful, physically intimidating wife. Far from an unsympathetic character, Androcles' wife, Megaera, urges her inattentive husband "to return to [his] duty" and "be a good husband," complaining, "It's not fair. You get me the name of a shrew with your meek ways, always talking as if butter wouldn't melt in your mouth. And just because I look a big strong woman . . . people say 'Poor man: What a life his wife leads him!' Oh, if they only knew. And you think I don't know. But I do, I do, I DO!"

Sara, too, knew better than most about the difficulties of living with Wood—whose chronic state of helplessness must have been as maddening to her as her theatrics were to him. Although she was likely well aware of Wood's lack of sexual interest in women, moreover, she could hardly have been prepared for his thinly disguised attraction to the

constellation of men at East Court Street (a group that included her son, no less). If she had confirmed the warnings of his friends prior to their marriage, then so too had Wood proven to be the man Phoebe and others had warned her about.

Beyond their emotional and sexual incompatibility, the couple had also incurred an extraordinary amount of debt during their brief marriage. In 1937 alone, Wood earned $24,000 from his work but spent, along with Sara, more than $50,000—an astonishing sum for the period, and one that belies the couple's seemingly modest lifestyle. As Nan later related, Wood and Sara were like children where money was concerned. "My brother wrote checks as long as there were blanks in his checkbook," she wrote, whereas Sara's "magic words were, 'I'm Mrs. Grant Wood. Charge it, please.' " Far more serious than the couple's spending was their failure to file income taxes between 1935 and 1938. Not only was this a rather reckless omission, given the press coverage of the artist's sales, but it was also a clear indication of the support Wood had lost in the move from Cedar Rapids—where David Turner and Fan Prescott had formerly handled the painter's finances with a far closer eye.

Because Sara convinced Wood to switch to a more financially aggressive dealer, she is often cast as a calculating figure—a woman whose interest in her own financial well-being, and that of her son, trumped any real concern for Wood's career. Unlike the demands Sherman made upon Wood, however, Sara's efforts to improve the artist's sales are somewhat more forgivable. Wood's postmarital decline in productivity must have been rather alarming for his wife—and especially so, in light of the couple's increasingly costly lifestyle. Cedar Rapids' most eligible bachelor had become, it seems, a profoundly disappointing breadwinner.

The Woods' marital turmoil came to a head in the summer of 1938, in a scene worthy of one of Shaw's dark comedies. Wood related its details to Nan, who wrote:

A bad emotional scene and argument preceded their separation in 1938. At the climax, Sara proclaimed she was having a heart attack. Grant, who had been through the same scene before, was unmoved. He asked Sara's son to call an ambulance, and he himself waited outside until it was gone. Years later, a nurse recalled

that Sara arrived with her own satin sheets and pillow cases because she couldn't stand hospital bedding. She couldn't stand hospital cooking, either, and had her maid bring meals to her. Grant went to Clear Lake for the weekend, leaving a note that if he found Sara at home upon his return, he would leave for parts unknown.

Sara—who, even by Nan's unsympathetic account, appears to have demonstrated a certain élan in her exit—left soon afterward for New York. In a gesture that rather neatly sums up the failure of their marriage, she made a point of surrendering Hattie's cameo to Nan, rather than Wood.

In her own version of these events, Sara confirms that she suffered a coronary occlusion during the final scene at East Court Street. Nan's suggestion that Wood ended their marriage with a note, however—a gesture that would have been cruel enough—does not appear in Sara's account. ("During those weeks" of recovery, she writes, "I had no word from Grant.") At the end of Sara's hospital stay, Dorothy informed her mother-in-law that she and Sherman were leaving for an extended vacation with Wood; when Sara returned to the empty house at East Court Street the following day, it was the Woods' housekeeper who informed her that the marriage was over. In later years, Sara continued to wonder how the marriage could have ended in such a humiliating way. "Perhaps there are still those who wonder why Grant drove me off," she wrote. "Who knows! I do not, but I do know that, given half a chance, our life together might have been a permanent thing"—a prospect that, in truth, does not sound as if it would have brought either much joy.

Divorce proceedings took place a year after the Woods' separation. No-fault divorce did not yet exist in 1939, yet there were a number of ways that someone as well-known and private as Wood could have shrouded the proceedings in strictly conventional language. Instead, his suit not only charged Sara with "inhuman treatment"—an accusation far less common than the boilerplate phrase "mental cruelty"— but it also claimed "such inhuman treatment as to endanger the life of the plaintiff."

Wood's allegation appears to suggest that physical abuse played some part in the couple's breakup (an indication, perhaps, that Sara

had assumed Maryville's role far more successfully than she had Hattie's). Given the abuse Sara herself had suffered in her first marriage, she found Wood's accusation infuriating. "If I live a thousand years," she writes, "I will never forget my violent reaction to this final disrespect." Whether or not Wood's wife actually battered him during their marriage—and it seems rather unlikely that she did—her emotional volatility and size appear to have carried, at the very least, the threat of physical intimidation. Deeply averse to any form of confrontation, Wood was marked by the physical bullying he had suffered growing up; if Sara represented a similar threat for him—justifiably or not—then his refusal to confront her directly, either at the end of their marriage or in the ensuing months, makes somewhat more sense.

Despite the damning nature of Wood's charges, Sara pleaded no contest to his suit. Her decision displayed no small measure of generosity, for as she later declared, the "full story" of their marital problems could easily have been "injurious to Grant in his teaching and painting." Had she attempted to countersue, however, Sherman had offered to testify against his mother on Wood's behalf. Sherman's loyalty to Wood derived from his financial dependency on the artist, rather than from any sense of genuine solidarity with him. Neither he nor Dorothy was in any hurry to relinquish their free lodgings at East Court Street, and indeed they remained there for a full year following Sara's departure—confirming her darkest fear that they had encouraged Wood "to eliminate me, but to retain the help of my daughter-in-law as hostess."

The collapse of the Woods' marriage initiated a depression from which many of the artist's friends believed he never fully recovered. As Bruce McKay later remarked, even during his marriage Wood's unhappiness seemed to reflect "a battle forever going on within himself"; following Sara's departure, this internal struggle only appeared to deepen—leading Wood to heavy drinking and a new sense of brittleness in his relationships. Confronting mounting bills and an audit from the Internal Revenue Service, the artist also faced increasing financial demands from Sherman and Dorothy. According to the artist's housekeeper, the Maxons continually "picked on" the artist for money, exploiting his generosity and also, no doubt, his weakness for Sherman. In the fall of 1939, Wood asked them to leave.

With evident satisfaction, Sherman claimed that his former stepfa-

ther would be incapable of coping by himself. Wood, however, was hardly alone in the house. Park Rinard remained, of course, joined in the summers by Eric Knight; by the start of the 1940s, moreover, the East Court Street ménage increased by two frequent guests. The first, a college friend of Rinard's named Ed Green, later became a lifelong collector of Wood's work and one of the artist's unofficial archivists. The second, a young artist named Willis Guthrie—who shared the artist's birthday, as well as his fondness for overalls—performed yard work and light carpentry in exchange for painting supplies.

Beyond this group of regulars, Wood's hospitality extended to an ever-widening circle of male friends in Iowa City. Paul Young, who met Wood through Madeline Darrough Horn, recalled attending dinner parties at East Court Street composed entirely of gay men; guests wore jackets and ties for these evenings, Young explained, even though they knew "there wouldn't be any women present." However much Wood might have enjoyed the company of so many attentive young men, his independence from Sara had come at a considerable price. Raw from the events of the preceding year, and humiliated to see Cedar Rapids proven right about his marriage, Wood's reserves of self-confidence reached an all-time low.

IN SPITE OF HIS profound despondency in this period, or perhaps because of it, Wood returned to his easel in September 1939 for the first time since completing *Sultry Night*. Adopting a feverish, round-the-clock work routine—in one marathon session, he painted for twenty-two hours without stopping—Wood focused his energies on an unusual new painting entitled *Parson Weems' Fable* (see color plate 24). The work's cathartic role is evident not only in the timing and process of its creation (notably, Wood painted it in the suite that his mother, and later Sherman and Dorothy, had occupied), but also in the psychological complexity of its composition. Its stark references to his recent personal crises, as well as to his chronic childhood anxieties, provide a startling illustration of the paper-thin wall that separated the artist's public role from his private life.

Wood's painting portrays the apocryphal story of the young George Washington and his father's cherry tree, a moralizing tale first told by the Reverend Mason Locke Weems in his 1806 biography of the Presi-

dent. In Weems's well-known account, the six-year-old Washington is rewarded for admitting he has destroyed his father's favorite tree—famously declaring, at the story's conclusion, "I can't tell a lie." From Weems's day onward, this fictional anecdote has formed a central part of Washington's mythology. Not only does it serve to illustrate the Founding Father's precocious integrity, but also Augustine Washington's loving inculcation of virtue.

Weems's story has long been dismissed by serious historians, yet it was the tale's very sense of fantasy that first attracted Wood to the subject. Fully acknowledging the account's historical inaccuracy, the artist argued for its preservation as a cultural artifact—claiming that "a valuable and colorful part of our national heritage is being lost, as a result of the analytical historians debunking biographers." As Karal Ann Marling has noted, Wood judged the national mood in 1939 rather keenly. Emerging from the Great Depression and facing once more the prospect of war, American audiences welcomed the reassurance of patriotic fantasies.

Whereas *Daughters of Revolution* had appeared in the bicentennial year of Washington's birth, *Parson Weems' Fable* coincided with the sesquicentennial of his inauguration—an anniversary widely celebrated in 1939, most visibly in the Washington-centered theme of the New York World's Fair (the very venue, in fact, where Wood's dealers chose to unveil this work). To assign Wood's interest in Washington exclusively to this moment of national nostalgia, however, would be to ignore the private function that American subject matter so often serves in his work. By distorting Parson Weems's tale through the lens of his personal experience—even depicting the young Washington in a way that led some critics to doubt the sincerity of Wood's patriotism—the artist ultimately reveals far more about himself than he does about national mythology. Indeed, the staging and dramatis personae of this work constitute a kind of Rosetta Stone to Wood's inner conflicts.

Parson Weems' Fable includes a number of highly unusual compositional choices, the most striking of which is the sharp distinction between its foreground and background. Immediately before us stands the life-size figure of Weems, the President's biographer. Appearing to occupy the viewer's own space, he pulls aside a heavy curtain and gestures with his outstretched hand; beyond this curtain, we encounter a brightly colored and artificial-looking environment. Steeply pitched

and organized in strict one-point perspective, this stylized scene is intentionally far removed from the striking realism of the foreground. The division between these two planes alerts us to the interior scene's fantasy, just as the curtain's fringe of ripe, red cherries suggests we have left the rational world behind.

Wood claims to have derived this unorthodox composition from early colonial sources. "One of the things about the old colonial portraits that has always amused me," he explained in a 1940 interview, "is the device of having a person in the foreground holding back a curtain from, or pointing at, a scene within the scene." Although the use of framing curtains was common enough in early American painting (a tradition Wood had previously referenced in *Portrait of Nan*), this scene-within-a-scene strategy belongs to only one well-known predecessor: Charles Willson Peale's *The Artist in His Museum* from 1822. In this self-portrait, Peale dramatically lifts a heavily fringed curtain and invites the viewer into his Philadelphia Museum. Dedicated to the study of American natural and political history, Peale's collection includes the reconstructed skeleton of a mastadon, neatly arranged rows of taxidermied birds, and a gallery of his own Revolutionary-era portraits.

The correspondences between Wood's painting and Peale's self-portrait are both explicit and subtly subversive. To begin with, Peale's historical and artistic links to Washington were particularly strong. Not only had the colonial artist served under Washington during the Revolutionary War, but he had also painted some of the best-known portraits of the first President—one of which the Brooklyn Museum purchased for a record sum in 1934 (a story *Time* magazine reported, in fact, alongside its first feature devoted to the U.S. scene). As if to reference his artistic link to the President, Peale appears to include one of his many Washington portraits in *The Artist in His Museum;* placed like a religious icon in the upper-left-hand corner of the painting, it marks the chronological entry point to the museum's portrait gallery.

If Peale's composition and presidential connections resurface in *Parson Weems' Fable,* however, then his museum represents the antithesis of the scene in Wood's painting. Peale's collection, after all, constituted a humorless, factual record of the American past—a rigidly organized assemblage of fossils, fauna, and Founding Fathers. In stark contrast, Wood presents the viewer with a tongue-in-cheek version of American

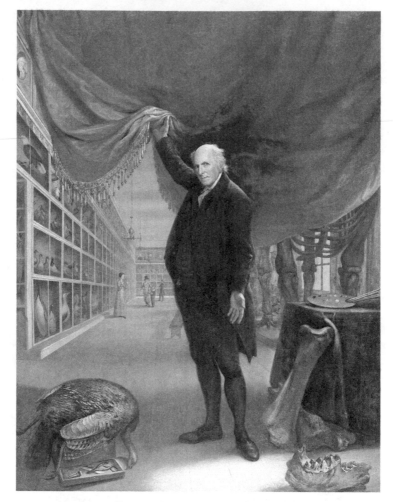

Charles Willson Peale, *The Artist in His Museum,* 1822

history that he knows to be patently false. Not only does the artist sub-
vert Peale's work in his choice of subject, then—suggesting that the
glory of American culture depends as much upon fantasy as it does
upon fact—but he also does so while hiding behind a parson's mask.
From the safety of this position, he takes perverse pleasure in getting
American history wrong.

Closer examination of Weems's figure suggests a form of deception
more sinister than the mere delivery of a tall tale. (As one critic noted,
"An underhanded smile lurk[s] somewhere in the canvas.") In contrast
to Peale's more open gesture, Weems's is quite literally underhanded;

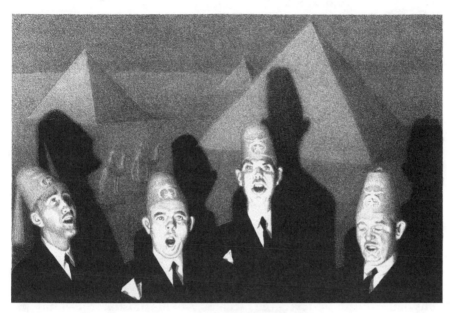

Grant Wood, *Shrine Quartet,* 1939

raising the curtain with his right hand, he turns the hand over and awkwardly twists it behind his back. Not only does the pose imply a sense of cunning—an effect heightened by the hand's shadowy portrayal—but it also summons traditional allegories of Deceit. In Bronzino's *Exposure of Luxury* (1540), to cite a well-known example of this iconography, the allegorical figure of Deceit offers the viewer a honeycomb with her left hand, while in her right—overturned, and placed behind her back— she holds the tail of her reptilian lower body. Wood's depiction of Weems's long, curving body suggests a similarly snaky form. By varnishing the parson's dark green coat with a crazed or "alligatored" effect, moreover—a technique that appears nowhere else in the painting—the artist even subtly evokes the skin of a reptile.

In the same year that Wood painted *Parson Weems' Fable,* he produced a lithograph for Associated American Artists that personifies fraud in a similarly theatrical way. *Shrine Quartet* depicts a group of Shriners singing in four-part harmony; dressed in dark business suits and wearing the characteristic fezzes of their fraternal order, they stand before a panorama of Egyptian pyramids. Illuminating these figures from below and casting the men's shadows across the mural behind them, Wood exposes their exotic setting as a sham. Not only **does this**

effect mock their provincial orientalism, but it also juxtaposes their small-town self-importance with the grandeur of history—a theme Wood had previously explored in *Daughters of Revolution*. The fact that these figures appear somewhat ridiculous, however, does little to dispel the sinister effect of their looming, spectral doubles and underlit faces. If the contorted pose of Parson Weems points to his underhanded character, then the men's shadows illustrate fraud's unsettling dual nature.

 Both of these portrayals of deceit—the misleading showman and the "shadow self"—may be traced to Wood's earlier painting, *The Birthplace of Herbert Hoover* (1931) (see color plate 14). The tiny figure at the center of this work points to the President's birthplace in a theatrical way, yet his projected shadow points directly to the wrong house. In this image and the two works from 1939, Wood clearly delights in leading us astray—while also ensuring that we know we are being misled. Like the good stage manager he was, he uses all the conceits of the theater to reveal the mechanics of his illusion: the grand gesture, footlights, and careful blocking.

Wood's fascination with illusion is particularly well illustrated by the curtain Weems lifts. Indeed, the artist invested curtains with nearly as much symbolic weight as the Gothic arch. Not only had the draped tablecloth of his first "studio" marked the separation between his real and imagined worlds, but so too did the theater curtains that captivated him as a child. When his aunt Sallie took him to a performance of *Uncle Tom's Cabin*, for example, the eight-year-old Wood had been more impressed by the play's theatrical framing than by the drama itself:

> Most of all I was fascinated by the stage. Once I'd set eyes on it I could not look elsewhere. In front, two velvet curtains parted to reveal a large picture lovely beyond description . . . Behind th[ese] curtain[s] was the enchanted world of make-believe, a world I little knew, but longed for with immeasurable yearning.

The guilty pleasure Wood derived from make-believe—a testament to the austerity of his upbringing, and to his early vocation as an artist—led him to fetishize these curtains just as he had Hattie's apron. If his mother's apron represented "home" for him, then curtains marked the boundaries of his fantasy life.

As an adult, the painter would re-create the curtained, imaginary world of his boyhood in a variety of settings. At the elaborate unveiling of *The Imagination Isles,* for example, Wood placed the mural as well as his pupils behind a large curtain—revealing this assembly only at the dramatic conclusion of his invitation to "enter" the imaginary landscape. Years later, the artist framed Turner Alley's most important space with a heavily fringed curtain much like the one Weems raises. Not only did this western alcove function as a stage for Cedar Rapids' Community Players, but it also served as the artist's studio and bedroom. Installed with a tasseled pull similar to the one over Weems's head, Turner Alley's curtain was designed to part as if by magic. Nan relates that her brother "[would] pull the cord, and the beautiful curtain would open silently, properly surprising our guests." In such instances, as in *Parson Weems' Fable,* Wood not only demonstrated the "cabalistic" role curtains played in his imagination (to use MacKinlay Kantor's word), but he also cast himself as the agent of their framed illusion.

The insistently theatrical elements of *Parson Weems' Fable*—its gesturing narrator, parted curtain, and steeply raked setting—are all orchestrated, of course, to showcase the star of the production: the child at center stage. As if to underscore this figure's dramatic artificiality, Wood masks the six-year-old Washington with Gilbert Stuart's famous 1796 portrait of the President (an image painted when Washington was in his mid-sixties). Such a jarring quotation—so oddly misplaced on a child's body, and so instantly recognizable as a borrowed image—produces an effect similar to that of *American Gothic:* the viewer doesn't know whether to giggle or shiver. Early critics of the painting found Wood's odd portrayal of the Founding Father deeply disrespectful. Responding rather unconvincingly to such criticism, the artist explained that since no childhood portraits of Washington had survived, he had had no other models to follow.

Not only does Wood's cobbled-together figure clearly satirize the President's sacrosanct image, but it also targets the "Founding Fathers" of American painting. Indeed, Stuart's iconic portrait functions here just as Leutze's equally famous *Washington Crossing the Delaware* does in *Daughters of Revolution;* in both cases, Wood lampoons the President's portraitists—his own artistic predecessors and rivals—more so than Washington himself. If we consider the meticulously ordered portraits in Peale's museum, moreover, it appears that Wood has even

taken a dig at Peale by way of Stuart. By placing the best known of all
Revolutionary-era portraits in a context both ridiculous and anachro-
nistic, he subverts Peale's—and by extension, his own father's—grim
adherence to the historical record.

As so often happens with Wood's satire, the joke ultimately turns
back on the artist himself—for there is no more revealing self-portrait
in all his work than the frozen man-child at the center of *Parson Weems'
Fable*. In addition to providing a rather striking illustration of the
artist's emotional makeup, this figure summons his inevitable identifi-
cation with the President. Not only do Wood and Washington share
the same initials, Masonic membership, and (very nearly) the same
birthday, but family legend also held that one of Wood's ancestors had
served on Washington's staff. The artist's contemporaries noted corre-
spondences between the two men as well. Publishing a caricature of the
artist's home from one of its readers in 1935, the *Cedar Rapids Gazette*
drew particular attention to the scene's imagined pairing of Wood's and
Washington's portraits:

> Mr. Wood will like it. For one thing, he and George Washington
> are pictured together! Although great Americans might have
> been in the back of [the artist's] mind, she based her grouping on
> the fact that they had the same initials. So they hang together,
> bespectacled Grant and curly George. Yet, perhaps, she couldn't
> have chosen two more typical Americans.

Comparisons such as this one—and the rarer, if similar, connec-
tions sometimes drawn between Wood and Lincoln—illustrate the
rather lofty public role assigned to the painter. He was considered not
only a "great" and "typical" American (however contradictory these
labels might appear to be), but also one incapable of dishonesty;
indeed, in its own nod to the Weems story, the *Des Moines Register*
claimed Wood "cannot paint a lie." Like Washington, too, Wood was
credited with throwing off the shackles of European colonialism. As
Craven declared in 1935, "[Wood] is one of the big men in the new
American school, a powerful force in our artistic declaration of inde-
pendence." Taking full advantage of such comparisons, and perhaps
even poking fun at them, Wood casts the young Washington as his
double in *Parson Weems' Fable*. The smugness critics perceived in the

boy's attitude—an element the artist confirmed as intentional—belongs to the artist alone.

The moment Wood chooses to illustrate from the parson's tale is as odd as the work's presidential homunculus. In the climax of Weems's account, Washington's father is "in transports" of joy at his son's honest admission, declaring affectionately, "Run to my arms, you dearest boy . . . run to my arms; glad am I, George, that you killed my tree; for you have paid me for it a thousand fold." By contrast, *Parson Weems' Fable* highlights the angry confrontation between father and son. If the parson's story is one of clemency and reconciliation, then Wood's image projects only the anxiety of impending punishment—a distortion that reflects his frequently esoteric approach to history. Garwood claims that "a good part of [Wood's] life was spent in recalling, preserving and restoring the past," yet the painter was ultimately more interested in reimagining history than he was in safeguarding it. Upon completing *Parson Weems' Fable,* to cite another example, Wood announced his intention to illustrate the story of Captain Smith and Pocahontas. In the artist's flipped version, however, he planned to portray Smith rescuing the Indian princess.

Wood's take on Weems's fable may distort its intended moral, yet it provides a crystal-clear illustration of his own relationship with his father. Indeed, the unresolved conflict at the heart of this painting reflects the very core of the artist's inner conflicts; Wood-as-Washington perpetually awaits Maryville's angry judgment, administered in this case not with a willow switch, but an entire tree. The unsettling character of this standoff led one Indianapolis critic to observe, with unintentional perception: "Clearly, the boy Washington is no subject for Grant Wood, who attributes his style to a 'straight-laced,' Puritanical bringing up. If he wishes to paint his own boyhood into a picture he should choose another subject. He might even call it *Grant Wood at the Age of Six.*" (It would be difficult to find a better subtitle for this work.) As if to underscore the father figure's malevolence in this image—or perhaps, to suggest his frightening identity as a corpse—Wood blackens the hand that grips the dying tree and sharpens the man's hat, coattail, and outstretched hand into threatening, hornlike points. The painting challenges paternal authority at nearly every turn, yet it remains unclear who the winner in this contest will be.

In the frozen mask that Washington presents to his father, we regis-

ter the crippling effects of Wood's childhood fear and the defensive function of his famous passivity. The boy's face is turned to stone—yet for this very reason, it betrays no discernible reaction to his father's threat; enlivened only by a pair of eyes that cut toward the right, he exhibits a subtle wariness that is almost comical. In contrast to the quick perception of this figure is the apparent sightlessness of his parent. Like the "blind" figures in *Return from Bohemia* and *Appraisal,* the father's downcast eyes appear to be closed—an element that renders this otherwise intimidating figure as inert as the farmer in *American Gothic.*

Surpassing the defensive power of the boy's mask are the multiple threats posed by his hatchet. With this weapon, Washington has destroyed his father's tree—an element not only traditionally associated with phallic power, but also specifically linked to Maryville himself (the connection between "Wood" and "wood" is unavoidable here). The artist conflates this doomed man and tree even in the palette he chooses; as Shirley Reece-Hughes has observed, the father's blackened right hand is streaked with what appears to be blood or cherry juice. Severed and oddly flaccid, the bleeding tree and its dangling fruit will soon wither and die.

In a more subtle example of the young Washington's potential for harm, we see his hatchet poised above the accusatory finger of his secondary "father," Parson Weems—whose hand is itself positioned in an undeniably phallic location. The axe's final cut is the deadliest of all. Aimed directly at the point in his father's shadow where the man's genitals would appear, it threatens his body in a way that mirrors the cherry tree's destruction. Following the sightline of the work's three emphatically extended hands, the viewer's eye is riveted to the site of this patricidal hatchet job.

The mystery of Maryville's return in this painting, and the superfluity of Wood's filial revenge within it, may be partly explained by the artist's recent divorce—an event that appears to have reopened a host of old psychological wounds. Not only did the demise of Wood's marriage reinforce the severance of Maryville's *family* tree (the fate of which had been sealed, in fact, when Wood married the fifty-one-year-old Sara), but it also paralleled the relationship he had known with his father. With Sara, as with Maryville, Wood found himself routinely paralyzed by the anger of an intimidating authority figure—and in both relationships, too, he felt he had failed the traditional expectations of his role.

Like Maryville, Sara steps rather easily into the role of Washington's father. White-haired, commanding, and a veteran of "trouser roles," she is an even closer physical prototype for this overdetermined figure—whose leotard-like leggings, indeed, recall the infamous tights she had worn as Alan-a-Dale. Not only does such a substitution echo earlier gender reassignments in Wood's work, but it also highlights the fact that Sara had, both literally and figuratively, "worn the pants" in the couple's relationship. Beyond these correspondences, Sara is both the tree that no longer bears fruit and the farmer who would harvest the tree—for it must be remembered that it was she, rather than Maryville, who tended cherry orchards on her farm.

Sara's presence in *Parson Weems' Fable* is further suggested by the painting's setting. Rather than depicting Washington's eighteenth-century house in this work (a structure Wood might easily have recreated here), he instead portrays his and Sara's Iowa City home—identified by its tall windows, iron star, and the green shutters Wood had carefully restored. There is no more potent symbol of the artist's marriage and subsequent exile from Cedar Rapids than this home, the side yard of which—rendered here as the Washingtons' orchard—was the very scene of the Woods' final showdown. Speaking of this last standoff, Sara later wrote: "Grant had planned the solution of our marital problems in the same meticulous way in which he planned every painting. As far as our life was considered, it was finished—the 'painting' was complete."

Beyond its primary connection to Sara, the Woods' Iowa City house conjured a host of other associations for the artist. Not only did it represent the source of his mounting debts, but it was also the site of his mother's death—an event that had led, in turn, to the arrival of Sherman Maxon, Park Rinard, Eric Knight, and others in the artist's unorthodox household. It was here, too, that Wood created *Parson Weems' Fable* itself (the only painting, in fact, he is ever known to have painted there). Like the farmhouse in *American Gothic,* then, Wood's Iowa City home constitutes a third actor in the painting's central scene. If *American Gothic*'s arched window had summoned the artist's all-seeing eye, however, then the "eyes" of Wood's house are tightly shuttered against the scene it faces—its façade as unreadable as the young Washington's defensive mask.

As a reminder of Wood's past as well as his present, *Parson Weems' Fable* both stops time and scrambles it; the painting is "timeless," then,

if not in the way critics traditionally apply this term. Evoking the irra-
tional qualities of a dream, Wood conducts us through Weems's parted
curtain into a world where nothing is as it appears. Curtains sprout
ripe fruit, colonial Virginia becomes Iowa City, a boy morphs seam-
lessly into old age, and the hyperrealism of Weems's veined hand gives
way to a landscape of fluorescently lit, childlike simplicity. As in dreams,
too, the work's layered iconography distills into a narrow range of
symbols—a compression of meaning that allows single figures or
objects to assume multiple roles.

Anton Ehrenzweig has noted that in works of art, as in dreams,
"unconscious symbolism fails to distinguish between opposites, dis-
places the significant to the insignificant, condenses incompatibles,
and ignores rational sequence of time and place"—a catalogue of
attributes that aptly describes the more baffling elements in *Parson
Weems' Fable.* Of these characteristics, it is the displacement of the sig-
nificant, or the marginalization of potentially explosive material, that
may explain the slave figures we see at the work's vanishing point.
Although they are superfluous to the parson's story, and therefore
reduced to a seemingly inconsequential passage within the painting,
this pairing of mother and son is at least as important to the work's hid-
den order as the figures of Washington and his father in the middle
ground.

Whereas both Benton and Curry routinely included images of
African-Americans in their paintings, the slaves in *Parson Weems' Fable*
constitute Wood's only use of such models. Critics in the artist's own
day failed to comment on these figures, yet their unusual presence in
this painting has prompted scholars in more recent times to address
this passage. James Dennis suggests, for example, that Wood intended
these figures to serve as moral foils to the work's protagonists. The artist
presents "a model of good conduct in the background," Dennis writes,
"where a black slave boy, the compositional parallel to Washington,
dutifully helps his mother pick ripe cherries"—a juxtaposition that
Wood intended, Dennis claims, as "a social comment on American
racism . . . [for] no matter how destructive George might be, he is in
the glowing white light of privilege."

Although Dennis perceptively signals the figures' oppositional role
in the painting, and reasonably identifies them as mother and son, his
claim concerning the slaves' social symbolism is unsupported by the

rest of Wood's work. Not only are the artist's paintings notable for their avoidance of divisive social issues, but they are also entirely silent on matters of race. If any message is to be gleaned from Wood's slave figures, then, it is certainly not one rooted in social justice—especially given the slaves' apparent contentment (a characterization that would have deeply rankled the artist's abolitionist grandparents, who were themselves natives of Washington's Virginia).

The opposition of black and white in this painting may be at least partially detached from the question of race. Rather than a juxtaposition of powerlessness versus privilege, the contrast appears to illustrate the difference between two kinds of parental relationships—one loving and responsible, the other frightening and uncontrolled. In the distorted logic of this dream-cum-nightmare, however, the juxtaposition of "good" and "bad" parents fails to align, respectively, with Hattie and Maryville. However frightening the central confrontation might be, it is the connection between mother and son that inspires the greater anxiety.

What Dennis identifies as cooperation between these background figures may be read, at another level, as a coded scene of sexual union. Echoing his depiction of the farmer in *Fruits of Iowa,* Wood subliminally indicates the female figure's sexuality by placing a full basket of cherries just below her waist. Beside the woman, her son carries a ladder whose phallic placement is further underscored by the thrusting posture of his body (indeed, in traditional dream analysis, the rhythmic climbing of ladders is itself identified with sex). The shadow cast by this ladder clearly penetrates the mother's silhouette, neatly reversing the castrating effects of the father and son's overlapped shadows. Such a lawless pairing represents, of course, a far greater crime than Washington's destruction of the tree—a factor that may explain the painting's disproportionate sense of dread and impending punishment.

To claim that these seemingly innocuous figures might illustrate an incestuous union is to elicit, no doubt, both alarm and disbelief. Surely, the interpretation goes too far—destroying the innocence of the artist's intentions, and perverting the blameless devotion of a loving son. In defending this reading, however—and, indeed, those that precede it in this book—I would argue that such a reaction only highlights our conscious resistance to the psyche's raw and anarchic operations. My readings attempt to record what I perceive in Wood's mind's eye—a process

fraught, certainly, with great difficulty. Not only will we never know the full extent of the artist's unconscious motivations, but as author and reader we inevitably bring our own psychological histories and perspectives to these images. The potential yield in the case of Wood's work, however, is simply too valuable to leave these images unmined. Our tools may be coarse or impaired, but the work can and should be done.

That Wood might have unconsciously suggested an incestuous scene in *Parson Weems' Fable* is not to say that he had, or even wished for, a sexual relationship with his mother. Rather, what we see in this image are the ways his love for Hattie bore the residue of his guilt for replacing Maryville—a position that suggests, prima facie, a problematically misaligned relationship between mother and son. Indeed, the painting's acute sense of anxiety is as centered on Hattie as it is on Sara or Maryville, and bleeds into nearly all of the work's central elements. Not only does Wood include the house where Hattie died, but also the curtain that framed her Turner Alley sleeping quarters—a space she shared with him for nearly a decade. Far from a tangential inclusion, then, the mother and son at the painting's vanishing point constitute the most straightforward illustration of Wood's "crime" against his father, as well as his lifelong fear of retribution.

However marginalized or camouflaged this background scene may at first appear, it occupies a particularly meaningful location from the standpoint of Wood's beloved Renaissance masters. Following the invention of one-point perspective, fifteenth-century artists frequently placed this device in the service of narrative—investing their vanishing points with scenes that illuminate the reading of the central composition. In Renaissance paintings of the Annunciation, for example, the works' vanishing points often include tiny depictions of Adam and Eve's expulsion from the Garden of Eden; thus, a scene of punishment throws into relief the angel's redemptive visitation to Mary. Not only did Wood encounter similarly conceived altarpieces at the Alte Pinakothek and on his 1924 trip to Italy, but he was also naturally attentive to the ways composition informed narrative—seen both in his unconventional viewpoints and familiarity with theatrical blocking.

Given Wood's earlier suggestion of an expulsion scene in *Arnold Comes of Age,* and oblique reference to Eve's temptation in *Portrait of Nan,* it is not surprising that the background figures and other elements of *Parson Weems' Fable* also suggest biblical accounts of the Fall.

Not only does Wood present a man and a woman at a fruit tree in this image—significantly, it is she who picks the fruit—but he also includes a snaky character who sets the scene in motion (a figure whose striking gesture, conversely, recalls Renaissance representations of God's disembodied, pointing hand). Weems's own description of Washington's father—an all-powerful figure who walks through his garden, demanding to know who has destroyed his favorite tree—similarly recalls the Genesis narrative. For Wood, it was no stretch to connect the God of the Old Testament with Maryville, a man of harsh judgment who was, as the artist confided in his autobiography, "more a god than a father to me."

Whereas a Renaissance artist might have placed a redemptive scene in the foreground, Wood follows crime with punishment. The artist's victory over his father—Maryville's sudden death, and the exclusive relationship Wood subsequently enjoyed with Hattie—will eventually be avenged. Although he belonged to no church as an adult, the painter confessed to being "scared stiff" by the fire-and-brimstone sermons he heard as a child; as if to illustrate this fear of divine judgment, he includes dark, threatening clouds above the mother and son in this painting. Even the shuttered house in *Parson Weems' Fable* appears to brace itself for the disaster about to unfold.

Summoning Adam and Eve's curse of mortality, Wood gives free rein to his Gothic fascination with death in this image. In nineteenth-century folk art, drooping trees like the one in Augustine Washington's hand conveyed the limpness of prostrate grief, whereas cherries symbolized the sweet, temporary nature of life. (For this reason, they often appeared in posthumous portraits of children.) The artist would have been familiar, as well, with the Victorian symbolism of shuttered windows—the sign of a house in mourning—and the funereal significance of curtains. Indeed, Hattie's grave itself abuts a nineteenth-century monument featuring a carved "veil of life" curtain (one that even includes a tasseled pull like the one seen in Wood's painting). The insistent quality of this morbid symbolism indicates that Wood's divorce had dislodged not only his grief for Hattie, but also the specter of his own mortality. The artist projects himself onto the shuttered house, the child framed in cherries, and the darkened figure at the painting's rear—a man whose skin, like the father's blackened hand, evokes the color of death.

Arguably Wood's last truly great painting, *Parson Weems' Fable*

embodies the very theology of his work. The painter's jubilant land-
scapes, tight-lipped portraits, and historical subjects are no more than
dress rehearsals for this final Passion Play—one that not only presents
the artist's greatest personal struggles, but also his most fertile sources
of inspiration. Like *American Gothic,* the painting is a ghost story
wrapped in the comforting illusion of a patriotic subject; and like his
very first image, the hen that sat on an impossible number of eggs, it is
also a testament to the power of fantasy. Appearing before us in the
guise of a parson, Wood himself ushers us into this imaginary world—
knowing all the while that he alone may navigate its terrain.

THE PSYCHOLOGICAL INTENSITY OF *Parson Weems' Fable* led, in
the following year, to Wood's final artistic exploration of his childhood:
Adolescence, a work that summons once again the twin themes of expo-
sure and punishment (see color plate 26). The artist's decision to revisit
this work, first sketched in 1931, was no doubt inspired by his renewed
sense of confidence as a painter—and also, as Benton later explained,
by the latter artist's threat to "steal" the composition if Wood refused to
paint it. Like many of Wood's most affecting works, the painting pro-
jects a palpable sense of unease in the guise of a humorous subject.
Regarding the viewer with a wary and partly averted gaze, the young
rooster at the center of this painting is depicted not as a swaggering or
aggressively crowing bird, but rather as a thin, silent, and nearly feath-
erless creature.

 In this final return to his arrested childhood, the artist emphasizes
not only the bird's painful sense of vulnerability but also its utter lack
of freedom. Bearing the haunted look of Wood's unfinished self-
portrait, and hemmed in like the painter's figure in *Return from
Bohemia,* this bird also recalls Pyle's awkwardly elongated figure in
Arnold Comes of Age (a work that Wood originally planned, in fact, to
call *Adolescence*). The two well-fed, mature chickens that flank the
young bird confront us with a look of watchful malevolence. The trio
sit along the ridge of a roof, yet flight is no more an option for the
rooster than the possibility of its giving a lusty crow. As dawn breaks in
the background, the bird's cry remains stifled in its unnaturally tall
neck—a feature neatly sliced by the work's horizon line. Not only do
the form and fate of the chicken's neck recall those of the doomed fig-

ure in *Victorian Survival,* but as Henry Adams has observed, the unde-niably phallic shape of this bird also (and similarly) suggests a scene of castration.

If Wood's connection to this central bird is clear enough—a portrait of the artist with his Parisian beard plucked off—then the identity of the rooster's companions is more fluid. Taking their cue from the title, most critics read the work as a humorous take on the restrictions of parental control. Indeed, such a reading is reinforced by Wood's child-hood memories of attending church with Hattie and Maryville; "I sat in the grim Calvinistic light like a wooden image," Wood recalls, "walled in by my parents." These flanking birds might just as easily stand in for Nan and Hattie, however, or for Benton and Curry. The artist's "parents" were hardly restricted to Hattie and Maryville alone.

In her description of a similar image, Sara suggests that *Adolescence* reprised the artist's earliest painted subject. "Wood's first painting," she explains, was "a picture of a barnyard fowl, poised gracefully on one foot, surveying the whole world as if she owned it. A poor thing, yes. I have seen it, for his mother carefully preserved it." Although no other record of this early painting exists, it is possible that the work she describes was an early version of *Adolescence.* More important than the mystery painting itself, however, is Sara's recounting of its inspiration—a story that suggests *Adolescence's* autobiographical di-mension in no uncertain terms.

The artist told his wife that once, as a young boy, he had snatched up a brooding hen in "a fit of self-loathing" and flung it to the ground, breaking the bird's neck. Following this rare outburst of adolescent rage, and "without knowing why," Sara writes, "he carefully plucked a few of the feathers from the dead body . . . [and] using the chicken feathers as a brush, he painted his first picture." Considered as a kind of parable, the story is rather illuminating—for the act of destruction Sara recounts is strangely consistent with the depiction of the rooster in *Adolescence.* Here we see not the proud hen that Sara cites as Wood's first subject, "surveying the world as if she owned it," but rather, the doomed young bird—and by extension, the miserable young boy—that the artist recalled from his adolescence.

The unusual arched frame that Wood designed for *Adolescence* is as potentially significant as the composition itself. The artist had previ-ously used this format only twice, and in each case he had done so in

order to create a specific allusion. *Victorian Survival*'s arched shape mimics a framed Victorian tintype, whereas the rounded top of *Sultry Night*'s painted version—as well as the charcoal sketch *Saturday Night Bath*—derive from the similar outline of a hayloft opening. The frame for *Adolescence* makes yet another architectural reference. Mimicking the tall, arched windows of East Court Street, it summons all of the house's varied (and in this context, clearly unpleasant) associations. The ambiguity of this "window" perspective further deepens the painting's dreamlike effect. Are we inside looking out, or outside looking in? In either case, the striking width of the frame reinforces the claustrophobia of the scene it surrounds.

The threat of exposure and punishment conveyed in Wood's last paintings played out in an all-too-real way toward the end of his life. Until very recently, the artist's leave of absence from the University of Iowa in 1940–41 has always been explained as the result of academic and pedagogical conflicts within his department—including Wood's lack of formal education, distrust of theory, and conservative, atelier-based teaching methods. Although all of these factors certainly played a part in the campaign mounted against him, Wood's colleagues also raised the more destructive charge that he was a homosexual—and more specifically, that he and Rinard were lovers. First revealed by Joni Kinsey in 2005, this previously unreported dimension of the 1940–41 controversy explains the acute depression into which the artist descended that year.

As far back as 1936, Wood had openly clashed with his departmental chair, Lester Longman. Dedicated to modernizing the university's art program, Longman considered Wood's pedagogy and work hopelessly outdated. With the addition of Horst Janson to the department in 1938, Wood acquired a second nemesis. Not only did Janson join Longman in his censure of Wood's teaching, but he also blamed the artist for his own temporary dismissal by university officials in 1940, for bringing students to a Picasso exhibition in Chicago. (Longman had immediately reinstated Janson.) Although Wood's involvement in Janson's firing has never been proven, earlier in the same year Wood had written a letter to the administration citing his grievances against Longman. Denied his request to establish an independent "creative art" department removed from Longman's control, Wood threatened to resign—but agreed, instead, to a sabbatical for the academic year 1940–41.

Hoping to bar Wood from returning, Longman and Janson

Grant Wood with Nan Wood Graham and her husband,
Ed Graham, during the artist's sabbatical in 1940–41

embarked on an obsessive campaign in the fall of 1940 to discredit the artist. As Kinsey relates the unfolding events, Wood's chairman first gave a public lecture at the Western Arts Conference in October where he "exposed," among other supposed transgressions, Wood's dependence upon photography (a charge that was hardly disastrous in 1940). Soon thereafter, and almost certainly at Longman's invitation, a reporter from *Time* named Eleanor Welch arrived in Iowa City to follow up on darker rumors regarding Wood's private life.

Suspicion of the artist's homosexuality had been circulating in the department for some time, it seems. As Sara later claimed, Wood's colleagues at the university had sympathized with her marital troubles "because they all knew what [her] problem had been" with her husband. Wood's students, too, appear to have been aware of his closeted status. In a 2002 interview, the celebrated artist Elizabeth Catlett— who in 1940 became the first African-American to receive an M.F.A. in sculpture at the University of Iowa—explained that "everyone knew" about Wood's sexuality.

It is a bitter irony that *Time,* the same magazine that had launched the U.S. Scene just six years before, would play such a pivotal role in Wood's fall from grace. Although the magazine never published

Welch's damning article, the investigation alone had a poisonous effect upon the artist's job security and peace of mind—for as Wood's and Longman's reactions indicate, the nature of the story's charges was no mystery. Demanding to know the identity of Welch's sources, Wood pleaded with university officials to rebut her story, claiming its allegations were "so serious that they indicate a deliberate campaign to destroy my reputation." Although Longman publicly disavowed any connection to *Time*'s inquiry, he nonetheless met at length with Welch in late 1941 to discuss what the university was now calling "the Wood problem." That November Longman sent a letter to *Time,* maintaining that Wood was a valued colleague, yet adding—in a statement clearly intended to confirm the magazine's suspicions—that "Mr. Wood's personal persuasions have nothing whatever to do with our granting his leave-of-absence."

The most explicit charge Kinsey has uncovered, recorded in the minutes of a 1941 meeting led by then–university president Virgil Hancher, is as brief as it is breathtaking. "It was also reported," the minutes read, "that comment has been made on 'the strange relationship between Mr. Wood and his publicity agent,' the inference and intimation indicating that Grant Wood was a homosexual, and that Park Rinard was involved." Rather astoundingly, Rinard himself is listed as one of the meeting's participants—yet no response from him appears in the record. However uncharacteristic, Rinard's silence in this case reflects the general ineffability of the charges against Wood. Indeed, beyond this short aside, the minutes record no further elaboration of the allegation. Wood's contemporaries were equally silent regarding the accusations he faced, yet they insisted that his final battle with the university left the artist in a state of profound depression. Writing to his friend John Reid in 1940, Wood himself claimed: "My feelings in this matter are too deep to translate into words."

In a 1967 letter to a student of Wood's work, MacKinlay Kantor revealed that the artist had managed to put at least some of his feelings into words. During the fall of 1941, Kantor explains, he and Wood met in New York:

> [Wood] was staying at the Barbazon [*sic*] Plaza Hotel on 58th Street, and we sat in the bar drinking for a long time; then went up to his room when the bar was closed, got hold of a bottle of whiskey—or else he had it with him—We spent literally the

whole night talking. . . . That night Grant told me a lot of things about his own life, and especially his youth, which he had never told before.

Kantor later elaborated upon these revelations in his 1972 memoir, *I Love You, Irene.* "[Wood] told me . . . how the whole sexual problem was a closed book to him, and why," he writes, adding, "It was a secret which I retain." Because the painter "did not admit or practice" a sense of "virility in the sexual sense," he goes on to explain, "people who did not know him well, and read about him or met him casually . . . whispered that he was a homosexual." For his part, Kantor insists that his friend was "nothing of the kind. He was simply asexual"—a label that echoed Cedar Rapids's own wishful thinking on the matter.

If Wood's surprising candor at the Barbizon Plaza was somewhat out of character, then the heavy drinking connected with this episode was only too typical of this stage in his life. Garwood claims, for instance, that by the late 1930s, Wood routinely drank "five highballs before dinner with no visible effect other than an appetite, and then [would] keep a glass in his hand most of the evening." In an interview with Bill McKim, a onetime Benton student, Henry Adams learned of another of Wood's all-night benders from 1941—this time at East Court Street. McKim claimed to have seen Wood consume two bottles of scotch over the course of an afternoon and evening; McKim kept pace with gin and bitters until the two passed out together on Wood's bed. The incident not only reveals the extent to which Wood abused alcohol in this period, but it also demonstrates—somewhat unsurprisingly—the ways in which his drinking led to reckless and even dangerous behavior. (The owner of Iowa City's legendary bar, Donnelly's, offered decades later that Wood was gay "only when he was drunk.")

Halfway through Wood's leave of absence in 1941, Thomas Hart Benton became embroiled in a controversy that no doubt heightened the Iowa painter's level of anxiety. In an interview widely reprinted in April 1941, Benton's homophobia not only sank to a new low, but for the first time it was also aimed at particular individuals: men with whom he worked at Kansas City's Nelson-Atkins Museum. In his typically brash fashion, Benton proclaimed:

Do you know what's wrong with the art business in America? It's the third sex and the museums. Even in Missouri we're full of

them. We've got an immigration on out there. And the old ladies who've gotten so old that no man will look at 'em think these pretty boys will do. Our museums are full of ballet dancers, retired businessmen, and boys from the Fogg Institute at Harvard, where they train museum directors and artists. They hate my pictures and talk against them. I wouldn't be in the museums except that people demand that I have representation.

The Kansas City Art Institute, where Benton had taught since he left New York, punished his comments by refusing to renew his contract for the following year. Benton retaliated by turning his dismissal into a cause célèbre. Claiming that his enemies at the Art Institute and the Nelson-Atkins Museum were "not quite regular in the plain American sense," he waged a public battle that became increasingly ugly.

Students, colleagues, and Kansas City backers loyal to Benton demonstrated that his own bigotry was rather broadly embraced. Indeed, as Michael Sherry has shown, by the 1940s many Americans believed not only that homosexuals posed a threat to American high culture, but that these men formed a highly organized, powerful "gay mafia" that needed to be rooted out and destroyed. At a rally in support of Benton's reinstatement, for example, students from the art department marched with signs bearing the image of a pansy, accompanied by the slogan "We Don't Want These!"—a declaration intended to illustrate their own right-mindedness, as much as their support for Benton. The *Kansas City Journal*, too, eagerly leapt to the artist's defense. Publishing a homophobic caricature of a fey, limp-wristed Benton, "Remodeled to Suit the Institute," the newspaper claimed that "a 'Twist of the Wrist' Could Regain Him His Job."

Although the Art Institute remained steadfast in its refusal to renew Benton's contract (the painter told a reporter: "Sissies have won over the will of my students"), his supporters, to a certain degree, carried the day. Clearly unsettled by Benton's claims of rife homosexuality in the academy, the Art Institute replaced Benton in the fall of 1941 with Fletcher Martin—an artist who embodied an almost cartoonlike heterosexual masculinity. "There is nothing 'sissy' about Benton's successor," the *Art Digest* wrote admiringly that fall. "Martin, six-foot, broad-shouldered, ex-sailor, prize-fighter and painter, rose to eminence in California . . . all without formal art training."

The controversy at the Kansas City Art Institute and popular reactions to Benton's firing would only have reinforced for Wood the extraordinary danger of his exposure. Despite the fact that Benton was ultimately punished for his homophobia—replaced, in a stroke of poetic justice, by a man whose insistent masculinity was even more striking than his own—his dismissal exposed a rather deep vein of popular prejudice. Longman still held the ultimate trump card against Wood, who knew that the University of Iowa was just as concerned about the image of its art-department faculty. Indeed, Longman's handpicked replacement for Wood in 1940–41 was no theory-driven modernist, as one might imagine, but the same untrained artist who subsequently replaced Benton: Fletcher Martin.

Immediately prior to its investigation of Wood, *Time* described his adjunct replacement as "the youngish, tough-looking, tough-talking, tough-painting, handle-bar mustached artist, Fletcher Martin." Elsewhere in the same article, *Time* describes Wood, its former regionalist golden boy, in comparatively unflattering terms. Speaking of his technique, *Time's* critic explains that he "paints slowly, fussing, niggling, spreading glaze after glaze to achieve the hard-candy-like effect that is his specialty." Ironically, the very style that had rescued Wood years before was now characterized as timid and saccharine. By contrast, Fletcher's best-known composition—a 1938 painting of fighting sailors entitled *Trouble in 'Frisco*—typified the humorless, high-testosterone subject matter that had eclipsed Wood's work.

As he had done following Sara's departure in 1938, Wood retreated in the summer of 1941 to Clear Lake—a scenic town located about a half-day's journey north of Iowa City. Setting up a studio in an abandoned railway depot there, Wood rented a nearby cottage with Rinard, whose parents lived in town. Appropriately enough, the name of Wood's summer rental was No-Kare-No-More. (When Eric Knight visited the pair that summer, he reportedly looked for a cottage he thought was called Don't-Give-A-Damn.) Although he was now far removed from the wagging tongues of Iowa City, Wood nevertheless demonstrated a kind of bunker mentality at Clear Lake. As the *Mason City Globe-Gazette* described his studio there:

When Mr. Wood goes to work he unlocks the freight-house door and slides it back. From within he takes a stepladder which

The former railway depot in Clear Lake, Iowa, that served as
Grant Wood's summer studio in 1941

he uses for getting into the building and draws in after him, clos-
ing the door and locking it from the inside. This procedure,
reminiscent of medieval days of moat and drawbridge, is very
effective, he says, especially since he goes into a further room,
making it impossible to hear anyone knocking.

If Wood's train-depot sanctuary bore echoes of his original studio
beneath the kitchen table, then "No-Kare-No-More" cottage reestab-
lished the comforting male idyll of Stone City. In addition to Knight,
both Arnold Pyle and Carl Flick visited Clear Lake that summer, where
they sketched, cooked, swam, and took expeditions on Wood's small
boat. (Given the group's prodigious smoking habits, Wood christened
this rowboat with the punning name "Tobacco Road.") Inside his
train-depot studio, Wood enjoyed pointing out a graffito that a previ-
ous tenant had scrawled on the wall: "Yours till hell freezes over and the
devil goes a-skatin'." However indirectly, the phrase captures what
Wood himself could never openly express to these men. In later years

Rinard described this summer as "one of the happiest in [Wood's] life," yet it was also to be his last.

In late summer, Wood received the welcome news that when he returned to the university in the fall, he was to be promoted to full professor and removed from Longman's chairmanship. In order to please all parties, university officials had performed a kind of shell game—transferring Wood from his old department, Graphic and Plastic Arts, to the School of Fine Arts. The distinction was a small one, but it allowed the university to maintain one of its best-known, and still one of its best-loved, professors. Despite the continued and troubling presence of Wood's secretary (who was referred to that summer, for the first time in print, as the artist's "companion"), the university clearly wished to avoid the kind of controversy Benton's case had ignited at the Kansas City Art Institute. Indeed, as Henry Adams first noted, President Hancher even went so far as to divide Wood's employment file in two—thereby ensuring that the incoming dean had no access to the portion containing potentially incriminating information.

An ecstatic Wood sent Nan the good news that August, writing: "Another major problem of mine has been solved and I am feeling grand about it." Indeed, by summer's end, a number of signs appeared to indicate a fresh start for the artist. Not only had he survived Longman's campaign against him, but he also completed and sold two large paintings at Clear Lake—*Spring in Town* and *Spring in the Country*—and made plans for an ambitious tour of public lectures that fall. Clearly relieved that *Time*'s investigation had collapsed, Wood's dealers began to plan another one-man show of his work for the following year.

The renewed sense of optimism surrounding the artist's career was short-lived. Plagued by signs of poor health in early fall, Wood taught just three weeks under his new arrangement at the university, and eventually postponed his fall lecture tour, as well. In November, exploratory surgery at the University Hospital revealed that the artist was suffering from an aggressive form of pancreatic cancer. Subsequent surgeries failed to halt the growth of Wood's tumors, and by February of 1942 it was clear that he was dying.

The stories of the painter's final days are dominated by his longing for escape—not from death, but from the life he had known. To Fan Prescott, Wood confided a recent dream in which he had been forced to carry an enormously heavy sheet of glass; though desperate to lay

Grant Wood sketching a student model for
Spring in the Country, 1941

down this invisible burden, he continued to wander aimlessly under its weight. In typical fashion, after recounting this rather sad (and transparent) dream to Prescott, the artist reportedly "laughed heartily."

More perceptive than he realized, Benton observed on his final visit to Wood: "It was as if he wanted to destroy what was in him, and become an empty soul before he went into the emptiness of death." According to Benton, Wood insisted that "when he got well he was going to change his name, go where nobody knew him, and start all over again with a new style of painting." Unlike some of the plans Wood proposed in his final days, this one may not have been as farfetched as it sounds. While visiting Nan in California the year before, he had been offered a position at Scripps College in Claremont—a move that might have led, had he remained healthy, to a happier phase in his career.

Grant Wood in Malibu, 1940, when the prospect of
relocating to California was still a viable option

Wood's final wishes, confided under heavy morphine sedation, were
by turns comical and heartbreaking. Iowa's famously unsophisticated
First Son revealed to his sister, for instance, that he wanted to sell his
Iowa City home and relocate to Palm Springs. In preparation for this
move, he instructed Nan "to be on the lookout for an Oriental house-
boy." (Unintentionally compounding the humor of this anecdote, the
artist's sister adds: "Although Grant['s request] was irrational, he was far
from despondent. In fact, you might even say he seemed 'Gay.' ") More
seriously, and repeatedly, the dying artist voiced his desire to paint
Maryville's portrait—a wish he confessed to Benton, Cone, and Nan
on separate occasions.

Recalling the halcyon days of Turner Alley, Wood told his sister to
"have my room made ready and my easel set up. I'm coming home to

paint. In the year ahead, I'm going to do the best work of my life. My first painting will be a portrait of our father," a work he envisioned as a companion piece to *Woman with Plants.* Indeed, in the artist's last days, his insistence upon painting this portrait became urgent enough that the University Hospital's administrator, Robert E. Neff, arranged for a room to be vacated on Wood's floor as a temporary studio. The portrait was never begun, yet in effect Wood had been painting it continuously for more than a dozen years.

On the night of February 12, 1942, just two hours shy of his fifty-first birthday, Wood died with Rinard at his bedside. His last word, "Nan," went unheard by his sister, who avoided her brother's deathbed much as Wood had their mother's. (Not only had the two siblings never discussed his terminal condition with one another, but until Rinard intervened, Nan had even sought to keep the diagnosis from Wood himself.) In the days that followed, the artist's body traveled in reverse the same itinerary Wood had charted in life: from Iowa City to Cedar Rapids, and at last to Anamosa. Following his memorial service at Turner's Funeral Home, held in the shadow of the carriage house at Turner Alley, Wood was buried alongside his mother in Anamosa's Riverside Cemetery. At the artist's graveside, mourners sang the hymn Wood had chosen for the occasion—Hattie's favorite, "Abide with Me."

IN THE LAST WORK Wood ever painted, a small landscape executed in the fall of 1941 (see color plate 25), the artist presents an Iowa corn-field bathed in fading light. Partly obscured by the dark shadows that reach across its steep foreground, the work suggests the artist's acknowledgment of his approaching death. By late fall, certainly, he knew he had only months to live. Rather than retreating to his studio or the realm of his own imagination, Wood painted this final work from direct observation—his eyes wide open and lingering, lovingly, on the hills that had held him a lifelong and willing captive.

Remarkable for its spontaneity and warmth of tone, the painting's style recalls the fluid brushstrokes and palette-knife scrapings of the twenty-year-old Wood—a time before Paris, Hattie's death, and the trials of his life in Iowa City. Today the work is known simply as *Iowa Landscape,* but Nan claims Wood gave it a more evocative title: *Indian Summer.* The artist had always loved the unpredictably warm weather

of late September and early October—a period that, to him, felt like a new beginning. "October days were like symphonies in my blood," Wood recalled; "symphonies of sound and smell and dripping color. The days were full of bird song again . . . and the nights were hushed with the mystery of the falling leaves . . . October was the long sunrise of Indian Summer." In an Indian summer, fall forgets its very nature and returns to a warmer, softer season. For a time, Demeter temporarily loosens her grip on the earth—inviting her exiled child to return once more into the sunlight.

EPILOGUE

WITHIN TWENTY-FOUR HOURS of Wood's death, a *New York Times* editorial declared that regionalism had preceded the artist to an early grave. "The so-called 'American Scene' furor which swept the land some years ago," it began,

> did not, in its full virulence, last a great while. Swarming little painters of barn and silo seemed, for a time, omnipresent. They propelled a thoroughly superficial movement, predicated upon ideas that were, in themselves, sound and true and fine, but ideas misunderstood and misapplied. It was a movement that, as such, dealt in externals alone, ignoring the substance beneath.

Following this assault, the *Times* made it clear it had come to praise Wood, not to bury him. Distinguishing him from the "swarming little painters" of the American scene, the editorial noted that Wood had "attained expression in his own way" during his career, inspired by "profound and usually hidden sources." Neither the painter nor his work, it continued, were easily "reconcile[d] with the character of the region [he] portrayed." Startling in its perception, and certainly unorthodox in the distinction it drew between the artist and the movement he so vigorously promoted, the *Times'* assessment also proved to be somewhat exceptional.

In the fall of 1942, the Art Institute of Chicago staged a memorial retrospective of Wood's work at its annual American exhibition, the same venue at which *American Gothic* and *Stone City* had debuted twelve years before. Even larger than the artist's 1935 Ferargil Gallery show, this retrospective presented Wood's work in ways that were as

far-reaching as they were artificial. Not only did its curators privilege his paintings over his prints and design work, but they also virtually ignored the impressionist style Wood had embraced for more than half his career. Of the forty-eight works on display, only five predated 1929—and of these, only three represented the artist's prolific Parisian imagery. (In contrast, the smaller Ferargil show had included fourteen works from Wood's earlier period.) As its catalogue indicated, the Art Institute chose instead to highlight works that illustrated Wood's "feet-on-the-ground," "authentic," and "orderly" sense of American character.

As the first museum to assemble a retrospective of the artist's work, the Art Institute lent Wood's art a new, scholarly legitimacy. Celebrating its own Wood masterpiece above all, the Art Institute proclaimed in its catalogue: "At rare intervals in the generations of man, a creative artist emerges who can sum up in a single work of art the distinctive character of a nation . . . Such an artist was the creator of *American Gothic*." Taking this praise a step further, Daniel Cotton Rich, the director of fine arts at the Art Institute, went so far as to credit Wood with "the discovery of America."

Swept away, if not entirely forgotten, were the artist's recent battles with his university colleagues and the rumors concerning his relationship with Rinard. Indeed, as if to inoculate Wood's reputation from this recent episode, the Art Institute asked his former secretary to write the catalogue's introductory essay. The choice was a strategic one. Not only did Rinard's participation help dispel suspicions that had surrounded Wood in the preceding year (reinforcing his official, rather than his personal, relationship to the artist), but his utter inexperience as a critic also lent this layman's assessment of the "people's artist," as Wood was now being called, a sense of reassuring credibility.

Beginning with a workingman's perspective—a brief commentary by the janitor who had cleaned Wood's studio—Rinard insists that the many "legends" and "conflicting stories" surrounding the artist had led to an unfortunate misperception of this "rare and colorful person." "One might well ask," he poses, "to what extent was he clever? To what extent sincere? When all the legend is cleared away, what kind of person was he?" Rinard answers by declaring: "Grant Wood was essentially a simple man," whose "simplicity was not an artifice, but the very keynote of his character." To those who might perceive a hidden

dimension in Wood's life and work—or worse, a false sense of naïveté—Rinard explains that the artist's "simplicity was sometimes misunderstood because he had along with it qualities a simple man does not usually have: poise, for example, shrewd insight, and flawless taste."

Rinard goes on to catalogue the relationship between Wood's art and his religious convictions—a faith so simple, indeed, as to have been virtually undetectable during the artist's lifetime—and applauds the "logical expression" and "factual authenticity" of his paintings. However well-intentioned, Rinard's analysis proved to be as misleading as some of the artist's more wildly inaccurate obituaries. Not only did several newspapers insist Wood was still married at the time of his death (inexplicably, one identifies his "widow" as a woman named Arline), but some also reported his survival by one or more sons.

In the years to come, nearly all of the messy realities of Wood's life—his youthful bohemianism and keen satire, his questionable bachelorhood and unorthodox marriage, his childlike helplessness and frequent depressions—would be resolutely painted over by his supporters. His death, it appears, had immunized both Wood and his work against the scrutiny that darkened his final years. As if to signal this new invulnerability, his dealers dusted off the remaining impressions of *Sultry Night* and sold them for the steeply elevated price of seventy-five dollars—this time without the brown wrappers.

Several months before Wood's memorial retrospective, Benton offered his own assessment of the artist's legacy. Sketching the future trajectory of Wood's reputation, he preposterously suggests that the artist's work would one day usher in a renaissance of American masculinity. "When this War is over," he claims,

> a new and better America, whipped into shape by sacrifice and hardened by a rebirth of male will is going to rise . . . When this new America looks back for landmarks to help gauge its forward footsteps, it will find a monument standing up in the midst of the wreckage. Twisted and broken, the refuse of America's prewar decadence will lie all about . . . The monument rising out of it will shine with the light of a strong personal and cultural identity . . . This monument will be made out of Grant Wood's works.

As chilling as it is absurd (imagine *Daughters of Revolution* projected at the scale of Mount Rushmore), Benton's vision was dutifully echoed by the other surviving member of the regionalist triumvirate. Curry, too, declared that Wood's paintings would eventually "stand like monuments to a better, stronger America."

The stridency of such rhetoric, combined with the chauvinist tone of Craven's writings, provided Wood's critics on the Left with a rather wide target. Discrediting his former colleague in a damning series of articles in the 1940s, Horst Janson compared his folk-inspired work to the aesthetics and philosophy of the Third Reich. Certainly, the connection Benton draws between Wood's imagery and a future culture "hardened by a rebirth of male will" smacks of fascist polemics—yet Benton's unfortunate praise, and Janson's condemnations, were only possible due to the painter's absence. Wood the Soldierly Patriot is as much a postmortem invention as Wood the Dangerous Demagogue.

As his work faced increasingly direct attacks in the late 1930s and early 1940s, Wood's once-influential inner circle began to shrink at an alarming rate. In 1937, Jay Sigmund—the bard of Waubeek, and arguably Iowa's first regionalist—died in a freak hunting accident along the Wapsipinicon River. After accidentally shooting himself in the leg, the fifty-one-year-old poet died from blood loss before help could be reached. Unable to face the loss of his friend, Wood refused to attend Sigmund's funeral. A year after Wood's own death, Eric Knight was killed in the war at the age of forty-six; his transport plane, which crashed over the jungles of Dutch Guiana (present-day Suriname), was never recovered. Three years later, Ed Rowan, too, was gone. Named to a number of prestigious Federal Arts Administration posts after the closing of Stone City, and still one of Wood's most steadfast supporters, the forty-seven-year-old Rowan died in 1946 while teaching at a military college in Biarritz, France.

Nineteen forty-six also saw the death of forty-eight-year-old Curry. Following a long period of professional setbacks, depression, and poor health, the artist succumbed to a heart attack in August of that year. Benton attributed Curry's final decline to his ill-fated Kansas State House mural cycle; following Curry's painfully public removal from this project in 1941, Benton claimed, "general physical failure had taken his big body to pieces little by little." When he last visited Benton in the fall of 1945, Curry confided: "Maybe I'd have done better to stay on

the farm. No one seems interested in my pictures. Nobody thinks I can paint. If I *am* any good, I lived at the wrong time."

As if to confirm Curry's dismal self-assessment, a month before his death he was prematurely memorialized—along with Wood and the still-living Benton—in a *P.M.* magazine cartoon by Ad Reinhardt. Entitled "How to Look at Modern Art in America," Reinhardt's diagram illustrates a tree in full bloom, inscribed with the names of contemporary American artists in its branches. Next to the tree is a cemetery (sown, appropriately, with corn) whose tombstones mark the graves of the regionalist triumvirate.

The postwar art scene was marked by the triumph of abstract expressionism—another much-touted "home-grown" movement, yet one whose dynamic forms utterly eclipsed the conservative, narrative style of the regionalists. (Rather fittingly, *New Yorker* art critic Robert Coates coined the term "abstract expressionism" the year of Curry's death.) The acknowledged leader of this new generation of artists was himself a onetime regionalist acolyte: Benton's former student, Jackson Pollock. In an uncanny echo of Benton's 1934 *Time* profile, *Life* now hailed Pollock as the new hero of American modernism. Asking its readers in 1949 if Pollock was "the greatest living painter in the United States," the magazine presented the artist in a swaggering pose against one of his colossal drip paintings. With his arms defiantly folded and a cigarette dangling from his lips, Pollock surpasses even his mentor's churlish brand of masculinity in this image. A new era in American art had arrived, and once again it fairly reeked of testosterone.

As Frances Stonor Saunders revealed in the 1990s, the success of postwar American abstraction was due in part to the support it received from the United States government—a relationship that weakened regionalism's formerly exclusive hold on conservative critics. Anticommunist agencies such as the Congress of Cultural Freedom, an organization funded through the Central Intelligence Agency, celebrated abstract expressionism as the embodiment of American individualism and capitalist bravado—the perfect foil, as the story was told, to the state-sanctioned, uniform aesthetic of Soviet socialist realism. Such comparisons only spelled bad news for the regionalists, of course, whose sunny farms and heroic plowmen bore an uncomfortable, if superficial, resemblance to contemporary Soviet imagery.

If the fortunes of regionalism fell rather precipitously in the 1940s,

then the succeeding decades witnessed the movement's gradual erasure from the story of American art. In Horst Janson's best-selling 1962 survey, *History of Art*—a work that became the standard textbook in the field—Wood's former colleague not only ignored regionalism altogether, but he also excluded any mention of Wood, Curry, or Benton. *The New York Times* was equally dismissive of the movement's loudest exponent. When Thomas Craven died at the age of eighty-one in 1969, his *Times* obituary described the once widely read critic as a "propagandist" and "unpopular" figure in the art world, whose "arrogant . . . and superficial style irritated many." Six years later, in 1975, the eighty-six-year-old Benton was found dead on the floor of his Kansas City studio. He, too, was remembered unkindly by the *Times*—which offered the backhanded compliment that "it was the untutored art lovers who loved Mr. Benton's work the most."

Maynard Walker, the dealer who first brought the regionalist trio together, was the last man standing. In 1985, he died at the age of eighty-nine. Rather amazingly, the third edition of Janson's *History of Art*—introduced the year after Walker's death, and three years after Janson's—continued to ignore the movement that the New York dealer had invented. In this revised and expanded edition, edited by Janson's son Anthony, the story of twentieth-century American art in fact *begins* with abstract expressionism.

Describing Pollock's work in terms that would have made even Craven blush, Janson *fils* claims the artist's "dribbling and spattering" represented "a storehouse of pent-up forces for him to release." Pollock, he continues, "is himself the source of energy for these forces, and he 'rides' them as a cowboy might ride a horse . . . He does not always stay in the saddle, yet the exhilaration of this contest, that strains every fiber of his being, is well worth the risk." Alongside the Action Painters' canvases—whose impressive size constituted a veritable "field of combat," in Anthony Janson's words—the work of the previous generation seemed disappointingly "pallid in comparison."

UNCONCERNED BY REGIONALISM'S DISMISSAL, yet hardly indifferent to attacks on Wood's reputation, Nan was her brother's most determined champion until her death in 1990. Indeed, it is fair to say that she began her life's work in 1942: shaping and protecting

Wood's memory, acting as his unofficial archivist, and proudly serving as *American Gothic*'s living embodiment. For the forty-eight years that she survived him, Nan acted as Wood's representative in interviews and presided over any civic event organized to honor him—including the 1951 opening of Cedar Rapids' Grant Wood Elementary School, the (long-delayed) 1955 dedication of Wood's *Memorial Window* at the Veterans Memorial Building, and the 1973 inauguration of Anamosa's first annual Grant Wood Art Festival. (In a strange twist of fate, Wood's former assistant Arnold Pyle was killed in an automobile accident on his way home from this event.)

 Nan's extraordinary devotion to her brother's memory made her a formidable opponent to his would-be biographers. "I have reacted with automatic fury," she wrote, "to those I believe were misrepresenting Grant's talent, career, devotion, or life story." Of this group, none incensed her more than Darrell Garwood, whose biography, *Artist in Iowa: A Life of Grant Wood,* appeared in 1944. Garwood's account contains its share of inaccuracies and myths (as had so many profiles in Wood's own lifetime), yet it was his frequent, and only partially veiled, suggestion of the artist's homosexuality that most infuriated Nan—who routinely insisted her brother had been an artist, not a "sissy."

Not only did Nan attempt to bar Garwood from reproducing Wood's paintings in his biography, but in the scrapbooks she maintained about her brother, she also furiously deleted the author's name from any article or letter that mentioned him. In more systematic fashion, she annotated her personal copy of *Artist in Iowa* with a litany of corrections and denunciations—sometimes as many as half a dozen on a single page (typical marginalia: "Lies!," "Rot!," "Slur," "Bunk!," and "Phooey!"). Not content to limit her remarks to the body of the text, Nan even inscribed the title page, beneath the author's name, with the words: "Wasn't fit to spit on. The worst liar on earth." More than twenty years after *Artist in Iowa* appeared, Nan wrote to an admirer of Wood's work: "I hope you do not have that lieing [sic], belittling book *Artist in Iowa* (supposedly about my brother Grant) in your Library. The man in the book is a complete stranger to all who knew Grant, and is a terrible insult to the memory of a great and good man."

To a certain degree, it is easy to sympathize with Nan's reaction. Not only is Garwood's rambling, overly intimate tone off-putting, but his repeated attempts to cast the painter as effeminate, "mincing," lazy,

and even slightly moronic also betray a certain viciousness. In her reactions to passages that question Wood's sexuality, however, Nan forfeits our sympathy; by attaching words like "nasty," "dirty," and "repulsive" to the author's veiled charges, she provides a clear indication of her own attitude toward homosexuals—a group that she surely knew included her brother. (As for Vida Hanson's suggestion that Wood "just wasn't interested in women," as reported by Garwood, Nan writes that Vida had "an evil mind" and an "unnatural interest in sex.") Wood's friend Paul Engle joined Nan in condemning the book, even while hinting at the artist's struggles with the closet—a nuance apparently lost on Nan, who pasted his review into her copy of Garwood's book. "No insight is shown," Engle writes, "into the real nature of Wood's life, of his peculiar and private problems, both as a man and artist, or his curious and often secretive personality."

When Scribner's asked Nan for permission to publish a new Wood biography in 1969, she refused on the grounds that its proposed author "didn't want my name on the book, and wanted to dig out his own material from the source." Indeed, by this date the artist's sister had barred no less than seven would-be biographers from writing what she continued to call Wood's "autobiography." Twelve years later Scribner's rejected Nan's own manuscript, a folksy, first-person narrative entitled *My Brother, Grant Wood.* Still fearful of journalist "stringers" who might impugn Wood's reputation—the artist's sister, it seems, had been as rattled by *Time*'s aborted 1941 investigation as he—Nan rebutted Garwood's insinuations with a handful of stories concerning her brother's lost female loves. It would take another twelve years (and three years after Nan's own death) before *My Brother, Grant Wood* found a publisher.

Long before she wrote about her brother's life, Nan attempted to create an unusual shrine to his memory. After selling Wood's Iowa City house in the fall of 1942, she announced to the *Cedar Rapids Gazette* that she planned to reproduce the house, down to the last mullion, in California. Proposing to live within this re-created setting herself, she intended to display *Portrait of Nan* there alongside her brother's unfinished self-portrait. (Given the relative size of the paintings—Nan's portrait being more than double the size of Wood's—the installation would have established her own precedence even more powerfully than her portrait had done at East Court Street.) Although this plan never

Nan Wood Graham and Dr. B. H. McKeeby pose with *American Gothic*
at the Art Institute's 1942 memorial retrospective.

materialized, Nan did retain the bed Wood designed for himself in
the mid-1930s. Adopting it as her own, Nan hung reproductions of
American Gothic, Portrait of Nan, and the *Memorial Window* over its
headboard—the three works for which she had modeled.

Around the time Nan announced her plans to reconstruct Wood's
home in California, she also produced one of the first known parodies
of *American Gothic.* Entitled *The Three of Us,* Nan's amateur oil was fea-
tured in the *Cedar Rapids Gazette* under the headline, " 'Sister Nan'
Adds Dash of Humor to the Grant Wood Art Tradition." The newspa-
per's caption reads: "Caricaturing her brother's famous *American
Gothic,* Nan Wood Graham, who posed for the woman in the portrait,
laughingly adds the artist himself to the group. Close observation
shows that two of the pitchfork prongs add tiny horns to the angelic
countenance of Grant Wood."

Whatever Nan's original intentions may have been for this work, its
satire (much like her brother's) appears to have gotten away from her.
Not only does she firmly consign her brother to the grave in this
image—submerging his figure at the base of her composition, in a
direct quotation from Wood's *Return from Bohemia*—but she also sug-

gests that his famously childlike innocence might have been a sham. By using the first person plural in her title, moreover (the "Three of Us" here refers to Nan, McKeeby, and Wood rather than to the more familiar "we three" of Turner Alley), the artist's muse took full control over her own image.

Nan had always embraced the curious fame that *American Gothic* lent her; "I was recognized," she once wrote, "even before the painting was completed." In the years after Wood's death, her sense of identification with the iconic work only increased. At her brother's memorial exhibition in 1942, for example, Nan persuaded a deeply reluctant McKeeby to pose with her before the painting. Playing her part with enthusiasm, Nan wore her mother's cameo for the occasion and mimicked the mournful expression of the painting's female figure. For the rest of her life, she would delight in pairing up with her "double," both at the Art Institute of Chicago and also in more lowbrow contexts. She enjoyed, for example, visiting *American Gothic*'s life-size replica at the Movieland Wax Museum in Buena Park, California—even obligingly (if somewhat confusingly) holding the pitchfork when she posed with the exhibit's wax mannequins. At the 1966 unveiling of this unintentionally campy installation, Nan exclaimed: "I never dreamed there would be a wax model of me in my lifetime!"

Nan's celebrity as the living "American Mona Lisa" continued to expand in the following decades. The fashion editor for the *New York Times* declared Nan's hairstyle in *American Gothic* the new "it" look for 1970, and in the following year the artist's sister appeared as the mystery celebrity on the television game show *To Tell the Truth*. In 1977, she was even given her own entry in *Who's Who of American Women*—a distinction that owed as much to her own publicity efforts as it did to the fame of her brother's work. Indeed, as late as the 1980s, the artist's octogenarian sister was still showing up on such popular programs as *Good Morning America* and *Entertainment Tonight,* happily talking about her role in creating American art's most recognizable image.

Nan seems to have viewed the rest of her brother's work in a more detached light. Not only did she sell *Portrait of Nan* three years after the artist's death, but in 1964 she also sold his remaining works and personal effects for the surprising sum of $30,000. (During his lifetime, individual works by Wood commanded prices of up to $10,000.) Stripped of her brother's originals, Nan's home became instead a gallery

Nan Wood Graham in 1975. Reproductions and parodies
of *American Gothic* eventually filled the walls of her
Riverside, California, home.
Photo © Joan Liffring-Zug Bourret Photos

for her personal collection of *American Gothic* parodies—scores of images that eventually covered the walls of her bedroom and dressing room. The only authentic "artifact" that remained, of course, was Nan herself. Rather revealingly, in a 1983 documentary Nan insisted that the female figure in *American Gothic* had "really become me"—an image reinforced by the costumey, high-necked, gingham gowns Nan favored when photographed with her brother's work.

Much as she might have delighted in *American Gothic* parodies—even coming to embody one herself—Nan's sense of humor regarding Wood's iconic image had its limits. Beginning in the late 1960s, she brought a number of lawsuits against those she believed had made "tasteless" caricatures of the painting. By 1977, she had sued *Look, Playboy,* NBC, Johnny Carson, and *Penthouse* for nearly $20 million in punitive damages. Nan insisted that the overtly sexual nature of these parodies would have shocked her brother, "who was very moral, and

would not approve of what had been done to his painting." These suits, however, claimed the defamation of her *own* character rather than Wood's. Nan insisted that the offending parodies constituted an invasion of her privacy, and "[held] her up to ridicule and disgrace"; as if to prove her point, one wag wrote to a local newspaper that "if some people really think that Nan Wood Graham posed for the . . . topless version [of *American Gothic*], she should be happy to pay $9 million to *Playboy* in appreciation." More humiliating for Nan was *Playboy*'s defense. In sanctioning its parody, the magazine had assumed the work's models were either unknown or long since dead.

In one of the last published photographs of Nan, the artist's eighty-eight-year-old sister—at this point blind, confined to a hospital bed, and wearing an ill-fitting wig—poses, perhaps for the last time, before a reproduction of *American Gothic*. A more Gothic juxtaposition is difficult to imagine. When she died three years later, in December 1990, Nan's *New York Times* obituary ended with one of her own more fitting observations: "Grant made a personality out of me. I would have had a very drab life without it." (The "it" to which Nan refers in this instance is appropriately ambiguous: does she mean her painted image, her reflected celebrity as the artist's sister, or both?)

Attendant on her brother's fame even in death, Nan arranged to be buried at the foot of his grave. Maryville's tombstone, just a few feet away, remains unaccompanied—whereas the gravesite of Nan's husband Ed, who died in 1967, is today unknown. Appropriately enough, at the memorial service held for Nan at the Grant Wood Elementary School the following year, school officials encouraged students to attend the service in *American Gothic* costume.

THE LAST PUBLIC EVENT Nan attended as her brother's surrogate, and certainly the most significant since his death, was the opening of the Whitney Museum's 1983 retrospective Grant Wood: The Regionalist Vision. Wood's critical rehabilitation had been a long time coming. More than a decade separated his 1942 memorial exhibition from the next—and rather modest—show of his work, a display of fifteen paintings sponsored by the Dubuque Public Library in 1955. Two years later, the Davenport Municipal Art Gallery (today, the Figge Art Museum) mounted a wider-reaching Wood retrospective—a show that signaled

its emerging role, along with the Cedar Rapids Museum of Art, as a primary (and sometimes lonely) stakeholder of Wood's legacy. Throughout the 1960s, not one institution organized a retrospective or special exhibition of the artist's work.

The following decade was only marginally better for Wood's reputation. The Cedar Rapids Museum of Art mounted impressive, back-to-back shows of his work in 1972 and 1973, yet by this date the painter had effectively disappeared from most critics' radar. When the Whitney Museum staged its 1983 retrospective, then—the first in more than half a century outside the Midwest—it was taking something of a risk. The show was not without its critics ("If [this retrospective] is an augury of exhibitions to come in the remainder of the eighties," Hilton Kramer wrote, "we are in for some dark times"), yet it ultimately proved to be a resounding popular success—a tribute both to the efforts of the show's curator, Wanda Corn, and to its resonance with the conservative zeitgeist of the 1980s.

From this show until our time, Wood's work and life story have become the blue-chip stock of American art; they maintain consistently high value and appear invulnerable to change. The most recent Wood retrospective, curated by Jane Milosch, debuted at the Cedar Rapids Museum of Art in 2005. Entitled Grant Wood at 5 Turner Alley, the exhibition coincided with *American Gothic*'s seventy-fifth anniversary and the opening of his former studio to the public. In the museum's press release, executive director Terence Pitts offered: "If you thought you knew Grant Wood before seeing this exhibition, you will be surprised." Indeed, the impressive variety of media in this show highlighted for the first time the full range of Wood's work as an artist, illustrator, and designer. Almost inevitably, however, the exhibition also told an all-too-familiar story about Wood's discomfort with impressionism, devotion to manual labor, and—above all—his "vision of the values that made this country great."

When I traveled to Cedar Rapids for the Turner Alley show in the fall of 2005, I was struck by how much twenty-first-century Cedar Rapids seemed to resemble the town Wood himself had known. Trains still rattle through the center of town, flanked by towering grain elevators; the wholesome smell of toasted oats still hovers over the city; and the bells of the Immaculate Conception Church on Third Avenue, whose tolling had reminded Wood of Paris, can still be heard from his

studio. Like the well-worn outlines of Wood's life story, however, these familiar signposts belie the complexity of the city's evolving identity. More than doubled in size since the Woods' arrival in 1901, Cedar Rapids has seen major economic, social, and political changes in the past century. One rather telling example of this evolution is the presence of a lively, and perfectly ordinary, gay bar within walking distance of Turner Alley—rather fittingly named "Alley Cat."

Another relatively recent development is the cottage industry Wood's work and life have inspired in his home state. In Cedar Rapids, the faces of his *American Gothic* couple peer out from countless business windows, billboards, and bus stations; like ambassadors for the Chamber of Commerce, the pair marks the city's identity in a way Wood never could have imagined. At Anamosa's Grant Wood Tourism Center and Gallery, visitors leaf through the gallery's collection of *American Gothic* parodies or purchase reproductions of Wood's work (including, appropriately enough, sympathy cards adorned with Wood's famous twosome). Anamosa's annual Grant Wood Art Festival has now celebrated "Wood's legacy and Iowa heritage" for more than thirty years, showcasing the work of local artists alongside pieces of the True Cross: artifacts like the artist's footstool, or an original beam from the Stone City Art Colony's restaurant.

In Stone City, a full-scale replica of the *American Gothic* house now stands near the state highway—a boon to those unable to make the longer pilgrimage to Eldon. Juxtaposed against the setting of Wood's first mature landscape, this uncannily misplaced structure invests the former site of his artists' colony with a surreal touch. At close range, the house is revealed to be no more than a stage prop—a false façade attached to a one-story shed. Even its Gothic "window" is only a flourish of trompe l'oeil painting. Unperturbed by this sham—if anything, delighted by it—tourists stop before the house, strike the requisite poses for a photograph, and are soon back on the road. The resulting image will seem authentic enough, as long as it's not examined too carefully.

CONSIDERING THE HOST OF figures who have glorified or lampooned Wood since his death, it is all too easy to miss the silence of the two figures who knew the artist best in his final years: Park Rinard

and Sara Sherman. Aside from the brief essay he wrote for Wood's memorial retrospective in 1942, Rinard thereafter wrote not a word on the artist's life or work. Sara, too, kept her own counsel following the artist's death. Despite the bitterness of the Woods' divorce and the hardships she faced in its aftermath, her loyalty to the painter never wavered. Better positioned than most to provide accounts of Wood's life—and certainly, standing to profit from doing so—each chose, instead, to honor the artist's memory in private ways. Whereas Rinard sought to make the world a more hospitable place for men like Wood, Sara attempted to explain the artist's complexities in a memoir that remained unpublished—perhaps intentionally so—at the time of her death.

Given the interest Wood's life continued to generate in the 1940s, despite the falling star of his work, Rinard's failure to complete the artist's biography is remarkable. Not only did he have Nan's hard-won blessing for the project, but he also remained under contract to Wood's editors at Doubleday—who announced in 1942 that Rinard's biography would be published the following year. Distractions in his personal life may have played some part in the book's delay (Rinard joined the navy after Wood's death and married in 1946), yet even these events cannot fully account for his resistance to the project. As late as 1967, Nan still hoped that he might finish the book.

In the end, Rinard's reasons probably stemmed from the dilemmas the biography itself presented. A hagiographic study would only have perpetuated the "colorful stories" he believed had clouded the artist's legacy, whereas a more truthful and nuanced approach might have exposed the artist's reputation to greater harm. In speculating why Wood and Rinard had never finished their joint project, Garwood perceptively offered: "It didn't seem like a good idea [for Wood] to debunk himself." Indeed, most of the legends that had sprung up around Wood had either appeared with his full consent or were manufactured by the man himself. To have written a more unvarnished account, then, would have forced Rinard to contradict Wood (or worse, to challenge Nan). Instead, Rinard chose to honor the artist in his private life—he and his wife named their first son Grant Wood Rinard—and in his distinguished career as a public servant.

Following his discharge from the navy, Rinard entered Iowa politics as an aide to Governor Herschel Loveless—a position that led to his role as a speechwriter and policy advisor to Harold Hughes, Iowa's

popular governor for most of the 1960s. In the following decade, Rinard joined the Washington staff of Iowa's U.S. senator John Culver. A powerful backroom policy broker, Rinard proved to be a tireless advocate for the civil rights of African-Americans, a vocal opponent of the Vietnam War and the death penalty, and an early supporter of the Equal Rights Amendment for women. "Park was so completely centered and certain in his liberalism," former Iowa attorney general Bonnie Campbell recalled, "that he knew instantly the proper position to take on an issue because of his fundamental sense of fairness." Indeed, at Rinard's funeral in 2000, Senator Culver went so far as to call his former aide "the intellectual godfather of Iowa's progressive agenda for half a century."

Notably, Rinard's sense of fairness extended to his defense of gay and lesbian civil rights—a courageous stance that struck even Culver's younger staffers as radical, and one twice mentioned in Rinard's congressional memorial service. As early as the 1970s, Senator Culver recalled, Rinard had predicted that the struggle for gay and lesbian equality represented the country's next great civil rights challenge. Not content to sit on the sidelines of this struggle, Wood's former secretary "spoke passionately about ending discrimination against gay Americans." It would be difficult to explain Rinard's commitment to this issue, especially during a period when its advocates were so scarce, without taking into account his profound loyalty to Wood. The artist might have led a far happier life, Rinard no doubt believed, had he been able to live in a more authentic way—safeguarded from the fear of losing his job, his reputation, or both, for being exposed as a homosexual.

If Rinard's career took him to the halls of Capitol Hill, then Sara's life from the 1940s onwards was one of ever more sharply diminished horizons. Following her separation from Wood in the fall of 1938, she attempted to return to radio production in New York City. She soon discovered, however, that potential employers considered the fifty-five-year-old Sara a more likely "candidate for a wheel chair." Finding herself in increasingly desperate financial straits that winter, she eventually sought work as a cook-housekeeper. Failing this, Sara later wrote, she planned "to take a tin cup and stand on the corner of Forty-second Street and Broadway"—an assessment that was not far from the reality of her situation. At this point she received no support from Wood, by her own choice, nor any from her son, by his. In December, Sara was placed in her first housekeeping position.

Although she was surprisingly philosophical about her new line of work, Sara found her first day a difficult one. "We drove to the home, which is really a beautiful place," she recalled, "and I was shown my quarters off the kitchen." The former mayor's daughter adds:

> I was about to learn the difference between entering a home by the "front door" and entering it by the "back door." There I was, having joined the so-called servant class, writhing inwardly at the fact that I could no longer call my soul my own. At least, not in the way that I had always been accustomed to.

After a punishing six months in this position, Sara left to try her luck in Los Angeles. Still hoping to find work in radio or theater management, she displayed her unsinkable—if somewhat eccentric—sense of style upon her arrival there. In spite of the ninety-five-degree heat, Sara searched for an apartment in a full-length fur coat. Ironically, she ended up sharing her first place in Los Angeles with Nan and Ed—an arrangement that lasted nearly six months, and one that suggests a closer bond between Sara and her ex-sister-in-law than Nan would later admit to in her memoirs.

Failing to find a place in the entertainment industry, Sara landed a position as a "lady's companion" and housekeeper to the daughter of a wealthy Oakland family. In her memoir Sara refers to this young woman, Alice Rheem, as "Alice in Wonderland"—not only because Alice "enjoyed . . . a cocktail" (Sara's role, it seems, was to keep her sober and out of sight), but also because she was a "sweet, normally charming person who had never grown up." Deeply affected by Alice's "obvious loneliness" and apparent ill treatment by her family, Sara seems to have immediately fallen for her.

"I shall never forget her standing at an open window waving to me and throwing me a kiss," Sara later wrote about Alice. "At that moment I knew why I had taken this position." Charged with keeping her at the family's estate in the San Juan Islands, off the coast of Washington state, Sara seems to have regained the easy companionship and sense of being needed that she clearly craved. Within a relatively short period, however, Sara's charge was sober, married, and out from under her care—a situation that left Sara, once again, both emotionally and financially unmoored.

Managing to stay on as the estate caretaker, Sara remained there

until the 1950s; when the house was later sold, she continued to support herself as a housekeeper and cook to seasonal renters in the islands. At seventy-five, Sara retired to a forty-dollars-a-month rental cabin on Orcas Island. When Nan came across an interview her former sister-in-law gave to the *Seattle Times* years later, she wrote with unconcealed relief (and not a little smugness) to Ed Green: "Glad she didn't say anything about Grant. Kind of pitiful, isn't it? Living in a shack and on Social Security." In 1968 Sara's property was purchased by Ed Bartholomew, a man who became like a surrogate son to the former singer and shared her love for Old Fashioneds. Bartholomew believed that Sara had never fully recovered from Sherman's premature death in 1954. "That was her whole life, her son," he said in a 2001 interview; "I might have filled that void. She outlived her whole family." In 1979, Sara died in a Bellingham nursing home at the age of ninety-six.

Bartholomew, who acted as her executor, carefully preserved the documents Sara left behind: an incomplete autobiography, original drafts for radio screenplays, and several written fragments on the subject of her famous second husband. Unbeknownst to Nan, Sara had had quite a bit to say about Wood. Although she had always brushed off interviewers' questions concerning the artist—tersely referring to her second marriage as "the Grant Wood episode"—she appears to have begun a biography of her ex-husband shortly after her move to Orcas Island in 1958. In this draft, Sara explains:

> The odd thing is that there is so little biographical detail about [Wood]. *Who's Who* gives him a few lines, but aside from the circumstances of his birth, education, his brief sojourn in Paris, his even briefer incursion into the realm of teaching, and the enumeration of his prizes, most of the space is taken up with a listing of his patrons.
>
> Which, in itself, is a peculiar thing.
>
> You see, during a certain period of his life, I knew him very well.

Considering the task before her, she continues:

> Perhaps we should let him alone; let him rest on his painting alone. On the other hand, it has never done an artist—in the long run—any great disfavor to know all about him. Oscar

Sara Sherman on Orcas Island, Washington, 1958

Wilde's genius runs just as purely and clearly today as if the world did not know how he spent his last years or the reason that was behind his final degradation. There is some parallel [here,] as we shall see.

In just a few short lines, this passage—which, alas, ends at precisely this point—manages to speak volumes. Sara's pointed reference to Wilde's "final degradation" leaves little to the imagination where Wood's homosexuality is concerned, yet it is clear she intended to paint a positive portrait of her ex-husband. Not only did she have genuine empathy for what she termed "war within the individual," but she also believed Wood's legacy had been undervalued. Ironically, the very fact that she abandoned this project may itself be considered a kindness. As Michael Sherry has demonstrated, the 1950s witnessed the height of the so-called Lavender Scare—a period when homosexuals, and homosexual artists in particular, were targeted for their supposed links to communism. (In the homoerotic magazine *Physical Culture,* of all places, Dr. Arthur Guy Mathews published a typical article in 1952: "Homosexuality Is Stalin's Atom Bomb to Destroy America!")

However publicly guarded Sara might have been regarding her ex-husband, she knew full well that his "secret" had been no such thing to his contemporaries—nor is it so today, despite critics' reluctance to enter Wood's closet. As John Seery demonstrated in 1998, Wood's homosexuality has been hinted at for so long, and by so many, that scholars often incorrectly assume that the story has already been told. Referring to a television interview between C-SPAN's Brian Lamb and Robert Hughes, whose 1997 survey *American Visions* had identified Wood as a "closeted homosexual," Seery quotes Hughes's remark that the artist's sexual orientation was "widely known in the literature"—to which Seery himself rightly adds, "I haven't found a peep to that effect."

The parallel Sara drew between Oscar Wilde and her ex-husband, then, is perhaps more fitting than she realized—for in his novel *The Picture of Dorian Gray,* Wilde provides a particularly useful metaphor for understanding Wood's contemporary fate. If Dorian Gray's hidden portrait unnaturally preserved his vitality, then *American Gothic* and the rest of Wood's work have functioned in exactly the opposite way. In this case it is the complex, flesh-and-blood man who has been removed from sight, while his all-too-familiar imagery has remained uncannily resistant to change. If we are able to summon Wood from behind that darkened Gothic window, we will see this painting—and all of his remarkable work—deepen before our eyes.

[ACKNOWLEDGMENTS]

This book is the product of a loud, boozy, long-ago Bastille Day party. That night I told my Grant Wood Story, for the hundredth time, to a new audience: the author/memoirist Danielle Trussoni, who graciously listened as I shouted about the closeted, brilliant Iowa painter behind the Painting with the Pitchfork (you'll have to imagine the miming part for yourself). Without Danielle's encouragement, this story might have remained nothing more than an (increasingly threadbare) cocktail-party yarn. I am profoundly grateful to her for her generosity, professional advice, and lovely writing—and also, indirectly, for introducing me to my literary agent, Rob McQuilkin. Rob's constant support—whether in phone calls from Prague, e-mails from speeding trains, or at a restaurant table long overdue for a turnover—has sustained me more than I can express here. His careful, insightful editing and sharp eye for narrative have transformed this once-hermetic project into a book that was far more rewarding to write (and hopefully, to read).

I owe an extraordinary debt of gratitude to my editor at Knopf, Victoria Wilson, who took a chance on this project when its allies were scarce and final form far from clear. I thank her for the talent and life-long experience she brought to this manuscript, and for her belief in its value. She has never let me forget that readers want enlightenment, not lecturing. I also wish to thank Carmen Johnson, who showed me such gracious patience during the editing process and so carefully oversaw the book's production.

Many friends and colleagues lent invaluable support to this project: Annie Belz, my student research assistant, who learned more about windmills, bats, and arcane 1930s trivia than she ever thought possible; Jesse Matz and Jessica Smith, who invited me to present my work at the Modernist Studies Association and The Huntington Library; and my Wheaton colleagues Gail Sahar, Claire Buck, and Christopher Hyde—who helped me to maintain balance, provided insight, and drew me (however reluctantly) into the digital age. Joe Flessa's never-ending encouragement, humor, and feedback were critical to my writing, as

was Beth Loffreda's attentive and generous reading of my manuscript when it/I was at an awkward stage. She, Joe, and Michael Lobel continually kept my head on straight throughout the book's little crises.

I am deeply grateful to the many talented scholars, curators, and aficionados of Wood's work who have enriched this book—including Terry Pitts, Director of the Cedar Rapids Museum of Art, and Teri Van Dorston, the Registrar there, who provided me with such generous support; Mary Bennett, Special Collections Coordinator at the State Historical Society of Iowa, who unearthed so many useful images, contacts, and a (much-treasured) heirloom sansevieria plant; Joan Liffring-Zug Bourret, who shared with me her memories, time, and marvelous photographs; Jim Hayes, who kindly hosted this stranger in his home, and who has been such a remarkable steward of Wood's legacy in Iowa City; Sean Strub and John Fitzpatrick, who shared their memories of Nan Wood Graham and others; and Kristy Raine at Mount Mercy College in Cedar Rapids, whose impressive work on the Stone City Art Colony has made a lasting contribution to the study of this period. I am greatly indebted, as well, to Wood scholars Jane Milosch, Sue Taylor, and Henry Adams—not only for the richness of their work, but also for their warm welcome to the field and insights they have so generously shared with me. I count myself lucky to work alongside them.

For reintroducing a critical figure in Wood's story, I offer Ed Bartholomew and his daughter, Donna Clausen, my profound gratitude. It was Ed who faithfully preserved the papers of his former tenant and Wood's ex-wife, Sara Sherman, and Donna who tirelessly transcribed, xeroxed, and catalogued her writings for me. I thank them for sharing (in Donna's words) "the little old lady we inherited with our property" on Orcas Island. They have restored Sara's marvelous voice, and rescued her from the footnote purgatory to which she had been too long relegated.

These acknowledgments would not be complete without at least a partial listing of the guest locations where the project came together: poolside note taking in Buffalo, under Matt Souza and Greg Vergotz's extraordinary care; a memorable afternoon of writing across from Nikki Cabral, at her grandmother's dining-room table; editing alongside Tonya Jackson, miles above the Atlantic; and a blissful, productive vacation *away* from the manuscript in Jonesport, Maine, courtesy of Kersti Yllö. Appropriately enough, final edits took place at Land's End

in Provincetown (aided by a few Cosmos and great company: cheers, Bianca and Sue!).

To my New England and Virginia families, I offer thanks for keeping me afloat—including my two wonderful sisters and sister-in-law; the Cabrals, one and all, who've welcomed me as one of their own; my supportive aunt and delightful, book-loving cousin Boo; and my generous father and his wife, who have created a home that my mother and grandmother might have happily mistaken for their own (and one where the cooking, it must be said, has been kicked up several notches. My apologies to the departed).

Lastly and most importantly, I would like to thank my partner and future groom, Edward Cabral, for his unfaltering faith in this project and its author. I couldn't begin to count the number of celebratory/consolatory meals and cocktails he has either made, ordered, or shaken for me every time the book appeared to be finished—or not. I depend upon his well-tuned ear for storytelling, his genuine enthusiasm for all things Wood (the only one who's told the Grant Wood Story at parties more often than I have is Ed), and his constant willingness to listen . . . to at least three different iterations of the book, usually while brushing his teeth in the morning. This final version is for him.

[NOTES]

For frequently cited sources, the following abbreviations are used:

AAA Archives of American Art, Smithsonian Institution—Reel no. 1216 (scrapbooks of Nan Wood Graham)

AE *Anamosa Eureka*

AI Darrell Garwood. *Artist in Iowa: A Life of Grant Wood.* New York: W.W. Norton, 1944.

AI-G Nan Wood Graham's annotated copy of Darrell Garwood's *Artist in Iowa;* State Historical Society of Iowa, Special Collections

CRG *Cedar Rapids Gazette*

DMR *Des Moines Register*

GMC Hazel Brown. *Grant Wood and Marvin Cone: Artists of an Era.* Ames: Iowa State University Press, 1972.

GWC John Zug, ed. *This is Grant Wood Country.* Davenport: Davenport Municipal Art Gallery, 1977.

LSN Julie Jensen McDonald, ed. *Grant Wood and Little Sister Nan: Essays and Remembrances.* Iowa City: Penfield Press, 2000.

MB Nan Wood Graham, with John Zug and Julie Jensen McDonald. *My Brother, Grant Wood.* Iowa City: State Historical Society of Iowa, 1993.

RB Grant Wood. *Return from Bohemia: A Painter's Story.* Archives of American Art, Smithsonian Institution—Reel no. D24

SFG Sherman family genealogy

SMS Sara McClain Sherman autobiography

Introduction

3 The story of Wood's doppelgänger: MB, 160.

3 Even Wood's mother: Hattie's failure to recognize her son's photograph is told in MB, p. 62.

3 "can spend two hours": [No author indicated], "The Happy, Busy Toiler in Overalls Who is Grant Wood, Iowa Artist," *Kansas City Times,* 14 February 1938 [AAA].

3 Such an uncanny talent: During World War I, Wood was stationed in Washington, D.C., where he worked for the American Expeditionary Force Camouflage Division; MB, p. 29. Given his penchant for self-effacement it is equally fitting, as Nan records, that he kept a pet chameleon in his studio; MB, p. 71.

4 "I'm the plainest": [No author indicated], "Grant Wood Denies Reputation as Glamour Boy of Painters," *Los Angeles Times,* 19 February 1940 [AAA].

4 "large, regular, and smooth": [No author or title indicated], *Daily Iowan,* 12 December 1926 [AAA]. Nan discusses this odd demonstration as well, claiming it "showed that Grant was the more relaxed"; MB, p. 135.

4 "it has been": Wanda M. Corn, *Grant Wood: The Regionalist Vision* (New Haven: Yale University Press, 1983), p. xiii.

4 Conservative champions: For Wood's greatest critics on the Left, see H. W. Janson, "Benton and Wood, Champions of Regionalism," *Magazine of Art* 39, no. 5 (May 1946); and Hilton Kramer, "The Return of the Nativist," *New Criterion* 2, no. 2 (October 1983).

5 "or it can be": Steven Biel, *American Gothic: A Life of America's Most Famous Painting* (New York: W. W. Norton and Co., 2005), p. 171.

6 To understand the discomfort: In her insightful (and often very funny) essay about *American Gothic,* historian Sarah Vowell expresses a similar sentiment. To really see the female figure in this image, Vowell writes, "requires actually looking at the painting. This is harder than it sounds. There's a lot of buildup that needs to be cleaned off. Scrape away that postcard of Ronald and Nancy Reagan in rickrack and overalls. As well as Paul Newman and his daughter on a package of Newman's Own organic cookies." Sarah Vowell, "Grant Wood's *American Gothic* Comes in Third at a Chicago Art Institute Exhibit," in Greil Marcus and Werner Sollors, eds., *A New Literary History of America* (Cambridge: Harvard University Press, 2009), pp. 640–4.

6 "Every masterpiece": Gertrude Stein, *Four in America* (New Haven: Yale University Press, 1947), p. vii.

7 To begin to separate: One notable exception during this period was James Dennis's thoughtful study of Wood's work, *Grant Wood: A Study in American Art and Culture* (New York: Viking Press, 1975).

7 "a timeless appeal": Joseph Czestochowski, *John Steuart Curry and Grant Wood: A Portrait of Rural America* (Columbia: University of Missouri Press, 1981), pp. 5, 11.

7 "intense sympathy": H. E. Wooden, "Grant Wood: A Regionalist Interpretation of the Four Seasons," *American Artist* 55, issue 588 (July 1991), p. 58.

7 "American of the best": Thomas Craven, "Home Grown Art," *Country Gentleman,* November 1935 [AAA].

7 "[bore] as genuine": [No author indicated], "U.S. Scene," *Time* 24, no. 26 (24 December 1934), p. 25 [AAA].

7 For his part, after seeing: "If you love America, you will love this show"; Malcolm Vaughan, "In the Art Galleries," *New York American,* 20 April 1935 [AAA].

7 "That [Wood's work] is American": Dorothy Grafly, "Strength of American Art Stressed in Carnegie Institute International," *Philadelphia Record,* 21 October 1934 [AAA].

7 How is it, then: In 1999, the Whitney Museum characterized Wood's imagery as "a world in which people worked collectively for the common good"; Barbara Haskell, ed., *The American Century: Art and Culture 1900–1950* (New York: Whitney Museum of Art, 1999), p. 224.

8 In his 2004 study: Thomas Frank, *What's the Matter with Kansas? How Conservatives Won the Heart of America* (New York: Metropolitan Books, 2004), p. 16.

8 "designed to preserve traditional": Jonathan Turley, "Do We Really Need a Federal Marriage Amendment?" *Jewish World Review,* 23 May 2002.

8 Reinforcing the belief: In April 2009, the Web site Wonkette featured a number of these parodies of *American Gothic,* with the following introduction: "One sign of the state's previous extreme heterosexuality was Grant Wood's famous painting, *American Gothic!* Boy, that sure is a symbol of traditional American values that everyone can easily recognize!" Comics Curmudgeon, "Grant Wood's Body Lies A-Mouldering in the Grave," Wonkette.com, 10 April 2009. My thanks to Michael Lobel for forwarding me this posting.

9 In 2004 the U.S. Mint: Leutze's *Washington Crossing the Delaware* appears on the New Jersey state quarter; Trumbull's *Declaration of Independence* is found on the two-dollar bill.

9 Wood "spent his career": The full text for the quarter's unveiling may be found on the U.S. Mint's Web site, www.usmint.gov.

10 "repository of national": Frank, *What's the Matter with Kansas?*, p. 16.

10 "a handy instrument": Kramer, "Return of the Nativist," p. 61.

ONE: Paint Like a Man

11 "Grant Wood was bon": "Iowa Artist Was Sent to the Cellar," DMR, 12 February 1939 [AAA]. Wood's inscription was still legible in 1944; AI, p. 18.

11 "scribbling on the walls": RB, frame 208.

11 "damp chill . . . and a musty": RB, frame 201.

12 His parents named: Nan and Wood both note that the name "Grant" came from their cousin Grant Smith; Wood explains, however, that "the great general [Ulysses S. Grant]" was the original source for the name; RB, frame 185.

12 "Well, we have": David Hinshaw, *Herbert Hoover: American Quaker* (New York: Farrar, Straus and Co., 1950), p. 3.

12 "the manliest": AE, 6 January 1886, as quoted in RB, frame 182.

12 "noble and sublime": [No author indicated], "DROPPED DEAD. Francis Maryville Wood, of Jackson Township, Is No More," AE, 21 March 1901 [AAA].

12 Joseph and Rebecca Wood: AI, p. 19.

12 Profoundly religious: AI, p. 20.

13 Although he certainly: In addition to Gibbon, mentioned below, Wood remembers Macaulay's and Hume's histories of England in his father's library; biographies of Abraham Lincoln and William Penn; and periodicals such as *Harper's Magazine;* RB, frame 175.

13 Not only did his: The Wood family Bible notes that Sarah (Sallie), Clarence, and Eugene "died unmarried"; Charles's later marital status is unknown [AAA].

14 "The end of this": A copy of both the Woods' and the Weavers' genealogies, as they were recorded in the family Bible, appears in Nan's scrapbooks [AAA].

14 "There was a certain": RB, frame 174. Because Wood worked with a ghostwriter on *Return from Bohemia,* the extent of his authorship is a matter of some dispute among scholars. My own belief is that Wood was the work's primary author. For my discussion of the autobiography and the issue of its authorship, see Chapter 4.

15 Not only had he banned: MB, p. 6. Maryville and Hattie's initial separation occurred while he was building their house; throughout this period, he lived with his parents and Hattie and Frank lived with hers.

15 "the most majestic": RB, frame 174.

15 "I never questioned": RB, frame 175.

15 "Maryville had been": AI, p. 23.

15 "long, grotesque figure": RB, frame 267.

15 "even the way he walked": RB, 170.

15 Peters also shared: Wood writes that "after dinner, he would invariably go into the parlor, removing his felt boots reverently before entering. There he would spend the afternoon, looking contentedly at the tintypes in the plush album"; RB, frame 272.

15 "twisted silence": RB, frame 191.

15 "hawklike" and subsequent quotations: RB, frames 170, 195, 233, 169, 233, 193.

16 "talon-like"/"whiskered lips": RB, frames 269, 194.

16 "[I was] caught [by] a jolt": RB, frame 170.

16 "all lonsome [sic]": Dated 1 October 1900 [AAA].

16 "real boy": AI, p. 21. For more on Frank, see RB, frames 172, 286.

16 For his part: MB, pp. 2, 11. Darrell Garwood confirms this characterization of Jack, who would "fly into fits of rage and swing his fists about, then be the finest fellow in the world a few minutes later"; AI, p. 27.

16 even holding his father's: RB, frame 250.

17 No doubt sensing: RB, frame 170.

17 "looked at Grant now and then": AI, p. 22.

17 "our two brothers": MB, p. 6.

18 "Closely confined": RB, frame 183.

18 "did not seem to belong": RB, frame 170.

18 "felt most strongly": RB, frame 194.

18 "At no other time": David Lubin, *Act of Portrayal: Eakins, Sargent and James* (New Haven: Yale University Press, 1985), p. 20. Anthony Rotundo also cites this decade as one of acute "male anxiety" in *American Manhood: Transformations in Masculinity from the Revolution to the Modern Era* (New York: Basic Books, 1993), p. 222.

18 Wood's was the first: Rotundo, *American Manhood,* p. 259.

19 Furthermore, child-rearing: G. Stanley Hall's two-volume treatise *Adolescence,* a model of this approach, was published in 1904.

19 "a healthy strain": Rafford Pyke, "What Men Like in Men," *Cosmopolitan* 33, no. 4 (August 1902), p. 403.

19 "I feel we cannot": Quoted in Michael Kimmel, *Manhood in America: A Cultural History* (New York: Free Press, 1996), p. 166.

19 "manly boys": "DROPPED DEAD," AE, 21 March 1901 [AAA].

19 "I had privacy": Arthur Millier, "Bible Belt Booster," *Los Angeles Times,* 7 April 1940 [AAA].

19 Even when concealed: AI, p. 21.

19 "The father liked": AI, p. 22.

20 Upon seeing Wood's: RB, frame 173.

20 As the artist himself: RB, frame 173.

20 "I was as bashful a child": Pownall, "Iowa Parents Hear Artist," *Des Moines Tribune,* 18 June 1936 [AAA].

21 "DROPPED DEAD": "DROPPED DEAD," AE, 21 March 1901 [AAA].

21 The artist expresses: RB, frame 173.

21 "I was crying": RB, frame 279.

21 "stern, haunting loneliness": RB, frame 174.

21 as the family travels: RB, frame 295.

22 "This association of Maryville's death": Sue Taylor, "Grant Wood's Family Album," *American Art* 19, no. 2 (Summer 2005), p. 55.

22 "I had a vague, calamitous": RB, frame 292.

22 "No account of [Wood's]": Hilton Kramer, "The Return of the Nativist," *New Criterion* 2, no. 2. (October 1983), p. 61.

22 "we're conditioned": [No author indicated], "Artist Who Discovered America Finds Nothing Interesting About His Career," *Los Angeles Times,* 19 February 1940 [AAA].

22 in the previous decade: Hazel Brown estimates the population of Cedar Rapids in 1890 was no more than 25,000; GMC, p. 5.

23 Towering grain elevators: Nan writes, "The smell of toasting oats . . . floated over the city"; MB, p. 54.

23 "He found it hard": MB, p. 9.

23 "to carry out Father's": MB, p. 10. When she brought home a copy of *The Wonderful Wizard of Oz* as a young girl, Nan was told by Hattie, "Your father would not approve"; MB, p. 10.

23 Hattie's attitude: MB, p. 11.

24 Chief among his: LSN, p. 78, and MB, p. 12. Garwood also cites Wood's junior-high-school teacher Robina Wilson as an early supporter; AI, p. 27.

24 From his teenage: Wood performed in these tableaux into his twenties; untitled 1939 clipping [AAA]; also MB, p. 36.

25 "I'd hate to see": Park Rinard's radio play *Grant Wood* was broadcast on 27 April 1940 as installment 30 of NBC Radio's *Art for Your Sake* program [AAA].

25 "For a farmer's son": Millier, "Bible Belt Booster," *Los Angeles Times,* 7 April 1940 [AAA].

25 "brutality" and "rough, manly": Quoted in Martin A. Berger, *Man Made: Thomas Eakins and the Construction of Gilded Age Masculinity* (Berkeley: University of California Press, 2000), p. 8.

26 "painting pansies": Phil Stong, *Hawkeyes: A Biography of the State of Iowa* (Iowa City: Dodd, Mead and Co., 1940), p. 39.

26 by the time the artist: David Halperin credits Charles Gilbert Chaddock with the introduction of the term "homosexuality" into the *Oxford English Dictionary;* Halperin, *One Hundred Years of Homosexuality and Other Essays on Greek Love* (New York: Routledge, 1990), p. 15.

26 The power of this new: The debate over the definition of contemporary homosexuality, one that I have necessarily reduced here, has a complex critical history. Michel Foucault's argument concerning the "invention" of the homosexual in the 1870s, a theory that he first posed in *The History of Sexuality,* is today generally accepted; Michel Foucault, *History of Sexuality, vol. 1* (New York: Pantheon Books, 1976).

26 a term whose modern: I am indebted to Anthony Rotundo's *American Manhood* for his reference to Pyke's article; Pyke, "What Men Like in Men," *Cosmopolitan* 33, no. 4 (August 1902), pp. 402–406. Rotundo notes the *OED*'s definition of "sissy" in *American Manhood,* p. 273. Prior to 1890, the term was simply a colloquialism for a younger female sibling (i.e., slang for "sister").

26 "sissy-soul": Pyke, "What Men Like in Men," *Cosmopolitan* 33, no. 4 (August 1902), p. 404.

26 "manliness was all": Quentin Crisp, *The Naked Civil Servant* (London: Jonathan Cape, 1968), p. 27.

26 By the 1890s: Michael Hatt, "Muscles, Morals, Mind: The Male Body in Thomas Eakins' *Salutat,*" in Kathleen Adler and Marcia Pointon, eds., *The Body Imaged: The Human Form in Visual Culture Since the Renaissance* (Cambridge: Cambridge University Press, 1993).

27 "Flanked by dark shadows": James M. Dennis, *Grant Wood: A Study in American Art and Culture* (New York: Viking Press, 1975), p. 19.

28 he reportedly "always" wore: In a CRG article from 1935, a fourteen-year-old Cedar Rapids girl named Jean Knight explains, "My daddy says [Wood] ALWAYS used to wear" a raccoon coat as a young man; Eliza Burkhalter, "14-Year-Old Painter Turns Tables on Grant Wood, Makes His Paintings Caricature Subject," CRG, 17 November 1935 [AAA]. According to Darrell Garwood, Wood still wore raccoon coats in his thirties; AI, p. 90.

28 Eager to begin: MB, p. 19.

28 Wood had long: James M. Dennis, "Grant Wood Works on Paper: Cartooning in One Way or Another," in Jane C. Milosch, ed., *Grant Wood's Studio: Birthplace of American Gothic* (New York: Prestel, 2005), p. 35.

29 That summer Wood embarked: AI, p. 29; see also Jane C. Milosch, "Grant Wood's Studio: A Decorative Adventure," in Milosch, ed., *Grant Wood's Studio,* p. 80.

29 "Have nothing in your houses": This line first appeared in William Morris's *The Beauty of Life* (1880).

29 "Painting is more work": "Artist Who Discovered America," *Los Angeles Times,* 29 February 1940 [AAA].

29 "[Wood] is a man": An assessment offered by a man named Dr. Myers on the NBC radio broadcast *Art for Your Sake,* 27 April 1940 [AAA].

29 "with equal facility": Thomas Craven, "*Scribner's* Examines: Grant Wood," *Scribner's* 101, no. 6 (June 1937), p. 17.

29 "Making jewelry": AI, p. 32.

29 Hoping perhaps to follow: AI, p. 33, and MB, p. 20.

29 Compared to the Handicraft: For contemporary images of these shops, see I. E. Quastler and Jules A. Bourquin, *Rock Island in Focus: The Railroad Photographs (1898–1975) of Jules A. Bourquin* (Dallas: DeGolyer Library, 2007).

30 "just turning a wheel": AI, p. 33.

30 A back injury: "One day at work," Nan relates, "Grant got a sudden pain in his back and couldn't straighten up. He quit, deciding Mother knew best"; MB, p. 20.

30 Surprisingly enough: Joseph S. Czestochowski, *Marvin D. Cone and Grant Wood: An American Tradition* (Cedar Rapids: Cedar Rapids Museum of Art, 1990), pp. 139, 188.

30 "the spirit that built": AI, p. 33.

30 "stand amidst gardens": William Morris, "A Factory As It Might Be," *Justice,* 17 November 1884, p. 2.

31 Acting as both: AI, p. 38. Wood's subsequent work with Kristoffer Haga was also shown at the Art Institute in 1916; Milosch, "Grant Wood's Studio," in Milosch, ed., *Grant Wood's Studio,* p. 80.

31 During the 1911–12: MB, p. 20.

31 "learned more drawing": AI, p. 37.

31 Three nights a week: AI, pp. 36–37, and MB, p. 21.

31 Although the artist's: AI, p. 37. Nan explains Wood's failure to pay for his classes more sympathetically; the instructor was so impressed by Wood's work, she claims, that he simply waived Wood's fees; MB, p. 21.

31 Wood's instructor at the university: My information concerning Cumming derives from Richard Leet's excellent study, "Charles Atherton Cumming: A Deep Root for Iowa Art," *American Art Review,* March–April 1997, pp. 114–119.

31 In 1911–12, Cumming: Cumming's subject for this mural was *The Departure of the Indians from Fort Des Moines;* Leet, "Charles Atherton Cumming," *American Art Review,* March–April 1997, p. 116. Wood's would-be mural project, a series for Washington High School devoted to Iowa history, never materialized; AI, pp. 36, 38–39.

32 Throughout the 1910s: As Wanda Corn has suggested, this kind of varied approach was typical of academic painters in a more general sense—but it must be remembered that Wood's first exposure to the practice came through Cumming; Wanda M. Corn, *Grant Wood: The Regionalist Vision* (New Haven: Yale University Press, 1983), p. 15.

32 At this large-scale: AI, p. 40.

32 Founded in 1905: For a fuller history of the Kalo Shop, see R. Tripp Evans, "A Profitable Partnership," *Chicago History* 24, no. 2 (summer 1995), pp. 4–21.

32 Lasting less than: AI, p. 39.

32 Although Wood and his supporters: Indeed, the first sentence of Dennis's 1975 Wood monograph reads: "Grant Wood for the most part taught himself to paint"; Dennis, *Grant Wood,* p. 19.

32 After the communal: AI, p. 39.

32 Indeed, it is: AI, p. 40. In a similar instance years later, Wood delightedly showed the painter Aaron Bohrod his side-yard sunbathing tent—a place where Wood said he

could privately disrobe "in full view of the populace of Iowa City." Bohrod described this "pagoda-like structure" in a 1942 interview; GWC, p. 62.

33 "had no friends among": AI, p. 40.

33 "foam[ed] with tales": GWC, p. 62.

33 With more time: Through an ingenious bit of persuasion, Wood convinced school administrators that because of his prolonged absences from the school, he was entitled to two months' free instruction. His full-time stint at the Art Institute did not even last this long; AI, p. 41.

33 By spring, Hattie had: AI, pp. 43–44.

33 The following year: In her annotated copy of Garwood's *Artist in Iowa,* Nan insists that Hanson—who she characterizes as lazy and undependable—had little role in building the Woods' Kenwood Park house. Instead, she credits Wood's friend Leonidas ("Lon") Dennis as her brother's building partner. The project could only have been undertaken, however, through Wood's friendship with Hanson—who paid most of the bills for the house, and who participated, at least to some degree, in its construction. AI-G, p. 47.

33 Eighteen-year-old Nan: Nan provides a stark picture of the Woods' living conditions at the time of her return to Cedar Rapids. The Wood and Hanson families, she explains, lived primarily on toast, coffee, canned beans, and baby food in the winter of 1917. AI-G, p. 51.

34 "the family unit became": MB, p. xv.

34 As children, for example: Ibid.

34 By contrast, the lives: Garwood reports (AI, p. 47) that Nan periodically lived with her aunt during this period—an arrangement that would make sense, given the limited space in the home—yet in her copy of his book, Nan writes, "I didn't stay with my aunt. I was right there in the shack." AI-G, p. 47.

34 "there were no cabinets": AI-G, p. 57.

34 "spend the dawn hours": MB, p. 15.

34 Working for the Woods': AI, pp. 31–32, and MB, p. 19.

36 "the girls went crazy": MB, p. 20.

36 In the spring: AI, pp. 34–35, 47.

36 Not long after Vida: Dennis, *Grant Wood,* p. 68.

37 "lacked the reckless": AI, p. 54. Next to this passage in her copy of Garwood's book, Nan pasted in a letter from Wood's friend Lon Dennis that reads, in part: "If Grant was in love, then he would have married before 30." (Wood was in fact only twenty-five when he met Dawn.) Dennis further explains, "marriage did not fit in with [Wood's] art." Leonidas ("Lon") Dennis to Nan Wood Graham, 24 December 1944; State Historical Society of Iowa.

38 "I guess I'm just": AI, p. 91.

38 "Our family never": MB, p. 28.

38 After an appendicitis: MB, p. 29.

38 "shy and gentle": MB, p. 30.

38 If he overslept: GMC, p. 13.

38 Prescott's indulgent: GMC, p. 14.

39 "by immediate or remote": GMC, p. 13.

39 "I'm one of the few": I am indebted to Richard Nelson, now a resident of Newport, Rhode Island, for sharing with me his fond memories of Miss Prescott and Dr. Florence (telephone interview with the author, 9 January 2010).

40 In one instance in the late 1920s: AI-G, p. 76.

40 Prescott worried only: Wood's eternal boyishness was seen as both his greatest

strength and weakness as a teacher. According to Garwood, early on Prescott had expressed concerns that Wood "might go off with the children and get lost somewhere. He may be a Pied Piper for all I know"; AI, p. 60.

41 Into the still-wet: Garwood describes Batchelder as a "designer who thought there was nobility in a good strong line"; AI, p. 32.

41 "I'm going to paint": MB, p. 33.

42 "one day [Wood] brought": LSN, pp. 85–86.

42 "fell . . . under the spell": William L. Shirer, *Twentieth-Century Journey: A Memoir of a Life and the Times* (New York: Simon and Schuster, 1976), p. 188.

43 "Impressionism was as": H. W. Janson, "The International Aspects of Regionalism," *College Art Journal* 2, no. 4 (May 1943), p. 111.

43 Indeed, Wood's introduction: Brady Roberts, James M. Dennis, James Horns, and Helen Parkin, *Grant Wood: An American Master Revealed* (San Francisco: Pomegranate Books, 1995), p. 15.

43 "an art gendered female": Norma Broude, "The Gendering of Impressionism," in Norma Broude and Mary Garrard, eds., *Reclaiming Female Agency: Feminist Art History After Postmodernism* (Berkeley: University of California Press, 2005), p. 219.

43 "quick and fluid": Broude, Ibid., p. 221.

44 "when I told my friends": Richard Peters, "Grant Wood, Noted Artist, Foresees U.S. as World Art Center." (This article, dated 11 January 1940, bears a banner from Cleveland but no newspaper name [AAA].

44 "the more one eye[d]": Quoted in Marion Elizabeth Rogers, ed., *The Impossible H. L. Mencken: A Selection of His Best Newspaper Stories* (New York: Doubleday, 1991), p. xxiii.

45 The "Grand Marshal": Richard Miller, *Bohemia: The Protoculture Then and Now* (Chicago: Nelson-Hall, 1977), p. 166.

45 "If art is responsible": Quoted in Diana Landau, *Iowa: The Spirit of America* (New York: Harry N. Abrams, 1998), p. 78.

45 "Only by going": Quoted in [no author indicated], "Red Beard Helped Him Get That Way Grant Wood Says," University of Minnesota's *Minnesota Chats* no. 7 (7 February 1939), [AAA].

45 "liberal, bourgeois,": Miller, *Bohemia*, p. 176.

45 "a serious study of French": Millier, "Bible Belt Booster," *Los Angeles Times,* 7 April 1940 [AAA].

45 "I got three dandies": Wood's postcards from Europe have, through time, become nearly illegible in their microfilmed format. This quotation appears in Dennis, *Grant Wood,* p. 63.

45 Appropriately enough: Destroyed in a 1932 fire, this painting was one of a pair the artists created of one another that summer. In 1942 Cone recalled: "Once for fun [in Paris] we painted portraits of each other. I was skinny and he drew my face long and cadaverous. I painted his face perfectly round. He labeled his portrait of me *Malnutrition* and mine of him *Overstimulation*." Boyd Carter, "As an Iowan Recalls Him," DMR, 13 December 1942 [AAA].

45 It was on this: Garwood claims (AI, p. 175) that Wood began to smoke at thirty, an age that coincides with this Paris trip.

46 "The simple possession": Miller, *Bohemia*, p. 171.

46 "prostitutes and bearded": Thomas Craven, *Modern Art: The Men, the Movements, the Meaning* (New York: Simon and Schuster; 1934 edition), p. 2.

47 "ridiculous" [and ff.]: Contemporary references to Wood's beard are surprisingly plentiful. The citations listed here derive from: Millier, "Bible Belt Booster," *Los Angeles Times,* 7 April 1940 [AAA]; Dennis, *Grant Wood,* p. 152; and "Iowa Cows

Give Grant Wood His Best Thoughts," *New York Herald Tribune,* 23 January 1936 [AAA]. Nan's recollection of the episode, and local reactions, appear in MB, p. 40.

47 "pink" and "flaming": Wood always referred to the reddish color of his beard as "pink," an odd label that was picked up by his critics; indeed, *Time* magazine referred to Wood's entire early career as his "pink whisker period" (22 April 1935) [AAA]. The "flaming" description of Wood's beard comes from an undated article (probably ca. 1940) from the *Cleveland News* entitled "Iowa Artist Tells How He Lost His French Beard" [AAA].

47 "[Wood's] beard, which crops": Nancy Marshall, "Purity or Parody? Grant Wood's *American Gothic,*" unpublished manuscript, p. 22. I am indebted to the author for sharing her insightful examination of this painting.

47 "We sell our sons": Craven, *Modern Art* (1934 edition), p. 62.

47 "men in tight trousers"/"on the hunt": Ibid., pp. 19, 30.

48 where, as late as 1898: Jeffrey Weeks reports that in a Kansas mental asylum in 1898, forty-eight homosexuals were castrated; Neil Miller, *Out of the Past: Gay and Lesbian History from 1869 to the Present* (New York: Random House, 1995), p. 23.

48 "no more significant": Richard Miller, *Bohemia,* p. 170.

48 "Gruff-voiced lesbians": Quoted in Neil Miller, *Out of the Past,* p. 159.

48 "I'm a picture painter": [No author indicated], "Stranded Nude in Center of Paris, Fate of Iowa Man"; otherwise unidentified clipping in Nan's scrapbooks (the interview was given in Iowa City in 1926) [AAA].

48 "Never before have I": Ibid.

48 "When the rest": Millier, "Bible Belt Booster," *Los Angeles Times,* 7 April 1940 [AAA].

49 evidenced by his short-lived: The *New York Tribune* notice of Wood's 1926 Galerie Carmine show featured a self-portrait signed "DeVolson," a practice Wood appears to have adopted around this time; MB, p. 55.

49 "I came back [from Paris]": Peters, "Grant Wood, Noted Midwest Artist, Foresees U.S. as World Art Center," *Los Angeles Times,* 11 January 1940 [AAA].

49 Taking a leave of absence: The full description of this year appears in MB, pp. 43–44, and AI, pp. 74–78.

49 with the exception: Both Nan and Garwood tell the story of this painting—an anecdote Wood himself seems to have often told; MB, p. 44 and AI, p. 77.

49 "I invite you": The typescript for this speech appears in Nan's scrapbooks [AAA].

51 "Grant later thought": In Nan's memoir she describes the speech as "too sweet and syrupy"; MB, p. 42.

52 "mincing": James M. Dennis, *Renegade Regionalists: The Modern Independence of Grant Wood, Thomas Hart Benton, and John Steuart Curry* (Madison: University of Wisconsin Press, 1998), p. 97.

53 Although the artist: MB, p. 42.

53 When a fire damaged: Ibid.

53 "They had always": MB, p. 48.

53 "a bunch of playboys"/"anyone who visited": Quoted in MB, p. 49, and Steven Biel, *American Gothic: A Life of America's Most Famous Painting* (New York: W. W. Norton and Co., 2005), p. 75.

54 After Wood returned: Wood moved into the loft in 1924, teaching one more year (1924–25) at McKinley; MB, p. 55.

54 Separated from the rest: MB, p. 52.

54 "unusual, without": Adeline Taylor, "Grant Wood Hailed from West to Berlin as Discovery," CRG, 25 January 1931 [AAA].

54 "From some warehouse": MacKinlay Kantor, *I Love You, Irene* (Garden City: Doubleday and Co., 1972), pp. 141–2.

56 When the artist arrived: Nan and Ed were married on 1 August 1924, and Wood arrived in Cedar Rapids later that same month; LSN, pp. 8, 71.

56 Wood's new brother-in-law: LSN, p. 71.

56 Unbeknownst to Nan: According to Nan, she had had no prior knowledge of Ed's former marriage, his fatherhood, or his battle with tuberculosis; LSN, p. 71, and MB, pp. 45–46.

57 "the marriage came": LSN, p. 8.

57 "The man who wooed": LSN, p. 71.

57 "Seeing our love": MB, p. 45.

58 "He preferred living": MB, p. 53.

58 In September 1926: CRG, 2 September 1926; cited GMC, p. 37.

58 "advance the cause": Ibid.

58 "Greenwich Village": Corn, *Grant Wood*, p. 23.

58 "were not colorful": GMC, p. 38.

59 "We were the queer": Quoted in Biel, *American Gothic*, p. 63.

59 "the most unique": GMC, p. 43.

59 "Studio House was *not*": Ibid.

59 "two old maids": GMC, p. 46.

59 "everything considered": Ibid.

59 Recounting the story: GMC, p. 47.

60 "A topic of conversation": [No author indicated], "There Have Been Brides and Brides but Bachelors Still Elude the Fair Sex," DMR, 23 June 1929 [AAA].

60 "Grant Wood is a bachelor": MacKinlay Kantor, "K's Column," *Des Moines Tribune-Capital*, 29 December 1930; although no author is indicated in the clipping, Nan inscribed "MacKinlay Kantor" next to the article [AAA].

60 "if a man wasn't": AI, p. 92.

60 "The front door": Kantor, "K's Column," *Des Moines Tribune-Capital*, 29 December 1930 [AAA].

61 "when people spoke"/"like the fragrance": AI, pp. 54, 72.

61 "rough and unkind gossip": Quoted in GMC, p. 137.

61 Hired in 1925: Dennis, *Grant Wood*, p. 166.

61 "as a matter of self-preservation": Craven, "*Scribner's* Examines: Grant Wood," *Scribner's* 101, no. 6 (June 1937), p. 17 [AAA].

61 "any earmarks": MB, p. 32.

61 "disliked this photograph": MB, p. 35.

61 "he felt silly": MB, p. 52.

63 The large hooked rug: Milosch, "Grant Wood's Studio," in Milosch, ed., *Grant Wood's Studio*, p. 95.

63 Stretching denim: The final look of the "bronzed" denim, purposely wrinkled and loosened, mimics medieval and Renaissance leather wall coverings—another sign of Wood's attachment to these periods. Jane Milosch, too, perceives a handlebar mustache form in these hinges; ibid.

63 the "unmannered" and mustachioed: Nan records that "most of the hired men wore mustaches and drank from large cups with a bar to keep the mustache out of the coffee"; MB, p. 3.

64 "a fine piece": Thomas Hoving, *American Gothic: The Biography of Grant Wood's Masterpiece* (New York: Penguin Group, 2005), p. 25.

64 "two old maps": MB, p. 70.

65 Removal of the portrait's: Corn, *Grant Wood*, p. 68.

65 The nineteenth-century map: Wanda Corn has thoroughly explored Wood's fascina-

tion with Iowan artifacts; see *Grant Wood,* and her essay "Grant Wood: Uneasy Modern," in Milosch, ed., *Grant Wood's Studio.*

65 "by its very nature": Svetlana Alpers, *The Art of Describing: Dutch Art of the Seventeenth Century* (Chicago: University of Chicago Press, 1983), p. 122.

65 "warm-hearted old Scot": Shirer, *Twentieth-Century Journey,* p. 188.

65 "authentic American manliness": Hatt, "Muscles, Morals, Mind," in Adler and Pointon, eds., *The Body Imaged,* p. 57.

66 "Daddy" Turner: MB, p. 70.

66 "the materials of past": Pownall, "Iowa Parents Hear Artist," *Des Moines Tribune,* 18 June 1936 [AAA].

66 the shirtless and barefoot: Similarly, in a now-lost mural Wood painted for Harrison High School in 1917, the artist presented three fully clothed male figures representing the Army, Navy, and Science, along with the seminude figure of Labor, "stripped for the tussle that may lie ahead"; this quote, by an unnamed contemporary critic, belongs to an unidentified clipping from 1917 in Nan's scrapbooks [AAA]. Nan mentions this mural as well, in MB, p. 27.

66 Remarking upon this difference: Alice Davidson, "Six Soldiers in Memorial Window Wonder How Soon They Must Make Room for Veterans of Another War," CRG (29 May 1938) [AAA].

67 Whether the dramatic shift: Nan claims the faces of these soldiers were altered by the German craftsmen, against Wood's preference. "The American military men had been transformed into uniformed saints with the pinched noses and small nostrils seen in Gothic art," Nan writes. "They wore the right uniforms, but they lacked the independent carriage, the forcefulness, the alert appearance, and the typical bone structure of the American face"(MB, p. 62). None of the *bodies* of the soldiers, however—with the sole exception of the Cannoneer—were so drastically altered.

67 First, he was struck: Both Wanda Corn and James Dennis have covered this aspect of Wood's artistic development in some detail; Corn, *Grant Wood,* pp. 28–29, and Dennis, *Grant Wood,* p. 67. Wood himself often spoke of his Alte Pinakothek experience, and Nan includes the story in her memoir as well; MB, pp. 67–68.

67 "There once was": H. W. Janson, "The International Aspects of Regionalism," *College Art Journal* 2, no. 4 (May 1943), p. 111.

68 Not only was he: The trip to Antwerp occurred the summer Wood and Cone were living together in Paris; GMC, p. 16.

68 Janson proposed: Janson, "International Aspects," *College Art Journal* 2, no. 4 (May 1943), p. 112.

68 Other scholars have suggested: See Corn, *Grant Wood,* p. 30, and Dennis, *Grant Wood,* p. 146.

69 "I had my fling": This article bears no title or descriptive information beyond its date (January 1936) and city (New York) [AAA].

70 "there was no need": Craven, *"Scribner's* Examines: Grant Wood," *Scribner's* 101, no. 6 (June 1937), pp. 20, 21.

70 "[had] been thoroughly": This quote comes from an undated/unattributed article entitled "Iowa Artist Tells How He Lost French Beard" in the *Cleveland News* [AAA reel 1216].

70 "he had a thorough": [No author indicated], "An Iowa Artist Discovers Iowa," *Literary Digest,* 13 August 1932, p. 13 [AAA].

70 The nature of this crisis: As Henri Gauthier-Villars declared in the first line of his 1927 study *The Third Sex,* "How can we speak of pederasty without making people

immediately think of Germany and its extraordinary organization of the 'vice,' more widespread there than in any other country in Europe?" Henry Gauthier-Villars (writing under the pseudonym "Willy"), *The Third Sex* (Urbana: University of Illinois Press, 2007), p. 15.

70 Unlike their counterparts: Jonathan Weinberg notes, for example, Marsden Hartley's criticism of Parisian flamboyance: "If you don't want the exotic kind of thing," Hartley wrote, "there is nothing." Weinberg, *Speaking for Vice: Homosexuality in the Art of Charles Demuth, Marsden Hartley, and the First American Avant-Garde* (New Haven: Yale University Press, 1993), p. 143.

70 which became, for a brief time: Miller, *Out of the Past*, p. 123.

70 "what amounted to a cult": Weinberg, *Speaking for Vice*, p. 147.

70 a mode in which he continued: Jane Milosch argues, on the contrary, that "instead of the impressionistic style of his earlier work, Wood's Munich paintings relied more on broad geometric forms, not unlike the 'puzzle pieces' of stained glass"; Jane C. Milosch, "*American Gothic*'s Munich Connection: A Window into Grant Wood's Regionalism," in Christian Fuhrmeister, Hubertus Kohle, and Veerle Thielemans, eds., *American Artists in Munich: Artistic Migration and Cultural Exchange Processes* (Munich: Deutscher Kunstverlag, 2010), p. 252. Judging from works like *36 Damm Strasse—Munich* or *The Blue House, Munich* (both 1928), however, it is clear that Wood remained committed to basic impressionist tenets: the dissolution of form through light, the recording of urban scenes, and the rapid application of paint.

71 "He was embarrassed": Christopher Isherwood, *Christopher and His Kind 1929–1930* (New York: Farrar Straus Giroux, 1976), p. 16.

71 "Blending in with the local": Milosch, "*American Gothic*'s Munich Connection," *American Artists in Munich*, p. 252.

71 "depressed and in some kind": Shirer, *Twentieth-Century Journey*, p. 274. Shirer goes into some detail about Wood's artistic epiphany, but he pushes the date back into the 1920s (perhaps in order to insert himself into the story); he claims that Wood told him in 1926, "despite the years in Europe, here [Paris] and in Munich and the other places, all I really know is home" (p. 274). Wood's Munich trip, of course, was still a couple of years in Wood's future at that point.

71 "unnatural" and "sleazy": The charge that Wood's impressionism was somehow "unnatural" runs through numerous stories, whose aim was to show that the artist's own tendencies had been perverted into this style. The use of the word "sleazy" appears in [no author indicated], "Stone and Stubble by Native Painters," *Vogue*, September 1934 [AAA].

71 "six wartime months": [No author indicated], "U.S. Scene," *Time* 24, no. 26 (24 December 1934), p. 24 [AAA].

72 "all of these early": Corn, *Grant Wood*, p. 64. Elsewhere in the same study (pp. 6–7), Corn refers to impressionism itself as "a timid form of modern painting"; Wood's chances for painting *boldly* within the style, then, seem to have been slim to begin with.

72 "the treacherous by-paths": [No author indicated], "Ravelings," *Iowa Stethoscope*, 21 August 1931 [AAA].

72 "I was taught": See Rinard, radio script for NBC Radio's *Art for Your Sake*, 27 April 1940 [AAA].

72 "I had been told": [No author indicated], "Red Beard Helped Him," University of Minnesota's *Minnesota Chats*, no. 7 (7 February 1939), [AAA].

73 "He made a careful": Ibid.; a similar version appears in [no author indicated], "Grant Wood, American Artist, Tells Reporter of Regionalism, Hobbies," *Los Angeles Times*, 29 February 1940 [AAA].

73 "the softest and most affected": Craven, *Modern Art* (1934 edition), p. 22.

73 In truth, Wood was: Rodolphe Julian had founded the Académie Julian in 1868 as a kind of safety valve for the more conservative École des Beaux Arts; by the time of Wood's arrival, it had earned a reputation as a progressive (and even permissive) institution that encouraged experimentation. Annie Cohen-Solal, *Painting American: The Rise of American Artists, Paris 1867–New York 1948* (New York: Alfred A. Knopf, 2001), pp. 65–66.

73 "Perversely, Grant seemed": AI, p. 75. James Dennis claims that in 1934 Wood reworked the surface of *The Spotted Man,* refining its visible spots to a finer texture (Dennis, *Grant Wood,* p. 237, n. 8). Even so, given Wood's clear attachment to the work, it is doubtful that the nude's original appearance crudely parodied pointillist technique.

73 One of very few works: In her annotated copy of Garwood's *Artist in Iowa,* Nan manages to both deny and confirm the painting's presence in Wood's studio—the very kind of flip-flop that usually indicates Garwood has touched a nerve. She writes that *The Spotted Man* "sold for big money to a Chicago Furniture man" (AI-G, p. 75), then later on explains Wood kept the painting, but did not display it (she claims he kept this rather sizable work tucked away in a drawer); AI-G, p. 82.

73 "disturbingly well-organized": Joseph S. Czestochowski, *John Steuart Curry and Grant Wood: A Portrait of Rural America* (Columbia: University of Missouri Press, 1981), p. 14.

74 "the usual loafing": Quoted in MB, p. 108.

74 "had acquired a special": Marquis Childs, *Literary Digest,* 13 August 1932 [AAA].

74 The taller of the two: James Dennis identifies these two figures in "Grant Wood Works on Paper: Cartooning One Way or Another," in Milosch, ed., *Grant Wood's Studio,* p. 45.

75 The anachronism of the figures': Sue Taylor, too, recognizes Nan and Hattie in these female figures, and Maryville in the figure for which David Turner modeled. She identifies the two remaining figures, however, as Wood's brothers Frank and Jack; Taylor, "Grant Wood's Family Album," *American Art,* p. 62. My only quibble with Taylor's thoughtful analysis is that Frank and Jack played such minor roles in the artist's memories of his childhood. Given the overdetermined nature of so much of Wood's work, of course, Taylor's interpretation and my own need not be mutually exclusive.

TWO: American, Gothic

77 Although the "Gothic" quality: Wood claimed that in the modern search for primitive sources, "the Gothic painters were the next step. I had always admired them, especially Memling"; MB, p. 67. Wood's attraction to the Arts and Crafts Movement—which advocated hand craftsmanship, rural simplicity, and even the revival of the guild system—had led him from an early age to associate his work with that of medieval artisans.

77 "gloom, terror, haunting": Steven Biel, *American Gothic: A Life of America's Most Famous Painting* (New York: W. W. Norton and Co., 2005), p. 51.

78 In the subcategory: Eve Kosofsky Sedgwick, *Epistemology of the Closet* (Berkeley: University of California Press, 1990), pp. 186–87. Her full treatment of this category appears in chapters 5 and 6 of her earlier work *Between Men: English Literature and Male Homosocial Desire* (New York: Columbia University Press, 1985).

78 "Once I started": Quoted in MB, p. 88.

79 "I spent twenty years": Katherine Kelley, "Paint America Is Grant Wood's Plea to Artists," *Chicago Tribune,* 5 April 1935 [AAA].

79 "[When] Grant Wood came": [No author indicated], "Red Beard Helped Him Get That Way Grant Wood Says," University of Minnesota's *Minnesota Chats,* no. 7 (7 February 1939), [AAA].

79 By this date, of course: The only version of Wood's homecoming story that specifically links it to the loft at Turner Alley is the one reported by William Shirer, who wrote in 1976: "Later Grant told me that on reaching home that year [1926] he had gazed at his mother standing to greet him at the door of his studio in the loft of the old coach house at Turner mortuary. She was wearing a familiar green apron with jagged edges and at her neck an old cameo he had brought home to her. . . . He hastily made a sketch." William L. Shirer, *Twentieth-Century Journey: A Memoir of a Life and the Times: The Start, 1904–1930* (New York: Simon and Schuster, 1976), p. 275.

 Not only does Shirer tell the story secondhand, and from a much later time, but he also fails to explain how this hasty sketch took another three years to materialize into a painting. The direct connection he makes to the Turner Alley loft is most likely made for personal reasons; Shirer had played in the carriage house as a boy, long before Wood lived there, and felt a special connection to the place.

80 The setting Wood describes: In a small 1920 oil entitled *Retrospection,* Wood painted an aproned Hattie next to the screen door of the family's kitchen in Kenwood Park.

80 "I looked up and saw": RB, frames 175–77.

80 In his original: MB, p. 68.

81 Comparing this work: Thomas Craven, "*Scribner's* Examines: Grant Wood," *Scribner's* 101, no. 6 (June 1937), p. 17.

81 The apron she wears: Of the similar apron Nan wore in *American Gothic,* she wrote that it could no longer be bought at the time; Nan Wood Graham, "I Posed for a Masterpiece," *The Woman,* September 1944, p. 44 [AAA].

81 Hattie's curiously doubled: It is not known whether Maryville himself wore a wedding ring, but given Hattie's other trappings of widowhood (described in greater detail below), it is possible that Wood intended this doubled band as a representation of his parents' marriage. Doubled bands such as this one also appear in the fifteenth-century portraits of Hans Memling; see, for example, his *Barbara van Vlaendenbergh Moreel* (1480).

81 Lastly, not only was: The window bay in which Hattie posed may be seen in Wood's impressionist-style work *Sunlit Studio* (ca. 1925–26).

82 At three, for example: Grant Wood, "Art in the Daily Life of the Child," *University of Iowa Child Welfare Pamphlets* no. 73, new series 1057 (10 May 1939), p. 5 [AAA].

82 Creating a symbolic: As the psychologist Jean Piaget explains this phenomenon: "A scribble can represent a great number of objects that would look very different to the analytic spectator. However 'abstract' the infant's drawing may appear to the adult, to him himself it is a correct rendering of a concrete, individual object." Anton Ehrenzweig, *The Hidden Order of Art: A Study in the Psychology of Artistic Imagination* (Berkeley: University of California Press, 1967), p. 6.

82 "I have what I've got": Quoted in GMC, p. 66.

82 Not only did he feel: Wood included the AE's gushing description of Hattie's wedding dress in his autobiography ("Superbly arrayed [in] green silk, with plush trimmings, [she] made a most queenly appearance"); RB, frame 182. As for her nightgown, MacKinlay Kantor recalled that Wood wore "an old pink flannel nightgown of his mother's" as part of a Cupid costume in the 1930s; GWC, p. 21.

82 Appropriately enough: In an unidentified article in Nan's scrapbooks (possibly 1939–

40), it is reported: "Recently Grant retouched the sky [on *Woman with Plants*] and built a new frame . . . On the sloping edges of the frame he placed a border of damask, made from an old tablecloth which belonged to his mother" [AAA].

82 Bearing at least: MB, p. 69.

82 Like the sitter herself: For standard treatments of the plant's iconography, see Wanda M. Corn, *Grant Wood: The Regionalist Vision* (New Haven: Yale University Press, 1983), p. 70; and James M. Dennis, *Grant Wood: A Study in American Art and Culture* (Columbia: University of Missouri Press, 1986), p. 72.

83 in the 1910s, he painted: The artist's portrait of Vida and her son Bobby is mentioned in GMC, p. 10, and AI, pp. 48–49.

83 Indeed, one of the crown jewels: In *The Seven Joys of the Virgin*, Mary receives the Magi in a stable that features a built-in planter to her left. In a lesser-known Memling altarpiece, also in the Alte Pinakothek's collection (*Mary in the Rose Bower*, 1435–40), the artist depicts the Virgin surrounded by potted topiary plants.

83 Given this source: Sue Taylor, too, suggests Wood's self-projection here; by signing his name among the potted plants at Hattie's elbow, Taylor writes, he was "identifying himself with the objects of her nurturing care." Sue Taylor, "Grant Wood's Family Album," *American Art* 19, no. 2 (Summer 2005), p.50.

83 "sublimely" overgrown: Dennis, *Grant Wood*, p. 100.

85 First associated: Nicholas P. Hardeman, *Shucks, Shocks, and Hominy Blocks: Corn as a Way of Life in Pioneer America* (Baton Rouge: Louisiana State University Press, 1981), p. 220.

85 At the Sioux City Corn: Betty Fussell, *The Story of Corn: The Myths and History, the Culture and Agriculture, the Art and Science of America's Quintessential Crop* (New York: Alfred A. Knopf, 1992), pp. 313–314.

85 "extends the shores": Guy Davenport, *The Geography of the Imagination: Forty Essays by Guy Davenport* (San Francisco: North Point Press, San Francisco, 1981), p. 12.

85 Steeped in this regional: Jane C. Milosch, "Grant Wood's Studio: A Decorative Adventure," in Jane C. Milosch, ed., *Grant Wood's Studio: Birthplace of American Gothic* (New York: Prestel, 2005), p. 98.

85 Although Wood's critics: Thomas Hoving, *American Gothic: The Biography of Grant Wood's Masterpiece* (New York: Penguin Group, 2005), p. 90.

85 "the pallid Classical": [No author indicated], "A People's Artist Passes," DMR, 15 February 1942 [AAA].

85 "how hard": Corn, *Grant Wood*, p. 70.

86 Grief-stricken and weary: This and the preceding attributes of Demeter are drawn from Michael Grant and John Hazel's *Who's Who in Classical Mythology* (London: Weidenfeld and Nicolson, 1973), pp. 134–141.

86 "Mother was standing": RB, frame 278.

86 "reached over and took": RB, frame 279.

86 "he thought the girl": MB, p. 68.

87 Unlike those who worked: James Dennis provides a useful look at Wood's surrealist and magic-realist contemporaries in *Grant Wood*, pp. 94–99. In discussing the Museum of Modern Art's 1943 American Realists and Magic Realists show, Dennis points out that the exhibition's director, Dorothy Miller, did not recognize a "fusion of inner and outer reality" in Wood's work. This does not mean, of course, that this synthesis did not exist for the artist himself.

88 "It wasn't her life": AI, p. 198.

88 "wondering, perhaps": Craven, "*Scribner's* Examines: Grant Wood," *Scribner's* 101, no. 6 (June 1937), p. 17 [AAA].

88 "solely to please": MB, p. 53.

88 Amazingly enough, Nan: Among her annotations to Garwood's *Artist in Iowa,* Nan underlines the phrase "an alcove in which he and his mother slept" and adds: "and sister." AI-G, p. 80.

88 In 1932 Wood created: GMC, p. 34. Wood's ex-wife, Sara, confirms that at the time of her arrival in 1935, Hattie's room remained unfurnished; SMS: Park Rinard fragment, p. 1.

89 "was proud of her boy": Craven, "*Scribner's* Examines: Grant Wood," *Scribner's* 101, no. 6 (June 1937), p. 17 [AAA].

89 "I'd like to marry": AI, p. 54.

89 Wood's insistence: Wanda Corn cites an unnamed friend of Wood's who described their bond as "excessive"; Corn, *Grant Wood,* p. 3. Thomas Hoving notes another who felt it "obsessive"; Hoving, *American Gothic,* p. 74.

89 Indeed, in at least two: Both of these slips are telling from a Freudian perspective. Park Rinard's typographical error appears in *Art For Your Sake,* 27 May 1940 [AAA]; Janson's misidentification appears in H. W. Janson, "The Case of the Naked Chicken," *College Art Journal* 15, no. 2 (winter 1955–56), p. 126. In Janson's article, he cites a "Mrs. Wood" living in Wood's studio in 1931 and subsequently refers to the artist as her husband. (Wood's marriage to Sara Maxon cannot explain the confusion here, as she and Wood were not married till 1935.)

90 Indeed, throughout: LSN, p. 143. See also, John Zug interview with Nan Wood Graham, 16 June 1976, State Historical Society of Iowa, Special Collections.

90 When the Cedar Rapids: MB, p. 70.

90 In 1929, for example: MB, pp. 68, 71.

90 The artist's hometown: Nan notes this accolade from the CRG (MB, p. 71), yet even she cautions that not everyone in town agreed with the assessment.

91 "queer Gothic window": Thomas Hart Benton, "Death of Grant Wood," Iowa *Demcourier* 12, no. 3 (May 1942), p. 10.

91 "Our cardboardy frame": Quoted in Irma R. Koen, "The Art of Grant Wood," *Christian Science Monitor,* 26 February 1932 [AAA].

91 "I simply invented": [No author indicated], "He Himself Explains *American Gothic,*" DMR, 4 December 1930 [AAA].

92 "Doorways and entrances": Quoted in MB, p. 55.

93 As one early observer: Mrs. Inez Keck, untitled letter to the editor, DMR, 30 November 1930 [AAA].

93 A self-described: In a letter to Mark Twain's cousin and biographer, Cyril Clemens, Wood confessed that as a child he had been attracted to the "lugubrious" sentimentality of the Victorian era; *Saturday Review of Literature* 25, no. 9 (28 February 1942), [AAA], p. 1.

93 Indeed, in his earliest: Wood abruptly ends his letter to his aunt: "mrs cheshire Died and was buried monday I have no more time to right to night so good buy to you" [AAA].

93 "getting lost": GMC, p. 16.

93 roles that he undertook: According to Garwood, Wood received the commission to decorate Des Moines' Dunn Funeral Home through Turner; AI, p. 13. For Wood's various tasks at Turner's, see Milosch, "Grant Wood's Studio," in Milosch, ed., *Grant Wood's Studio,* p. 84.

93 Indeed, Wood's paintings: GMC, p. 34.

94 once inside the artist's: Wood had made these casts in high school; Milosch, "Grant Wood's Studio," in Milosch, ed., *Grant Wood's Studio,* pp. 93–95.

94 In certain respects: Even Jane Milosch's thorough study of Wood's studio (ibid.,

pp. 78–109) references its macabre elements only in a brief aside. The coffin-lid doorway, she writes, was "a humorous reminder of the mortuary next door" (p. 93).

94 Not only do its squat: Numerous accounts by Wood's friends and relatives attest to his delight in costume parties. See particularly LSN, pp. 96, 104, 143.

94 "stood bleak and curtainless": RB, frame 293.

94 "As he put together": MB, pp. 73–74.

95 A closer look: Sue Taylor has also identified this figure as a substitute for Hattie; see her excellent analysis of *American Gothic* in her essay, "Grant Wood's Family Album," *American Art,* especially pp. 49–50.

95 At the time he began: Following the sale of *Woman with Plants* to the Cedar Rapids Art Association in 1929, Nan explains, Wood "fully intended to paint another portrait of Mother"; MB, p. 70.

95 Not only did the artist's: At seventy-one, Hattie found the endless sittings for *Woman with Plants* profoundly exhausting; AI, p. 104. Beyond the discomforts of posing, she appears to have found little joy in any activity where attention was focused so intently upon her.

95 To have painted: Photographs of the Woods' home, which was destroyed by fire in 1984, reveal striking similarities to the Eldon house. A white clapboard farmhouse, it featured slender porch posts and a steep, centrally pitched window gable on its second story—the only feature missing here is the Gothic window.

96 he had posed for Wood: As McKeeby explained in a 1935 DMR interview: "[Wood] told me that he wanted . . . a man . . . who would not rebel at the distortion that might be necessary to carry out his theme. The painting was in no manner intended to be a portrait." [No author indicated], "Model in Wood's Famous Painting Breaks Silence," DMR, 24 March 1935 [AAA]. Although Nan's face was distorted for the artist's purported theme of Gothic elongation, McKeeby's likeness in the painting was unmistakable; only his expression is uncharacteristic.

96 As appropriate as McKeeby's: McKeeby's obituary (6 January 1950) appears in Nan's scrapbooks without any other identifying information; in its text, the dentist's personality is described by his granddaughter as sharply at odds with his portrayal in *American Gothic* [AAA]. For his part, William Shirer described McKeeby as a "good-humored city man who had never held a hayfork in his life." Shirer, *Twentieth Century Journey,* p. 276.

96 "tall and gaunt" (and following quotations): RB, frames 168, 181, 224.

96 "a lean and lanky": MB, p. 5.

96 As if to signal: Maryville's glasses frames are now in the collection of the Figge Art Museum in Davenport, Iowa. That the frames seen in *American Gothic* are not McKeeby's is suggested by contemporary photographs; McKeeby's frames were larger and octagonal in shape.

96 "tintypes from my own": *Kansas City Times,* 14 February 1938 [no other identifying information; AAA].

96 That he had chosen: Wanda Corn has demonstrated, for example, that a yearbook illustration Wood drew in 1908 was based on a photograph of Hattie as a child; Corn, "Grant Wood: Uneasy Modern," in Milosch, ed., *Grant Wood's Studio,* p. 115. Given Wood's similarly mimetic use of other family imagery (*Victorian Survival*'s distorted reflection of his aunt Matilda Peet's image comes to mind), it seems that Wood's comment refers to a mental impression rather than to any known photograph.

96 "a quality bleak": RB, frame 166.

97 "His eyes pierce you": Walter Pritchard Eaton, "American Gothic," *Boston Herald,* 14 November 1930 [AAA].

97 Because we instinctively: James Elkins, *The Object Stares Back: On the Nature of Seeing* (New York: Simon and Schuster, 1996), p. 167.

97 "Always," Wood recalls: RB, frame 216. Maryville's peculiar blindness/inattention is mentioned in at least five other places: RB, frames 168, 172, 190, 208, 235.

97 The artist routinely: One of the best synopses of this debate may be found in John Seery's "Grant Wood's Political Gothic," *Theory and Event* 2, no. 1 (1998), pp. 8–11. Matthew Baigell was the first to publicly note Wood's strange self-contradiction in this interview; see Baigell, "Grant Wood Revisited," *Art Journal* 26, no. 2 (winter 1966–67), p. 116.

98 Even more remarkable: Grant Wood, "He Himself Explains 'American Gothic,' " DMR, 4 December 1930 [AAA]. Wanda Corn claims that Wood "was so surprised and delighted with the painting's national acclaim, he was in no rush to correct the record, letting *American Gothic* enjoy its own independent life as a rural married couple"; Corn, "Grant Wood: Uneasy Modern," in Milosch, ed., *Grant Wood's Studio*, p. 125. Given the swiftness with which he responded to the painting's other misinterpretations, however, it is curious that he would not have corrected such a fundamental error. Whether Wood considered this pair a father-daughter combination or not, he did not insist on this interpretation until Nan did.

98 "I am not supposed": Nan Graham, "What the Woman Who Posed Says," DMR, 4 December 1930 [AAA]. Eleven years later, in his most pointed explanation of *American Gothic*'s figures, Wood paraphrased Nan's first take on the painting:

> The persons in the painting, as I imagined them, are small town folks, rather than farmers. Papa runs the local bank or perhaps the lumber yard. He is prominent in the church and possibly preaches occasionally. In the evening, he comes home from work, takes off his collar, slips into his overalls and an old coat, and goes out to the barn to hay the cow. The prim lady with him is his grown-up daughter. Needless to say, she is very self-righteous like her father. I let the lock of hair escape to show that she was, after all, human. (letter from Grant Wood to Mrs. Nellie B. Sudduth, 21 March 1941; quoted in Corn, "Grant Wood: Uneasy Modern," in Milosch, ed., *Grant Wood's Studio*, p. 125).

98 Wood claimed the latter: Grant Wood, "He Himself Explains," DMR, 4 December 1930 [AAA].

99 albeit a rather antiquated: In a letter to the DMR, a farmer's wife from Washta, Iowa, claimed after seeing the painting, "We at least have progressed beyond the three-tined pitchfork stage!"; DMR, 14 December 1930 [AAA].

100 Dis [as Satan is named]: Davenport, *The Geography of the Imagination*, p. 15.

100 "little red grocery": RB, frame 293.

100 Only their opposing ages: Camille Paglia notes that the Greeks considered the pair almost as twin sisters; Paglia, *Sexual Personae: Art and Decadence from Nefertiti to Emily Dickinson* (New Haven: Yale University Press, 1990), p. 156.

100 Her look of resignation: In a story related to the Persephone myth, Artemis gives a woodland nymph sanctuary in Hades, where the nymph encounters Persephone—who is described as "sad, but no longer registering alarm in her countenance / Her look was such as became a Queen—the Queen of Erebus / The powerful bride of the monarch of the realms of the dead." Thomas Bulfinch, *Bulfinch's Mythology* (New York: Crown Publishers, 1979), p. 56.

100 "provocative curl": Thomas Hoving, "Judging Great Art by Both Instinct and Intellect," *Providence Journal,* 17 June 2005, B5.

101 This hint of sexual: In a caricature Wood's students produced for the dry bar at the Stone City Artist Colony in 1934, the salacious farmer's daughter appears as a standard type—illustrating that Wood's contemporaries not only recognized this character, but also felt it had regional resonance; see Kristy Raine, "When Tillage Begins: The Stone City Art Colony and School," http://www.mtmercy.edu/busselibrary/schome.html.

101 "Medusa's glare": Laurie Schneider, "Ms. Medusa: Transformations of a Bisexual Image," *Psychoanalytic Study of Society* 9 (1981), p. 122.

101 "Mr. Wood may have": Mrs. Earl Robinson, "An Iowa Farm Wife Need Not Look Odd," DMR, 30 November 1930 [AAA].

102 "I wish that jealous": Nan Graham, "What the Woman Who Posed Says," DMR, 4 December 1930 [AAA].

102 "whose excessive duty": Corn, *Grant Wood,* p. 133.

102 Whereas *Woman with Plants: American Gothic* was awarded the prestigious Norman Wait Harris Bronze Medal at the show as well as the Art Institute's $300 Purchase Award.

102 "perhaps [the artist]": Mrs. Inez Keck, untitled letter to the editor, DMR, 30 November 1930 [AAA].

102 "the missing link": Mrs. Earl Robinson, "An Iowa Farm Wife Need Not Look Odd," DMR, 30 November 1930 [AAA].

103 "This is a portrait": Walter Pritchard Eaton, "American Gothic," *Boston Herald,* 14 November 1930 [AAA].

103 "I admit the fanaticism": This quote appeared twice in the year of Wood's death; first in the CRG (5 September 1942) and then again in Park Rinard's catalogue introduction to the artist's memorial exhibition at the Art Institute of Chicago [AAA].

103 "the expression of a gay": Robert Hughes, *American Visions: The Epic History of Art in America* (New York: Alfred A. Knopf, 1997), p. 442.

104 In Wood's own day: As Karal Ann Marling writes about this period, "the generation of the twenties wanted to revenge themselves on their fathers, [but] the generation of the thirties needed the comfort of their grandfathers"; Marling, "Of Cherry Trees and Ladies' Teas: Grant Wood Looks at Colonial America," in Alan Axelrod, ed., *The Colonial Revival in America* (New York: W. W. Norton and Co., 1985), p. 295.

104 "American Normalcy Displayed": C. J. Bulliet, "American Normalcy Displayed at Annual Show/Iowa Farm Folks Highest Spot," *Chicago Evening Post,* 28 November 1930 [AAA].

104 "one of the finest": Marguerite Williams, "American Art in New Trend, Show Reveals," *Chicago Daily News,* 29 October 1930 [AAA].

104 Although the Art Institute's: Steven Biel excavated this fascinating piece of its history in his *American Gothic,* p. 28.

104 "is interesting, because": Undated brochure for the Art Institute's 1930 exhibition [AAA].

104 "The biggest 'kick' ": Quoted in Edward Rowan's article "Grant Wood's Paintings Talk of Art Circles in Chicago," CRG, 7 November 1930 [AAA].

104 "As a symbol [Wood]": Untitled review of Wood's one-man show at the Ferargil Gallery, New York; *New Yorker,* 4 May 1935 [AAA].

105 "[it] remains AMERICAN": Bulliet, "American Normalcy Displayed," *Chicago Evening Post,* 28 November 1930 [AAA].

105 "an American with an original": Undated brochure for the Art Institute's 1930 exhibition [AAA].

105 "comes from the simple": Gilbert Seldes, "Notes and Queries," *Today,* 18 May 1935 [AAA].

105 "severe sense of fact": Dorothy C. Miller and Alfred H. Barr Jr., *American Realists and Magic Realists* (New York: Museum of Modern Art, 1943), p. 5.

105 "suppressed his native": Arthur Millier, "Bible Belt Booster," *Los Angeles Times,* 7 April 1940, p. 15 [AAA].

105 "purling brooks": [No author indicated], "Stone and Stubble by Native Painters," *Vogue,* September 1934 [AAA].

105 "toga virilis": Quoted in Dennis, *Grant Wood,* p. 52.

105 "Grant Wood is calling": Seldes, "Notes and Queries," *Today,* 18 May 1935 [AAA].

106 "Midwestern tang": [No author indicated], "Ravelings," *Iowa Stethoscope,* 21 August 1931 [AAA].

106 "stiff job": Adeline Taylor, "Grant Wood Hailed from West to Berlin as Discovery," CRG, 25 Januray 1931 [AAA].

106 "sweat[ing] blood": [No author indicated], "Artist Who Discovered America Finds Nothing Interesting About His Career," *Los Angeles Times,* 19 February 1940 [AAA].

106 Even once he had: AI, p. 108.

106 "Grant Wood Hailed": Taylor, "Grant Wood Hailed," CRG, 25 January 1931 [AAA].

107 "were shocked and couldn't": MB, p. 81.

107 "a tall, skinny youth": MB, p. 110.

107 He had only avoided: According to Nan, the stranger claimed to have been conceived when Wood was working on a mural project in Waterloo, Iowa—a series completed only three years before; MB, p. 110.

107 "with long black hair" (and subsequent quotes): GMC, p. 67.

109 "a talented youth": AI, p. 78. Ely was Garwood's source.

109 Instead, she claims: MB, pp. 45–46. Nan provides only the name "Margaret" in this memoir, yet Sue Taylor notes Nan's use of a full name—Margaret Wittlesly—elsewhere. Taylor, "Grant Wood: A Brilliant Subterfuge," delivered at the "Grant Wood's World" Symposium, University of Iowa (24 April 2010). Whether real or fictional, Margaret Wittlesly appears to have served as a convenient substitute for Bordet.

109 "there was never a single": MB, p. 46.

109 The first of these, Carl Flick: For a full treatment of this relationship, see Peter Hoehnle, "Carl Flick and Grant Wood: A Regionalist Friendship in Amana," *Iowa Heritage* 82, no. 1 (Spring 2001), pp. 2–19.

110 Following his graduation: [No author indicated], "Wood Works," *Time,* 22 April 1935, p. 56.

111 notably inspiring, as Jane Milosch: Jane C. Milosch, "*American Gothic*'s Munich Connection: A Window into Grant Wood's Regionalism," in Christian Fuhrmeister, Hubertus Kohle, and Veerle Thielemans, eds., *American Artists in Munich: Artistic Migration and Cultural Exchange Processes* (Munich: Deutscher Kunstverlag, 2010), p. 251.

111 Not only did the two: The Butterfly Teashop was located just down the street from Wood's studio—a boon for the artist, whose prodigious coffee-drinking habit was as well known as his love for company. Whenever Pyle was working with the artist, it seems, Wood found reasons to take coffee breaks; MB, p. 81.

111 but Wood also gave his assistant: When Wood cropped his 1931 painting *Appraisal,* discussed in chapter 3, he gave Pyle the bottom third; MB, p. 83. Wood gave Pyle his charcoal self-portrait in 1932; MB, p. 109.

112 In traditional readings: Corn, *Grant Wood,* p. 124.

113 The downcast head: I am indebted to Joe Flessa, who first made this weeping-willow reference.

113 Not only was Wood: At the Kalo Shop it was the house style, regardless of the maker, to intertwine monograms in this way; R. Tripp Evans, "A Profitable Partnership," *Chicago History* 24, no. 2 (summer 1995), p. 9.

114 in Paris, Wood: MB, p. 45.

114 "When Grant Wood attended": Taylor, "Grant Wood Hailed," CRG, 25 January 1931 [AAA].

114 "He spoke like": AI, p. 15.

114 More than any other: Wood's famous absentmindedness is noted in many places; see particularly Dorothy Dougherty, "Grant Wood Liked to Work with Soil," CRG, 12 April 1942 [AAA]. James Dennis writes that Wood "tended to be impractical, especially about times, schedules, and getting from one place to another. He consistently relied on a guardian mother, either his own or a surrogate, to help keep . . . his life in order"; Dennis, *Renegade Regionalists: The Modern Independence of Grant Wood, Thomas Hart Benton, and John Steuart Curry* (Madison: University of Wisconsin Press, 1998), p. 99.

114 "suggest the life and character": "Funeral Services for Grant Wood: February 14, 1942" [AAA].

115 "Grant Wood is a member": Lincoln Kirstein, "An Iowa Memling," *Art Front,* July 1935.

115 Wood's words emerged: AI, p. 15. In her annotated version of Garwood's *Artist in Iowa,* Nan vehemently denies that her brother had a halting speech pattern, explaining: "Grant had a very pleasing voice (I can obtain a recording of same)"; AI-G, p. 73. No extant recordings of Wood's voice are known today, but the tic Garwood describes was frequently remarked upon by Wood's contemporaries. Wood's friend William Shirer, for example, called Wood's speech patterns "hesitant and sparing," "reticent and awkward"; the halting quality of Wood's monologues is visually represented in Shirer's memoir with a series of interrupting ellipses. Shirer, *Twentieth-Century Journey: A Memoir of a Life and the Times: The Start, 1904–1930* (New York: Simon and Schuster, 1976), pp. 189, 274.

116 "mocks everything": Corn, *Grant Wood,* p. 88.

118 "This choker cuts": Corn, "Grant Wood," in Milosch, ed., *Grant Wood's Studio,* p. 111.

119 "an agreeable bad-blood letting": Margaret Thoma, "The Art of Grant Wood," *Iowa Demcourier* 12, no. 3 (May 1942), p. 11.

119 "the shadow of her": RB, frame 246.

119 "black eyes, coal-black hair": MB, p. 23.

120 "trappings of a colonial": Dennis, *Renegade Regionalists,* p. 94.

120 Given the inevitable: According to Garwood, *Portrait of Nan* was painted in 1931 and later postdated to 1933 (the date by which it is known today). He notes that the painting was first shown at the Iowa State Fair in 1931; when it failed to win first prize, he explains, Wood reintroduced the portrait as a new work in 1933 (AI, p. 211). In her notes alongside Garwood's passage, Nan nowhere corrects the 1931 date Garwood assigns to her portrait—she simply adds, "My portrait was entered for Exhibition only. Grant had long since retired from contesting" (AI-G, p. 211). The painting's 1931 date is further substantiated by an article in the *Cedar Rapids Gazette* (the February 1931 "Art News of the Little Gallery"), which notes Nan's portrait at a reception held for Wood [AAA].

121 *Portrait of Nan* is of a young": Emily Genauer's undated review from the *New York Herald Tribune* appears in Nan's scrapbooks [AAA] as well; MB, p. 112.

121 "did not want things": MB, p. 112.

121 "latter-day *Mona Lisa*": MB, p. 112.

121 "As I was showing": MB, p. 111.

122 As for Nan's suggestion: AI, p. 157.

122 The inclusion of birds: Wanda Corn summons these associations in her own analyis: "As it perched, young and vulnerable in the cupped hand of his sister," she writes, "[the chick] conveyed [Nan's] tenderness—and the plum . . . as an artistic convention . . . has always symbolized femininity." Corn, *Grant Wood,* p. 102.

122 "an effect of cruelty": Kirstein, "An Iowa Memling," *Art Front,* July 1935, p. 6.

122 Known for her quick: Nowhere is Nan's sharpness more evident than in her annotations to Garwood's *Artist in Iowa* (State Historical Society of Iowa, Special Collections). In the book's endpapers she refers to her brother's Cedar Rapids supporters as "the stupid little people who really did nothing but exploit him"; she writes that Paul Hanson is "fat" and his wife Vida "Mrs. E. Roosevelt's double" (AI-G, pp. 38 and 34); Henry Ely is a "sponger" (AI-G, p. 34); and Garwood himself is "not fit to spit on" (AI-G, title page).

122 At the time Wood: LSN, p. 73.

122 "They were resentful": LSN, p. 71.

122 It is perhaps fitting: [No author or title indicated], *Los Angeles Times,* 18 December 1955 [AAA].

123 "represented for Wood": Corn, *Grant Wood,* p. 102.

123 According to Garwood: AI, pp. 157–58. Garwood claims that the chick in Nan's painting eventually choked to death on a rubber cigarette that Wood kept in the studio; the plucked chicken, he claims, later became the model for *Adolescence,* first sketched in 1931 but not painted until 1940 (see chapter 4). Nan rebuts this story in LSN, p. 140, but only to say the chicken had survived the incident. It was not in her nature to leave Garwood's other claim unchallenged if she felt it were untrue.

123 As if to signal: Wanda Corn writes that "Wood . . . had misgivings over having pictured his married sister as single [in *American Gothic*], there being so much prejudice at the time against women who did not marry. So he made a portrait of her with her long marcelled blond hair, rendering her as the modern and stylish woman he knew her to be"; Corn, "Grant Wood," in Milosch, ed., *Grant Wood's Studio,* p. 126. It is curious, however, that this more realistic portrayal of Nan continues to ignore her married status; the fingers of her left hand are certainly visible enough to have included a ring, and Wood was scrupulous about such details.

123 "shameless"/"vegetable smugness" (and subsequent quotation): Kirstein, "An Iowa Memling," *Art Front,* July 1935, p. 6.

124 "I have reached": This bizarre aside appears in Wood's undated review of Allen's book. Bearing the heading "Grant Wood Dislikes Blurbs, Attacks Modernistic Art," the review is from an otherwise unidentified column (possibly from the CRG?) entitled "Among the Books" [AAA]. The position of the review in Nan's scrapbooks, along with the date of the book, suggest the review preceded Nan's portrait.

124 "an up-to-date rural": MB, p. 112.

125 In the coded imagery: The homoerotic conflation of fruit and the youthful male body may be found in numerous examples from the Renaissance and baroque periods, yet the three artists cited here provide particularly well-known examples of the phenomenon. In Caravaggio's *The Fruit Seller* (1593), a young boy offers the viewer a basket full of various fruits, whose soft, clefted forms are visually repeated in his own exposed/clefted shoulder; see Daniel Posner, "Caravaggio's Homo-erotic Early Works," in *Art Quarterly* 34, no. 3 (1971). In Botticelli's *Primavera* (1482), a seminude Mercury ignores the Three Graces to pluck, instead, a fleshy peach from a nearby

tree; as Camille Paglia says of this figure, "Mercury turns his back on the whole scene, in superb indifference. He will pluck his own fruit, and of his own kind" (Paglia, *Sexual Personae*, p. 151). Lastly, in Cellini's more overtly homoerotic sculpture *Narcissus* (1548), a nude youth sits on top a pile of fruit, his buttocks resting directly on the forms they are intended to mimic; Laurie Schneider Adams notes this conflation in *Art and Psychoanalysis* (New York: Westview Press, 1993), pp. 274–276. In an echo of the Cellini image, Wood's comical nude *Charles Manson as Silenus* (1928), discussed in chapter 4, portrays a grossly overweight male nude reclining on an overflowing basket filled with fruit. Whether or not Wood was familiar with the visual strategies of these Italian works, it is important to understand that the same coded sexual iconography that occurred to these homosexual artists would almost certainly have occurred to him as well—especially given that he was, by his own admission, "pear conscious."

125 "identifying homosexual": Jonathan Weinberg, *Speaking for Vice: Homosexuality in the Art of Charles Demuth, Marsden Hartley, and the First American Avant-Garde* (New Haven: Yale University Press, 1993), p. 41.

125 Given the chick's: Nan herself insisted this was no Easter chick; "we were raised in a strict Quaker tradition," she writes, "and although Quaker families today are more relaxed in such matters, the Wood family viewed Easter as the Resurrection, period. Easter chicks, eggs, and rabbits were out of place—fables, like Santa Claus—and we were to have no part of them" (a ban that must therefore have made these symbols all the more irresistible to Wood). In the same passage, Nan explains she and Ed had been married "eight years that Saturday night before Easter"; MB, p. 111.

125 "at the age of six or seven": LSN, p. 128.

126 We will never know: As Laurie Schneider Adams describes this phenomenon: "Screen memories compromise the wish to remember with the resistance against remembering. This occurs when an image associated with the event is remembered instead of the event itself, whose content was most likely sexual." Adams, *Art and Psychoanalysis*, p. 18. On p. 274, Adams catalogues the five hallmarks of a screen memory: the memory typically dates back to a period before the age of seven; it is vivid; its manifest content is usually improbable; it involves some form of sexual or "primal scene" undertones; and it is almost always riveting—arresting the attention and focusing the gaze. Rozen's account conforms to all five.

126 "the most beautiful": Paglia, *Sexual Personae*, p. 154.

127 The artist's contemporaries: GMC, p. 91, and AI, p. 61.

127 "violently polka-dot": Marcia Winn, "Front Views and Profiles," *Art Digest*, 1 January 1945 [AAA].

127 In the plant: James Elkins, *The Object Stares Back: On the Nature of Seeing* (New York: Simon and Schuster, 1996), p. 80.

127 "cyclophobia": Ibid., p. 76.

127 Not only did he: Wood is known to have painted only two female nudes in his career; both are now considered lost, and neither was remotely erotic. The first was a portrait of Paul Hanson's wife, Vida, briefly mentioned in chapter 2. Hazel Brown writes: "Grant studied Vida while she was nursing her baby and decided to do a mother-and-child study. At first he would not let her see the painting because he had painted her in the nude . . . She was embarrassed and a little angry"; GMC, p. 10. The only other known female nude Wood painted was, according to James Dennis, "a very comical female nude that he painted one night inside the liquor cabinet of his friend Dr. Wellwood Nesbit of Madison, Wisconsin"; Dennis, "Grant Wood Works on Paper: Cartooning in One Way or Another," in Milosch, ed., *Grant Wood's Studio*, p. 38.

127 "I don't like to paint": Nan Wood Graham, "I Posed for a Masterpiece," *The Woman,* September 1944, p. 45 [AAA].

128 Taking into account the perceptual: Renato Almansi, "The Face-Breast Equation," *Journal of the American Psychoanalytic Association* 8 (1951), p. 58.

128 If at first glance: The circles and dots on Nan's apron in *American Gothic* function in a similar, if far less dramatic, fashion. Wanda Corn describes the decorative pattern of this apron as a "miniature breast-hieroglyph"; Corn, *Grant Wood,* p. 133.

128 "as sharp as splinters": This letter, written to an uncited newspaper editor, appears on the second page of Nan's scrapbooks; Nan's age is indicated as four months [AAA].

128 "It's the last portrait": MB, Graham, p. 112.

THREE: Wood into Stone

129 "Sudden success also brought": GWC, p. 17.

130 "nature as a source": Joseph Czestochowski, *John Steuart Curry and Grant Wood: A Portrait of Rural America* (Columbia: University of Missouri Press, 1981), p. 11.

130 "the order and harmony": Ibid., p. 14.

130 "Let radical artists": Quoted in GMC, p. 87.

130 "in vague terms": [No author indicated], "Grant Wood, Brilliant Painter of the Midwestern Scene," *London Studio* 15, no. 83 (February 1938), p. 88 [AAA].

131 Wood showed his first: By the date of the Art Institute show, Wood had already shown *Stone City* at two other venues: first, in early August 1930, at Ed Rowan's Eldon Art Gallery; and second, later the same month, at the Iowa State Fair in Ottumwa. At the State Fair, *Stone City* won first prize in the senior division of landscape and *Arnold Comes of Age* won first prize in the oil portrait section (Pyle's own *Church at Old Stone City* won second place in the landscape division); as noted in the *Ottumwa Courier* (21 August 1930). I am grateful to Kristy Raine for sharing all of this information with me, including a scan of the *Courier* clipping, via e-mail (5 January 2010).

131 The hardened characters: *Stone City* received no awards at the Art Institute show, yet it was later awarded the landscape prize at the Iowa State Fair; LSN, p. 11.

131 "look[ed] like the work": [No author indicated], letter to the editor, *Omaha World-Herald,* 9 May 1931 [AAA].

131 "a naked statement": Thomas Craven, "*Scribner's* Examines: Grant Wood," *Scribner's* 101, no. 6 (June 1937), p. 21.

131 Situated along a picturesque: Kristy Raine's Web site, "When Tillage Begins: The Stone City Art Colony and School," represents the most comprehensive source devoted to Stone City and the art colony Wood later created there; http://www.mtmercy.edu/busselibrary/schome.html. I am indebted to her work in this section.

132 the site was a favorite: Pyle painted studies of Stone City in the 1920s that mirror the viewpoints Wood himself used. Given the artists' close association, it is almost certain these trips were undertaken jointly.

132 "Never-Never Land": [No author indicated], "Grant Wood Exhibits at Ferargil Galleries," *New York Post,* 20 April 1935 [AAA].

132 Closer to home, Wood's: Wanda Corn and James Dennis both wrote about Wood's fascination with the willowware or "Blue Willow" pattern; see Wanda M. Corn, *Grant Wood: The Regionalist Vision* (New Haven: Yale University Press, 1983), p. 100, and James M. Dennis, *Grant Wood: A Study in American Art and Culture* (New York: Viking Press, 1975), p. 100.

132 "You shall see brilliantly": The typescript of Wood's entire *Imagination Isles* speech appears in Nan's scrapbooks [AAA].

133 "inflated hillocks": [No author indicated], "International Opened with Fine Showing, Limited in Scope," *New York World-Telegram,* 17 October 1936 [AAA].

133 "gentle, insistent": James Elkins, *The Object Stares Back: On the Nature of Seeing* (New York: Simon and Schuster, 1996), p. 128.

133 Creating clay models: AI, p. 204.

133 "generous helpings": Elizabeth Clarkson Zwart, "The Front Row" (otherwise unidentified/undated clipping; possibly 1931) [AAA].

133 "immaculate marzipan": Hilton Kramer, "The Return of the Nativist," *New Criterion* 2, no. 2 (October 1983), p. 61.

134 "I contented myself": RB, frame 208.

134 "wasn't much of a punishment": MB, p. 2.

134 "Grant had sugar": MB, pp. 56.

134 Indeed, Wood's prodigious: *Omaha Bee-News,* 28 January 1937 [AAA].

134 "a visible refusal": Eve Kosofsky Sedgwick, *Epistemology of the Closet* (Berkeley: University of California Press, 1990), p. 192.

134 "rounded, massive contours": RB, frame 165.

134 "Mingling eroticism": Corn, *Grant Wood,* p. 90.

135 "gigantic, reclining goddess": Corn, *Grant Wood,* p. 90.

135 an attitude Corn: In her analysis of *Daughters of Revolution,* whose figures she reads as subliminally phallic, Corn writes that Wood's "anxiety about the modern, as well as it would seem about women, played out through his hyperbolized female bodies"; Wanda M. Corn, "Grant Wood: Uneasy Modern," in Jane Milosch, ed., *Grant Wood's Studio: Birthplace of American Gothic* (New York: Prestel, 2005), p. 127.

135 Featuring a smoking: Nan identifies the billboard in *Stone City* as a Chesterfield ad (MB, p. 83) but erroneously claims the sign reads: "It Satisfies." The actual Chesterfield slogan, as seen on Wood's billboard, reads: "They Satisfy."

136 "Mr. Wood watched": [No author indicated], "Grant Wood, Iowa Artist, Has Won International Fame," *Waterloo Courier,* September 1931 (no more specific date given) [AAA].

136 George Chauncey has demonstrated: George Chauncey, *Gay New York: Gender, Urban Culture, and the Making of the Gay Male World, 1890–1940* (New York: Harper Collins, 1994), pp. 3, 52.

136 In the rhythmic rise: Sigmund Freud, in A. A. Brill, ed., *The Basic Writings of Sigmund Freud* (New York: Random House, 1995), p. 358.

136 Although *Young Corn:* The dedication panel Wood attached to this work reads, "To the memory of Miss Linnie Scholoeman, whose interest in young and growing things made her a beloved teacher at the Woodrow Wilson School"; Dennis, *Grant Wood,* p. 246, n. 8a. Nan describes the conditions of the work's commission and sale in MB, p. 91.

137 "the most erotic": Corn, *Grant Wood,* p. 90.

137 "I could see": RB, frame 278.

137 "they buried him": RB, frames 279–280.

138 "I first began": RB, frame 210.

138 Whereas *American Gothic*'s: MB, p. 91.

138 "I wouldn't give": AI, p. 117.

139 "at last put Iowa": [No author indicated], "Grant Wood Is One Artist of Renown Appreciated in His Own City," CRG, 11 February 1931 [AAA].

139 "doings had been local news": MB, p. 81.

139 "The entire event": [No author indicated], "Folk Jam Little Gallery to Honor Grant Wood, Artist," CRG, 12 February 1931 [AAA].

139 A Harvard-educated: Corn, *Grant Wood*, p. 19.

139 Not only did he: Garwood claims that Ed Rowan, who directed Carnegie-funded projects in a variety of locations within the state, had invited Wood to Eldon to give a sketching exhibition; AI, p. 105. Nan notes that Wood discovered the house while driving in Eldon with his former student John Sharp, a native of the town; MB, p. 73. These two accounts, however, need not be mutually exclusive—as Steven Biel indicates in *American Gothic: A Life of America's Most Famous Painting* (New York: W. W. Norton, 2005), p. 20.

140 As traditional readings: Corn's thorough treatment of this painting appears in *Grant Wood*, pp. 80–82.

140 As Wood's friend: GMC, pp. 71–72.

141 "one had a special": GMC, p. 51.

141 Lackersteen's gruff nature: Brown fondly recalls Lackersteen's affectionate sharpness with Wood and the other men, as well as her partner's sarcasm and occasional use of four-letter words; GMC, pp. 40–42, 45, 46.

141 "Oh, that's just": GMC, p. 42.

141 Not only does the bird: Nan identifies this bird as a rooster rather than a hen, and explains that it lived in the studio with Wood. "Grant grew fond of the rooster," she writes, "calling him a 'good old boy' "; MB, p. 83.

142 In a nod: Wanda Corn illustrates the first version of *Appraisal* in *Grant Wood*, p. 114; the portion Wood later removed (MB, p. 83) constituted approximately one-third of the original work.

142 In shortening: The lower portions of the women's coats originally lent both garments a distinctly vaginal appearance. This subliminal element was visible in the city woman's paired, fur-lined sleeve ends and in the slackened, woolen opening of the country woman's sweater. (Buttoned at the bottom and safety-pinned at the top, this sweater features a torso-length opening from which the bird appears to emerge.)

143 Even the horse: Wood's inspiration for Revere's horse came from an old rocking horse owned by his friend Charles Clark; MB, p. 89.

143 Inspired by Longfellow's: RB, frame 199.

143 "By the trembling": Longfellow, "The Landlord's Tale," stanza 5, lines 37–41, in *Tales of a Wayside Inn* (London: Bell and Daldy, 1867), p. 11.

144 "He saw the gilded": Longfellow, "Landlord's Tale," stanza 11, lines 95–98.

144 "brings his audience": Karal Ann Marling, "Of Cherry Trees and Ladies' Teas: Grant Wood Looks at Colonial America," in Alan Axelrod, ed., *The Colonial Revival in America* (New York: W. W. Norton, 1985), p. 314.

144 "glaring electric": Karal Ann Marling, "Don't Knock Wood," *ARTnews* 82, no. 7 (September 1983), p. 97.

144 Even the cylindrical: Dennis, *Grant Wood*, p. 109.

145 "The background has already": [No author or date indicated], *Dubuque Catholic Tribune*, reprinted from the *Kansas City Star* [AAA].

145 "talk about cyclones": RB, frame 199.

145 "The younger children": RB, frame 200.

146 "She was a strong woman": RB, frame 200.

146 "We Quakers can only": RB, frame 173. Indeed, well into the twentieth century, many Quaker boarding schools still banned works of fiction from their libraries; David Hinshaw, *Herbert Hoover: American Quaker* (Farrar, Straus and Co., New York: 1950), p. 50.

146 "only [be] gratified": This phrase is from Maryville's eulogy, delivered by the Rev-

erend Daniel Russell and reprinted in Maryville's AE obituary, "DROPPED DEAD. Mr. Francis Maryville Wood, of Jackson Township, Is No More," 21 March 1901 [AAA].

146 Ostensibly a celebration: Dennis, "Grant Wood Works on Paper," in Milosch, ed., *Grant Wood's Studio*, pp. 41–42.

147 The work was promptly: Ibid., p. 42.

147 "physical proof": Quoted in Patricia Wheeler, *"My Roots Are in This Soil": A Guide to Herbert Hoover National Historic Site* (Cincinnati: The Creative Company, 1993), frontispiece.

147 Wood later became: MB, p. 92.

147 "He eschews loud": Hinshaw, *Herbert Hoover*, p. 39.

148 By replacing this feature: Wood won this prize at the age of thirteen, in a national contest sponsored by the Crayola crayon company in 1905; LSN, p. 7, and AI, pp. 26–27.

148 The Stone City Art Colony: Kristy Raine's Web site, "When Tillage Begins: The Stone City Art Colony and School," catalogues the biographies of all known participants in the colony. http://www.mtmercy.edu/busselibrary/schome.html.

149 In the former Green: Raine notes that the property belonged to the father-in-law of Iowa poet Paul Engle, who had also been a student of Wood's at McKinley Junior High; http://www.mtmercy.edu/busselibrary/schome.html.

149 Not surprisingly, the red-checkered: MB, p. 99.

150 "the elaborate . . . mid-Victorian": This CRG article (17 July 1932) is quoted in MB, p. 99.

150 To disarm such criticism: AI, p. 151.

150 "to razz and befuddle": [No author indicated], "Stone City Likely to Become Conspicuous Episode in American Art," DMR, 31 July 1932 [AAA]. The strange name for this society may have been prompted—unsurprisingly—by Wood's boyhood memories. As Nan claims: "Banana oil was another common odor in our house. Grant used a lot of it. One day he was using it when Mother was baking a custard pie. The pie took on the banana flavor, and we were afraid to eat it"; MB, p. 11.

151 "There is a remarkable": Keith Kerman, "The Quarry Town That Came to Life as an Art Center," *St. Louis Post-Dispatch*, 13 August 1933 [AAA].

151 "a school to which": GMC, p. 77.

151 "brotherly, man-to-man": [No author indicated], "Stone City Likely," DMR, 31 July 1932 [AAA].

151 "Wood's dreams": John E. Seery, "Grant Wood's Political Gothic," *Theory and Event* 2, no. 1 (1998), p. 12.

151 First, female students: Although the faculty at Stone City was almost exclusively male, the student body represented a more even mix of men and women. Of all the Stone City students who have been documented, sixty are women and forty-eight are men. Figures here derive from Kristy Raine's Web site, http://www.mtmercy.edu/busselibrary/schome.html.

151 even given the presence: Sue Taylor has found anecdotal evidence suggesting Wood and Dornbush shared a lover at Stone City, a man named Kelly Greenwell. Neither she nor Raine, however, have been able to substantiate the claim or identify Greenwell among the colony's known students. Taylor, "Grant Wood: A Brilliant Subterfuge," delivered at the "Grant Wood's World" Symposium, University of Iowa, Iowa City (24 April 2010).

151 John Bloom, the colony's: Kristy Raine writes that Wood sometimes shared his sleeping quarters with students; see Raine, "When Tillage Begins," http://www.mtmercy.edu/busselibrary/schome.html. In a personal communication with the

author (17 December 2009), Raine explained that it was John Bloom who shared Wood's wagon that first summer—an arrangement that may have been less crowded than one would suppose. A contemporary CRG article (17 July 1932) notes that the wagon accommodated several men at one time: "folding beds . . . give ample room to the occupants when sleeping hours are over"; MB, p. 99. Pyle taught frame-making at the colony, and was therefore a permanent resident during the summer—whereas Flick, who spent extended periods at Stone City as a student, would have been housed, like Pyle, in one of the colony's ice wagons; see Peter Hoehnle, "Carl Flick and Grant Wood: A Regionalist Friendship in Amana," *Iowa Heritage* 82, no. 1 (Spring 2001), pp. 8–9.

152 Given his rural: Corn, *Grant Wood*, p. 25.

153 "Not many flowers": Jay Sigmund, *Land o' Maize Folk* (New York: James T. White and Co., 1924), p. 9.

153 "men full of toil-sting": Inserted at the beginning of Nan's scrapbooks, the poem is dated 19 December 1926 [AAA].

153 "just a simple Middle Western": [No author or title indicated], *Los Angeles Examiner*, 19 February 1940 [AAA]. Although this article appeared nearly a decade after the closing of Stone City, Wood's connection between farming and painting began around the time of the colony's founding.

154 "I'm a pretty good": [No author indicated], "Grant Wood Denies Reputation as Glamour Boy of Painters," *Los Angeles Times*, 19 February 1940 [AAA].

154 "all the really good": [No author indicated], "Cow May Help Solve America's Problems," *New Orleans Times-Picayune*, 24 January 1936 [AAA].

155 "We are farmers": Joseph Pollett, "Roughnecks," *Art Digest* 4, no. 11 (1931), p. 23.

155 "to dress up": Kramer, "The Return of the Nativist," *New Criterion* 2, no. 2 (October 1983), p. 62.

155 "He dresses in old": [No author indicated], "Ravelings," *Iowa Stethoscope*, 21 August 1931 [AAA].

155 "We on the sunset": D'Harnoncourt is quoted in the *Omaha World-Herald*, 1933 (clipping otherwise unidentified) [AAA].

155 "Wood was an American": Helen Magner, "Pencil Sketches," *New Castle [Indiana] Courier-Times*, 18 February 1942 [AAA].

155 Unaware of the irony: Not only was denim first produced in France (its current name is a bastardization of *serge de Nîmes*), but overalls themselves were of European origin; Guy Davenport, *The Geography of the Imagination: Forty Essays by Guy Davenport* (San Francisco: North Point Press, 1981), p. 13.

156 "In wearing his denims": Corn, "Grant Wood," in Milosch, ed., *Grant Wood's Studio*, p. 129.

156 "Grant Wood is the all-time": Quoted in MB, p. 1.

156 Indeed, even the central: GWC, p. 22, and MB, p. 97.

156 In 1928 the DAR: Wanda Corn gives the full details of Wood's and the DAR's mutual animosity; Corn, *Grant Wood*, pp. 98–100 and 155 n.35. William Shirer claims that the American Legion (of which Wood was a member) objected just as strenuously to his German trip; Shirer, *Twentieth-Century Journey: A Memoir of a Life and the Times: The Start, 1904–1930* (New York: Simon and Schuster, 1976), p. 277.

157 By contrasting Washington's: Nan claims that "Grant was sick and tired of a little clique of women who had done nothing in this world on their own, put on airs and considered themselves aristocrats and above us common folk, solely because they or their mother belonged to the D.A.R. Grant hated snobbery and said this was supposed to be a free country and we had no true aristocracy, which is as it should be." GWC, p. 22.

157 In order to underscore: Marling, "Of Cherry Trees," in Axelrod, ed., *The Colonial Revival,* p. 316.

157 Several widely read: These works include Bernie Babcock's *Washington in Love and Otherwise* (1925) and John Fitzgerald's *The Washington Scandals* (1929), both cited by Marling—who notes, as well, Washington's suggestive pose in Leutze's iconic painting; ibid., pp. 307, 316.

157 "become *almost*": [No author indicated], *Kansas City Times,* 14 February 1938 [AAA].

158 "sly exercise in camp": Robert Hughes, *American Visions: The Epic History of Art in America* (New York: Alfred A. Knopf, 1997), p. 442.

158 "enter our experience": Kramer, "Return of the Nativist," *New Criterion* 2, no. 2 (October 1983), p. 63.

158 "Camp always has an underlying": Quoted in David Bergman, ed., *Camp Grounds: Style and Homosexuality* (Amherst: University of Massachusetts Press, 1993), p. 4. The original citation appears in Christopher Isherwood, *The World in the Evening* (New York: Avon, 1956), p. 106.

158 the phallic, elongated: Wanda Corn, too, notes the phallic character of the women's portrayal in *Daughters of Revolution:* "[Their] heads and necks are like asparagus spears," she writes, "or, more wickedly, like fleshy phalluses. The sexual metaphor is not far-fetched given the way Wood shaped the three noses, particularly the two on the left side that look decidedly like the male member"; Corn, "Grant Wood," in Milosch, ed., *Grant Wood's Studio,* p. 126.

159 Wood undertook this painting: M. Sue Kendall, *A Guide to the Collection of Regionalist Art at the Davenport Museum of Art* (Davenport: Davenport Museum of Art, 1993), p. 10. Nan confirms the origin of this work, adding it was Wood himself who had first suggested the contest; MB, p. 108.

159 It is worth noting that: Flick portrayed himself in the style of Wood's early, Memling-inspired portraits; he substitutes the village of West Amana for the rural landscape seen in his mentor's self-portrait, and wears a white, long-collared shirt identical to the one in Wood's original work. Flick's self-portrait appears in Hoehnle, "Carl Flick and Grant Wood," *Iowa Heritage,* p. 19.

159 Although he submitted: The DMR published eight of the competition entries, including Wood's, on 3 April 1932. In this early version of the painting, the artist wears a carefully rendered pair of overalls and a white shirt; these and other elements were later painted out.

160 "Self portraits are partly": T. J. Clark, "Gross David with the Swoln Cheek: An Essay on Self-Portraiture," in Michael S. Roth, ed., *Rediscovering History: Culture, Politics and the Psyche* (Stanford: Stanford University Press, 1994), p. 276.

160 ultimately, he covered: After Wood's death, Nan asked Marvin Cone "to paint what he thought Grant would want" in this unfinished passage. Cone partly obliged, writing to Nan, "I have repainted only the little, somewhat triangular shape [at the base of the painting], following very carefully the original lines"; MB, p. 109. It is to Cone's credit that he essentially preserved the painting in its original state. Nan's request, on the other hand, is a striking example of the way she attempted to clean up her brother's work after his death, even at the expense of its authenticity.

160 "The Old Masters": MB, p. 83.

161 "sincere reverence"/"a satire on religious": Both critics are quoted in James Dennis, *Renegade Regionalists: The Modern Independence of Grant Wood, Thomas Hart Benton, and John Steuart Curry* (Madison: University of Wisconsin Press, 1998), p. 167.

161 "at times found it": Charles Eldridge, "Prairie Prodigal: John Steuart Curry and Kansas," in Patricia Junker, ed., *John Steuart Curry: Inventing the Middle West* (New York: Hudson Hills Press, 1998), p. 91.

161 "I'd rather draw a picture": Quoted ibid., p. 91.

161 "surprisingly alike": Keith Kerman, "The Quarry Town That Came to Life as an Art Center," *St. Louis Post-Dispatch,* 13 August 1933 [AAA].

162 The *Omaha Bee-News* noted: This caption appears in a 1933 article in the *Omaha Bee-News* (otherwise undated) [AAA].

162 rather tellingly: This misidentification appears in the *Omaha Bee-News* article cited above [AAA].

163 Wood's profiles most often: [No author indicated], "Grant Wood Is One Artist of Renown Appreciated in His Own City," CRG, 11 February 1931; see also Thomas Hart Benton, "Death of Grant Wood," Iowa *Demcourier* 12, no. 3 (May 1942), p. 5. Descriptions of Wood as "cherubic" and "seraphic" appeared throughout his life, including a lengthy description of the artist by Thomas Craven; "Home Grown Art," *Country Gentleman,* November 1935 [AAA].

163 "massive, fleshy": Henry Adams, "Space, Weather, Myth and Abstraction in the Work of John Steuart Curry," in Junker, ed., *John Steuart Curry,* p. 116.

163 "of a born football player": Thomas Craven, "Grant Wood, of Iowa," *Chicago Herald,* 2 January 1935 [AAA].

163 "a potent footballer": [No author indicated], *Time* 24, no. 26 (24 December 1934), p. 25 [AAA].

163 "masculine force that dominated": Dennis, *Renegade Regionalists,* p. 145.

163 "when [Curry] was working": Adams, "Space, Weather," in Junker, ed., *John Steuart Curry,* p. 116.

164 "rugged foundations": Adeline Taylor, "One Famous Artist Sketches Another." No date or other identifying information accompanies this article, but the sketch that she describes in this piece was Curry's portrait of Wood, executed in 1933 [AAA].

164 "perhaps [Curry and Wood's] most portentous": Ibid.

164 Although enrollment: See Raine, "When Tillage Begins," http://www.mtmercy.edu/busselibrary/schome.html.

164 At the start: Ibid.

164 not only did he refuse: AI, p. 160.

165 the location of which: MB, p. 121, and AI, p. 162.

165 if he pursued a third: The complete story of Hattie and Turner's collusion appears in AI, pp. 162–163.

165 Fittingly, Wood drew: Corn, *Grant Wood,* p. 108.

166 Because the local PWAP: Ibid.

166 "The *Register* can think": Quoted in MB, p. 120.

166 "my boys": MB, p. 118.

166 "I'll never forget": MB, p. 118.

167 "People, old and young": Quoted in MB, p. 122.

167 "One of the most significant" [No author indicated], *Art Digest* 7, no. 20 (1 September 1933), p. 10 [AAA].

168 "widely talked of": Quoted in Hughes, *American Visions,* p. 356.

168 "In the Prairie states": [No author indicated], "Kansan at the Circus," *Time,* 10 April 1933.

169 "were again beginning": [No author indicated], "U.S. Scene," *Time,* 24 December 1934, p. 25 [AAA].

169 At nearly seven feet: MB, p. 113.

169 "*Dinner for Threshers* is from": Grant Wood, letter to the editor, *Time,* 21 January 1935 [AAA]; see also MB, p. 114.

169 "the big event": RB, frame 238.

170 "best overalls": RB, frame 238.

170 "laughed and spat" [and following quotes]: RB, frame 240.

170 "He was known": RB, frame 240.

171 "I did my best"/"shook the earth": RB, frames 243, 240.

171 "the engine was . . . hot": RB, frame 243.

171 "I clambered up": RB, frame 243.

172 "the last of our grain": RB, frame 243.

172 "ravenous men": RB, frame 242.

172 "I went around": RB, frame 243.

173 Entitled *Thunder and Lightning:* Garwood explains the lengths to which Wood went to relocate this print. Known alternatively as *Wild Horses* and *Black and White Beauties,* it had once "hung in almost every farmhouse [Wood] had ever been in"; AI, p. 169. As the Woods prepared to leave their farmhouse in 1901, Wood recalls, he looked above the stove in the sitting room, where "a clean oblong betrayed the place where *Thunder and Lightning* had hung, that memorable picture of the black horse and the white horse frightened by a terrific storm"; RB, frame 292.

173 "All is touched": In this review of *Dinner for Threshers,* Gladys Trautman quotes directly from Robert Louis Stevenson's reaction to John Singer Sargent's portrait of his family; Trautman, untitled review, *Time,* 18 February 1935 [AAA].

173 "cleanliness": *American Magazine of Art,* December 1934 (no author or title listed) [AAA].

173 "monumental simplicity": Edward Alden Jewell, "In the Realm of Art: The Nation Paints its Walls," *New York Times,* 27 May 1934 [AAA].

174 More recent critics: Corn, *Grant Wood,* p. 104.

174 "my family": Grant Wood, letter to the editor, *Time,* 21 January 1935 [AAA].

174 Not only does the man's: Garwood was the first to identify Maryville's position in the painting; AI, p. 169.

175 "Father ate a hearty": MB, p. 8.

175 a number that: RB, frame 251.

175 Also known as the "beloved": The swooning figure of the Apostle John is often more easily identified in Last Supper imagery than the traitorous Judas Iscariot; indeed, in the early Renaissance imagery of Giotto and Fra Angelico (whose work critics linked to *Dinner for Threshers*), John fairly climbs onto Christ's lap. The scriptural source for this pose comes from John 13:23 ("Now there was leaning on Jesus' bosom one of his disciples, whom Jesus loved" [KJV]). The only one of Jesus's disciples to accompany him at his crucifixion, John is often associated with the women who also attended him there—particularly the Virgin Mary, whom Christ entrusts to John's care.

176 Starting in the 1920s: Corn, *Grant Wood,* p. 104.

176 In the fall of 1934: Hughes, *American Visions,* p. 438.

176 "the first great American": Henry R. Luce, "The American Century," reprinted in M. J. Hogan, ed., *The Ambiguous Legacy* (Cambridge: Cambridge University Press, 1999).

176 featuring, for the first: Hughes, *American Visions,* p. 438.

177 "the only time that *Time*": Ibid., p. 439.

177 "crazy parade"/"arbitrary": [No author indicated], "U.S. Scene," *Time* 24, no. 26 (24 December 1934), p. 24 [AAA].

177 "the French schools": Ibid.

177 "chief philosopher"/"the most virile": Ibid., p. 25.

177 "A play was written": Quoted in Henry Adams, *Thomas Hart Benton: An American Original* (New York: Alfred A. Knopf, 1989), p. 220.

178 "Kansas City was a vaudeville": Quoted in Adams, *Thomas Hart Benton,* p. 61.

179 "did a lot of quite unnecessary": Quoted ibid., p. 243.

179 "the freaks and the interesting": [No author indicated], *Art Digest* 7, no. 20 (1 September 1933), p. 10ff.

179 "summed up by consumptive": Quoted in Adams, *Thomas Hart Benton,* p. 84.

179 "When I was a little child": Thomas Hart Benton, *An Artist in America* (Columbia: University of Missouri Press, 1937), p. 12.

180 "by the strange splotches": Adams, *Thomas Hart Benton,* p. 58.

180 According to a contemporary: Ibid.

180 "rather handsome man": Ibid., p. 36.

180 "had a fancy for me": Benton, *An Artist in America,* p. 40.

180 "Underneath the pretensions": Quoted in Adams, *Thomas Hart Benton,* p. 65.

181 "as if I were down": Ibid., p. 48.

181 "that enabled him to transform": Ibid., p. 32.

181 Adams claims that: In an e-mail message to the author (6 January 2010), Adams notes that "the claim that Benton believed Grant Wood was gay comes from two sources: a verbal source, Eleanor Piacenza, and a written source, the unpublished journal of one of his [Benton's] students, Robert Macdonald-Graham"; Adams cites these sources, as well, in his College Art Association paper, "The Truth About Grant Wood" (delivered 24 February 2000), p. 6.

182 "if being in the closet": Sedgwick, *Epistemology of the Closet,* p. 225.

182 "predisposed to pugnacity": H. W. Janson, "Benton and Wood, Champions of Regionalism," *Magazine of Art* 39, no. 5 (May 1946), p. 198.

182 "black-haired young slut": Benton, *An Artist in America,* p. 22.

182 "from the moment": Ibid., p. 31.

183 "the rich, sensual": Ibid. Darrell Garwood claims that Wood, too, "enjoyed the physical act of putting on paint." In the margin of her annotated copy, Nan—on whom the implied sensuality of Garwood's phrase is not lost—writes: "nasty insinuations" AI-G, p. 104.

183 "down there": Ibid., pp. 44–45.

183 "Something snapped": Adams, *Thomas Hart Benton,* p. 134.

183 "corresponded to emotional": Ibid., p. 245.

183 "unsavory crew [of] commercial": Thomas Craven, *Modern Art: The Men, the Movements, the Meaning* (New York: Simon and Schuster, 1934 edition), p. 250.

184 "as close, as inseparable": Quoted in Adams, *Thomas Hart Benton,* pp. 65, 40.

184 "temper, broad humor": Craven, *Thomas Hart Benton,* p. 23.

184 "was a good cook": Benton, *An Artist in America,* p. 40.

184 "There is nothing precious": Craven, *Thomas Hart Benton,* p. 23.

184 "an unfathomable loneliness": Craven, *Modern Art* (1934 edition), p. 242.

184 "my leanings toward art": Ibid.

184 "Could we have foreseen": Ibid., p. 250.

185 "inspired his people": Thomas Craven, *Men of Art* (New York: Simon and Schuster, 1931), p. 1.

185 "sane, healthy and industrious": Ibid., p. xv.

185 "healthy act of labor": Craven, *Modern Art* (1934 edition), p. xxi.

185 "We have seen a new art": Ibid., p.xix.

185 "The artist is losing": Ibid., pp. 29, 30–31.

186 "that arrant American"/"ambassador": Ibid., p. 23.

186 "painted without guts" (and following quotations): Ibid.

186 "If Wilde had lived": Ibid., p. 52.

186 "thoroughly American boyhood": Ibid., p. 333.

186 "under the poisonous"/"distinguished": Thomas Craven, *Thomas Hart Benton: A Descriptive Catalogue* (New York: Associated American Artists, 1939), p. 10.

186 "indoor esthetes": Craven, *Modern Art* (1934 edition), p. 344.

187 "It is unfortunate": Janson, "Benton and Wood," *Magazine of Art* 39, no. 5 (May 1946), p. 186.

187 "Americans of the best": Thomas Craven, "Home Grown Art," *Country Gentleman,* November 1935 [AAA].

187 "he has won": Craven, *Modern Art* (1940 edition), p. 336.

187 In *Modern Art* he confesses: Craven, *Modern Art* (1934 edition), p. 19.

187 "dark, flashing eyes"/"cocky": Craven, *Thomas Hart Benton,* pp. 11, 13.

187 "athletic youthfulness" Craven, *Modern Art* (1934 edition), p. 334.

188 "had plenty of meat": See Craven, "*Scribner's* Examines: Grant Wood," *Scribner's* 101, no. 6 (June 1937), p. 6.

188 "large head and neck": Quoted in Adams, "Space, Weather," in Junker, ed., *John Steuart Curry,* p. 116.

188 "It is [Wood's] misfortune": Lewis Mumford, "The Art Galleries: A Group of Americans," *New Yorker,* 4 May 1935 [AAA].

189 Careful not to identify: Nan describes the SPCS in MB, pp. 122–123. Garwood, who gets the group's name slightly wrong (he calls it "the Society to Prevent Cruelty to Speakers"), discusses the club's founding in AI, pp. 177–178.

189 "the worst style": MB, p. 122.

190 "flamboyant and meaningless": [No author indicated], "Grant Wood Tells of Development of True American Art," CRG, 28 March 1931 [AAA].

190 "My response to this passage": Written some time in the mid-1930s, Wood's letter is quoted in full in the *Saturday Review of Literature* 25, no. 9 (28 February 1942), p. 10 [AAA].

190 "I tried to sweat out": Mark Twain, *The Adventures of Huckleberry Finn (Tom Sawyer's Comrade)* (New York: Harper and Brothers, 1884), p. 139.

190 "I hadn't seen no house": Ibid., p. 133.

191 Wood's attraction: Nan describes the Woods' Anamosa parlor (based, of course, on her brother's memory) this way:

> The Weavers [Hattie's family] . . . presented [Hattie and Maryville] with an elegant set of parlor furniture. The framework was golden oak, and each piece was upholstered in two tones of plush—gold and amber, amber and green, green and yellow. Mother's savings bought a luxuriant Wilton velvet rug, cream colored and bordered with a golden-brown scroll. It was decorated with a scattering of pink cabbage roses, a motif repeated in the gilt wallpaper, creating the most elegant parlor for miles around. (MB, p. 7)

Given such an eye-popping profusion of colors and patterns, it appears that Wood's beloved boyhood home had itself been decorated in the "worst style of the late Victorian period."

193 "So codified did this pose": David Deitcher, *Dear Friends: American Photographs of Men Together, 1840–1918* (New York: Harry N. Abrams, 2001), pp. 144.

193 While Benton played: AI, p. 178.

193 "There's Fun as Well": Dorothy Pownall, "There's Fun as Well as Fame in the Life of the Artist, as Proved by Benton and Wood," DMR, 20 January 1935 [AAA].

193 Wearing white roses: Corn, *Grant Wood,* p. 46.

193 "I am modest": Quoted by Pownall, "There's Fun as Well as Fame," DMR, 20 January 1935 [AAA].

194 "I should tip": Quoted ibid.

194 "one advances neither": Lewis Mumford, "The Art Galleries: A Group of Americans," *New Yorker*, 4 May 1935 [AAA].

194 "That Grant Wood should": James Johnson Sweeney, "Grant Wood," *New Republic*, 29 May 1935 [AAA].

194 "[Wood] has no need": Craven, "*Scribner's* Examines: Grant Wood," *Scribner's* 101, no. 6 (June 1937), p. 22.

194 "If you love America": Malcolm Vaughan, "In the Art Galleries," *New York American*, 20 April 1935 [AAA].

194 "an almost mythical figure": Forbes Watson, "The Phenomenal Professor Wood," *American Magazine of Art* 38, no. 5 (1935), p. 285 [AAA].

195 Nan claims that: MB, p. 129.

FOUR: A Fabled Life

197 As Bruno Bettelheim: Bruno Bettelheim, *The Uses of Enchantment: The Meaning and Importance of Fairy Tales* (New York: Alfred A. Knopf, 1976), p. 38.

198 "digress[ed] from his single track": "Grant Wood and Sara Sherman Maxon to Be Married Tonight in Minneapolis," CRG, 2 March 1935 [AAA].

198 "They Can Laugh At Critics": *Albuquerque Tribune*, 7 March 1935 [AAA].

198 Compounding the surprise: The Woods' wedding was held at the home of Sara's son, Sherman Maxon, in Minneapolis; the only attendants at the ceremony were Sherman; his wife, Dorothy; the pastor; and two witnesses; original wedding certificate, collection of Ed Bartholomew. Hazel Brown confirms that none of Wood's family or friends from Cedar Rapids were present; GMC, p. 82.

198 A good deal older: Not only does Sara appear to have been heavier than Wood, but Nan confirms that she was also taller; MB, p. 127.

198 Although she claimed: In the Sherman family genealogy, Sara twice crossed out her 1883 birthdate and replaced it with a date of 1890; SFG, pp. 74, 81). Census records indicate Sara was sixteen in 1900—and therefore nineteen when she married Alonzo Maxon in 1903, rather than a far more improbable thirteen. Garwood claims that in 1935, Wood and Sara were forty-four and forty-nine, respectively—a report that may reflect the general belief in Wood's circle; AI, p. 188.

198 "it is generally reported": GMC, p. 80.

198 In an interview: See "Grant Wood and Sara Sherman Maxon to Be Married," CRG, 2 March 1935 [AAA]; and AI, p. 188.

198 Attempting to add: In an otherwise unidentified article from Nan's scrapbook, dated 2 March 1935, its title—"Grant Wood Marries Childhood Sweetheart"—is corrected in Nan's own hand: "Not true. They never met until a few months before their marriage." The *Albuquerque Tribune* made the same mistake, claiming "their marriage culminated a childhood romance" (7 March 1935) [AAA].

199 first cousin to the formidable: The Shermans' connection to General Sherman is confirmed in an undated letter from Sara to Shirley Collier, in which she mentions that her father was "a first cousin of General W. T. Sherman of the famous 'war is hell' expression"; communicated to the author by Donna Clausen in an e-mail message, 9 May 2008. Henry Sherman's creamery business is noted in SMS, p. 9, and SFG, p. 75.

199 Although she had spent: Sarah Secrest Sherman's Virginia/Kentucky roots are recorded in SFG, p. 76; Sara speaks of her mother's "loyalty to all things Southern" in SMS, p. 7.

200 Not only was their: SMS, p. 5.

200 "childhood days": SMS, p. 95.

200 "I was a complete misfit": SMS, p. 18.

200 "she never came down": SMS, p. 13.

200 "Mama . . . told me": SMS, p. 29.

200 she also dismissed: When Sara auditioned for Genevieve Clark Wilson as a teenager, she recalls, "Mama, who was ever one to put and keep me in my place, was highly embarrassed by the enthusiastic reaction of Mrs. Wilson"; SMS, p. 24.

200 "never failed to remind": SMS, p. 8.

200 Another inheritance: In light of Sara's difficult relationship with her mother, it is tempting to think she herself might be responsible for the slight difference in their names. In Sara's copy of her family genealogy, however—edited by her sister Edith— her name at birth is recorded as "Sara"; although Sara changed her birth year in this document, she did not alter her name (and it is doubtful that Edith, who was far closer to her mother, would have changed the spelling of her mother's namesake). Given Sarah Secrest Sherman's elevated self-image, it may simply be that she wished to be the only Sarah in the family.

200 "my little aristocratic": SMS: Alice Rheem fragment, p. 10.

200 "hated girls": SMS, Outline, p. 1. For Sara's fondness for sports, the Wild West, and rodeo, see SMS, p. 19 and Alice Rheem fragment, p. 4.

200 "lone wolf" [and following three quotes, in order]: SMS, pp. 19, 18, 36, 92.

201 "that queer little girl": SMS, p. 19.

201 "would take refuge": SMS, p. 20.

201 "understood and encouraged": SMS, p. 13.

201 "From the time we moved": SMS, p. 18.

201 "I was no doubt": SMS, p. 19. Sara later seems to have thought better of using such a strong label; in her typed manuscript, she crosses out the *b* in "bitch" (though it remains legible) and replaces it with a handwritten *w*.

201 "[fought] for freedom": SMS, p. 22.

201 "had the same curiosity": SMS, p. 20. Sara's mentions her precocious vices in SMS, Outline, p. 3.

201 After hearing her sing: A friend of Sara's mother suggested that she audition for Wilson and Frederick Stock, the conductor of the Chicago Symphony Orchestra. Sara claims to have been fifteen at the time of the encounter, but we may add at least two years to this; SMS, p. 24.

201 "What a woman!": SMS, p. 28.

201 "the love and understanding": SMS, p. 34.

201 "my adorable brother": SMS, p. 25.

202 "childish excursions": SMS, p. 19.

202 a "calamitous" match: SMS, p. 29.

202 "the quiet and exceedingly": SMS, p. 25.

202 "Had all of the realistic": SMS, p. 30.

202 "was only attracted": SMS, p. 29.

202 Sara considered: SMS, pp. 30–31.

202 "I felt that at least": SMS, p. 35.

202 In the early 1910s: For the full story of Sara's stage breakthrough, see SMS, pp. 45–48.

202 Following the composer's death: Sara served as artistic director for Chicago's Triangle Film Corporation; SMS, p. 55.

202 "plum crazy": SMS, p. 59.

203 By her mid-forties: The nature of Sara's illness is unknown; some time in the early 1930s(?), she claims, "the upshot of all of this physical condition of mine was that I

was put in the hospital in Chicago, where I underwent an operation to end all operations, and as a matter of fact it very nearly did end me"; SMS, p. 77. Sherman's financial dependence is cited in SMS, p. 38.

203 "On the granting": SMS, p. 91.

204 Her father and mother: Ernest died the day of "Black Thursday," 24 October 1929. It is tempting to view his death as a casualty of the stock-market crash, yet there is no evidence (negative or positive) that the two events were connected. At this date, he was sixty-one years old and executive secretary of the Insurance Federation of Minnesota; see SFG, p. 80.

204 "Little did I know": SMS, p. 92.

204 "She seemed somehow": GMC, p. 81.

204 The couple seem to have met: In an otherwise unidentified clipping from Nan's scrapbooks, dated 25 November 1934 (most likely from the CRG), Sara is listed as one of the guests at this dinner, which Sigmund gave in honor of the writer Christopher Morley (Sara's sister Phoebe was a friend of Morley's as well). Wood is also listed as an attendee, yet he is not specifically linked to Sara in this article, as he soon was in the paper [AAA].

204 "The night we were": SMS, p. 92.

204 During their subsequent: In the typescript of John Zug's interview with Nan Wood Graham (16 June 1976; State Historical Society of Iowa, Special Collections), Nan claims on p. 40 that Sara had met Hattie *prior* to meeting Wood—this is not the account that Sara herself gives.

204 "impressed me much": SMS, p. 92.

204 "a little wizened": SMS, p. 16.

205 "a good housekeeper": Quoted in GMC, p. 81.

205 "dressed fit to kill": MB, p. 127.

205 "had grave misgivings": MB, p. 129.

205 "I am sure we are": Quoted GMC, p. 79.

206 "Grant was regarded": AI, p. 188.

206 "whose attitude toward me": SMS p. 103.

206 "wouldn't work if": SMS, p. 103.

206 "knew more about Grant": SMS, p. 100.

206 "questioned the wisdom": SMS, p. 100.

206 "particularly acute": SMS, p. 85.

206 "seen too much": SMS, p. 92.

206 "some of his friends": Sara's use of quotation marks around the word "woman" in this instance was no doubt intended to emphasize the source of Cedar Rapids' amazement; her revealing use of punctuation also suggests, of course, her self-perception as a tomboy; SMS, p. 94.

207 "friendship . . . based on": SMS, p. 97.

207 "I had no idea": SMS, p. 116.

207 "shy Bachelor": [No author indicated], "U.S. Scene," *Time* 24, no. 26 (24 December 1934), p. 26 [AAA].

207 "tall, white-haired": GMC, p. 14.

207 "a woman of powerful": MB, p. 11.

207 Neatly symbolizing this: In the wedding photographs that appeared in the press, Sara is wearing the famous brooch.

207 "The food we had consumed": SMS, p. 96.

208 "we went as Mr. and Mrs.": SMS, pp. 100–101.

208 "he was a trifle timid": SMS, p. 95.

208 "My wedding night": SMS, p. 30.

208 "it was the nights": SMS, pp. 33–34.

209 "problem"/"far beyond [Maxon's] comprehension": SMS, p. 31.

209 "Mrs. Wilson, my teacher": SMS, p. 30.

209 "Here at last": SMS, p. 99.

209 "mere physical attraction": SMS, p. 49.

209 "completely impossible": SMS, p. 94.

209 "the fates had worked": SMS, p. 99.

209 "the man whom I thought": SMS, p. 116.

209 "the impression of a schoolboy": SMS, p. 95.

209 "the affection that had" SMS, p. 35.

210 "Iowa took on new": SMS, pp. 98, 101.

210 "a more or less intriguing": SMS, Alice Rheem fragment, p. 2.

210 "a lovely Irish": William L. Shirer, *Twentieth-Century Journey: A Memoir of a Life and the Times: The Start, 1904–1930* (New York: Simon and Schuster, 1976) p. 187.

210 "driving and forceful": Irene Monroe, "Most Famous Grant Wood Painting Was Never Painted," *Davenport Democrat-Times,* 3 February 1957 [AAA].

210 "stunning pajamas": [No author or title indicated], *Milwaukee Journal,* 1 April 1935 [AAA].

211 "an innovation": GWC, p. 56.

211 "We think Mrs. Wood": GMC, p. 90.

211 "One of the things": SMS, p. 104.

211 "I went with Grant": SMS, p. 104.

211 his new wardrobe: Nan writes that beginning in 1935,

> Grant now began to dress more casually. He still bought dark blue suits, but he added brown to his wardrobe and light tan shirts to go with the brown suits. He changed from all black neckties to various subdued colors, rust with brown being his favorite. He bought black and white checkered trousers and chose ice-cream pants to be worn with a brown sports jacket [and] glasses with white or silver frames. (MB, p. 134.)

211 "the real reason": SMS, p. 104.

211 "for the first time": SMS, p. 99.

211 "a great appeal": SMS, p. 100.

212 "which he could not control": In a five-page document hereafter referred to as "Sara Sherman: Fragment X," Sara writes that Wood described himself at nine as "a great hulking boy, with a shock of reddish hair and thick haunches which he could not control"; Sara Sherman: Fragment X, p. 2.

212 "grim, gaunt, relentless": Sara implies both Wood's animosity toward Maryville and Maryville's presence in *American Gothic.* "You remember the man in that picture [*American Gothic*], his grim, gaunt, relentless features. Yes, every school child knows those features almost as well as he knows those of his own father. Only, *he* likes his father." Sara Sherman: Fragment X, p. 2.

212 "Grant was sent": Sara Sherman: Fragment X, p. 4. In this manuscript fragment, Sara refers to Wood throughout simply as "X." (In the context of her writing, it is indisputable that Wood and "X" are one and the same.) For fluency's sake, I have substituted Wood's name for "X" in this quotation.

213 where she had at last: SMS, Park Rinard fragment, p. 1. Sara explains that the room Wood had remodeled for Hattie's private use in 1932 had never been occupied: "Mother Wood had never had a room of her own," Sara writes, "so I proceeded to buy furniture and bedding, and other appropriate appointments for this room that I was determined she should have."

213 "Mother Wood had not": SMS, p. 106.

213 "Never in my life": SMS, p. 106.

213 In late July, David: In her autobiography (SMS, p. 109), Sara implies that Turner wanted the Woods out of Turner Alley immediately; yet Garwood, who later interviewed Turner, reports he offered Wood and Sara another year's lease (until July 1, 1936); AI, p. 193.

214 "terrifically upset": SMS, p. 109.

215 "Cedar Crick": Quoted in GMC, p. 91.

215 "It was a rare event": GMC, p. 91.

215 When she invited: This story, which seems to have made the rounds in Cedar Rapids, is recorded both by Nan (MB, pp. 149–150) and Hazel Brown (GMC, p. 91).

215 "Sara was what": Confided to the author during a tour of Wood's former studio, 15 September 2005.

215 Similarly funereal: William Kittredge describes this "stained-glass window" of canning jars in an article entitled "I Went to School to [sic] Him," Iowa *Demcourier* 12, no. 3 (May 1942), p. 20 [AAA].

216 Sharing the news: MB, p. 128.

217 Not only had the artist: Explaining her own refusal to attend her brother's deathbed in 1942, Nan claimed that "when Mother died, he had reacted the same way"; MB, p. 180. Vida Hanson's failed visit is described in AI, p. 196.

217 "exorbitant price": SMS, p. 112.

217 "white and drawn": MB, p. 129.

217 Placing his mother: Nan explains how she and Wood arranged Hattie's burial in MB, p. 129. According to Garwood, the decision to bury Wood next to Hattie was made only after the artist's death, and almost as an afterthought (AI, p. 248). That Wood had planned to reserve this plot for himself, however, seems abundantly clear; there were but two spaces left in the Weaver lot when Hattie died, and no more living Weaver relatives.

217 Wood claimed to have based: AI, pp. 197–198.

217 Although he paid: MB, p. 133.

218 Built in 1858: AI, p. 193. For a complete history of Wood's Iowa City home, see Richard Alan King, *1142: The History and Growth of the N. Oakes—Grant Wood—Dr. Pauline Moore—James P. Hayes House* (Hiawatha, Iowa: Cedar Graphics, 2008). Wood bought the house from "Aunt" Fannie Oakes, the daughter-in-law of the original owner (see King, *1142*, p. 26).

218 "practicing fairyland": Quoted in GMC, p. 83.

219 "crammed with quaint bits": MacKinlay Kantor, "K's Column," *Des Moines Tribune-Capital,* 29 December 1930 [AAA].

219 Beginning in the 1920s: See the introduction and excellent essays in Alan Axelrod, ed., *The Colonial Revival in America* (New York: W. W. Norton and Co., 1985).

220 "enthusiastic collectors": This photograph of Sara and Wood inspecting the candy dish appears in an otherwise unidentified DMR clipping, probably from 1937; its caption reads in full, "Grant Wood and his wife are enthusiastic collectors of flint glass. They are shown above examining new pieces in their Iowa City home" [AAA]. My use of the word "admiring" here was suggested by Edward Cabral (told you I'd give you credit, baby).

220 "the memories of a farm": Donald Durien, [untitled article], *American Home,* January 1937 [AAA].

220 Sara was an enthusiastic: SMS, p. 61. My assumption concerning Sara's distaste for antiquing is based on her own admission that she considered traditionally feminine

pastimes a "bore." ("Incidentally," she wrote in her seventies, "I always have and still do feel the same way.") SMS, p. 10.

220 "a handy man": AI, p. 45.

220 "was an extraordinary": Quoted in GMC, p. 83.

220 "He was used to a studio": AI, p. 201.

220 "Things worked out best": Nan Wood Graham, letter to the editor, *Saturday Evening Post,* 27 October 1965 [AAA].

221 Not only did Wood: Nan writes that her portrait "occupied the place of honor above the living room fireplace. Grant planned the color scheme of his living room entirely around *Portrait of Nan.* The flowered wallpaper, the dark rose upholstered Victorian gentleman's chair, and the dark green drapes all repeated the colors of the painting." MB, p. 112.

221 Beneath the painting: The combination lounge chair and footstool Wood designed in 1938 were produced by the H. R. Lubben Company in Cedar Rapids. Calling it the "Grant Wood Lounge and Chair," the company used Wood's image in promotional material for the furniture, which was briefly mass-produced; see Jane C. Milosch, "Grant Wood's Studio: A Decorative Adventure," in Jane C. Milosch, ed., *Grant Wood's Studio: Birthplace of American Gothic* (New York: Prestel, 2005), p. 106.

221 "I suggested to Grant": SMS, p. 113.

221 "had no conception": SMS, p. 113.

221 "Only the gods know": SMS, p. 113.

222 "In talking over": SMS: Divorce fragment, p. 3.

222 "At no time": Ibid.

222 Attentive and financially: Nan claims that the adoption scheme was Sara's idea (MB, p. 150); yet this assertion strains belief, given Sara's almost immediately negative reaction to Wood's and Sherman's closeness. Considering Sherman's distant and difficult relationship with his father, Alonzo, as well as his later financial dependency on Wood, it is far more likely that he, rather than Sara, encouraged the plan.

223 "I had no idea": SMS, p. 114.

223 "There are those": SMS, p. 113.

223 The year after: MB, p. 139, and James M. Dennis, *Grant Wood: A Study in American Art and Culture* (New York: Viking Press, 1975), p. 240.

223 In *The Radical:* Lea Rosson DeLong not only confirms Sherman and Dorothy's modeling for Wood (see her excellent study, *Grant Wood's Main Street: Art, Literature, and the American Midwest* [Ames: University Museums, Iowa State University, 2004]), but she has also discovered a preliminary, finished drawing for *The Radical*—one that portrays Sherman far less aggressively than he appears in this final version. I first saw this image in her presentation, "Drawing and *Main Street,*" delivered at the "Grant Wood's World" Symposium, University of Iowa, Iowa City (24 April 2010).

223 a feature neither: In photographs of Sherman Maxon from this period, including one now in Ed Bartholomew's possession, he is clean-shaven. Lewis makes no note of Bjornstrom's having a mustache.

223 a look of hauteur: I am indebted to Wanda Corn for her take on this detail; Wanda M. Corn, *Grant Wood: The Regionalist Vision* (New Haven: Yale University Press, 1983), p. 114.

224 a sensitive yet hardly: James Dennis notes this disconnect, claiming that Wood's figure "displays a far more delicate disposition than Lewis had imagined"; Dennis, *Grant Wood,* p. 122.

225 Wood's colleague Charles Sanders: MB, p. 139.

225 "narratives of confrontation": Wanda M. Corn, "Grant Wood: Uneasy Modern," in Milosch, ed., *Grant Wood's Studio,* p. 112.

225 "pseudo-opposition": Eve Kosofsky Sedgwick, *Epistemology of the Closet* (Berkeley: University of California Press, 1990), p. 183.

225 a figure for which: Wood visited Amana in 1932 to attend an opening of Flick's paintings at the Homestead Hotel, where he gave a painting demonstration using an image of a large, white draft horse. The following year he created the *Draft Horse* and *Race Horse* pair, the first of which features a figure that clearly resembles Flick. Peter Hoehnle, "Carl Flick and Grant Wood: A Regionalist Friendship in Amana," *Iowa Heritage* 82, no. 1 (Spring 2001), pp. 11–12.

227 "some form of transportation": Grant Wood, "Art in the Daily Life of the Child," *University of Iowa Child Welfare Pamphlets* no. 73 (10 May 1939), p. 6, [AAA].

227 "gay print": Nelson, "Grant Wood's New Hand-Colored Lithographs Stir World of Art," *Iowa Press Citizen,* 23 September 1939 [AAA].

227 "There's a suspicion": [No author indicated], "Red Flannels Elude Search," *Minneapolis Tribune,* 28 December 1934 [AAA].

229 "a major emotional crisis": Joseph M. Flora, *Vardis Fisher* (New York: Twayne Publishers, 1965), p. 18.

229 "without pretense": Ibid., p. 20.

229 "[he] was assured": Quoted ibid., p. 30.

229 "So divorced": Vardis Fisher, *In Tragic Life* (New York: Doubleday, Doran and Co., 1932), p. 401.

229 a technique that Fisher's: Flora, *Vardis Fisher,* p. 45.

229 "When far from her": Fisher, *In Tragic Life,* p. 356.

230 Filling in the rest: The livestock at the top of Wood's image reference Edward Hicks's *Peaceable Kingdom* (1834).

230 the same hairstyle Nan wears: MB, p. 74.

230 "to paint a double-faced man": MB, p. 110. The source for Wood's split image was a specially commissioned sculpture by Florence Sprague, who created the image with a live model from Stone City in the summer of 1933. [No author indicated], "Artist, Sculptor Use Their Imaginations for Design," DMR, 28 January 1934. Noted in Dennis, *Grant Wood,* p. 240, n. 5.

231 "it was one thing": MB, p. 110.

231 "had so many irons": MB, p. 33.

231 "With each figure": Nancy Marshall, "Purity or Parody? Grant Wood's *American Gothic*" (unpublished manuscript), p. 4.

232 "Revolt was not part": In her memoir, which was not published until 1993, Nan notes that Mott admitted ghostwriting this essay; MB, p. 124. Wanda Corn explores the issue more thoroughly in *Grant Wood* p. 153, n. 85.

232 "Eastern seaport cities": Luther Mott, "Revolt Against the City," reprinted in Dennis, *Grant Wood,* p. 230.

232 Wood himself had never: Wanda Corn notes Wood's admiration for Reginald Marsh; Corn, *Grant Wood,* p. 153, n. 85.

232 ironically, given Ferargil: Mott claims that "the long domination of our own art by Europe, and especially by the French, was a deliberately cultivated commercial activity—a business—and dealers connected with the larger New York galleries played into the hands of French promoters because they themselves found such a connection profitable"; Mott, "Revolt Against the City," in Dennis, *Grant Wood,* p. 230.

233 "frontier virtues"/"Anglo-Saxon reserve": Ibid., pp. 231, 233.

233 "intimacies"/"artificial values"/"cosmopolitanism": Ibid., pp. 233, 231.

233 "Gertrude Stein comes": Ibid., p. 231.

233 "far less typically American": Ibid., Mott's words here resonate with the conservative political rhetoric of our own time; on the campaign trail in 2008, Republican vice-presidential candidate Sarah Palin announced at a rural rally: "We believe that the best of America is in these small towns . . . those wonderful little pockets of what I call the real America"; delivered in Greensboro, North Carolina, 16 October 2008.

233 As late as the 1970s: When James Dennis reprinted "Revolt Against the City" in his 1975 monograph on Wood, he did so without any indication that Mott had ghost-written the essay.

233 "lost its masculinity": [No author indicated], "Mr. Benton Will Leave Us Flat—Is Sick of New York and Explains Why," *New York Sun,* 12 April 1935; several newspapers reprinted this essay, as did Benton himself in his 1937 autobiography, *An Artist in America* (Columbia: University of Missouri Press, 1937).

233 "the concentrated flow": Ibid.

234 "Benton has included": Grant Wood, "Grant Wood Reviews *An Artist in America* by Thomas Hart Benton," *Saturday Review of Literature* 17, no. 2 (6 November 1937), p. 9 [AAA].

235 leery of her husband's: SMS, Park Rinard fragment, p. 2. Simultaneously, this project also constituted Rinard's master's thesis for the English department at the University of Iowa. Submitted in 1939 as "Return from Bohemia: A Painter's Story, Part I," his thesis is virtually identical to the unfinished book manuscript of the same name.

235 how or when the two men: In an interview with the author (Iowa City, 25 April 2010), John Fitzpatrick—who had known Rinard well—claims it was Rinard who packed Wood's studio in preparation for the move to Iowa City (Rinard, at this point, had not yet assumed his official role as Wood's assistant). Fitzpatrick explains that Rinard himself was vague about how and when he and Wood first met (an indication, perhaps, that Rinard simply did not remember the circumstances). Paul Juhl, too, notes that Rinard and Wood had known each other socially before working together. Paul C. Juhl, *Grant Wood's Clear Lake Summer* (Iowa City: Brushy Creek Publishing, 2007), p. 4.

235 "This [writing] arrangement": SMS, Park Rinard fragment, p. 3.

235 "my sixth sense": SMS, p. 116.

235 The "set-up" at East Court: Sara later revised her own timeline where Rinard's first appearance is concerned. In her autobiography, she claims: "It was during this summer [in Waubeek] that a young chap came to live with us, who had been hired by a New York publisher to write a book on Grant's life"; SMS, p. 106. In a later revision, however (SMS, Park Rinard fragment, p. 2) she claims Doubleday's book offer was only made as they were leaving Waubeek. In this version, Rinard is hired "after we were moved and settled in Iowa City"—and therefore, following Hattie's death and Sherman and Dorothy's arrival. Even in the first version of her manuscript, Sara cites her son's arrival prior to Park's permanent residence with them (SMS, p. 115). It is possible, of course, given Sara's prior acquaintance with Rinard, that she may have invited him to the Waubeek cottage as a guest that summer.

235 "sitting on top": Sara uses this evocative phrase on two separate occasions; SMS, p. 116, and SMS, Divorce fragment, p. 1.

235 "In a way, this may be": SMS, p. 106.

235 "The book was never": SMS: Park Rinard fragment, p. 3.

235 "Parkus": MB, p. 164.

236 By the end of his first: Rinard modeled for the jacket cover Wood designed for Kenneth Roberts's *Oliver Wiswell* (1940). Juhl, *Grant Wood's Clear Lake,* p. 9.

236 "general utility man": Juhl, *Grant Wood's Clear Lake,* p. 6.

236 That Rinard later married: Henry Adams provides a different take on Rinard's sexual orientation: "According to Wallace Tomasini, former Dean of the School of Art at the University of Iowa, who got to know him well, Rinard married and 'was very defensive about the homosexual thing.' But Tomasini adds: 'I think Park was gay. I have no proof of that. He impressed me as being closeted, as all the other people who were part of that group.' " Henry Adams, interview with Wallace Tomasini (1 August 2002); cited in Adams, "The Truth About Grant Wood" (first delivered at the College Art Association, 24 February 2000), p. 23, n.31. The defensiveness that Tomasini perceived in Rinard may simply have stemmed from the suspicion that surrounded his relationship with Wood. Such an attitude does not, in and of itself, indicate that Rinard himself was gay.

238 "one of Wood's": Sue Taylor, "Wood's American Logic," *Art in America* (January 2006), p. 91.

238 "Three top-notch American": "Life Goes to a Party with Tom Benton, Grant Wood, and John Curry at the Kansas City Beaux-Arts Ball," *Life* 4, no. 2 (21 March 1938), p. 62 [AAA].

238 "an orgy in the worst": Hosted on 5 March 1938 by the Kansas City Art Institute at the Hotel Muehlebach, the event was considered a rowdy disaster; Henry Adams, *Thomas Hart Benton: An American Original* (New York: Alfred A. Knopf, 1989), p. 278.

239 "swelling and breathing": Corn, *Grant Wood,* p. 90.

240 Due to the Comstock: Whitney Davis, "Erotic Revision in Thomas Eakins's Narratives of Male Nudity," *Art History* 17, no. 3 (September 1994), p. 316.

242 By Wood's day: Henry Adams's excellent examination of *Swimming* catalogues all of the work's potentially homoerotic dimensions. See Adams, *Eakins Revealed: The Secret Life of an American Artist* (New York: Oxford University Press, 2005) pp. 305–26.

242 "like the hands on a clock": Adams, *Eakins,* p. 306.

242 Wood's work, in turn: Adams sees these forms in Wood's painting, as well; in his 2000 paper "The Truth About Grant Wood," he explains that "the buttocks I see in *Spring Turning* are definitely not female—they are not fleshy, soft, and rounded, but relatively hard and firm, like that of an adolescent boy" (p. 13). Given our similar takes on Wood, it is not surprising that we came to the same reading independently; I am grateful to Henry for sharing his paper with me.

242 "I liked to stand": RB, frame 195.

242 Promoting the youthful: Thomas Waugh, *Hard to Imagine: Gay Male Eroticism in Photography and Film from Their Beginnings to Stonewall* (New York: Columbia University Press, 1996), pp. 402–403, 405.

243 "knows how to mold": [No author indicated], *Scholastic* 21, no. 3 (22 October 1932) [AAA].

243 "These ruts which cut": Jay Sigmund, "Land of Clod and Furrow" (1933); Sigmund dedicated the poem to Wood, and Nan included it in her scrapbooks [AAA].

243 "could make [even] the sophisticated": John Steuart Curry, "Grant," Iowa *Demcourier* 12, no. 3 (May 1942), p. 20.

243 "too damn many": Quoted in Watson Forbes, "The Phenomenal Professor Wood," *American Magazine of Art* 38, no. 5 (1935), p. 289.

243 "frills and curves"/"purely decorative": [No author indicated], "Grant Wood, Brilliant Painter of the Mid-Western Scene," *London Studio* 15, no. 83 (February 1938), p. 91 [AAA].

243 "decorative, in the lighter": Thomas Craven, "*Scribner's* Examines: Grant Wood," *Scribner's* 101, no. 6 (June 1937), p. 21.

244 "[Wood's] satire": Henry McBride, *New York Sentinel,* October 1936 (no exact date given) [AAA]. Wood did paint a landscape called *Spring Plowing,* but not until three

years after McBride's review; in this instance, the critic clearly intended to write *"Spring Turning."*

244 Created to support: Corn, *Grant Wood*, p. 49.

244 In 1937, Wood, too: It is Sara who originally suggested Wood sign on with Associated American Artists; SMS, p. 104.

245 "The dealer who up till now": John Selby, "Grant Wood Denies He's Art Prophet" (undated clipping, c. 1937) [AAA].

246 "began carving": GMC, p. 94.

246 That same year: Corn, *Grant Wood*, p. 154, n. 93.

246 "Scholastic Gothic": GMC, p. 95.

246 Declaring the work: The postal ban on *Sultry Night* is mentioned in numerous sources (MB, p. 141; AI, p. 210; Corn, *Grant Wood*, p. 50). In advertisements in the late 1930s, Associated American Artists announced that "more than 140 subjects are now available; among them landscapes, marines, *nudes* [my italics], character, sporting and architectural studies" [AAA]. The female nudes Associated American Artists sold were no doubt considered a decorous part of the Western tradition; images of stripped-down farmers were not.

246 Cutting the print: Corn, *Grant Wood*, p. 50; AI, p. 210.

246 "In my boyhood": MB, p. 141. Selby includes the same quotations in "Grant Wood Denies He's Art Prophet" (undated clipping, c. 1937) [AAA].

246 "Hired men were given": LSN, p. 28.

247 Given the artist's accounts: Grant Wood, letter to the editor, *Time,* 21 January 1935 [AAA].

247 "sissified": Irene Monroe, "Most Famous Grant Wood Painting Never Painted," *Davenport Democrat-Times,* 3 February 1957 [AAA].

247 Not only had he shocked: Both Hazel Brown and Nan make special note of these expeditions; GMC, p. 10, and MB, p. 25.

247 "Hood and Wood": MB, p. 32.

248 Funcke had agreed to pose: Thomas Hart Benton identifies Funcke (misspelled "Funke") as the model in an undated letter [AAA]. I am grateful to Sue Taylor for her reference to Funcke's request, and for her identification of the work's current owner (the Muscatine Art Center, Muscatine, Iowa). Sue Taylor, "Grant Wood: A Brilliant Subterfuge," delivered at the "Grant Wood's World" Symposium, University of Iowa, Iowa City (24 April 2010).

249 "the fulfillment of an old": [No author indicated], "Red Flannels Elude Search," *Minneapolis Tribune,* 28 December 1934 [AAA].

249 "[Wood] is throwing": [No author indicated], "Grant Wood to Unveil in Early Spring His Painting Glorifying Red Flannels," *Kansas City Star,* 18 January 1935 [AAA].

249 "hot sketch": Adeline Taylor, "Grant Wood Obtains Suit of Red Flannel Underwear; Now He Can Start *The Bath: 1880,*" *Cedar Rapids Gazette,* 6 January 1935 [AAA].

249 Nan recalled that the painting's: Monroe, "Most Famous Grant Wood Painting," *Davenport Democrat-Times,* 3 February 1957 [AAA].

251 "about as pornographic": MB, p. 141.

251 By invoking the solid: Michael Hatt, "Muscles, Morals, Mind: The Male Body in Thomas Eakins's *Salutat,*" in Kathleen Adler and Marcia Pointon, eds., *The Body Imaged: The Human Form and Visual Culture Since the Renaissance* (Cambridge University Press, Cambridge: 1993), p. 68.

251 In his first full-scale: Beyond the work described here, Wood depicted male nudes in similar statuary form on three subsequent occasions in the 1920s. First, in 1925, Wood made two clay figures for the Church of the Immaculate Conception in Cedar

Rapids; "he did these first in the nude," Garwood writes, "carefully outlining each saintly muscle. Then he covered them with ecclesiastical robes"; AI, pp. 84–85. Second, in 1927 Wood reprised the seminude figure from *First Three Degrees of Free Masonry* that he had based upon the *Discus Thrower*. Part of a graphic design Wood created for the Cedar Rapids Community Chest, this figure flanks—like the soldiers in his later *Memorial Window*, and the farmers in his earlier *Adoration of the Home*— a fully clothed, allegorical female figure; this graphic is included at the start of Nan's scrapbooks [AAA]. Last, Wood's original sketch for the Cannoneer of 1812, for his 1929 *Memorial Window*, is based upon Polykleitos's well-known *Doryphorus* ("The Spear Bearer").

252 His decision to quote: Widely reproduced in engravings, photographs, and casts, *The Tyrannicides* statue group (as well as the painting's other statuary sources) would have been familiar to Wood through the Cedar Rapids Art Association and its Carnegie-funded library, as well as from Cumming's classes at the University of Iowa. (In addition, Wood had taken Greek history at Washington High School; AI, p. 29.) During the artist's 1924 trip to Naples, he most likely saw the original work.

252 "shrinking and shadowing": AI, p. 209.

252 "American Adam": Dennis, *Grant Wood*, p. 220.

252 "glorifies the reassuring": H. E. Wooden, "Grant Wood: A Regionalist Interpretation of the Four Seasons," *American Artist* 55, issue 588 (July 1991), p. 58.

253 Beginning with the solitary: My reading goes right to left—although Wood's preparatory drawing for this print would have been the reverse of the final image.

254 Presented to its subject: James M. Dennis, "Grant Wood Works on Paper: Cartooning One Way or the Other," in Milosch, ed., *Grant Wood's Studio*, p. 39. Although Dennis dates this work to 1928, several sources supply a 1938 date. The later date is highly unlikely, however, not only due to the work's style but also given Wood's extraordinary reaction to *Sultry Night*'s suppression in 1937. That he would have created such a shocking image within a year of the postal ban seems unlikely.

254 and for his generation: Charles Eldredge provides one of the best discussions of this phenomenon; Eldredge, "Prairie Prodigal: John Steuart Curry and Kansas," in Patricia Junker, ed., *John Steuart Curry: Inventing the Middle West* (New York: Hudson Hills Press, 1998), especially pp. 100–106.

254 "Walking along the road": RB, frame 213.

255 "tasseling out": Nicholas P. Hardeman, *Shucks, Shocks, and Hominy Blocks: Corn as a Way of Life in Pioneer America* (Baton Rouge: Louisiana State University Press, 1981), p. 210.

255 Regionalist art of the 1930s: The Curry example that follows is one of the more straightforward examples of the anthropomorphized cornstalk, yet Jonathan Weinberg has identified an even more frankly homoerotic example, from a slightly later date, in Jared French's regionalist mural *The Farm* (1938). In this image an unusually muscular and shirtless farmer holds a thick, unhusked ear of corn in his right hand, while an equally well-developed farmhand—his arm around the farmer—looks admiringly on. A third figure kneels before the farmer, holding a dangling bunch of carrots at the man's crotch. For French's image and Weinberg's discussion of it, see Weinberg, *Male Desire: The Homoerotic in American Art* (New York: Harry N. Abrams, 2004), pp. 74–75.

255 "a self-portrait": Eldredge, "Prairie Prodigal," in Junker, ed., *John Steuart Curry*, p. 10.

255 "I have tried to put": John Steuart Curry to Elizabeth Navas, 30 June 1939; curatorial files, Wichita Art Museum, Wichita, Kansas. My own source for this letter is Eldredge, "Prairie Prodigal," in Junker, ed., *John Steuart Curry*, p. 105.

256 "At first I did not": Thomas Craven to John Steuart Curry, 27 January 1935) [Curry papers/AAA, reel 166, frame 511]. Once again, I am indebted to Charles Eldredge for his own citation of this source; see Eldredge, "Prairie Prodigal," in Junker, ed., *John Steuart Curry,* p. 105.

256 Wood's model was: GWC, p. 48.

256 "I believe . . . in the night": Quoted in Betty Fussell, *The Story of Corn: The Myths and History, the Culture and Agriculture, the Art and Science of America's Quintessential Crop* (New York: Alfred A. Knopf, 1992), preface.

256 Another feature: Ibid., p. 61.

256 As Henry Adams has demonstrated: Adams, "The Truth About Grant Wood," p. 15. I find Adams's reading of this image, and of the "corn-hole" openings in the artist's 1937 lithograph, *January* (p. 17), wonderfully insightful.

257 The live model for *Sultry Night:* In an interview that Mary Bennett conducted with Ruth McCuskey Weller in 1993, Weller claimed to know the identity of *Sultry Night's* model. "Park Rinard called me to photograph a drawing," she says. "[Wood] had done a drawing from a photo. I nearly fainted. I know who it was. I don't know if he's even around here now." She goes on to identify the model as simply "James." "He had a whole bunch of those [photographs?] of James," Weller explains, adding, "we weren't used to seeing that in a photograph. I was a little surprised that Grant Wood would do that. I didn't believe he'd be interested in doing a shock thing." Mary Bennett, interview with Ruth McCuskey Weller, 1 September 1993; State Historical Society of Iowa, Special Collections.

Weller worked for Fred Kent, the official University of Iowa photographer from 1915 to 1971. She often photographed models for Wood, and was asked to destroy the prints/negatives once he finished his work. Whoever took the nude photographs of James (whose identity I have not been able to determine), it is clear that Wood did not destroy them.

As for the connection Weller draws between James and *Sultry Night,* I maintain my own theory (elaborated further on) that the model was probably Wood's housemate, Eric Knight. Not only might Weller have been legitimately mistaken about the model, but it is also possible that Wood himself wished to mask the model's true identity.

258 Foerster appears: [No author indicated], "Grant Wood Rejects the 'Flourish and Gaiety' of Urban Artists," *New York Herald Tribune,* 23 April 1939 [AAA]; this article identifies Norman Foerster and Carl Seashore as the right- and left-hand figures, respectively.

258 Not only did Wood: Nan provides the earliest examples of Wood's punning titles and wordplay. In high school, Wood created a caricature of a fat man in swim trunks, plagued by a mosquito, that he called *Living on the Fat of the Land;* in another, he portrayed an acquaintance named Lorrey, eating, entitled *Lorrey Ate* (a pun on "laureate"). As for the 1917 landscape Wood gave to Nan, entitled *Quivering Aspen,* the artist and Nan enjoyed referring to it as "Quivering Aspirin." Added to these examples is one of the artist's favorite yarns: leaving church early to milk the Lord family's cow, he told his mother he was off do "the Lords' work." For all, see MB, pp. 10–11, 28.

258 Given the midsummer: Knight spent four summers at East Court Street, beginning in 1938; during the rest of the year, the writer lived with his wife on a farm outside of Philadelphia. In June 1941, the CRG ran a photograph of Wood and Knight at Wood's piano. The caption reads: "Seldom is such rare talent to be found under one rooftop as in the Grant Wood home at Iowa City, where dwell Painter Wood and

Writer Eric Knight . . . The two are great friends, [whose] discussions of the relations of all the arts to life often run far into the night." Whether the newspaper intended its own wordplay on the author's name in this final word choice, given the whiff of innuendo this profile naturally raises, is uncertain; [No author or title indicated], CRG, 29 June 1941 [AAA].

259 "invited more than fifty": AI, pp. 209–10.
259 "it might be thought": AI, p. 210.
259 "alibi of innocence": Waugh, *Hard to Imagine,* p. 18.
260 "The painting suffered": MB, pp. 141–2.
260 *Sultry Night*'s patron: Nan names the painting's patron as Dr. Wellwood Nesbit of Madison, Wisconsin: MB, p. 142. Today the painting is in the possession of James Dennis, author of the first monograph on Wood's work (confirmed by Jane C. Milosch [Iowa City, 23 April 2010] and John Fitzpatrick [Iowa City, 25 April 2010]).
260 "a hell of a time": Quoted in Watson Forbes, "The Phenomenal Professor Wood," *American Magazine of Art* 38, no. 5 (1935), p. 289.
261 "a traumatic nightmare": MB, p. 149.
261 Sara's increasing unhappiness: GMC, p. 93, and MB, pp. 149–50.
261 "left [the Woods'] employ": MB, p. 150.
261 "Sara is working on it": Dennis, *Grant Wood,* p. 243, n. 4a. Garwood notes, too, that Wood often claimed, "Sara takes care of everything"; AI, p. 215.
261 Wood's attraction: Garwood notes Wood's love for this play and explains, furthermore, that he chose *Androcles and the Lion* for the Cedar Rapids Community Players' 1929 debut at his studio; AI, p. 112.
261 "to return to [his] duty": George Bernard Shaw, *Androcles and the Lion* (London: Constable and Co., Ltd., 1916).
262 In 1937 alone: MB, p. 149.
262 "My brother wrote": MB, p. 149.
262 Not only was this: Sara claims Wood had failed to file taxes even before their marriage ("I finally solved the problem with the help of a businessman in Cedar Rapids," she adds); SMS, Park Rinard fragment, p. 1. In this earlier period, however, Turner and Prescott would hardly have overlooked such an omission—and given the artist's IRS problems following his divorce, Sara's memory of the situation may have served to correct her own reputation for fiscal irresponsibility (one confirmed by more than one of her contemporaries). A more detailed accounting of Wood's IRS troubles is found in AI, p. 218. For Turner's and Prescott's involvement with Wood's finances, see GMC, p. 94.
262 "A bad emotional scene": MB, pp. 150–51.
263 In a gesture: MB, p. 151.
263 "During those weeks": SMS, p. 117.
263 when Sara returned: SMS, p. 117.
263 "Perhaps there are still": SMS, p. 112.
263 "inhuman treatment": The divorce clippings in Nan's scrapbooks are even more extensive than Wood's wedding coverage. This quote comes from an unidentified article from 25 September 1939 (possibly CRG) [AAA].
264 "If I live a thousand": SMS, Divorce fragment, p. 7.
264 "full story"/"injurious": Ibid.
264 Had she attempted: MB, p. 151.
264 "to eliminate me": SMS, Divorce fragment, p. 3. Sara was not the only one in Wood's life to see through Sherman; Nan referred to him as a "parasite" (AI-G, p. 203).
264 "a battle forever": Quoted in GMC, p. 91.
264 "picked on": MB, p. 150.

264 With evident satisfaction: MB, p. 151.

265 The first, a college: Nan, who developed a lifelong friendship with Green, notes his first appearance in MB, p. 159.

265 The second, a young: MB, p. 160.

265 Paul Young, who met Wood: I am indebted to Sean Strub for sharing with me the reminiscences of Paul Young, a close family friend and onetime secretary to Madeline Darrough Horn (whose *Farm on the Hill* Wood had illustrated in 1936). In an e-mail communication with the author (17 April 2010), Sean wrote: "Grant was friendly to Paul and invited him to several all-male dinner parties at the house on Court Street. Paul said they were not campy 'out' kind of affairs, but there was no question that it was a party of homosexual men. . . . Paul said he always wore a jacket and tie to the dinners at Grant's house, even though he 'knew there wouldn't be any women present.' "

265 in one marathon session: AI, p. 226.

265 notably, Wood painted: Today, the historical marker outside Wood's Iowa City home proclaims this unusual fact.

266 "a valuable and colorful": [No author indicated], "Iowa Artist Paints Second Oil in Series of Historical Works Depicting Folklore in America," *Iowa City Press-Citizen,* 6 January 1940 [AAA].

266 As Karal Ann Marling: For Marling's excellent treatment of this period, and of Wood's connection to Washingtoniana, see her essay "Of Cherry Trees and Ladies' Teas: Grant Wood Looks at Colonial America," in David Axelrod, ed., *The Colonial Revival in America* (New York: W. W. Norton and Co., 1985).

266 the very venue: Ibid., p. 297.

267 "One of the things": [No author indicated], "Grant Wood Tells Story of Latest Work; Artist was Inspired by 1938 Essay," *Iowa City Press-Citizen,* 6 January 1940 [AAA].

267 a story *Time* magazine: [No author indicated], "U.S. Scene," *Time* 24, no. 26 (24 December 1934) [AAA].

268 "An underhanded smile": Quoted in AI, pp. 227–28.

270 "Most of all I was": RB, frame 248. Even as an adult Wood was transfixed by the illusion of stage scenery. Writing Nan and Hattie from Paris in the summer of 1920, he remarks that the backdrops of the Paris Opéra were so convincing that "you could see out all over the city"; MB, p. 38.

271 Years later, the artist: Adeline Taylor of the CRG notes the curtains' placement and function in her extensive 1931 feature on Wood. The studio's "ash rose curtain," she writes, "cuts off the west end, where walls mysteriously give out beds, or lends itself to amateur theatricals"; Taylor, "Grant Wood Hailed from West to Berlin as Discovery," CRG, 25 January 1931 [AAA].

271 "[would] pull the cord": MB, p. 52.

271 to use MacKinlay Kantor's: MacKinlay Kantor, *I Love You, Irene* (Garden City: Doubleday and Co., 1972), p. 141.

271 Responding rather unconvincingly: [No author indicated], "Iowa Artist Paints Second Oil in Series of Historical Works," *Iowa City Press-Citizen,* 6 January 1940 [AAA].

272 Not only do Wood and Washington: AI, p. 223.

272 "Mr. Wood will like": Eliza Burkhalter, "14-Year-Old Painter Turns Tables on Grant Wood, Makes His Paintings Caricature Subject," CRG, 17 January 1935 [AAA].

272 and the rarer: The *Chicago Journal of Commerce,* for example, offered: "They tell us that Abraham Lincoln's first study was by the open fire and that his first 'ciphering was done by figuring on the back of a shovel with a piece of charcoal. **Grant goes the**

historian one better and claims his first study was underneath the oil cloth of the kitchen table, and his first drawing that of an old Plymouth Rock hen." [No author indicated], "Grant Wood to Address Members of Woman's Club,' *Chicago Journal of Commerce,* 20 March 1937 [AAA]. At Wood's funeral service, he was once again compared to Lincoln; like the assassinated President, the pastor claimed, Wood too had "pass[ed] on at a supreme moment, at a crowning hour." M. Willard Lampe address, funeral services for Grant Wood, 14 February 1942, p. 3 [AAA].

272 "cannot paint a lie": [No author indicated], "Grant Wood Defends Cherry Tree Art," DMR, 4 January 1940 [AAA].

272 "[Wood] is one of the big": Thomas Craven, "Home Grown Art," *Country Gentleman,* November 1935 [AAA].

272 The smugness critics: Bob Sherwood, "Grant Wood Disclaims Desire to Belittle Washington," CRG, 26 February 1939 [AAA]. See also AI, p. 225.

273 "Run to my arms": Mason Locke Weems, *A History of the Life and Death, Virtues and Exploits of General George Washington* (Philadelphia: J. B. Lippincott Co., 1918).

273 "a good part of [Wood's]": AI, p. 199.

273 In the artist's flipped version: The composition of this projected work would have mirrored Wood's strategy in *Parson Weems' Fable*—in which he illustrates an already apocryphal account and then subverts its narrative structure. James Dennis notes the Pocahontas–Smith reversal in his *Grant Wood,* p. 239, n. 12, as does Garwood in AI, p. 229.

273 "Clearly, the boy": This unattributed/undated clipping in Nan's scrapbooks is identified only by the newspaper's name, the *Indianapolis News;* it is almost surely from 1939 [AAA].

274 as Shirley Reece-Hughes has observed: I am grateful to Ms. Reece-Hughes, Assistant Curator of Paintings and Sculpture at the Amon Carter Museum in Forth Worth, Texas, for sharing this observation with me. Telephone communication with the author, 28 January 2010.

274 Severed and oddly: Discussing his composition for *Parson Weems' Fable,* Wood said that: "I flopped the tree every conceivable way, unsuccessfully. Then, as a last resort, I tried a drooping effect, and considered it successful." [No author indicated], "Grant Wood, American Artist, Tells Reporter of Regionalism, Hobbies," *Los Angeles Times,* 29 February 1940 [AAA].

274 Aimed directly at: In her similarly Freudian approach to this painting, Sue Taylor notes the artist's "wickedly casting [George Washington] as a castrating son, axe in hand." Taylor, "Wood's American Logic," *Art in America,* p. 90.

275 Beyond these correspondences: Sara writes about her farm in Michigan: "Beside the house, there were twenty-five acres, five of which were a productive asparagus patch, and the rest of it was planted with productive fruit trees, pears, cherries, peaches and such"; SMS, p. 58.

275 Rather than depicting: Washington's boyhood home in Stafford County, Virginia, was the setting for Parson Weems's tale; although the Washingtons' house did not survive into the nineteenth century, the artist would have found ample eighteenth-century sources to draw upon in recreating the structure.

275 "Grant had planned": SMS, p. 117.

275 It was here, too: Wood kept a small studio behind the house at East Court Street that he occasionally used in warm months, but he did most of his work at his university studio. Not only was it unusual for him to have painted inside the house—Sara's absence may have had something to do with this new sense of freedom—but it is also remarkable that no subsequent paintings appear to have been completed here. Garwood, who rarely mentions Wood's studio routines, writes of *Parson Weems'*

Fable: "Grant finished the painting at home rather than at his studio. Dinner guests came out [to the house]. He ate with them, and went back to his painting"; AI, p. 226.

275 If *American Gothic*'s arched: Even the shutters at East Court Street would have borne strong associations for the artist. As the historical marker outside his former home explains, "[Wood] rescued most of the original shutters, which a previous resident had fashioned into chicken coops, and restored them to their present condition."

276 As in dreams, too: The "compression of meaning" Freud indicates in dream analyses is also referred to as "condensation" or "overdetermination"; Sigmund Freud, in A. A. Brill, ed., *The Basic Writings of Sigmund Freud* (New York: Random House, 1995), p. 288.

276 "unconscious symbolism": Anton Ehrenzweig, *The Hidden Order of Art: A Study in the Psychology of Artistic Imagination* (Berkeley: University of California Press, 1967), p. 262.

276 "a model of good conduct": Dennis, *Grant Wood,* p. 113.

276 "a social comment": Dennis, *Renegade Regionalists: The Modern Independence of Grant Wood, Thomas Hart Benton, and John Steuart Curry* (Madison: University of Wisconsin Press, 1998), p. 89.

277 a characterization that: AI, p. 19.

277 Beside the woman: Freud, *Basic Writings,* p. 340. James Dennis notes the curious position of this ladder as well, even if he does not read the composition as subliminally sexual. "Holding a ladder in line with the main thrust [!] of perspective," he writes, "a well-behaved young man helps his mother pick cherries from a healthy tree as storm clouds gather to disrupt their momentary contentment"; Dennis, *Renegade Regionalists,* p. 89.

278 In Renaissance paintings: The Italian Renaissance artist Fra Angelico, who painted numerous well-known versions of the Annunciation, uses this expulsion/visitation strategy in several instances—including, most notably, his 1430 and 1434 *Annunciation*s (in the Prado Museum and the Museo Diocesano, Cortona, respectively). Another important example of this formula may be seen in Giovanni di Paolo's *Annunciation and Expulsion from Paradise* (1435). Whether or not Wood knew these specific works, this use of damnation/redemption foils is widespread enough (and represents a strategy that might have occurred to him independently) that we cannot discount its potential role here.

279 "more a god": RB, frame 175.

279 "scared stiff": Appropriately enough, the sermon that made the greatest impact on Wood was one devoted to the destruction of Sodom and Gomorrah. The artist claims he felt the minister's finger "pointing directly at me!"; RB, frames 225–226.

279 Indeed, Hattie's grave: This gravestone, which stands just behind Hattie's, is that of Lewis and Elizabeth Kinsey (deceased 1887 and 1892, respectively).

280 and also, as Benton: [No author indicated], "Wood Works," *Time,* 22 April 1935, p. 56.

280 a work that Wood: GMC, p. 72.

280 Not only do the form: Henry Adams, "The Truth About Grant Wood," p. 17.

281 "I sat in the grim": RB, frame 224.

281 "Wood's first painting": Sara Sherman: Fragment X, pp. 4–5.

281 "a fit of self-loathing": Ibid.

282 First revealed by Joni Kinsey: I am deeply indebted to Joni L. Kinsey's coverage of this controversy, one that has long been shrouded in confusing or misleading details; Kinsey, "Cultivating Iowa: An Introduction to Grant Wood," in Milosch, ed., *Grant Wood's Studio,* p. 29.

282 Not only did Janson: Ibid., p. 32.

282 Although Wood's involvement: This letter is quoted in full in MB, pp. 168–69.

283 Soon thereafter: Given his immediate (and later) connections to the journalist, it seems likely that Longman provided Welch with the initial tip about Wood; Nan, too, believed he had a part in Welch's appearance. MB, p. 170.

283 "because they all knew": SMS, Divorce fragment, p. 8.

283 "everyone knew" about: When Sean Strub interviewed Elizabeth Catlett in 2002, she explained that among her peers "everyone knew" about Wood's homosexuality. Catlett had her own struggles with Longman, whom she found to be racist as well as homophobic. E-mail communication to the author from Sean Strub (17 April 2010).

284 "so serious that they": Wood to George F. Kay, dean of the College of Liberal Arts, 19 November 1940, Edwin Green Papers, Grant Wood file, University of Iowa Special Collections, cited in Kinsey, "Cultivating Iowa," in Milosch, ed., *Grant Wood's Studio,* p. 131, n. 31.

284 "the Wood problem": In the spring of 1941, Longman wrote to university officials "to provide bases for a fair and workable, a constructive and stable solution of the Wood problem"; Ibid., p. 131, n. 38.

284 "Mr. Wood's personal": Longman to Eleanor Welch, 18 November 1940; "Statement made to *Time* Magazine Upon Request," Edwin Green Papers, cited in Kinsey, "Cultivating Iowa," in Milosch, ed., *Grant Wood's Studio,* p. 131, n. 32.

284 "It was also reported": Notes of a meeting with Virgil Hancher, Park Rinard, and Dan Dutcher, held 7 May 1941 (dated 8 May 1941); Edwin Green Papers, cited in Kinsey, "Cultivating Iowa," in Milosch, ed., *Grant Wood's Studio,* p. 131, n. 33. Nor was the question of Wood's homosexuality Hancher's only concern. In a confidential memo of less than a week earlier (2 May 1941), Hancher wrote: "[Ed] Rowan stated that a report was current that Grant Wood was very rapidly drinking himself to death." Henry Adams first brought this memo to light in his presentation "Grant Wood Revisited," delivered at the "Grant Wood's World" Symposium, University of Iowa, Iowa City (24 April 2010).

284 "My feelings in this": Quoted in GMC, p. 99.

284 "was staying at the Barbazon": MacKinlay Kantor to Mrs. Charles Jerdee, 31 October 1967 [AAA].

285 "five highballs before": AI, p. 215.

285 In an interview with Bill McKim: In an e-mail communication (5 January 2010), Adams described to me "a conversation with Bill McKim, one of Benton's students, who recalled visiting Wood on Mother's Day, the year before he died [May 1941]. At the time, Wood consumed two bottles of scotch in a single afternoon and evening, while Bill drank gin and bitters, until they both finally passed out together on a bed in Wood's bedroom." Adams mentions this incident, as well, in "The Truth About Grant Wood," p. 1.

285 The owner of Iowa City's: When Sean Strub asked Harold Donnelly in the 1970s if he believed Wood had been gay, this was his response. "I don't know if Harold was serious about that," Strub writes, "or if it was just a flip comment." Donnelly's, which closed in 1974, had been a favorite haunt of Wood's. E-mail communication to the author from Sean Strub (17 April 2010).

285 "Do you know what's wrong": Quoted in Adams, *Thomas Hart Benton,* p. 304.

286 "not quite regular": Quoted in Adams, *Thomas Hart Benton,* p. 307.

286 Indeed, as Michael Sherry: For the most complete examination of this topic, see Sherry's excellent study, *Gay Artists in Modern American Culture: An Imagined Conspiracy* (Chapel Hill: University of North Carolina Press, 2007).

286 "We Don't Want These!": The photograph of the students' protest (which Adams illustrates in *Thomas Hart Benton,* p. 308) first appeared in the *Kansas City Star* in May 1941.

286 "Remodeled to Suit": This caricature, by the cartoonist Cal Alley, appeared in the *Kansas City Journal,* 5 May 1941.

286 "Sissies have won over": [No author indicated], "Benton Ousted," *Art Digest,* 15 May 1941 [AAA].

286 "Martin, six-foot, broad-shouldered": Ibid.

287 "the youngish, tough-looking"; [No author or title indicated], *Time,* 23 September 1940 [AAA, reel 1216].

287 Setting up a studio: [No author indicated], "I'm Most Familiar with Iowa Scenery," *Mason City Globe-Gazette,* 1 July 1941 [AAA]. Paul Juhl's *Grant Wood's Clear Lake Summer,* cited previously, provides the most thorough treatment of Wood's time at Clear Lake that summer.

287 When Eric Knight: Juhl, *Grant Wood's Clear Lake Summer,* p. 14.

287 "When Mr. Wood goes": [No author indicated], "I'm Most Familiar with Iowa Scenery," *Mason City Globe-Gazette,* 1 July 1941 [AAA].

288 In addition to Knight: Peter Hoehnle, "Carl Flick and Grant Wood: A Regionalist Friendship in Amana," *Iowa Heritage* 82, no. 1 (Spring 2001), p. 12.

288 Tobacco Road: Juhl indicates the rowboat's name in *Grant Wood's Clear Lake Summer,* p. 24; it is his hunch, as well (communicated in writing to me), that the name is a pun.

288 "Yours till hell": Given the frequency with which this graffito is mentioned, Wood must have pointed it out to his visitors. See MB, p. 172, and AI, p. 239. Garwood mistakenly assumes that Wood himself wrote the phrase; Juhl explains that the studio's graffiti was left by "traveling hobos" (*Grant Wood's Clear Lake Summer,* pp. 21–22).

289 "one of the happiest": [No author indicated], "Spring Brings Memories of Grant Wood to Park Rinard," *Mason City Globe-Gazette,* 26 March 1954 [AAA].

289 In order to please: MB, pp. 170–71.

289 "companion": [No author indicated], "I'm Most Familiar with Iowa Scenery," *Mason City Globe-Gazette,* 1 July 1941 [AAA].

289 Indeed, as Henry Adams: Adams, "The Truth About Grant Wood," p. 3.

289 "Another major problem": MB, p. 171.

289 Plagued by signs: AI, p. 241.

289 In November, exploratory: Sue Taylor has at last put to rest the widely misreported claim that the artist died from liver cancer. "Regarding the artist's final illness," she writes, "it is important to note, according to Randall W. Lengeling (interview with [Taylor], November 14, 2003), that Wood died of pancreatic cancer, which had spread to his liver, not of liver cancer as reported in the literature; the latter implies alcoholism, for which there is no evidence in Wood's case. A letter to Lengeling, dated February 4, 1992, summarizing Wood's medical history, from Lewis January, professor emeritus of medicine at the University of Iowa, is on file among the Wood documents in Special Collections at the University of Iowa Library, Iowa City." Taylor, "Grant Wood's Family Album," *American Art* 19, no. 2 (Summer 2005), p. 67, n. 25. The original location of Wood's cancer appears to have been unknown to Nan herself, who copiously annotated and corrected Garwood's biography, but did not correct his reporting that Wood had died from liver cancer (AI-G, p. 243).

290 "laughed heartily": AI, p. 248.

290 "It was as if he wanted": Benton, "In Defense of Grant Wood's Art," CRG, 23 December 1951 [AAA].

290 "when he got well": Ibid.

290 While visiting Nan: During Wood's lecture trip to California in February 1940, Millard Sheets, head of the art department at Scripps College in Claremont, "said that he wanted [Wood] to teach at Scripps College, and he had almost decided to accept—unless things changed considerably at the University of Iowa"; MB, p. 165.

291 "to be on the lookout": Graham, letter to the editor, *Saturday Evening Post,* 27 October 1965, p. 122 [AAA]. The year before the artist's death, Nan relates, Wood had also asked her to make a pair of "pongee" pajamas for him—his favorite pair, brought to him from "the Orient" by the graduate dean of the University of Iowa, George Stoddard, had begun to wear out; MB, p. 165.

291 More seriously: In addition to sharing this plan with Benton and Nan, cited above and below, respectively, Wood repeated the request to Cone—who noted it in a radio interview on April 17, 1942, two months after the artist's death. Joseph Czestochowski provides a full transcript of this program in *Marvin D. Cone and Grant Wood: An American Tradition* (Cedar Rapids: Cedar Rapids Museum of Art, 1990), pp. 206–09.

291 "have my room made": Graham, *Saturday Evening Post,* 27 October 1965, p. 122 [AAA]; see LSN, p. 120.

292 Indeed, in the artist's: AI, p. 246.

292 His last word: AI, p. 249.

292 Not only had the two: Nan's discussion of Wood's final hours, and of Rinard's intervention in sharing Wood's diagnosis, are found in MB, pp. 179–80.

292 At the artist's graveside: Wood's complete funeral service (held 14 February 1942) is included in Nan's scrapbooks [AAA].

292 Today the work: MB, p. 178.

293 "October days": RB, frame 256.

EPILOGUE

294 "The so-called 'American Scene' ": [No author indicated], "Grant Wood," obituary, *New York Times,* 14 February 1942 [AAA].

295 "feet-on-the-ground"/"authentic"/"orderly": Art Institute of Chicago, *The Fifty-third Annual Exhibition of American Paintings and Sculpture October 29–December 10, 1942* (Art Institute of Chicago, 1942) [AAA].

295 "At rare intervals": Ibid.

295 "the discovery of America": Quoted in GMC, p. 104.

295 "people's artist": [No author indicated], "A People's Artist Passes," DMR, 15 February 1942 [AAA].

295 "legends"/"conflicting stories": Park Rinard's introductory essay, Art Institute of Chicago, *Fifty-third Annual Exhibition* [AAA].

295 "simplicity was not": Ibid.

296 Rinard goes on to catalogue: "Faith is the strength of simple men, and locked deep within him, Grant Wood had faith. He believed . . . in the existence of a power for good and order beyond this life. This faith he painted in his pictures." Ibid.

296 "logical expression"/"factual authenticity": Ibid.

296 Not only did several: In a clipping from Nan's scrapbook identified as a *New York Times* article (14 February 1942), the mysterious "Arline" and her two sons by Wood make their appearance; the day before, the *New York Sun* (13 February 1942) had reported Wood was survived by Sara Wood, "a widow whom he married in 1940" [AAA]. In an otherwise unidentified clipping, in 1944 a St. Louis newspaper printed an image purported to be the work of Grant Wood's son; in her scrapbook, Nan wrote next to this clipping: "Impostor. Grant had no children" [AAA].

296 As if to signal: Nan, who after 1942 worked with Associated American Artists as Wood's representative, notes the revival of *Sultry Night*'s fortunes; MB, p. 141.

296 "When this War is over": Benton, "Death of Grant Wood," Iowa *Demcourier* 12, no. 3 (May 1942), p. 6.

297 "stand like monuments": John Steuart Curry, "Grant," Iowa *Demcourier* 12, no. 3 (May 1942), p. 18.

297 Discrediting his former: H. W. Janson, "The International Aspects of Regionalism," *College Art Journal* 2, no. 4 (May 1943); and Janson, "Benton and Wood, Champions of Regionalism," *Magazine of Art* 39, no. 5 (May 1946).

297 Unable to face: MB, p. 130.

297 Named to a number: For Rowan's biography, see Kristy Raine's Web site "When Tillage Begins: The Stone City Art Colony and School," http://www.mtmercy.edu/busselibrary/schome.html.

297 "general physical failure": Quoted in Henry Adams, *Thomas Hart Benton: An American Original* (New York: Alfred A. Knopf, 1989), p. 322.

297 "Maybe I'd have done": Quoted ibid.

298 As if to confirm: Ad Reinhardt, "How to Look at Modern Art in America," *P.M.* [New York], 2 June 1946, p. 16.

298 Rather fittingly: Coates coined the term in the 30 March 1946 issue of the *New Yorker.*

298 The acknowledged leader: For the fullest exploration to date of the relationship between Benton and Pollock, see Henry Adams, *Tom and Jack: The Intertwined Lives of Thomas Hart Benton and Jackson Pollock* (New York: Bloomsbury Press, 2009).

298 "the greatest living painter": [No author indicated], "Jackson Pollock: Is He the Greatest Living Painter in the United States?" *Life,* 8 August 1949, pp. 42–45.

298 As Frances Stonor Saunders: Frances Stonor Saunders, *Who Paid the Piper: The CIA and the Cultural Cold War* (New York: Granta, 1999).

299 "propagandist"/"unpopular": [No author indicated], "Thomas Craven, Author, Dead: Caustic Art Critic and Lecturer," *New York Times,* 1 March 1969.

299 "it was the untutored": [No author indicated], "Thomas Hart Benton Dies: Painter of American Scene," *New York Times,* 20 January 1975.

299 "dribbling and spattering": H. W. Janson and Anthony Janson, *History of Art* (New York: Harry N. Abrams, 1986), p. 696.

300 In a strange twist: For Pyle's full biography, see Kristy Raine's Web site "When Tillage Begins," http://www.mtmercy.edu/busselibrary/schome.html. Wood scholar James Dennis, a passenger in Pyle's car that night, survived.

300 "I have reacted": MB, p. 184. Nan was extraordinarily sensitive to any suggestion that Wood might have been affected; indeed, in one of her scrapbooks, next to a critic's assessment of Wood's presumed artistic temperament, Nan felt compelled to write in the margin "*not* artistic." In a 1957 interview, she said that her brother was "a neat man, but not 'sissified' "; see Irene Monroe, "Most Famous Grant Wood Painting Was Never Painted," *Davenport Democrat-Times,* 3 February 1957 [AAA].

300 "sissy": The following exchanges appear in the transcript of John Zug's interview with Nan Wood Graham, conducted 16 June 1976 (State Historical Society of Iowa, Special Collections):

> Zug: Was Grant a sissy as told in the other book?
> Graham: [That was] nastiness on Garwood's part. There was nothing sissy about Grant Wood whatsoever.
> [pp. 29–30]
> Zug: Is it true he had no interest in girls?
> Graham: Not true at ALL!
> [p. 39]

300 Not only did Nan: Both Cole Porter and Charles Vanderbilt Whitney wrote Nan in 1944, granting her request to bar Garwood from reproducing the Wood paintings they owned [AAA]. When Hazel Brown wrote her 1972 memoir about Cone and Wood, Nan similarly sued Brown's publisher, the Iowa State University Press, for using illustrations of Wood's work without permission. Nan was paid $1,500 in damages, and the publisher had to pull the illustrations from subsequent editions of the book; LSN, p. 59.

300 "I hope you do not": Nan's letter to Frank Paluka, who had written her for permission to quote Wood, 13 June 1965 [AAA].

300 "mincing": AI, p. 72.

301 In her reactions: Nan's characterizations may be partly understood (if not excused) given the 1944 date, and considering her extraordinary sensitivity to questions about her brother's sexuality. According to both John Fitzpatrick and Sean Strub, openly gay men who knew Nan beginning in the 1970s, Nan later welcomed friendships with gay men and even, according to Strub, "sort of prided herself on accepting gay people." Interview with John Fitzpatrick, Iowa City (25 April 2010); and e-mail communication to the author from Sean Strub (17 April 2010).

301 "nasty," "dirty": AI-G, pp. 22, 91, and 119.

301 "just wasn't interested": AI, p. 91.

301 "an evil mind": AI-G, endpapers. Nan, who was furious with Vida for cooperating with Garwood, makes a litany of disparaging remarks about her in these annotations—about everything from her looks to her cooking to her mistreatment of animals; it was only after Paul's death in 1968 that Nan offered her an olive branch. "Many years have passed and a lot of water has passed under the bridge," she wrote to Vida, "and I guess it is time to bury the hatchet." Letter from Nan Wood Graham to Vida Hanson (2 June 1968) in Don Hanson file, Cedar Rapids Museum of Art.

301 "No insight is shown": Paul Engle, "Biography of Grant Wood Is in a Chummy, Tasteless Vein," *Chicago Sunday Tribune,* 3 December 1944.

301 "didn't want my name": LSN, pp. 108–9.

301 Indeed, by this date: Ibid.

301 Twelve years later: LSN, p. 109.

301 Still fearful: LSN, p. 136.

301 After selling Wood's: [No author indicated], "Grant Wood's Home Sold; Sister to Reproduce It," CRG, 19 October 1942 [AAA].

301 Although this plan never: Ibid.

302 "Caricaturing her brother's": Dorothy Dougherty, " 'Sister Nan' Adds Dash of Humor to the Grant Wood Art Tradition," CRG, 20 September 1942 [AAA].

303 "I was recognized": MB, p. 76.

303 "I never dreamed": LSN, p. 108. In January 1968, Nan was named honorary director at the Movieland Wax Museum [AAA].

303 The fashion editor: MB, p. 77.

303 *To Tell the Truth:* LSN, p. 108.

303 Indeed, as late: LSN, p. 133.

303 Nan seems to have: Nan sold *Portrait of Nan* to the Encyclopaedia Britannica Collection in 1945; Marcia Winn, "Front Views and Profiles," *Art Digest,* 1 January 1945 [AAA]. The 1964 sale to the Davenport Municipal Art Gallery (today the Figge Art Museum) is treated in LSN, pp. 13, 105; the purchase included a staggering 381 works of art and all of the artist's remaining personal possessions. Nan, it seems, had had little choice but to sell the works. As she wrote to Ed Green in June 1969, "Money

from selling the collection to Davenport is a godsend to me now, for, no doubt, I would have had to work at my age"; LSN, p. 108.

304 "really become me": LSN, p. 13.

304 Beginning in the late: In 1967 alone, Nan sued Johnny Carson, NBC, and *Look* and *Playboy* magazines (the suits were settled out of court for an undisclosed amount); LSN, p. 13. A decade later, she sued Larry Flynt's *Hustler* magazine, but the case was dismissed. Steven Biel covers these suits in detail in *American Gothic: A Life of America's Most Famous Painting* (New York: W. W. Norton, 2005), pp. 152–55.

304 "who was very moral": LSN, p. 58.

305 "[held] her up to ridicule": LSN, p. 57.

305 "if some people really": LSN, p. 58.

305 In one of the last: This framed newspaper clipping, a gift to the author from Katherine Conway, was found in a New England thrift store along with (appropriately enough) a collection of *American Gothic* parodies. The printed source for this 1987 clipping is unknown, but the caption below Nan's photograph reads:

> Famous Face: Nan Wood Graham, 88, sister of artist Grant Wood, was 30 when she posed in Eldon, Iowa with the Woods' family dentist for *American Gothic*. The painting angered many Iowa farmers. 'They said if farmers really looked like that, they better take to bootlegging,' she recalled Monday. Graham, now blind, lives in Menlo Park, California.

Nan was then living at the LeHavre Convalescent Hospital in Menlo Park. LSN, p. 14.

305 "Grant made a personality": [No author indicated], "Nan W. Graham, 91, Model for Daughter in 'Gothic,' Is Dead," *New York Times,* 17 December 1990.

305 whereas the gravesite: In Nan's will she left two cemetery lots to Ed's son from his first marriage. Ed himself was buried in one of these; yet Nan suggested to Ed's son that he sell both lots, disinter Ed, and rebury him next to his first wife; LSN, p. 132. I have been unable to determine if he did so—or, indeed, to discover the location of the plots in question.

305 Appropriately enough: LSN, p. 87.

306 "If [this retrospective]": Hilton Kramer, "The Return of the Nativist," *New Criterion* 2, no. 2 (October 1983), p. 63.

306 "If you thought you knew": The Cedar Rapids Art Museum's press release for *Grant Wood at 5 Turner Alley* is quoted here from the online Resource Library, operated by the Traditional Fine Arts Organization, www.tfaoi.com.

306 "vision of the values": The museum's press release reads:

> Wood is the quintessential painter of America in the twentieth century, as the Smithsonian is the quintessential American museum [Grant Wood at Turner Alley later traveled to the Smithsonian's Renwick Gallery.] In the period between the World Wars, American artists discovered their most important subject was America itself. No artist is a better example of this than Grant Wood. Wood had a vision of the values that made this country great and he poured this vision directly into the pieces he created from 1928 to 1942. (Resource Library, www.tfaoi.com)

306 Trains still rattle: Nan mentions the trains and church bells, as well as the smell of toasted oats; MB, p. 54.

307 More than doubled: As of the 2000 census, Cedar Rapids had a population of over 120,000; a century earlier, the population was estimated at 55,000.

307 "Wood's legacy": See the official Web site for the Grant Wood Art Festival: www.grantwoodartfestival.anamosachamber.org.

308 As late as 1967: LSN, p. 108.

308 "It didn't seem like": AI, p. 206.

308 Instead, Rinard chose: I have drawn most of the details of Rinard's post-1942 life and career from his congressional memorial service.

309 "Park was so completely": *Congressional Record*, 5 December 2000, p. S11557; http://thomas.loc.gov/cgi-bin/query/R?r106:FLD001:S61556.

309 "the intellectual godfather": Ibid.

309 "spoke passionately about": Ibid., pp. S11556, S11557.

309 "candidate for a wheel chair": SMS, p. 120.

309 "to take a tin cup": SMS, Front and Back Door fragment, p. 2. Accounts vary on the support Sara received from Wood following their separation. Sara claims she was forced to borrow $100 from George Stoddard, a friend in Iowa City, to cover her travel expenses to New York (SMS, p. 119); she would not have sought domestic work that winter, it seems, had Wood been providing ongoing support. Upon the couple's divorce in September 1939, Sara was awarded $5,000—an amount that may have allowed her to leave her Michigan employer [AAA].

310 "We drove to the home": SMS, Front and Back Door fragment, p. 3.

310 "I was about to learn": SMS, p. 124.

310 In spite of the ninety-five: SMS, Divorce fragment, p. 6.

310 Ironically, she ended: Ibid.

310 "Alice in Wonderland"/"enjoyed"/"sweet": SMS, Alice Rheem fragment, p. 2.

310 "I shall never": SMS, Alice Rheem fragment, p. 3.

311 "Glad she didn't": This 1969 letter appears in LSN, p. 108. Nan mentions the article with more specificity (MB, p. 152), naming the author (Don Duncan) and source (*Seattle Times*). Among Sara's papers is an otherwise undated/unidentified article from 1969 by Don Duncan, entitled "Orcas Island Calm Shelters One Who Knows Art of Life."

311 "That was her whole": Julie Muhlstein, "Essence of a Life Well Lived Fits Neatly in Basket," *Everett Herald,* 6 May 2001, p. B2.

311 "the Grant Wood episode": Quoted in Duncan, "Orcas Island Calm," *Seattle Times,* 1969.

311 "The odd thing is": Sara Sherman: Fragment X, pp. 1–2.

312 "war within the individual": SMS, p. 86.

312 As Michael Sherry has demonstrated: For more on this period, see Sherry's excellent *Gay Artists in Modern American Culture: An Imagined Conspiracy* (Chapel Hill: University of North Carolina Press, 2007).

312 In the homoerotic magazine: Ibid., pp. 30–31.

312 "closeted homosexual": "Far from being a sturdy son of the soil," Hughes writes, "Wood was a timid and deeply closeted homosexual"; Robert Hughes, *American Visions: The Epic History of Art in America* (New York: Alfred A. Knopf, 1997), p. 439.

313 "widely known in the literature": John Seery, "Grant Wood's Political Gothic," *Theory and Event* 2, no. 1 (1998), p. 11.

[SELECTED BIBLIOGRAPHY]

A Note on Primary Sources

THE PRIMARY DOCUMENTS for this study stem from three principal sources: Grant Wood's unpublished autobiography, *Return from Bohemia: A Painter's Story;* the copious scrapbooks that his sister, Nan Wood Graham, maintained; and the unpublished writings of Wood's ex-wife, whose full maiden name was Sara McClain Sherman (by way of her marriages, she was also known as Sara Sherman Maxon and Sara Wood).

The manuscript for *Return from Bohemia* is housed on microfilm at the Smithsonian Institution's Archives of American Art (reel D24, frames 161–295). Although this signed, undated document bears Wood's name alone (and is annotated in his own hand), the work was ghostwritten by his secretary, Park Rinard, and is virtually identical to Rinard's master's thesis, "Return from Bohemia: A Painter's Story, Part I," housed at the University of Iowa. I have used the Smithsonian version in my text, citing the Archives of American Art (AAA) and relevant frame numbers.

Nan Wood Graham's scrapbooks, also preserved on microfilm at the Archives of American Art, are an invaluable resource for letters, newspaper clippings, and other printed ephemera concerning Wood's life and work. Far too numerous to list here, the material from these scrapbooks is cited in the notes with its original source (wherever possible) and accompanied by the abbreviation "AAA." The scrapbooks appear on a single microfilm reel [#1216], yet the frame numbers of this reel repeat, and are in some cases illegible; for this reason, I have not indicated frame numbers in my notes. Sources may be found in roughly chronological order in Nan's six scrapbooks, which cover the period 1900–1975.

Nan's annotated copy of Darrell Garwood's *Artist in Iowa: A Life of Grant Wood* (New York: W. W. Norton and Co., 1944), constitutes another valuable document for Wood scholars. Preserved in the Special Collections of the State Historical Society of Iowa, it is thick with editorial comments and pasted-in notes that not only correct details in Garwood's biography, but also (in some cases) provide entirely new information. This document also tells us a great deal about Nan herself—whose comments, directed toward Garwood and several of Wood's contemporaries, often display a juvenile mean-spiritedness.

Upon her death in 1979, Sara Sherman left her unpublished writings and family genealogy to her executor, Ed Bartholomew, of Orcas Island and Marysville, Washington. Bartholomew's daughter, Donna Clausen, has ordered these documents (with the exception of the genealogy) by item number, referred to here as "DC Item #1," "DC Item #2," etc. For the sake of clarity, I have also given them descriptive titles.

I. *Sara McClain Sherman Autobiography (DC Item #1);* 125 pages; typed/annotated (signed "written by Sara Sherman"); undated, but apparently written some time in the late 1950s or early 1960s. Included with the autobiography are five related fragments, which constitute additions to, or revisions of, the larger manuscript:

I.a: *Early Years Fragment (DC Item #10);* six pages (first page missing); typed/undated; corresponds to manuscript pp. 15–23 and 46–49.

I.b: *Park Rinard fragment (DC Item #8);* three pages; typed/undated; corresponds to manuscript pp. 109–111.

I.c: *Divorce fragment (DC Item #9);* seven pages (first page missing); typed/undated; corresponds to manuscript pp. 113–119.

I.d: *Front and Back Door fragment (DC Item #6);* seven pages; typed/undated.

I.e: *Alice Rheem fragment (DC Item #2);* six pages (first page missing); typed/undated.

II. *Sara Sherman Autobiography: Outline* (DC Item #3); 13 pages; typed/handwritten; undated.

III. *Sara Sherman: Fragment X* (DC Item #4); 5 pages; typed; written in 1959.

IV. *Sherman Family Genealogy;* 84 pages; typed and undated; written by Sara's father, Henry David Sherman, who died in 1917; revised/expanded by her sister Edith Sherman Averill in 1936.

Adams, Henry. *Eakins Revealed: The Secret Life of an American Artist.* New York: Oxford University Press, 2005.

———. "Grant Wood Revisited," delivered at the "Grant Wood's World" Symposium, University of Iowa, Iowa City (24 April 2010).

———. *Thomas Hart Benton: An American Original.* New York: Alfred A. Knopf, 1989.

———. *Tom and Jack: The Intertwined Lives of Thomas Hart Benton and Jackson Pollock.* New York: Bloomsbury Press, 2009.

———. "The Truth About Grant Wood." Delivered at the annual meeting of the College Art Association, 24 February 2000. Session title: "Regionalist Practices on the Margins of Queer Culture," chaired by Michael Plante of Tulane University.

Adams, Laurie Schneider. *Art and Psychoanalysis.* New York: HarperCollins, 1993.

Adler, Kathleen, and Marcia Pointon, eds. *The Body Imaged: The Human Form in Visual Culture Since the Renaissance.* Cambridge: Cambridge University Press, 1993.

Almansi, Renato. "The Face-Breast Equation." *Journal of the American Psychoanalytic Association* 8 (1951).

Alpers, Svetlana. *The Art of Describing: Dutch Art of the Seventeenth Century.* Chicago: University of Chicago Press, 1983.

Art Institute of Chicago. *The Fifty-third Annual Exhibition of American Paintings and Sculpture, October 29–December 10, 1942.* Chicago: Art Institute of Chicago, 1942.

Axelrod, Alan, ed. *The Colonial Revival in America.* New York: W. W. Norton and Co., 1985.

Baigell, Matthew. "Grant Wood Revisited." *Art Journal* 26, no. (Winter 1966–67).

Bennett, Mary. Interview with Ruth McCuskey Weller, 1 September 1993. State Historical Society of Iowa, Special Collections.

Benton, Thomas Hart. *An Artist in America.* Columbia: University of Missouri Press, 1937.

———. "Death of Grant Wood." Iowa *Demcourier* 12, no. 3 (May 1942).

Berger, Martin. *Man Made: Thomas Eakins and the Construction of Gilded Age Masculinity.* (Berkeley: University of California Press, 2000).

Bergman, David, ed. *Camp Grounds: Style and Homosexuality.* Amherst: University of Massachusetts Press, 1993.

Bettelheim, Bruno. *The Uses of Enchantment: The Meaning and Importance of Fairy Tales.* New York: Alfred A. Knopf, 1976.

Biel, Steven. *American Gothic: A Life of America's Most Famous Painting.* New York: W. W. Norton and Co., 2005.

Broude, Norma, and Mary Garrard, eds. *Feminism and Art History: Questioning the Litany.* New York: Westview Press, 1983.

―――, eds. *Reclaiming Female Agency: Feminist Art History After Postmodernism.* Berkeley: University of California Press, 2005.

Brown, Hazel. *Grant Wood and Marvin Cone: Artists of an Era.* Ames: Iowa State University Press, 1972.

Bulfinch, Thomas. *Bulfinch's Mythology.* New York: Crown Publishers, 1979.

Chauncey, George. *Gay New York: Gender, Urban Culture, and the Making of the Gay Male World, 1890–1940.* New York: HarperCollins, 1994.

Cohen-Solal, Annie. *Painting American: The Rise of American Artists, Paris 1867–New York 1948.* New York: Alfred A. Knopf, 2001.

Comics Curmudgeon, The. "Grant Wood's Body Lies A-Mouldering in the Grave." Wonkette.com, 10 April 2009.

Congressional Record, 5 December 2000, http://thomas.loc.gov/cgibin/query/R?r106 :FLD001.

Corn, Wanda M. *Grant Wood: The Regionalist Vision.* New Haven: Yale University Press, 1983.

Craven, Thomas. *Men of Art.* New York: Simon and Schuster, 1931.

―――. *Modern Art: The Men, the Movements, the Meaning.* New York: Simon and Schuster, 1934, revised and expanded, 1940.

―――. "*Scribner's* Examines: Grant Wood," *Scribner's* 101, no. 6 (June 1937).

―――. *Thomas Hart Benton: A Descriptive Catalogue.* New York: Associated American Artists, 1939.

Crisp, Quentin. *The Naked Civil Servant.* London: Jonathan Cape, 1968.

Curry, John Steuart. "Grant." Iowa *Demcourier* 12, no. 3 (May 1942).

Czestochowski Joseph S. *John Steuart Curry and Grant Wood: A Portrait of Rural America.* Columbia: University of Missouri Press, 1981.

―――. *Marvin D. Cone and Grant Wood: An American Tradition.* Cedar Rapids: Cedar Rapids Museum of Art, 1990.

Davenport, Guy. *The Geography of the Imagination: Forty Essays by Guy Davenport.* San Francisco: North Point Press, 1981.

Davis, Whitney. "Erotic Revision in Thomas Eakins's Narratives of Male Nudity." *Art History* 17, no. 3 (September 1994).

Deitcher, David. *Dear Friends: Photographs of Men Together, 1840–1918.* New York: Harry N. Abrams, 2001.

DeLong, Lea Rosson. "Drawing and *Main Street,*" delivered at the "Grant Wood's World" Symposium, University of Iowa, Iowa City (24 April 2010).

―――. *Grant Wood's Main Street: Art, Literature, and the American Midwest.* Ames: University Museums, Iowa State University, 2004.

Dennis, James M. *Grant Wood: A Study in American Art and Culture.* New York: Viking Press, 1975.

―――. *Renegade Regionalists: The Modern Independence of Grant Wood, Thomas Hart Benton, and John Steuart Curry.* Madison: University of Wisconsin Press, 1998.

Duncan, Don. "Orcas Island Calm Shelters One Who Knows Art of Life." *Seattle Times* (undated; Sara McClain Sherman papers, possibly 1969).

Ehrenzweig, Anton. *The Hidden Order of Art: A Study in the Psychology of Artistic Imagination.* Berkeley: University of California Press, 1967.

Elkins, James. *The Object Stares Back: On the Nature of Seeing.* New York: Simon and Schuster, 1996.

Evans, R. Tripp. "A Profitable Partnership." *Chicago History* 24, no. 2 (summer 1995).

Fisher, Vardis. *In Tragic Life.* New York: Doubleday, Doran and Co., 1932.

Flora, Joseph M. *Vardis Fisher.* New York: Twayne Publishers, 1965.

Forbes, Watson. "The Phenomenal Professor Wood." *American Magazine of Art* 38, no. 5 (1935).

Foucault, Michel. *History of Sexuality,* vol.1. New York: Pantheon Books, 1976.

Frank, Thomas. *What's the Matter with Kansas? How Conservatives Won the Heart of America.* New York: Metropolitan Books, 2004.

Freud, Sigmund (A.A. Brill, ed.). *The Basic Writings of Sigmund Freud.* New York: Random House, 1995.

Fussell, Betty. *The Story of Corn: The Myths and History, the Culture and Agriculture, the Art and Science of America's Quintessential Crop.* New York: Alfred A. Knopf, 1992.

Garwood, Darrell. *Artist in Iowa: A Life of Grant Wood.* New York: W. W. Norton, 1944.

Graham, Nan Wood, with John Zug and Julie Jensen McDonald. *My Brother, Grant Wood.* Iowa City: State Historical Society of Iowa, 1993.

Grant, Michael, and John Hazel. *Who's Who in Classical Mythology.* London: Weidenfeld and Nicolson, 1973.

Halperin, David. *One Hundred Years of Homosexuality and Other Essays on Greek Love.* New York: Routledge, 1990.

Hardeman, Nicholas P. *Shucks, Shocks, and Hominy Blocks: Corn as a Way of Life in Pioneer America.* Baton Rouge: Louisiana State University Press, 1981.

Haskell, Barbara, ed. *The American Century: Art and Culture, 1900–1950.* New York: Whitney Museum of Art, 1999.

Hinshaw, David. *Herbert Hoover: American Quaker.* New York: Farrar, Straus, and Co., 1950.

Hoehnle, Peter. "Carl Flick and Grant Wood: A Regionalist Friendship in Amana." *Iowa Heritage* 82, no. 1 (Spring 2001).

Hoving, Thomas. *American Gothic: The Biography of Grant Wood's Masterpiece.* New York: Penguin Group, 2005.

———. "Judging Great Art by Both Instinct and Intellect." *Providence Journal,* 17 June 2005.

Hughes, Robert. *American Visions: The Epic History of Art in America.* New York: Alfred A. Knopf, 1997.

Isherwood, Christopher. *Christopher and His Kind, 1929–1930.* New York: Farrar, Straus, and Giroux, 1976.

———. *The World in the Evening.* New York: Avon, 1956.

Janson, H. W. "Benton and Wood, Champions of Regionalism." *Magazine of Art* 39, no. 5 (May 1946).

———. "The Case of the Naked Chicken." *College Art Journal* 15, no. 2 (winter 1955–56).

———. "The International Aspects of Regionalism." *College Art Journal* 2, no. 4 (May 1943).

Janson, H. W., and Anthony Janson. *History of Art.* New York: Harry N. Abrams, 1986.

Juhl, Paul C. *Grant Wood's Clear Lake Summer.* Iowa City: Brushy Creek Publishing, 2007.

Junker, Patricia, ed. *John Steuart Curry: Inventing the Middle West.* New York: Hudson Hills Press, 1998.

Kantor, MacKinlay. *I Love You, Irene.* Garden City: Doubleday and Company, 1972.

Kendall, M. Sue. *A Guide to the Collection of Regionalist Art at the Davenport Museum of Art.* Davenport: Davenport Museum of Art, 1993.

Kimmel, Michael. *Manhood in America: A Cultural History.* New York: The Free Press, 1996.

King, Richard Alan. *1142: The History and Growth of the N. Oakes—Grant Wood—Dr. Pauline Moore—James P. Hayes House.* Hiawatha, Iowa: Cedar Graphics, 2008.

Kirstein, Lincoln. "An Iowa Memling." *Art Front,* July 1935.

Kramer, Hilton. "The Return of the Nativist." *New Criterion* 2, no. 2 (October 1983).

Landau, Diana. *Iowa: The Spirit of America.* New York: Harry N. Abrams, 1998.

Leet, Richard. "Charles Atherton Cumming: A Deep Root for Iowa Art." *American Art Review* 9, no. 2 (March–April 1997).

Longfellow, Henry Wadsworth. *Tales of a Wayside Inn.* London: Bell and Daldy, 1867.

Lubin, David. *Act of Portrayal: Eakins, Sargent and James.* New Haven: Yale University Press, 1985.

Marling, Karal Ann. "Don't Knock Wood." *ARTnews* 82, no. 7 (September 1983).

Marshall, Nancy. "Purity or Parody? Grant Wood's *American Gothic*" [unpublished manuscript].

McDonald, Julie Jensen, ed. *Grant Wood and Little Sister Nan: Essays and Remembrances.* Iowa City: Penfield Press, 2000.

Meyer, Richard. *Outlaw Representation: Censorship and Homosexuality in Twentieth-Century American Art.* Boston: Beacon Press, 2002.

Milosch, Jane C. "*American Gothic*'s Munich Connection: A Window into Grant Wood's Regionalism." In Christian Fuhrmeister, Hubertus Kohle, and Veerle Thielemans, eds. *American Artists in Munich: Artistic Migration and Cultural Exchange Processes.* Munich: Deutscher Kunstverlag, 2010.

Milosch, Jane C., ed. *Grant Wood's Studio: Birthplace of American Gothic.* New York: Prestel, 2005.

Miller, Dorothy C., and Alfred H. Barr, Jr. *American Realists and Magic Realists.* New York: Museum of Modern Art, 1943.

Miller, Neil. *Out of the Past: Gay and Lesbian History from 1869 to the Present.* New York: Random House, 1995.

Miller, Richard. *Bohemia: The Protoculture Then and Now.* Chicago: Nelson-Hall, 1977.

Morris, William. "A Factory As It Might Be." *Justice,* 17 November 1884.

Muhlstein, Julie. "Essence of a Life Well Lived Fits Neatly in Basket." *Everett Herald,* 6 May 2001.

Paglia, Camille. *Sexual Personae: Art and Decadence from Nefertiti to Emily Dickinson.* New Haven: Yale University Press, 1990.

Pyke, Rafford. "What Men Like in Men." *Cosmopolitan* 33, no. 4 (August 1902).

Pollett, Joseph. "Roughnecks." *Art Digest* 4, no. 11 (1931).

Posner, Daniel. "Caravaggio's Homo-erotic Early Works." *Art Quarterly* 34, no. 3 (1971).

Quastler, I. E., and Jules A. Bourquin. *Rock Island in Focus: The Railroad Photographs (1898–1975) of Jules A. Bourquin.* Dallas: De Golyer Library, 2007.

Raine, Kristy. "When Tillage Begins: The Stone City Art Colony and School." http://www.mtmercy.edu/busselibrary/schome.html.

Reinhardt, Ad. "How to Look at Modern Art in America." *P.M.* [New York], 2 June 1946.

Roberts, Brady, James Dennis, James Horns, and Helen Parkin. *Grant Wood: An American Master Revealed.* San Francisco: Pomegranate Books, 1995.

Rogers, Marion Elizabeth, ed. *The Impossible H. L. Mencken: A Selection of His Best Newspaper Stories.* New York: Doubleday, 1991.

Roth, Michael S., ed. *Rediscovering History: Culture, Politics and the Psyche.* Stanford: Stanford University Press, 1994.

Rotundo, E. Anthony. *American Manhood: Transformations in Masculinity from the Revolution to the Modern Era.* New York: Basic Books, 1993.

Saunders, Frances Stonor. *Who Paid the Piper: The CIA and the Cultural Cold War.* New York: Granta, 1999.

Schneider, Laurie. "Ms. Medusa: Transformations of a Bisexual Image." *Psychoanalytic Study of Society* 9 (1981).

Sedgwick, Eve Kosofsky. *Between Men: English Literature and Male Homosocial Desire.* New York: Columbia University Press, 1985.

———. *Epistemology of the Closet.* Berkeley: University of California Press, 1990.

Seery, John. "Grant Wood's Political Gothic." *Theory and Event* 2, no. 1 (1998).

Shaw, George Bernard. *Androcles and the Lion.* London: Constable and Co., Ltd., 1916.

Sherry, Michael S. *Gay Artists in Modern American Culture: An Imagined Conspiracy.* Chapel Hill: University of North Carolina Press, 2007.

Shirer, William L. *Twentieth-Century Journey: A Memoir of a Life and the Times: The Start, 1904–1930.* New York: Simon and Schuster, 1976.

Sigmund, Jay. *Land o' Maize Folk.* New York: James T. White and Co., 1924.

Stein, Gertrude. *Four in America.* New Haven: Yale University Press, 1947.

Stong, Phil. *Hawkeyes: A Biography of the State of Iowa.* Iowa City: Dodd, Mead and Co., 1940.

Taylor, Sue. "Grant Wood: A Brilliant Subterfuge," delivered at the "Grant Wood's World" Symposium, University of Iowa, Iowa City (24 April 2010).

———. "Grant Wood's Family Album." *American Art* 19, no. 2 (Summer 2005).

———. "Wood's American Logic." *Art in America* (January 2006).

Thoma, Margaret. "The Art of Grant Wood." Iowa *Demcourier* 12, no. 3 (May 1942).

Turley, Jonathan. "Do We Really Need a Federal Marriage Amendment?" *Jewish World Review,* online op-ed, 23 May 2002.

Twain, Mark. *The Adventures of Huckleberry Finn (Tom Sawyer's Comrade).* New York: Harper and Brothers, 1888.

Vowell, Sarah. "Grant Wood's *American Gothic* Comes in Third at a Chicago Art Institute Exhibit." In Greil Marcus and Werner Sollors, eds. *A New Literary History of America.* Cambridge: Harvard University Press, 2009.

Waugh, Thomas. *Hard to Imagine: Gay Male Eroticism in Photography and Film From Their Beginnings to Stonewall.* New York: Columbia University Press, 1996.

Weems, Mason Locke. *A History of the Life and Death, Virtues and Exploits of General George Washington.* Philadelphia: J. B. Lippincott Co., 1918.

Weinberg, Jonathan. *Male Desire: The Homoerotic in American Art.* New York: Harry Abrams, 2004.

———. *Speaking for Vice: Homosexuality in the Art of Charles Demuth, Marsden Hartley, and the First American Avant-Garde.* New Haven: Yale University Press, 1993.

Wheeler, Patricia. *"My Roots are in This Soil": A Guide to Herbert Hoover National Historic Site.* Cincinnati: The Creative Company, 1993.

Willy (pseudonym of Henri Gauthier-Villars). *The Third Sex.* Urbana: University of Illinois Press, 2007 [reprint/translation of *Troisième Sexe,* 1927].

Wood, Grant, with Park Rinard. *Return from Bohemia: A Painter's Story.* Washington: Archives of American Art, n.d. . Reel D24, frames 161–295; see "A Note on Primary Sources," above.

Wooden, H.E. "Grant Wood: A Regionalist Interpretation of the Four Seasons." *American Artist* 55, issue 588 (July 1991).

Zug, John. Interview with Nan Wood Graham, 16 June 1976. State Historical Society of Iowa, Special Collections.

Zug, John, ed. *This is Grant Wood Country.* Davenport: Davenport Municipal Art Gallery, 1977.

[INDEX]

Page numbers in *italics* refer to illustrations.

Abstract Expressionism, 298–9
Académie Julian, 31, 49, 72–3, 331*n*
Action Painting, 163–4, 299
Adams, Henry, 181, 183, 242, 256–7, 281, 285,
 289, 316, 350*n*, 360*n*, 363*n*, 368*n*, 371*n*
Adams, Laurie Schneider, 101, 341*n*
Adolescence (color plate 26), 123, 280–2,
 340*n*
Adoration of the Home (color plate 2), 36–7,
 50–3, 63, 66, 85, 362*n*
Adventures of Huckleberry Finn, The (Mark
 Twain), 190
Aesthetic Movement, 25, 115, 179–80, 186,
 224, 227; *see also* Whistler, James McNeill;
 Wilde, Oscar
Albuquerque, New Mexico, 195, 198, 205
Allen, Mary Cecil, 124, 340*n*
Alpers, Svetlana, 65
Alte Pinakothek (Munich), 67–8, 79, 81, 83,
 85, 105, 278, 33*n*; *see also* Wood, Grant:
 and Munich
Amana colonies, 109–110, 358*n*
American art, 7, 9, 25–6, 43, 93, 104–5,
 120–2, 129–30, 132, 143, 167–9, 176–7,
 179–80, 183–5, 188, 194–5, 219, 232–5,
 242–6, 267, 271–2, 285, 298–9, 306, 373*n*;
 individual artists and movements
American Gothic (color plate 7), 5, 8, 68, 87,
 90–107, *99*, 110, 116–17, 119–22, 124,
 126–8, 139, 142, 156, 158, 195, 230, 246,
 257–8, 274–5, 280, 294–5, 300, 302–6, *302*,
 304, 313, 336*n*, 344*n*, 355*n*; cameo featured
 in, 81, 83, 86–87, *87*, 95, 100, 119, 126, 207,
 263, 303, 332*n*, 354*n*; critical reception of,
 5, 90, 93, 97–8, 100, 101, 102–7, 131, 156–7,
 161, 337*n*; parodies/reproductions of, 5–6,
 9, 302–5, *304*, 307, 315, 320*n*, 373*n*;
 relationship of two figures, 5, 91–2, 97–8,
 102, 106, 336*n*; unsettling effect of, 5, 91–2,
 95–6, 121, 138, 146, 156, 212, 230, 231–2,
 307; *see also* Eldon, Iowa
American Legion, 346*n*
American Magazine of Art, 173, 194
American Revolution, 9, 66, 143–44, 156–8,
 267, 272

American-scene, *see* regionalism; Wood,
 Grant: and regionalism
Ames, Iowa, 165
Anamosa Eureka, 19, 21
Anamosa, Iowa, 11, 17–19, 21–3, 45, 54, 77,
 81, 92, 94–5, 100, 148, 169, 176, 200, 210,
 237, 246, 292, 300, 307, 351*n*; *see also*
 Grant Wood Art Festival; Riverside
 Cemetery; Wood, Grant: childhood in
 Anamosa; Wood, Grant: family farm
Anderson, B. B., 32
Androcles and the Lion (George Bernard
 Shaw), 261, 364*n*
Angelico, Fra, 173, 349*n*, 367*n*
Antioch County School, 23, 145–6, 156
anti-Semitism, 179
Antwerp, Belgium, 68
Appraisal (color plate 13), 139–142, *141*, 157–9,
 226, 274, 338*n*, 344*n*
Arbor Day, 9, 156, 246
Aristogeiton, 252, *253*
Armory show, 167–8, 177
Armstrong, Rolf, 48
Arnold Comes of Age (color plate 11), 11–113,
 115–16, 248, 278, 280, 342*n*
Arnolfini Marriage, The (Jan van Eyck), 92
*Arrangement in Grey and Black, No. 1:
 Portrait of the Artist's Mother* (James
 McNeill Whistler), 81
Art Front (magazine), 122
Art Institute of Chicago, 31–3, 43, 90, 102,
 104–5, 131, 136, 138, 180, 186, 294–6, *302*,
 303, 324*n*, 325*n*, 342*n*
Artist in America, An (Thomas Hart
 Benton), 234
Artist in His Museum, The (Charles Willson
 Peale), 267–8, *268*
Artist in Iowa (Darrell Garwood), 36, 300–1,
 340*n*, 375
Arts and Crafts Movement, 28–31, 91, 94,
 331*n*; *see also* Kalo Art Craft Community;
 Wood, Grant: and craft; *individual
 practitioners*
Associated American Artists, 244–6, 262,
 266, 269, 289, 296, 361*n*; *see also* Wood,
 Grant: and prints
Aunt Sallie, *see* Wood, Sallie

Aunt Tillie, *see* Peet, Matilda
Averill, Edith (*née* Sherman), 201, 353*n*, 376

Babbitt (Sinclair Lewis), 9, 45
Baigell, Matthew, 336*n*
Banana Oil Art Research Society, 150, 189, 345*n*
Baptism in Kansas (John Steuart Curry), 161, 168
Barnum, P. T., 118
Barr, Alfred, 105
Bartholomew, Ed, 311, 316, 352*n*, 357*n*, 375
Bartlett, Larry, 94
Barton, Ralph, 180–1
Bastille Day (Providence), 315
Batchelder, Ernest A., 28–31, 41, 326*n*
Bath: 1880, The, 249–50
beards/mustaches, *see* Wood, Grant: beard; Wood, Grant: beards/mustaches in work of
Beardsley, Aubrey, 186
Beaux Arts ball, 114, 238–9, *239; see also* Wood, Grant: and costumes/costume parties
Bellingham, Washington, 311
Belz, Annie, 315
Bennett, Mary, 316, 363*n*
Benton, Mildred, 179
Benton, Rita (*née* Piacenza), 182, 193, 207, 238
Benton, Thomas Hart, 48, 71, 167–9, 176–188, *181*, 191–4, *192*, 196, 207, 232, 238–9, *239*, 244, 276, 280–1, 285, 289–91, 296–9, 350*n*, 361*n*, 368*n*, 370*n*, 371*n*; homophobia of, 178–88, 193, 233–5, 285–7; *see also* regionalism
Berlin, 45, 47, 70, 106
Bettelheim, Bruno, 197
Beverley, Julia Bruce, 317
Biarritz, France, 297
Biel, Steven, 5, 77, 104, 337*n*, 344*n*, 373*n*
Birthplace of Herbert Hoover, The (color plate 14), 143, 146–8, 157, 270
Bjornstrom, Miles, 223
Bloom, John, 151–2, 345–6*n*
Blue House, Munich, The, 330*n*
Bohrod, Aaron, 33, 324–5*n*
Bordeaux, France, 64
Bordet, Marcel, 109, 111, 236, 338*n*
Boston, 143, 148
Boston Herald, 103
Boston Tea Party, 157
Botticelli, Sandro, 125, 139, 340*n*
Bourret, Joan Liffring-Zug, *304*, 316
Bronzino, Agnolo, 269
Brooklyn Museum (New York), 267

Broude, Norma, 43
Brown, Hazel, 59, 140–141, 204, 207, 211, 217, 341*n*, 344*n*, 352*n*, 372*n*
Brown, John, 12
Bruegel, Pieter, 85
Buck, Claire, 315
Buena Park, California, 303
Buerkel, Sue, 317
Buffalo, New York, 316
Bulliet, C. J, 104–5
Butterfly Teashop (Cedar Rapids), 111, 113, 338*n*
buttocks, *see* Wood, Grant: buttocks, fascination with

Cabral, Edward Brizida, v, 317, 356*n*
Cabral family, 317
Cabral, Maria José, 316
Cabral, Nikki, 316
Café du Dôme (Paris), 45
California, 28, 286, 290–1, *291*, 301–4, 310, 370*n; individual cities and institutions*
Campbell, Bonnie, 309
Capone, Al, 104
Caravaggio, Michelangelo, 125, 340*n*
Carnegie Foundation, 139, 344*n*, 362*n*
Carson, Johnny, 304, 373*n*
Catlett, Elizabeth, 283, 368*n*
Cedar Rapids Art Association, 42, 90, 335*n*, 362*n*
Cedar Rapids Community Players, 54, 271, 364*n*
Cedar Rapids Gazette, 54, 58–9, 66, 106, 114, 139, 150, 198, 218, 220, 272, 301–2
Cedar Rapids, Iowa, 3, 18, 21–5, 27–36, 39–42, 44–6, 51–4, 56, 58–61, 63–4, 69, 74, 79, 81, 85, 90, 93, 95, 98, 104, 109–10, 125, 131, 136, 139, 141, 145, 149, 151–2, 165, 196, 198, 201–2, 204–6, 210, 213–15, 217, 219, 247, 251, 254, 256, 262, 265, 271, 275, 292, 300, 306–7, 373*n; see also* Wood, Grant: teenage years in Cedar Rapids; *individual institutions*
Cedar Rapids Museum of Art, 306, 316, 373*n*
Cellini, Benvenuto, 125, 341*n*
Central Intelligence Agency, 298
Century of Progress fair (Chicago), 168
Charles Manson as Silenus, 254, *255*, 341*n*, 362*n*
Chauncey, George, 136
chauvinism, *see* Wood, Grant: and nationalism/patriotism
Chesterfield cigarettes, 135–6, 343*n*
Chicago, 32–3, 43, 104, 131, 139, 168, 183, 201–3, 206, 229, 282, 353*n; see also* Art Institute of Chicago

Chicago Daily News, 104
Chicago Evening Post, 104
Chicago Tribune, 79
Childs, Marquis, 70
Christ Church (Boston), 144
Christian Coalition, 7
Christopher and His Kind (Christopher Isherwood), 71
Church of the Immaculate Conception (Cedar Rapids), 306, 361–2n
civil rights, 8–9, *9*, 163, 236, 309
Civil War, 18, 199–200, 218
Claremont, California, 290
Clark, Charles, 344n
Clark, T. J., 160
Clausen, Donna, 316, 352n, 375
Clear Lake, Iowa, *see* Wood, Grant: at Clear Lake
Clemens, Cyril, 190
Clemens, Samuel Langhorne, *see* Twain, Mark
Clingstone, *see* Driver, Jane
Coates, Robert, 298
cock ring, 119
Cocks-Combs, 83–4, *84*
cocktails, 169, 210, 285, 311, 315, 317
Collins, Iowa, 102
Comstock laws, 240
Cone, Marvin, 34, 36, *36*, 41, 44–6, 57, 64, 68, 110, *154*, 217, 291, 326n, 347n, 370n, 372n
Cone, Winifred (*née* Swift), 36, 61, 217
Congress of Cultural Freedom, 298
Conway, Katherine, 373n
Cook's Pond (Cedar Rapids), 247
Copley, John Singleton, 105
corn (color plates 17 and 22), 11, 54, 85, 104, 123, 132, 134, 136, *137*, 153, 160, 219, 254–7, 292, 298, 362n, 363n; *see also* King Corn; Wood, Grant: corn in work of Corn, Wanda M., 4, 72, 85, 102, 116–18, 123, 134–5, 156, 225, 239, 306, 324n, 328–9n, 330n, 335n, 336n, 340n, 342n, 343n, 346n, 347n, 358n
Cosmopolitan (magazine), 26
Country Gentleman (magazine), 187
Craftsman, The (Gustav Stickley), 28
Craven, Richard, 183–4
Craven, Thomas, 7, 47, 70, 73, 81, 88–9, 131, 163, 177, 183–8, 233, 243, 256, 272, 299
Crisp, Quentin, 26
Critius and Nesiotes, 252–3, *253*
cubism, 168
Culver, John, 309
Cumming, Charles, 31–2, 324n, 362n

Cupid, *see* Wood, Grant: Cupid, identification with
Currier and Ives, 148, 158, 189; *see also* Wood, Grant: and prints
Curry, John Steuart (color plate 22), 160–4, *162*, 167–9, 177, 188, 207, 234, 238–9, *239*, 243–4, 255–6, 276, 281, 297–9, 363n; *see also* regionalism
Curry, Kathleen, 207, 238
Czestochowski, Joseph, 7, 130, 370n

dada, 168
Daily Iowan, 4, 166–7
Daily Show with Jon Stewart, The, 45
Dante Alighieri, 100
Daughters of the American Revolution (DAR), 156–7, 346n
Daughters of Revolution (color plate 19), 156–9, 244, 246, 258, 266, 270–1, 297, 343n, 346n, 347n
Davenport, Guy, 85, 100
Davenport, Iowa, 59
Davenport Municipal Art Gallery (now Figge Art Museum), 305–6, 372–3n
Death on the Ridge Road (color plate 20), 195–6
Declaration of Independence (John Trumbull), 9
Decline and Fall of the Roman Empire (Sir Edward Gibbon), 15, 146
Deitcher, David, 193
De Koven, Reginald, 202–3
DeLong, Lea Rosson, 357n
Demcourier (magazine), 119
Demeter, *see* Wood, Grant: and Demeter imagery
Dennis, James, 83, 120, 145, 163, 252, 276, 320n, 324n, 329n, 331n, 333n, 339n, 341n, 342n, 359n, 362n, 364n, 367n, 371n
Dennis, Leonidas (Lon), 325n
Depression, *see* Great Depression
Derain, André, 195
Des Moines, Iowa, 38, 90–1, 93, 324n
Des Moines Register, 60, 91, 98, 101–2, 166, 193–4, 220, 272
Des Moines Tribune-Capital, 60, 218–19
Design in Theory and Practice (Ernest Batchelder), 28
Dinner for Threshers, 169–176, *170–1*, *173*, 191, 196, 349n
Discus Thrower, The (Myron), 252, 362n
Donnelly, Harold, 368n
Donnelly's bar (Iowa City), 285
Dornbush, Adrian, 148, 150–1, 153, *153*, *154*, 345n
Doryphorus (Polykleitos), 362n

Doubleday, 235, 308, 359n
Draft Horse, 225–6, *226*, 358n
Driver, Jane, *see* Clingstone
Dubuque Public Library, 305
Duncan, Thomas W., 192, *192*
Durham, Helen Mann, 317
Durham, Susan Watkins, 317
Dutch Guiana (now Suriname), 297

Eakins, Thomas, 25, 241–2, *241*
Earl, Ralph, 105
Easterly, Natalie, 317
Eaton, Walter Pritchard, 103
effeminacy, 18–20, 25–7, 52–3, 59–61, 63, 66,
 71, 104, 115–16, 151, 157, 163, 179–80, 184,
 190–4, 220, 224–8, 233–5; *see also*; Wood,
 Grant: effeminacy, charges/fears of
Ehrenzweig, Anton, 276
Eldon, Iowa, 91, 94, 100, 139, 307, 335n,
 342n, 344n
Elkins, James, 127, 133
Ely, Henry, 51, 109, 338n, 340n
Emil Frei Art Glass Company (Munich),
 69, *69*
Engle, Paul, 42, 129, 301, 345n
Entertainment Tonight (television show), 303
Equal Rights Amendment, 309
Evans, Jane Durham, 317
Evans, Jane Emerson, 317
Evans, Roy T. (Sandy), 317
Evans, Virginia Brent, 317
Evans, Virginia Hamilton, 317
expatriates, 45, 48–9, 109, 167, 233
Exposure of Luxury (Agnolo Bronzino), 269
Eyck, Jan van, 92

"Factory as It Might Be, A," (William
 Morris), 30, 131
Fall Plowing (color plate 8), 136–8, 216
*Fanciful Depiction of Round-House and Power
 Plant*, 30–1, *30*, 131
"Farewell to New York" (Thomas Hart
 Benton), 232–4
Farm on the Hill (Madeline Darrough
 Horn), 213, *213*, 248–9, *249*, 365n
Farm, The (Jared French), 362n
Farmer with Corn and Pigs (color plate 17),
 256, 277
farming, *see* Wood, Grant: and farming
Farran, Don, 139
fascist aesthetics/rhetoric, 179, 185–7, 233,
 297
fauvism, 168
Federal Arts Administration, 297
Federal Marriage Amendment, 8, 9
femininity, 12, 18, 20, 43–4, 71, 115, 122–3,

126, 157, 159, 163, 172, 175, 179, 190–1, 193,
 200–2, 211, 228, 243, 340n, 356–7n; *see also*
 effeminacy; Wood, Grant: and vaginal
 imagery
Ferargil Gallery (New York), 7, 168–9, 194–5,
 232, 245, 294–5
Fertility, 256–7, *257*
Figge Art Museum, *see* Davenport Municipal
 Art Gallery
Finn, Huckleberry, 190, 225
First Three Degrees of Free Masonry, 251–2,
 253, 362n
Fisher, Vardis, 228–31
Fisher, Vivian, 229
Fitzpatrick, John, 316, 359n, 372n
Flemish painting, *see* Northern Renaissance
 painting
Flessa, Joe, 315, 338n
Flick, Carl, 109–11, *110*, 152, 149, 225, 288,
 338n, 346n, 347n, 358n
Florence, Italy, 139, 185
Flynt, Larry, 373n
Foerster, Norman, 257–8, 363n
Fogg Institute, Harvard University, 286
folk art, *see* Wood, Grant: and folk art
Fort Dodge, Iowa, 38
Foucault, Michel, 26
Four Seasons, 242–3, 248
Frei Körper Kultur, 242
French, Jared, 362n
Fruits of Iowa (color plate 17), 256, 277
Funcke, Peter, 248, *248*, 361n

Galerie Carmine (Paris) 64, 92, 109, 327n
Gallegos, Señorita Pepita, 59
Garwood, Darrell, 15–17, 19, 29, 33, 36, 60–1,
 73, 88, 123, 206, 220, 259, 273, 285, 300–1,
 308, 339n, 340n, 349n, 350n, 356n, 372n,
 375
Gauthier-Villars, Henri (aka Willy), 329n
"Gay Nineties," 190, 227
Genauer, Emily, 120
Germany, 64–5, 67–71, 73, 85, 91, 106, 109,
 156–7, 175, 242, 330n; *see also* Alte
 Pinakothek; Berlin; Weimar Republic;
 Wood, Grant: and Munich
Gibbon, Sir Edward, 15, 146
Gill's Hill (Monticello, Iowa), 200
Giotto di Bondone, 174, 349n
Glaspell, Susan, 59
Godley, Jesse, 242
Golgotha, 196
Good Morning America (television show), 303
Gothic art and architecture, 30, 48, 63, 74,
 76–7, 91, 113, 132, 215, 248, 270, 288, 328n,
 329n; *see also* Northern Renaissance

painting; Wood, Grant: Gothic motifs in work of
Gothic novels/horror, 77–8, 92, 117–20, 125–6, 138, 228, 279–80, 305
Gothic revival, 28–9, 77, 91–2, 94, 219, 258, 307
Grafly, Dorothy, 7
Graham, Edward Emmett, 56–8, 97, 122, 195, 205, *283*, 305, 310, 341n, 373n
Graham, Nan Wood (color plate 10), 3, 11, 14, 17, 23, 33–5, 38, 41, 47, 50, 53, 61, 75–6, *75*, 86–9, 107–9, 114, 175, 119–128, 134–5, 139, 151, 159, 165, 195, 198, 205, 207, 209–10, 216–17, 220–2, *222*, 230, 232, 246–7, 249, 261–3, 271, 281, *283*, 289, 291–2, 299–305, 308, 310–11, 316, 322n, 325n, 334n, 340n, 347n, 364n, 369n, 370n, 372n, 372–3n, 373n, 375; *American Gothic*, role in, 94–102, *99*, 116, 120–4, 126, 230, 300, 302–5, *302*, *304*, 335n; spitefulness of, 34, 57, 95, 98, 101–2, 122, 125–6, 128, 205, 300–1, 304–5, 311, 340n, 350n, 364n, 371n, 372n, 375; wedding/marriage of, 34, 56–7, 58, 97, 122–3, 125, 128, 195, 328n, 341n; *see also Portrait of Nan*; Wood, Grant: relationship with sister
Grangerford, Emmeline, 190, 225
Grant, Ulysses S., 12, 321n
Grant Wood Art Festival (Anamosa), 300, 307
Grant Wood Elementary School (Cedar Rapids), 300, 305
Grant Wood Tourism Center and Gallery (Anamosa), 307
Grattan, Emma, 24, 207
Great Depression, 6, 26, 144, 203, 218–19, 233, 244, 266, 354n; *see also* New Deal; Public Works of Art Project
Green, Ed, 265, 311, 372–3n
Green, John Aloysius, 131
Green Mansion, 131–2, 149, 154, 345n
Greenwell, Kelly, 345n
Greenwich Village (New York), 58, 69–70, 150
Groucho Marx, 238
Guthrie, Willis, 265

H. R. Lubben Company (Cedar Rapids), 357n
Hades, *see* Wood, Grant: and Hades imagery
Haga, Kristoffer, 32, 324n
Hall, G. Stanley, 19
Haman, Phoebe (*née* Sherman), 204, 206, 235, 262, 354n
Hancher, Virgil, 284, 289, 368n
Handicraft Guild, 28–30, 32, 34

Hanson, Bobby, 37, 83, 341n
Hanson, Paul, 33–4, 36–7, *37*, 61, 111, 114, 223, 325n, 340n, 341n, 372n
Hanson, Vida, 33, 36–8, *37*, 61, 83, 223, 301, 340n, 341n, 356n, 372n
Harmodius, 252, *253*
Harnoncourt, René d', 155
Harrison High School (Cedar Rapids), 329n
Hartley, Marsden, 330n
Hartmann, Sadakichi, 25
Harvard University, 139, 286
Hatt, Michael, 65, 251
Hatter, Dawn, 37–8, 89, 325n
Hayes, James P., 316, 356n
Henderson, Helen, 201
Hepburn, Katharine, 216
Hermes, *see* Wood, Grant: and Hermes imagery
heterosexism, 134–5, 158, 225, 238–40, 252, 286–7, 320n
Hicks, Edward, 230, 358n
Hilton, Paris, 5
Hipparchus, 252
History of American Art, A (Sadakichi Hartmann), 25
History of Art (Horst Janson), 299
History of Sexuality, The (Michel Foucault), 26
Homer, Winslow, 25
homophobia, 103–4, 178–88, 193, 286, 301, 312–13, 372n; *see also* Benton, Thomas Hart: homophobia of
homosexuality, 8, 26–8, 33, 39–40, 47–8, 53, 59–61, 63, 66, 70–1, 73, 103–4, 108, 125, 136, 140–2, 151, 158, 178–88, 190–1, 193, 206, 209, 218, 225–30, 233–6, 242, 247, 250, 252, 261–2, 265, 282–7, 289, 291, 300–1, 307, 309, 312–13, 323n, 329–30n, 340–1n, 350n, 360n, 362n, 365n, 368n, 371n, 372n; *see also* queerness; Wood, Grant: and homosexuality
Honorary Degree, 246, 258, 363n
Hoover, Herbert, 12, 146–148, 270; *see also Birthplace of Herbert Hoover, The*
Hopkinton, Iowa, 12
Horn, Madeline Darrough, 213, 248–9, 265, 365n
Hotel Montrose (Cedar Rapids), 256
Hoving, Thomas, 100
Hubbard Ice Company (Cedar Rapids), 149, *149*, 165
Hughes, Harold, 308
Hughes, Langston, 193
Hughes, Robert, 103–4, 158, 177, 313, 374n
Hustler (magazine), 373n
Hyde, Christopher, 315

I Love You, Irene (MacKinlay Kantor), 285
Idaho, 229
Imagination Isles, The, 49–53, *51*, *51*, 63, 132–3, 166, 271
impressionism, *see* Wood, Grant: impressionist style of; *individual artists*
In Tragic Life (Vardis Fisher), 229–31, *231*
Indian Creek (Cedar Rapids), *see* Wood, Grant: and Indian Creek
Indianapolis, Indiana, 273
Inferno (Dante), 100
Internal Revenue Service, 262, 264, 364*n*
International Exhibition of Modern Art, *see* Armory show
Iowa, 8–9, *9*, 12, 18, 26, 31, 45, 47, 49, 52, 59, 64–5, 68–71, 78, 85, 87, 90–1, 98, 101–2, 105, 111, 130–1, 135, 138–9, 143–8, 152–3, 159, 161–3, 165–6, 173, 177, 182, 195, 198–9, 206, 208, 210–11, 215–16, 219–20, 235, 254, 256, 285, 291–2, 297, 308–9, 315; *see also* Midwest; *individual cities, counties, and institutions*
Iowa (Don Wright), *9*
Iowa City, Iowa, 3, 31–2, 166, 189, 191, 196–8, 211, 214–15, 217–19, 220, 222, 233, 238, 259, 265, 275–6, 283, 285, 287, 291–2, 301, 316
Iowa Federation of Women's Clubs, 159
Iowa Landscape/Indian Summer (color plate 24), 292–3
Iowa Press-Citizen, 227
Iowa State University, 165–6, 169
Iowa Writers' Workshop, 258
Isherwood, Christopher, 70–1, 158

J. G. Cherry Company (Cedar Rapids), 61, 63, 155, 227
Jackson, Edna Barrett, 58
Jackson Junior High School (Cedar Rapids), 38
Jackson, Tonya, 316
Janson, Anthony, 299
Janson, Horst W., 43, 67–8, 90, 182, 186–7, 282–3, 297, 299, 320*n*, 334*n*
January, 363*n*
Japanese prints, 28
Jewell, Edward Alden, 105, 161
Johnson, Carmen, 315
Johnston, Dr. Florence, 39–40, 325*n*
Jones County, Iowa, 64, 210
Jones, Doris, 261
Jonesport, Maine, 316
Juhl, Paul C., 359*n*, 369*n*
Julian, Rodolphe, 331*n*

Kalo Art Craft Community, 32, 113, 324*n*, 339*n*

Kansas, 161–3, 169, 177, 255, 327*n*
Kansas City Art Institute, 167, 178, 286–7, 289
Kansas City, Missouri, 3, 169, 178, 180, 238–9, 285, 299
Kansas City Star, 180, 249
Kansas Cornfield (John Steuart Curry; color plate 22), 255–6
Kansas State House murals (John Steuart Curry), 297
Kantor, MacKinlay, 54–5, 60, 192, *192*, 206, 249–50, 271, 284–5, 332*n*
Keck, Mrs. Inez, 102
Kelly, Harold, 34, 36, 111
Kennicott, Carol, 223
Kent, Fred, 363*n*
Kentucky, 199
Kenwood Park (Cedar Rapids), *see* Wood, Grant: and Kenwood Park
Kerman, Keith, 161
Kern, Jerome, 202
Key West, Florida, 153
Killian's department store (Cedar Rapids), 41, 44
King Corn, 85, 254, 256
King Cotton, 254
Kinsey, Joni L., 282–4, 367*n*
Kirstein, Lincoln, 115, 123–4
Knight, Eric M., 257–9, *258*, 265, 275, 287–8, 297, 363*n*, 363–4*n*
Kramer, Hilton, 10, 22, 133, 155, 158, 306, 320*n*

Lackersteen, Mary, 59, 140–2, 204, 211, 344*n*
Lamb, Brian, 313
Lampe, M. Willard, 366*n*
Land o' Maize Folk (Jay Sigmund), 153
"Landlord's Tale, The," (Henry Wadsworth Longfellow), 143–5
Land's End, Provincetown, 316–17
Lassie Come-Home (Eric Knight), 258
Lavender Scare, 286, 312
Lengeling, Randall W., 369*n*
Lenox College (Hopkinton, Iowa), 12–13
Leo, Ernest, 201
Leonardo da Vinci, 5, 83
Leutze, Emanuel, 9, 156–8, 271, 320*n*, 347*n*
Lewenthal, Reeves, 244–6; *see also* Associated American Artists
Lewis, Sinclair, 223–5, 228, 230; *see also* *Babbitt*; *Main Street*
Liederman, Maurice, 244–6; *see also* Associated American Artists
Life (magazine), 238, 298
Lilies of the Alley, 59, 227–8, *228*
Lincoln, Abraham, 272, 321*n*, 365–6*n*

Lincoln Arcade (New York), 183
Linn County, Iowa, 64–5
Little Gallery (Cedar Rapids), 74, 139–41, 148
Lobel, Michael, 316
Loffreda, Beth, 316
London Studio (magazine), 243
Longfellow, Henry Wadsworth, 143–5
Longman, Lester, 282–4, 287, 289, 368*n*
Look (magazine), 304, 373*n*
Loomis, Kate, 31–2
Los Angeles, California, 310
Louvre (Paris), 68
Loveless, Herschel, 308
Luce, Henry, 176

Macdonald-Graham, Robert, 350*n*
Madison, Wisconsin, 193, 246, 341*n*, 364*n*
magic realism, 87, 333*n*
Magner, Helen, 155
Main Street (Sinclair Lewis), 223–6, 357*n*
Malibu, California, 291, *291*
Malnutrition, 326*n*
Manet, Édouard, 105
Mansfield House (Cedar Rapids), 59
Marling, Karal Ann, 144, 157, 266, 337*n*, 347*n*, 365*n*
Marsh, Reginald, 232
Marshall, Nancy, 47, 231–2, 327*n*
Martin, Fletcher, 286–7
Marx, Groucho, *see* Groucho Marx
Marxists, 186, 233
masculinity, 6, 12, 18–20, 25–7, 31, 43, 46–7, 52–3, 60, 63, 65–6, 70–1, 106, 119, 125, 130, 134–5, 137, 142, 147, 157, 163–4, 170–3, 175, 177, 183, 185, 193, 200–1, 223, 225–8, 233, 240–3, 254–7, 286–7, 296, 298–9, 322*n*; *see also* phallic imagery; Wood, Grant: effeminacy, charges/fears of; Wood, Grant: masculine anxiety of; Wood, Grant: and phallic imagery
Masonic Library (Cedar Rapids), 251
Mathews, Arthur Guy, 312
Matisse, Henri, 195
Matz, Jesse, 315
Maxon, Alonzo Jones, 202, 209, 352*n*, 357*n*
Maxon, Dorothy (*née* Crippen), 203, 222–4, *224*, 235, 263–5, 352*n*, 357*n*, 359*n*; *see also Perfectionist, The*
Maxon, Sara Sherman, *see* Sherman, Sara McClain
Maxon, Sherman, 202–3, 209, 222–4, *224*, 235–6, 262–5, 275, 309, 311, 352*n*, 357*n*, 359*n*, 364*n*; *see also Radical, The*
McBride, Henry, 243–4, 361*n*
McCosh, David, 164, 166
McGee, Willis, *see* Cabral, Edward Brizida

McKay, Bruce, 107, 264
McKeeby, Dr. Byron H., 94, 96, 302–3, *302*, 335*n*
McKim, Bill, 285, 368*n*
McKinley Junior High School (Cedar Rapids), 42, 51, *51*, 110, 132, 172, 242, 247, 345*n*
McKinley, William, 21–2
McMurtrey, Leona, 229
McQuilkin, Rob, 315
Medici, Lorenzo de', 139
Medusa, *see* Wood, Grant: and Medusa imagery
Memling, Hans, 83, 331*n*, 332*n*, 333*n*, 347*n*
Memorial Window (color plate 6), 64, 66–7, *67*, 111, 126, 156, 300, 302, 362*n*
Men of Art (Thomas Craven), 185
Mencken, H.L., 44–5, 91, 103, 121
Menlo Park, California, 373*n*
Metropolitan Museum of Art (New York), 219
Michigan, 202–3
Midland (Frank Luther Mott, co-editor), 189
Midnight Ride of Paul Revere (color plate 15), 143–6, 148
Midwest, 8–9, 44–5, 48, 60, 67, 69, 91, 103–4, 120–1, 123, 145, 147, 153, 155, 161, 167–9, 176–7, 183, 188, 233–4, 256, 306; *see also* regionalism; *individual cities, counties, and states*
Millier, Arthur, 105
Milosch, Jane, 71, 111, 306, 316, 328*n*, 330*n*, 334–5*n*
Milwaukee Journal, 210
Minneapolis, Minnesota, 28–9, 36, 58, 196, 203, 352*n*; *see also* Wood, Grant: in Minneapolis
Minneapolis School of Design and Handicraft, *see* Handicraft Guild
Minneapolis Tribune, 227, 249
Modern Art: The Men, the Movements, the Meaning (Thomas Craven), 185–6
Mona Lisa (Leonardo da Vinci), 5, 121, 303
Monet, Claude, 63
Monticello, Iowa, 199, 201–2, 204, 210
Montmartre (Paris), 45
Montparnasse (Paris), 185, 188
Morley, Christopher, 354*n*
Mormonism, 229
Morris, William, 29, 30–1, 131
Mott, Frank Luther, 189, 232–3, 237, 358*n*, 359*n*
Mount Mercy College (Cedar Rapids), 316
Mount Rushmore (Keystone, South Dakota), 297
Mount Vernon, Iowa, 39

Mourner's Bench, 172, 174, *174*, Movieland Wax Museum (Buena Park, California), 303, 372*n*

Mumford, Lewis, 188

Munich, *see* Wood, Grant: and Munich

murals, public, 31, 49–53, 149–50, 169, 178–9, 194, 242–3, 256, 297, 324*n*, 329*n*, 338*n*, 362*n*; *see also* Wood, Grant: murals

Murphy, Bianca Cody, 317

Museum of Modern Art (New York), 194, 333*n*

Music, 41–3, 177, 191

Mussolini, Benito, 185–6

My Brother, Grant Wood (Nan Wood Graham), 301

Myron, 252

National Archaeological Museum (Naples), 253

National Broadcasting Company (NBC), 304, 330*n*, 323*n*, 324*n*, 373*n*

National Socialism, 70, 187, 297; *see also* fascist aesthetics/rhetoric

Near Sundown (color plate 25), 216

Neff, Robert E., 292

Nelson, Richard, 39, 325*n*

Nelson-Atkins Museum, 285–6

Neosho, Missouri, 177, 180, 193

Nesbit, Wellwood, 341*n*, 364*n*

Neue Sachlichkeit, 68–9

New Deal, 147; *see also* Great Depression; Public Works of Art Project

New England, 144–5, 161, 317, 373*n*; *see also* Boston

New Orleans Times-Picayune, 154

New Republic (magazine), 194

New York City, 39, 45, 104, 155, 167–9, 177–8, 180–3, 194, 202, 204, 206, 208, 232–33, 236, 263, 266, 284, 309; *see also* Greenwich Village; *individual galleries and museums*

New York Herald, 92, 120

New York Sun, 124

New York Times, 105, 173–4, 294, 299, 303, 305, 370*n*

New York World's Fair, 266

New Yorker (magazine), 104, 194, 243, 298

Newman, Paul, 5, 320*n*

No-Kare-No-More cottage (Clear Lake, Iowa), 287–8

North Star Oatmeal Mill, 23

Northern Renaissance painting, 67–9, 71, 81, 83, 85, 92, 105, 113, 116, 132, 175, 275, 331*n*; *see also* Gothic art and architecture; Wood, Grant: and Old Master painting; *individual artists and works*

Nude Bather, 248, *248*, 361*n*

nudes, *see* Wood, Grant: and the female nude; Wood, Grant: and life drawing; Wood, Grant: and the male nude

Oakes, Nicholas, 218

Oakland, California, 310

O'Donnell, Slim, 170–2

Old Master painting, *see* Wood, Grant: and Old Master painting; *individual artists and works*

Old North Church (Boston), 143, 145

Old South Meeting House (Boston), 144

Omaha Bee-News, 162

Omaha, Nebraska, 3

Omaha World Herald, 131

Orcas Island, Washington, 311–12, *312*, 316, 375

Orwell, George, 48

Ottumwa, Iowa, 342*n*

Overstimulation (Marvin Cone), 45, 326*n*

Oxford English Dictionary, 26, 323*n*

P.M. (magazine), 298

Painters of the Modern Mind (Mary Cecil Allen), 124, 340*n*

Paglia, Camille, 126, 336n, 340*n*

Palin, Sarah, 359*n*

Palm Springs, California, 291

Paris, 3, 41–2, 44–50, *50*, 58, 64, 67–71, 79, 104–5, 109, 114, 161, 167–8, 177–8, 180, 182–3, 185–7, 232–3, 292, 295, 306, 311; *see also* school of Paris; Wood, Grant: and Paris; *individual neighborhoods and institutions*

Park Ridge, Illinois, *see* Wood, Grant: and Kalo Art Craft Community/Park Ridge

Parson Weems' Fable (color plate 23), 5, 197, 265–80, 366*n*, 366–7*n*

Passions Spin the Plot (Vardis Fisher), 230

Peale, Charles Willson, 105, 267–8, *268*, 271–2

pederasty, 252, 329*n*

Pedersen, Daniel, 32

Peet, Matilda (Aunt Tillie), 116–17, *117*, 127, 190, 335*n*; *see also* Victorian Survival

Penthouse (magazine), 304

Perfectionist, The, 223–4, *224*

Persephone, *see* Wood, Grant: and Persephone imagery

Peters, Dave, 15–16, 18, 46, 53, 82, 84, 145, 242, 321*n*

phallic imagery, 53, 106, 112, 119, 125, 134, 137, 141–2, 156, 158, 163, 171–2, 182–3, 223, 244, 251–8, 274, 277, 299, 343*n*, 347*n*, 362*n*; *see also* Wood, Grant: and phallic imagery

Philadelphia Museum, 267, 271–2
Philadelphia Record, 7
Physical Culture (magazine), 312
Piacenza, Eleanor, 350*n*
Piacenza, Rita, *see* Benton, Rita (*née*
 Piacenza)
Picasso, Pablo, 195, 282
Picture of Dorian Gray, The (Oscar Wilde),
 313
Pitts, Terence, 306, 316
Playboy (magazine), 304–5, 373*n*
Pocahontas, 273, 366*n*
pointillism, 73, 191, 331*n*
Pollett, Joseph, 155
Pollock, Guy, 224–5
Pollock, Jackson, 43, 183, 298–9, 371*n*
Polk County Courthouse (Des Moines), 31
Polk Elementary School (Cedar Rapids), 23
Polykleitos, 362*n*
Porter, Cole, iv, 372*n*
Portrait of John B. Turner, Pioneer (color
 plate 18), 64–6, 71, 78–9, 90, 105, 156
Portrait of Nan (color plate 10), 120–8, 135,
 221–2, *222*, 267, 278, 301–3, 339*n*, 340*n*,
 357*n*, 372*n*
postimpressionism, 168
Prague, Czech Republic, 315
Prescott, Frances (Fan), 38–42, *40*, 89, 114,
 156, 207, 210, 262, 289–90, 325–6*n*, 364*n*
Price, Frederic Newlin, 168
Public Works of Art Project (PWAP), 165–6,
 195
Pyke, Rafford, 26
Pyle, Arnold (color plate 11), 67, *67*, 110–13,
 111, 115–16, 132, 152, 236, 280, 288, 300,
 338*n*, 342*n*, 346*n*, 371*n*; *see also Arnold
 Comes of Age*

Quaker Oats, 23, 306
Quakers, 12–13, 19, 129, 146–7, 230, 341*n*,
 344*n*
queerness, 3, 20–1, 48, 59, 78, 91, 108, 134,
 173, 201, 225, 228; *see also* homosexuality
Quivering Aspen, 363*n*

Race Horse, 225–6, *226*, 358*n*
racial injustice, 163, 276–7, 309, 368*n*
Radical, The, 223–5, *224*, 357*n*
Raine, Kristy, 316, 342*n*, 345*n*, 345–6*n*
Raphael, 6
Reagan, Nancy, 320*n*
Reagan, Ronald, 7, 320*n*
Reece-Hughes, Shirley, 274, 366*n*
regionalism, 6, 31, 68, 71, 85, 152, 167–9,
 176–7, 179, 183, 187–9, 194–6, 207, 232–4,
 238, 244–5, 267, 283, 287, 294, 297–9,

362*n*; *see also* Wood, Grant: and
 regionalism; *individual artists and works*
Reid, John, 205, 284
Reinhardt, Ad, 298
Rembrandt van Rijn, 90
Renaissance painting, 5–6, 67, 83, 125, 139, 160,
 173–4, 269, 275, 278–9, 340–1*n*, 349*n*, 367*n*
 see also Northern Renaissance painting;
 Wood, Grant: and Old Master painting;
 individual artists and works
Retrospection, 332*n*
Return from Bohemia (autobiography), *see*
 Wood, Grant: autobiography
Return from Bohemia (pastel), *ii*, 73–76, *74*,
 139–40, 274, 280, 302, 331*n*
Revere, Paul, 143–6; *see also Midnight Ride of
 Paul Revere*
"Revolt Against the City" (Frank Luther
 Mott), 232–3, 237, 358*n*
Rheem, Alice, 310, 376
Rich, Daniel Cotton, 295
Rimbaud, Arthur, 152
Rimsky-Korsakov, Nikolai, 41
Rinard, Grant Wood, 308
Rinard, Park, 25, 89, 109, 235–8, *237*, 265,
 275, 282, 284, 287–9, 292, 295–6, 307–9,
 359*n*, 360*n*, 363*n*, 368*n*, 370*n*, 374*n*, 375–6
Riverside, California, 304
Riverside Cemetery (Anamosa), 217, 292,
 305, 356*n*
Robin Hood (Reginald De Koven), 202–3,
 203, 275
Robinson, Mrs. Earl, 101
Rock Island Railroad, 29–30, 36, 56, 324*n*
Rodin, Auguste, 252
Roosevelt, Eleanor, 340*n*
Roosevelt, Theodore, 19, 226
Rosedale school, 31–2
Rouen Cathedral series (Claude Monet), 63
Rowan, Ed, 74–5, 139–142, *141*, 148, 150, 157,
 297, 342*n*, 344*n*, 368*n*, 371*n*
Rozen, Martha, 125, 341*n*
Russell, Daniel, 344*n*

Sahar, Gail, 315
St. Louis Dispatch, 150–1
St. Luke's Hospital, 30
same-sex marriage, 8–9, *9*, 316–17
San Juan Islands, Washington, 310–11
Sanders, Charles, 225
Sandow, Eugen, 240–2, *241*
Sarony, Napoleon, 241
Saturday Night Bath (drawing), 250–1, *250*,
 256
Saturday Night Bath (print/illustration),
 248–9, *249*, 250

Saunders, Frances Stonor, 298
Schmeckebrier, Laurence, 161
Scholoeman, Linnie, 343n
school of Paris, 42–3, 64, 68, 161, 167, 177, 185–6, 232
screen memory, 16, 125–6, 341n
Scribner's, 301
Scripps College (Claremont), 290, 370n
Seashore, Carl, 363n
Seattle Times, 331, 374n
Secrest, Sarah Elizabeth, *see* Sherman, Sarah Elizabeth (*née* Secrest; mother of Sara McClain Sherman)
Sedgwick, Eve Kosofsky, 78, 134, 182, 225, 331n
Seery, John, 151, 313, 336n
Selby, 245, 251
Seldes, Gilbert, 105
Self-Portrait (color plate 12), 159–60, 301, 347n
Self-Portrait (Thomas Hart Benton), *181*, 182
Senior Class, 27–8, *28*
Sentimental Yearner, 223–5, *224*
Seven Joys of the Virgin, The (Hans Memling), 83, 333n
Shaffer, Van Vechten, 85
Sharp, John, 344n
Shaw, George Bernard, 261–2
Sheets, Millard, 370n
Sherman, Edith Alice, *see* Averill, Edith (*née* Sherman)
Sherman, Ernest Anderson, 201, 204, 209, 354n
Sherman, Henry David, 199–202, 204, 209, 352n
Sherman, Phoebe Margaret, *see* Haman, Phoebe (*née* Sherman)
Sherman, Sara McClain (aka Sara Sherman Maxon, Sara Wood), 196, 198–215, *199*, *203*, *214*, 217–18, 220, 221–3, 235, 238–9, 261–5, 274–5, 278–9, 283, 287, 296, 308–13, *312*, 316, 334n, 352n, 353n, 353–4n, 354n, 356–7n, 357n, 359n, 364n, 366n, 366n, 374n, 375–6
Sherman, Sarah Elizabeth (*née* Secrest; mother of Sara McClain Sherman), 199–202, 204, 352n, 353n
Sherman, William Tecumseh, 199–200, 352n
Sherry, Michael, 286, 312, 368n, 374n
Shirer, William, 42, 71, 210, 330n, 332n, 335n, 339n, 346n
Show Boat (Jerome Kern), 202
Shrine Quartet, 269–70, *269*
Shriners, 269–70

Sigmund, Jay, 152–3, 195, 204, 213–14, 243, 297, 354n
Simpson, Wallis Warfield, 215
Sistine Madonna (Raphael), 6
Sioux City, Iowa, 85
Sioux City Journal, 45
Smith, Captain John, 273, 366n
Smith, Jessica, 315
Smithsonian Institution, 373n, 375
Society for the Prevention of Cruelty to Speakers (SPCS), *see* Wood, Grant: and Society for the Prevention of Cruelty to Speakers
"Song of India" (Nikolai Rimsky-Korsakov), 41–2
Sorrento, Italy, 49
Souza, Matt, 316
Soviet art/politics, 298, 312
Spilt Milk, 212–13, *213*
Sprague, Florence, 358n
Spring (*Four Seasons* murals), 243
Spring in the Country, 289–90, *290*
Spring in Town, 289
Spring Plowing, 244, 360–1n
Spring Turning (color plate 21), 239–44
Spotted Man, The (color plate 3), 72–3, 135, 191, 331n
Stalin, Joseph, 312
Stamats, Billie, 215
Stamats, Herbert, 215
State Historical Society of Iowa, 316
State University of Iowa, *see* University of Iowa
Stein, Gertrude, 6–7, 156, 186, 193, 233
Stewart, Jon, 45
Stickley, Gustav, 28
Stoddard, George, 370n, 374n
Stone City (color plate 9), 131–6, 138, 216, 240, 294, 342n
Stone City Art Colony, *see* Wood, Grant: and Stone City Art Colony
Stone City, Iowa, 131–3, 148, 150, 210, 307, 342n; *see also* Wood, Grant: and Stone City Art Colony
Stong, Phil, 26
Strub, Sean, 316, 365n, 368n, 372n
Stuart, Gilbert, 90, 271–2
Studio House (Cedar Rapids), 59, 141, 204
Sultry Night (lithograph), 244–61, *245*, 282, 296, 361n, 362n, 363n, 371n
Sultry Night (painting), 259–60, 282
Sunlit Studio, 332n
surrealism, 87, 186, 228, 271, 307, 333n
Swift, Winifred, *see* Cone, Winifred (*née* Swift)

Swimming (Thomas Eakins), *241*, 242, 360n

synchromy, 42, 177

tableaux vivants, *see* Wood, Grant: and tableaux vivants

Tame Flowers, 226–7, *227*

Taylor, Adeline, 114, 164, 218

Taylor, Sue, 22, 238, 316, 331n, 333n, 335n, 338n, 345n, 361n, 366n, 369n

Thinker, The (Auguste Rodin), 252

Third Reich, *see* National Socialism

Third Sex, The (Henri Gauthier-Villars, aka Willy), 329n

Thirty-six Damm Strasse—Munich, 330n

Thomas, Frank, 8, 10

Thoreau, Henry David, 256

Three of Us, The (Nan Wood Graham), 302

Time (magazine), *see* Wood, Grant: and *Time*

Times Club, 189, 191, 193

To Tell the Truth (television show), 303

Tom of Finland, 223

Tomasini, Wallace, 360n

transvestitism, 178–9, 233, 227, 332n

Trouble in 'Frisco (Fletcher Martin), 287

Trumbull, John, 9, 320n

Trussoni, Danielle, 315

Turner Alley, *see* Wood, Grant: studio at Turner Alley

Turner, David, 53–4, 58, 64–5, 75–6, 93, 114, 139, 165, 213–15, 217, 262, 331n, 355n, 364n

Turner Funeral Home (Cedar Rapids), 53, 93, 217, 292

Turner, John B. (color plate 18), 64–6, 71, 76, 96, 156, 205; *see also Portrait of John B. Turner, Pioneer*

Twain, Mark, 190

Tyrannicides, The (Critius and Nesiotes), 252–3, *253*, 362n

U.S. Scene, *see* regionalism; Wood, Grant: and regionalism

Uncle Clarence, *see* Wood, Clarence

Uncle Tom's Cabin (Harriet Beecher Stowe), 270

University Hospital (Iowa City), 289, 292

University of Iowa, 4, 31, 166–7, 189, 214, 232, 235–6, 258, 282–4, 287, 289, 360n, 362n, 363n, 370n, 375

University of Wisconsin-Madison, 246

Upper Alton, Illinois, 179

Van Antwerp Place (color plate 1), 41, 43

Van Dorston, Teri, 316

Vasari, Giorgio, 67

vaudeville, 45, 178

Vaughan, Malcolm, 194

Velázquez, Diego, 105

Vergotz, Greg, 316

Verlaine, Paul-Marie, 152

Veterans Memorial Building (Cedar Rapids), 64, 66, 126, 156, 300; *see also Memorial Window*

Victorian era, 12, 18–19, 26–7, 85–6, 91–3, 99, 113, 116, 118–19, 122, 130–2, 134, 137, 143, 147, 150, 189–93, 219, 225, 227, 230, 240–2, 279, 282, 334n, 351n, 357n; *see also* "Gay Nineties"

Victorian Survival (color plate 16), 5, 116–20, *117*, 127, 146, 156, 191, 196, 281–2, 335n

Vidal, Gore, 44

Vietnam War, 309

Virgin and Child or *Madonna with a Vase of Flowers* (Leonardo da Vinci), 83

Virginia, 12, 199–200, 219, 276–7, 317, 366n

Volund Crafts Shop, 32–3

Vowell, Sarah, 320n

Walker, Maynard, 167–9, 176, 179, 183, 194, 299

Wapsipinicon River, Iowa, 131, 133, 152, 297

War of 1812, 66

Washington, Augustine, 266, 273, 276–7, 279

Washington Crossing the Delaware (Emanuel Leutze), 9, 156–8, 271, 320n, 347n

Washington, D.C., 38, 177, 309

Washington, George, 9, 156–8, 265–7, 271–7, 279, 347n, 366n

Washington High School (Cedar Rapids), 27, *27*, 34, *36*, 324n, 362n

Washta, Iowa, 102, 336n

Waterloo Courier, 135–6

Waterloo, Iowa, 33, 75, 338n

Watson, Forbes, 194

Waubeek, Iowa, 153, 195, 213–14, *214*, 297, 359n

Waugh, Thomas, 259

Weaver, DeVolson, 12, 25, 49, 327n

Weaver, Hattie, *see* Wood, Hattie (*née* Weaver)

Webster, Daniel, 165

Weems, Parson Mason Locke, 265–6, 268–74, 276, 280, 366n

Weimar Republic, 70–1, 242

Weinberg, Jonathan, 70, 125, 330n, 362n

Welch, Eleanor, 283–4, 368n

Weller, Ruth McCuskey, 363n

Welles, Clara Barck, 32

West Amana, Iowa, 109, 347n

West Branch, Iowa, 146

Western Military Academy (Upper Alton, Illinois), 179
Whistler, James McNeill, 81, 167, 169, 186
White, Robert Francis, 164, 166
Whitman, Walt, 152
Whitney, Charles Vanderbilt, 372*n*
Whitney Museum (New York), 7, 10, 168, 178–9, 194, 305–6, 320*n*
Wild Flowers, 226–7
Wilde, Oscar, 45, 179, 186, 224, 227, 311–12, 313
Williamsburg, Virginia, 219
Wilson, Genevieve Clark, 201, 209, 353*n*
Wilson, Robina, 323*n*
Wilson, Victoria, 315
Wittlesly, Margaret, 109, 338*n*
Wizard of Oz (L. Frank Baum), 322*n*
Woitescheck sisters, 34
Woman with Plants (color plate 4), 78–88, 90, 95, 97, 99, *99*, 102, 105, 112, 116, 119–20, 122–3, 128, 159, 176, 216, 292, 332*n*, 335*n*
Wood, Charles, 13, 321*n*
Wood, Clarence, 13, 23, 217, 321*n*
Wood, Eugene, 13, 321*n*
Wood, Frank, 14–17, 19, 24, 29, 33–4, 89, 145, 321*n*, 331*n*; *see also* Wood, Grant: relationship with brothers
Wood, Grant:
 and abstraction, 41–2, 49, 64, 68, 87, 124, 131–2, 167–8, 177, 195, 239, 243–4, 257, 332*n*; academic style of, 32, 52–3, 63, 127, 251–2, 253, *253*, 324*n*; African-Americans in work of, 276–9; alteration/destruction of work, 53, 65, 72, 78, 99, 111–12, 138, 142, 147, 159–60, 256–7, 260, 333*n*, 338*n*, 339*n*, 347*n*; ambivalence about region/homecoming, 6, 9–10, 44–5, 49, 69–70, 73–4, 76–9, 83–4, 87–8, 90–1, 102, 106, 120, 156–7, 169, 176, 224, 270, 292, 294; and antiques/collecting, 64–5, 83, 120, 132, 136, 143, 159, 189–91, 218–21, 243, 249, 266, 273, 275, 344*n*, 356*n*, 357*n* (see also Wood, Grant: and willowware china); appearance of, 17–18, 23, 27, 44, 46–7, 49–50, 60–1, 63, 67, 71–2 75, 94, 114, 155–6, 160–4, 170, 188, 191, 212, 225, 246, 272, 348*n*, 355*n*; and aprons, 79–82, 84, 95, 176, 270, 332*n*, 342*n*; archaic/anachronistic character of work, 4–5, 10, 15, 20, 22, 24, 31, 64–8, 76, 85, 90–1, 102–3, 105, 109, 120, 129, 132, 136–8, 143–50, 156–7, 169, 174, 176, 189–93, 218–20, 233, 248–9, 253, 260, 265–8, 271–3, 275–6, 331*n*, 336*n*, 366*n*; army career of, 38–9, *39*, 40, 296, 319*n*; arrested development of, 12, 22, 40–1, 54,

76, 90, 106, 111, 113–15, 129, 139, 206, 210, 225, 247, 272, 273–4, 276, 279–80, 325*n*; artistic training, 4, 11, 28–9, 31–3, 42, 49, 52, 69, 72–3, 105, 127, 311, 324*n*, 325*n*; and artists' colonies, 32, 58–9, 148–156, *153*, *154*, 160–5, 166, 195; artist's signature of, 49, 116, 176, 327*n*, 333*n*; autobiography (*Return from Bohemia*), 3, 11, 14–15, 21–2, 48–9, 73, 77, 80, 97, 134, 137, 145, 148, 161, 219, 235–8, 242, 308, 321*n*, 375; and Bacchus imagery, 173, 254, *255*; banishment to cellar, 11, 15, 23, 54, 81, 133–4, 215; bathing habits of, 33, 54, 59, 212, 246–7, 288, *291*; bathing imagery in work of, 112–13, 115, 244–60; beard, 44, 46–7, *46*, 49, 61, 63, 72, 191, *192*, 206, 281, 327*n*; beards/mustaches in work of, 15–16, 63, 111, 151, 191, *192*, 206, 223–4, *224*, 252, 287, 328*n*, 357*n*; birth/birthday, 11, 14, 16, 19, 76, 79, 83, 175–6, 236, 240, 265, 272, 292, 311; and blackmail attempt, 107–8, 111, 236, 335*n*, 338*n*; "bohemian" period, 6, 41–2, 45–9, 54, 58–9, 67, 69–73, 77–8, 87, 96, 120, 150–1, 155, 187–8, 238, 296; breasts in work of, 127–8, 175–6, 342*n*; bullying of, 16–17, 23, 47, 249, 263–4, 274–5, 280; buttocks, fascination with, 16, 115, 135–7, *154*, 172–3, *173*, *174*, 240–4, *241*, *241*, *290*, 360*n*; camouflage work, 4, 38, 129, 278, 319*n*; and camp, 60, 103–4, 141, 158–9, 190–93, *192*, 303, 365*n*; and canning jars, 80–1, 134, 215–16; castration/impotence in work of, 48, 118, 101, 119, 157, 274, 277, 280–1, 366*n*; and chaperones, 56, 58–9, 90, 98, 116, 118–19, 127, 150, 207, 281; and chickens (color plate 26), 15–16, 20, 82, 92–3, 120–1, 123–6, 128, 140–2, 147, 156, 158, 169, 212, 280, 280–2, 340*n*, 344*n*, 366*n*, 367*n*; childhood in Anamosa, 11, 15–18, 19, 21–22–3, *22*, 53–4, 63, 65, 75, 77–8, 80–2, 87, 92–6, 99–100, 103, 106, 113–14, 128–31, 133–4, 138, 142–3, 145–6, 148, 156, 161, 164, 169–74, 176, 190–1, 196, 198–200, 210, 211–12, 219–20, 225, 242, 246–7, 256, 260–1, 265, 270, 273–4, 280–1, 351*n*; childlike qualities/passivity of, 38–9, 46–7, 49–52, 82, 114–15, 132–4, 139, 143–4, 163, 237, 247, 261, 264–5, 274, 276, 279, 296, 303, 339*n*; and classical allusion, 12, 24, *50*, 52–3, 60, 84–8, *87*, 99–102, 113–14, 123–4, 126–8, 138, 163, 173, 216, 242, 251–2, 253–5, *253*, *255*, 269, *269*, 293, 332*n*, 362*n* (*individual deities*); at Clear Lake, 263, 287–9, *288*; and clothing, 3, 23–4, 26–8, 38, *39*, 46, 61–3, 67, 75, 79–82, 95, 100, 102, 119–20, 126–7, 135, 140, 151, 155–6,

159–60, 162, 170, 172, 175–6, 191, 205, 210–12, 219, 223–5, 234, 240, 249, 256, 265, 269–70, 304, 323*n*, 332*n*, 344*n*, 355*n*, 370*n* (*see also* Wood, Grant: and aprons; Wood, Grant: and costumes/costume parties; Wood, Grant: and overalls); confessions of, 211–12, 284–5, 289–92; continuous narrative, use of, 76, 138, 175–6; corn in work of (color plate 17), 54, 85, 104, 123, 132, 134, 136–7, *137*, 160, 219, 254–7, *257*; and corporal punishment, 15, 23, 145–6, 172, 174, 263–4; and costumes/costume parties, 24, 39–40, 48, 60, 63, 82, 94, 114, 136, 159, 163, 175, 191, *192*, 238–9, *239*, 273–5, 280, 305, 332*n*; and craft, 4, 24–5, 28–9, 31–2, 34, 54, 64, 66–7, 69, 72, 113, 150, 172, 174, 215, 219, 221, *222*, 295, 302, 306, 307, 329*n*, 330*n*, 357*n* (*individual media*); and critics, 4–7, 10, 29, 41–2, 44, 50, 64, 70–3, 77, 85, 90, 92–3, 97–8, 101–6, 120–4, 130–6, 138–9, 155–8, 163–4, 167–9, 173–4, 176–7, 194–5, 198, 232–3, 238, 243–4, 249–52, 259–60, 262, 268, 271–4, 276–7, 287, 295–8, 306; crushes, 34, 36, 57, 108–111, 113, 159–64, 170–2, 222–3, 235–6, 248, 257–9, 261–2, 265, 275, 288; Cupid, identification with, 12, 60, 114, 123, 163, 332*n*; curtains, fascination with, 54, 56, *56*, 94, 107, 120, 138, *150*, 266–7, 270–1, 276, 279, 365*n*; death/illness of, 30, 38, 61, 71, 73, 109, 114, 155, 198, 245, 279, 289–94, 296, 303, 305, 308, 356*n*, 366*n*, 368*n*, 369*n*, 370*n*; and deception, 55, 78, 109, 118, 129, 144–5, 158, 176, 188, 198, 225, 232, 268–70, 272, 296, 303, 307, 363*n*; decline in reputation of, 297–9, 306, 308, 312; and Demeter imagery, 84–8, 99–100, 102, 124, 216, 254, 293; depression, battles with, 16, 21, 68–71, 129, 166, 214, 261, 264–5, 282, 284, 296; and doubles/doppelgänger, 3, 47, 100, 161–4, *162*, 231–2, 270, 272, 370*n*; drinking habits of, 45, 48, 58, 207–8, 220, 230, 254, 264, 284–5, 368*n*, 369*n*; East Court Street house (Iowa City), 196, 215, 217–223, *218*, *222*, 235–6, *237*, 258–9, 259, 261–5, 275, 278–9, 282, 285, 301–2, 316, 324–5*n*, 356*n*, 357*n*, 363*n*, 365*n*, 366–7*n*, 367*n*; effeminacy, charges/fears of, 19–21, 25, 47, 50, 52–3, 59–63, 65–6, 70–1, 105, 108, 114–16, 129, 151, 158–60, 162–3, 187, 190–1, 193–4, 218, 220, 224–8, 233–5, 243–4, 247, 249, 287, 300, 371*n* (*see also* Wood, Grant: and homosexuality); emotional makeup of, 4, 16–17, 19–21, 38, 43, 50, 72, 78, 90, 108, 113–14, 129, 131–2, 146, 151, 166, 172,

183, 190, 205, 207, 210, 212, 220, 223, 238, 245–6, 249, 261, 264–5, 272–5, 281–2, 284, 288–9, 291, 296–7, 319*n* (*see also* Wood, Grant: depression, battles with; Wood, Grant: shyness/self-effacement of); eroticism in work of, 52–3, 63, 66–7, 73, 77, 100–1, 106, 111, 113, 115–16, 123–6, 131, 133–6, 141–2, 157, 171–3, 196, 223, 239–44, 244–60, 350*n*; exhibitionist tendencies of, 32–4, 48, 247, 324–5*n*; exhibitions, 4, 7, 41, 43–4, 64, 90, 92, 102, 104, 109, 122, 131, 135–6, 167–9, 176, 194–5, 232, 259, 266, 289, 294–6, *302*, 303, 305–6, 308, 339*n*, 342*n*; and eyeglasses, 46, *46*, 96, 128, 211, 219, 225, 272, *290*, 335*n*, 355*n*; and fairy tales, 20, 23, 197, 218, 322*n*; fame of, 3, 11, 33–4, 54, 68, 90, 102, 104, 106–7, 120–1, 129, 131, 138–9, 142, 148, 155–6, 159–61, 166, 169, 176, 193–5, 197–8, 216, 219, 232, 238, 246, 272, 287, 289, 291, 303, 305; family farm, 11–12, 17, *17*, 18, 22, 131, 169, 172, 174–6, 191, 199, 246–7, 254, 335*n*, 349*n*, 351*n* (*see also* Wood, Grant: banishment to cellar; Wood, Grant" "studio" in Anamosa kitchen); and farming, 4, 11–12, 16, 25, 63, 65, 84–5, 87, 99, 130, 133–7, 153–5, 165, 169–172, 177, 212, 225, 242–4, 247, 256–7, 275, 346*n* (*see also* Wood, Grant: and milking); and father figures/fatherhood, 15, 53–4, 66, 76, 107–8, 139, 147, 157–8, 161, 166, 183–4, 219, 222–3, 236, 271–2, 274, 281, 296, 357*n*, 370*n*; and the female nude, 52, 59, 119, 123–4, 127–8, 134–5, 246, 341*n*; finances of, 21, 24, 33, 36, 38, 42, 53–4, 73, 89–90, 110–11, 114, 129, 133, 147, 164, 168–9, 217–19, 222–3, 232, 244–5, 262, 264, 275, 303, 309, 324*n*, 357*n*, 364*n*, 374*n*; first drawings/painting, 11, 19–20, 81, 92, 134, 148, 280, 281, 345*n*, 366*n*; and First World War, 4, 33, 38, 39, *39*, 40, 46, 56, 60, 66, 156–7, 319*n*; flowers/plants in the work of, 59, 61, 79, 81–5, *84*, 95, 115, 128, 132, 316, 189, 215, 224, *224*, 226–8, *227*, *228*; and folk art, 93, 113, 120–2, 132, 143, 146, 149–50, 230, 256, 267, 279, 297; folksy/populist character of, 4, 9, 11, 32, 61, 72, 78, 93, 123, 129, 140, 151, 155–7, 159, 167, 195, 197, 219, 225, 237, 245–6, 272, 289, 291, 295–7, 304–5, 320*n*, 346*n*, 370*n*; and food, 11, 32, 80, 93, 107, 110, 119–21, 123–5, 133–5, 149, 169, 172, 207–8, 212, 220, 222, 261, 265, 285, 287, 345*n*, 367*n* (*see also* Wood, Grant: fruit in work of); frames in work of, 65, 82, 110, 149, 251, 260, 270–1, 281–2, 333*n*; and Freemasonry,

Wood, Grant *(continued)*
251–2, *253*, 272; fruit in work of, 85–6,
120–5, 132–3, 135, 256, 265, 267, 274–7,
279, 340–1*n*; and funeral industry, 36,
53–4, 59, 86, 93–4, 215, 217, 292, 334*n*;
funereal motifs in work of, 54–5, 57, *57*,
60, 66–7, 74, 76–7, 86, 93–4, 101, 112–13,
118–19, 136–8, 172, 174, *174*, 190, 195–196,
215–16, 219, 274–5, 278–80, 292, 303, 307,
334–5*n*; furniture design, 24, 54, 172, 174,
174, 221, *222*, 302, 307, 357*n*; and
gardening, 17, 20, 81–2, 99, 138, 215, 235;
gaze, role in work of, 74, 80, 92, 94, 96–7,
99, 101–2, 112, 119, 121–4, 126–8, 135, 140,
156, 172, 176, 221, 223–4, 238, 243, 251, 253,
259, 274–5, 280, 292, 305, 336*n* (*see also*
Wood, Grant: and eyeglasses); gender
reversal/androgyny in work of, 76, 79, 82,
102, 115–6, 119, 128, 139–42, 157–9, 175,
228, 242–3, 275, 303, 332*n*; and gossip, 40,
58, 60–1, 90, 98, 106–7, 118, 151, 196, 215,
230, 283, 285, 287, 295, 308, 347*n*, 364*n*;
Gothic motifs in work of, 30, 63, 74,
76–8, 91, 92–4, 113, 117–19, 125–6, 138,
173–4, 215, 228, 230–1, 246, 258, 270,
279–80, 307, 313, 331*n*; and Hades
imagery, 84, 99–101, 124, 273, 288; and
Hermes imagery, *50*, 52–3; hideaways, 19,
49–50, 54–5, 57, 87, 89, 92, 133, 138, 165,
287–8; and history painting, 64, 119, 129,
142–8, 248–9, 265–80, 366*n* (*individual
works*); and homosexuality, 4, 9, 25, 28, 33,
38, 40, 47–8, 59–61, 63, 70–1, 77–8, 103–4,
108, 115, 125, 134–8, 140–2, 151–2; 158–9,
181–2, 187–8, 191, 193, 198, 206–8, 221,
223–8, 229–31, 233–6, 247, 249–51, 252,
259–62, 264–5, 282–7, 289, 291, 300–1,
307, 309, 312–13, 315, 345*n*, 350*n*, 360*n*,
365*n*, 367*n*, 368*n*, 372*n* (*see also* Wood,
Grant: and blackmail attempt; Wood,
Grant: crushes; Wood, Grant: effeminacy,
charges/fears of); illustration work, 53, 61,
93, 223–6, 228–31, 248–9, 306, 335*n*, 359*n*,
365*n*; imagination/fantasy, role in the
work of, 5, 20, 30–1, 49–52, 65, 73, 75–9,
81–2, 91–2, 97, 106, 129, 130–3, 143, 145–6,
148, 247, 254, 256, 261, 265–8, 270–1, 273,
280, 292; impressionist style of, 32, 41–4,
63–4, 67–8, 70–3, 92–3, 104–6, 130, 168,
292, 295, 306, 330*n*, 332*n* (*individual
works*); incest, suggestion in work/life of,
34, 57, 77, 79–80, 88–90, 92, 94, 97–8,
101, 123–5, 128, 135, 216, 277–8, 334*n*, 367*n*;
and Indian Creek, 33, *35*, 248, *248*; and
interior decorating, 4, 24–5, 29, 31, 54, 63,
70, 93, 139, 172, 189–91, 217–221, 328*n*; and

Iowa history, 64–5, 131–2, 235, 296, 307,
324*n*, 328–9*n*; Italian travels of, 49, *50*, 56,
58, 72, 81, 83, 253, 278, 362*n*; and Kalo Art
Craft Community/Park Ridge, 32–3, 58,
113, 151, 247, 339*n*; and Kenwood Park,
33–5, *35*, 45, 56, 80, 248, 325*n*, 332*n*; and
landscape imagery, 41, 50, 64, 67, 78–9,
81–3, 86–7, 93, 105, 111–12, 119, 129, 130–8,
148–50, 152, 159, 196, 216, 239–44, 251,
252–4, 260, 276, 280, 292–3, 307, 342*n*
(*individual works*); "Latin Quarter"
scheme, 58–9, 148; lecture career, 177, 195,
234, 236, 238–9, 289; and life drawing
(color plate 3), 31, 33, 59, 72–3, 127, 150,
154, *154* (*see also* Wood, Grant: and the
female nude; Wood, Grant: and the male
nude); lost works of, 37, 260, 281, 326*n*,
329*n*, 341*n*; and male community, 32, 40,
48, *69*, 70–1, 149, 151–2, *152*, *153*, *154*,
161–2, *162*, 164, 166, 170–1, 173, 175, 242,
269–70, 288–9, 345–6*n*, 365*n*; and the
male nude (color plates 2 and 3), 32–3, 36,
48, 52–3, 59, 66–7, 70, 72–3, 112, 115, 125,
134–8, *154*, 240–3, *241*, *242*, 244–60, *245*,
248, *249*, *250*, *253*, *255*, 324–5*n*, 329*n*, 341*n*,
361–2*n*, 363*n* (*individual works*); mannerist
elements in the work of, 112, 116–19,
120–1, 125, 131, 138, 151, 156, 158, 191, 243–4,
260, 269, 280; marriage prospects of,
36–8, 57–8, 60, 89–90, 95, 102, 108–9, 128,
159, 195–6, 198, 204–9, 296, 325*n*; marriage
to Sara Sherman Maxon, 196–9, *199*,
205–15, *214*, 217–23, 235, 238–9, 261–5,
274–5, 278–9, 283, 287, 296, 308, 309,
311–13, 316, 334*n*, 352*n*, 354*n*, 357*n*, 359*n*,
364*n*, 366*n*, 374*n*; masculine anxiety of, 6,
18–20, 25, 27–9, 38, 43–4, 48, 52–3, 58,
60–1, 63, 65–6, 70–1, 76, 89, 106, 125,
129–30, 153–5, 157, 160–4, 170–2, 190–1,
195–6, 198, 211–12, 223–8, 240–3, 254–7,
265, 274, 285, 287, 296; and Medusa
imagery, 84, 101–2, 126–7, 274;
metalwork/jewelry design, 4, 24–5, 29,
31–2, 113, 150, 219, 339*n*; and milking,
154–5, 212–3, *213*, 363*n*; in Minneapolis,
28–9, 36, 58, 196, 352*n*; and misogyny/fear
of women, 21, 33, 38, 116–19, 127–8, 135,
156–7, 190–1, 264, 343*n*; models, use of,
36–7, 53, 58–9, 67, 72, 94–6, 111, 120,
122–3, 128, 135, 140, 154, *154*, 156, 223–6,
248–9, 251–2, 256–9, 271, *290*, 302, 305,
331*n*, 335*n*, 357*n*, 359*n*, 363*n*; and Munich,
64–5, 67–71, *69*, 73–4, 78–9, 83, 88, 96,
106, 129, 130, 239, 278, 330*n*, 346*n*; murals
(color plates 2 and 17), 25, 30, 49–53, *51*,
132, 149–50, *150*, 165–6, 169, 242–3, 247,

256, 271, 324*n*, 329*n*, 335*n*, 338*n*; and
namesakes/nicknames, 12, 34, 49, 58, 235,
258, 272, 308, 321*n*; and nationalism/
patriotism, 5–8, 42, 71, 77–8, 90, 103–5,
129–30, 142, 145, 148, 155, 157–8, 167–9,
176–7, 185, 187–8, 193–4, 219, 233, 244–5,
266, 271, 280, 295–7, 306, 373*n*; and
Native Americans, 15, 254, 273, 366*n*;
obituary inaccuracies, 296, 370*n*; and
Old Master paintings, 4, 34, 67–9, 71, 81,
83, 90, 92, 105, 116, 125, 132, 160, 173–5,
269, 278–9, 349*n* (*see also* Northern
Renaissance painting; Renaissance
painting); and older women, 23–4, 38–9,
86, 118–19, 127, 145–6; 156–7, 159, 190,
198, 205, 207, 323*n*, 339*n*, 346*n*; and
orientalism, 28–9, 269–70, 291, 324*n*,
370*n*; and overalls, 3, 28, 61, 63, 75, 101,
150, 151, 153, 154–6, 154, 160, 162, 162, 170,
172, 176, 211, 216, 225, 230, 234, 237, 240,
256, 265, 290, 346*n*, 347*n*; and Paris, 3,
41–2, 44–6, 46, 49, 50, 54, 56, 58, 61, 64,
67–71, 79, 92, 104–5, 108–9, 114, 151, 161,
168, 281, 292, 295, 306, 311, 330*n*, 365*n*;
patrons/collectors of, 31, 51, 53, 75, 93, 109,
195, 232–3, 216, 243, 245, 265, 311, 331*n*,
341*n*, 364*n*, 372*n* (*see also* Turner, David);
and Persephone imagery, 84–7, 87,
99–102, 124, 126, 128, 336*n*; and phallic
imagery, 53, 82, 84, 105–6, 112, 119, 125,
134, 137, 141–2, 156, 158, 171–2, 223,
244, 251–8, 274, 277, 343*n*, 347*n*; and
photography, 3, 36, 61, 118, 191–3, 219, 283,
307, 335*n*, 363*n*; (*see also* Wood, Grant:
and tintypes); and politics, 7, 8, 146–7,
165–6, 188, 267; and portraiture, 27, 37,
38, 45, 53, 64–6, 78–88, 90, 95, 99–100,
103, 105, 111–113, 115–31, 139–42, 169, 173,
176, 193, 221–2, 230, 267, 271–2, 279, 280,
291–2 (*individual works*); and prints, 28,
65, 148–9, 157–8, 172–3, 189, 212–13,
223–7, 244–246, 251, 256–7, 259, 269–70,
295, 349*n*, 362*n* (*individual works*);
productivity of, 32, 54, 77, 106, 119, 122,
129, 156, 196–7, 220, 228, 239, 245–6,
260–2, 265, 280; protégés of, 67, 67,
108–13, 110–11, 110, 111, 115–16, 132, 152,
159, 265, 288; punishment themes in work
of, 21, 65–66, 73, 76, 84–5, 87–88, 97,
99–102, 113, 115, 118–19, 124, 138, 172, 174,
196–8, 260, 273–5, 277–80, 280–2 (*see also*
Wood, Grant: and corporal punishment);
and puns, 45, 91, 138, 170–2, 202, 227,
247, 258, 274, 288, 363*n*; realist style of,
63–9, 71, 73, 78, 105–6, 130–1, 167, 244,
257, 267, 276, 287; and regionalism, 6, 31,

68, 71, 77, 85, 129–30, 148, 152–3, 156,
167–9, 176–7, 187, 188–9, 194–6, 198, 207,
232–4, 238, 244–5, 267, 283, 287, 294,
297–9; rehabilitation in 1980s, 7, 130,
305–6; relationship with brothers, 16–17,
29, 32, 34, 36, 217; relationship with father,
3, 11, 15–22, 38, 66, 76–7, 80–1, 89, 93,
97–8, 103, 116, 129, 137–8, 146–8, 152,
154–5, 157, 161, 164, 174–6, 184, 196, 200,
212, 217, 219, 230, 242, 264, 273–5, 277–9,
281, 291–2, 336*n*, 355*n*; relationship with
mother, 17–18, 23–4, 34, 44–5, 58, 69, 77,
79–90, 95–7, 103, 107, 123, 152, 159, 164–5,
175–6, 190, 195–6, 200, 207, 209, 215–17,
219–21, 230–1, 264, 270, 277–9, 281;
relationship with sister, 17, 34, 57–8, 77,
95–8, 102, 107, 116, 123–8, 159, 165, 195,
209, 221–2, 222, 281, 292, 299–305, 347*n*;
and religion, 4, 20, 37, 44, 52, 91, 103, 109,
129, 145–6, 230–1, 273, 279, 281, 292, 296,
306, 341*n*, 367*n*, 370*n*; religious imagery in
the work of, 66, 73–4, 76, 80, 83–5, 84,
99–100, 113, 123, 125, 132, 143–6, 160,
173–6, 196, 230, 248, 252, 273, 278–80,
302, 341*n*, 349*n*, 361–2*n*; sabbatical from
University of Iowa, 282–5, 283, 287–9, 291;
and satire, 4, 78, 91, 94–6, 101–4, 116–17,
121, 136, 139–42, 145, 147–8, 150, 156–9,
165, 189–3, 223–5, 243–4, 246, 254, 256,
258, 267–73, 280–1, 296, 363*n*; and
sculpture, 59, 94, 133, 149, 227–8, 239, 243,
246, 251–3, 253, 297, 358*n*, 361–2*n*; and
Second World War, 186–7, 296–7; and
self-portraiture (color plate 12), *ii*, 27–8,
27, 45, 50, 73–76, 74, 111, 123, 148, 159–60,
175, 216, 224–6, 272, 280–1, 301, 338*n*;
shadows in work of, 27, 112, 138, 196, 216,
232, 269–70, 274, 277, 279, 292; shyness-
/self-effacement of, 3–4, 6, 16–17, 20,
23–4, 33–4, 38, 45, 48, 55, 93, 97, 106, 129,
159–60, 163, 177, 193, 195, 207–8, 220, 232,
236, 238, 246, 260, 288, 301, 319*n*; smoking
habits of, 45–6, 134–6, 162, 162, 220–1,
288; and Society for the Prevention of
Cruelty to Speakers (SPCS), 189–93, 189,
192, 219, 232, 351*n*; and spinsters, 13, 59, 95,
97–8, 102, 119, 123, 127–8, 152, 157, 336*n*,
340*n*; and stained glass, 64, 66–7, 69, 69,
215, 329*n*, 330*n*; and Stone City Art
Colony, 148–56, 149, 150, 152, 153, 154,
160–6, 177–8, 195, 234, 288, 297, 307, 316,
337*n*, 345*n*, 345–6*n*, 346*n*, 358*n*; "studio" in
Anamosa kitchen, 19, 23, 54, 82, 87, 89,
92, 149, 169, 172, 175–6, 189, 189, 191, 270,
366*n*; studio at Clear Lake, 287–8, 288;
studio at Turner Alley, 53–8, 55, 56, 57, 60,

Wood, Grant *(continued)*
 63, 73, 79–81, 88–90, 93–4, 107, 109–10,
 148, 159, 164–5, 195–7, 205, 207, 213–15,
 219–20, 227, 230, 247, 271, 278, 291–2,
 303, 306–7, 332*n*, 334–5*n*, 334*n*, 344*n*,
 355*n*, 356*n*, 365*n*; and subconscious
 imagery, 5–6, 10, 16, 53, 65, 75–8, 80–4,
 87–8, 92–3, 97–8, 102–3, 106, 115, 121,
 124–8, 130–2, 134–8, 159, 165, 171–2,
 215–16, 230, 239–40, 250–1, 253–7, 265–6,
 273–80, 281–2, 289–90, 294, 344*n*;
 suspicion of art theory/academia, 121, 150,
 154–5, 189, 195, 234, 246, 282; and tableaux
 vivants, 24, 34, 94, 107, 176, 191, 219;
 teaching career of, 31, 38–41, 44, 46, 49, *51*,
 54, 110, 148–9, 154, *154*, 164, 166–7, 195,
 264, 271, 282–4, 287, 289, 311, 325–6*n*,
 327*n*; teenage years in Cedar Rapids, 24–5,
 27–8, *27*, 34, *36*, 53, 61, *62*, 94, 96, 125, 148,
 154, 201, 212, 247, 281, 285, 345*n*; and
 theater, 4, 24–5, 34, 38, 45, 52, 54, 56, 58,
 63, 94, 118, 120, 129, 138, 143, 169, 175–6,
 190–1, 218, 225, 238, 243, 261, 266,
 269–71, 273–5, 278, 280, 307, 364*n*, 365*n*
 (*see also* Wood, Grant: and costumes/
 costume parties; Wood, Grant: curtains,
 fascination with; Wood, Grant: and
 tableaux vivants); threats to career of, 61,
 107–108, 166, 188, 197, 207, 232, 236, 244,
 245–6, 259–60, 264, 282–7, 308–9; and
 Time, 163, 168, 176–7, 182, 194, 207, 267,
 283–4, 287, 289, 298, 301, 327*n*, 358*n*; and
 tintypes, *13*, *14*, 15, 96, 116, *117*, 119, 191,
 193, 219, 321*n*, 335*n*; titles, significance of,
 72–3, 82, 84, 91, 141, 144, 159, 226, 240,
 244, 247, 251, 258–9, 280, 292, 363*n*; and
 transparency, 5, 6, 10, 78, 87, 139–40, 142,
 148, 185; trees in work of, 9, 14, 83, 112–13,
 115, 125, 132, 135, 138, 148, 156, 253, 265–6,
 273–5, 277, 279, 338*n*, 366*n*; and U.S.
 Postal Service ban, 246, 259–60, 361*n*,
 362*n*; and vaginal imagery, 123–6, 137, 142,
 344*n*; vanishing points, use of, 92, 175,
 267, 276, 278–9, 367*n*; voice/speech, 20,
 23–4, 61, 82, 114–15, 118, 237–8, 339*n*; and
 voyeurism, 115, 172, 244, 246–9, 251, 280;
 and willowware china, 132, 159, 219, 243,
 342*n*; windmills in work of, 81, 160, 176;
 working method of, 4, 24, 29, 32, 41–2,
 49, 63, 72, 78, 106, 118, 121–2, 127, 133–4,
 142, 159–60, 163, 220–21, 245–6, 248,
 257–8, 265, 269, 275, 278, 281, 287, *290*,
 292, 331*n*, 363*n*, 350*n*, 366*n*, 366–7*n*;
 individual works

Wood, Hattie (*née* Weaver; color plate 4),
 3, 13–20, *14*, 23–4, 33–5, 38, *40*, 45, 53,
 55–6, 58, 60, 63, 69, 75–6, 78–90, *88*,
 107, 109, 112, 116, 119–20, 123, 130,
 151–2, 159, 164–5, 175–6, 190, 198, 200,
 204–5, 207, 209–11, 213, 219, 220–2,
 231, 263–5, 270, 277–9, 281, 321*n*, 322*n*,
 332*n*, 335*n*, 345*n*, 355*n*; *American Gothic*,
 connection to, 95–102, *99*, 303; death
 of, 3, 195–7, 215–17, 221, 239, 275, 278–9,
 292, 356*n*, 359*n*; *see also Woman with
 Plants*; Wood, Grant: relationship with
 mother
Wood, Jack, 14–17, 19, 29, 34, 217, 322*n*,
 331*n*; *see also* Wood, Grant: relationship
 with brothers
Wood, Joseph, 12–14, 277
Wood, Maryville, 3, 6, 11, 12–15, *13*, 15–20,
 25, 27, 38, 53, 66, 76, 79–81, 89, 119, 129,
 133, 146–8, 152, 154–5, 161, 164, 173, *173*,
 199–200, 212, 217, 219, 242, 264, 272–5,
 277–9, 281, 291–2, 321*n*, 322*n*, 336*n*, 349*n*;
 American Gothic, role in, 96–101, 119, 146,
 184, 212, 274, 355*n*; appearance of, 13, 96,
 174, 212; death of, 12, 21–3, 82, 86, 93, 95,
 137–8, 174–6, 196, 211, 237–8, 273–4, 279,
 305, 344–5*n*; wedding of, 12–13, 15, 81, 82,
 332*n*; *see also* Wood, Grant: relationship
 with father
Wood, Nan, *see* Graham, Nan Wood
Wood, Rebecca, 12, 277
Wood, Sallie (Aunt Sallie), 13, 16, 119, 190,
 270, 321*n*
Wood, Sara, *see* Sherman, Sara McClain
Wooden, H. E., 252
Woodrow Wilson School (Cedar Rapids),
 343*n*
Woodstock, Vermont, 104
Woollcott, Alexander, 243
Works Progress Administration (WPA); *see
 also* Public Works of Art Project 165
Wright, Don, 9

*Yellow Doorway, St. Emilion (Port des
 cloîtres de l'Eglise Collegiale)* (color plate 5),
 63–4
Yllö, Kersti, 316
Yoseloff, Tom, 193
Young Corn, 136, *137*, 216, 343*n*
Young, Paul, 265, 365*n*

Zimmerman, Harland, 94
Zug, John, 354*n*, 371
Zwart, Elizabeth Clarkson, 133

FRONTISPIECE and 74: Grant Wood, *Return from Bohemia*, 1935. Crayon, gouache, and pencil on paper, 23½ x 20 in. © Estate of Grant Wood / Licensed by VAGA. Figge Art Museum, Davenport, Iowa.

9 Don Wright, *Iowa;* first published April 7, 2009. © Tribune Media Services, Inc. All rights reserved. Reprinted with permission.

13 Francis Maryville Wood. Tintype, c. 1875. State Historical Society of Iowa, from Nan Wood Graham.

14 Hattie D. Weaver. Tintype, 1874. State Historical Society of Iowa, from Nan Wood Graham.

17 Wood farmhouse in Anamosa, Iowa. Date unknown. Cedar Rapids Museum of Art Archives.

22 Grant Wood in 1901. State Historical Society of Iowa, from Nan Wood Graham.

27 Grant Wood, *Senior Class,* 1908. Washington High School *Reveille.* Cedar Rapids Museum of Art Archives.

30 Grant Wood, *Fanciful Depiction of Round-House and Power Plant,* 1920. Oil on canvas, 35¾ x 72¾ in. Cedar Rapids Museum of Art, on permanent loan from St. Luke's Methodist Hospital Collection. L1975.10.

35 Shed along Indian Creek, c. 1916–17. Cedar Rapids Museum of Art Archives.

35 3178 Grove Court, Kenwood Park. State Historical Society of Iowa.

36 Washington High School class of 1910. State Historical Society of Iowa.

37 Paul C. Hanson, 1909. Postcard sent by Paul Hanson from Dubuque, Iowa, to Mrs. A. L. Adams, Cedar Rapids, Iowa. Cedar Rapids Museum of Art Archives, gift of Don Hanson.

37 Vida H. Hanson, 1923. Cedar Rapids Museum of Art Archives, gift of Don Hanson. Photo: Paul C. Hanson.

39 Grant Wood, 1917. Cedar Rapids Museum of Art Archives.

40 Hattie Wood, 1919. Courtesy of the Grant Wood Archive, Figge Art Museum, Davenport, Iowa.

40 Frances "Fan" Prescott in the 1920s. Cedar Rapids Museum of Art Archives. Photographer unknown.

46 Grant Wood, 1920. Cedar Rapids Museum of Art, gift of John B. Turner II in memory of Happy Young Turner. S7.7. Photo: Marvin Cone.

50 Grant Wood, Christmas Card, 1923. Cedar Rapids Museum of Art.

51 Grant Wood with his McKinley Junior High School art students, 1921. Cedar Rapids Museum of Art Archives.

51 *The Imagination Isles* (detail), 1921. State Historical Society of Iowa.

55 5 Turner Alley, Cedar Rapids. Author photo (2009).

56 5 Turner Alley interior, looking west, c. 1925. Cedar Rapids Museum of Art Archives. Photo: John W. Barry.

57 Grant Wood, door to 5 Turner Alley, 1924. Painted wood, fabric, glass, and wrought iron, 78 x 29⅞ x 1¾ in. Cedar Rapids Museum of Art, gift of Harriet Y. and John B. Turner II. 72.12.15.

62 Grant Wood, 1910. Cedar Rapids Museum of Art Archives.

67 Grant Wood, sketch for *Cannoneer, War of 1812 (Memorial Window)*, 1928. Charcoal, ink, and pencil on paper, 79¾ x 22¾ in. © Estate of Grant Wood / Licensed by VAGA. Figge Art Museum, Davenport, Iowa.

69 Grant Wood in Munich, Germany, fall 1928. State Historical Society of Iowa, gift of Joan Liffring-Zug Bourret.

75 Nan Wood, 1917. State Historical Society of Iowa, from Nan Wood Graham.

84 Grant Wood, *Cocks-Combs*, c. 1925–29. Oil on canvas, 21½ x 21¼ in. © Estate of Grant Wood / Licensed by VAGA. Private Collection.

87 Cameo from *American Gothic*. Figge Art Museum, Davenport, Iowa.

88 Hattie Wood, 1929. State Historical Society of Iowa.

99 Grant Wood, *American Gothic* (detail), 1930 (see color plate 7). Oil on beaver board, 30¹¹⁄₁₆ x 25¹¹⁄₁₆ in., unframed. Friends of American Art Collection, 1930.934, © The Art Institute of Chicago and VAGA / Estate of Grant Wood. Photography © The Art Institute of Chicago.

99 Grant Wood, *Woman with Plants* (detail), 1929 (see color plate 4). Oil on composition board, 20½ x 18 in. Cedar Rapids Museum of Art.

110 Carl Flick, 1937. State Historical Society of Iowa. Photo: Paul E. Kellenberger.

111 Arnold Pyle, 1932. Cedar Rapids Museum of Art Archives. Photo: John W. Barry.

117 Matilda Peet, tintype, 3½ x 2⅛ in. Courtesy of the Grant Wood Archive, Figge Museum of Art, Davenport, Iowa.

137 Grant Wood, *Young Corn*, 1931. Oil on masonite panel, 24 x 29⅞ in. Cedar Rapids Community School District Collection, on loan to the Cedar Rapids Museum of Art. L1.70.3.177.

141 Grant Wood, *Appraisal* (detail), 1931 (see color plate 13).

141 Ed Rowan, 1932. Cedar Rapids Museum of Art Archives. Photo: John W. Barry.

149 Stone City Art Colony, 1932. State Historical Society of Iowa. Photo: John W. Barry.

150 Grant Wood at Stone City Art Colony, summer 1932. Cedar Rapids Museum of Art Archives. Photo: John W. Barry.

152 Students at the Stone City Art Colony, 1932. State Historical Society of Iowa. Photo: John W. Barry.

153 Adrian Dornbush and Grant Wood, summer 1932. Cedar Rapids Museum of Art Archives. Photo: John W. Barry.

154 Life-drawing class at Stone City Art Colony, 1932. State Historical Society of Iowa. Photo: John W. Barry.

162 John Steuart Curry and Grant Wood at the Stone City Art Colony, Iowa, 1933. Cedar Rapids Art Museum Archives. Photo: John W. Barry.

170–71 Grant Wood, *Dinner for Threshers*, 1934. Oil on hardboard panel, 20 x 80 in. Fine Arts Museums of San Francisco, gift of Mr. and Mrs. John D. Rockefeller 3rd, 1979.7.105.

173 Grant Wood, *Dinner for Threshers* (detail), 1934. Oil on hardboard panel, 20 x 80 in. Fine Arts Museums of San Francisco, gift of Mr. and Mrs. John D. Rockefeller 3rd, 1979.7.105.

174 Grant Wood, *Mourner's Bench*, c. 1921–22. Oak, 37 x 49 x 16 in. Cedar Rapids Community School District Collection, on loan to the Cedar Rapids Museum of Art. L1.70.3.169.

181 Thomas Hart Benton, *Self-Portrait*, 1925. Oil on canvas, 30 x 24 in. © T. H. Benton and R. P. Benton Testamentary Trusts / UMB Bank/Licensed by VAGA. Collection of Jessie Benton Lyman.

189 Interior, The Society for the Prevention of Cruelty to Speakers, Iowa City, Iowa c. 1935. State Historical Society of Iowa, Society for the Prevention of Cruelty to Speakers Collection.

192 Grant Wood and Thomas Hart Benton, 1935. State Historical Society of Iowa, Society for the Prevention of Cruelty to Speakers Collection.

192 Thomas Duncan and MacKinlay Kantor, c. 1936. State Historical Society of Iowa, Society for the Prevention of Cruelty to Speakers Collection.

199 Grant and Sara Wood, c. 1935. Courtesy of the Grant Wood Archive, Figge Art Museum, Davenport, Iowa.

203 Sara Sherman Maxon, c. 1912. Used by permission of Ed Bartholomew / Estate of Sara McClain Sherman.

213 Grant Wood, *Spilt Milk,* for Madeline Darrough Horn's *Farm on the Hill* (New York: Scribner, 1936). Colored lithograph, 7 x 9½ in. Cedar Rapids Museum of Art.

214 Grant and Sara Wood, 1935. Cedar Rapids Museum of Art Archives.

218 1142 East Court Street, Iowa City, Iowa, c. 1935. Cedar Rapids Museum of Art Archives.

222 Grant Wood and Nan Wood Graham, c. 1939. Cedar Rapids Museum of Art Archives.

224 Grant Wood, *The Radical,* 1936. Crayon, gouache, and pencil on paper, 20½ x 16 in. Private Collection.

224 Grant Wood, *The Perfectionist,* 1936–37. Black and white crayon, graphite, black ink, and transparent and opaque watercolor on brown wove paper, 25⁹⁄₁₆ x 19¹⁵⁄₁₆ in. Fine Arts Museums of San Francisco, gift of Mr. and Mrs. John D. Rockefeller 3rd, 1979.7.106.

224 Grant Wood, *Sentimental Yearner,* 1936–37. Crayon, gouache, and pencil on paper, 20½ x 16 in. Minneapolis Institute of Arts.

226 Grant Wood, *Draft Horse* and *Race Horse,* 1933. Charcoal, pencil, and chalk on paper, 16 x 22½ in. (oval). Private Collection.

227 Grant Wood, *Tame Flowers,* 1938. Hand-colored lithograph, 7 x 10 in. Cedar Rapids Museum of Art.

228 Grant Wood, *Lilies of the Alley,* 1925. Ceramic, paint, wire, and found objects, 12 x 12 x 6½ in. Cedar Rapids Museum of Art, gift of Harriet Y. and John B. Turner II. 72.12.38.

231 Grant Wood, *In Tragic Life* jacket cover, 1934; Vardis Fisher, *In Tragic Life* (New York: Doubleday and Doran, 1934). Photograph, State Historical Society of Iowa; by permission of Random House, Inc.

237 Park Rinard and Grant Wood, late 1930s. Courtesy of the Grant Wood Archive, Figge Art Museum, Davenport, Iowa.

239 John Steuart Curry, Grant Wood, and Thomas Hart Benton, 1938. *Life* 4, no.2 (21 March 1938), p. 62.

241 Napoleon Sarony, *Eugen Sandow,* 1893. Library of Congress.

241 Thomas Eakins, *Swimming,* 1885. Oil on canvas, 27⅜ x 36⅜ in. Amon Carter Museum, Forth Worth, Texas, Purchased by the Friends of Art, Fort Worth Association, 1925; acquired by the Amon Carter Museum, 1990, from the Modern Art Museum of Fort Worth through grants and donations from the Amon G. Carter Foundation, the Sid W. Richardson Foundation, the Anne Burnett and Charles Tandy Foundation, Capital Cities / ABC Foundation, *Forth Worth Star-Telegram,* The R. D. and Joan Dale Hubbard Foundation and the people of Fort Worth.

245 Grant Wood, *Sultry Night,* 1937. Lithograph, 9 x 11¾ in. Cedar Rapids Museum of Art, gift of Peter O. Stamats. 85.3.7.

248 Grant Wood, *Nude Bather* (alternate title: *Peter Funcke at Indian Creek, Cedar Rapids, Iowa*), c. 1920. Oil on canvas, triptych, 24 x 50 in. © Estate of Grant Wood / Licensed by VAGA. Collection Muscatine Art Center, Muscatine, Iowa. Gift of E. Bradford Burns. 1995.93.

249 Grant Wood, *Saturday Night Bath,* for Madeline Darrough Horn's *Farm on the Hill* (New York: Scribner, 1936). Colored lithograph, 7 x 9½ in. Cedar Rapids Museum of Art.

250 Grant Wood, *Saturday Night Bath,* 1937. Charcoal on paper, 19 x 23 in. © Estate of Grant Wood / Licensed by VAGA. Private Collection.

253 Grant Wood, *First Three Degrees of Free Masonry,* 1921. Oil on canvas, triptych, 32 x 99 in. The Grand Lodge of Iowa / Iowa Masonic Library, Cedar Rapids, Iowa.

253 Critius and Nesiotes, *The Tyrannicides:* Harmodius (right) and Aristogeiton. © National Archaeological Museum, Naples.

255 Grant Wood, *Charles Manson as Silenus,* 1928. Chalk and paint on paper, 36 x 29 in. © Estate of Grant Wood / Licensed by VAGA. Private Collection.

257 Grant Wood, *Fertility,* 1939. Lithograph, 8¹⁵⁄₁₆ x 11⅞ in. Cedar Rapids Museum of Art, gift of Harriet Y. and John B. Turner II. 72.12.67.

258 Grant Wood and Eric Knight, 1941. State Historical Society of Iowa, from Nan Wood Graham.

268 Charles Willson Peale, *The Artist in His Museum,* 1822. Oil on canvas, 104 x 80 in. Pennsylvania Academy of Fine Arts.

269 Grant Wood, *Shrine Quartet,* 1939. Lithograph, 7½ x 12 in. Cedar Rapids Museum of Art, gift of Mr. Peter O. Stamats and Mr. Larry K. Zirbel. 85.6.1.

283 Grant Wood with Ed Graham and Nan Wood Graham, 1940. State Historical Society of Iowa, from Nan Wood Graham.

288 Grant Wood's studio in Clear Lake, Iowa, 1941. Cedar Rapids Museum of Art Archives.

290 Grant Wood sketching a University of Iowa student model for *Spring in the Country,* 1941. State Historical Society of Iowa.

291 Grant Wood, Malibu, 1940. Courtesy of the Grant Wood Archive, Figge Art Museum, Davenport, Iowa.

302 Nan Wood Graham and Dr. B. H. McKeeby next to *American Gothic,* Art Institute of Chicago, c. 1942. Cedar Rapids Museum of Art Archives.

304 Nan Wood Graham, Riverside, California (1975). © Joan Liffring-Zug Bourret Photos.

312 Sara McClain Sherman, Orcas Island, Washington, 1958. Used by permission of Ed Bartholomew / Estate of Sara McClain Sherman.

COLOR PLATES

1. Grant Wood, *Van Antwerp Place,* 1922–23. Oil on composition board, 12⅞ x 14⅞ in. Cedar Rapids Museum of Art, gift of Harriet Y. and John B. Turner II. 72.12.78.

2. Grant Wood, *Adoration of the Home,* 1921–22. Oil on canvas attached to wood panel, 22¾ x 81⅜ in. Cedar Rapids Museum of Art, gift of Mr. and Mrs. Peter F. Bezanson. 80.1.

3. Grant Wood, *The Spotted Man,* 1924. Oil on canvas, 32 x 20 in. © Estate of Grant Wood / Licensed by VAGA. Figge Art Museum, Davenport, Iowa.

4. Grant Wood, *Woman with Plants,* 1929. Oil on upsom board, 20½ x 17⅞ in. Cedar Rapids Museum of Art, museum purchase, 31.1.

5. Grant Wood, *Yellow Doorway, St. Emilion (Port des Cloîtres de l'Eglise Collegiale)*, 1924. Oil on composition board, 16½ x 13 in. Cedar Rapids Museum of Art, gift of Harriet Y. and John B. Turner II. 72.12.78.

6. Grant Wood (designer), *Memorial Window*, 1928–29. Emil Frei Art Glass Company, Munich, Germany (fabricator). Stained glass, 24 x 20 ft. Courtesy of the Veterans Memorial Commission, Veterans Memorial Building, Cedar Rapids.

7. Grant Wood, *American Gothic*, 1930. Oil on beaver board, 30¹¹⁄₁₆ x 25¹¹⁄₁₆ in., unframed. Friends of American Art Collection, 1930.934, © The Art Institute of Chicago and VAGA / Estate of Grant Wood. Photography © The Art Institute of Chicago.

8. Grant Wood, *Fall Plowing*, 1931. Oil on canvas, 30 x 40¾ in. The John Deere Art Collection, Deere & Company, Moline, IL.

9. Grant Wood, *Stone City*, 1930. Oil on composition board, 30¼ x 40 in. © Estate of Grant Wood/Licensed by VAGA. Joslyn Art Museum, Omaha, Nebraska.

10. Grant Wood, *Portrait of Nan*, 1931. Oil on masonite, 34½ x 28½ in. (oval). © Estate of Grant Wood / Licensed by VAGA. Chazen Museum of Art, University of Wisconsin–Madison, Collection of William Benton, 1.1981.

11. Grant Wood, *Arnold Comes of Age*, 1930. Oil on composition board, 26¾ x 23 in. © Estate of Grant Wood / Licensed by VAGA. Sheldon Museum of Art, University of Nebraska–Lincoln, NAA—Nebraska Art Association Collection. Photography © Sheldon Museum of Art.

12. Grant Wood, *Self-Portrait*, 1932–41. Oil on masonite panel, 14¾ x 12⅜ in. © Estate of Grant Wood / Licensed by VAGA. Figge Art Museum, Davenport, Iowa.

13. Grant Wood, *Appraisal*, 1931. Oil on composition board, 29½ x 35¼ in. Dubuque Museum of Art. On long-term loan from the Carnegie-Stout Public Library, acquired through the Lull Art Fund.

14. Grant Wood, *The Birthplace of Herbert Hoover*, 1931. Oil on masonite, 30 x 40 in. © Estate of Grant Wood / Licensed by VAGA. Des Moines Art Center Permanent Collections; purchased jointly by the Des Moines Art Center and The Minneapolis Institute of Fine Arts; with funds from the Edmundson Art Foundation, Inc., Mrs. Howard H. Frank, and the John R. Van Derlip Fund, 1982.2.

15. Grant Wood, *Midnight Ride of Paul Revere*, 1931. Oil on masonite, 30 x 40 in. © Estate of Grant Wood / Licensed by VAGA. The Metropolitan Museum of Art, Arthur Hoppock Hearn Fund, 1950 (50.117). Image copyright © The Metropolitan Museum of Art/Art Resource, New York.

16. Grant Wood, *Victorian Survival*, 1931. Oil on composition board, 32½ x 26¼ in. Dubuque Museum of Art. On long-term loan from the Carnegie-Stout Public Library, acquired through the Lull Art Fund.

17. Grant Wood, *Farmer with Corn and Pigs, Fruits of Iowa* Mural for Hotel Montrose, 1932. Oil on canvas, 71¼ (H) in. Collection of Coe College, Cedar Rapids, Iowa, gift from the Eugene C. Eppley Foundation.

18. Grant Wood, *Portrait of John B. Turner, Pioneer*, 1928–30. Oil on canvas, 30¼ x 25½ in. Cedar Rapids Museum of Art, gift of Harriet Y. and John B. Turner II. 76.2.2.

19. Grant Wood, *Daughters of Revolution*, 1932. Oil on masonite panel, 20 x 40 in. Cincinnati Art Museum, The Edwin and Virginia Irwin Memorial, 1959.46.

20. Grant Wood, *Death on the Ridge Road*, 1935. Oil on masonite panel, 39 x 46¹⁄₁₆ in. in frame © Estate of Grant Wood / Licensed by VAGA. Williams College Museum of Art, Williamstown, Massachusetts, Gift of Cole Porter (47.I.3).

21. Grant Wood, *Spring Turning*, 1936. Oil on masonite panel, 18⅛ x 40 in. © Estate of Grant Wood / Licensed by VAGA. Reynolda House Museum of American Art, Winston-Salem, North Carolina.

22. John Steuart Curry, *Kansas Cornfield,* 1933. Oil on canvas, 60 x 38 in. The Roland P. Murdoch Collection, Wichita Art Museum, Wichita, Kansas.

23. Grant Wood, *Near Sundown,* 1933. Oil on masonite panel, 15 x 26½ in. © Estate of Grant Wood / Licensed by VAGA. Spencer Museum of Art, Gift from George Cukor, 1959.0070.

24. Grant Wood, *Parson Weems' Fable,* 1939. Oil on canvas, 38⅜ x 50⅛ in. Amon Carter Museum, Forth Worth, Texas, 1970.43.

25. Grant Wood, *Iowa Landscape / Indian Summer,* 1941. Oil on masonite panel, 13 x 15 in. © Estate of Grant Wood / Licensed by VAGA. Figge Art Museum, Davenport, Iowa.

26. Grant Wood, *Adolescence,* 1940. Oil on masonite panel, 20⅜ x 11¾ in. Image courtesy of Abbott Laboratories.